JOHN CONSTABLE

JOHN CONSTABLE

A Portrait

JAMES HAMILTON

PEGASUS BOOKS

NEW YORK LONDON

JOHN CONSTABLE

Pegasus Books, Ltd.
148 West 37th Street, 13th Floor
New York, NY 10018

Copyright © 2022 by James Hamilton

First Pegasus Books cloth edition November 2022

ISBN: 978-1-63936-272-1

10 9 8 7 6 5 4 3 2 1

Printed in the United States of America
Distributed by Simon & Schuster
www.pegasusbooks.com

For Zoë, my granddaughter;
to the memory of Ronald Brymer Beckett;
and to Mrs Watkins of Daisy Green.

Contents

III. *Opera: 1816–1828*

IV. *Unfinished Symphony: 1828–1837*

'I must take care of being an author, it is quite enough to be a painter.'

<div style="text-align:right">John Constable to William Purton, 17 December 1834</div>

Illustrations

East Bergholt House, 1810. Oil on board, 18.1 x 50.5 cm. V&A, London © V&A

A barge below Flatford Lock, 1810. Oil on canvas, 19.7 x 32.4 cm. Yale Center for British Art, New Haven © Alamy

Dedham Vale: Morning, 1811. Oil on canvas, 78.8 x 129.5 cm. Elton Hall Collection

Barges on the Stour at Flatford Lock, 1811. Oil on canvas laid on panel, 26 x 31.1 cm. V&A, London © Alamy

The Village Feast, East Bergholt, 1814. Oil on canvas, 23. 33.5 cm. National Museum of Fine Arts, Budapest © Alamy

Boat-Building near Flatford Mill, 1815. Oil on canvas, 50.8 x 61.6 cm. V&A, London © Alamy

Weymouth Bay, 1816. Oil on millboard, 20.3 x 24.7 cm. V&A, London © Alamy

Plate section 2

The White Horse, 1819. Oil on canvas, 131.5 x 187.8 cm. Frick Collection, New York © Alamy

Branch Hill Pond, Hampstead, 1819. Oil on canvas, 25.4 x 30 cm. V&A, London © Alamy

The Hay Wain, 1821. Oil on canvas, 130.5 x 185.5 cm. National Gallery, London © Alamy

Storm clouds over Hampstead, c.1822. Oil on millboard, 40.6 x 69.2 cm. Lowell Libson & Jonny Yarker Ltd, London

Golding Constable shooting duck on the River Stour, 1827. Pencil, 22.5 x 33.2 cm. Lowell Libson & Jonny Yarker Ltd, London

View from Hampstead Heath, looking towards Harrow, 1821. Oil on canvas, 25 x 29.8 cm. Manchester Art Gallery © Bridgeman Images

Salisbury Cathedral from the Bishop's Grounds, 1823. Oil on canvas, 87.6 x 111.8 cm. V&A, London © Alamy

A rain storm over the sea, 1824. Oil on paper laid to canvas, 22.2 x 31 cm. Royal Academy of Arts, London © Alamy

The Leaping Horse, 1825. Oil on canvas, 142.2 x 187.3 cm. Royal Academy of Arts, London © Alamy

The Cornfield, 1826. Oil on canvas, 143 x 122 cm. National Gallery, London © Alamy

Chain Pier, Brighton, 1826-27. Oil on canvas, 127 x 183 cm, Tate Britain, London © Alamy

Hadleigh Castle, 1829. Oil on canvas, 122 x 164.5 cm. Yale Center for British Art, New Haven © Alamy

The Opening of Waterloo Bridge seen from Whitehall Stairs, June 18th 1817, 1832. Oil on canvas, 134.6 x 219.7 cm. Tate Britain, London © Alamy

Cenotaph to the Memory of Sir Joshua Reynolds, 1836. Oil on canvas, 132 x 108.5 cm. National Gallery, London © Alamy

Salisbury Cathedral from the Meadows, 1837. Mezzotint, by David Lucas, after John Constable. © Alamy

Arundel Mill and Castle, 1837. Oil on canvas, 72.4 x 100.3 cm. Toledo Museum of Art, Ohio © Alamy

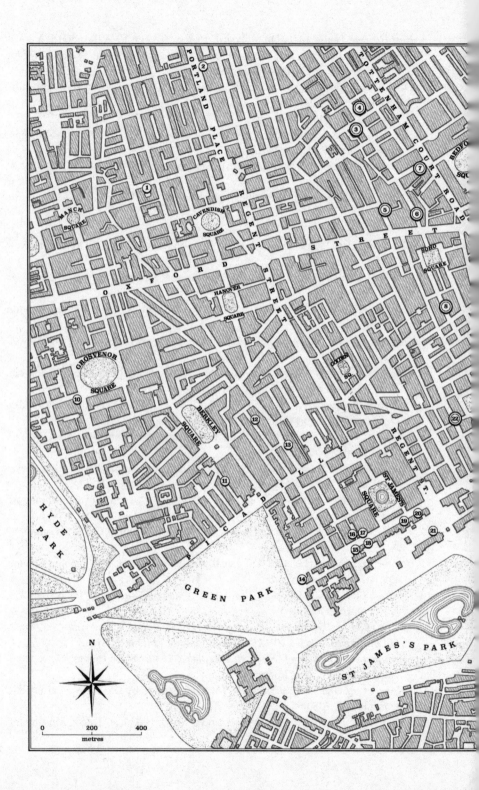

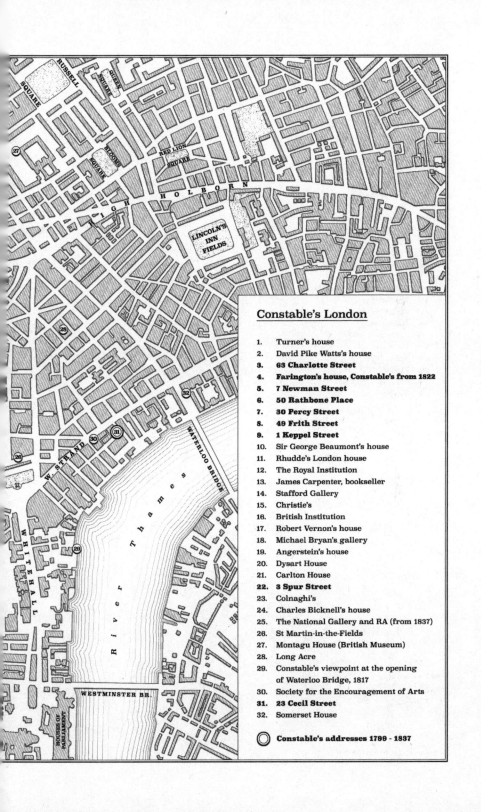

Constable's London

1. Turner's house
2. David Pike Watts's house
3. **63 Charlotte Street**
4. **Farington's house, Constable's from 1822**
5. **7 Newman Street**
6. **50 Rathbone Place**
7. **30 Percy Street**
8. **49 Frith Street**
9. **1 Keppel Street**
10. Sir George Beaumont's house
11. Rhudde's London house
12. The Royal Institution
13. James Carpenter, bookseller
14. Stafford Gallery
15. Christie's
16. British Institution
17. Robert Vernon's house
18. Michael Bryan's gallery
19. Angerstein's house
20. Dysart House
21. Carlton House
22. **3 Spur Street**
23. Colnaghi's
24. Charles Bicknell's house
25. The National Gallery and RA (from 1837)
26. St Martin-in-the-Fields
27. Montagu House (British Museum)
28. Long Acre
29. Constable's viewpoint at the opening of Waterloo Bridge, 1817
30. Society for the Encouragement of Arts
31. **23 Cecil Street**
32. Somerset House

◯ **Constable's addresses 1799 - 1837**

The Stour Valley in Constable's Day

1. Assembly Rooms
2. St Mary's Church, Dedham
3. Grimwood's School
4. Dedham Hall
5. Dedham Mill
6. Constable's studio
7. The Lion
8. The Gables (later the Bear Inn)
9. West Lodge
10. The Lambe School
11. John Dunthorne's cottage
12. East Bergholt House
13. Little Court
14. St Mary's Church, East Bergholt
15. Old Hall
16. William Travis, surgeon
17. The Rectory
18. King's Head
19. Burnt Oak
20. Flatford Lock
21. Dry dock
22. Valley Farm
23. Flatford Mill
24. Willy Lott's house
25. The Spong

- - - - - - - - - Half hour's walk between East Bergholt and Dedham

Golding Constable's approximate land holdings in East Bergholt and Flatford

River Stour

S U F

E S

Dedham

To The Rookery & Langham

To Colchester

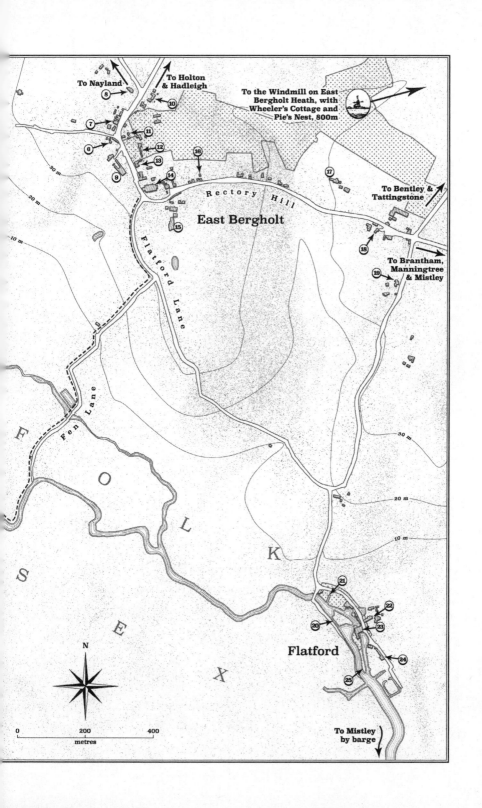

To Nayland
8

To Holton
& Hadleigh
10

To the Windmill on East
Bergholt Heath, with
Wheeler's Cottage and
Pie's Nest, 800m

7
11
6
12
9 13 16
14
17

30 m
20 m
10 m

To Bentley &
Tattingstone

18

15 *Rectory Hill*

East Bergholt

Flatford Lane

To Brantham,
Manningtree
& Mistley
19

Fen Lane

F
O
L
K

30 m

20 m

10 m

S

E

X

N

21
22
23
20
Flatford
24
25

To Mistley
by barge

0 200 400
 metres

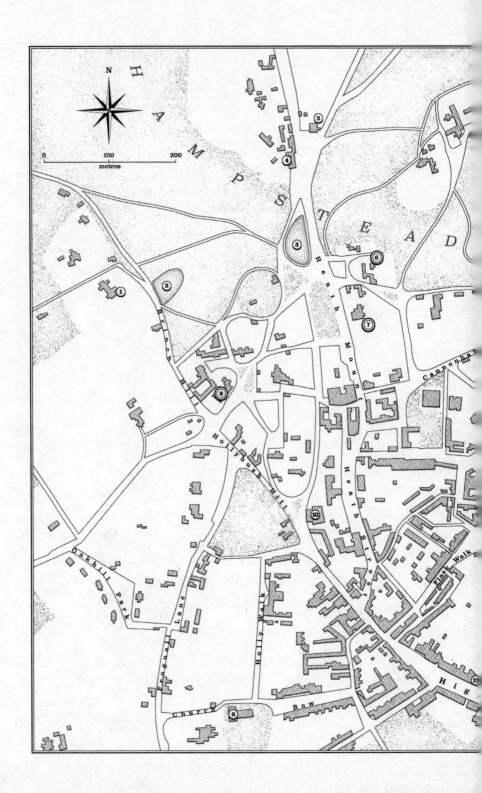

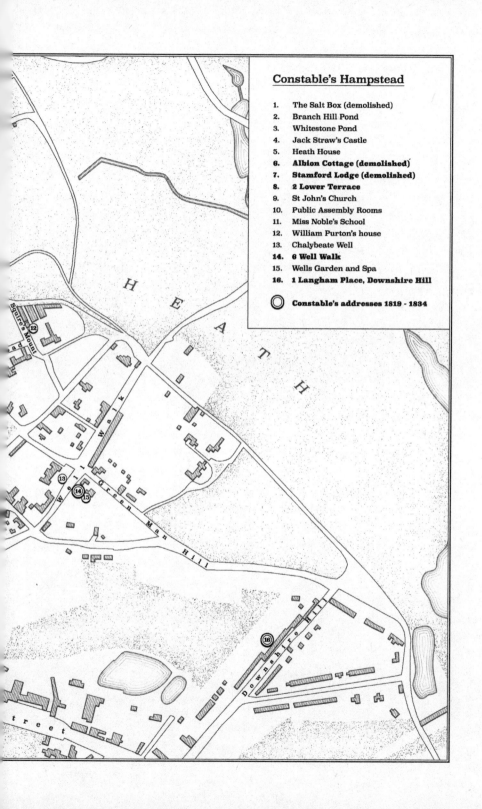

Constable's Hampstead

1. The Salt Box (demolished)
2. Branch Hill Pond
3. Whitestone Pond
4. Jack Straw's Castle
5. Heath House
6. **Albion Cottage (demolished)**
7. **Stamford Lodge (demolished)**
8. **2 Lower Terrace**
9. St John's Church
10. Public Assembly Rooms
11. Miss Noble's School
12. William Purton's house
13. Chalybeate Well
14. **6 Well Walk**
15. Wells Garden and Spa
16. **1 Langham Place, Downshire Hill**

⊚ **Constable's addresses 1819 - 1834**

Acknowledgements

My thanks go to all these generous and helpful people who have assisted the creation of this book: Nicola Allen, Woburn Abbey; John Bachelor; Claire Barker; Hugh Belsey; Mark Bills, Director, Gainsborough's House; Claire Browne, HCUK Group; Fiona and Tom Carville; Marjorie Caygill; Tanya Christian, Suffolk Records Society; Valerie Constable; Jane Corbin; Bury Record Office staff; Jeff Cowton, Wordsworth Trust, Grasmere; Tom Fenton; James Fishwick; Rosie Fogarty, Barclay's Group Archives; Stephen Freer, Archivist, Merchant Taylors' Company; Brad Feltham and Barbara Galloway, Artists' General Benevolent Institution; Corinne Gibbons; Sally Gilbert, Archivist, Merchant Taylors' School; Adrian Glew, Federica Beretta and Victoria Jenkins, Tate Archive; Amanda Goode, Archivist, Emmanuel College, Cambridge; Victor Gray, Archivist, Helmingham Hall; Francis Greenacre; David Hackett; Harriet Hansell, Society of Antiquaries; Emma Harper; Ipswich Record Office staff; John Hibbert; Ellen Higgs, Waddesdon Archive; Penny Hopwood; Francesca Hillier, Archivist, British Museum; Malcolm Holmes; Penny Hughes-Stanton, Constable Trust; Chris Hunt; Richard Jenkyns; Simon Jervis; Rev. Roxane Liddell; Anne Lyles; Stephanie Macdonald; Peter Mcdonald; Margaret Macmillan; Norman Macsween; Jane McCausland; James Miller; Irene Money; David Moore-Gwyn; Susan Morris; Tessa Murdoch; Oswyn Murray; the Earl of Plymouth; Mark Pomeroy, Archivist, Royal Academy; Sir William and Lady Proby; Jennie de Protani, Archivist, The Athenaeum; Christine Pullen; John Martin Robinson; Emma Roodhouse, Colchester and Ipswich Museums; Michael Rosenthal; Lucy Saint-Smith, Friends House Library; the late Anne Sanders; Maria Sienkiewicz, Barclay's Group Archive; Nicholas Sign, Editor, *Suffolk Review*; Karen Smith; Ingrid Smits; Janaki Spedding; John Spedding; Nicholas Stogdon; Suffolk Local

History Council; Suffolk Records Society; Luke Thorne, Linnean Society; John E. Thornes; Lord Tollemache; Michel Tollemache Fine Art London; Karen Waddell and the British Library News Reference Team; Rosemary and Stephen Watkins; Jenny Watts-Russell; Patrick Wildgust, Laurence Sterne Trust; Jonny Yarker; and in East Bergholt: Charity Birch, Jenny Chapman, the late Pansy Cooper, Alicia Herbert, Paul and Birte Kelly, Traute Leseberg, John Lyall, Chris and Coral McEwan, Nicki Reed and Patricia Wright. Six readers, each of whom is named above, have been patient, diligent and firm with my text, and I thank them all for their good sense and steering. My agent and friend, the late Felicity Bryan, her colleague Carrie Plitt, Alan Samson, Sarah Fortune, Sue Lascelles and Kate Moreton of Weidenfeld & Nicolson, and Jamie Whyte who drew the maps, have helped this book through to publication. My wife Kate Eustace has been living with Mr Constable now for long enough, and I thank her from the bottom of my heart for her love and forbearance.

Quotations have been made by gracious permission of Her Majesty Queen Elizabeth II, and by permission from the Suffolk Records Society, East Bergholt Society, Tate Archive, Val Constable and the Earl of Plymouth. If there are any copyright holders whose permission I have failed to ask, please would they accept my apologies and contact me.

Author's Note

Constable had a consistent practice in his correspondence and journals of placing 'e' before 'i' in words such as 'feild', 'beleive' and 'peice'. He could spell perfectly well, but this is just what he did. For clarity, and the avoidance of irritation and the over-use of *'sic'* I have silently adjusted these spellings to 'field', 'believe', 'piece' and so on.

This book has fewer illustrations than its text desires, so I recommend that readers use the internet to search for pictures discussed, most of which will be readily available from references given.

James Hamilton
November 2021

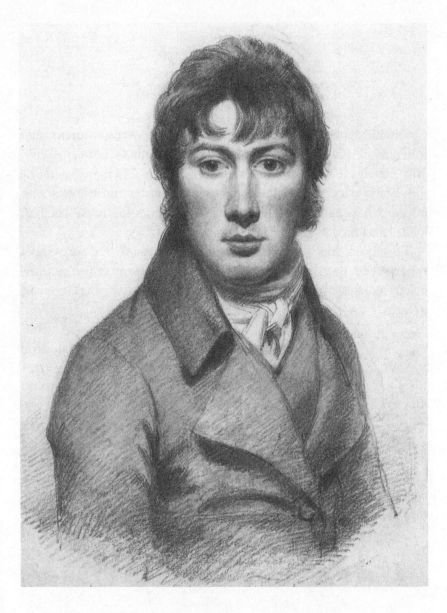

Self Portrait, *c.*1804
Pencil and black chalk, with red and white chalk,
National Portrait Gallery, London

Introduction

'It has rather a more novel look than I expected'. So wrote John Constable of *The Hay Wain* in 1821, three or four days before sending it to be shown in public for the first time.[1] Surprise and astonishment veined his response to his work, as it did to the passage of his life, the growth of his family, and the security of his friendships. All was hard won, little predictable, and nothing mapped out in advance.

The grand canvases on which Constable's reputation rests are as carefully plotted in composition and facture as is the best architecture or the most intricate novel. They are machines to satisfy the eye and raise the mind on account of the everyday affairs that they relate – a cart crossing a stream with no threat from torrent or crocodile; a boy on a horse jumping over a towpath barrier and nowhere an angry chasing dog or a man with a gun. All so unexciting, and no narrative, just background murmur. However, when he gives us Salisbury Cathedral beset by lightning on one side and a rainbow on the other it is clear that something must be going on inside.

There is more, however: he was also an energetic and argumentative correspondent, one of the most revealing and lyrical letter-writers of the Regency and late Georgian periods. Family letters shine light not only on Constable himself, but on his parents who had an enduring concern for him, and continued to look over his shoulder until their deaths. They reveal too the commotions of his siblings and his wider family, who serve to define the social and economic landscape out of which he grew.

Constable's paintings show him to be attentive to detail, spontaneous in gesture, brave in his use of colour, and so powerful an advocate for his native landscape that even after two hundred years his work is scrutinised for social and agricultural information. What we learn from his paintings is that Constable had deep local knowledge of the Suffolk and Essex borderlands, and

in his many studies of the clouds above Hampstead a strong experimental burn to express meteorological processes. He had an understanding of the human tides in London and Brighton, and a rare ability through gesture and attack to transform his vehement nature into paint. Suffolk, Essex, London, Hampstead, Brighton, Salisbury, Weymouth: such a tight geographical boundary within the south and east of England, only 150 miles in a straight line more or less east–west, serves to define the physical boundaries of the world view of this man of passion, opinion and discord.

'Constable wrote as he painted, with an acute and serious eye on the subject, with a spontaneous precision of imagery'.[2] This percipient observation was made in 1951 by Jonathan Mayne, the modern editor of the first biography of Constable written by his friend Charles Leslie (1843). However, Leslie was so fond of his friend, and had known him for so long, that it may be the case that he failed to set the necessary distance between lens and subject. Having revealed Constable to have been sweet and gentle (as he was, sometimes), it took nearly fifty years for Richard Redgrave to give him a rougher ride.[3] Constable was complex and troubled, and despite contradictory signals in the letters we begin to glimpse the man behind the façade that his paintings inevitably construct. While his exhibited 'six-footers' reveal focus and command of scale, letters reveal paranoia and unease. Where his oil studies and drawings show a clarity of vision and a determination to set down natural phenomena the instant he saw them, letters exhibit spitting angers and a lack of control: 'The world is well rid of Lord Byron,' he wrote on news of the poet's death, 'but the slime of his touch still remains.'[4] At a moment of triumph he lost his temper to such a degree that he scared away a Parisian art dealer who was buying from him. One remark from his wife speaks volumes: 'you are such a fidget and so nervous.'[5] He was easily distracted: busy painting skies? He goes down to the River Thames to buy a boat for his best friend. Stumbling over the composition of *The Leaping Horse*? He trawls Long Acre in search of a new carriage for his picky sister.

John Constable lived when the world turned round. He was born the year America declared independence, and was a

thirteen-year-old trainee miller when the Paris Bastille was stormed at the start of the French Revolution. He was a slow beginner as an artist: in 1805, the year of the Battle of Trafalgar, he was twenty-nine, painting portraits of Suffolk and Essex gentry and religious subjects of egregious sentiment that brought him a bit of money and local fame. Across these same years, the discoveries in natural sciences pioneered by Humphry Davy and Michael Faraday were beginning to challenge received views of the way the world works.

Other new insights filtered gradually into improvements in understanding agriculture, meteorology, manufacture and the management of warfare, and questioned the dogmas of religion. In the 1790s, when Constable was helping his father's men in the ancient process of grinding corn between millstones, the geologist William Smith drew radical conclusions on the age of the earth from fossil seashells in the strata revealed in canal cuttings. In 1813, when Constable was painting boys fishing on the Stour, Humphry Davy identified iodine, a by-product of the manufacture of gunpowder, cooperating with a group of French scientists in Paris as he did so. Eight years later, in 1821, the year *The Hay Wain* was first exhibited, Michael Faraday discovered how to generate electricity and make it flow through wires, under control. Intellectual and practical leaps in understanding come in unexpected combinations, and it is these flickering conjunctions of action and events that must be captured if we are to begin to understand the passage of the life of John Constable.

Global exploration in the years after the Battle of Waterloo (1815) developed apace just as Constable was delving in his paintings deeper into Suffolk and Essex. Across the same years in which Constable painted, by dull London light, some of his most limpid Stour Valley subjects, London became by leaps and bounds the largest and filthiest city in the world. The wider world that Constable explored was not the Americas or Africa, but sluices in the mill pond at Flatford, the heaths at Hampstead, and the water meadows around Salisbury. For Constable, the elemental and violent were found not in the battlefields of Europe, nor in Faraday's laboratory, but in the clouds above

Hampstead Heath and lightning around the bulk of Salisbury Cathedral.

A thread of tragedy winds through Constable's paintings; something inside them barks at the shin, and despite the calm of a cart in a millstream or a boy astride a horse, it draws pain from deep within. This is evident particularly in later work – the pale morning sun in his full-scale sketch for *Hadleigh Castle* is hidden behind the castle's keep, a marrowbone long sucked dry. The bleak Thames estuary is alive only with the noise of wheeling seagulls, some wandering cows, and a herdsman and his dog under a post-apocalyptic sky.

The sudden and unexpected acclaim Constable received from French artists in the mid-1820s interfered with the painfully slow growth of his reputation at home. That shocked him, and alerted him to painting's stealthy power. It led in the twentieth century to amnesia and miscasting: when the Impressionists took the flak for their use of broken colour, modern subjects and the lurid tones of industrialisation, he who had opened their eyes was long dead, and his modern reflections – faster carts, speedier ploughs, novel sea-bathing, smelly steamers – were quaintly old-fashioned and heading for the museum already. When the smoke cleared, Constable could not possibly have emerged as the revolutionary he was when the shock of the new was vibrating about Monet, Manet, Pissarro, Caillebotte and Cézanne. Nor did it help his twentieth-century reputation that in character and opinion Constable was ultra-Conservative and a reactionary, and failed to fit the prototype of the artist as free-wheeling Democrat or, later, 'leftie'; and nor did he get drunk at Royal Academy dinners, insult his elders and scandalise. Britain has not been a nation of revolution, so when a revolutionary flashes past unexpectedly at home, we miss it.

One particular word of warning recurs in Constable's letters and journals: 'ruin'. He also had an anxiety about passing time, something he revealed to others close to him. When once these come to attention, things begin to fall into place. The nature of his habitual mode of dress then seems normal: black coat, black hat, black jacket, black trousers, black gloves, black handkerchief. The black handkerchief and gloves may have been mourning, but

they fitted his style. John Constable, who was needy of friendship and love and lived much of his adult life with a continuous debilitating toothache, made the familiar seem utterly strange. Two hundred years later familiarity has become its easy mark, and its compelling strangeness obscured. Sometimes we cannot see things when they are staring us in the face.

So, this is John: he's a little worried about his future. His father wants him to carry on the family business in the valley of the River Stour – a windmill, two watermills, some cottages, a mill-basin and dry docks on the Suffolk–Essex borderlands. There's a sea-going vessel, river barges, and a name in London at the Corn Exchange. The business has a complex turnover, and is weather-dependent and tricky, but with some modest acres of arable land and heath around East Bergholt and Flatford, it's there, waiting for him.

John's older brother, named Golding like their father, should inherit; but that cannot happen as young Golding is lazy and simple. He has convulsions, epilepsy; he might fall on the floor at any moment, foam at the mouth and embarrass the family. He can't keep his mind on anything for long. John, however, has been working the mills and learning; he is sensible, a competent book-keeper, and has an unusual instinct for weather. Young Golding might have been jealous, and caused problems in the family, but he is good-natured, and spends his days out in the country with a gun.

With the firm's profits and prospects secure, Golding Constable senior built a new family house, completed in 1774, prominent beside his little town's main street: East Bergholt House. Released from their damp mill house at Flatford, there are new sounds in their new home, new echoes in the hall, new views from upstairs, and two excited little girls running about, Ann ('Nancy') age eight and Martha ('Patty') age seven. Then, on 11 June 1776, when the baby Golding is under two, at night or perhaps at dusk, his brother arrives, the fourth child, John. The baby is sickly, so his father sends for an old friend living nearby, the Rev. Walter Wren Driffield, to christen the boy, and put him in his mother's arms, to be close should he die.[6]

I

Overture

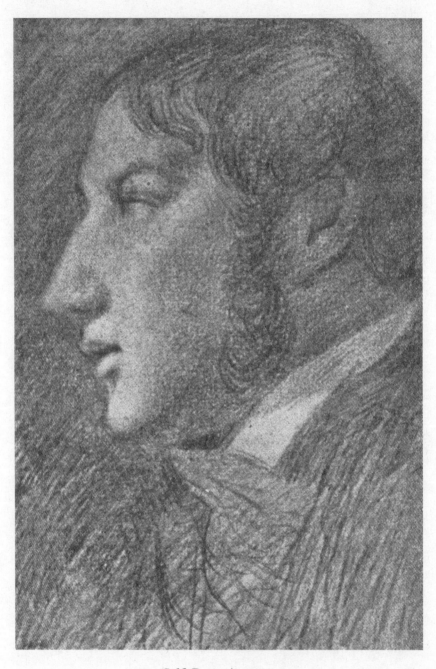

Self Portrait, 1806
Pencil, Tate Britain, London

1. Golden Constable

Golding Constable's millstones, turning by the converted power of wind or water, transformed golden rivers of threshed corn into fine powdered flour that might puff clouds into the air to dance in shafts of light. He turned gold into flour, then flour into gold. Golding was well named, and while his corn might have looked golden only in some lights, it nevertheless provided a constant living.

Golding Constable's Christian name descended from his maternal great-grandfather, Richard Golding, a minor landowner at Cavendish near Sudbury in Suffolk. There, in 1706, Richard's daughter Judith Golding (bapt. 1675) married Edward Garrad, a tanner of Bures St Mary. Their daughter, named Judith after her mother, was baptised in 1708 and in 1729 this Judith Garrad married John Constable, also of Bures St Mary, south-east of Sudbury.[1] Their third child, our Golding, born in 1739 on the family farm in Bures, would become the father of John Constable RA. That is how the sonorous and glowing name became attached to the Constables: in the register of pew owners in East Bergholt church he is listed, serendipitously, as 'Golden Constable'.[2] It is through roots like these, grown deep into Stour Valley soil, that John Constable the painter held his ground.

The painter's grandfather owned and farmed land two miles north of Bures St Mary.[3] This is shown on Bryant's Map of Suffolk (1826) as 'Constable's Farm'.[4] The Constables were, like so many of their kind in the nineteenth century, obsessed by family descent. A family tree, drawn up during the 1830s by the archaeologist and genealogist Edward Dunthorne of Dennington, Suffolk, takes the lineage back to Ivon, Viscount Constantine 'in Normandy'. In the twelfth century, six generations on from Ivon, the family has become 'Constable' rather than 'Constantine', to mark, apparently, the Constableship of Chester 'which it formerly enjoyed'.[5] Fifteen generations later we reach the

seventeenth and eighteenth centuries, where John Constable's paternal great-grandfather, Hugh Constable of Bures St Mary, is the youngest of five sons of Sir Philip Constable, 1st Bt. (d. 1666). He had two monks, Philip and Thomas, among his brothers, and two nuns, Anne and Elizabeth, among his first cousins, indicating a trace of religious, even papist, purpose. While the accuracy of this tree is doubtful in its earlier generations, what is clear is that the Constable family believed it to be correct, and that the search for ancestry, begun in John's lifetime and encouraged by his younger sister Mary, was deliberate and intense.[6]

Golding's uncle Abram Constable, his father's surviving elder brother, was the immediate source of his livelihood and the good fortune it brought. He owned the undershot watermill, 'where I now dwell'[7] as his will states, in the valley at Flatford on the River Stour: a date stone on the building is inscribed 'AC 1753'. The settlement was called Flatford because it was a flat ford, where cattle could cross. Having a sharp business brain, Abram also profited further down the line of trade by transporting corn and flour in his own barges, manned by his own crew, to the wharf in the Stour estuary at Mistley, and direct to London. There it would be sold at the Corn Exchange in Mark Lane, where men in their tight black coats and hats would sniff the grain and consider. On the homeward route his vessels carried Tyne coal, 'night soil', and anything else to be shipped. Thus he was a coal, corn and sewage merchant as well as a miller, and built up these profitable trades, despite oncoming age and lameness, until his death. His was a neatly constrained business, centred on the mill and its buildings at Flatford, some dry docks where he could construct and repair other vessels, and his London house in Mark Lane. He did not own the windmill on the high ground of East Bergholt heath nor yet the mill at Dedham: these would come into the picture later. Weekly reports in the *Ipswich Journal* reflected the importance of the corn trade to the community. With their dateline 'Mark Lane' they might read: 'our supply of wheat continues to increase . . . our market was very thin of grain today . . . we have had rapid sales . . . flour has become scarce at the wharves.'[8]

Abram and his wife, Isabella, had no children, and of his many nephews he chose Golding to favour with inheritance. There was

also a nephew-in-law, his niece Elizabeth's husband, Christopher Atkinson, who was already working for him. However, there was a difficulty; there was something fly about Christopher. This would come to show itself before long, but while Christopher seems to have made good money for the firm, Abram nevertheless decided on Golding to succeed him. Golding was the same age as Atkinson but somehow more reliable, and family, not an in-law. Golding's natural business sense and his strength of character must have been already evident to Abram, because, according to family legend, an older brother of Golding's was set to inherit. However, he and Abram fell into argument at Flatford Mill, and in his anger this 'brother' threw Abram's crutch into the river. Shocked at this uncouth behaviour, Abram retorted, 'There goes crutch, mill, and all.'[9] There is a problem here, because Golding did not have an older brother, so the ill-tempered young man in that story was most probably Christopher Atkinson. If so, that fit of temper changed everything. On such fragile hinges does history turn: no sudden quarrel, no crutch in the water, no inheritance for Golding, no meeting in London with his wife, no marriage and no John Constable RA.

The corn and coal trade had, despite fluctuations, been good to Abram Constable. He invested his profits well. The ever-hungry maw of London paid well for corn and flour, and on the Suffolk and Essex borders Tyne coal and London's sewage for fertiliser were in high demand. So when Abram came to sign his will in October 1763 he provided for Isabella in the interest on £5000 of Navy security at 4 per cent, £1000 of which she could cash if she needed to do so.[10] To his brother John and his daughters he gave the remainder of the Navy stock to come to them after Isabella's death.[11] He remembered three other nephews, but the most generous bequest went to Golding: Consols, Bank of England stock, and 'Copyhold Messuage Mill and Mill house' and outbuildings in East Bergholt and Flatford, its wharf and dry dock – 'in my own occupation'.[12] To Christopher Atkinson Abram left his 'two shares and estate' in the Corn Exchange, but not the contents of the Mark Lane house, which also went to Golding. Abram died within the year. The will is tight and clear, and in particular it reveals how deeply tied into East Bergholt Abram

and Isabella were, how clear was their understanding that the
roots of Abram's fortune lay in Suffolk, not London, and how
important it was to keep it in the family. The black plain-lettered
ledger stone set in the middle of the nave of St Mary's Church,
East Bergholt, is a clear statement of Abram and Isabella's posi-
tion within the community.

Golding travelled often from East Bergholt to Mark Lane to
keep an eye on that end of the business, and also to keep an eye
on Atkinson. He disliked London, its smell on the air, which he
noticed as soon as he got to Ilford, seven miles out.[13] He will
have ridden along what is now the A 12 – Colchester, Chelmsford,
Brentwood, Romford, Ilford and on into London. Presumably, on
the way home, the London smell vanished once he had passed
Ilford, and the rain-washed airs of the Suffolk fields grew ever
fresher. These journeys had their encouragements, because he
came to know the talkative eighteen-year-old Ann, daughter
of William Watts of Upper Thames Street and Hermitage
Dock, a wealthy timber merchant and barrel maker. He and
Ann were married on 6 May 1767, Ann's nineteenth birthday.[14]
Thus they brought two large families into alliance: Ann Watts's
sisters had married into the Allen and the Gubbins families,
so to those family names Golding and his siblings added nine
more from his side: Atkinson, Garrad, Grimwood, Kingsbury,
Mason, Parmenter, Robinson, Sidey and Smith. These names
crop up in John Constable's early life: they were all intensely
family-minded, and would batten on to each other as needs
may be.

Ann was a cheerful, jaunty young woman, intelligent, affec-
tionate, sociable and kind. She, as all her siblings, was well and
comprehensively educated, if only on the evidence of the high
level of expression in Ann's robust and entertaining letters and
the clarity of her handwriting. It is through the letters that we
are able to uncover something of the nuance in the background
to Ann's family's life: she became the nerve centre of the family,
sending out news, advice and instruction, worrying about hopes
and difficulties, and sharing celebration of triumphs. As she
illuminates family prejudices, expressions and discord, family
secrets, history and health, and the varying family fortunes, we

can hear her voice.

Ann and Golding were twenty-eight and thirty-seven respectively when John was born, so by the time he was in his midthirties, when her surviving letters to him were written, Ann was becoming an elderly woman – though from her energy we would not know it. Golding was well into his seventies by this time, and 'a remarkably stout and heathy man' with striking bright blue eyes, his 'smiling trophies'.[15] For such a man to continue his profession as mill-owner and manager is remarkable for that period, and demonstrates something of the strength of the stock that also formed John Constable. He would mope about his miserable love life, and suffer from colds, rheumatics, depressions and the excruciating toothache brought on by village dental treatment, but from his parents he inherited enough resolution, strength of mind and perseverance to lift him over life's obstacles and arm him for the future.[16]

2. Family Album

A nn Constable developed a penetrating, analytical ability that is rare in a recorded life of a country woman of the period, certainly outside the novels of Jane Austen. She was indeed an Austenish figure, deeply involved with the betterment and progress of her six children. For John's part she becomes anxious about his health, his career, his finances and in due course his slow, torturous courtship, which she attempts to control. She keeps her ear to the ground to report local gossip, and relates news of accidents, injuries, deaths and local rogues going to prison, and has an overweening respect for the local clergy. The tone she adopts with John in his thirties must echo the line she took with her children in their nursery and school years. Another aspect of Ann's letters is her clear but anxious news of the business pressures that her husband is under, his having to carry out expensive repairs to mill infrastructure, the state of the harvest, good or bad, and the complexities of maintaining and crewing Golding's vessels.

Ann and Golding had a close, long and loving marriage, which John would hold up as a model. There were three girls and three boys: Ann ('Nancy'), Martha ('Patty'), Golding, John, Mary and Abram. These names had followed one another through earlier generations like ducklings on the millstream, and as the mother duck Ann kept her children under her wing well into their adult lives. Golding Constable, busy and preoccupied, encountered and dealt with business stresses and tried to foresee future opportunities and difficulties. He was wealthy within the limits of his business, hugely respected locally, and while he does not seem to have invented any mechanical refinement, he certainly knew how to adapt and modernise his equipment, and he extended his business efficiently, balancing the books. Golding Constable can be seen as the Suffolk equivalent of pioneer late-eighteenth-century midland and

northern industrialists, men making iron in Derbyshire or cloth in Lancashire. It was never easy: 'my father had sad times to contend with in early life', John's brother Abram said years later.[1]

Golding's business demanded all his physical strength, mental energy and business acumen. He bought the practically new windmill on East Bergholt heath in 1769, and by 1793 he was also tenant of the five-gang undershot mill at Dedham, co-owned with the solicitor Peter Firmin of The Rookery mansion house, Dedham. Firmin also owned land and property in Dedham, Stratford St Mary, Langham and Wix in Essex.[2] Until the mid-1810s Golding was in partnership with his nephew William Garrad of Bures as 'Constable and Garrad Corn Merchants', and rented a warehouse at Upper Ground, Southwark.[3] In the dry docks at Flatford he built barges: another line of business for this busy man. Since his uncle Abram's death, business and its turnover had expanded greatly and together Golding's mills and boatyard created employment and prosperity in good times, and a semblance of security in bad.[4]

Golding's men were strong, bluff, purposeful. They could jack up a sail and shift a millstone together, repair a grain-chute, lash up a pulley – whatever was needed. They had to be constantly on the alert for bad weather: after one miserable evening, Nancy wrote to assure John and Abram that 'Windmill Sails all safe, the thatch upon the Wheat Stack secur'd. It was with us a very stormy boisterous night. I fear we shall read of much damage to the Shipping. Mr Revans [their clerk] wishes to hear of the Balloon [one of the company's boats]. Let us hope the old adage is true'.[5] That adage must surely be 'it's an ill wind that blows nobody any good'.

When a new miller had to be hired the advertisement will have read something like this one, published in the *Ipswich Journal* in 1788:

A Miller wanted ... One that has been used to work in a windmill, can write well and come well recommended for his honesty, sobriety and industry ... A married man will be preferred, if not too large a family.[6]

So the man had to be practised, literate, sober, honest, hard-working and without too much baggage. Running a series of mills was a complex, at times dangerous, operation, fraught with financial and physical risk and bound by legal agreements and obligations. When the watermill at Nedging, fourteen miles to the north of East Bergholt, flooded its surrounding fields in 1757, the claim by the landowner for compensation caused local discord and discontent which involved a dozen witnesses and took six months of wrangling to sort out, concluding at the Court of the King's Bench in Hadleigh.[7] There was always a mechanical or personnel problem somewhere, and constant competition: according to Emmanuel Bowen's 1762 map of Suffolk there were fifty-six watermills in the county, while Bryant's map of 1826 shows seven windmills within Samford Hundred alone, the Hundred in which East Bergholt and Flatford stand.[8] Maintenance and improvements were endless and always necessary, as Ann described in a surviving fragment of a letter:

> [. . .] soon hopes to visit the Mills &c. He has in contemplation, a great repair & alteration at Dedham Mill – which as it must be for the benefit of <u>succeeders</u>, cannot be disapproved, tho' the expense <u>there</u> may cause privations elsewhere.[9]

By the time John was twenty-one, and at a tipping point in his life, his siblings were getting on with theirs: Ann, 'Nancy', the oldest, by now twenty-nine, remained attached to her parents, never married, and lived with them at East Bergholt House. The next down, Martha, 'Patty', married Nathaniel Whalley, the heir to a London cheese business, and was busy having children.[10] They had started married life in America Square, Minories, Aldgate, but as Nathaniel's business grew they moved out to Temple House, East Ham, from whence he could travel into the city to deal in cheese. Patty was placid, kind, gentle, a nexus for news, and wrote letters round the family just like their mother did.

When Nancy came of age her mother gave her advice for life, which we can be sure that she gave also to the other children. Ann Constable's Christmas message of 1789 was severe in its guidance:

And now my dear girl, let me remind you, that although this Season is peculiarly set apart for cheerfulness & pleasure . . . [m]any are apt to employ this holy season in scenes of vanity & folly . . . affection & kindness to Brothers & Sisters, not giving the preference to strangers, rather than one's own blood, and last of all, that feeling for, & assisting (as far as prudence will permit) the distress of the poor & needy . . . remembering that the kindness we shew to the poor from a true desire of pleasing God (not an ostentatious shew before men) he reckoneth as done to himself & will reward us accordingly.[11]

With her profound Anglican Christian faith, Ann created a foundation for her children's lives.

The oldest son of the family, Golding, the third child and the natural heir to the mills, had become an endless trial. While they held him in a warm embrace, the family was exasperated by his indolence, self-centredness and what was almost certainly epilepsy. By 1792 he was putting his skill with his gun to good use as a gamekeeper for the Actons of East Bergholt.[12] How useful he was is anybody's guess; their mother confided to John: 'Golding is well but gains possession of more apathy than ever – yet good tempered as usual'.[13] There is no clear record of real plain-speaking in the family about Golding's illness until years later, when the youngest, Abram, by now running the mills, told John that Golding:

sometimes has a fit but not very lately, they drop him, & take away his senses for a moment but he soon recovers. He is however far from right & totally unable to do anything, that is to say, to be left to him to do, which perhaps you will say is nothing new. He seems to have lost all kindness for any body or any thing, but is entirely engross'd in himself, his mind more contracted than ever.[14]

As the children's lives developed their own peculiarities became apparent: after their parents died Nancy lived near the windmill on the heath with her brother Golding, who built his career as a gamekeeper and land agent. Mary, who seems to have developed a problem with money, had deep anxieties, but did not marry and

loved and cared for animals with a passion. She had a particular fondness for her big brother John, and she alone seems to have called him 'Johnny'.[15] Only Patty, sensible Patty who married well, escaped the nest into what her parents would have considered a respectable family life. The family's saviour, in worldly and village eyes, was the convivial young Abram, who eventually took on the business, ran it extremely well, and was a blessing to his parents. Everybody loved Abram. And then there was John, who wandered about in the countryside, longed for a lady friend, and might have made quite a good parson if they had let him, but more of that later.

Thus, the Constables of East Bergholt were a well-to-do county family within the boundaries of their time and class: they went to church, they admired the rector, she busied herself around the village and was charming to the villagers, he made plenty of money and built a large house. Horses clattered in their stable yard, while dogs of all kinds ran about: 'nobody's [dogs] here look as well as ours', John wrote, 'we never have distemper or mange or any thing to irk them'.[16] Golding senior held public offices in the county: sometime churchwarden in East Bergholt, a Commissioner of the River Stour Navigation Board, a grand juror at Bury Assizes, and a Guardian of the Samford House of Industry (i.e. the workhouse) at Tattingstone, five miles to the north-east.[17] A fellow miller described him in 1785 as 'a man of fortune and a miller [who] has a very elegant house in the street and lives in the style of a country squire.'[18] He could do this because the war with France enabled him to benefit from the high prices that agricultural produce could generally command.

Golding seems to have been a kind employer – indeed James Revans, whom Golding described in his will as 'my old and faithful clerk', 'lived and died' serving the Constables.[19] Revans was particularly close in the family: 'he used to <u>dance</u> me on his foot', John wrote later.[20] Another employee, Joseph King, told John after Golding's death that he had thrashed corn in the same barn for seventy years. That tells us that King must have been taken on by old Abram Constable at the beginning, and his nephew had inherited this loyal countryman with Flatford Mill: 'my father's men were picked Men not "Wooden Men"', Mary recalled.[21]

Loyalty was second nature: 'Poor Joe Cook is almost at the point of Death', Nancy reflected when Golding died, 'he always express'd a wish he might not survive his Master'.[22] Tough men, too, for Joe Cook must have survived, as years later Abram writes that 'Old Joe Cook came to work again this morning at Flatford – above 80 he is – 'tis wonderful.'[23] A man likely to have been an overseer was Mr Spargin, who offered smallpox vaccinations around the parish at 2/6d a shot.[24] On the water side of the business Golding employed boatmen, one of whom was Zachariah Savell, mate of the sea-going barge *Telegraph*, whom Golding had to rescue when he was taken by a press gang in London.[25]

James Revans, Joseph King, Joe Cook, Zachariah Savell, Spargin the Vaccinator: these were just five of Golding's employees, trusty, constant, inventive, and continuing down the line. There was also Prestney, their gardener at East Bergholt House, who had political connections and was a freeman of Colchester; 'Old Abrams', a servant whose mother's portrait Constable seems to have painted in about 1804; 'Old Crosbie' who died in 1807, and a second 'Old Crosbie', probably the son, who took on the farm and dairy at Flatford with his wife in 1836. Henry Crush and Gribling were millers at Flatford, Gosling was a sawyer, and there was Hart whose role in the business is unknown, but whose widow lived on, supported by the Constables, until 1833: 'we have a nice nurse for her', Abram told his brother.[26] Other likely casual employees were Bird the local plumber and glazier, his successor John Dunthorne, and young Henry Heckford, 'an industrious and rather ingenious mechanic' who died aged twenty-eight of a bowel complaint, leaving a pregnant widow and two children.[27]

With their girls and boys and maids and servants and millworkers and farmhands the Constables are almost a family of fiction. Jane Austen springs obviously to mind – she was writing her novels in Hampshire at the same time as Ann was writing her letters in Suffolk about similar social lives – but in her letters Ann approaches the quirkiness of Laurence Sterne's *Tristram Shandy*, Tobias Smollett's *The Adventures of Roderick Random* and Henry Fielding's *Tom Jones* in her family detail. In one letter of 1812 Ann evokes a breathless atmosphere in the house: 'We still have no man servant, & our females on the tip toe of expectation

for matrimony.'[28] The elder Constables conducted their lives as if they were still caught in the eighteenth century, which they certainly were, and happy to be so. All families have sayings, and Ann's letters are the medium through which Constable family sayings are preserved: 'Let every one mind one & let that be ourself', Ann would say. John had that from his mother in a letter of 1808, but there is little doubt that she had said it to her children again and again as they grew up; and: 'Do not let trifles turn concord into discord – but let us bear and forbear.'[29] She coined some golden epithets, such as this welcome addition to the canon of collective nouns: 'a consultation of surgeons'.[30]

Ann and Golding, who referred to themselves as 'Darby and Joan', were the kind of parents that any family of children might admire, despite instances when the sons muttered among themselves that Golding was stingy. That is hardly unusual:

> You know money comes loath from our Father, & that he thinks any sum a great one, that goes away in a lump as it were, without value <u>apparent</u>. He has now sent what I think will clear you of all [debt].[31]

Diplomacy and protocol were as active in the Constable family as anywhere: 'You know as much as myself', Abram wrote to John:

> my Father appears to condemn, he likes outward attention as much as most, and to my Mother expresses his disappointment when not receiv'd. I could assay many things were I with you that I do not like to say on paper, but enough hereon.[32]

Golding had a relaxed and affectionate sense of humour, able to have a good laugh with John Dunthorne, a tenant and occasional employee, at John's ups and downs as an artist-in-training.[33]

External shadows that cast themselves on the family, ones which they worked hard to obscure, included the conviction of Christopher Atkinson for fraud, and Ann's brother Thomas, who had a long liaison with a 'loose woman', which resulted in two children, eventual marriage and 'a melancholy finish . . . His life was not a virtuous one I fear.'[34] Another of Ann's brothers, the able, responsible and wealthy David Pike Watts, comes heavily

into the story later on, but the oddest, and perhaps the most fascinating uncle of all, and one whom John may have been able to admire during his childhood, was Ann's brother John. He was a sailor, tattooed from neck to ankle, having first gone to sea aged fifteen, joining the Navy in 1775. He became a midshipman on the *Resolution* under Captain William Bligh, and sailed with Bligh on Captain Cook's third and final voyage to the South Seas from 1776 to 1780.[35] Shipmates included the expedition's artist John Webber, and, as carpenter, James Cleveley, the brother of the marine painter twins John and Robert Cleveley.[36] John Watts's drawings of wildlife are a product of this voyage, as was his discovery of a new species of shark, which was, briefly, named after him.[37]

John Constable was four or five years old when Uncle John Watts returned from the South Seas with stories and tattoos. These had been applied to him 'by some Natives of the Islands he visited in the course of the Voyage'. He had tales to tell. Watts sailed again to New South Wales on the First Fleet, the inaugural transport fleet of convicts to New South Wales, 1787–89, and when calling in Tahiti was of particular value to the expedition because he could now speak the local language.[38] He returned to England via Canton, continued his naval career, and died at sea as captain of HMS *Osprey* off West Africa in 1801.[39] A miniature portrait of Captain Watts shows him stern, resolute and reliable, buttoned up tight in his naval officer's jacket and collar, with no hint of the tattoos beneath.[40]

John Constable came from a resolute, reliable, but buttoned-up family: there was nothing of the wild, naked or savage in his upbringing, except his uncle's tattoos, if he ever saw them.[41]

3. East Bergholt

I t takes half an hour to walk between Dedham and East
Bergholt. When John Constable made the journey home he
would cross the river on the road to Stratford St Mary, and walk
along its banks for half a mile or so until branching left, uphill,
gradually at first, approaching East Bergholt. The valley was, and
remains, a huge, flat, green expanse with a river running through
it, encircled by higher ground. It is partitioned by hedges, and
now greened by trees, but in the eighteenth and early nineteenth
centuries it was yet more closely hedged and divided, providing
acres for arable and pasture for cattle.[1]

He would take the well-trodden path across the vale, noticing
high up to the left the brash red brick façade of West Lodge
standing out in shock. This must be one of the earliest little bits
of red in a green landscape that he will have seen regularly, dis-
covering how, together, reds became redder and greens greener.
Through copse and scrubby wood, and bridging the river again,
the path begins to wind up the surprisingly steep Fen Lane,
until, at the junction with Flatford Lane, he would turn left and
trudge the last few hundred yards up past the white Suffolk brick
Old Hall to the south-west corner of East Bergholt's St Mary's
Church and its village street, known then as now as 'The Street'.

Arrival on this corner holds another surprise, for the church
tower is a bewildering stump. The churches of Suffolk are
famous for their grand towers of flint and stone that proclaim
themselves from afar. St Mary's Stoke-by-Nayland (tower com-
pleted mid fifteenth century[2]) commands its ridge; St Peter and
St Paul's Lavenham, its tower completed by 1525, surmounts the
higher of the town's two hills; the tower of St Mary's Dedham
was finished by 1520. These towers and many others bob and
jive in the landscape as roads weave towards them, and declare
the richness of the wool trade that gave them their existence.
East Bergholt was a prosperous cloth-making town, but its tower

plans came too late, and as a result St Mary's differs markedly from neighbouring churches. Begun nearly a century after St Mary's Stoke-by-Nayland as the wool trade was shrinking, and as political, royal and religious passions brought about Cardinal Wolsey's execution and caused bitter conflict in England, the East Bergholt tower had reached only to its first stage above the ground before all work on it was abandoned, and the town gradually shrank.[3]

The stump that remains of St Mary's tower evokes the aftermath of a bombardment at worst, or at best extreme disappointment and destruction of plans and hopes. Immediately, therefore, East Bergholt has something unsettling about it. 'It is not built yet', John Kirby wrote of the tower in 1764, suggesting, perhaps, some hope for the future.[4] The village grew its own legends surrounding the towerless church: that it once had a steeple that was 'partly thrown down many years ago and never rebuilt', and that 'the parish built it in the day time and the devil pulled it down at night'.[5] The town, 'formerly a flourishing place' as Frederic Shoberl wrote in 1813, had lost its core industry and was by now reduced to a village with an unusual array of grand houses.[6] It was 'esteemed one of the handsomest [villages] in England', John Crosier remarked. 'It stands exceedingly high, inasmuch that you may see over the chimneys in Dedham.'[7]

St Mary's Church is a seductive place, which might entice any receptive boy into its timeless rituals. Golding had bought a pew for his family in 1787,[8] thus drawing them all irrevocably into the life of the church with its clear light, its march of elegant Gothic arches, and its clusters of evocative monuments and grave slabs. Beneath one of these their forebears Abram and Isabella Constable lie: 'Abram Constable / formerly of Bures in this County / but late of London Cornfactor / ... / also / of Isabella his wife'. Other local grandees – the Eyres of Little Court and The Gables, the Robertses of West Lodge, the Godfreys of Old Hall, the composer William Jones, and Edward Lambe the seventeenth-century founder of the village charity school – all have memorials in St Mary's.

High above the vale, East Bergholt on its plateau had always been isolated. Today, further isolated by the A12, it is approachable

with ease by car only from Manningtree (east) and Hadleigh (north-west). Having 1,151 inhabitants in 1811 and five inns, the village clusters to the south-west of the heath in a bulge around crossroads to Stoke-by-Nayland and Hadleigh.[9] When a new inn, The White Horse, set up in the village in rivalry with The Bear, The Eagle, The Ship and The Three Cups, its landlord hung this verse below its sign:

> My new White Horse shall kick the Bear
> And make the Eagle fly
> Shall turn the Ship right bottom up
> And drain the Three Cups dry.[10]

The incomplete church at the heart of the village remains the hub around which The Street turns. Looking west, on the right-hand side, is (now) a line of modest houses with narrow front gardens beyond which Golding Constable's East Bergholt House once stood, while on the left is West Lodge, commanding the landscape from the valley.[11] In the easterly direction, The Street winds tight between the south-east corner of the churchyard and Old Hall, where it once formed a market place. Old Hall was owned at the time of Constable's birth by the corrupt and disreputable Richard Rigby MP, Prime Minister Lord North's Paymaster General, inter alia.[12] He spent heavily to make the wharf-side village of Mistley, five miles east, into a popular spa town, and attracted architects including Robert Adam to develop it. Rigby failed, but not before Adam had remodelled Mistley's church of St Mary the Virgin, thus adding a layer of metropolitan sophistication to the Stour Valley to open the eyes of young and old to the power of art and design.[13] In East Bergholt further on, down Rectory Hill, which dips suddenly and just as promptly rises again, is the Rectory, set well back behind trees – the fine house that Dr Durand Rhudde acquired with his livings of Brantham with East Bergholt and Great Wenham. The Rectory was extended after Rhudde's day, but even so it and its grounds suggest that the Church Militant could be as powerful and as resourceful as the richest mercantile system, and could reward its priests accordingly. Further along this road, which leads on to Brantham, Manningtree and the Mistley wharfs, is a crossroad

with Flatford and the river down to the right, and to the left the lane circling the heath. This passes Golding Constable's wind-mill and coal yard, before winding back to East Bergholt and the family's house. In size, bulk and stature – red brick, three storeys, parapet, with gravel sweep from the road and plenty of room for walled gardens and lawns – Golding's was comparable both to West Lodge opposite and the Rectory.

After Golding's death in 1816 East Bergholt House was sold. Its stature, and through it Golding's achievement in business, became clear in the public prints:

> A very excellent brick MANSION HOUSE ... suitable for a genteel family. The house comprises an entrance hall, with grain ceiling and a geometrical staircase, two parlours, drawing room, and kitchen on the ground floor; four sleeping rooms on the second floor, with dressing rooms, and four attics, a store-room and wine vault, with excellent cellars under the whole, two stables for 8 horses, coach house, and every requisite office suitable to the Mansion, with a spacious garden, shrubbery, &c; adjoining to which are 36 acres, and upwards, of very good arable and pasture land, with a barn. The Mansion and 15 acres are freehold, and 21 acres are copyhold.[14]

By 1816, there was a lot of building going on in East Bergholt, 'midway between Ipswich and Colchester, and 59 miles from London, to and from which place coaches pass daily within a short distance' as the 1816 sales particulars express it. This came at the price of the removal from public use of common land on the heath and the enclosure of the former village green behind the wall of West Lodge. Frederic Shoberl declared that 'the residences of the Rector, the Rev. Dr Rhudde, Peter God-frey Esq, Mrs Roberts, and Golding Constable Esq give the place the appearance far superior to that of most villages.'[15] Ann Constable told news of more expansion; William Eyre, the son of the composer Joseph Eyre of Little Court next door to East Bergholt House, was building his own fine house, The Gables, with a gravel sweep: 'Mr Eyre is building away – I fear castles in the air tho' I must say it is a great improvement to the entrance to our pretty village, & so will you think.'[16]

Two hundred years had to go by before the isolated settlement high above the vale, with its stub of a church tower, could once more assert itself and raise its hand to the future. Time then was marked by the church bells, caged in the absence of a tower in East Bergholt's churchyard; time now, Golding's time, marched by the tides between Brantham and Mistley, and the rising and the falling of the waters where *Telegraph, Balloon* and *Swallow* would tie up at Mistley quay, 'very noble and convenient, with large granaries over it and on one side a dock for building vessels of small burthen.'[17] Golding Constable had faith in the years to come as he saw his family grow, watched his windmill turn and his grindstones grind, and counted the bags of flour onto the cart that would trundle them down to the river within the hour.

Golding Constable was one of many landowners in East Bergholt, and by no means one of the largest or grandest. The East Bergholt Enclosure Award, drawn up shortly after Golding's death, reveals him to have had modest land holdings among about 110 other named freeholders and copyholders of the parish.[18] His land was tightly circumscribed in three parcels that did not connect to one another: a long, narrow stretch including East Bergholt House and directly behind it to the north-east (approx. 36 acres); a further three acres on the heath, which included the windmill; and perhaps two acres around Flatford Mill and its dry docks on the north bank of the river. To walk from his house to his windmill Golding had to cross other people's land, or go the roundabout route on the road with his horse. At Flatford he was surrounded by at least four other owners whose interests complicated the route of the towpath. One quirk of the River Stour was that the towpath jumped from bank to bank depending on the willingness of landowners to accommodate it.[19] Between Sudbury and Brantham the path changed sides thirty-three times, six changes in Bures alone, and between Flatford and East Bergholt's boundary with Dedham the banks, according to the 1817 Enclosure map, had sixteen different owners. For this reason the horses had to be trained to leap onto barges and to be calm while being carried back and forth across the river standing on their special platform in the prow.

East Bergholt's boundary, which spreads wide around the

heath and down to the river at Flatford, is described in the Enclosure Award, winding from 'a point in the middle of the River Stour near an Oak boundary tree in a meadow belonging to Robert Hardy called Mentle Hill', via 'a boundary mark in the south fence of a meadow belonging to Thomas Nunn . . . to a boundary mark in Stack Yard Meadow belonging to the Rev. William Deane . . . to a notch in the west fence of Priest's field . . . to Fish Pond Close and Bergholt Hill', and on by way of Plashy Field, Little Florence and the north-east corner of Float Meadow, back to the beginning again.[20] John Constable is himself named in the Award as the owner of the tiny cottage by the village green which he used as a studio, as well as seven other small parcels of land in his name which Abram was to buy from him. 'The village has been quite in a bustle about the division of the Common', he wrote:

> I hope all will end amicably, but where so many interests are brought together, some may peradventure clash . . . I have an allotment about the size of this room which I shall give to my brother Golding – it will be near the windmill.[21]

Where the sales particulars of East Bergholt House say that the property included fifteen freehold and twenty-one copyhold acres, these were the fields behind the house that the family was prepared to sell, while Abram retained the other two parcels.[22] These and the additional acres that Golding rented from time to time were the fabric from which Constables had drawn their livelihood for decades as landowners and tenants.[23] Their business was of course heavily dependent on the weather: they must have been greatly cheered in the summer of John's birth, for reports from across England told of 'a plentiful harvest' in August 1776, even though by Christmas this had depressed flour prices to 24 shillings a bushel.[24] In 1809 as the 'great flood' of the Stour was subsiding, the cost of wheat rose to 102 shillings a bushel, and the harvest was 'precarious'.[25] Then things would change; two years later Ann told John: 'All our harvest was finished on Saturday . . . barn full – & a beautiful stack of barley in the Heath field.'[26]

The agriculturalist Arthur Young of Bradfield Combust near

Bury St Edmunds travelled England in the 1760s and 1770s to study farms, their management and yields. His home patch of Suffolk and Essex he noted 'as remarkable for excellent hus-bandry . . . as any in the kingdom . . . The great fertility of the soil, and the incomparable use they make of it, I have observed above.'[27] Observing Hadleigh, north-west of East Bergholt, he noted 'much sandy loam called woodcock land', and reported that 'they plough but once for wheat, sow 2 bushels, and get 26 bushels on an average.'[28] Young notes also that 'the farmers carry their corn 25 miles', which demonstrates that corn to be ground at Golding's mills could have come from as far away as Bury and Stowmarket. The Constable family and its ramifications ran yet deeper into Stour-flooded lands: in the 1790s a 'Miss Constable' sold by auction her farm at Wix, south of the wharves at Mistley, lock, stock and barrel. The *Ipswich Journal* advertisement for the sale presents a vivid picture of what a modest working farm comprised in our period: ten horses of various types and ages, fourteen head of cattle various, five carts various, ploughs, har-rows, butter-making equipment and so forth.[29]

The River Stour was the main artery through which the life-blood of the Suffolk/Essex border landscape flowed. An Act of Parliament in 1705 had allowed the river gradually to be made navigable to barges from Sudbury to the sea, 'very beneficial to trade, advantageous to the Poor and convenient for the convey-ance of coals and other goods and merchandizes . . . very much tend[ing] to the Employing and Encrease of watermen and Seamen and as a means to preserve the Highways.'[30] By 1817, thirty-six barges plied the river – three at least belonged to Golding Constable – and by 1821 forty-one vessels went up and down through its fourteen locks and twelve toll stages.[31] There were constant quarrels over water use, as bargees needed to cap-ture heads of water to float their barges, while millers needed a reliable flow to keep their grindstones turning. By owning both mills and barges Golding could generally manage things to suit himself.

II

Operetta: 1783–1816

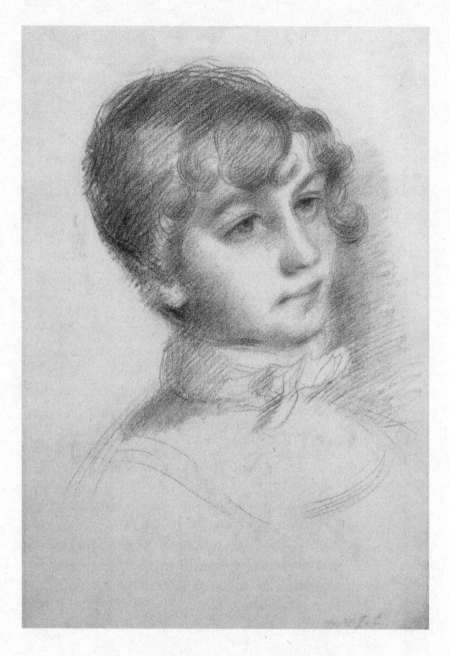

Maria Bicknell by John Constable, *c.*1809
Pencil, Tate Britain, London

4. The Don and the Friday

From innumerable boyhood walks in the country John began to bring home drawings. This was ominous, and began to cast its shadow. Before reality broke, Ann and Golding thought that John, growing up, beloved by his sisters, respectful of his elder brother, might find a vocation as a parson, or willingly accept such a vocation if it were thrust upon him. He would not necessarily have been consulted as this plan evolved, but nevertheless there were a number of role models to hand. Golding's good friend and confidant, the Rev. Walter Wren Driffield, who had rushed to East Bergholt House near midnight to christen the baby, was a model of what a country parson should be.[1] On Golding's death in 1816 Driffield had written in deep mourning: 'He was my old and much esteemed friend.'[2] East Bergholt's Rector, Dr Rhudde, was an alternative example of what a well-connected churchman might achieve in this world, while another local churchman, the Rev. Brooke Hurlock of Lamarsh and Dedham, demonstrated how a parson could organise his money so as to bring rich returns. John had a wide spectrum of Anglican example to draw upon at a very early stage.

In 1783, aged seven, John was sent to board weekly at Stilleman King's school, fifteen miles from home at Fordstreet, Aldham near Colchester.[3] He evidently failed to settle, and was moved to a grammar school in Lavenham, fifteen miles northeast of East Bergholt, run by the Rev. William Blowers. It was a stretch for Blowers to refer to himself as 'the Rev.', as he was merely a deacon, ordained in the Diocese of Norwich in 1782, only a year before John Constable joined his school.[4] There was another grammar school available in Lavenham, but perhaps because he appeared to be a parson, Blowers got the boy, who may by now have known that he was destined by his parents for the priesthood.[5] Attendance at Blowers's school was a disaster: Constable recalled that despite Blowers advertising that 'proper

masters attend his school for French, Dancing, Music and other polite accomplishments', he was thrashed mercilessly, and learnt little beyond the delights of contemplating revenge. The school house in Barn Street, Lavenham, a former merchant's house, has the bare bottom and legs of a boy carved into timbers beside its front door, and while this is sixteenth-century decoration, it must have cast a thrill of terror into the minds of the pupils who passed it daily.[6]

Blowers's dismal headmastership coincided with a crisis at East Bergholt House, which led to John being removed from Lavenham, his second change of school at an early age. The explanation by Constable's first biographer, C. R. Leslie, that Golding found his son 'disinclined to the necessary studies',[7] is not convincing, as there is a better reason why their determination for John to enter the church crumbled to nothing. Young Golding's epileptic fits and chronic idleness led his parents to accept that he would be incapable of running the family business. John was the obvious replacement. This will have been around 1788 when Golding was fourteen and John twelve. The youngest, Abram, then about five years old, was far too young to be reliably considered, and so John Constable's embryonic life in the priesthood was snuffed out before it had begun.

A life of mills and milling it would be for John, therefore; a change marked also by his change of schooling, now to the grammar school in Dedham, the half-hour walk across the vale from East Bergholt. This school was run in an elegant house just to the east of the church by the humane and learned Rev. Dr Thomas Letchmere Grimwood, MA (Cantab.), who came from a long line of teachers and scholars whose Latin-inscribed memorials can be seen in St Mary's, Dedham. Two books at least survive that connect Constable to his later school years and perhaps to Grimwood himself – Thomas Day's moral tale of two schoolboys, *The History of Sandford and Merton* (1788), and *Juvenile Introduction to History – or, Historical Beauties for Youth* (1790). With his developing sense of purpose he has inscribed both 'John Constable', with the dates 1789 and 1790 respectively.[8] Grimwood called his curious pupil 'honest John', and, spotting something particular, suggested that he was 'too much of a genious to be a merchant'.[9]

John, in place of the disappointing younger Golding, was now the heir, and it was for him to learn how the business ran and how its mills worked. He had to learn about canal and river craft and their management; he had to understand the way the canal operated – the banks, the sluices, the locks, the towpath – and how barges were built beside Flatford Mill and floated off for work. The wind could whip across East Bergholt heath, so he also needed to develop a close knowledge of the weather, its changeability and how to read clouds, because it was the clouds that carried the message of change, and knowledge of weather-change could tip the balance between profit and loss. The small outline of a windmill – their windmill – which John engraved on a fragment of mill timber, and signed and dated 1792, points to an emerging power of observation, a desire to record an image, and a sense of ownership.[10]

John had a ready hunger for knowledge of the business, and the many variables it had to contend with: he worked in the business 'for about a year . . . where he performed the duties required of him carefully and well.' That will have been around 1792 and 1793 when he was sixteen or seventeen. He was tough and hard-working, enjoyed being in the open air, and with his fresh face, bright eyes and quick smile soon became known as 'the handsome miller'. He must have become a skilled carpenter under Golding's care; years later his wife remarked of a handyman in Brighton that 'he seems as good a carpenter as you are.' The white coat and hat he wore at work indicated his managerial role – he was the owner's son, and in tune with the management of the business.[11]

Nevertheless, these duties conflicted with the other serious purpose which was emerging during his walks in the country. 'Oh! Now I see you are in your painting-room', Dr Grimwood would say when John's attention wandered during lessons, so clearly his habits were well known. Among his youthful exercises were twenty-two neat ink copies of grotesque heads illustrating Johann Caspar Lavater's *Physiognomy*.[12] The English translation by Samuel Shaw was widely advertised in the *Ipswich Journal* around publication date, and a copy of that book, signed and dated 'Constable, August 93', has also survived.[13] These tight little teenaged expressions of angst, each about three inches

high, are set out four to a page and exhibit the fine penmanship
Constable was learning.[14] Other drawings that begin to indicate
a direction in life include a small oval with watercolour of a
cottage and packhorse bridge of 1793, probably copied from an
engraving, found in 2020 in a scrapbook descended from his
Mason cousins.[15] Further early drawings in ink are of shipping
copied in 1794 perhaps from prints after the ship- and sea-
painters John Cleveley or Dominic Serres.[16] These are images
not so hard to come by, particularly for the nephew of a seaman
who had sailed with John and Robert Cleveley's brother James
into the Pacific.

A year later his drawing had vastly improved, and he made
three intense, detailed and consequential copies in pen, ink and
wash of subjects from engravings by Nicholas Dorigny after
Raphael's cartoons, *Christ's charge to Peter, The blinding of Elymas*
and *The death of Ananias*.[17] These are big drawings, each 20 by
30 inches [50 x 75 cm], and must be seen as challenges from
beyond him, tests of his aptitude, vision and drive. If he had only
made one such drawing from Raphael it might perhaps have been
self-directed; but three together suggests outside forces at work,
and prompts the question where did he get these greatly admired
engravings to copy, for Golding and Ann were not art collectors.

Ann and Golding must have agonised together over their de-
cision to change John's direction from the church to the mill, to
remove him from God and give him to Mammon, and direct him
to the local trades in grain and coal. It cannot have been easy.
They did not yet seem to reckon seriously with John's developing
talents, even though these were already amply demonstrated in
the insistent improvement in their scope and skill. He had by now
made a very good friend in the village, John Dunthorne, a local
wanderer six years his senior, who had turned up and, in 1793,
had married an East Bergholt widow, Hannah Bird (née Oxley).
She and her late husband, a plumber and glazier, were Golding's
tenants in the cottage beside the entrance to the Constables' sta-
bles.[18] John Dunthorne, highly intelligent but undereducated, a
bit of a chancer, autodidact, impecunious, one who seemed to
slip through life, had slipped into Hannah Bird's life and cottage,
picking up her former husband's trade at the same time. Ann

Constable skewered Dunthorne pretty well, to her own satisfaction, certainly:

> To take in a man, from an advertisement, without a change of raiment or a shilling in his pocket & marry him – put him in possession of her house, furniture, trade, and what very property she had – surely he ought to be grateful at least.[19]

Shabby perhaps, loquacious no doubt, fascinating indeed, John Dunthorne engaged John Constable's interest in his teenage years. With the late Mr Bird's tools and custom (according to Ann) Dunthorne worked lead and mended local pipes and roofs; he glazed windows round about, painted and decorated, and generally made houses smart and secure. He became the local odd-job man who leaded the Rectory roof for Dr Rhudde in 1796, and will have worked for Golding at busy times.[20] There was, however, much more to John Dunthorne than odd-jobbing, and more also to his known accomplishments as painter of inn signs, coats-of-arms and funeral hatchments, landscape views and portraits.[21] Having a wide local reputation in the technical way he was invited to paint 'some perspective on the wall behind the organ in Hadleigh Church', information that might have drawn Charles Leslie to patronise him in these words: 'Mr Dunthorne possessed more intelligence than is often found in the class of life to which he belonged.'[22] He was a man of ingenuity and such strong technical bent that it comes as little surprise that he was also a highly skilled maker of musical instruments, a talent that raises him way above the ordinary. Two, perhaps three, cellos survive from Dunthorne's hand, one at least being marked with his label.[23] He and John played music together, John on his flute, Dunthorne on one of his own instruments. As Constable grew into manhood he and Dunthorne went out in the lanes and fields to paint side by side. The friendship was encouraged, despite differences in class and status plainly apparent: it kept them both busy. When John's father saw them coming home across the fields he would say, 'Here comes Don Quixote with his Man Friday';[24] Dunthorne was presumably the Don and Constable the Friday; or the other way round.

Years later the printmaker David Lucas recalled their

proto-professional way of going about things, something Lucas can only have heard from Constable himself. The two Johns would take a couple of easels into the fields day after day, set up in front of a view and paint until the shadows changed significantly. Then they would move to another spot, and start their next picture. At the same time the next day they would return to the first point, continue for half an hour or so, and move on again.[25] Such a practical and companionable way of working is somehow anachronistic; it feels like artists painting together in the late nineteenth or early twentieth centuries.[26] Their obsession with catching a moment of light is an Impressionist principle, and reveals something of the wealthy openness of the untaught mind. Constable's early determination to see landscape clearly, to express it directly, and to be willing to learn from whomsoever might wish to instruct him, developed as a result of his association with Dunthorne and his apparent lack of orthodox tuition.[27] It must have been from Dunthorne that he learnt about the use of painters' paraphernalia: the easel, the paintbox, the palette, and the practice of pinning paper or card to a painting board to hold it steady. Many of Constable's outdoor oil sketches have pin holes in their corners. John Constable was so very lucky to have found John Dunthorne eager to talk, paint, advise and play music with, and to have him at his gate.

It says a great deal for Golding and Ann that they fostered the friendship. On their walks side by side, the two Johns talked and discussed their lives and dreams: we can be sure of this because they remained in touch for years, and the early correspondence between them (1799 to 1803) reveals enduring friendship.[28] However, there was yet more to Dunthorne, as his will and posthumous sale records reveal. By the time of his death in 1844 he was wealthier in property and effects than most cottagers and odd-jobbers might be: he had become freeholder of a 'cottage with pightle and appurtenances' as well as a 'double cottage with garden and appurtenances . . . near the White Horse Inn' – this is about three quarters of a mile to the east of St Mary's Church, towards Manningtree.[29] His sale at this property comprised not only 'neat household furniture', with six bedsteads and bedding, chests of drawers, a mahogany chiffonier, sofa, Pembroke table,

Kidderminster carpet and so on, but also 'several oil paintings, prints, drawings, and sketches; picture frames, 6 portfolios ... engraving tools, camera lucida, violin; about 80 volumes of Books (principally on scientific subjects), &c., &c.' Also within this impressive list were a '36-inch reflecting telescope (4 inches diameter), 12 inch ditto, 18 inch refracting ditto'. Such belongings, his print collection, books, telescopes, camera lucida, and his cello-making skill, among much else, raise John Dunthorne way above the status of 'local character'.[30] However, it is impossible to be sure if the telescopes originally belonged to him or to his son, young Johnnie Dunthorne, whom we shall meet later as Constable's studio assistant. Young Johnnie died unmarried and without a house of his own in 1832, twelve years before his father, and already highly knowledgeable about using and collecting telescopes. Telescopes were, as Constable would put it, 'John[nie]'s forte'.[31]

Together, after painting in the fields all day, these two friends might sit and play in Dunthorne's cottage. Constable plays his flute; Dunthorne plays his cello; Hannah Dunthorne stirs the stew; young Dunthornes throw knucklebones or look out at the stars. Outside a blackbird signals the close of day, an owl hoots, and the rector's carriage blazes by. Then the village falls silent as a full moon rises. The clouds are high, the breeze low, the mood companionable. When the music stops, Constable stands up, bids his farewells, and crosses the stable yard. He may be carrying a folio of old prints to look at – among them perhaps Dorigny's engravings after Raphael – as he slips into East Bergholt House through the back door. When Constable has left, Dunthorne and Johnnie take one of the telescopes out into the street and together look up at the shining moon.

5. The Grand Caesar

During the decades of his youth and young manhood, two wealthy churchmen ministering in the Stour Valley significantly affected John Constable's life. These were the Rev. Durand Rhudde, 'Rector of East Bergholt cum Brantham and Wenham', as his elegant oval memorial in St Mary's, East Bergholt, expresses it, and the Rev. Brooke Hurlock, Domestic Chaplain to John, Duke of Argyll, and for over forty years from 1761 Rector of Holy Innocents, Lamarsh, Essex.[1]

Brooke Hurlock had inherited his brother's farm, manor and estate at Elmstead near Colchester in 1776, and in 1794 and 1799 had become wealthy enough to give mortgages totalling £6500 on properties near Haverhill in Essex and Stoke-by-Clare, Suffolk.[2] These agreements between landowner and rector were tightly written and, in their large-format vellum manifestation, apparently draconian: most of them were witnessed by the ubiquitous Dedham solicitor Peter Firmin. They are part of a pattern of legal agreements involving Brooke Hurlock and lands in Suffolk and Essex belonging to individuals including John Timms Hervey-Elwes, the heir of John Elwes MP, a celebrated miser and the alleged model for Dickens's Scrooge. Hurlock and his wife Lucy had themselves been obliged, in 1793, to surrender to the Lord of the Manor properties in Hitcham, near Stowmarket which he claimed he had inherited in 1770.[3] When he died in 1803, Hurlock, who promoted himself in his will document (or at any rate is so described) as the 'Right Reverend' Brooke Hurlock, left generous bequests to his daughter Lucy and his four sons, named his friend and executor the Rev. John Fisher DD as a residuary beneficiary, and bequeathed his living at Lamarsh to his trustees, empowering them to sell it for the best price. According to Holy Innocents' list of Rectors, hanging in the chancel at Lamarsh, Hurlock was not succeeded formally as Rector until 1812, so whatever happened during and after

Hurlock's tenure took some years to resolve. Despite his forty-two years there as Rector, no wall-plaque memorial to Hurlock was raised in Holy Innocents, Lamarsh. Latterly he lived at Hill House, Dedham, fifteen difficult miles from Lamarsh, and it is there that a marble plaque remembering him and his wife was installed, high on a wall in St Mary's Church.

Dr Durand Rhudde also had plenty of money during his ministry, enough indeed to make Hurlock seem reduced by comparison. He was the eldest of the three children of the Rev. John Rhudde, a vituperative divine who had begun his career as a dissenter, but became, latterly, Rector of Portesham in Dorset.[4] Durand was educated at Merchant Taylors' School in Suffolk Lane, City of London (1742–8), and then, as a 'poor scholar', he matriculated in 1752 at King's College, Cambridge, at the comparatively young age of sixteen or seventeen.[5] He married in 1760 Mary Shergold, the sister and sole heir of George Shergold, a broker and the publisher of the influential twice-weekly stock market price index *Course of the Exchange*. To celebrate this marriage the Rhuddes had a set of four silver candlesticks engraved with the arms of Rhudde impaling Shergold.[6] George Shergold, a bachelor, had investments in bankrupt property, and in 1776, when Sheriff of Buckinghamshire, he bought Southlands, a large estate in Iver, from trustees in bankruptcy.[7] By now Durand Rhudde had been ordained, but even as vicar of Shepherdswell in Kent (1774–82), he continued to be involved with Shergold in land deals one hundred miles away in Iver.[8] He became Rector of Brantham and East Bergholt, Suffolk, in 1782, and four years later added Great Wenham to his portfolio.[9] The total of the livings for these three parishes was £1300, plus the use of a large rectory.[10] Rhudde was appointed Chaplain to the Chapel Royal in 1790, the year in which, perhaps 'preaching for a bishopric', he addressed the congregation at St Paul's Cathedral at an Anniversary Meeting of the Sons of the Clergy on the text: 'Pure religion and undefiled before God … is this … to keep himself unspotted from the world'.[11]

'Unspotted' he was not, for it gets better and better. When William Maurice Bogdani, his sister Deborah's husband, died in 1790, Rhudde inherited swathes of land and property in

south-eastern Suffolk, between the estuaries of the Deben and the Orwell – Newbourne, Hemley, Walton and Felixstowe. This Rhudde would hold for his lifetime, and then, as Bogdani's will demands, it would pass to his eldest daughter, Maria Elizabeth Bicknell. On her death it would go to his other daughter, Harriet Rhudde, while on her death the inheritance would pass to Maria's heirs.[12] As a special bequest, just for him, Bogdani also left Rhudde 'my three mahogany cases containing ivory handled knives and forks and silver table and dessert spoons'. So, Rhudde was well provided for, loaded with land, livings, candlesticks and cutlery.

In 1788, Messrs Shergold and Co. of 50 Lombard Street, the company owned by George Shergold, regularly advertised 'An Amazing Advantage' in the *Ipswich Journal*, the offer of large pay-outs in a financial scheme that claimed to be 'strictly legal and peculiar to themselves . . . as safe as the Bank of England'.[13] Shergold died that year, and, less minor bequests, Rhudde's wife Mary inherited his entire estate, which included the lease of Shergold's London house, 13 Stratton Street, Piccadilly. On Mary's death in 1811 this all passed to Rhudde himself.[14] The wealth that Rhudde so freely displayed in London and Suffolk derived entirely from his sister's generous husband and from his wife's venal brother. None of it, apart from his stipends as a Rector, was actually of his own earning. Display it he did: from his extensive rectory at the edge of East Bergholt he would drive to his other parishes and up to London. Ann Constable would watch his comings and goings: 'The Doctor's new chariot and patent lamps continually blazing by.'[15] Willy Lott, whose family owned Valley Farm at Flatford and the adjacent house by the mill, described Rhudde as 'the Grand Caesar'.[16]

Both of these moneyed and worldly churchmen had influence on John Constable's early development. Hurlock, whose rectory at Lamarsh Constable painted very early in his discovery of the art of landscape painting, was the father of Lucy Hurlock, a woman eleven years his senior whom Constable befriended in the late 1790s.[17] For his part, Rhudde was the severe, unkind and unwarranted blockage in the course of Constable's troubled romance with his granddaughter, Maria Bicknell.

6. Young Baronet and Bishop-in-Waiting

F urther up the social scale were two crucial friendships that
John Constable's parents fostered, even though they might
have realised that this risked working against their own plans for
John. One was with a baronet, the other with a yet more senior
churchman. The temptation to show off her clever son to local
grandees was, perhaps, too much for keen-as-mustard Ann to
resist, and in the mid to late 1780s, when he was ten or eleven, she
introduced John to Rachel, Lady Beaumont. Her first husband,
the 6th baronet Sir George Beaumont of Dunmow, had died in
1762, and in due course his widow married John Gates, a busi-
nessman and mill owner of Dedham.[1] As etiquette allowed, she
held on to being 'Lady Beaumont' regardless, while her son, nine
years old when he inherited, became Sir George Beaumont, 7th
baronet. John Gates moved in cultured circles locally and lived
in a fine house opposite the church, and while his and Golding's
business interests bore some alignment, John Gates was a cut
above the Constables. Nevertheless, Lady Beaumont with her
wealth and connections was having a good time in Dedham, and
she and the young baronet were people to know. According to a
letter written by John many years later, his mother had known
the 7th Baronet as 'a little boy'. Unless she had met him through
some other connection, this must be a misunderstanding as Sir
George will have been about fifteen when his mother remarried
and came to Dedham.[2]

While it may have been John Dunthorne, it may equally
have been Lady Beaumont who lent young John Constable the
Dorigny engravings after Raphael – she or a member of her
circle in Dedham, or perhaps the young baronet himself. This
was probably in the summer of 1795, the year in which Con-
stable's drawings after Raphael are dated.[3] Beaumont's was an
unexpected fortune, amassed by his trustees during his minority.
When he came of age the young man had to learn how to use

his money, whom to befriend, and what path to follow. He went to Eton and Oxford, studied watercolour drawing and sketching, met the influential painters Richard Wilson and Joshua Reynolds, married, and spent two years on an Italian Grand Tour. By now his path was set: Beaumont admired artists and actors, collected work by the former, acted in the amateur theatricals of the latter, and was developing an art collection that became one of the most important and influential in the country. He also became a serious amateur painter, one who might have become 'professional' had not wider interests, his wealth and the social priorities he chose, intervened. Beaumont was an astonishing man to know, and over time his patronising interest in the youthful John Constable became a prolonged friendship.

Naturally John was in awe of Beaumont's tales of the art world, and the pair may indeed have sketched together in the Stour Valley. Beaumont was of a thoughtful and generous turn of mind, a trait which accompanied the munificence that induced him to show his collection off to artists and others: by the century's turn he owned paintings by Claude and Poussin, Rembrandt and Rubens, many old master prints, and was in the practice of buying work by living artists where they fell into step with his taste. Beaumont was a patron of modern literature also, being of crucial financial and emotional support to William Wordsworth and his family in the Lake District in the early 1800s.

Beaumont – or Dunthorne – may also have been the source of other things such as an engraving after Claude's *The Embarkation of Carlo and Ubaldo*, a copy of which Constable drew and inscribed in full formal order 'Claude Gelee Le Lorrain pinx. J. Constable del. 1795.'[4] He was learning already about art historical shorthand: *pinx.* = 'pinxit, he painted it'; *delin.* = 'delineavit; he drew it'. Beaumont loved Claude with a passion, and would take his own little Claude, *Landscape with Hagar and the Angel*, wherever he went fitted into the roof of his carriage: 'he travelled with it; carried it about with him'.[5] When Constable first saw the painting in Dedham it electrified him, this limpid evening landscape with the figures meeting in a grove of trees, a small lake beyond, and a bridge and a castle in the distance. It is the kind of classic treasure that every young artist of the

1. *John Constable* by Ramsay Richard Reinagle, and 2. *Ramsay Richard Reinagle* by John Constable, both 1799. The portrait of Reinagle was later improved for Constable by John Hoppner.

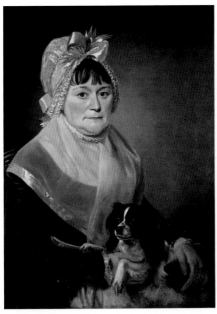

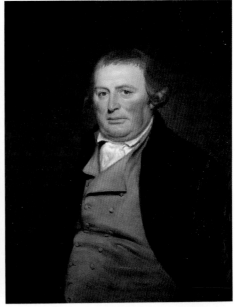

3. *Ann Constable* by Ramsay Richard Reinagle, 1799.

4. *Golding Constable* by his son, John Constable, 1815.

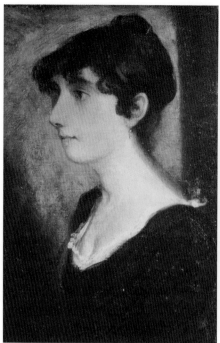

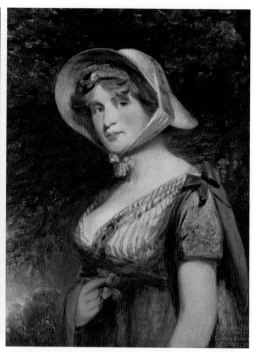

5. *Thomasine Copping*, who Constable met at Helmingham Hall, Suffolk. Private collection, United Kingdom.

6. *Lady Louisa Manners*, later Countess of Dysart, by Constable after John Hoppner, 1823.

7. *Ann and Mary Constable*, Constable's eldest and youngest sister, 1814.

8. *Frances, Mrs James Pulham*, 1818, wife of a solicitor of Woodbridge, Suffolk.

9. *Maria Constable with her children Johnny and Minna*, 1820. A quickly painted informal study of Constable family life.

10. *Charley Constable*, 1835. John and Maria's third child, painted shortly before he sailed to China as a naval midshipman, aged 14.

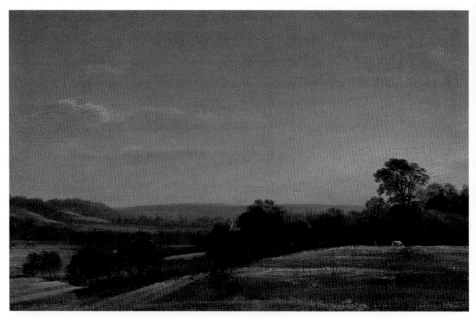

11. *Dedham Vale: Evening*, 1802, looking west from the back of West Lodge.

12. *Esk Hause, Lake District*, 1806: 'The finest scenery there ever was.'

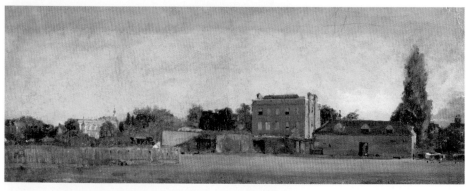

13. *East Bergholt House*, 1810, John Constable's birthplace.

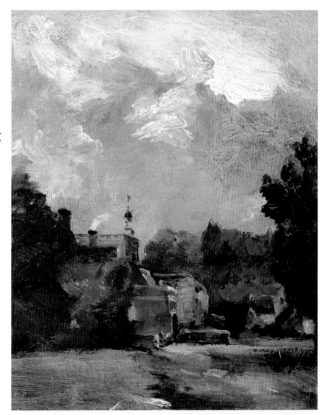

14. *St Mary's Church from Church Street, East Bergholt,* 1809, a spirited study demonstrating Constable's growing mastery of expressing the movements of light, air and cloud.

15. *Christ Blessing the Elements of Bread and Wine,* 1810, commissioned from Constable as an altarpiece for St James's Church, Nayland, Suffolk.

16. *A barge below Flatford Lock*, 1810. The pale afternoon summer light lifts the tonality of this painting of warmth, calm and silence.

17. *Dedham Vale: Morning*, 1811. So important was the success of this painting to Constable that he told Maria that he said his prayers before it.

18. *Barges on the Stour at Flatford Lock*, 1811. The last light of day caught in a moment.

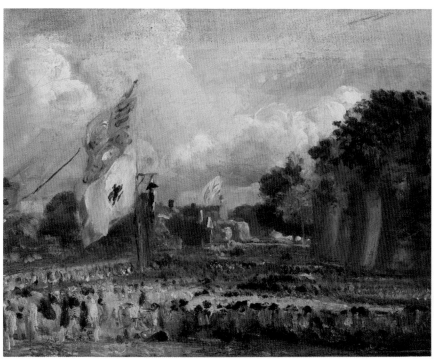

19. *The Village Feast, East Bergholt*, 1814, part of national celebrations for peace. These turned out to be premature.

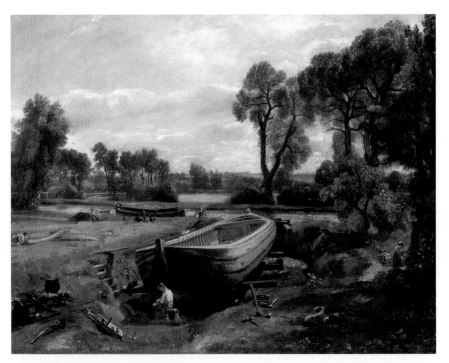

20. *Boat-Building near Flatford Mill*, 1815, a convincing record of the building of a barge, painted on the spot.

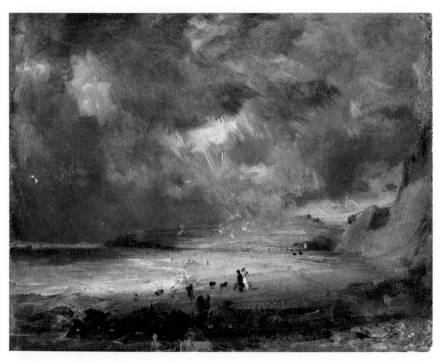

21. *Weymouth Bay*, 1816, painted during John and Maria's honeymoon in Dorset. The location is probably Bowleaze Cove.

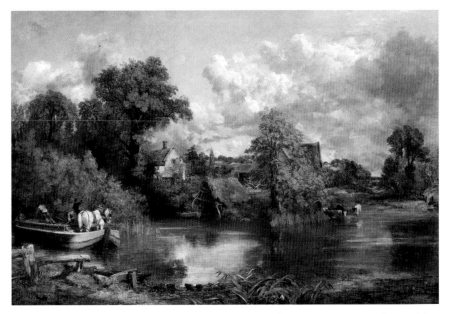

22. *The White Horse*, 1819. When first exhibited at the Royal Academy this was titled '*A scene on the River Stour*'.

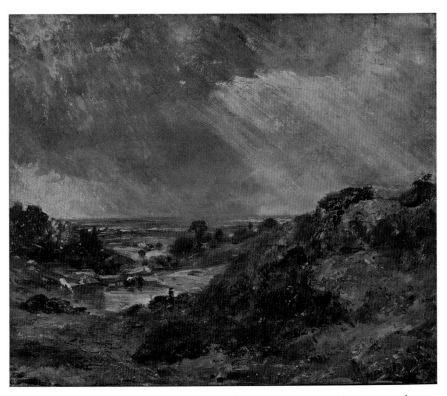

23. *Branch Hill Pond, Hampstead*, 1819. The rainstorm sweeping across the heath will soak the artist and all.

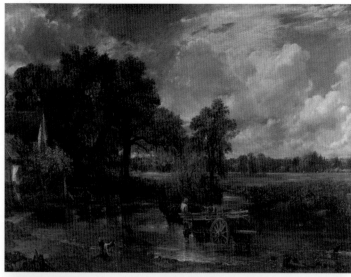

24. *The Hay Wain*, 1821. On its first exhibition this was titled '*Landscape: Noon*'.

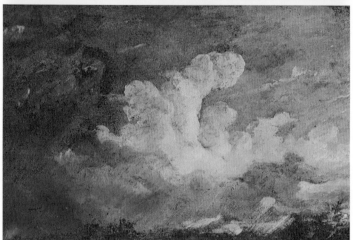

25. *Storm clouds over Hampstead*, c.1822. The sky, Constable wrote, formed 'the "key note", the standard of "Scale" and the chief "Organ of sentiment"' in a picture.

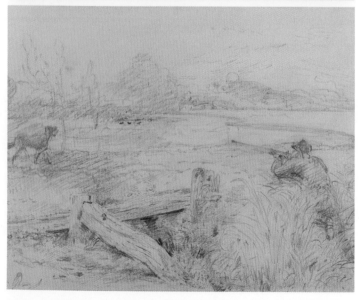

26. *A Sportsman: Golding Constable* [John's brother] *shooting duck on the River Stour*, 1827.

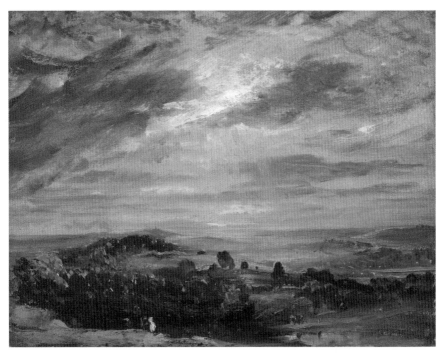

27. *View from Hampstead Heath, looking towards Harrow*, 5pm, August 1821: 'very fine bright & wind after rain slightly in the morning.'

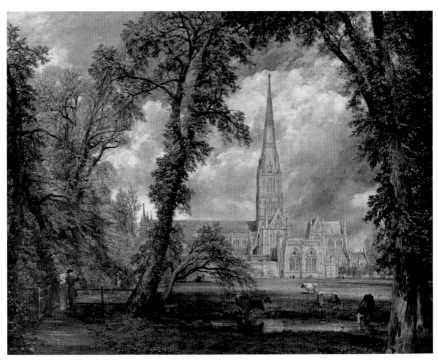

28. *Salisbury Cathedral from the Bishop's Grounds*, 1823. 'My Cathedral looks very well . . . considering how much I dreaded it . . . It was the most difficult subject in landscape I ever had on my easel.'

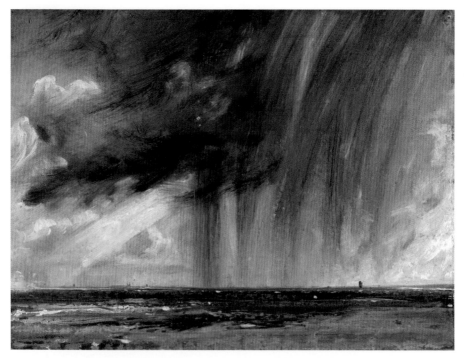

29. *A rain storm over the sea*, 1824. The power of this expression of storm and sunlight, painted in minutes, must have surprised even the artist.

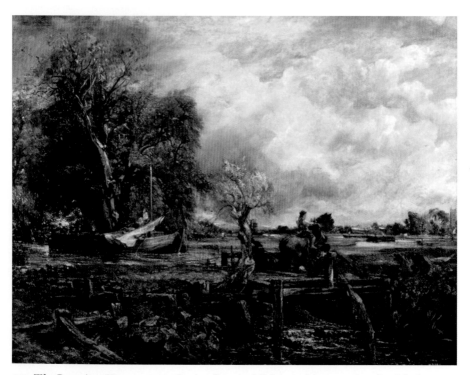

30. *The Leaping Horse*, 1825. On its first exhibition this was simply titled *'Landscape'*.

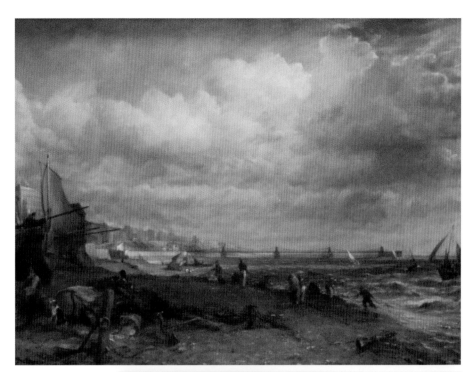

31. *Chain Pier, Brighton,* 1826-27. The culmination of many studies made when Constable visited Maria, who was convalescing at the seaside.

32. *The Cornfield,* 1826. In the months after Constable's death this was bought for the nation in the artist's honour by 'a body of subscribers'.

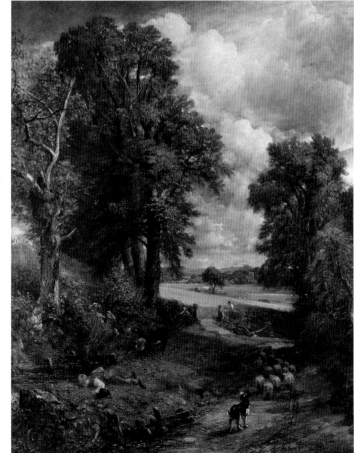

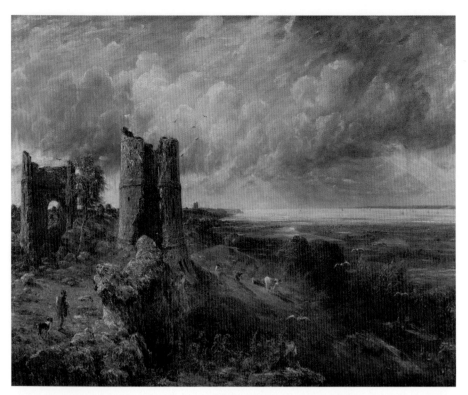

33. *Hadleigh Castle*, 1829. Exhibited with the lines from Thomson's *Seasons*: 'Rude ruins glitter; and the briny deep . . . reflects a floating gleam.'

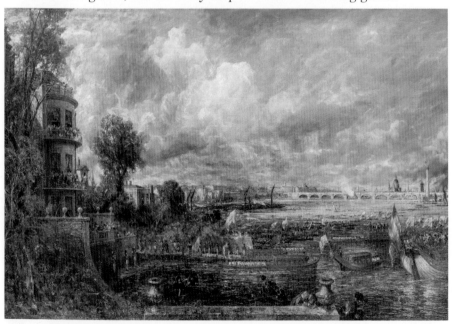

34. *The Opening of Waterloo Bridge seen from Whitehall Stairs, June 18th 1817*, 1832. Constable's first studies were made in 1817. He would agonise over the subject for fifteen years.

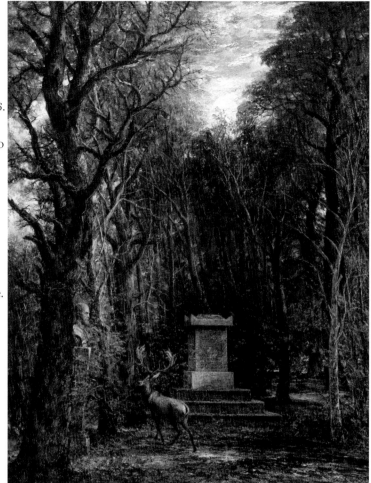

35. *Cenotaph to the Memory of Sir Joshua Reynolds*, 1836. Constable's tribute both to Reynolds and to his friend Sir George Beaumont, who erected this memorial at Coleorton, Leicestershire.

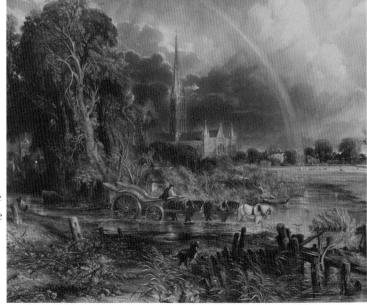

36. David Lucas, *Salisbury Cathedral from the Meadows*, 1837. The last Lucas mezzotint that Constable would approve before his unexpected death.

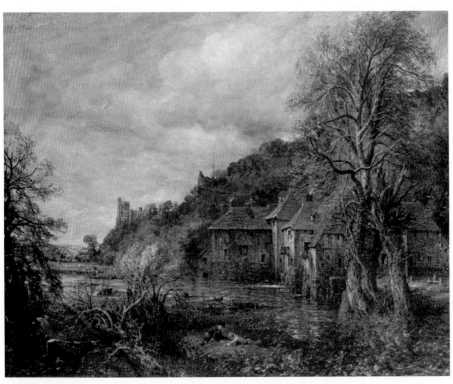

37. *Arundel Mill and Castle,* 1837. Constable's final painting, left on his easel at his death.

period was expected to admire and aspire to. At the same form-
ative age Turner saw his first painting by Claude in Sir John
Angerstein's collection in Pall Mall. He was overcome by it, and
allegedly burst into tears.[6] Beaumont was proud to talk to young
John Constable about his Claude, about old masters, and the life
of the artist, and was greatly impressed by Constable's Raphael
copies.[7] Here clearly was a talented and impressionable young
lad, and Beaumont took him under his wing, inviting him to see
more of his paintings, and encouraging him to come one day to
London to see his collection at his house in Grosvenor Square.

Dedham was a haven where wealthy Londoners could escape
the capital. Of Sir George Beaumont's many artistic friends,
one, the artist and diarist Joseph Farington, paid a visit to the
town with him in September 1794. 'Fine day', he wrote in his
diary:

> After breakfast walked with Sir George, and made a sketch of
> Dedham vale from the grounds above the Revd Mr Hurlock's
> ... The country about Dedham presents a rich English land-
> scape, the distance towards Harwich particularly beautiful.[8]

With its long street curving beside the church, Dedham had
become a little Bath-in-the-East with fine houses and the Assem-
bly Rooms where balls and concerts were held.[9] The developing
promise of Mistley Spa was nearby, as was the fashionable sea-
side town of Lowestoft. Beaumont took his mother – widowed
again in 1787 – to spend summers in Lowestoft with other
well-connected grandees from round and about. The *Ipswich
Journal* reported one 1788 exeunt in which Sir George, his
wife and mother, the Eyres of East Bergholt, and Miss [Lucy]
Hurlock all trooped off to Lowestoft, which had 'of late years
been much improved as a bathing place, on account of the con-
venience of the machines, the excellence of the air, the extensive-
ness of its sea prospect, and the beauty of the country adjoining
to it.'[10]

The ambitious churchman Canon John Fisher and his wife
Dorothea, a Suffolk heiress, would also play a central role in Con-
stable's life. Dorothea Fisher's family, the Scriveners, had owned
Sibton Abbey, near Yoxford, and it was her family money, an

income of more than £1600 a year,[11] that supported the rise of
John Fisher through the cloisters of the Church of England and
into the embrace of royalty. He was the eldest son of the rector
of a parish in the Isle of Wight, vicar of a city parish in Peter-
borough and chaplain to its Bishop. Having grown up in Church
circles, John Fisher learnt how to find his way around its politics,
and through that skill, his Cambridge education, and the sparkle
in his eye, he rose. At St John's College, where he was a Fellow
and Tutor, he was noted for 'the suavity of his manners and the
peculiarly felicitous manner with which he conveyed instruction'.
One contact led to another, and in 1780 he was appointed tutor
to the thirteen-year-old Prince Edward, later the Duke of Kent,
a younger son of George III and Queen Charlotte.[12] Fisher
was an effective operator, a cheerful and sociable smoothie who
moved well in royal circles. 'Mr Fisher is . . . never unwelcome,'
wrote the diarist Fanny Burney.[13] He gained the confidence of
the king, who rewarded him with the posts of Royal Chaplain
and Deputy Clerk to the Closet. He was also appointed Treas-
urer to the Dean and Chapter of St George's Chapel, Windsor,
at a time when the chapel was being comprehensively and ex-
pensively renewed by James Wyatt. As the Rev. Dr Samuel Parr
expressed it:

> Unsoiled by courts and unseduced by zeal,
> Fisher endangers not the common weal.[14]

Cross-currents in courtly opinion, however, also pointed to
Fisher's hasty temper and easily alarmed vanity.[15] Fisher went
back and forth to Windsor in pursuit of his duties, and there
came to know Fanny Burney, who remarked on his wife in words
that only she could invent:

> Mrs Fisher seems good natured, cheerful, and obliging, nei-
> ther well nor ill in her appearance, and I fancy, not strongly
> marked in any way. But she adores Mr Fisher, and has brought
> him a large fortune.[16]

Lucky Fisher, 'a charming creature, generally known in soci-
ety as the King's Fisher'.[17]

While always maintaining his Windsor connections, Fisher

became in 1790 Rector of Langham, a parish in the gift of the Duchy of Lancaster. He worked hard, and probably lobbied hard for his preferment, and in 1802 was rewarded with the See of Exeter, its Bishop's Palace and its £2000-a-year living. Five years later he was translated to Salisbury, with its Bishop's Palace in the Close, £4000-a-year living, ex-officio Chancellorship of the Order of the Garter, and use of the grace-and-favour Salisbury Tower at Windsor. Life was good for senior Church of England bishops in the early nineteenth century, particularly those connected to royalty, and the King's Fisher, an expansive bon viveur, made the most of it. This was the classic career of the ambitious churchman of the period. Fisher was determined to continue the improvements to the palace and grounds at Salisbury begun by his predecessor, Bishop John Douglas, and set about creating landscaped walks between the cathedral and the river.

Despite Fisher's worldly success, he and his wife had their miseries. Edward, their only son, was mentally ill and had been put quietly away in a distant rectory.[18] Fisher's brother, the Master of Charterhouse, Rev. Dr Philip Fisher, had a lively son of his own however, and it was this young John Fisher whom the Bishop took under his wing, groomed for the Church, and embraced as balm to his old age. Bishop Fisher had befriended the Rev. Brooke Hurlock, who made him a beneficiary in his will and one of his executors, and it might have been Hurlock who introduced the Bishop to his daughter's friend, the young John Constable.[19] In discovering Bishop Fisher, Constable struck gold. Fisher's talent for drawing in the landscape brought them together, and Fisher himself produced landscape drawings on his travels in England and Europe.[20] While these are amateurish and conservative, they nevertheless revealed common ground between the pair when they met in the Stour Valley during the summer of 1798. From this starting point John Fisher the senior churchman and John Constable the uncertain son of a leading local merchant became good friends.

By the end of the 1790s Constable could count on Dunthorne the plumber, Beaumont the art collector, and Fisher the churchman: three men, three walks of life, three economic and social brackets, three crucial ingredients in his early life. He could also

count on their wives or mothers: the put-upon Mrs Dunthorne, the charmed Lady Beaumont, and Dorothea Fisher who would compare John's male beauty to that of 'one of the figures in the works of young Raphael'.[21] His influential supporters also included the novelist, poet and philanthropist Elizabeth Cobbold, who, with her friend the painter Daniel Gardner, went sketching with young John Constable in the landscape around her husband's Cliff Brewery in Ipswich. Elizabeth Cobbold praised Constable's sketches fulsomely: 'those early praises from the lips of that benevolent lady ... became a stimulus to his exertions before he was raised to the eminence of a first-rate landscape painter.'[22]

Other notable local families whom the Constables associated with included the Robertses of West Lodge, the Reades and later the Godfreys of Old Hall, the Rookes of Langham Hall, the Newmans of the Old Lecture House Dedham, the Whitmores of Dedham Hall, the Firmins of Rookery House, the Bridges of Lawford Place, near Mistley, and the Probys from Stratford St Mary. The Bicknells, a London family who would play a central role in Constable's life, visited Dedham for long periods, and also became well known to the Constable family.

Ann Constable had her finger on the pulse of the Stour Valley, and noted such details as the 'castles in the air' of William Eyre,[23] who kept a bear in his attic: '[it] promises a great deal of mischief & tho he managed with some skill it has bit him twice – it is very ridiculous to see it follow him over the high pales – seems afraid of nothing but a broom.'[24] William Eyre's house, The Gables, later became The Bear Inn.[25] Ann is a curtain-twitcher inasmuch as she observes everything going on in the village from her front window: 'The coaches pass with so much velocity that I did not observe [Dr Rhudde], but I find he returned yesterday.'[26]

The attention being paid to John presented a serious problem for Ann and Golding, who had not yet given up on his running the family's businesses. Sensing the dangers of intellectual and moneyed people beginning to move in on their twenty-year-old son and turning his head, they sent him to Edmonton, north of London, to keep the boy on side as their trainee manager. In

Edmonton he would stay with his mother's younger sister, Jane, and her husband, Thomas Allen, a successful brewer sensible in business and, of course, family.

7. This cardinal purpose

Thomas Allen's brewery in Wapping, a few hundred yards east of the Tower of London, was profitable and productive in this vibrant and compressed part of the city. St Katherine's Docks were yet to be dug, but already need for docks beside the river was acute as industries grew in and around the parish, trades and population expanded, and the wharves and jetties became increasingly inadequate and unstable. Allen, Constable's uncle, had been brewing in Nightingale Lane (now Thomas More Street) since at least 1776,[1] and had made enough money for him and his family to live both in Finsbury Square, north of the brewery, and in a villa in Edmonton.

Allen's mind was never wholly on brewing or drapery: he was a studious, reflective man, a student of botany able and dedicated enough to contribute to James Sowerby's corpus *English Botany* (1790–1813). 'Plants are his delight', Mary Constable would write in 1824.[2] In 1793 Allen was well-connected scientifically: having a 'zeal for natural history' he was nominated by both Sowerby and George Adams the younger, scientific instrument maker to George III, to be a Fellow of the Linnean Society, devoted to the practice and application of taxonomy.[3] Thus, he was close to the centre of botanical collecting and research in his day. Five years later, Allen was elected a Fellow of the Society of Antiquaries of London, expressing his further interest in archaeology, antiquarianism and history.[4] Nevertheless he remained in business as a brewer, being listed in the *London Directory*, by now in partnership with Robert Allen, until at least the 1810s.[5] Thereafter he vanished into Europe to look for plants, ending up, to his family's bewilderment, in Malta.[6]

Intellectual enquiry funded by the profits and comforts of business lay at the root of the milieu that John Constable found himself thrown into in 1796: a family and circle of friends in which conversation was wide-ranging. These attributes were not

particularly marked in the Constables of East Bergholt, and had his parents given it more thought they should have realised that by sending John to Edmonton their original intention to give him practical experience in a brewery and draw him back into a life as a merchant might backfire. Brewers such as Cobbold, Whitbread and Allen were renowned for their practical intelligence and application: theirs was a profession that combined theoretical science and experiment with daring commercial investment, and the scaling-up of domestic systems into industrial production. Knowledge of the brewing business would transform John's understanding of the mercantile life. However, the young man was so finely balanced in his choice between business and art that exposure to the lively life of Edmonton might have taken him either way: tipped his balance back to business, to Golding's delight, or guided him towards art, and destroy his parents' dreams.

Edmonton had an unusually strong non-conformist, even rebellious outlook, which had brought the accusation that 'the head of the serpent' dwelt there and in nearby Enfield.[7] Early Quaker leaders preached in the town, and even in the 1790s the place was a hotbed of opposition to the established Church, with Independents (later known as Congregationalists) having two active chapels by 1788. The Quakers rebuilt their meeting house there in 1790. Influence from Quaker brewers and bankers was particularly powerful in the town; the Barclay and Hoare banking families played their part in supporting Edmonton's meeting houses, as did the Quaker brewer Samuel Whitbread.

Beyond all that, Edmonton was also famous in the popular literature of the day, being the anticipated destination of William Cowper's comic hero John Gilpin, the 'citizen of credit and renown'. Gilpin's wife had persuaded him to have a break from his linen drapery and give her a holiday at The Bell at Edmonton to celebrate their twentieth wedding anniversary: 'These twice ten tedious years / No holiday have seen', she tells him. The plan went pear-shaped, but the point here is that *The Diverting History of John Gilpin* became one of the most popular narrative poems of its day when it appeared in book form in 1785, and illustrated Edmonton as a place of retreat for Londoners. Cowper published

it in a volume with his long blank verse poem *The Task*, which itself later became an enduring favourite with Constable, and Cowper a crucial literary influence for him. Perhaps Constable came to know Gilpin's diverting local history at the fireside in Edmonton as the Allen family read it together, and it may have been there that he was also introduced to Cowper through *The Task*.

It was not only the Allens who proved so intriguing to John Constable, but the atmosphere of Edmonton and the circle that his uncle's friends created: there was John Adams, a schoolmaster, mathematician and former sailor, in love with Hogarth's engravings, and the compiler of a table of logarithms from 1 to 10,860; John Thomas Smith, a failed actor and sculptor's assistant who made good at last as an entrepreneurial engraver, author and ultimately museum curator; Sir James Winter Lake, Bt., a grandee merchant baronet who had lucrative trading links to Canada; Charles Gower, a sad Oxford undergraduate with a grandiose and over-inventive brain; and John Cranch, an enthusiastic pedagogic artist from a Devonshire Quaker family who battened on to young Constable and helped him to see the world in a new light. John Constable refers to all these men in later correspondence.

These literary, artistic and intellectual friends paid enough attention to Constable for him to remember them frequently and warmly in his correspondence. J. T. Smith lived with his family in Duck Lane, and, having tried his hand as an actor and as an assistant to the sculptor Joseph Nollekens, his trajectory as a draughtsman and printmaker was now clear. His father, Nathaniel Smith, who had also worked for Nollekens, had a print shop at Rembrandt's Head, St Martin's Lane, Westminster. There he kept 'the best specimens of prints . . . that very large collection . . . probably the most considerable one in London'.[8] The entrepreneur Sir James Winter Lake, FSA, Deputy Governor of the Hudson's Bay Company, lived with his large family at Fir Hall, Edmonton.[9] He too had a notable print collection and library, extensive enough to take eight days to dispose of at auction in 1808. He had introduced J. T. Smith to Edmonton, and employed him as a drawing master to his daughter across the years in which Smith was compiling his volume *Antiquities of London and*

its Environs (published 1800). This collection of nearly two hundred engraved plates, dedicated to Winter Lake, was in progress while Constable lived at Edmonton, and as letters between him and Smith reveal, the older artist later encouraged Constable to journey around Suffolk and Essex to observe antiquities and curiosities, and draw them.

Another of the friends who turned up to talk was Charles Gower, a man about ten years Constable's senior, and one who, like Constable, seems to have been unsure of his future. Gower was in the middle of delayed studies in medicine when he and Constable met, and was suffering from an identity crisis. 'I am sorry to hear your friend Gower is so full of trouble,' Constable wrote later to Smith, 'but you well know my dear Friend we cannot go through this world without any.'[10] Gower was also concerned with the production and possibly the editing of the 1795 edition of Thomas Bardwell's *A Practical Treatise on Painting in Oil Colours*, first published in 1756, an invaluable cornucopia of information about pigments, varnishes, and tips for the student of painting.[11] 'Gower had considerable talents,' a fellow physician wrote, 'but they were directed every way but the right. He made medicine a plaything . . . and he died in obscurity.'[12]

The schoolmaster John Adams pioneered the mathematics of marine navigation and instrumentation, as his engraved portrait by J. T. Smith of 1795 indicates. His *Mathematician's Companion*, with its pages of dense logarithmic calculation, was published in 1796, the year Constable lived among these friends. Adams was famous in his Edmonton schoolroom for pointing out the virtues and vices in Hogarth's *Idle and Industrious Apprentices*, and for thrashing those pupils whom he determined fell short of a proper moral standard. This miscellaneous group, who together contributed to Edmonton's intellectual life, was a little university which revealed to John Constable something of the wide range of possibilities open to him beyond the Stour Valley: 'learned Friends' he called them: the Quaker salutation 'Friends' may be indicative.[13] It demonstrated to him that the practice of art had a living connection to the life of the mind.

The most immediate and lasting influence on Constable at

Edmonton came from the painter and polemicist John Cranch.[14]
He took Constable in a new direction, into the theory and his-
tory of art, and lent Constable some books including Leonardo
da Vinci's *Treatise on Painting* and Francesco Algarotti's *Essay
on Painting*. Everything that came subsequently to underpin
Constable's knowledge of art and art history revolved around
these books and others on the list that Cranch wrote out for him.
Headed 'Painter's Reading, and a hint or two respecting study',
and numbered 1 to 18, this list began to focus Constable's life.[15]

Leonardo was number one on Cranch's list, Roger de Piles's
Lives of the Painters number two. Following them were vol-
umes of historic writing on art and artists including Hogarth's
Analysis of Beauty, Charles-Alphonse Du Fresnoy's *De Arte
Graphica* [English translation titled *The Art of Painting*], Daniel
Webb's *Inquiry into the Beauties of Painting* and Algarotti's *Essay
on Painting*. Then come treatises by Anton Raphael Mengs, Ger-
hard van Lairesse, Jonathan Richardson father and son, and Sir
Joshua Reynolds's *Discourses*, the fifteen lectures Reynolds gave
between 1769 and 1790 to students at the Royal Academy. Reyn-
olds's *Discourses* were the latest thing in art teaching, but even
so Cranch added a warning, perhaps because he had heard some
of them himself; he had certainly read them thoroughly. 'Be cau-
tious [that Reynolds's writing] does not bias you,' Cranch ad-
vised Constable, 'against <u>familiar</u> nature, life and manners, which
constitute as proper and as genuine a department of imitative art
as the <u>sublime</u> or the <u>beautiful</u>.' He added that in his view Tobias
Smollett's comic novel *Roderick Random* was 'as . . . pleasing, and
. . . as necessary as [Milton's] Paradise Lost.'

Cranch had been a good friend of Reynolds, a fellow Devonian,
and his family had actively assisted the young Reynolds when he
was at the beginning of his starry career as a painter.[16] So having
met another determined but uncertain and unfledged young
artist Cranch must have found himself duty-bound, if only by
family tradition, to help him on his way. Cranch warned Con-
stable further in his assessment of Reynolds, that while being
'of the highest order of literature' the *Discourses* established 'an
<u>aristocracy of painting</u>', betraying students into contempt for

'everything but <u>grandeur and Michelangelo</u>.' This firm advice warned Constable against swallowing whole received ideas that were revered in the education of artists, but which were, after all, questionable, and some already thirty years old. Many intakes of art students had worked their way through the Royal Academy Schools since Reynolds first taught in its lecture theatre. It would have been easy for Constable, from his prosaic East Anglian background, to lap up such published metropolitan art instruction uncritically, so the lucky meeting with a contrarian such as Cranch gave him the tools he needed to form and to know his own mind. What Cranch's 'Painter's Reading' suggests, with its subtitle 'hint or two respecting study', is that it contains the boiled down essences of their conversation. Cranch's advice tallied well with Constable's questioning nature.

Cranch the mature Devonian, nearly fifty years old by now, and Constable the young Suffolk lad, twenty, had met halfway between their respective homelands and talked in the middle about painting as a crucial function of civilisation: the ordinary as important as the exceptional; *Roderick Random* as relevant as *Paradise Lost*. Cranch goes on to say that in his view the 'truth' of Teniers and Hogarth's 'wit and moral purposes' would 'for ever be, at least <u>as</u> useful, and diffuse as much pleasure' as 'the mere <u>sublimities'</u> of Giulio Romano and Raphael. Cranch believed that rather than expand and clarify the minds of young artists, Reynolds's *Discourses* achieved the exact opposite, confining students 'into a narrower or more inaccessible province.'

Cranch not only gave Constable a booklist, he also gave him material to generate the antennae he would need if he were to progress as an artist. Having listed the book titles 1 to 12, he continued, at number 13, thus: 'Poetry and history' – i.e., read it! Then:

14. [Look at the works of great masters, whether in the originals or in good prints] 'in order to ascertain by what courses of <u>thought</u>, and by what combinations and <u>contrivances</u>, those works were produced.' [That is, try to understand what they did and how they did it.]

15. 'The works of bad painters may be made highly useful, where truths and falsehoods may be ascertained by <u>comparison</u> with good pictures and with Nature.'[17]

16. 'The most general <u>habitudes</u> of men and things; or Nature as she is more or less perverted by the social institutions.' [Look at the ordinary, the quotidian; beware the course of fashion.]

17. 'Nature herself, as divested and distinguished from all accident, and from all the preceding considerations.' [Just observe nature; see what you find.]

18. 'The art of selecting and combining, from the whole, that which in exhibition will best satisfy at once the eye, the imagination and the understanding; or that which will come nearest to this cardinal purpose.' [Make a picture; use your eye, brain and imagination.]

In short, Cranch's advice amounted to this: understand what artists do and why they do it; look at everything, the good, the bad, and the ugly; also look at ordinary things; observe nature and think about it; use your eyes and your head. Nothing could be clearer and more sensible than that.[18]

Cranch has dated this crucial document 30 September 1796, and we can take it that on that day John Constable took his first confident step along the path ahead, certain of his direction. From that day on he had access to the intellectual means to consider himself to be an artist, and living examples of practices to avoid. Cranch's directives became Constable's Magna Carta, and as his career unfolds we can watch him attending to its paragraphs again and again, and returning to them as his touchstone. He made sure he got hold of as many of the recommended books as he could, and later told Smith how much he was enjoying Leonardo and Algarotti.[19] In his library after his death were copies of Leonardo, Algarotti,[20] de Piles, Hogarth, du Fresnoy (the Mason edition), Webb, Dubos, Mengs, Lairesse, Richardsons elder and younger, and Reynolds.[21]

Cranch lived for most of his life in Bath, and was, according to J. T. Smith, a self-taught artist 'in oil, after he was thirty six years of age'.[22] Constable would later opine that a self-taught

artist was one taught by a very ignorant person.[23] This was one of Constable's nostrums: enthralled by Cranch as Constable undoubtedly was, it was Cranch's thoughtful advice on reading that was of inestimable value to him, rather than his lame painting style. Samuel Redgrave's *Dictionary of Artists of the English School* names Cranch as an 'amateur', a pejorative term in that context, and goes on to reveal that he had worked as an attorney's clerk in Devon.[24] He must have worked hard and diligently, as the attorney left him £2000: 'with these means he came to London'. He was not a success as a painter, even though his works have a crispness about them that is charming and unexceptionable. In 1799, however, Constable tells us that Cranch 'has left off painting'.[25] As a theorist and teacher Cranch had talents that Constable, for one, drew immense benefit from. He copied, or otherwise followed, some of Cranch's pictures and his manner of painting, so while Cranch led him well in theories of art, he might have misled him as a painter. The painting Constable made of the Rev. Brooke Hurlock's house at Lamarsh in 1797 or 1798 is distinctly Cranchian.

Cranch's portrait, engraved by J. T. Smith in 1795, shows him to be wigless, with collar-length untidy hair set back beyond a high brow, and wearing a wide-lapelled jacket and a linen stock. He has a firm chin, an arrow-sharp nose and penetrating hooded eyes. His half-smile is discreet and interrogative. Unopened, held in front of him, is a volume of Shakespeare as a talisman. We can be fairly sure that, given the date of the portrait, this is exactly how Cranch was when Constable met him: sober, intelligent and radical.[26] After he had 'left off painting', however, Cranch took to showmanship: 'his whole time and thoughts are occupied in exhibiting an old, rusty, fusty head of Oliver Cromwell! Where he got it I know not; 'tis to be seen in Bond Street, at half a crown admittance.'[27] Thereafter, Cranch disappears from Constable's surviving correspondence.

8. Smith and Gainsborough

Constable kept in touch with the intelligent, able and re-sourceful John Thomas Smith following their meeting in Edmonton. Nine lengthy letters survive to Smith from Constable, one half only of the correspondence that continued for at least three years. Smith asked Constable to make drawings of country places such as cottages, churches and so on as etching subjects, and perhaps paid him for them, while Constable nervously asked if he could borrow Ruisdael engravings to copy: 'but as they are very scarce and dear, perhaps you would not like to trust them [to me].'[1] Smith also gave Constable etching instruction, and sent him some of his own drawings for guidance, while his father, Nathaniel, lent Constable 'one of the most lovely drawings I ever beheld', a landscape by Anthonie Waterloo.[2] Through the Smiths Constable also received a plaster bust of the Medici Venus, and an Apollo and other casts to draw, giving him essential practise for what must have been discussed as a future attempt to become a student at the Royal Academy Schools. Constable assured Smith that 'I devote all my evening to the study of anatomy', another requirement for the student artist, and another indication that Constable's ambitions had been discussed between them.[3]

Ann and Golding had every right to be perplexed at the out-come of John's autumn in Edmonton. There are complex cross-currents apparent, and contradictory messages coming out: he seems to be doing one thing, and telling his parents another. While he was still at Edmonton Golding wrote to him tersely. This letter is lost, but from John's reply it is clear that he was not ready to admit to his parents that he was contemplating a change in direction; in fact the letter conveys his confidence that he was on track to join his father's business. He writes here in a neat, clear, straight, well-spaced hand; with no sign of ruled margins or lines to guide, and with only three errors neatly crossed out, the letter is surely a fair copy of a well-worked and considered draft. John

demonstrates with deliberation his suitability for and his accept-ance of the clerk's role that Golding had immediately in mind for him: there are no artistic intentions or insecurities apparent here. He offers two pathetic and transparent excuses for not writing back straight away: the first was that he had 'a very bad pen and no knife to mend it', and the second that it was getting dark.[4] He reassures his father that he was not trying to get a job in London, even if that was to learn more about the corn trade. Golding had suggested that John seek work with his uncle Christopher At-kinson, the husband of his deceased older sister Elizabeth, who was still hanging on to his corn trade interests. Why Golding should suggest this is not clear, as Atkinson was a thoroughly bad hat, having been convicted of defrauding the army's Victualling Board in 1783, fined £2000, made to stand in the pillory outside the Corn Exchange, and imprisoned for twelve months. Atkinson was the Member of Parliament for Hedon, near Hull, at the time, and consequently expelled from the House of Commons. This was a mere setback, however: Atkinson stood again for Hedon, and in 1796 was re-elected.[5] 'If it is your real wish that I should apply to Mr Atkinson,' Constable wrote, 'I certainly will do it, but he is not a man I should apply to by choice.'[6]

When he returned to East Bergholt at the end of 1796, John Constable was a changed young man. He was filled with new ideas, and sensible of new and exciting possibilities, but never-theless he returned to his former duties in the Counting House, and appeared to his parents to have put his ambitions to be an artist aside. Surprisingly, it was J. T. Smith himself who seems to have helped John Constable reach that decision after talking through the options with him. Both Smith and Cranch had given him much good advice on looking, reading, drawing and etching, and saw his value and potential as an artist. It was Smith, how-ever, who recognised the particular difficulty Constable faced at home, his orthodox rural 'middle-class' background, the social and parental expectations upon him, and the struggle he would face were he to try to make a living as an artist. Smith would not encourage Constable to sacrifice himself to the whims of the world of art.

Constable had worked very hard for Smith, procuring at least

three new Suffolk subscribers to *Remarks on Rural Scenery*, the volume of engravings and texts that Smith had long been preparing. He also encouraged members of his family to subscribe: Thomas Allen (and his aunt Jane Allen in her own right), his cousins James Gubbins and Ann Mason of Colchester, his sister Mary Whalley and his uncle David Pike Watts are all named in the subscription list.[7] The subscription pages also list 'John Constable, Esq: 2 copies': one for himself, and one also, we might suggest, for his parents. There were crossroads ahead: Smith gave him some firm advice, words that Constable perhaps did not want to hear. He responded like this:

> My dear Friend I must now take your advise and attend to my Father's business as we are likely to lose an old servant (our Clark [*sic*]) who has been with us these eighteen years.

That was it. All he could see ahead of him, now, was a life as the manager of a corn merchant's business stretching on for ever:

> I certainly see it will be my lot to walk through life in a path contrary to that which my inclination would lead me.[8]

If that seemed to be the end, it was not: Smith had something else up his sleeve, an idea to keep Constable's blood up. He urged him to go to Ipswich and find out about Gainsborough, to discover how a young Suffolk artist with talent and application might develop a career. Smith knew that John Constable needed a lodestar such as Gainsborough to steer by, so in the spring of 1797, at Smith's behest, the young man walked about Ipswich seeking traces of Thomas Gainsborough. This came to nothing, as Constable reported:

> I have not been able to learn any thing of consequence respecting [Gainsborough] ... not for the want of asking, for indeed I have talked with those who knew him. I believe in Ipswich they did not know his value till they lost him.[9]

He also told Smith about correspondence he had had with an Ipswich drawing master, who recalled the places along the Orwell estuary where the young Gainsborough had drawn,

Bramford, Nacton and Freston. The similarities between the young Gainsborough drawing views in his locality and Constable's own youthful practice were becoming clearer. The expedition to Ipswich, though superficially fruitless, did have the effect of encouragement, and indeed Constable was prepared also to ride over to Sudbury to find out more about Gainsborough for Smith.

Golding and Ann got wind of the brains behind John's expedition, and in veiled language, a skill long mastered, Ann made her and Golding's concern and displeasure very plain. She wrote to Smith, flattering him, and thanking him for being 'so warm in commendations of my Son John . . . his future conduct I trust will ever merit the favor of your friendship'. She added, firmly and clearly:

> We are anticipating the satisfaction of seeing John at home in the course of a week or ten days, to which I look forward with hope that he will attend to business – by which means he will please his Father, and ensure his own respectability, comfort & accommodation.[10]

By now, however, Golding and Ann will have had a copy of *Remarks on Rural Scenery* in their hands, with its endorsements in the subscription lists from family members, all proudly given in the back of the book. They will also have noticed familiar Edmonton names there – Sir James and Lady Winter Lake and John Cranch – and Suffolk men and women whom they admired: Robert Bradstreet, Elizabeth Cobbold, Charles Gardner, Lucy Hurlock and Benjamin Strutt of Colchester. Thus, *Remarks on Rural Scenery* showed them that art had its purposes, acknowledged by many, and that only conviction and deliberation would lead to accomplishment.

By the end of 1797, a year after Constable had come home from Edmonton, he was riding two horses at the same time: on the one hand, to please his parents 'and ensure his own respectability', he was back working in the family business; on the other he had identified, but was prepared to sacrifice, his own path: the way 'my inclination would lead me'. This is clear evidence of a profound family issue, which may have taken the whole of 1798

to resolve. At the end of 1797 his parents were confident that he would 'attend to business', but early in 1799 he had abdicated from a life of mills and milling and set off for London. With his parents' explicit support he began to follow his path for a life of art.

Two critical events contributed to this volte-face: one was J. T. Smith's visit to East Bergholt in late October and November 1798, where Smith met Lucy Hurlock and perhaps also some of the other Suffolk subscribers to *Remarks*. It is almost certain that he stayed with the Constables at East Bergholt House, where he would of course have met Golding, Ann and young Abram, for in December Constable wrote to Smith when he heard his friend was unwell: 'all our friends here join with me in sincerely hoping you continue recovering'.[11] The second change of circumstance was that Abram had now turned sixteen, and was already learning the business. This was the hinge in Constable's life, and J. T. Smith was instrumental in oiling it.

At the end of January 1799, a few days before he set off for London, Constable visited Elizabeth Cobbold in Ipswich. The Quaker author, abolitionist and prison reformer Priscilla Wakefield was a fellow guest, and she took a shine to this 'pleasing modest young man who had a natural genius for painting'.[12] Cobbold and Wakefield were both forceful women who got things done through the power of their connections, writings and intellect, and it was Constable's particular good fortune that he had their encouragement at this moment of change. Priscilla Wakefield gave him a letter of introduction to her friend Joseph Farington, the influential Royal Academician whose value as a diarist and as the memory and conscience of the Academy vastly outweighed his modest talents as an artist.[13] Farington was a friend not only of Priscilla Wakefield, but of the Cobbolds, and more importantly of Sir George Beaumont, who knew them all and had already introduced Farington to Dedham Vale, Mistley, East Bergholt and Langham. How tight and enriching these cultured circles were.

9. A lusty young man

John Constable, aged twenty-three in 1799, was a lusty young man with a keen interest in women of his age. If occasional usage in his writing is any guide, he had an appealing Suffolk brogue, and was 'above average height with dark hair and eyes, a Roman nose, and a pleasing expression', with exuberant sideburns as well.[1] Daniel Gardner demonstrated much of this in his affecting portrait in which he places his young friend in left profile, his sharp, elegant nose and gentle descending mouth contrasting with the flick of his brown fringe and sideburns, and his soft hazel eyes.[2] This is a portrait that marks Constable's determination to become an artist, rather than settle down to the lifelong routine of managing a milling business.

Human cosiness warmed Constable, both in his own extended family, and with the Allens and Smiths of Edmonton who included him lovingly in their lives. He was charmed by John and Anne Smith, and it is clear he would turn up at teatime in Duck Lane like clockwork: 'I hope Mrs Smith, and little girl, are well to whom I beg to be remember'd, likewise Mrs S for her civility, as I often gave her the trouble of making a Dish of Tea extraordinary.'[3] Two subsequent letters close with increasingly affectionate greetings for the Smith family: he sends his 'best respects to Mrs Smith and your Worthy Father . . . I hope your little girl is well.'[4] Nathaniel Smith, expert print-seller and collector, had been kind and generous, and Constable was grateful: 'pray make my best respects to your worthy father . . . and Mrs. S – not forgetting to send a kiss to your little one.'[5]

Female vivacity and exuberance at any youthful age enchanted him: he became 'the handsome miller' to young women around East Bergholt.[6] Handsome he was, but this was a double-edged compliment: he was not a miller, and everybody knew it: Golding employed others as millers at East Bergholt, Flatford and Dedham. Received history has it that John had only one love,

Maria Bicknell – but not a bit of it: there were many others in advance of Maria. Lucy Hurlock, the daughter of the wealthy Rev. Brooke Hurlock, was eleven years his senior, so romance between them seems unlikely, though he clearly had a particular fondness for her. She befriended him at the latter end of the 1790s, and John introduced her to his friends, guided her as she tried to learn to draw, and they shared delight when they looked closely together at the Anthonie Waterloo drawing lent by Nathaniel Smith. He encouraged Lucy to subscribe to J. T. Smith's *Remarks on Rural Scenery*, a book she would need if she really did want her drawing to improve.[7] But the life of an artist was not one she felt persuaded to share, and she accepted the offer of marriage from an older man, Thomas Blackburne, from King's Lynn, miles away.[8]

From Lucy's one surviving letter, sent to him in London in April 1800, eight months before the marriage, we can deduce that Constable's ambition and drive as an artist had been high among their subjects of conversation. This was evidently to Lucy's increasing tedium, and may have been terminally claustrophobic for her, certainly boring. 'I do not mean to obtrude on your time,' she wrote, 'time now of so much importance to you.' Lucy assured him that she would look forward to seeing his paintings on show, 'your performance at the exhibition . . . [to] obtain a sight of the production of gradual progress of an early genius . . . we shall be glad to hear how you are going on.'[9] She knew Constable would go far, but not with her, so this was goodbye. As a wedding present he gave the new Mr and Mrs Thomas Blackburne a set of four large watercolour drawings of the Stour Valley, which together create a wide view across a landscape that he and Lucy both knew well. This panoramic quartet has an insistent presence, and bore a message: John Constable could imagine that over long years of marriage, Lucy, Mrs Thomas Blackburne, might be reminded of him whenever she entered the room where the drawings hung.[10]

Lucy Hurlock was not, however, the only woman in Constable's vision in 1800. Maria Newman, daughter of a former Rector of Dedham, was almost exactly Constable's own age when she married a senior army officer, Lt. Col. Harcourt Master.[11] They

too were given a large ink and watercolour drawing as a wed-
ding present, of *The Old Lecture House, Dedham*, where Maria
had lived.[12] Was she another of John's frustrated affections? He
paid close attention to his brother-in-law Nathaniel Whalley's
sisters Catherine and Alicia when he stayed with the Whalley
family at Fenton in Staffordshire in 1801: 'Mr Jno Constable &
my daughters took an airing on Horse back – fine hay weather
PM ... daughters with Mr J Constable rode to Cellar-head &
Watley rock &c ... Mr John Constable & my Daugtrs took an
airing to Hand Church, Acton &c ... At Home. Daughters & Mr
J Constable took an airing to Meaford'.[13] It goes on and on: if
these were initial stages of courting, we might assume that his
hopes were usually high and his intentions generally good.

Reportedly, Constable fell in love with Jane Bridges, the daugh-
ter of George Bridges of Lawford Place near Mistley, when
he painted the family group portrait in 1804.[14] Sittings were
curtailed as a result. Yet another who passed across his line of
sight in 1806 and 1807 was Amy Whitmore, a relation of Sadler
Whitmore of Dedham Hall. Constable was, by now, drawing
and painting portraits on commission, and Amy is the subject
of the largest pencil portrait he ever drew.[15] Commissioned as
this portrait surely was, it is fully inscribed 'John Constable /
Jan.y 6th 1807', and its directness and full-face affectionate gaze,
with large soft eyes and an informal tilt of the head, signals an
admiration that would be out of place in what might merely
have been a business relationship.[16] Other intimate and sensuous
drawings of young women of his age are the sisters Sophia and
Harriet Cobbold, and the six Hobson sisters of Markfield House,
Tottenham.[17] These may all have been studies for Cobbold or
Hobson family portraits, but they are overwhelmingly of the
sisters in the families: a quick count reveals that eighty-eight are
girls and women, while only eleven are men. If there were family
group portraits in the wind, Constable was clearly not paying
sufficient attention to the whole.

When he left East Bergholt for London he kept a room up-
stairs in his parents' house to work in when from time to time he
came home: this was common knowledge, so when a party came
over from Lavenham to see what he was up to, his mother was

ready. One of them, the poet Ann Taylor, granddaughter of the engraver Isaac Taylor, recalled years later:

> We had been invited to walk over to Bergholt to see his paint-
> ings . . . and availing ourselves of this, one morning, we found
> his mother, Mrs Constable, a shrewd-looking, sensible woman,
> at home. There we were, five girls, all 'come to see Mr John
> Constable's paintings,' and as we were about to be shown up
> into his studio, she turned and said dryly, 'Well, young ladies,
> would you like to go up all together to my son, or one at a
> time?'[18]

Ann Taylor had been introduced to the Constable family, she recalled, in December 1799. By this time John was living in London, so he was evidently back home for Christmas. She was bowled over by him: 'so finished a model of what is reckoned manly beauty I never met with as the young painter; while the report in the neighbourhood of his taste and excellence of char-acter rendered him interesting in no small degree.' Ann Taylor knew it, and John's mother knew it: John was a catch, and Ann Constable was making essential matchmaking preliminaries. Indeed, as Ann Taylor remembered, they felt sorry for him, as the locals had been fed the line that John was 'a hero in distress', and had swallowed the rumour that Golding 'wished to confine [John] to the drudgery of his own business . . . to us this seemed unspeakably barbarous.'

Again and again the subject of people's daughters crops up: Constable seems to have talked about daughters a lot. This is an account of a conversation he had soon after he moved to London:

> Constable was acquainted with Mr Rooke who lived at Lang-
> ham Hall near Dedham, but they quitted it, and now reside
> in or near London, it is supposed, on account of their family,
> having five grown up daughters unmarried, who it might be
> prudent to produce more to the world for a chance of forming
> connexions. The daughters are handsome.[19]

Discussing the family of a new friend, John says:

Reinagle has 8 daughters and two sons. His wife is a very prudent woman, a good manager, and has brought up her daughters with propriety.[20]

There may be a pattern developing here. John's younger brother, Abram, the author of many loving and newsy letters, remarked in 1808 on the coming visit of the Colchester solicitor William Mason and his family, 'They reckon on seeing you, I gave them your address.' Mason's wife was Anne Parmenter, John's first cousin only six years his senior, the daughter of his Aunt Judith. The families visited each other regularly, and John had of course known their daughter, Jane, as a little girl. Now, however, Abram suspected, 'I know you will not mind losing a little time with them, Jane is to be with them, you will think her grown.'[21] Jane did soon become a portrait subject for Constable, a fresh-faced, bright-eyed, nervous young woman in an Empire-line white dress, with a white lace shawl and a white silk waistband, getting ready to face the world.[22] Constable himself had by now become the subject of female gossip and enquiry: 'Your father and I were at Sudbury on the 4th instant, at Mr Frost's – where you were much enquired after by Miss Evans and Miss Frost ... They are good tempered pleasant unaffected girls, & seem artless.'[23] And then there were more: decades later, in 1821, Constable's particular friend John Fisher reminded him about a Miss Webber and a Miss Cookson, two young women Constable will have met in Salisbury: 'exert yourself for ancient love's sake', he wrote. 'Don't let your wife see that last sentence.'[24]

As his portraits become increasingly accomplished and characterful in the 1800s a manner runs through those he made of young women, principally Jane Mason and Amy Whitmore, whose wide eyes and engaging poses might reflect on the artist's feelings. In the close society of the Stour Valley, these and others were part of a contained local family and friendship circle of a social level that would satisfy his parents' matrimonial expectations for him, if not his own needs in a wife.

One sparky girl who appeared in the village from time to time was the eleven- and twelve-year-old granddaughter of Dr Rhudde, Rector of East Bergholt. This was Maria Bicknell,

bright, cheerful, dark-haired and fine-featured, a daughter of the successful and well-placed London solicitor Charles Bicknell and his invalid wife. Rhudde and his wife had a special love for Maria: 'Your Grandmamma,' her older half-brother Charles Henry Bicknell told her, 'is forever making enquiries after Maria, and longs so much to see her, that you would think it was a little Queen she was talking of.'[25] Grandmamma would very soon have that opportunity, for over Christmas 1800 Maria's parents sent her to East Bergholt to stay with Grandmamma and Grandpapa. There was much for her to do in and around the village: friendly families, country walks, attending church. What could be more convenient for an elderly rector and his wife than to have the young girl occupied, and to allow her to walk in the country with that reliable, interesting and sensitive young man, Golding Constable's boy?

10. Devoted to art

John Constable's years as an art student in London brought him both liveliness and loneliness. He found somewhere to live, but trusting friendships were harder to secure. His first, enduring and affectionate association came when he took his letter of introduction from Priscilla Wakefield to Joseph Farington in Charlotte Street, Soho. The pair talked politely, but from Farington's elliptical diary entry it looks as if he was not over-impressed, and missed the Dedham Vale connection: 'Mr J. Constable of Ipswich calld, with letter from Mrs W.'[1] In getting Constable's home town wrong, this usually punctilious old Academician may not have been paying full attention. Then he added, referring presumably to the young visitor, 'd[?D]evoted to art therefore not necessary to profess it.' This may suggest that Constable came across as overenthusiastic, inducing Farington to see him as amateurish, overly passionate in his response to painting, and insufficiently critical to take it up as a career. However, characteristically giving his opinion whether invited to do so or not, Constable told Farington: 'first pictures of Gainsborough his best, latter so wide of nature.'

Farington may not have realised what had hit him. Constable would consume his time and energy, intervene in his brain and diary, and as the years went by, move into his street, and, after Farington's death, move into his house. But over the following nine days, Constable called on Farington three more times, each visit building up to reveal his chief ambition, to be accepted as a student at the Royal Academy Schools in Somerset House. He was importunate, and Farington soon acquiesced. First Constable brought some sketches he had made around Dedham to show Farington, who told him that he must 'prepare a figure', that is, a drawing from life or from a cast. Four days later he had done just that, bringing Farington his 'drawing of torso for admission to Acad'. This clearly did the trick, and on 4 March 1799

his mentor provided him with a letter of introduction, which he immediately took round to the Keeper of the Royal Academy, the sculptor Joseph Wilton, Academician in charge of student admissions.[2] Inch by inch Constable ground himself into the edges of the Academy with a relentlessness that became characteristic, displaying in the process the annoying persistence that may have become a cause of the delay in his full acceptance into the Academy fold for some years.

Farington gradually warmed to John Constable, however, and during their conversations found out more about him: 'Father a Merc[han]t who has now consented that C. shall devote his time to the study of Art'.[3] Together they looked at Farington's collection of Dutch paintings. That same day, 4 March, Constable wrote excitedly to John Dunthorne: he is admitted as a student at the Royal Academy! His drawing of the plaster cast of the Belvedere Torso in the Royal Academy collections got him in! He's going to make an oil copy of a little Ruisdael that Farington will lend him! It was not strictly true that Constable had been admitted as a student, though he will have wished it so: Wilton had merely admitted him on probation to draw from the plaster casts in the Antique Academy – not quite the same thing.[4]

Constable tried to make the most of London to ward off homesickness, and Dunthorne was his constant ally, touchstone, and the target of his news. Life in London, so far, was good, and he was keeping his spirits up. Across these early weeks he thought constantly of home, looking forward to seeing the leaves on the trees in East Bergholt in the summer, when he felt he would be 'better qualified to attack them than I was last summer.'[5] Then he hands out advice to Dunthorne, perhaps tactlessly: 'all the time you can conveniently spare from your business', Constable cheerily tells him, 'may be happily spent in this way, perhaps profitably, at any rate innocently.' He mentions the lay figure, an articulated model human figure that Dunthorne is making for him as an artists' composition aid: 'I hope to see it finished when I return, together with some drawings of your own from nature.' This correspondence with John Dunthorne, and Joseph Farington's terse diary entries, are the two contrasting sources that document John Constable's strains and releases in London.

He studied hard and drew well: 'I have been working day and night', Constable told Smith.⁶ Sitting beside him in the cast collection were other talented young men such as Augustus Wall Callcott, Richard Cook, Samuel Lane, Ramsay Richard Reinagle, and the scion of the architectural family, Matthew Cotes Wyatt.⁷ Soon they would be joined by the fourteen-year-old prodigy William Mulready, and the breezy young Scot, David Wilkie. At the end of the year Constable's studentship was confirmed, and on 21 June 1800 he was finally admitted.⁸

For a while, Ramsay Reinagle, just a year older, was a good friend. Constable moved into his rooms at 23 Cecil Street, off The Strand, five minutes' walk from the Academy. As these two likely lads, loose in London, got to know each other they painted each other's portrait, each homing in on the dreamy, romantic quality the other was cultivating: Constable looks down, avoiding the beholder's gaze, while Reinagle glances sideways, considering something: we might be looking at Wordsworth painted by Coleridge, and Coleridge painted by Wordsworth. Of the pair, Reinagle's image of Constable is clearly the better portrait: Constable will have realised that immediately; he had not yet developed the insight he needed to catch the character of his new, sophisticated friend.⁹ New openings in London, and new friends around, were causing Constable to develop new ways of thinking, and if Reinagle had suggested to him that they both have a go at painting portraits, Constable went along with it: there could be money in portraits; he would think about taking it up.

Ramsay Reinagle was well travelled, clever, and in the swim.¹⁰ His father, Philip Reinagle, had worked for years in the studio of Allan Ramsay, Principal Painter in Ordinary to George III, first as an apprentice, then as an assistant overseeing the industrial production of Ramsay's court portraits of the King and Queen Charlotte.¹¹ Philip Reinagle also had a side-line in buying up old paintings, cleaning, repairing and selling them on. After Allan Ramsay's death in 1784, Philip Reinagle broke out of the studio system and became a distinguished animal and sporting painter. When Constable met his son, Philip Reinagle was an Associate of the Royal Academy, and even at the late age of fifty, and with a large family to support, he had a sparkling future ahead of him.

Philip Reinagle's background of years of drudgery followed by late release and acceptance into the Academy was a serious and perhaps admonitory example for Constable of how long and hard art training might be before it flowered into ultimate success.

By the time he and Constable met, Ramsay Reinagle had already exhibited seventeen paintings at the Royal Academy, having shown there almost every year from 1788, when he was thirteen. This beat the young Mulready and the young Turner, who was fifteen when he made his exhibiting debut. The young Reinagle, the firstborn of the family, was an infant prodigy, or so he claimed to be many years later. Writing in 1847, he said he was

> born with a natural genius for music and drawing. I drew pretty well at 4 years old, and painted my first picture when only six. Before I was 4 years old I played my own invented melodies which I accompanied with a . . . harpsichord.[12]

This was quite an accomplishment, and he knew it. He might have thought he would become another little Mozart, one who could also draw. Among these first exhibits was a painting of dead game, and what Reinagle later described as 'a large Landscape, which was honor'd by a central situation' in the Academy.[13] He sold his paintings well, and as he recalled 'at 16 years old, I was able to present each of 8 sisters £20 a year to relieve my most amiable and highly talented Father, who taught me the Art of painting'. Across those few years at the end of the century the Reinagles were the family to watch, and Constable was captivated by them, in love with their life of art and their apparent success.

In Cecil Street the two young men copied old masters together, and inter alia Reinagle talked Constable into going part shares in a Ruisdael landscape that they thought would make them some money: together they bought it for £70 to spruce up in the Reinagle family way. The Reinagles had a family saying: 'picture painted one day – sold the next, – money spent the third': Constable initially went along with this entrepreneurship against his better judgement.[14] Ramsay had travelled widely with his father: his early Academy exhibits indicate passage through Holland, Germany and south into Italy to Rome and Naples, while John

Constable had been to London, Ipswich and the East Anglian coast, and as yet no further. Ramsay Reinagle was an artful dodger who knew the ropes of the art business; what the young Constable had learnt were the ropes of the milling business.

Ramsay Reinagle was, however, curious about East Anglia, and in the summer of 1799, in the warmth of this new friendship, Constable took him home to show off this London fellow, glowing with town bronze. He may already have talked enthusiastically to Reinagle about J. T. Smith and his Edmonton experience, and passed on his excitement about the Suffolk landscape in words that he had used to Smith:

> Tis a most delightfull country for a landscape painter, I fancy I see Gainsborough in every hedge and hollow tree.[15]

Reinagle met John Dunthorne and Lucy Hurlock and their Suffolk friends, and of course he met Ann and Golding. He and John must have worked together side by side, each painting Ann's portrait, for two practically mirror-images of Ann and her dog exist, the most accomplished and complete version by Reinagle, the less accomplished by Constable.[16] This was just as they had painted each other's portrait, with a similar technical imbalance.

This was a summer of rain, 'the most wretched weather I ever remember for the season',[17] but when they could, he and Reinagle went out drawing and painting together, sitting side by side drinking it all in. Dedham vale flooded in these storms, an unexceptionable occurrence for Constable, but a particular novelty for Reinagle and a good subject for them both. However, very soon something changed in the friendship, perhaps sparked by Reinagle's coming marriage in June 1801, and by February or March 1800 Constable had moved out of Cecil Street and into rooms of his own just across Oxford Street, at 50 Rathbone Place. It was there that Lucy Hurlock wrote the letter that, while establishing a distance between them, must have given Constable a degree of comfort. He told Dunthorne of his low spirits:

> This fine weather almost makes me melancholy; it reveals so forcibly every scene we have visited and drawn together. I even love every stile and stump, and every lane in the village, so

deep rooted are early impressions.[18]

In July that year, 1800, Constable travelled to Helmingham Hall, twenty miles north of East Bergholt, where the nervous, elderly and reluctant Wilbraham, Earl of Dysart, had just succeeded to the title as the 6th Earl.[19] As well as its portraits and other family pictures, Helmingham had a large park planted with ancient oaks: Constable sat among these, observing them in their glossy shade, and making bold, decisive drawings, in which one particular tree with a curious serpentine curve in its trunk is singled out: this has distinctly Cranchian overtones.[20] His admission to Helmingham, perhaps to copy a portrait, may have been on account of his father's local connections, but it also came as a relief after his break with Reinagle and with Lucy Hurlock's coming marriage. 'Here I am quite alone amongst the oaks and solitude of Helmingham Park', he told Dunthorne; not entirely alone, however, as one of the drawings shows a young woman in a poke bonnet crossing a bridge.[21]

> I have quite taken possession of the parsonage finding it quite em[p]ty. A woman comes from the farm house (where I eat) and makes the bed, and I am left at liberty to wander where I please during the day. There are an abundance of fine trees of all sorts; though the place upon the whole affords good objects rather than fine scenery . . . I have made one or two drawings that may be useful. I shall not come home yet.[22]

This reads like heaven on earth: solitude, paid work, time to draw on his own, cooked meals, and a woman to tidy up after him. He would be invited to work for the Dysarts again in 1807.

Confiding to Farington in March 1801, Constable expressed disappointment and hurt with Reinagle and his circle of friends. They had evidently spoken unkindly about his painting, to which he retorted that those young artists looked 'only to the surface & not to the mind. The mechanism of painting is their delight. Execution is their chief aim.'[23] What he might have meant here was that they were not thinking or caring deeply enough about the subject. He was confident that he would eventually get his share of the profit from the Ruisdael, but continues:

I hope to be able to keep more to myself than I did in former times, in London. I have been among my old acquaintances in the art, and am enough disgusted (between ourselves) with their cold trumpery stuff. The more canvas they cover, the more they discover their ignorance and total want of feeling.[24]

And cover canvas they did: in 1799 and 1800 Ramsay Reinagle exhibited eight views in Italy and Germany, milking his late European tour as much as he could, and in 1801, among five portraits and two Essex subjects, Reinagle would show *View of Dedham Vale during the floods in 1799*.[25] This was Constable's patch, and much to his chagrin: he himself would not get a painting of his Suffolk, or a painting of anything, into the Academy until the following year. 'I have seen [Reinagle] twice', Constable added to Dunthorne, 'he calls [his Dedham landscape] his best picture, and there is plenty of light without any light at all.' It is not clear if this is meant to be a compliment, or an early and perhaps justified example of the catty remarks about fellow artists in which Constable would later indulge.

Constable's main focus, now, beyond his first experience of classwork with plaster casts and drawings from the life model,[26] was the intensive copying of old master paintings which young students were expected to study. He was extremely fortunate in having Farington and his collection on such close and easy terms, and perhaps through Farington he again found Beaumont, who showed him the incomparable collection in his house on the corner of Grosvenor Square and South Audley Street. There he had built a top-lit gallery, where, by 1804, Rubens's monumental *Château de Steen* hung, as well as Rembrandt's *Lamentation over the Dead Christ*, Wilson's *The Destruction of Niobe's Children*, and the *Landscape with a Man washing his Feet* at a Fountain by Poussin. Claude's *Landscape with Hagar and the Angel*, and his three other Claudes were nearby. Later in the decade *The Stonemason's Yard* by Canaletto would enter the house. Beaumont's paintings were an education in themselves.

Beaumont was particularly generous to the young man whom he might reasonably have claimed to have discovered in Suffolk. The date of the following letter is uncertain, but it is an

indication of Beaumont's avuncular attitude towards Constable, and his concern for the young man's health:

> Walk to Grosvenor Square in the fresh air, look at any painting of mine for as long as you please, then my boy go home and paint it again from memory. Come as often as you would like to do so until your copy is finished. Then bring it to me for inspection. The regular exercise, the change of scene, the agreeable employment will together work the cure. Be assured.[27]

Towards the end of May 1800 Constable dined with the Beaumonts at Grosvenor Square, with Farington, the architect Robert Smirke and the painter and engraver Thomas Daniell as fellow guests. Farington made his usual detailed note of the proceedings, with a table plan which shows that Constable had the honour of sitting next to their host. This indicates that this was, most probably, the first time Constable had been invited, and illuminates something of his potential interest to Beaumont, and Constable's evident presentability.[28]

There were many further meetings between Constable and Beaumont, the older man assiduously and generously following up his interest by looking closely at Constable's paintings. They may have worked together in Beaumont's painting room, certainly Constable had looked hard at Beaumont's paintings and took the opportunity to study his manner. When he showed Farington his painting of *Old Hall, East Bergholt*, Farington reported that '[Constable's] manner of painting trees is so like Sir George Beaumont's that they might be taken for his.'[29] An admirable quality in Constable, one that Beaumont will have noticed early on, was that the younger man knew what he was talking about. He had had the benefit of Cranch's guidance to foundation texts in art history, and could discuss all this and test its relevance and value in conversation. That, for a young man up from the country, was exceptional.

Beaumont was not, however, a man to trust without question on matters of patronage and support. Some younger artists suffered his volatility and others his prejudice: he disliked Turner, thought little of Callcott, and over-praised the mediocre artist George Arnald. On the other hand he supported Thomas Girtin,

David Wilkie and, for a while, the unreliable poisonous gossip Benjamin Robert Haydon. Artists had to be careful – investment could go down as well as up: 'Haydon is now Sir George's Hero, who is with him every day. Wilkie is on the decline in favour.'[30] Dinner conversation at the Beaumonts would from time to time reach heights of criticism and analysis, such as on Easter Sunday 1804 when the company went hammer and tongs at the art world: 'Hoppner superior to Lawrence'; Élisabeth Vigée Le Brun's 'paintings resemble waxworks'; Turner's seas 'look like pease soup . . . and batter'; and that Prince Hoare's latest musical farce was 'a most foolish production'. Lady Beaumont bent Farington's ear about their mutual (absent) friend Constable: 'he seems to be a weak man', she said. There was much more spoken that Farington did not or would not recall, but this is enough to warn that the Beaumonts were not to be wholly relied upon as supporters. However, by 'weak' Lady Beaumont may simply have meant that Constable was prone to illness, which he was.[31]

Gradually, dismissive chat emerged in Beaumont's circle about this young Suffolk artist. Beaumont remarked in 1802 that Constable 'wants application', a criticism that suggests that he was thought to be lazy. A kinder interpretation, because Constable was anything but lazy, would be that the young artist was suffering from the depressions and toothaches that dogged him, and which might have suggested indolence to a brisk, early nineteenth-century mind. Beaumont's relationship with Constable, however, was special: he had known Constable since his youth, had encouraged him, and shown him his most treasured paintings and had lent some of them to him to copy. They had breathed the same air in Suffolk, and had acquaintances there in common. Constable was practically family.

11. Boldness, care and patience

These were vibrant years for culture in London; London was the place to be. Over a thousand people packed into the Royal Institution lecture theatre in Albemarle Street in January and February 1802 to hear the 24-year-old Humphry Davy lecture on the newly romantic, thrilling subject of Chemistry. Davy was beautiful, charismatic and dangerous: 'The forms and appearances of the beings and substances of the external world are almost infinitely various,' he declared, raising his arms in acclamation, his voice in delight, 'they are in a state of continuous alteration.'[1] The apparently firm structure of the natural world was, Davy showed, as unstable as the political and social systems of nations. Nothing was entirely as it seemed. Somerset House, a mile or so from Albemarle Street, on the river's edge, was home to yet more of this unsettling thought. Not only did the Royal Academy reside there, but also the nation's think tank for science, the Royal Society, and the Society of Antiquaries, whose members delved into history and archaeology. The offices of government and the Admiralty were also in Somerset House, in the wings running south towards the river. Painting and sculpture, their students and practitioners, could rub shoulders with natural philosophers (or scientists as we call them now), historians, proto-archaeologists, politicians and administrators, senior military figures and aristocracy, disturbing orthodox patterns of thought.[2]

Those great parts of the centre of London that embraced commerce, society, religion, law, politics and intellect, were held in a loop between Albemarle Street in Mayfair and the eastern end of the Strand. Nearer Somerset House than Albemarle Street, but on the walking route between, was the Society for the Encouragement of Arts, Manufactures and Commerce in John Adam Street. There, artists, manufacturers, inventors, investors, the overconfident and the marginally insane gathered to thrash

out new ideas and turn them by invention and innovation into practical production. Cash prizes and medals were handed out there, and the Society maintained a thriving in-house museum of models and devices of all kinds. The line linking John Adam Street with the expensive new Thames-side apartments in the Adelphi nearby, Somerset House and Albemarle Street, where at no. 50 John Murray published mind-disturbing books, was the Silicon Valley of the age. Constable found himself in the heart of it all.

The art market was alive in London: James Christie set up his art auction house in Pall Mall in 1766, selling old master paintings real, fake or cobbled together. Across the street on the north side was the Shakespeare Gallery, run by the entrepreneur John Boydell. This thrived until the market tired of Shakespearean and Miltonic subjects, and Boydell went bust. His building was taken over in 1805 by a consortium of grandees to form the British Institution, not to be confused with Davy's scientific Royal Institution. The British Institution for Promoting the Fine Arts in the United Kingdom was an art-exhibiting organisation that sought a role somewhere between the Royal Academy, the art trade, and town and country private collections. Pall Mall was galleryland: not only Christie's and Boydell and his succession settled there, but the first home of the Royal Academy had been at its eastern end, in the building where Christie's began, the top floor of a print warehouse. Michael Bryan's gallery was in the street, showing the Orléans collection, with its paintings by (or claimed to be by) Titian, Tintoretto, Veronese, Rubens and Rembrandt, while the banker Sir John Angerstein had his grand collection at 100 Pall Mall. The Stafford Gallery, where the Duke of Bridgewater's paintings were shown, was around the corner in Cleveland House, St James's. Small art dealers and print-sellers were everywhere. London had become a world city through which art and money flowed.

A central foundation of Constable's training was to gain knowledge through looking at and studying the principles and peaks of European art history. These presented themselves to him in the paintings he was able to see in the sale rooms and in gentlemen's collections. John Cranch had already recommended

this method, and Constable's diligence in following it reflects his respect for his teachers, and his single-mindedness and steely determination to learn from anybody. As he put it to Dunthorne, 'the more facility of practice I get, the more pleasure I shall find in my art.'[3]

At the Royal Academy, Constable honed his drawing skills. Coupled with principles of composition and historical narrative, drawing formed the core of the Academy's tuition. At its foundation in 1768 there were Professorships of Painting, Architecture and Perspective, the three columns of visual academic study. Other professorships emerged as time went on, such as Anatomy and Poetry, all laying weight on the founding principles of teaching that would lead the student towards consideration of the centrality of body, mind and story. An element that is glaringly absent here is the eye, not the careful recording or servant eye, but the eye that explores, questions and looks out at nature; the eye that is a torch.

Sir Joshua Reynolds, the Academy's founding father, was long gone, though the shadow of his example remained. Of the three Professors of Painting who impinged on Constable in his student years in London, one, James Barry, had been sacked in 1799 in disgrace for having impugned the Academy and accused it of financial mismanagement. If his name was little mentioned after 1800 it nevertheless hung around silently like a bad smell. Another, John Opie, professor from 1805 until his premature death in 1807, was one political radical married to another, the author Amelia Opie. This couple raised the hackles of the Academy's 'Court party'. The third, and most appreciative, influential and supportive of Constable, was the Swiss émigré Henry Fuseli, painter of dreams, the supernatural and the weird. Fuseli's paintings carried the whiff of eroticism, decoction and decay, and remain memorable.

A duty of the professors was to lecture to the students: Barry, Opie and Fuseli offered clear insights and guidance distilled from the orotund prolixities of the day: '*Selection* and *perfection* are your objects in all things, and not mere casual fact. Everything is bad, and to be rejected, when better can be found' (Barry); 'drawing ... must be acquired by assiduous study and practice;

and cannot be bought for money, nor taught by precept merely'
(Opie); 'the first demand on every work of art is that it consti-
tute one whole, that it fully pronounce its own meaning, that
it tell itself' (Fuseli).[4] The professors, as their lectures demon-
strate, were eager and dedicated to their students and to training
them within a social and historical network: a common thread
running through the lectures is the insistence that the students
were aware of the long history of painting and their place in its
stream. This is where Constable also received, by observation, an
early understanding of how, and how not, to lecture.

Constable may not have taken all these teachings in, but some
of it will have stuck, and added gloss to the art history he had
absorbed in Edmonton. What he had to teach himself, by trial
and error, brotherly advice, and from such treatises as *The Art of
Painting* by Gerhard van Lairesse, was how to paint. Lairesse's
treatise, published in Holland in 1710 and translated into English
in 1738, had been recommended to him by Cranch for its 'many
usefull hints and helps of study, and many ingenious things to
facilitate practice'.[5] Constable's copy remained with him all his
life.[6] Across its 654 pages it offers a gamut of tuition; but in its
opening pages there is this, the three 'essential qualifications' of
an artist:

1. Boldness of hand, in the dead-colouring [i.e., the first
 blocking out of the masses in the composition]
2. More care, circumspection and labour in the second
 colouring
3. Thorough patience and attention in the re-touching or
 finishing of a picture; the nigher to perfection, the more
 care.[7]

Boldness, care and patience: these three. What he also had to
learn by trial and error was, in the use of oil paint, what colour
could go on top of which, what effects a coloured ground or a
white one might have on the light in the painting, and how to
liquefy powdered or thickly pasted pigment, so that it stands on
the edge between implacable stiffness and impossible fluidity.

'Chiaroscuro', the calculated oppositions of light and dark
within a painting, was a vital topic for painters, which Constable

wrestled with. Second only to 'ruin', 'chiaroscuro' would become his watchword. He learnt from Fuseli that natural light 'is not always legitimate chiaroscuro in art.' It is the business of the artist to arrange it.[8] 'Brilliancy in colour,' Fuseli continued, 'is less required than unison . . . the simplest tone well managed may become, not only harmonious, but rich and splendid, it is then the tone of nature.' Fuseli, an escapee from his native Zurich, and a close friend there of the physiognomist J. C. Lavater, saw the point of Constable very early on. Perhaps Constable was still a student when Fuseli confided something of the teacher's despair to him: 'As the conveniences and instruments of study increase' – i.e. lay-figures, callipers, graphic telescopes – 'so will always the exertions of the students decrease.'[9] He saw Constable as an old head on young shoulders, an artist to note and a talent to watch, hard-working and determined. This certainly became the case later on, and it may have grown its roots during their early encounters in a teacher–student relationship. One thing they shared from the start was an admiration and knowledge of the works of Lavater, the source for Constable's youthful drawings of grotesque heads.

Constable's other mentor in London, Joseph Farington, kept his ear to the ground, and his finger on the pulse of the Academy. He listened to everybody who would gossip with him or give him titbits of information, used his own insight to filter what he heard, and consigned it with energy, daily, to his diary. He would offer Constable advice as clearly and as generously as he could. Farington was the Information Exchange of the Academy, and Constable listened to him carefully. Across the years in which Constable 'pursued his decided conviction with ardour', the Academy to which he so ardently aspired was a political hotbed. This is how the parties lined up: royalists, or the 'Court' party, were those artists instinctively and expressly sympathetic to George III, the Academy patron, to the pursuit of war with France and America, and to the suppression of dissent. They included William Beechey, Francis Bourgeois, Joseph Farington and the architect James Wyatt. The 'Academicals', on the other hand, were those who supported democratic and republican politics, and actively or passively sympathised with its

aims. These included Thomas Banks, James Barry, Henry Fuseli, Thomas Girtin, John Hoppner, John Opie, George Romney, Martin Archer Shee, Robert Smirke, Thomas Stothard, J. M. W. Turner and the Academy President, Benjamin West.[10] In a balance of artistic genius, the 'Academicals' would patently weigh heaviest.

Something of the spleen that these artists faced from the establishment was recorded by Farington. Of Barry, he wrote: 'it was sufficient ground for suspension or removal to prove that a Member avowed democratical opinions, – which Barry had done';[11] Banks: 'barred from Admiralty competition because of his professed political principles'; the Academy declined to mark his death in 1805 in case it was accused of endorsing Banks's 'democratical ideals';[12] Shee: 'violently disposed to democracy';[13] Fuseli friendly with 'revolution men'.[14] John Opie was specific: 'the object of Wyatt's party is to throw all possible power into the hands of the Crown, thereby to have during the present King's life the command of everything [in the Academy]'.[15] This was the manner in which the Royal Academy seethed in the years in which Constable was a student, and he was not oblivious to it. These were some of the same people who would vote on his nomination to become, in the first instance, an Associate of the Royal Academy: ARA. Coming from country stock, a successful merchant background, allied to the Church of England and dependent on the support, patronage and friendship of fellow Anglicans, Constable nevertheless showed in his paintings a free-thinking tendency, a novel manner of painting whose 'look' his audiences would have to learn. As a natural Tory, Constable had inertia to overcome in standing for election as ARA if he were to attract the votes of 'the left'. He also had to learn to be ingratiating where necessary and to curb his tongue, something of a challenge for him.

By January 1802 Constable was digging deeper, drawing both from the life model, as well as studying the landscape beneath the skin, the musculature of the human body. The Academy's Professor of Anatomy, Joshua Brookes FRS, lectured in his private theatre in Blenheim Street, Mayfair. These sessions were gruesome affairs, the dissected corpses on Brookes's slab being kept

well away from Somerset House lest they pollute the place with
their stink and issue. Constable invested in an expensive book
with formidable engraved illustrations to consolidate his under-
standing, John Innes's *A Short Description of the Human Muscles*,
and under Brookes's tuition he came to draw 'many extremely
accurate and beautiful coloured drawings of a large size' from
a close study of the cadavers.[16] 'I am so much more interested
in the study than I expected,' he told Dunthorne, 'and feel my
mind so generally enlarged by it.'[17] He was less impressed by
his fellow students: 'Many of the young men in this theatre are
reprobates.'

At the life classes in Somerset House, Constable had the
thrill of an unexpected and delightful meeting with a man he
knew from home. This was Samuel Strowger, a tall, handsome
former Life Guard, who modelled in the life classes. Constable
remembered him from the Stour Valley, where Strowger had
worked on farms before joining the army. On his discharge, this
'beautiful ploughman', as he had been known in Suffolk, came to
the Academy in November 1802 as Head Porter, with additional
modelling duties, and became 'the most intelligent and faithful
of servants'.[18] Strowger was said to have had an almost perfect,
symmetrical body, and having been a soldier could hold a pose,
and bear the physical strain of standing still on a podium. He
had faced musket shot and cavalry charge, so he could certainly
cope with the attentions of art students, even the reprobates.
'Handsome miller' met 'beautiful ploughman', and Constable no
longer felt alone.

As time went by, there was something else from home to cheer
John Constable: a distinguished gentleman would turn up at
his door now and then with a pretty girl on his arm. This was
Charles Bicknell of Spring Gardens with his daughter Maria,
now growing up, calling with a smile and an unspoken purpose,
to say hello. As Constable later recalled,

> There was a time when your father would not have passed my
> door [in London] but was calling on me with you on his hand,
> and was inviting me to his house when he knew of our mutual
> attachment.[19]

Something was going on between them, and Charles Bick-
nell knew it. Instinctively, he encouraged it warmly. Constable
needed cheering, as he had been hurt by Ramsay Reinagle, and
felt himself to be outside the rowdy in-crowd of young Academy
students and the reprobates in the anatomy classes.

12. Constable's Seven Articles

Having moved out of Cecil Street in 1800, Constable described his excitement at being in his own apartment in Rathbone Place. He told John Dunthorne that its largest room

> has three windows in front. I shall make that my shop [i.e. workshop], having the light from the upper part of the middle window, and by that means I shall get my easel in a good situation.[1]

The windows were filthy, however, and the room not as bright as he had hoped:

> I seldom go out as I am so much confined to work at present. I paint by all the daylight we have, and that is little enough, less perhaps than you have [at East Bergholt] by much. I sometimes however see the sky, but imagine to yourself how a purl [*sic*] must look through a burnt glass.[2]

Dunthorne understood Constable's insights into landscape, the necessity of clear light to paint by, his quiet confession about loving 'every stile and stump, and every lane in the village', and above all his intimate admission that:

> I have enjoyed serenity of soul . . . and I have acquired considerably, what I have so long and ardently desired – patience in the pursuit of my profession.[3]

Constable could talk safe in the knowledge that his words would not become gossip in the hothouse of the London art world. John Dunthorne was a man of integrity whose natural intelligence overcame his apparent lack of education. Nevertheless they had different goals in life. Dunthorne would take on any project as long as it brought him cash and perhaps a bit of fun and local praise. His funeral hatchments for deceased grandees, such as Sarah Roberts and Admiral Sir Richard Hughes,

brought acclaim, and his sign for the Duke of Marlborough inn
at Dedham was for a while the talk of the villages. 'It is aston-
ishing what a capital Picture he made of it', Constable's mother
said. 'Too good I greatly fear for the gain – compleat armour,
truncheon, & peruque, to boot.'[4]

Constable's imperative now was to focus alone on his work
without distraction or temptation. Reinagle married in June
1801, and while his courting might have been in process before
Constable moved out of Cecil Street, the coming marriage must
have added to the stress between them. Constable would open up
only to Dunthorne:

> You know I do not like men who force their tongue to speak
> a language whose source is not in their heart. It is difficult to
> find a man in London possessing even common honesty . . . Mr.
> R[einagle] wanted me to dine with him to day, but I declined
> it, this would be reviving an intimacy which I am determined
> never shall exist again, if I have any self command. I know the
> man and I know him to be no inward man.[5]

What he saw as loose metropolitan friendship had stung
Constable, and he wanted a touch of Dunthorne's old, compan-
ionable Suffolk staunchness. When he told Dunthorne he had
been paid to paint a landscape background to an embroidered
picture of an ox, he knew it would make him smile.[6] Constable
is concerned that Dunthorne try to develop his own talents as
an artist further, but in the main he talks about himself: how he
finds it necessary 'to fag at copying, some time yet, to acquire
execution'; how to maintain his privacy after shutting the door
on Reinagle; and how he is nervous of being ripped off by land-
lords.[7] He is also frank to Dunthorne about his troubles and his
chronic toothache:

> I have had much ado to keep my mind together enough to
> write to be understood owing to a pain in one side of my head,
> particularly in my teeth and lower jaw, which has caused one
> cheek to swell very much.[8]

He has more bouts of homesickness, and is concerned also at
reports of Dunthorne's health:

I never hear of an arrival from E. Bergholt but I forthwith
take my hat & stick and trudge off for the news . . . My mother
says you are not well . . . and that you have been obliged to
have medical advice. Great allowance must be made for the
unwholesomeness of your business.[9]

These insights reflect Constable's belief that artistic talent, his
own and that in others, should be nurtured in tranquillity; that
life in London made him anxious; and that part of him remained
irrevocably in East Bergholt. He was also plain to Dunthorne
about his religious beliefs, which were orthodox Anglican of
the period, and which he held strongly, devoutly and without
question. He would study the Bible with intent, and while he
may not yet have taken custody in London of the Constable
family Bible – this would surely be with his parents at East
Bergholt House – he did have his Book of Common Prayer
with him. His copy, bound with the Psalms, is inscribed 'J.C.
1800'.[10] Constable's Christian faith emerges when he reflects to
Dunthorne on the anatomy lessons of Dr Brookes. Constable
believes that:

> no study [other than astronomy] is really so sublime, or goes
> more to carry the mind to the Divine Architect. Indeed the
> whole machine which it has pleased God to form for the ac-
> commodation of the real man . . . is as wonderful as the con-
> templation of it is affecting.[11]

These extempore effusions about religion went only to Con-
stable's closest: John Fisher would be another recipient, but
Dunthorne's importance to him cannot be overrated.

Such richly expressed convictions demonstrate something that
we already know – that John Constable was reassured by Angli-
can Christianity, and, it follows, by the friendship and presence of
Anglican clerics. The many clerics with whom we know he was
or had been in regular contact, the Reverends Wren Driffield,
Grimwood, Newman, Fisher father and son, and Hurlock, gave
him confidence, support, assurance, certainty and living exam-
ples of faith in action. It was only the pathetic Rev. Mr Blowers,
the schoolmaster of Lavenham, and the worldly Rev. Dr Durand

Rhudde of East Bergholt, Brantham and Great Wenham who shook his confidence, damaged his equilibrium and caused him to question the integrity of men in holy orders. Paradoxically, where he found enlightenment, understanding and encouragement was not so much in the example of Anglican clergy, but in the informal, peaceful, Quaker-inclined cerebral folk of Edmonton, and his Quaker friends the Wakefields, the Hobsons and the Cobbolds.

Dunthorne was, in 1802, a sick man, possibly suffering from lead poisoning, certainly at a low physical ebb. He longed to see his friend John Constable: 'How I am wishing from week to week I could see you as I have no comfortable companion for any serious instructive conversation', he wrote.[12] He had pains in his chest and side, he hawked and spat, and was fevered and losing weight, all of which 'set at defiance the powers of medicine . . . I never could learn from the Doctor what my complaint is. But I believe it is upon the liver.' He found it impossible to paint or draw, but was managing to do some things with his hands, and would finish the cello he was making:[13]

how often I wish for your good and instructive company to set aright the many vague ideas of my mind which often like the false lights of a Bad Picture throw the whole into confusion.

These are strong, intelligent, well-formed words that illuminate something of the equality of the friendship that emerged unexpectedly at the gates of East Bergholt House. It was rooted in art and music, in conversations about painting, and it kept Constable grounded and in touch with the spirit of his home village. It was, extraordinarily, encouraged by Golding and Ann, probably because neither of them was fully aware of its depth and persistence.

This is about the time when, thinking about life and his future, Constable drew a self-portrait with an unsettling brown-eyed gaze, red lips and red and rosy cheeks. These are indicative of an open-air life, certainly, but also perhaps of toothache.[14] The frontal pose suppresses his elegant nose, here foreshortened. He wears a neat double-breasted coat buttoned across, and a white stock at his neck. His dark hair is cut with much volume – almost

bouffant – and he has an exuberant fringe and sideburns. Evi-
dently he has worked hard to tidy himself up for the drawing
session, wanting to show himself at his neatest: this is a portrait
to demonstrate his skill and presentability to potential clients, or
to a young woman on the lookout for a husband. He did have, or
come to have, a problem with tidiness: the son of the artist John
Martin remembered, many years later, that Constable could be
a mess: 'in person . . . he was untidy, for he lived . . . constantly
in the wild, plashy, wet, dripping woods, during storm, rain and
wind.'[15]

Constable had his first work accepted at the Academy in 1802.
This was a major breakthrough indeed, but what he painted re-
mains a mystery: catalogued baldly as 'A Landscape', he described
the exhibit only to Dunthorne, as 'a kit kat size, that is two and a
half, by three, feet'.[16] Farington, on seeing the picture in Consta-
ble's rooms, was polite: 'I told him his picture had a great merit
but is rather too cold.'[17] As a young man in London Constable
was being pulled in a multiplicity of directions. He suffered con-
flicts of priority and purpose as his skills developed, conflicts in
his new London friendships after his fallout with Reinagle, and
conflicts within himself, between portraits and landscape, East
Bergholt and London. His evident ambition to excel in 'the Art',
as it was respectfully known by its devotees, was patronised but
in his view not adequately recognised. He was raw, unhappy and
insecure, recalling later: 'For long [I] floundered in the path –
and tottered on the threshold – and there never was any young
man nearer being lost than myself.'[18] This rawness enabled him
recklessly to give unasked-for opinions on fellow artists. He
complained to Farington that after seeing *Calais Pier* and *The
Opening of the Vintage of Macon* at the 1803 Academy exhibition,
he felt that Turner had become 'more and more extravagant and
less attentive to nature'.[19] Of Callcott he opined in 1806, having
seen the large canvas *The Return from Market*, that:

> it was a fine picture, but treated in a pedantick manner, every
> part seeming to wish to shew itself; that it had not an air of
> nature; . . . the whole not lucid like Wilson's pictures, in which
> the objects appear as if floating in sunshine.[20]

Constable lashed out in his opinions: we are told by Henry Trim-
mer that he was 'endowed with a great flow of words, and well-
informed'.[21] He disagreed with his young contemporaries about
Turner's paintings: they thought they were 'of a very superior
order'; Constable on the contrary could not 'reconcile them as
being true to Nature.'[22] Farington noted all this down in his desire
for completeness, wondering perhaps the while why it was that
Constable sheltered himself beside the older generation – him-
self, Beaumont, Pike Watts, Cranch and Smith – rather than the
young bloods of his own age. Where were Constable's loyalties?
Where was his home? Where was his art going? Where did his
domestic priorities lie? He was very family-minded, concerned
for the health of his elderly parents, very fond of his cousins and
aunts, and preternaturally attached to home. He was the first child
to be born in the bright new East Bergholt House, the outward
sign of Golding's success and status, and unlike Nancy, Patty
and young Golding, he knew the family's mills only as places
of work, not as home. Therefore he had his own detachment
from the windmill on the heath, and the watermill at Flatford,
and could see them as subjects of curiosity, rather than, as East
Bergholt House and its gardens had become, the crucibles of
memory that would in 1815 prompt his pair of canvases *Golding
Constable's Flower Garden* and *Golding Constable's Kitchen Garden.*[23]

This all contributed to his ill health, this and his loneliness
in coming back to empty lodgings as the life of London swirled
around him. He began to suffer from a bad chest and from depres-
sions – 'melancholy', as he described it to Farington – and his at-
tacks of toothache continued. Farington was understanding and
genial, but he was also on the lookout for gossip as the Academy's
silent recording angel: 'Constable called. He described to me the
melancholy state in which his mind has been for sometime.'[24] It
cannot have been all gloom, however: on showing Benjamin West
a painting that had been rejected from the Academy exhibition,
the President told him: 'Don't be disheartened young man, we
shall hear of you again; you must have loved nature very much
before you could have painted this.'[25] West then picked up a piece
of chalk, made deft marks on Constable's work, and, certain that
this student would listen, reminded him that 'light and shadow

never stand still.'

Even so, Constable began to wobble seriously in his intentions, and probably sought advice from too many directions. Bishop Fisher advised him to go in May 1802 to Windsor to be interviewed for the post of Drawing Master at the new Military Academy at Marlow. He must have been offered the job on the strength of the drawings he had made there, because he returned to Farington for consultation.[26] 'I gave him my opinion', Farington reported. This was firm, knowing advice: Farington considered the wider picture, understanding that for this particular student painting was a life's work, not an employment. He advised 'that as [Constable] stood in no need of it, he should not accept a situation which would interfere with his professional pursuits.'[27] Constable was not just another topographer, and they both knew it. He took this advice that he wanted to hear, and a few days later told Dunthorne 'had I accepted the situation offered it would have been a death blow to all my prospects of perfection in the Art I love.'[28]

In this same letter to Dunthorne, Constable set out what amounts to his manifesto: 'for these few weeks I believe I have thought more seriously on my profession than at any other time of my life'. Here are what might be called Constable's Seven Articles. The numbering is mine, the order and words are Constable's own, and grasp at the direction he had identified and confirmed:

1. There is no <u>easy</u> way of becoming a painter.
2. Nature is the fountain's head.
3. I am come to a determination to make no idle visits this summer or to give up my time to common place people.
4. I shall endeavour to get a pure and unaffected representation of the scenes that may employ me with respect to colour particularly.
5. There is room enough for a natural painture [*sic*].
6. <u>Truth</u> (in all things) only will last and can have just claims on posterity.
7. Exhibiting . . . shows me where I am, and in fact tells me what nobody else could.

It is highly pertinent that it was to Dunthorne that he expressed these Articles of Faith rather than to any of his Academy contemporaries or to those senior figures in the Academy whom he needed to impress. John Dunthorne, no 'common place' person he, was John Constable's confessor, guide, philosopher and friend.

Constable overcame his crises and his indecisions. He was not torn apart by them, because he was naturally self-interested, single-minded and stubborn. He also had the gifts of five good men to keep him focussed: Beaumont's knowing worldliness, Cranch's erratic intellect, Dunthorne's practicality and sense of fun, Farington's attention to detail, and Smith's busy business. He had latched on to Farington pretty comprehensively from the start, to the extent that there are at least two dozen diary entries between 1799 and 1806 beginning 'Constable called'. He might have become a bit of a bore. As a 'new' artist he was making his presence felt in the Academy, but sometimes, as Farington's diary reveals, he worked against his own interests by polishing his high-mindedness:

> Constable called. Does not think of exhibiting, conceiving that nothing is gained by putting pictures in competition with works which are extravagant in colour and bad taste wanting truth.[29]

That was his reported view, but it went against the tenor of Cranch's advice of 1796, and the last of his declarations to Dunthorne. Farington advised him:

> I told him much wd be gained by it as he wd in an exhibition see his own works with 'A fresh eye' and better judge their real quality.

Now, 1803, he was at last beginning to see his way forward, and it was for Dunthorne that he analysed his new feelings, and laid out the terms of his determination:

> I feel now, more than ever, a decided conviction that I shall some time or other make some good pictures. Pictures that shall be valuable to posterity, if I reap not the benefit from

them. This hope, added to the great delight I find in the art, buoys me up, and makes me pursue it with ardour.[30]

He began now to get out more, out of London, into the country – his Stour Valley country – and around. His focus and working practice gradually changed. He was able to escape regularly to his sister Patty and her family in East Ham, and spent five months with them in 1801 at Fenton in the Staffordshire potteries, where Patty Whalley's parents-in-law lived. He and young Daniel Whalley, Nathaniel's brother, travelled on to the Peak District of Derbyshire, where John made many workman-like pencil and wash drawings.[31] Who should they bump into at the entrance to the valley of Dovedale, sitting there, making a sketch, but that man who got everywhere, Joseph Farington, 150 miles from home.[32] How they must have laughed.

Another extended journey took place with his father's good friend Robert Torin, a ship's captain in the East India Company. Torin was about to set off on his final voyage to China, and in the spring of 1803 he took Constable from Gravesend to Deal on a farewell jolly. He was 'near a month on board . . . making drawings of ships in all situations'.[33] What he was doing in the Thames estuary was exactly what Turner did, and would continue to do, in the waters around the southern English coast: observe and draw the multitudinous populations of shipping, and the light that enveloped them all. Both artists became entranced for their lifetimes by the sea's inshore sparkle. 'I saw all sorts of weather,' Constable told Dunthorne. 'Some the most delightful, and some as melancholy. But such is the enviable state of a painter that he finds delight in every dress nature can possibly assume.' Those could be Turner's words, they reflect Turner's exact feelings, and indicate the connections at this time between the early ambitions of these two talented, hyperactive and intractable young men, the one preternaturally wary of the other.

Even as Constable doggedly pursued landscape as his chosen subject, his father, as Farington heard, felt he was 'pursuing a shadow – wishes to see him employed'.[34] Nevertheless in September 1802 Golding helped him to buy a tiny cottage across the Green from East Bergholt House, next to the smithy, to use as a

studio. There 'he works hard [on portrait painting] and has time
in the afternoons to cultivate landscape painting.'[35] Golding's
anxieties were mildly assuaged when Constable's work took this
reassuring direction: portrait painting could at least provide
a meagre and intermittent income. Farington, however, was
trying to turn the screw the other way, exhorting him towards
landscape painting, and urging him, as had Cranch, to look at
nature more and put a brake on his old master copying: 'I . . .
recommended him to study nature, and particular art less.'[36]

Constable grew up with painters his age and younger who
found fresh ideas in nature, and were bold enough to demon-
strate it: Callcott, Mulready, Turner and Wilkie. However, it
was the talk of older artists, Cranch, Beaumont and Smith, that
bent his ear. The paintings of Cranch led him towards nocturnes
and genre, and Beaumont's towards competing interests: Dutch,
Flemish, Claude, the Picturesque, and Rubens's *Château de Steen*.
Smith's example and enterprise attracted Constable to observe
the 'ivy-mantled tow'r' and 'straw-built shed' of Gray's *Elegy*.
While Constable looked carefully and with courtesy in those
directions, and closely studied Ruisdael and his seventeenth-
century Dutch brother artists, he had seen very early on that
there was also somewhere else to look.

What Constable and others of his generation of students
discovered was that the Picturesque traduced nature by forcing
it into composition. It might have been a nostrum of the Pictur-
esque movement that organised nature was better appreciated in
painting, but they could see for themselves that out in the fields
that was not the case: a low viewpoint might produce the silhou-
ette of a hillside with a lone figure against the sky; a high view-
point might release a wide panorama stretching from elevated
land to the sea. Since boyhood, John Constable had got to know
the fields and lanes of the Stour Valley, and the heights of East
Bergholt and Langham, and he had done so through the soles of
his boots. He did not need to be told how to construct a landscape
painting; he could see for himself.

13. Portraits prevail too much

John Constable was confused, certainly in the first half of his life, by sudden changes in direction imposed upon him which he was powerless to influence; conflicting opportunity, insistent alternatives, and advice from all sides. If he had any ambitions to be seen locally as a new, young Gainsborough, setting out on a starry career in portraiture with landscape painting as a burgeoning add-on, he found his path clouded by circumstance. 'Portraits prevail too much', he said of the 1803 Academy exhibition, but even so he persisted in the art, improving rapidly on the standard of his Reinagle portrait and the portrait of his mother.[1] Word got around Suffolk and Essex, as Dunthorne revealed: 'I hear you have been doing something in the Portrait way which does you great credit.'[2] Standing together behind East Bergholt House, Dunthorne and Golding would share with good humour news of John's progress:

> I have been with your Father several times of late ... we seldom part without mentioning you ... I am glad to hear him speak of your painting in quite a different way to what he formerly did – we had a good laugh about you the other day.[3]

Opinion in East Bergholt House was changing and the level of confidence in Constable at home was riding high. Nevertheless, his earnings from portrait painting locally were minuscule and from landscape painting negligible. He told Farington in 1804 that he charged two guineas each for life-size head-and-shoulders portraits, or three guineas if they wanted him to include a hand.[4] This might be the equivalent of about £100 or £150 in the early twenty-first century. These were ludicrously low prices, set to attract 'farmers &c to indulge their wishes and to have their children and relatives painted'. They probably reflect the scale of charges that Dunthorne also offered for the portraits he painted.[5] However, Constable found pricing difficult, and

continually undervalued himself, and indeed, so few portraits have emerged securely dated between 1801 and 1805 that either examples are languishing unknown, or he was fantasising about entering a market that did not exist for him.[6] When suggesting to Farington that he would tentatively price a landscape at five guineas, he was very firmly told that he could not ask less than ten.[7] His prices gradually became more realistic, while remaining comparatively low: 'my price for a head is 15 guineas', he wrote in 1813.[8]

Constable was profoundly thoughtful and attentive to his elders as a student painter, and also as a son to his parents. Respect for the older generations – artists or family – flowed through him like blood in his veins, and it was perhaps because of the persistence of this respect that he took so long to assert himself. The wilful Turner, a brilliant portrait painter in embryo on the evidence of his *c.*1798 *Self-Portrait*, dismissed portrait painting immediately and bust out into landscape. Constable persevered with portraiture, thus creating further agonies for himself because he became so good at it, and in demand so early on.

One auspicious early portrait commission suggests that once his mother realised that there were opportunities here she was on to him like a ferret to put himself about locally. George Bridges, the owner of wharfs at Mistley, may have had Reynolds, Gainsborough or Romney in mind, but chose Constable because he was local, available, cheaper, talented and, more to the point, still alive. The scale of the portrait of *George Bridges and his family* (1804), a sophisticated and complex composition that echoes Romney, was a mistake.[9] It is far too big and ambitious a work for him to have sensibly taken on: Constable is at this stage an artist of intimacy, proximity and close observation. The composition is scaled up to fit Bridges's house, Lawford Place, a grand mansion outside Mistley.[10] Constable may have been pushed into the commission by family pressure to please Bridges; indeed, according to family legend, 'it was done as a matter of friendship &, it is said, because he admired one of the daughters (Jane) of the family and not being a great portrait painter he did not sign it.' Jane is the girl seated at the harpsichord, looking towards the viewer. Falling in love spoilt it all.[11]

George Elmer, a business partner of Bridges, commissioned in 1804 a portrait of himself, a work that turned out to be intense and intimate.[12] Small scale, intimate portraiture is where Constable's strengths lay. Elmer's daughter treasured the work after his death: '[she] is so happy she has it as it is such a likeness of her Father.'[13] Other local families put their names in his book: there must have been talk of family portraits of the Cobbolds and the Hobsons, and, to prepare for them, Constable went to Ipswich and Tottenham respectively, to soak up their family atmospheres.[14] Both families had pretty daughters, and we can see how they claim most of his attention in the dozens of pencil drawings that fill his sketchbooks. In the speed, fluidity and quantity of these studies Constable is evidently working on and improving his technique as a trainee portrait painter – there is minimal hint of landscape interest – and exploring across a compressed period of time composition, pose and emotion within the tiny compass of a sketchbook. Where better to practise portraiture than on captive family members and the daughters of friends; there is nothing here to suggest that he is not committed to portraiture as his path for the future. However, a Cobbold family portrait would have been a tricky composition to pull off, as John Cobbold had twenty-one children by two wives, both called Elizabeth. Seventeen of his children were living in 1804/05.[15] Constable also stayed with his Gubbins cousins in Epsom and drew many pencil and ink studies of them, but as cousins they would have expected his ever-present earnestness, and humoured any inelegant amorous approaches.[16]

When he found a portrait subject that had a touching strain of emotion, such as the big-eyed Amy Whitmore gazing softly at him, he could raise a tremor. Other portraits gradually emerge from his brush, and comprise equally family, friends, and commissioned subjects. His portrait of his first cousin, *Captain Richard Gubbins* (1804/05),[17] the son of his maternal aunt Mary Gubbins, has eyes that drill through the beholder to a point beyond. As they do so the soldier puts his hand on his sword hilt. He has a crisp set to his mouth, and a fashionable curl of hair on his forehead. 'We were brought up children together', Constable noted some years later.[18] Evidently a brave and formidable young man,

Richard Gubbins, five years younger than his artist cousin, sur-
vived ten years of war in America and Europe, and was a captain
in the 24ᵗʰ (Warwickshire) Regiment of Foot in 1805.[19] Having
fought in America and been promoted to Colonel, he commanded
the light infantry in Paris after the fall of Napoleon. His aunt,
Ann Constable, wrote of him as having 'come off with life &
honour, how happy it makes us to have so brave a fellow in the
family.'[20]

There is one small, informal portrait that has a contradictory
clarity and mystery that is distinctly unsettling, and might at-
tract any number of narratives. This is Constable's portrait of
Thomasine Copping, fully and formally titled, signed and dated:
'Thomasine Copping / John Constable Pinxt / 1808'. It was
almost certainly not a commission, but a portrait painted by
desire. Despite its date, it has the look of having been produced
at the other end of the nineteenth century by Leighton, Watts
or Whistler, rather than by an uncertain young artist trying to
find his way in the wake of Reynolds and Gainsborough. Not
only does he give Thomasine an elegant swan neck and low-
cut neckline, but she also has an expression of such vulnerable
introspection that we might suspect there was romance in the
air. This is a portrait with edge and purpose: Thomasine Cop-
ping may have been a maid at Helmingham Hall, in which case
Constable could have met her there in 1800. Coppings are listed
as tenants at Helmingham, and a number of others appear in
lists of Helmingham marriages and deaths. Among them is the
marriage of Thomasine Copping and Jeremiah Howe of Helm-
ingham, confirming the inscription on the back of the canvas,
'Thomasine Howes of Helmingham in Suffolk painted by John
Constable in 1808'.[21]

John Constable's portraits were becoming increasingly accom-
plished, and when he painted his father around 1815 he caught
not just his beefy single-mindedness, but also his quiet humour
and empathy.[22] Golding, 'always anxious to see me engaged in
Portraits', undoubtedly gave his son his opinions as the one
closely observed the other: 'My father['s] . . . ideas are most
rational', Constable reflected.[23] These 'rational' ideas settled
around urging his son to choose, if he must, a genre in art that

would make him some money and give him the independence and
financial security that was eluding him. Paint what people want
to buy, Golding advised.

Nevertheless, there remained a tension that John Constable
had to resolve. Things were inexorably changing. He moved in
1805 from Rathbone Place to 3 Spur Street, off Leicester Square,
a house belonging to the book and print-seller John Thane, and
two years later to 13 Percy Street with Thane's son William,
art dealer and picture restorer. In March 1810 he moved again,
to 49 Frith Street.[24] Constable was beginning now to foster a
new confidante, one whose growing presence on the scene grad-
ually closed down his correspondence with Dunthorne. This
was the by now eighteen- or nineteen-year-old Maria Bicknell,
the Rector's grand-daughter. Sooner or later he fell in love
with her.

In one of his many conversations with King George III in the
1770s and 1780s, Gainsborough remarked that when he painted
landscapes he was starving, but when he painted portraits,
people bought his landscapes.[25] So Gainsborough found hope in
a portrait/landscape career balance early on, and so might Con-
stable, although he will not have thought about it in this way,
or known of this exchange. Ever one to misread signs, he took
another path and began to contemplate a third option, church
altarpieces. During the summer of 1805, Dr Rhudde commis-
sioned him to paint *Christ Blessing the Children* for his Brantham
church, St Michael's.[26] Everybody except John Constable seemed
to know what was best for John Constable, and it might appear
that an altarpiece would not only demonstrate the breadth of his
abilities as an artist and impress the Academy, but it would also
impress Dr Rhudde, whose good opinion would please Consta-
ble's mother. There was undoubtedly a hidden agenda on Ann's
part: the more John became accepted and acclaimed as a leading
local painter of portraits and altarpieces, the more he would
get along in Suffolk and Essex, and the more he would become
known, appreciated and patronised by the local gentry.

John Constable's landscapes were piling up in his studio – he
continued to paint subjects around and about, including Dedham
vale, the estuary of the Stour at Mistley, and Flatford Mill:

'lumber' his father called them.[27] Despite a generous annuity from Golding and the occasional debt paid for him by Ann, Constable was always short of money, so the altarpiece commission was a reasonable step for so truly religious and talented a young man to take.[28] We might approach the conclusion that Constable's family, specifically his parents, gave him the permission he required and the blessing he craved to be a painter, on condition that he was sensible about it and made a living. If this prioritised the painting of portraits and developing a local reputation painting religious subjects, so be it: it was all the same to them. Theirs was the passive role, which Ann expressed by wringing her hands on the sidelines: 'Dear John how much do I wish your profession proved more lucrative, when will the time come when you will realize!!! [I much] fear – not before my glass is run out.'[29]

His uncle David Pike Watts's contribution, however, was different, overactive, as he crashed into the scene. Pike Watts was a man with money and wide social connections, which he generously and strategically made available to John. Where Ann and Golding might be the passengers in John's career development, Pike Watts got onto the carriage and tried to take over the reins. Pike Watts did not hold back when giving advice. He did not think much of the Brantham painting of Christ blessing the children, and said so: 'allow me gently and kindly to give my opinion.'[30] Constable had invited him to his painting room in Spur Street or Percy Street, not once, but twice, and wanted to hear his thoughts as the painting went along. Pike Watts gave them to him straight. This is what he said when he saw it for a second time, and in his view it had got worse, not better:

> The character of the Picture is so much alter'd that in my sight it is not the same which interested my sentiments. The <u>mind</u> of the Picture had fled . . . The soul of that Picture and which attached it to me was <u>Devotional Sentiment</u>. I see little of that Sentiment now in the Picture . . . I grieve at the change.

This was devastating criticism, but Constable took it on the chin. The opinion may have led him to make yet more amendments, and when Ann saw this truly hideous altarpiece completed and installed she was more accommodating than her brother:

The hands, and the glory is fine, but the figure too plump; &
countenance too common a likeness . . . the drapery in point of
colour too pink and too blue . . . and the infant, although <u>sick</u>
<u>unto death</u>, yet no reason surely that the whole colour, or the
form of the head should be so small. In truth my dear John,
tho' in all human probability my head will be laid low ere it
comes to pass – yet with my present sight, I can perceive no
cause or just impediment that you should not in due time, with
diligence & attention, be the performer of a Picture worth
£3000.[31]

The comparison Ann was making here was with Benjamin
West's *Christ Healing the Sick*, for which the President of the
Royal Academy had orchestrated an appeal for £3000 to buy it
for the nation. He raised the money in three days. West was not
a favourite with either Ann, or with her brother. Pike Watts had
tried to buy one of West's paintings, and had asked the artist its
price. West prevaricated, but eventually named a figure which
was more than Pike Watts wanted to pay. In response West of-
fered it for less, 'provided Mr Watts would keep it secret.'[32] This
turned Pike Watts off the whole deal, and indeed, off Benjamin
West.

David Pike Watts, six years younger than his sister Ann, had
had a staunch upbringing under the tuition of Alexander Cruden,
an 'education . . . not the best', as he told Farington, followed by a
difficult early manhood.[33] In his early adult years David had fallen
in love with the daughter of Benjamin Kenton, a wealthy wine
merchant and property developer of Aldgate and the Minories.
Kenton persistently objected to their proposed marriage, and as
a result his daughter faded into sickness and died. All this we
learn from Pike Watts's obituary in the *Gentleman's Magazine*.[34]
Such careless dismissal of happiness would in due course have
its faint echo in the life of John Constable, and while David went
on to marry elsewhere and have a family, Kenton was so ashamed
that his behaviour had brought such pain that at his own death
in 1800 he left his fortune of around £200,000 to David Pike
Watts. With this jackpot Pike Watts was able to retire from busi-
ness, and set himself up as a prosperous London city-dweller in

Portland Place, where he kept a fine carriage and horses.[35] Pike
Watts was full beyond the brim of the milk of human kindness
and charity, and became well known as a collector – he owned
Gainsborough's *Cornard Wood* from at least as early as 1808/09.
He took pleasure in organising parties and having a good time,
and for his pains Ann dismissed him unkindly as a 'milk sop'
– 'a soft, mild, effeminate, feeble-minded man' in Dr Johnson's
definition.[36] With Allen the brewer, and Kenton, Pike Watts and
Whalley all in trade together, beer, wine and cheese formed a
complementary background to the corn, flour and coal of the
Constable economy.

Coming to London, John Constable was faced with an ap-
proaching three-way collision, and being caught like a rabbit in
the lights as carriages bore down upon him. In the first were his
natural instincts, as honed by years of growing up in the Stour
Valley and working in Golding's businesses: observation of trees
in their season, the meadows, the river; sky, clouds, sunsets; ritu-
als of ploughing, sowing, scything, milling and its machineries;
the barges, the sailing craft, London at arm's length – all this
seen through his own peculiar vision, the lens of those sensibili-
ties and dextrous talents with which he was blessed. Bound into
this was his friendship with John Dunthorne, the genius manqué,
brilliant maker of musical instruments, painter of portraits and
landscape, collector of prints, telescopes and scientific books.
If Constable's first mature experience of sitting in a field and
putting paint onto a piece of paper came with Dunthorne beside
him, and it looks as if it did, we have the situation of a latent,
emerging genius eye to eye with a wilder spirit in tune with his
passion for landscape. In this same carriage was the advice and
encouragement he received in the unexpected surroundings of
Edmonton from John Cranch, who showed him a different, old-
fashioned path towards the smooth facture of landscapes that
might have led him astray, and John Thomas Smith, whose mis-
firing energies demonstrated the power of Gainsborough and
the dead-end of anachronistic rustic subject matter.

Now for the second carriage rushing towards the uncertain
young John Constable. This was the pull of the cultured upper
classes in the Stour Valley and beyond: Sir George Beaumont, his

art collection and worldly status, Beaumont's mother living in
Dedham, the dandy Fishers, the aspirant Bicknells, the haughty
Rhudde, the allure of moneyed London. This might all have been
more dangerous for him than Dunthorne's innocent instruction
from the other side of the tracks. These people showed Constable
what was fashionable in art rather than, with exceptions, what
was of value. In the third carriage was the London art world of
the day, those with the power and advice who could see Consta-
ble's raw talent and put their arms around him: Farington, Beau-
mont again, Benjamin West, Fuseli, Pike Watts and the presence
and example of Turner and other young contemporaries. Even
as this coach rushed towards him its occupants were fighting at
the reins. These three carriages collided, but the rabbit got out
of the way just in time.

In his surviving early work there is little to mark out John
Constable as a remarkable artist. He was good at drawing tum-
bledown cottages and the gnarled inconsequence of wooded
dells, but so were others of his age. There are also many light-
filled drawings of shipping, windmills and church spires. He
saw, or was shown to see, landscape almost entirely through
the tradition of the Picturesque. Almost entirely: in his oil of
Dedham Vale from the Coombs of 1802 there is a new spirit emerg-
ing that goes beyond Claude and his picturesque echoes in early
nineteenth-century British art – Constable's trees blow in the
wind, his light flickers and his clouds move.[37] There are other
small paintings that follow this track,[38] but from the point of
view of his making a successful career and a comfortable living,
the most promising aspect of this young man's work is clearly his
portrait studies. To confirm this point within the family, Consta-
ble's portraits of siblings and cousins – people who would sit for
him because they loved him and would give him their time – are
high among his achievements of the first decade of the century.
Portraits of both his brother Abram, with fashionable curls and
sideburns, and of his cousin Jane Mason grew from the pencil
studies rediscovered in 2020.[39] This pair of drawings may well
have been made in or soon after June 1808, when Abram told his
brother that the Masons were coming to London, and assured
him that Jane was older now, and much more interesting.[40]

Towards portrait painting, an interested observer might say, is where Constable appeared to be going. Nevertheless, as he slapped down a paint-loaded brush, and saw his trees move and his skies fill with cloud, it was increasingly clear that he himself saw things differently. He was beginning to understand the meaning of landscape, its potential moral force, and the expressive power of painterly gesture.

14. Through the walls we flew

'Whither Constable?' the painter might have asked himself during the bombardment of advice he suffered over his Brantham altarpiece. The bossy but well-intentioned and practical David Pike Watts came up with an answer in 1806: travel to the Lake District to seek out what would be for him new ideas and to experience new landscape forms, new destinations, and to meet new people. There could be money in portraits; but for a young man drawn to landscape painting there was only struggle, and Pike Watts suggested that his nephew faced this dilemma head on.

There was nothing new about Pike Watts's proposal. He will have been thinking about introducing his nephew to the Picturesque, following the fashionable practice among eighteenth century artists and writers travelling in the Lake District to marvel at its landscape. He hoped that this would revive John's spirits, and bring him back to the narrow way of Picturesque composition, or perhaps dampen his ardour for landscape entirely. There was much contrast to be overcome: Constable came from curvaceous, sandy, sedimentary Suffolk; Pike Watts sent him to a granitic, glaciated, volcanic landscape, one gouged by ice millennia ago, enriched by lava flows, articulated by radial lakes profoundly deep, clothed in thick woodland, and overtopped by mountains. These might have raised his emotions to a new plane, and shocked him into refocussing, but if the uplift occurred it was not sustained. Charles Leslie recounted that he had 'heard him say the solitude of mountains oppressed his spirits',[1] a reflection that clearly came out of later conversation. Though he made dozens of watercolours and drawings when he was there, between late August and the end of October 1806, Constable's paintings of autumn in the Lake District retain a gloominess, with little of the lightness of heart that enlivens the Picturesque. Furthermore, he was not, and never would be, an enthusiastic painter

of autumn: Constable's seasons, with few exceptions, would be spring and summer, and even his high summers were painted in winter as he prepared his work for the annual exhibition at the Academy in time for its late April opening.

Nonetheless he was busy and sociable. He travelled with George Gardner, the son of Daniel Gardner, and stayed initially at Pike Watts's Windermere house, Storrs Hall. John and Jessy Harden, tenants of Brathay Hall nearby, became particular friends. Jessy kept a journal in which she turns her eye on John Constable and the energy he showed when the party went out to sketch in the hills:

> He is the keenest at the employment [of sketching] I ever saw
> & makes a very good hand of it. He . . . chose the profession
> of an Artist against the inclination of his friends, at least so
> he says, & I don't doubt him. He is a genteel handsome youth.[2]

Charles and Sophia Lloyd were other friends in the area, living at Low Brathay, a farmhouse on the Brathay estate. Charles Lloyd was the son of the Quaker banker from Birmingham whose banking enterprise has continued to our day. He was, in Constable's view, 'a poet of some merit, of rather a desponding turn of mind',[3] and in league, partnership and mixed and volatile friendship with the poets Robert Southey, William Wordsworth and Samuel Taylor Coleridge. They were all well knitted: Wordsworth's brother Christopher was engaged to be married to Lloyd's sister, Priscilla, and Coleridge, Wordsworth and Lloyd had collaborated in the creation of Coleridge and Wordsworth's first anonymous collection of poems, *Lyrical Ballads*. It was there that Coleridge's 'Rime of the Ancient Mariner' first appeared, in the front of the volume of the first (1798) edition, with Wordsworth's 'Lines written a few miles above Tintern Abbey' fitted in at the end.

At the Lloyds, Constable met Wordsworth, his wife Mary with their three children, and Wordsworth's sister, Dorothy. The family, living in the next valley on the edge of Grasmere, were on their way south to the midlands of England to stay with Sir George Beaumont at his country house, Coleorton, in Leicestershire. The patronage and interest of Beaumont, exceedingly

generous and welcoming to the Wordsworths, was one particular
that Constable and Wordsworth had in common.

William Wordsworth was a strong physical presence in any
company, and might well quieten those, like Lloyd, who found
themselves 'depressed [i.e. humbled] in his society' and found
his self-projection hard to take.[4] With tall bearing, fine aquiline
nose and a voice that commanded attention, Wordsworth was
always a room's focus. The critic William Hazlitt noticed the
'fire in [Wordsworth's] eyes', and that when he read his poetry
with his 'northern burr like a crust on wine his eye beams with
preternatural lustre, and the meaning labours slowly up from
his swelling breast'.[5] He published his poems, as he admitted
in the Preface to the second edition of *Lyrical Ballads* (1800),
'as an experiment', and experimental they are with their close
and novel engagement with country people, rural workers and
cottage families, and their rich emotional insight. Small details
and ordinary words illuminate person and circumstance, as in
the story of the heroic but decayed huntsman, Simon Lee, whom
the poet found struggling vainly to cut an old tree root, and did
the task for him in a moment.

Despite such deep humanity coming off the page, Constable
later talked to Farington of 'the high opinion [Wordsworth]
entertains of himself'.[6] Farington's diary record of this conver-
sation suggests that Wordsworth and Constable talked about
schooldays, their early experiences of nature, and the growth
in their powers of perception. Decades later – after Constable's
death – Wordsworth recalled 'the pleasure of making Mr Con-
stable's acquaintance when he visited [the Lake District] long
ago'.[7] There is little to go on, but Farington's report of Consta-
ble's remarks has some weight: Wordsworth told Constable that
while 'he was a boy going to Hawkshead School, his mind was
often so possessed with images, so lost in extraordinary concep-
tions, that he has held by a wall not knowing but he was part
of it.'[8] Wordsworth reportedly used the word 'images' here; pic-
tures, suggesting that they discussed the 'look' of landscape, how
landscape might be expressed in a picture, and Constable's early
joy at touching nature. He had already confided to Dunthorne
that 'there is room enough for a natural painture,' and William

Wordsworth may have been only the second person to receive that confidence from Constable.[9]

The curious remark that Wordsworth makes to explain how 'his mind was often so possessed with images' is puzzling, but we must allow that it was reported by Constable to Farington over a year later, and written down after this long delay. Perhaps Wordsworth read and discussed early parts of *The Prelude* with Constable at Brathay, and included this, part dream, part memory, of Furness Abbey, with its cross-legged Knight / And Stone-Abbot'. The poet is with his friends, a group of young men wheeling their horses in the Abbey's roofless nave:

> The shuddering ivy dripped large drops, yet still,
> So sweetly 'mid the gloom the invisible bird [*a wren,*
> *before named*]
> Sang to itself, that there I could have made
> My dwelling-place, and lived for ever there
> To hear such music. Through the walls we flew
> And down the valley . . . '[10]

In later life Wordsworth spoke again of the experience he had described to Constable, of how he would hold on to a wall or a tree on the way to school to steady himself against being overwhelmed by youthful philosophising:

> I was often unable to think of external things as having external existence, and I communed with all that I saw as something not apart from, but inherent, in my own immaterial nature. Many times when going to school have I grasped at a wall or tree to recall myself from this abyss of idealism to the reality.[11]

Wordsworth and Constable shared common ground in the business of feeling, and concurred that the imagination is the driver and lifts one up and away from hard reality. Constable seems to have held on to this thought for over a year before telling Farington, who wrote it down as best he could.

If the word 'experiment' or 'experimental' had cropped up in their conversation it would have tweaked Constable's ear, as his first experimental notes are written on his Lake District

watercolours: 'Saddle back and part of Skiddaw Sep 21 – 1806 Stormy Day – Noon.' and '25 Sepr. 1806 – Borrowdale – fine cloudy day tone very mellow like – the mildest of Gaspar Poussin & Sir G. B. & on the whole deeper toned than this drawing.'[12] It was impossible even there, particularly in the company of William Wordsworth, for Constable to escape the long reach of Sir G. B.

'The solitude of mountains oppressed his spirits': if this is the case, what was it in particular that oppressed him, the mountains themselves or the expression of them by Wordsworth's mountainous spirit? There in the Lake District, in the same room were William Wordsworth and our thirty-year-old, late maturing, receptive, uneasy artist – the richest unformed sensibility of the era in the painting way. He already knew what could grow out of solitude and quiet reflection on surroundings: 'here I am quite alone', he wrote to Dunthorne in 1800, 'amongst the oaks and solitude of Helmingham Park . . . I shall not come home yet.'[13] Later he would write to Dunthorne, then the most receptive touchtone of his inner self, of having discovered, and enjoyed, 'serenity of soul . . . patience in the pursuit of my profession.'[14] These may be considered Wordsworthian qualities, ones which might foster the receptivity required to understand and engage artist and poet.

Wordsworth's expression of the Lake District was of such moment that it might itself have become oppressive to others, particularly to somebody whose groove was in the rolling turns of Suffolk rather than the mountains of the north. By now Wordsworth had walked down through France, across the Alps, become embroiled and certainly endangered within the currents of the French Revolution, seen violent death in Paris, fallen in love, expressed his love with passion, conceived a child, and parted with his pregnant lover.[15] Of all this, Constable had experienced only falling in love. The pair, one a radical, the other an uneasy young Tory, had little common life experience except eventful schooldays and their infinite correspondence with Nature, which they demonstrated in the only ways they knew; and those they stumbled over. Had Wordsworth spoken about his experiences in France with Constable, it did not register. Constable was not a

naturally restive traveller in search of new horizons – the road between East Bergholt and Ipswich rendered riches enough for him.

There were many days of uplift for Constable in the Lake District, so we might reasonably doubt the report of his apparently 'oppressed . . . spirits'. Some of these days he spent happily walking in the hills and drawing both on his own and with Gardner and the other friends: getting on for one hundred watercolours and drawings survive.[16] One, of Esk Hawse, he inscribed: 'The finest scenery that ever was'.[17] When it rained, however, and it rained often, he stayed indoors and painted portraits. These turned out to be the most useful products of the Lake District trip, as Jessy Harden wrote in her journal:

> Yest[erda]y rained all day, so Mr Constable got some oil colours & painted a portrait of me which he executed wonderfully well considering he was only 5 hrs. about it. He is a clever young man but I think paints rather too much for effect.[18]

On another wet day he painted a portrait of Jessy's husband, John, a man Constable described as being high-spirited, 'composed of Whip Syllebub & Spruce Beer', whatever that means, and portraits of Charles and Hannah Lloyd, their baby, and Charles's brother James.[19] In addition there are drawings of musical evenings and conviviality that indicates they all had a jolly good time at Brathay as the rain came down.[20] While the Lake District visit produced watercolours which formed the basis of the ten or more mountain oil paintings he would later exhibit, at least six portraits also emerged. If Constable arrived in the Lake District as a landscape painter, he left it as a competent, and perhaps a momentarily determined, painter of portraits.

On his return to London Constable found an official letter waiting for him. This informed him that he had been called up to serve in the militia, to train as a soldier, to fight for His Majesty, and to accept an abrupt change in career.

15. Industrious, temperate and plainly dressed

The call to serve his monarch gave an unwelcome certainty to Constable's uncertainty, and threatened to scupper the trajectory he had planned. It surely cannot have come as a complete surprise, however, as in 1806 Britain was under severe and continued threat of invasion by Napoleon's armies. Constable's extended family had a strong military thread within it: his heavily-tattooed uncle John Watts was a naval captain; eight of his first cousins served in the army and navy: David Pike Watts's sons David and Michael were respectively army captain and ensign; Richard and James Gubbins were army officers; four Allen cousins, children of the Edmonton family, were or would become serving army officers. John Constable could not expect different treatment at this dangerous hour; indeed, a reasonable family conversation point at the time might have been that John's chances of survival and success as a soldier were higher than his chances of survival and success as an artist.

He himself had other ideas, of course; he stuck to them, and Pike Watts seems to have been genuinely consistent in helping him to achieve them. Pike Watts had family bite, understanding and insight that others such as Farington could not have. They went together to exhibitions and auctions,[1] and Pike Watts invited his nephew to dinner – a regular occurrence; his door at 33 Portland Place was always open: 'I shall be glad to see you when it suits you to call here. The hours are the same, breakfast 9 or 1/4 past 9. Dinner 5.'[2] He was sensitive to John's manifold anxieties. By now these were compounded: he was lonely and lovelorn, smitten by the charms of Maria Bicknell, while at the same time encountering obstructions at the Academy, and the new threat of military call-up.

Others of his cohort, such as Turner, Wilkie and Mulready, were rocketing past. At the 1807 Academy exhibition, Turner exhibited the large and glowing *Sun Rising through Vapour* and

his controversial and politically laced genre subject *A Country Blacksmith Disputing upon the Price of Iron*; Wilkie showed his *Blind Fiddler*; and Mulready, aged twenty-one and a half, had already exhibited nine paintings. In 1807 he would show four more. Turner relished dispute and challenge, he was aggressive and could behave badly; Wilkie charmed everybody; Mulready was a one-boy youthful revolution. Constable, on the other hand, plodded along. He tried a fresh tack away from the Stour Valley by putting three new landscapes before the public, including *Bow Fell, Cumberland* and *View in Westmorland, Keswick Lake* (i.e. Derwentwater).[3] These attracted little serious notice, but one Academy visitor that year might have given them a second look.[4]

That visitor was William Wordsworth, staying for the season in London with Beaumont. Evidence of meetings between Wordsworth and Constable after Brathay is slight, but what survives is significant. It is clear that they were together in Beaumont's house in Grosvenor Square in 1807, as years later the lawyer and diarist Henry Crabb Robinson told Dorothy Wordsworth this:

> He [Constable] seemed [at Beaumont's] to have retained just impressions of your brother's personal distinction among the poets, though too passionately and exclusively attached to his own art, to allow himself leisure for the study of any other. He is said to be a very promising landscape painter.[5]

Memory of their contact lasted with Constable, and as late as 1836, the year before he died, he wrote to Wordsworth and touched his memory of their mutual friend: 'it was from [Beaumont's] hands that I first saw a volume of your poems – how then can I can I [*sic*] ever be sufficiently grateful.'[6] The repetition of 'can I' here may be a slip of the pen, but it may equally be an unconscious and unobserved emphasis on a matter of deep significance recollected in tranquillity thirty years later.

It is very likely that the volume Beaumont showed to Constable in April or May 1807 (and that Constable subsequently held and read, surely) was Wordsworth's *Poems in Two Volumes*, published in London in April 1807. This included 'Resolution and Independence', 'I wandered lonely as a cloud', better known

now as 'Daffodils', and 'Ode: Intimations of Immortality'. These
poems would give Constable the confidence that he had long
sought and grasped for, licence to feel and to express his feel-
ings. Constable's meeting with Wordsworth's poems focussed
his painting, and allowed him to begin to break free from David
Pike Watts's grip. There was a struggle of the imagination at the
heart of all this, the lure of his instinct against the tug of the or-
thodox, to continue with his quick painting outdoors against an
easy temptation to follow the herd. 'I wandered lonely as a cloud'
was something Constable could say he had been doing in the
Stour Valley since childhood. After Wordsworth saw Constable's
three Lake District paintings in Somerset House, and perhaps
muttered something kind about them, Constable began to trust
his own eyes, and stop looking back.

Nevertheless, there was a Sword of Damocles – call-up for the
militia – hanging over his head. The rule was that he had to find
a substitute to join the colours in his place, if he did not intend to
go for a soldier himself. Pike Watts came to his side to ease him
in the twin challenges posed by call-up and by his frustrations
as a painter. Orthodox religion was the guide and comforter
that uncle and nephew shared: 'You do not expect to pass this
life always a smooth stream unruffled.'⁷ Keep battling on, Uncle
David exhorted. They would go out and about together, dinners
with the Beaumonts, and with Farington and others. Conversa-
tion at one London dinner that they attended continued in the
carriage home. Evidently a disagreement had taken place, as Pike
Watts recounted it:

Fragment of a Conversation in the carriage going home:
'Well if J[ohn] C[onstable] has disobliged me this evening,
I can see many good properties to atone for one error. He is
industrious in his profession, temperate in diet, plain in dress,
frugal in expenses, sedulous in the pursuit of science and on
the progress of his art, and in his professional character has
great merit.'⁸

So, by October 1807 well-connected people were already becom-
ing impressed by John Constable despite his low profile at Acad-
emy exhibitions. Growing attention in London had its backwash

in East Bergholt and Dedham, where the powerful local lawyer Peter Firmin, with 'eighty thousand pounds to play with' according to Ann, mentioned the name 'John Constable' in even more exalted circles.[9] Wilbraham, the 6th Earl of Dysart, had noticed a temperate young man in a party visiting his house at Ham, near Richmond, and was sure he had seen him somewhere before. Firmin had been of the party: was this 'the Mr Constable who had copied the picture at Helmingham', the Earl asked Firmin. Indeed, the same, Firmin replied: 'Mr Constable, an artist and connoisseur . . . an artist of considerable merit.'[10] As a result, Constable returned to Helmingham and Ham, and to the Dysart house in Pall Mall, to copy more of the many portraits in the Dysart collection in need of duplication for the family.[11] This was the beginning of a life-long relationship which developed for Constable into employment, affection and support.

The 6th Earl took to John Constable: he noticed the painter's reserve, being himself a very shy and complex man, thrust at a late age into his earldom. Farington draws a crisp pen portrait around the man, and tells us all we need to know about the background of the commissions that Constable would come to enjoy from the extended Dysart family:

> Lord Dysart . . . is a very shy man & comes into a room sideways or almost backwards. He is a very good man & kind to all who are dependent upon him. He has more than £30,000 a year . . . Lady Louisa Manners . . . is his Lordship's Sister.[12]

Dysart's confidence and affection for Constable developed in 1810 to the extent that he would buy a small landscape painting from him.[13]

This 6th Earl was part of an engagingly complex family. The 5th Earl married Magdalene Lewis of Malvern Hall, Solihull, and his younger brother, later to become the 6th Earl, married Magdalene's sister Anna Maria. The sisters' brother, Henry Greswold Lewis, inherited Malvern Hall. This house comes bravely into our story in due course. On the 6th Earl's death in 1821, his sister Louisa Manners became the Countess of Dysart in her own right, lived to be ninety-five years of age, and became one of Constable's most affectionate and enduring patrons. As

the family monuments in the church at Helmingham attest, theirs was a family of achievement and tragedy. Of the 5th and 6th Earls' other brothers, George was drowned on a voyage to Lisbon, John was killed in a duel, and William was lost in the frigate *Repulse* in a hurricane. Their nephew Lionel was killed by the bursting of a shell before Valenciennes, 1793.[14]

Across the period of his introduction to the Dysarts, Golding and Ann continued to cheer their son on:

> I am glad to hear of your assiduity which I doubt not will ultimately be crowned with success – tho' I hope you will not injure your health, nor trifle with the blessings you injoy of so excellent a constitution by too close confinement.[15]

Assiduous: that was another complimentary observation, this one from his mother. While continually trying to organise his life in London, Ann remained unshakeably certain of John's genius and abilities. She knew also that he needed those helpful gestures that only a mother can provide, and took his clothes in for repair, and made new shirts for him. She worried more about fashion than he ever did, 'whether the cambric frills are deep enough . . . but Abram says they will do; – if they prove too deep, it will be easy to cut off the hem and rehem them.'[16] She wants him neat and tidy; she knew that no sitter would be comfortable in front of a shabby portrait painter, particularly if the sitter were a charming young woman of marriageable age and temperament.

Constable must have been particularly on edge while his call-up for the Middlesex Militia was active. That obstacle had been hanging over him for more than a year before he found a substitute, one James West, to take the King's shilling in his place. In February 1808, at his new rooms in 13 Percy Street, he received the certificate that released him: John Constable was not to become a soldier.[17] Now Pike Watts reappeared like a benign genie from the bottle, always encouraging, always actively engaged and in league with his nephew as he attempted to progress.

His letter of June 1808 may have grown out of a conversation between the pair, and reads as a not-so-subtle piece of further career advice. Pike Watts was having a short early summer break in Cheltenham, where there were 'Balls, Plays,

Libraries, Lounges in the Town; and out of it, beautiful scenes, Hills, rich Foliage, Orchards, a luxuriant Vegetation.'[18] He had found 'a Tract on Scotland which is among the "light Summer Reading" at Watering Places'.[19] This discussed the attachment of Scottish kings to the arts, as understood at the time, and Pike Watts copied out some paragraphs for his nephew pertaining to portrait painting. The extracts demonstrated how accomplished Scots artists were, and how they showed that there was money to be made not only in Scotland, but more especially in London, particularly in painting portraits. He instances William Aikman, 'an excellent painter of portraits ... in London where he was much esteemed and constantly employed.' The tract went on to name Allan Ramsay, the Runcimans, Henry Raeburn, Alexander Naysmith, and other Scots 'eminent in London', including the Adams family of architects and the engineer John Rennie. Using as an example the success that could be gained in London, the purpose of this long transcription was surely to encourage John in portraiture, and show him the strength of the opportunities in the capital for portrait painters.

It might just be that if he were to follow his uncle's advice the world of portraiture would be there for the taking, as he certainly had the talent and the application. His portraits of his cousin *Jane Inglis*, formerly Jane Mason (*c.*1808–9),[20] and the thirteen-year-old *Mary Freer* (1809)[21] show the standards he would attain, and are masterpieces by any measure. Even John Constable must by now have known that John Constable could be a portrait painter with a future of financial and social success in front of him, if he wanted it. Perhaps that scared him off; getting too close to people; having constantly to be a diplomat, courtier and sycophant, when in reality he could be subject to depressions and an insatiable longing to be out in the country. Portrait painting was the carousel he was now riding, but he wanted to get off.

His patrons demanded more and more: the Earl of Dysart asked him to copy the grand full-length Reynolds portrait of his late wife, *Anna Maria, Countess of Dysart as Miranda in Shakespeare's Tempest*, as well as a second head-and-shoulders version, and 'disagreeable sprawling things ... Lady Louisa Manners has got a wretched copy by Hoppner from Sir J. Reynolds which

she wishes me to repaint.'[22] He had painted his largest original portrait yet, the two-metre-high *Barker Children* of 1809, for a family known to his parents in the Stour Valley.[23] The dimensions of these portraits are extreme – the largest nearly two and a half by one and a half metres – and demonstrate in their quantity that Constable was not daunted by scale. He was engaged to paint another two-metre-high portrait in the Reynolds manner of retired Captain Thomas Western, RN, of Tattingstone Place, north-east of East Bergholt.[24] Western and the Constables knew each other well: as a Guardian and sometime auditor of the House of Industry at Tattingstone and its supplier of corn, Golding was a regular visitor to the village.[25] Ann reported that the Westerns and the Constables exchanged visits: 'he was at our house on Thursday last.'[26] When he heard this commission was in the offing Constable wrote laconically: 'I must procure a supply of the crimson, ruddy, and purple tints and the deepest dye . . . Captain Western is a <u>very large subject</u>'.[27]

Thomas Western was also a large personality. He had served in the West Indies as Captain of HMS *Tamer* harrying both French and American vessels,[28] but the pinnacle of his career came when in 1807–8 he commanded HMS *London*. She was one of the dozen or more ships in the naval flotilla that carried Prince John, Regent of Portugal, his family and his court, to Brazil when Napoleon threatened Lisbon. The Regent gave Western's wife a necklace of amethysts for her trouble, and elevated him to Knight Commander of the Royal Portuguese Military Order of the Tower and the Sword.[29] In the year of his return to England, Western inherited Tattingstone Place from a cousin.

This commission was important for Constable, but in the event it seems to have told him 'never again': it is his most overblown and perhaps his worst portrait. Nevertheless his mother laid great store by it, and told him so: Western was 'a <u>large subject</u> for a canvas', she wrote, 'but one that you will display your approved abillitys [*sic*] on and I have no doubt will ensure you credit and skill in <u>that branch</u> of the Arts.'[30] A week later Ann admonished him in what we may take as his parents' principled point of view on the priorities of Constable's career. The only way to win the love and affection of a young woman who was

becoming increasingly interesting to him, was to begin to make some money and *paint portraits*:

> You seem now my dear John in that situation that Fortune will place the Ball at your Toe, and I trust that you will not kick it from you. You can now so greatly excel in Portraits, that I hope it will urge you on to pursue a path, so struck out to bring you Fame and Gain – by which you can alone maintain with respectability the Fair Object of your best & fondest hopes!![31]

However, if the Western portrait, and Constable's other early paintings on this scale gave him anything of lasting value, it was experience of handling large canvases and exercise in managing the creation of complex imagery of wide extent and scale.

Pike Watts was constantly on the lookout for ways to increase John's experience of people, places and old master paintings. In August 1812 he was in Kent, dining at Ide Hill, near Sevenoaks with the Rev. Matthew Bloxham, and evidently discussed his nephew's stalled career. Bloxham offered to invite the young painter to 'pass a day or two, or week or two at his place', and show him round the area.[32] Nearby, and easy of access for Bloxham's guests, was the Duke of Dorset's Knole Park, 'where there are some rare old Pictures, a most venerable Mansion, also several of Sir Joshua's Paintings'; Lord Frederick Campbell's Coomb Bank 'where are some Rubens, Murillo, Old Franks, Snyders'; Lord Amhurst's Montreal, 'some Michelangelos and Sir Joshuas'; Mr Ward's 'Squiring Park' (correctly, Squerryes Court), Westerham, 'Rubens, Van Dycks, Titians'; and the Rev. Matthew Peters RA, former Chaplain to the RA, and the only Academician ordained minister. Peters lived at Brasted Place, where he would show Constable 'his own works and many valuable Engravings.' All these collections, Pike Watts added, 'are within an easy walk [of Ide Hill]. Mr Peters 2 miles. Lord F Campbell's about the same distance.' Pike Watts was fully dedicated to turning John Constable from a Suffolk boy with huge talent but limited experience, into an artist of renown, connection and breadth of knowledge. He urged him to get out there and get on with it:

> I would recommend you to go as soon after your return from

EB as may suit your other engagements, as the Autumn is the
season for the fine Scenery before October and November. The
prospect alone from the Parsonage at Ide Hill on a clear day
is itself a delightful scene ... The country is beautifully di-
versified, it is quite a landscape for an artist's eye. I think this
scheme would both amuse & interest you.

Constable never made this tour.

There was another kindness not to be ignored: Pike Watts gave
his nephew a new flute, perhaps in exasperation at his apparent
inability to get on with things, get moving, stop moping. Watts
will have known about Constable's duetting with Dunthorne in
East Bergholt, so the present of the flute was a particular kind-
ness. The fact that it was not a very good flute, and soon failed,
may have been down to Watts's lack of expertise, rather than
flawed generosity. 'If one has a flute at all,' Abram wrote to John,
'it may as well be a good one.'[33] Pike Watts knew, as Reynolds had
demonstrated, that in portrait painting money followed energy
and talent. Pike Watts earnestly wished to remind his nephew
of this, and thus encourage him to do more, much more. They
must have discussed the money Reynolds had made from portrait
painting, as Pike Watts sent his nephew a copy of James North-
cote's newly published *Memoirs of Joshua Reynolds* (1813) to keep
his spirits up, his work on track, and pound signs in his eyes:

> I present you with your Friend Northcote's life of your exem-
> plar Sir Joshua. Accept it with my good wishes. It may amuse
> you as reading, it may inform you as history, it may animate you
> as evidence of what <u>may be done</u> by what <u>has been done</u>; and
> if not to the high extent of [£]100,000, to the comfortable
> seat of [£]50 or [£]40 or [£]30 or £20,000, but only <u>touch</u>
> the [£]20,000 and the rest follows as the steps of a ladder.[34]

Both mother and uncle were now taking him by the collar to
shake some sense into him. People in East Bergholt and Dedham
knew Constable painted landscape, and might see him sitting on
his own by Flatford Mill with his paintbox, brushes and easel.
Ann told her son that his Uncle David 'was so much taken with
one of your sketches of Flatford Mill, House &c that he has

requested you to finish it for him'.[35] Pike Watts might have been
flummoxed had Constable retorted: 'It *is* finished.' Few wanted
his landscape paintings, they were messy, unclear and very, very
green: 'Landscape which found me poor at first and keeps me so',
he would confide to Maria in a knowing paraphrase of a line in
Oliver Goldsmith's *The Deserted Village*.[36]

Portrait painting was the profession where, the world might
think, John Constable would make his fortune, and Pike Watts
and Ann became outspoken and energetic art critics as Consta-
ble's career developed. Ann had the infallible nose of mothers for
that which is no concern of theirs, as Arnold Bennett observed
in other times, other circumstances, and of a father rather than a
mother.[37] 'Energy and good temper gives a grand finale to your
pictures,' she told John:

> When you fag at your work, it never pleases either the per-
> former or the beholders. Finish therefore well & as soon as
> you can – & then come to Bergholt, & let us injoy friendly
> converse without offence either given or taken where none is
> intended.[38]

There were other business opportunities: Constable's altarpiece
for Brantham became an advertisement for him, and in these
years of renewal, reconstruction and liturgical change in the
Church of England, other local churches required his services.
St Mary's, Stoke-by-Nayland, a high and proud Suffolk church
whose tower is visible for miles around, contemplated the com-
missioning of *The Agony in the Garden* for an altar. There is a
study, with measurements, of a composition for St Mary's set
into an arch in a sketchbook of 1810, but this idea came to noth-
ing.[39] It may be that the commission, and the energy behind it,
was transferred down the hill into the river valley to St James's,
Nayland, with the subject changed to *Christ Blessing the Elements*.[40]
The commissioner here was one of Constable's aunts, Golding's
younger sister Martha Smith, another 'Patty', a wealthy widow
living in Nayland.[41] Pike Watts put his oar in too, in the light
of the Brantham altarpiece. He suggested Constable copy Carlo
Dolci's *Blessing of the Bread and Wine* at Burghley House, which,
he reminded his nephew, had been copied as an embroidery by

Mary Linwood, the needlewoman who had once given Constable the task of painting a landscape to set off her embroidered cow.[42] Accepting the Nayland commission, Constable borrowed his brother Golding to model the figure of Christ.

Clearly the family was chafing at their perception of John's lack of progress in getting the Nayland altarpiece started – certainly Ann was: too much of his time was being spent painting landscapes. There is a pencil drawing by Constable showing the initial conception for the reredos at Nayland, with a blank where the painting would be.[43] Above the drawing, in Ann's handwriting, is the exhortation: 'Pray turn your mind to some good subject soon'.[44] She buzzed off this remark to her son: 'I now hope you will soon have leisure and desire to work on your Nayland [altarpiece]', adding as instruction rather than advice that at the edge of the canvas he should inscribe the verses from I Corinthians, 11: 23–6, the words of Christ at the Last Supper, 'neatly lettered & gilt, it would not only look well but be very explanatory to a country congregation'.[45] But he had not even started it, and it was not until the following month that Ann could say, 'I rejoice to hear you have begun your Altar piece and have no doubt it will give satisfaction to all parties.'[46] Ann Constable had invested much social credit in the altarpiece coming to fruition. Her sister-in-law Smith expected it; and so did Dr Rhudde: they had all wanted an 'Agony in the Garden', as proposed for Stoke-by-Nayland: '[Dr Rhudde] talked kindly of you, & your works; and most earnestly wishes you to change the subject of your Altar piece.'[47] What a relief it was to Ann to receive her son's letter as she wrote this one:

> Judge then of the pleasure your note has given me – also, that you shall make it a Capital Picture, one that I hope will always fix your fame. Whenever you begin a work with zeal, you have always succeeded.

At last, here was some parental confidence in John Constable's future, though it was clear that Aunt Smith had some anxieties of her own, specifically in reflecting 'on what a slender thread her life hung.'[48] Aunt Smith wanted 'to see your performance', said his mother, so please get on and finish it.

Constable's painting at Nayland was the centrepiece of a clas-
sicised reredos in oak, with a pediment above the painting, and
columns and panels on either side.[49] When it was installed, Ann,
Golding, David Pike Watts and John's elder sister Nancy went
together to see it: '[We] filled [David's] barouche and four; so
that we rather astonished Nayland. Our grandeur was transitory
– but I trust our happiness will be lasting.'[50] The *Ipswich Journal*
had already published a letter full of praise. 'A very masterly
performance,' the correspondent proclaimed, 'the subject most
expressively sublime, interesting, and appropriate.'[51] More sig-
nificantly, however, Constable was described as 'a respectable and
ingenious artist, the nephew of Mrs Smythe [*sic*], relict of the
late Thomas Smythe, Esq. a native and inhabitant', and 'son of
Golding Constable Esq. of East Bergholt'. In rooting the artist's
family connections so securely, the letter confirms the local as-
sessment of John Constable's level of attainment.

David Pike Watts stayed in the church looking at the painting
'above an hour, although it was cold, he of course bare headed.
He seemed as if he could not leave contemplating it.'[52] Uncle
David took copious notes as the organ played; he was a tough
nut to crack, and very hard to please. Even before his mother had
written to tell of the barouche party to Nayland, Pike Watts had
written a long letter to John: 'Allow a Friend to point out some
apparent defects as they occur to him.'[53] There follow twenty-five
numbered points of criticism: it is unclear to Pike Watts if the
figure is standing or sitting; there is too much dark background;
head too round; eyes too large; face too fat; lips too pale; face too
small; shoulders slope too much – and so on. The chalice, Pike
Watts asserts, however, 'is admirable . . . it is truly excellent.' But
these are details,

> and now having boldly and frankly (too bold and too frank)
> given my simple and unskill'd observations, I repeat my first
> declaration that with all these minute and captious exceptions,
> as a <u>Whole</u> it is a fine Work.

Later, Ann criticises the altarpiece staunchly:

> I wish the Nayland picture was as highly finished [as the

landscape you have painted for Mrs Roberts] – and still hope
that in the summer you will see it again, & varnish it at least.
There always appeared to me much crudeness about it – the
beard in particular - & the 'tout ensemble' is certainly not rich
enough in colour.[54]

This all came at a pressing time. Farington and another senior
Academician, Thomas Stothard, were actively urging Constable
to put his name down as a candidate for an Associateship at the
Academy. Reviews were trickling into the national press: the
landscape bought by Lord Dysart was described in *Ackerman's
Repository* as 'fresh and spirited ... a very masterly perfor-
mance', and the *Examiner* as 'chaste ... singular but pleasing'.[55]
He was also busy for an important but bothersome member of
the extended Dysart family, Henry Greswold Lewis, who had
summoned him in 1809 to Malvern Hall to paint the house and
grounds, and to prepare portraits of himself and his ward Mary
Freer. Greswold Lewis, Louisa, Countess of Dysart's brothers'
wives' brother, was one of Constable's chattier clients, one who
befriended him immediately. Ann Constable encouraged her son
in this introduction, hoping 'that it will prove to your advantage',
warning that Lewis 'is a very eccentric character, he is a friend of
value to you – and such, artists must cultivate.'[56]

Over the next few years Constable dealt with Lewis's order for
his portrait and four copies.[57] They absorbed his time and energy,
and divided his focus, but nevertheless good and valuable business
they were. Lewis looks slightly to the right, wearing a bright,
white stock and a black coat with a brown fur collar. His quiet
smile betokens kindness and humour, while behind him a mottled
red curtain creates a comfortable background that confirms the
blush of his warm red cheeks. As it turns out, the curtain was
not a curtain at all, but Mary Freer's coat, seen across her knee
in her portrait, and now spread out behind Lewis.[58] A curious
aspect of the portrait is that it is practically identical in pose,
direction of gaze, its half-length form, size, scale, lighting and
demeanour to John Hoppner's portrait of Sir George Beaumont,
painted in 1803 and exhibited at the Academy in 1809, the year
of Hoppner's death. Constable will have seen Hoppner's tender

portrait in Grosvenor Square, and has clearly studied it, for in his portrait of Lewis, which is practically a 'version' of Hoppner's, he shows similar tenderness and affection. This new, long-lasting and friendly commission, with its further connections to the Dysarts and Manners, together comprised a lucrative series at 15 guineas or more a head. If he felt that the Dysarts were close to monopolising him, Constable nevertheless reported that the outcome of the extended Dysart family's commissions was that he found himself 'leaving London for the only time in my life with my pockets full of money.'[59]

'My thoughts are often with you', Abram said to John early in 1812.[60] Abram's letters to his brother are the fullest and most informative of all in the siblings' surviving correspondence between themselves.[61] Each letter invariably fills a folded sheet, both sides, tight top and bottom, often with additional tiny writing in the corners and margins. Abram uses a fine pen and has good, clear copperplate handwriting in narratives that are taken up with family news, implied assurances of John's central importance within the family, and the weight of expectation upon him. John's portrait of Abram, painted around 1806, reveals a handsome young man, reflective and thoughtful. Abram liked to be up with the times on fashion, and as the long sideburns attest in the portrait, John knew it. He was the party-goer of the family: Dedham and East Bergholt and their surroundings were alive with routs and balls in the season and out of it, and as their mother told John:

> Abram will tell you all the news, also what a caperer he has become – dance after dance, with his <u>neighbours' daughters</u>. He will also tell you of our Venison Feast &ccc ... A grand dance at Mrs Bridges, Lawford, on Monday last – upwards of a hundred invitations ... Miss Godfrey and young George opened the ball.[62]

It was around these years that Golding, with Abram at his side, had a cautious business partnership as Corn Merchants with their cousin William Garrad of Bures. The Garrads were the family that Ann described unkindly to John as 'the heavy heeled Garrads' when she gave news of a coming local dance, 'the Manoeuvres of

the "Light Fantastic Toe'" at Bures. The Garrads had 'attitude',
Ann averred – 'therein they excel'.[63] Ann's meaning is opaque,
but in any event this would be a tricky business arrangement,
and so it seemed to prove. Despite being a family matter – cousin
William Mason, solicitor of Colchester, was their legal mind –
agreement appears to have been complicated: 'We have proceeded
very far with . . . William Garrad's business & I think the next
time he [Mason] comes it will be finally <u>settled</u>.' As Golding
Constable's life drew to its close, so it seems as if Abram wanted
to wind up the Corn Merchant business of Constable, Garrad &
Co.[64] Abram marked his central role at home and in the business,
now that their parents were ageing, by his adopting a particular
seal for his letters: the family crest of a three-masted ship in
full sail above 'AC' in monogram.[65] This was the new, confident
image for Constable and Co. of East Bergholt and Flatford now
that John had confirmed his decision, and demonstrated that he
would not be deterred from a life as a painter.

He was also beginning to take control of what it was he would
paint. He was summoned back to Tattingstone Place in August
1814, much to his annoyance, to change the colour of the uni-
form to blue when Captain Western was promoted Rear-Admiral
of the Blue: this was four months before Western's death. Stuck
inside at Tattingstone on hot August days Constable wrote to
Maria: 'I grudge the fine weather exceedingly and I sincerely
hope this will be the last portrait from my pencil.'[66]

16. Pray be careful of yourself

There were now, or seemed to be, two John Constables: the John Constable in London, trying to make his way among his contemporaries in the Royal Academy, who was known to the leaders and movers as interesting, personable and competent, industrious, temperate, plainly dressed, frugal and sedulous. This John Constable could be spotted in Somerset House dressed in his habitual black, but he led a lonely life when he went home to his rooms to read quietly, or study anatomy, and draw and paint until the light fell dead. He was restless and moved from one address to another in Soho: 23 Cecil Street, then 50 Rathbone Place, then 3 Spur Street, 13 Percy Street, 49 Frith Street, 7 Newman Street (briefly), then in 1811 – settling at last – 63 Charlotte Street. In 1803, when between addresses, he entered his paintings in the Academy exhibition as from his sister Martha's home, 15 America Square, the Minories. This John Constable, if known at all, was known as a painter of landscape rather than a portrait painter: he did not overtly solicit portrait commissions in London, and had never yet tried to exhibit any portraits there. Had one turned up at the Academy with his name attached to it his colleagues might have thought there was surely some mistake.

The other John Constable lived in Suffolk and painted in his studio cottage by the village green at East Bergholt. There he was a portrait painter of growing reputation and developing technique who also painted altarpieces and landscapes. 'I think myself it is the best I have done,' he wrote of his portrait of William Godfrey. 'I wish all they tell me about it could make me vain of my portraits.'[1] Even Dr Rhudde found the generosity to praise this work. He told Abram: 'and an excellent portrait it is, and does your Brother John the greatest credit. If he can paint such portraits as these he may get Money.'[2] Furthermore, Constable's portrait of the well-connected parson the Hon. Rev. George Bridgeman brought praise and generated confidence:

'My reputation in that way is much upon the increase', he wrote, '[it] is doing me a great deal of service, as these are people connected with all higher circles.' George Bridgeman was the brother of Henry Greswold Lewis's brother-in-law, Orlando, 1st Earl of Bradford, so this was a higher circle, certainly, but it was also a tight one, connected to the wider Dysart family, and not as socially spread as it might usefully be. Constable knew he had to associate with the right people to be a success as a portrait painter, but in being monopolised by the Dysarts he was caught in a loop.

> My pictures of [Lady Heathcote and her mother, Lady Louisa Manners] occupy either end of the large drawing room in Grosvenor Square. They have magnificent frames and make a great dash ... She has 'a little dance' on Friday, when my pictures will be seen for the first time publicly.[3]

These, however, were not 'his' portraits, but copies after Hoppner and Reynolds.

Constable's own portraits are reminiscent of Joseph Wright of Derby, an artist of the earlier generation, similarly torn between painting faces and painting landscape, or of George Romney, with some traces of the elegance of form of Thomas Lawrence. There appear to be forty-six recorded portraits between *The Bridges Family* of 1804 and 1816, four being of the same man, Henry Greswold Lewis, and two of Bishop Fisher. Those of family and friends were not necessarily paid for, so altogether this hardly makes an adequate income.

For all his friendliness towards Constable, Beaumont did not buy a painting from him; he did not even sit for his portrait. Beaumont's guineas did not slip into Constable's pockets, as they did for other younger artists. The aristocratic collectors behind the formation and running of the British Institution would have nothing to do with Constable, indeed were blind to him. The Earl of Dysart's 30 guinea purchase of *A Landscape* from the 1810 Academy exhibition may just have been the act of a friend, for the 6th Earl was a commissioner of copies, not an active art collector. This friendly act is in step with a remark that shows that Constable had an ease of passage into the Dysart houses:

'[Beaumont] wishes to see the Gainsboroughs at Lord Dysart's, and in return he is to take me to the Marquess of Stafford's Gallery'.[4] There, in addition to the old masters, he would see Turner's *Dutch Boats in a Gale*, known as *The Bridgewater Sea Piece*, for which Turner had been paid 250 guineas in 1801. Early commissions and purchases of Constable's landscapes came from people in East Bergholt, such as John Reade and Sarah Roberts, and one or two others affectionate towards their handsome local painter. Thus it was only Constable's determination to see it through that kept him going at landscape painting, with the support and confidence first of his family, and then of Maria Bicknell. Nathaniel Smith put Constable's early drawings and paintings in his St Martin's Lane shop window, but it is impossible to know if any of these were sold.

Flatford Mill, well sheltered down its steep hill from prevailing winds, had become centrally important to Constable as a subject with its trees and water, brick and wet wood, sky, clouds and fresh air. His mother was his greatest supporter at home, telling him: 'pray be diligent and paint with energy – remembering the prize you have in view', and 'do not be <u>supine</u>.'[5] To help him out she sent 10/6d to a frame maker: 'I only mention it, that you may be at rest about this trivial debt – debt being a burden on a generous mind.'[6] Ann believed she could tell him how to manage a career in art, and in his many moments of self-doubt he might have thought she was right. In the end it all came down to her concern for his health:

> Pray be careful of yourself. I form an idea that the warmth of the Academy room, smoke from lamps or many candles, & then coming into the air & streets of London are most inimical to tender chests & lungs – therefore do not be too adventurous – not sit up <u>too late</u>.'[7]

Constable took his health extremely seriously, to the point of hypochondria. He would go to East Bergholt to recover from what he called a 'Cold', and told Farington that his lungs were 'susceptible . . . subject to inflammation'.[8]

Still he was stuck, being pressured to go in other people's direction again and again – first portrait paintings, then altarpieces,

then more portraits. John Constable was now thirty-six years
old, and nowhere near achieving the recognition that he craved.
But within his own East Bergholt family he was the chosen one.
His siblings focussed their romantic desire for some glimmer of
worldly glory onto John, and bombarded him with advice and
concern. They all wanted to help him reach the success and
recognition they knew he deserved, and the reflected glory they
could bask in. Golding Constable, their father, a man of few
words and fewer letters, was rightly proud of his success as a
businessman in the corn and coal trade, and proud of his enter-
prise as an entrepreneur. Even so, he had his doubts, and his wife
may have had palpitations from time to time over John's troubles.

Constable's painting of landscape in the 1800s took him into
ways of working that only Turner had the strength of mind to
explore. Being ignored, or dismissed, gave Constable the time
and freedom to evolve his own manner and to create painterly
effects that may have surprised even him. He was learning to
translate what he could see into paint, rather than painting
landscape by formula. Stretching his vision and relaxing his
hand, some of his oil studies elongate right and left, pulled out
long and wide, as in the 1808 *View near Dedham*, and the view
of Durand Rhudde's house, *The Rectory, East Bergholt, from the
back of Golding Constable's House*.[9] The paintwork of the latter
is urgent and demonstrative in the long-footed 'L' shape over-
topped by a rectangle of cloudy sky. He persevered with this
manner in the latter years of the decade, enriching his browns
and many greens with rose, yellow, red, purple and orange to an
extent that is nearly shocking. They show him travelling out of
the Stour Valley, evidently staying with the Bicknells at 'Louisa's
Cottage' on Putney Common and the Gubbinses at Epsom, but
returning again and again to his own haunts to express his vision
with turbulent, well-loaded brushstrokes and dabs of broken
colour.[10] Then he can return to calm again, giving us *A Barge
below Flatford Lock* and *East Bergholt House* in all their panoramic
grandeur.[11]

Nobody else in England was painting in oil with such indul-
gent freedom, even abandon. Constable's *Barges on the Stour, with
Dedham Church in the Distance* of around 1811, painted there and

then as the light fell out of the sky, has a fluidity that Turner alone could match in the panel paintings he made in the open air on the Thames in 1805.[12] Turner, however, was painting for his market; Constable was not, because he did not have one. The energy of Constable's delivery, one may say his 'devil-may-care', the way he drags white paint onto river water painted dark green and still wet, as in *Flatford Mill from the Lock*, and his clouds, pulled on with a stiff brush, is an energy born of an amalgam of desperation and glorious independence, because it was clear to him that nobody was interested, and he could not sell these anyway.[13] He is moving towards what might be the essence of his ambition in landscape expression, which he could describe in 1825 as 'lively – & soothing – calm and exhilarating, fresh – & blowing.'[14]

In the meantime, however, in his oil studies of the 1800s, Constable created a sense of discovery, not only of the modest places depicted, but of his audacity in painting such incidentals, sitting within them as he did so. A reddish, mid-brown ground shows through in many of the studies, in which Constable uses brushes well loaded with paint to evoke smoothly spread branches of elm or the surprised exclamation of poplars against the sky. A deep-red brick cottage or tiled roof might appear between the trees, a splash of sunlight enliven a gable end, and to one side the glimpse of a field of golden corn. There may also be the flash of reflecting water, and the surprise of a touch of red in a farm worker's jacket. In the ever-moving air and shifting light in Constable's oil studies something else might catch the eye, a white dove illuminated against a dark cloud or a distant squally shower: it is the light against the dark in Constable that is so affecting.

Constable turns the liquidity of his paint into a pictorial element in itself, veering between what might be called 'rough painting', such as this *Flatford Mill from the Lock*, and 'smooth painting', *The Valley of the Stour, with Dedham in the Distance*, where the fields beyond the bridge at Flatford are an intense barely modulated green, and shine like a polished front door.[15] This is the 'finish' that Farington urged him to go for, and not only Farington, but Beaumont, Pike Watts, the critic Robert Hunt in print, and even his mother.[16] 'Finish' was all, the smooth,

glossy surface where no brushwork is betrayed. In Constable's case the final 'finish' might reflect the difference in intention between studies made for his own purposes and works intended for exhibition, but that is not entirely clear. This is all leading up to the painting that is his first serious and considered public marker of who he is and what he does: *Dedham Vale: Morning*, exhibited at the Academy in 1811. So important was this hesitant picture to him, and so crucial was it that it should succeed, that it had 'cost him more anxiety than any work of his before or since . . . that he had even said his prayers before it.'[17]

Dedham Vale: Morning, is a long, smooth, panoramic picture that was the culmination of the oil studies of the vale in which he allowed bands of colour to evoke the sweep of the wide horizon.[18] A thin ash tree squirms on the left, marking the beginning of a landscape that could go on for ever. In its title – *Morning* – it begins to mark time. What this tells us is that by 1811, when he was already close to Maria Bicknell and in the trying foothills of courtship, he was confident enough to conceive of such an ambitious painting of the home turf that the couple would enjoy together when they could. This was the same landscape that he and Lucy Hurlock had walked and sketched together eleven or twelve years earlier. The Dedham vale that Constable painted when Maria was rising in his heart is the same Dedham vale that he had once painted as a wedding present for Lucy Hurlock.

17. Seven years since I avowed my love for you

By the time Ann Constable urged her son 'pray be careful of yourself', and 'not to sit up <u>too late</u>' – November 1811 – she was in the thick of the handling of what she understood of John's attachment to Maria Bicknell. She took to herself the role of Envoy to the Court of Dr Rhudde. The Rector's 22- or 23-year-old granddaughter had continued to be a regular visitor to East Bergholt, and as the young guest of her grandparents she had become well known around the village. When he was home, John had been charmed and enlivened over the years by the presence of this slip of a girl growing up, one who brought light to the village and joy to the elderly. There are a handful of drawings and paintings of Maria which suggest an easy famil-iarity between the two as they found themselves spending time in each other's company: a small oil panel shows an enchanting, light-hearted flightiness in Maria's direct, even challenging, pose; while in a pencil drawing there is firm decisiveness in the set of her mouth and her steady gaze.[1] In appreciating these qualities, looking at her closely and expressing them so clearly, Constable revealed something of the treasure that he may gradually be realising that he might have in store.

Maria's father, Charles Bicknell, was a senior and highly placed London solicitor, employed both by the Prince Regent and the Admiralty. He knew everybody, was welcomed everywhere, and was at the epicentre of the administration of royal and naval law and politics. He and his second wife, also called Maria Elizabeth – Rhudde's daughter – lived in an Admiralty-owned house: 3 Spring Gardens Terrace, Charing Cross. This was just beside the Admiralty, and equidistant between Whitehall and the Prince Regent's Carlton House.[2] He would also travel to 32 Lincoln's Inn Fields (later 23 Norfolk Street, off the Strand) where he had a solicitor's practice in partnership with his friend Anthony Spedding.[3] Mrs Bicknell was a chronic invalid,

committed at all times to her sofa, but nevertheless she brought
her five children up in the light of Maria and Richard Edge-
worth's two-volume *Practical Education* (1798): 'To make any
progress in the art of education,' the Edgeworths averred in the
Introduction to their first edition, 'it must be patiently reduced
to an experimental science.'[4] Having Maria and her sisters away
at school or at East Bergholt, where experiments could safely be
conducted, was a blessing for such a busy lawyer and his afflicted
wife.

The Bicknells sent Maria and her sister Louisa to the Misses
Hintons' school for young ladies at Wood End House, Hayes, a
small town west of London rich in education establishments.
The Misses Hinton provided a comprehensive education for girls
who expected to marry well: the study of French language and
manners was high in the curriculum, as were dancing, drawing,
music, Italian, geography and writing.[5] Maria learnt her beauti-
ful handwriting there, and developed a rich turn of phrase that
betokened her education. Her sense of obedience, which would
emerge as the years went on in respect of her father's expressed
wishes, was a strongly developed character trait. The Edge-
worths' advice was this:

> By associating pleasure with those things which we first desire
> children to do, we should make them necessarily like to obey
> ... Bid your child do things that are agreeable to him [*sic*],
> and you may be sure of his obedience.[6]

Maria enjoyed her young life without apparent care. Surviving
letters to her older half-brother Charles Henry, and her half-
sister Sarah, then at Brighton, show strong affections between
the seven children. Sarah was finding the sea air 'very service-
able' to her health, while Durand, Maria's seven-year-old brother,
was at Dr Burney's school in Greenwich. Charles was very proud
of Durand, his half-brother, who 'looks for all the world like a
Soldier in his scarlet jacket – with the assistance of so brave a
fellow what has his majesty to fear?'[7] Charles Henry and Sarah
(later Mrs Samuel Skey) were Bicknell's children by his first wife,
Mary Firebrace, daughter of the landowner Richard Firebrace
of Southminster, Essex.[8] They had married in 1773; she died

in 1780.[9] Seven years later Bicknell married the heiress Maria Elizabeth Rhudde.

The Bicknells and Rhuddes were middle-class, professional families, loyal to the Crown, the law, the Church and to the security and health of the nation; indeed, that is where their income and social standing came from. In reflection of this benign state of affairs they sent their children away to school, maintained homes in London and the southern counties, convalesced in Brighton, and travelled with ease around the south of England. They had every expectation of eventual peace and prosperity, notwithstanding the alarms of foreign wars, and could not and would not countenance defeat. As father- and son-in-law respectively, Durand Rhudde and Charles Bicknell had a relationship replete with confidences, in which less perhaps was said than was understood. When Bicknell was summoned to meet the Prince Regent in Brighton in 1805, Rhudde commented: 'Your Reception at the Pavilion must have been highly gratifying, and I sincerely wish, that no Expectations of Advantage which you may be induced to form from your Reception there, may ever be disappointed.'[10] This was the era of patronage in which family connections were of signal importance in 'Expectations of Advantage'. Despite whatever security protocols the Admiralty might have had at the time, Bicknell, as its Solicitor, was content to accede to his father-in-law's demand for advance notice of one particular perceived danger, the invasion of Britain by Napoleon's armies:

> Your letter appears to confirm the general Alarm, as you say that at the Admiralty, it is fully expected, the long threatened Invasion will be very soon attempted ... as you are at the Fountain Head of Intelligence, I should be obliged to you, to communicate any Thing, that you may think interesting to my Views and Wishes.[11]

The Prince Regent also made good use of Charles Bicknell. He would summon him briskly to Windsor for matters of urgency to the Prince, so urgent indeed that on one occasion Bicknell had to make the 25-mile journey from Spring Gardens at once:

> I wish you would contrive to come down here, this evening

about nine or ten o'Clock, or at <u>any rate</u> at a <u>very very very
early Hour indeed</u> Tomorrow Morning, as I must leave this
place at latest before ten o'Clock for I have some very particu-
lar matter of business to talk over with you, & which I can not
easily do in a hurry, & I must see you, before I stand upon my
journey.[12]

Bicknell was a good and loyal servant, clearing up here and
there the Prince's messes and indiscretions, as well as spreading
his bounty: he successfully interceded for mercy to be given to
Alan Macleod, convicted of publishing a libel on the Prince in
the London papers, on the grounds that Macleod was contrite
and had been betrayed 'by the misrepresentations of your Royal
Highness's enemies'.[13] 'God save great George our Prince',
Bicknell would write above his signature. For years he fought off
creditors, one big issue being the installation of gas supply and
fittings to Brighton Pavilion: over the year 1816–17 the Prince
owed his contractors £448.15s.0d.[14]

The correspondence during John and Maria's long courtship
(together more than 170 letters between them survive from before
their marriage) reflects the edge of the perceived difference in
their social background in a sequence that moves from elation
to despair and back again (and again). Their eventual marriage
comes as something of a relief to all. Maria's handwriting, so
well learnt and practised with the Misses Hinton, flows sweetly
and legibly, gaining in clarity with growing evidence of the de-
termination that she – they – should make a success of their
courtship and draw it to a satisfactory conclusion. John's letters
are equally particular and clear, calm and equable, a manner
that as his life went on he tended to abandon to furious expres-
sion with 'crinkum crankum scribbles'; scattered ink blots and
crossings out. His exasperated friend John Fisher found some
of his letters impossible to read: 'I did not say your writing was
not "nice", but only that it was unintelligible. Your last letter is
worse.' Reinagle would also write of Constable's illegibility, his
'crinkum crankum scribbles'. [15]

It was not long before Charles Bicknell, fostering the attach-
ment, took John under his wing. Bicknell became very fond of

the young man, encouraging the match in its early stages, calling on John with Maria on his arm, and, as John recalled in 1814, 'inviting me to his house when he knew of our mutual attachment.'[16] That was a state of affairs greatly pleasing to Ann, who had seen too many young women back off in the face of John's urgency and ambition. She needed therefore to nurse her relationship with the central local figure in the circle, the Rector, whom she would meet at least on Sundays at the church door.

The first surviving letters from Ann Constable to John are from 1807 and 1808, well before his serious courting of Maria got under way, and four years before the earliest surviving letter between the lovers. The only route into examining the foundation years of the romance therefore is through letters from Ann. 'Dr Rhudde very obliging', Ann reports to John in December 1807, the first available hint of the Rector noticing one of his most prominent, not to say most pushy, parishioners.[17] There are no more clues for eighteen months, until June 1809 when Ann tells her son: 'Dr Rhudde is unusually kind & courteous, better so than otherwise'.[18] Between these two dates it may gradually have dawned on both Ann (who would surely have known first) and the Rector that something was going on.

Across these intermediate months John was struggling with his altarpieces and portraits on commission, and was travelling to East Bergholt to steep himself in the lie of the Suffolk/Essex borderlands. By March 1810 he was living at 49 Frith Street, fifteen minutes' walk to Maria's parents in Spring Gardens Terrace. If there was any sniff of an atmosphere between John and Rhudde it will have shown by now. Instead, Rhudde's kindness and courtesy towards the Constable parents continued in these years, and appears to represent the status quo. Rhudde would carry letters for Ann to London: '[an] obliging conveyance so voluntary on the Doctor's part, who goes to London tomorrow & returns to the Rectory on Wednesday sennight'.[19] This was a generosity that Ann urged her son to notice by calling on the Rector, 'should you find inclination or opportunity ... no. 13 Stratton Street, Piccadilly – do as seemeth you best.'

Far from showing any displeasure, parents on both sides appeared to encourage this match at its roots. There is little to

demonstrate discord, until Ann realised that she should have included the bachelor curate Henry Kebbell in the party when she invited Maria and her younger sisters Louisa and Elizabeth to tea. Kebbell was thin-skinned: 'lo and behold he told me, that really he was never so much hurt in his life, that <u>he</u> was not invited by me, to <u>meet</u> the <u>Miss</u> Bicknells when they drank tea with us. This I soon adjusted.'[20] The mistake got back to the Rector, as it surely would, as Ann found out when she asked Kebbell 'if anything was amiss, to break the peace with your grand Pacificator'. Advising some pretty social footwork, Ann urged her son again to 'make a point of calling in Stratton Street' when the Rector was next in London. 'How soon and how easily is friendship shipwreck as it were.' Affairs seemed to be on track, because, indeed, 'the Doctor was very courteous to me last Sunday.'[21]

By now John must have declared his love to Maria, and would naturally have hoped her family would be delighted. All the signals pointed to this being the case: Abram went to tea at the Rectory, John enjoyed a slab of Rectory-made brawn.[22] There was even a commission in the offing: Kebbell's request for Constable to draw the Rector's portrait, 'if you can obtain the Doctor's leave & catch him as well as yourself in happy mood.' Ann promised to mention it.[23] All seemed happy and contented, and in July 1810 Rhudde shared his carriage with Ann on a journey home from London. Whatever early bumps there might have been on John and Maria's journey to marriage appear to have been made as naught by the engaging Ann and the unctuous Rector working in tandem, smoothing the passage:

> The Doctor was all what courtesy or kindness could urge him to . . . How far preferable this to animosity – thank God that seems to have ceased – never more to return . . . Pray God bless you my dear John with health – as without that blessing all your endeavours will be futile. . . . Do not let trifles turn concord into discord – but let us bear and forbear is the wish of your affectionate Mother.[24]

As a telling sign that all was now well, that the union might progress to a conclusion, Rhudde accepted the gift of a watercolour of East Bergholt church, drawn for him especially by John. It

was a copy of a painting by John that Ann herself owned and cherished; she practically instructed John in the task. We can be quite sure that Rhudde had seen Ann's version on a parish visit to East Bergholt House – indeed, Ann will have shown it off to him. 'Have [the copy] <u>neatly framed</u> and glazed', Ann directed, 'as a present from you to Dr Rhudde – it is so much what he wishes for.'[25] Ann got Dunthorne to make an inscription for it to go on the back of the frame. This is still in place, a neatly lettered oval in a garland of leaves:

A South East view of East Bergholt Church, a drawing by John Constable & presented in testimony of respect to Durand Rhudde D.D. the Rector. February 26, 1811.

This, 'the prettiest & best drawing I ever beheld', went down very well with Rhudde: 'It is most beautiful', he told Ann, 'I am quite proud of it. How can I possibly make you some return, Mrs Constable, I cannot imagine.' Ann, bobbing, replied: 'The amends are in your very gracious reception, Rector.' Then Ann wags a warning finger at her son: 'You will not take any gratuity from Dr Rhudde, I know.'[26]

Stratton Street, Rhudde's house in London, was – is – halfway along Piccadilly on the north side. Number 13 looked towards the gardens of Devonshire House, the London home of the Duke of Devonshire. To the right, on the other side of Piccadilly, was Green Park. This sophisticated address was inherited by Rhudde's wife from her brother, George Shergold. Constable did as his mother advised, more than once, and called also on Maria's parents across the park in Spring Gardens Terrace, which curved behind Charing Cross and Whitehall, within sight and smell of the King's Mews where the royal horses trotted out.[27] This area of London held patrons of power and influence for an ambitious and talented young artist. John Constable, however, would patrol them neither for profit nor advancement, but for love.

While juggling with her diplomatic skill the delicate matter of John's love life, Ann urged her son to pull himself together when he was feeling down. This is her earliest expression – March 1810 – of the suggestion that John might now be contemplating marriage:

Your last letter in most parts pleased me because written with
more energy than usual. You must exert yourself if you feel
a desire to be independent – and you must also be wary how
you engage in uniting yourself with a house mate, as well as in
more serious & irrevocable yokes.[28]

Mrs Rhudde, the Rector's wife and the source of part of his
fortune, was dying. She had been ill for months, 'no person but
the Doctor and their domestics ever see her'.[29] 'Lamentably weak,'
Ann reported to John in January 1811. 'Sees no body – indeed her
mind now seems quite gone.' The poor woman was convinced
that her daughter and son-in-law, the Bicknells, were poison-
ing her.[30] Ann had picked up that bit of gossip from the local
surgeon, William Travis, who had heard it from the Rhudde's
servant, Thomas, who had presumably heard it from poor Mary
Rhudde herself. Mary lingered for only a few more weeks, and
died on 19 March 1811. After the funeral, Rhudde gave Ann 'a
handsome mourning ring', and having seen John in London,
he reported on his return the 'glad tidings' of his 'health and
spirits.'[31]

Durand Rhudde, an easy target with his worldly riches and
local grandeur, has been fingered as the main blockage in the
passage of John and Maria's courtship. In the affair's early
stages, however, there is no evidence for this. Indeed, the families
appeared to lie alongside one another in expectation of an event
that would unite them. This had gone so far as to encourage
Golding to ask for Charles Bicknell's explicit assistance in his
high Admiralty office for the release of Zachariah Savell, the
Mate of Golding's vessel *Telegraph*, who had been press-ganged
into His Majesty's service. *Telegraph* remained stranded on the
river at Pickle Herring Wharf, her Master absconded, and 'left to
the care of two old men, and a child, without provisions, money
or credit. The gang staid on board as long as the beef lasted.'[32]
Without *Telegraph*, Golding's business would lose money heav-
ily, and lose time. 'Will you take this letter,' Golding asked John,
'& call on Mr Bicknell, who can inform you if any thing can be
done to recover this desirable man.' Bicknell was the official to go
to for recompense and justice in shipping matters, one charged

inter alia with the task of offering rewards for the apprehension of smugglers.[33]

By the time of the first surviving letter between them, 23 October 1811, John and Maria may already have imagined, if not talked of marriage. Intimacy had been growing for over two years: Constable, with his close attention to detail, reminded Maria in February 1816 that it was 'seven years since I avowed my love for you'.[34] If he says seven years he means seven years, plus or minus a month or two, so spring 1809 will have seen the watershed. At a low moment in 1811 he challenged Maria: 'Am I asking for that which is impossible when I request a few lines from you?'[35]

There must now have been some kind of difficulty, for very soon came a change of attitude between the parties, one so radical that it shook the houses of Rhudde, Bicknell and Constable to their foundations.

18. An artist unprovided for

'I thank you most sincerely for your very elegant Present, of a view of my Church,' Rhudde wrote to Constable on 16 March 1811. This was two months after he had received the unsolicited gift from Ann, and three days before his wife, mortally ill, died. Rhudde did not want to give the drawing up, so he enclosed a bank note for Constable to buy 'some little article by which you may be reminded of me, when I am no more.'[1] Knowing now the seriousness of John and Maria's intentions, knowing his own mind, and being used to wielding control in his parishes and his family, Rhudde set about creating distance, while at all times remaining courteous to the Constable family, and appearing squeaky clean.

Through the will of her great uncle, Rhudde's brother-in-law William Maurice Bogdani, Maria was high in the pecking order for the inheritance of extensive estates in south-east Suffolk: all that was required was the deaths of her sickly mother and her Aunt Harriet to trigger her share of Bogdani's property.[2] Maria also stood to inherit a quarter of her mother's portion of Dr Rhudde's own fortune. Charles Bicknell will have known all this only too well: he had been a colleague of Bogdani's father, William Bogdani, a director of the Board of Ordnance responsible for supplying cannon for ships. While the destiny of Bogdani's estates was beyond Rhudde's control, the division of his wife's property was entirely in his hands, and his son-in-law would have had no say in the matter. Rhudde's younger daughter, Harriet, who became Mrs Edward Farnham when she married into an old Leicestershire family in 1795, was secure in that respect, as she would have Rhudde's London house settled upon her as part of his 'real Estates of what nature or kind so ever it may be'.[3] She could also expect the Suffolk part of the Bogdani estates – pro tem – in the likely event of her sister's death. However, Harriet could not take them with her: on her

death they would pass not to her husband, but revert to Maria and her surviving Bicknell siblings. This may explain something of the chill disdain that Aunt Harriet would show to Maria even as far as her marriage and the birth of her first child. Both sides, Bicknell and Rhudde, eyed the Bogdani inheritance hungrily.

Theirs was a material world, and Rhudde had form in using marriage for family advantage: when Harriet and Edward Farnham married it was in consideration of a property settlement between Farnham and Rhudde's brother Anthony.[4] He also benefitted from Bogdani's marriage to his sister. In sum, Maria's putative inheritances derived from a disparate pair of great uncles by marriage, both being channelled through their brother-in-law-in-common, her grandfather, the Rev. Dr Durand Rhudde, DD, the spider at the centre of the web. Rhudde knew that as the law stood all the property that might descend to Maria would become John's once they were married. He himself had been a beneficiary under this law when he married Mary Shergold in 1760.

The gift of John's drawing of St Mary's Church, East Bergholt, must have wrong-footed him and prudence required him to give Constable a little something in payment. There is an irony in the timing of Rhudde's inelegant response, but needs must. Having himself benefited by marriage to a woman of fortune who was now at death's door, he did not want to see that advantage squandered by his granddaughter's marriage to a poor man. Irony is here piled on irony, for Bogdani's grandfather, father and uncle were, like John Constable, all artists.[5]

Across the spring and summer of 1811 Constable showed *Dedham Vale: Morning* at the Academy. He was 'in much uneasiness of mind', he told Farington, because the painting was hung very low in the Ante-Room, suggesting, he imagined, that he might have 'fallen in the opinion of the members of the academy'.[6] In June he had a heart-to-heart with Farington about 'the particular circumstances of his situation in life'.[7] The subject of his love life must have been the issue here, for if it had been an art world problem Farington would undoubtedly have noted it down in detail. Discretion here suggests that it was a personal problem that he and Constable discussed.

High in Constable's mind was the fact that Maria had been carried off by her parents to stay with her half-sister, Sarah Skey, and her two boys at Spring Grove, her husband's extensive estate outside Bewdley in Worcestershire.[8] Charles Bicknell was himself becoming uneasy about the risks that Constable might pose to the security of his family's inheritances, and this new distance being established between John and Maria was a severe signal that the relationship between them should cease. However, Sarah Skey, being the daughter of Charles's first wife, was nothing to do with Rhudde. She had her own secure income, her own mind, and signalled that she was sympathetic to John and Maria's plight. The opportunity arose for John to help her up into her carriage when she and Maria were setting off from Spring Gardens Terrace. Sarah Skey allowed this intimate courtesy, and report of it gave Ann much pleasure:

> I am very glad you had the opportunity of handing Mrs Skey into her carriage – she is a charming and good woman, & her Sister [Maria] must be happy to be with her, as no doubt they are Congenial Minds – for my own part I think it much more desirable to have our much esteemed Miss Bicknell with her, than to be in the continuous way of molestation.[9]

Charles Bicknell had six children living from his two marriages. The eldest, Sarah Skey, was well provided for. His second, Charles Henry, a soldier, had died in 1799. While Maria's younger brother Durand would die in 1811, there was a second younger brother, Samuel, who would be their father's likely heir. With two younger unmarried sisters, Louisa and Elizabeth Catherine, to account for, Maria's inheritance from her father was likely therefore to be modest, and the chances of both her mother and Harriet Farnham dying were remote. It was essential, therefore, that Maria marry a rich man, or a man with rich prospects, *and* keep her rich-as-Croesus grandfather placated and on side to maintain her interest in her mother's inheritance, without putting his own interests at risk. John Constable, as far as they could reasonably see, could not match up, could never provide the riches that the family had been used to and felt were so essential, and could never please Rhudde. So, misery, bravely faced, for Maria.

John was distraught: 'I have called twice at your house since the return of your family from Worcestershire, without being so fortunate as to see any body . . . I can hardly call again at Spring Gardens.'[10] Maria herself was kept back in Worcestershire, and from there she replied, firmly drawing things to a close:

> You are fully aware of the constant uneasiness I have caused [my mother], but you know not the grief I feel when I distress her . . . the sooner we accustom ourselves to what is inevitable the better . . . I have too long given way to a delusion that I might have known must sooner or later have an end.[11]

Here was John Constable's life experience repeating itself: eleven years earlier he had had a letter from Lucy Hurlock bearing a comparable message, and there had also been rebuffs or disappointments from or on behalf of Jane Bridges, and possibly also Amy Whitmore, Thomasine Copping and others. Maria's misery continued: 'it will hurt your feeling as much as it has done mine . . . can I wilfully make [my parents] unhappy?' and so on. She is the sensible one, she thinks; this can never work. But she evades touching on the reason they will not be married: John's lack, in her parents' view, of prospects. It would have been difficult enough for him to marry this very senior London solicitor's daughter even if he had been heir to his father's business – then he would have been 'in trade' – but as he was an unknown artist it was impossible.

John had no intention of leaving it there, and the situation made him ill – 'the most severe indisposition I have ever experienced'.[12] He said he had only read Maria's letter once, so clearly he was refusing to listen: 'it is impossible for me to think for a moment of relinquishing every hope of our future union, however unfavourable our prospects may be at present.'[13] He had taken his courage in both hands and called at Spring Gardens Terrace again. Uncle David Pike Watts, watching from the sidelines, wanted to hear immediately what had happened: 'As you did not appear here yesterday . . . I infer your not calling, that your interview with Mr B. was unpropitious.'[14] Pike Watts continued encouragingly, exhorting his nephew to listen to music, play his flute, read the Psalms – anything – and remember:

It may mortify you but it will not <u>unman</u> you . . . If you weakly
sink that heroic character, you would have been but a feeble
Prop to a Woman who puts herself in Your Protection. Arise!
revive! bravely surmount even Shipwreck and Ruin!

But would John listen? Unsettled in his accommodation as in his
love life, he left Frith Street to lodge with a painter friend John
Jackson in Newman Street. In December 1811 he would move yet
again, to 63 Charlotte Street, opposite Farington's house. He was
finding it hard to focus. 'The first and chief remedy is Prayer',
Uncle David told him. 'Sincere Communion with Heaven; Satan
watches every weak moment! Resist him and he will flee from
you!'[15] The Constable and Watts families were rooting for John
in his quest for his love, and engaging the Almighty to the cause.
Charles Bicknell, however, equivocated, and knowing her father's
tendencies, Maria warned John not to get his hopes up:

> I hope you will not . . . view what passed in Spring Gardens
> too favourably, you know my sentiments, I shall be guided by
> my Father in every respect. Should he acquiesce in my wishes
> I shall be happier than I can express, if not, I shall have the
> consolation of reflecting that I am doing my duty, a charm
> that will stifle every regret and in the end give the greatest
> satisfaction to my mind.[16]

Maria had been promised a 'wished but fearfully dreaded letter'
from her father, setting out his position in the matter once and
for all. John seemed relaxed about it: 'let me hope that there will
not be so much (as you imagine) depending on one letter alone
from your Father, though it certainly must be of the greatest
importance.'[17] The letter was, as Maria expected, 'reasonable and
kind', characteristic of the man 'who even in anger is mild'.[18] His
only objection to the marriage, Maria reported, was money, or
as she put it, 'that necessary article Cash.' Neither of them had
enough of it. 'I wish I had it,' she sighed, 'but wishes are vain.'
Maria was a practical young woman, perfectly clear on the point
that no marriage can survive without money: 'we must be wise,
and leave off a correspondence that is not calculated to make
us think less of each other . . . You will still be my friend, and I

will be yours.' If that looked like the end, Maria revealed a ray of hope: she would not write to John any more, 'at least <u>till I can coin</u>', but in reality she was saying 'forget it'.

That might have been that, if it were not for John Constable's own urgent impetuosity and the energies of his campaigning mother. John was blind to Maria's insistence that they should end it all, so she had to repeat herself: 'cease to think of me, forget that you have ever known me.'[19] John's courageous response to that was to catch the next coach to Bewdley. He turned up on Mrs Skey's doorstep, and together John and Maria spent what he described as 'some of the happiest hours of my life'.[20]

Ann Constable knew perfectly well where things stood between the lovers, and that Maria's letters to John were 'the greatest treasure I possess in the world'.[21] With Ann on side, John and Maria might yet marry: 'pray be diligent and paint with energy – remembering the prize you have in view', she told him.[22] That refers not so much to John's ambitions as an artist, but to his grasping of the shining prospect of Maria as his wife. Golding was also cheering for the couple, with a miller's practicality and good purpose:

> If my opinion was requested it would be not to give up your female acquaintance in toto; but by all means defer all thoughts of a connection until some removals have taken place, & your expectations more certainly known.[23]

In other words, until somebody pivotal had died. 'I fear your too great anxiety to excel,' Golding continues,

> may have carried you too far above yourself; & that you make too serious a matter of the business & thereby render yourself less capable . . . Think less & finish as you go . . . Be of good cheer John; as in me you will find a parent & a sincere friend.

A few days later, 'being of the opinion that money is short with you at this time',[24] Golding sent his son a cheque for £20 – the equivalent sum now would be £1000 or more. Evidently John felt strong enough, or proud enough, to refuse the help, as the cheque was not cashed. Rallying round to help a brother in distress, his sister Mary hove into view and moved into John's

Charlotte Street rooms to look after him and keep him cheerful now that all seemed lost in his suit to win Maria's hand. 'I hope you are more comfortable,' Abram wrote,

> now dear Sister Mary is with you, I was uncommonly glad she came to you, knowing her company would dispell many of those gloomy hours of thinking you must have when quite alone . . . she feels the happiness of contributing to a Brother's comfort, & I doubt not you will find a benefit of female converse sufficient to enable you to close application to a Suit in which you must succeed, but not without.[25]

A useful death was not yet on the cards for John and Maria, far from it: the recently bereaved Rector was being wooed determinedly by a local widow, Mrs Everard, and Rhudde was having a lovely time. Initially Ann saw this as a positive: 'Methinks I have no objection to the Doctor's being touched by Cupid – as it may cause him to have a fellow feeling for others in the same situation.'[26] Therein, however, lay the problem: Ann noticed that Dr Rhudde 'smiles and bows to us, yet something still rankles in his heart.'[27] Dr Rhudde was beginning to spend money even more conspicuously than usual, much to the amusement of the village. His gardener made a flowerbed in the shape of two large hearts, and before taking Mrs Everard to Cromer for the summer of 1812 Rhudde bought a pair of expensive horses to draw his carriage in style. 'Do not think I am an advocate for servility, believe me not', Ann wrote to John. 'It is civility only I plead you; I expect nothing like lenient measures or compliance at the Rectory, but I dread the idea of a rupture, tho' it required great resolution & composure to avoid it. To see the sway Mrs Everard has there, is really surprising.'[28]

Ann now worked double time at her diplomacy on John and Maria's behalf, but it was surely a lost cause. In throwing her weight around at the Rectory to the extent that servants and gardeners began to laugh at her, Mrs Everard turned the Rector's head and John and Maria were the losers. The pride that the Rector felt at his acquisition of his pair of horses was short-lived. One of them died – it 'so very lately cost 65 guineas – almost a Bank for an artist'[29] – so he hired replacements: 'Mrs E. has taken

up another week's residency at the Rectory – but the Doctor has now another pair of horses, & the same Lady has had the <u>first chance</u> with them yesterday.'[30] Mrs Everard was the problem – the Constables referred to her as 'Miss Durable', and 'our blooming Village Maiden'[31] – her arrival on the scene changed attitudes fundamentally. Ann was perplexed and, frankly, appalled:

> My mind dear John is very ill at ease on this subject . . . in times like the present the prospects for matrimony to an artist unprovided for is absolutely impractical. These are serious considerations that weigh me down . . . I cannot ever again venture to express my sentiments, to Mrs B[icknell] or indeed any of the family for fear of involving myself in fresh troubles & making bad worse – but till you have admittance as before, I can never be happy.[32]

The only way was to earn money: even Dr Rhudde said so, and this might have been code that all was not lost: 'if he can paint such portraits as these he may get <u>Money</u>!'[33] On the other hand, perhaps not: 'My father mentioned my success [painting portraits] at General Rebow's,' John told Maria, 'but the Doctor would not hear my name. I fear I must have committed some new sin, or revived some old one.'[34]

There was anxiety with the Constables, but all was not well in the Bicknell family either. The Prime Minister, Spencer Perceval, was assassinated in the House of Commons in May 1812, and the backwash of that crime swept into Spring Gardens Terrace. Maria, still in Worcestershire, heard it all from her mother:

> We have been living . . . [in] constant alarms & confusion, surrounded by Guards as our only chance of security, indeed distress, has appeared in every face since Mr Perceval was assassinated.[35]

One resident of the Terrace 'became the colour of a lemon when she heard of it, & was obliged to be put on the bed to hinder her from fainting'; another, a government official, Philip Cipriani, with his 'uncommon fine feelings', panicked in case 'any omission had proceeded from his department in the Treasury which had given the [suspect?] the pretence for committing the

horrid deed.' Cipriani's daughter got into such a state that she had
to be sent 'to reside for some time in the west of England'. The
Prime Minister's murder took the Bicknells' minds off immedi-
ate family problems. They managed to get out of the house to
go to 'the water coloured [*sic*] Exhibition [on] Saturday & were
much pleased as the pictures are chiefly from the best [living]
Masters'.[36] It was perhaps tactless, certainly unthinking, for Mrs
Bicknell to declare to Maria how much she enjoyed the work of
the established masters of watercolour when Maria was herself
suffering the unhappiness of separation from her own young
master of the art.

That Maria was determined is clear. While her firmness in
trying to call it off went against her own desires for the future,
it was entirely in consideration of others, and of the duty that
she owed to her parents. That it took so long reflects on Maria's
courage and stoicism. She told John, 'time alone can cure our
griefs, hope may still support us.'[37]

19. Hearts so united

John Constable returned to East Bergholt in June 1812, and, courageously, took the opportunity to accompany his mother to the Rectory. No doubt she pressed him to do so, and he was rewarded when the inconstant Rector actually shook hands with him on the doorstep: 'am I to argue from this that I am not entirely out of the pale of salvation?' he asked Maria. 'But it is better so than open war.'[1] Ann later noticed 'a gleam of sunshine come over a long frowning cloud' and thought things might be improving when she heard that matters were 'so complicated & so intricate, that none but the parties themselves can solve – tho' a parent may hope.'[2]

In Constable's East Bergholt painting room, life had some pretence of calm. A keen young local boy, Dunthorne's fourteen-year-old son Johnnie, worked diligently grinding colours: 'he is a clever little fellow and draws nicely all "of his own head".'[3] Another new friendship also came into play: the nephew of the Bishop of Salisbury, also named John Fisher, twelve years Constable's junior, had taken a degree at Cambridge and was now training for the priesthood. During Maria's exile in Worcestershire, the Bishop had Constable to stay in Salisbury, where he drew the cathedral and surrounding landscapes,[4] and there was the rumbustious nephew. They had already met in London, and had been attracted to one another instantly: young Fisher had a jaunty flippancy – 'harum scarumly amusing', as he described himself [5] – that appealed to Constable, who took life very seriously indeed. An initiative that emerged in Salisbury was the promise of a portrait of the Bishop to add to the cathedral's collection, with a second version to go to Fisher's former See at Exeter.[6] This commission delighted Constable's mother, who hoped it might buff John's relationship with Dr Rhudde. If anyone could improve matters, Ann could, but she always risked going too far. The wily old Rhudde, poker-faced to a degree, gave

only an enigmatic response on hearing the news of a Bishop of Salisbury portrait. He said 'he <u>was glad</u> to hear it, that was just as you should do – & this was more than I have heard of him say of you, a long time.'[7]

In the meantime, and against the odds, the lovers' correspondence flourished across 1812. Maria was moved quietly about like a hostage to Richmond in Surrey, to Bognor in Sussex, Brighton, Wimbledon and Putney, and back to Spring Grove. It was even suggested that she might be taken to Wales.[8] John, on the other hand, stayed now in London, now in East Bergholt, now in Salisbury. John amused Maria with the latest about their neighbour William Eyre's pet bear which had just died, and despite the fact that he had been bitten all over by the creature, 'Mr Eyre is inconsolable'.[9] There was an election underway, and the Constables, staunch Tories, were sent by the Godfreys of Old Hall 'a great many yellow ribbons for Sir William Rowley', the Whig candidate. This shocked them, but they dutifully decorated East Bergholt House for the lord of the manor, 'the first [yellow ribbons] that were ever on this house.'[10] Maria felt 'sorrow's piercing dart' fall on her at Bognor when she wrote to 'my dearest John',[11] and warned him not to try to visit her: 'my heart would give so ready an assent . . . but . . . you had far better, not, "find me at Bognor", I do not think my sister would like it.'[12] To ease her heartache she made 'a fine collection of stones & pebbles', and began to practise her drawing.[13]

John did not always present his best case to Maria: 'you know Landscape is my mistress', he told her, ''tis to her I look for fame, and all that the warmth of imagination renders dear to Man.'[14] Maria coped with this admission: 'your letters afford me a continual source of pleasure', she responded.[15] The heat of their courtship is in these letters: she is his 'beloved Maria', his 'dearest Maria. He describes her as 'the only object of my affections . . . on whom I have so long fixed all my hopes of happiness in this world'; she tells him 'how happy I shall be to see you again . . . my dearest John . . . believe me ever your affectionate Maria.'[16]

The fire in their hearts found echo in a fire below John's rooms. In the small hours of 10 November 1812, four days after this loving exchange, the upholsterer's workshop at the back of

63 Charlotte Street burst into flame. The street was in uproar: Farington, living opposite, was shaken out of sleep by his servants; Constable tumbled out of bed as the fire destroyed the workshop and began to attack the house. Amidst shattering glass, and flames and smoke beginning to curl around the staircase, Constable helped the upholsterer and his pregnant wife, 'almost destracted', out of the building, and carried his writing desk, his 'most valuable letters', and his in-progress copy of the portrait of Lady Heathcote downstairs. He then dashed up to the attic to rescue the servant's valuables, the poor woman 'in great distress, as all her fortune was in her garret', and came triumphant into the street through the smoke with her treasured 'pockets'. Farington took some of Constable's things into his house, David Pike Watts put him up in Portland Place for the duration, and a neighbour, John Henderson, the dentist, gave him a room to paint in for as long as it took to repair the house.[17] 'How sincerely and fervently thankful I am that you sustained no personal harm', Maria wrote to her hero; '[how] happy', said his mother, 'that you and all are preserved from hurt ... I am most anxious lest you have taken cold, or suffered in anyway from the fright.'[18]

It was not too long before Constable was able to get his rooms straight again. 'We are now repairing the house here with a thorough painting', he told Maria the following June. With interior decoration advice from young Lady Heathcote, he turned his rooms pink and crimson: salmon-coloured wallpaper, and crimson upholstered sofa and chairs. The walls and doors of his painting room became 'a sort of purple brown from the floor to the ceiling – not sparing even the doors or doorposts, for white is disagreeable to a painter's eyes, near pictures.'[19]

John and Maria were beginning to be able to be together from time to time. They read the poetry of William Cowper, John quoting lines from *The Task* which shine light on their love:

> And witness, dear companion of my walks,
> Whose arm this twentieth winter I perceive
> Fast locked in mine, with pleasure such as love.[20]

'How delighted I am that you are so fond of Cowper', John told Maria, 'but how could it be otherwise – for he is the poet

of Religion and Nature ... Nothing can exceed the beautiful appearance of the country at this time.'[21] John took consolation from Cowper: 'I have had all Cowper's works on my table – I read his letters most. He is an author I prefer to almost any other, and when I can trust myself with him, I am always the better for it.'[22]

William Cowper was the sensitive and emotionally fragile poet of the age, greatly admired by Constable's generation, loved also by Wordsworth, and protected through his life by the gentle humane souls who recognised his mental plight and took care of him. His friend the writer William Hayley wrote Cowper's life, and collected his poems in volumes published from 1803. It is these that focussed Constable's understanding and affection.[23]

In Hayley's *Life of Cowper* John and Maria met a poet from whose difficulties they could learn together, though John's depressions were nothing to those of the poet. They quoted Cowper to one another as if it were their private language. The poet would slip into John's correspondence later in life when he wrote to Archdeacon John Fisher in 1821 of 'my "careless boyhood"',[24] and put 'careless boyhood' into inverted commas:

> Woulds't thou, possessor of a flock, employ
> (Apprised that he is such) a careless boy,
> And feed him well, and give him handsome pay
> Merely to sleep, and let him run astray?[25]

Constable must have recommended Hayley's *Life of Cowper* to others: an intriguing entry in Farington's Diary of May 1803 records a visit from Constable and ends with the remark: 'I dined and was the evening alone chiefly reading Hayley's Life of Cowper'.[26]

There were yet more books discussed between John and Maria: Edmund Burke's *Philosophical Enquiry on the ... Sublime and Beautiful*, and the Rev. Archibald Alison's *Principles of Taste*, Alison's last essay being, for John, 'by far the most beautiful thing I ever read.'[27] Here Constable found insights into painting that he may not have received from his Academician peers, but were clearly indicated to him by this influential Scottish divine: 'The beauty of any scene in nature,' Alison writes,

is seldom so striking to others as it is to a landscape painter
... Every little circumstance of form and perspective, and
light and shade, which are unnoticed by the common eye, are
important in theirs, and, mingling in their minds the ideas of
difficulty, and facility in overcoming it, produce altogether an
emotion of delights, incomparably more animated than any
that the generality of mankind usually derive from it.[28]

Alison's understanding is that different people see things dif-
ferently; that emotion in landscape, more or less invisible to the
'generality of mankind', is real and can be expressed by artists,
and by implication that the practice of such art is a vocation.
Colour choice plays its part, as Constable certainly understood:
'The vivid green, for instance, which is so pleasing in a cheerful
landscape would ill suit a scene of Melancholy or Desolation.
The brown heath ... would be intolerable in a landscape of
Gaiety.'[29] As for fickle fashion, and the eighteenth century taste
for ruins, Alison has this to say:

> The profusion with which Temples, Ruins, Statues, and all
> other adventitious articles of Italian scenery was lavished,
> became soon ridiculous. The destruction of these, it was found,
> did not destroy the Beauty of Landscape. The power of simple
> nature was felt and acknowledged.[30]

Maria Bicknell had a rare quality of empathy which emerged
as they read the philosophy of aesthetics together. It was a
refreshing and essential complement to John's fierce and pur-
poseful selfishness: 'you will think me the greatest egotist in the
world', he told her, and he would be right.[31] Her empathy was to
lay the foundation for what John came to believe was the most
understanding and complementary of marriages: Maria was a
sensible foil to John's sensibility, and John recognised this thread
of gold within her, 'free from that sordid wretched feeling, a
covetous disposition.'[32] Maria was resolute in her understanding
and acceptance that painting was Constable's 'mistress': 'I trust
I may have the satisfaction of knowing that you are steadfastly
pursuing painting', she wrote in February 1812.[33] She displayed
soft humour and teased at their problem as the days ticked slowly

by: 'we should both of us be bad subjects for poverty, should we
not?' she said. 'Even Painting would go on badly, it could not
survive in domestic worry.'[34]

Maria's strength of mind was a foil to John's frequently ex-
pressed despair, but even now she was beginning to reveal her
concern at the apparent fragility in her health, an early onset of
signs of tuberculosis: 'I should not love you if you did not feel
my absence, but feel it as a Man, rejoice that I shall be acquiring
health and that you will be getting on with a profession upon
which so much depends.'[35] She was concerned that John might
take his eye off the ball and

> allow others without half your abilities to outstrip you in
> the race of fame, and then look back with sorrow on time
> neglected, & opportunities lost, and perhaps blame me as the
> cause of all this woe. Exert yourself while it is yet in your
> power, the path of duty is alone the way to happiness.[36]

She had already taken him to task for what she saw as his new
reluctance to promote his interests as an artist and 'shun society'.
She feared he was becoming reclusive on account of her: 'it is
certainly paying me a very ill compliment, if you would like to
remain single it would do very well.'[37] Put yourself out there,
she is telling him.

Maria was a natural scholar, a reader and a thinker. Her let-
ters reveal her to be a stylist also, attracted to sentence forms
that convey both her intelligence and her grace: exiled at Spring
Grove she wrote: 'I am to remain quiet for some months. I shall
hear from you, I shall think of you, and you know I am even to
look at you.' John must have given her a portrait, but which one?
The one with the sensitive nose, by Daniel Gardner, or the one
with the beguiling eyes, the self-portrait?[38] Maria read a great
deal, Cowper above all: 'I think I could read his Task for ever, I
am always flattered, and pleased, when I find my taste coincides
with yours.'[39] A wash drawing of Cowper, copied by Constable
from the engraved frontispiece of Hayley's *Life and Posthumous
Writings of William Cowper*, may have been painted for Maria:
John inscribed it neatly and fully with Cowper's dates.[40] When
John quoted 'Fame is the spur', a phrase from Milton's *Lycidas*, he

knew she would get the reference.[41] She read through the libretto of William Crotch's oratorio *Palestine* after Constable had been to see it,[42] and enjoyed the long poem *The Sabine Farm* by Robert Bradstreet of Higham Hall, near Stratford St Mary, a local friend of Constable's.[43] She 'admired it exceedingly', this nostalgic view of Italy in the time of Horace, with its evocative descriptions of 'the miracles of Art, that rise / Endless, to tempt, and tire the dazzled eyes': 'I believe I might be the more interested in it, as you had read it, and recommended it.'[44] She was dissatisfied by Amelia Opie's novel *Valentine's Eve*, just published: 'dismal' she called it, 'I wish no more [such things] would come my way.'[45] This comes as little surprise, as John Opie and Amelia Opie were active radicals, fundamentally opposed to the Tory cause, upon which Constable and Maria were wholly reliant. Maria drew subjects of her own, telling John about her Robin Goodfellow study,[46] and teased him about drug use in the months when John Martin's *Sadak in Search of the Waters of Oblivion* was being exhibited at the Royal Academy:

> What do you think of accompanying Sadak in his search for the Waters of Oblivion, but were they now within my reach I could not drink them, I have too long known the pleasure derived from a certain Gentleman's society to relinquish it.[47]

Maria was not so much 'a strange creature' as she came to describe herself, but a rare one, selfless, literate and sociable, entirely committed to John becoming known and successful. She fully understood John Constable's sense of ambition, feared he risked losing it, and put herself and her own talents at his disposal. Knowing they cannot meet too often, she tells him:

> We are both very unfortunately situated (but really you must think me very silly to tell you what is so evident), then we can make writing alleviate many of our troubles, and be to us, one of our highest pleasures. I used to dislike it excessively, but now there is no enjoyment I shall like so well.[48]

With this to drive them, they had a lot of fun in their correspondence, word play for example in this text for an amusing exhibition catalogue: 'The Seige of Troy by Ten-iers; A Country

Ball by Dance; Laughing Girl by Smirke; Game by Bird; Pigs by Bacon', and so on.[49] Maria knew, too, something of the nature of his drive and single-mindedness, and that she would have to help him manage his time, even to the extent of restricting their meetings:

> but however my dear John we must try it, and that is, the not meeting often in London. You perfectly well know what terrible havoc it makes with your time . . . your time is infinitely valuable to me, I cannot have it lost, the genius of painting will surely one day or other rise up against me for too often keeping one of her favourite pupils from a study that demands his exclusive attention.[50]

Time, and the use or misuse of it, was a constant issue with Constable. Maria talks about his time here, and Lucy Hurlock, in a comparable train of thought, wrote in 1800 of how she did not mean 'to obtrude on your time; time is now of so much importance to you.'[51]

The ticking of the clock, the passing of the years, and the slow, slow headway in art and love, caused much anxiety between John and Maria. He might have felt an additional twinge of anguish when he was commissioned by Thomas Fitzhugh, a landowner from Denbighshire, to paint a marriage picture for his bride-to-be, Philadelphia Godfrey of Old Hall, East Bergholt. Fitzhugh wanted Philadelphia to have something that would remind her of home. 'I have almost done a picture of "the Valley" for Mr Fitzhugh', Constable told Maria in 1814, adding: 'a present for Miss G. to contemplate in London.'[52] This, with its cows reminiscent of the Dutch seventeenth-century painter Albert Cuyp, the panoramic extent of Dedham Vale in flood, and its admirable 'finish', is a firm statement by Constable that despite everything he could paint for a market, could toe the line if he wanted to, and need not always present himself as a revolutionary hothead. So conservative is it that it had for decades been attributed variously to Thomas Hofland and Ramsay Reinagle – anyone but John Constable.[53] While working on the canvas for a happier couple and contemplating the meaning of the river flood he had so decidedly painted into his Fitzhugh landscape,

Constable could nevertheless think about Maria. Flood signals harvest and the fecundity hoped for between both Thomas and Philadelphia Fitzhugh, and between John Constable and Maria Bicknell. Quoting again their favourite poet, Maria told her suitor: 'hearts so united as ours can never be separate – but even in another life shall meet again, as our dear Cowper expresses it, "on that peaceful shore – where tempests never beat nor billows roar."'[54]

20. Entirely and forever yours

The Bicknells and the Constables had unresolved questions to face over the ever-growing-more-inevitable union of Maria and John. To Charles Bicknell, the social priority was to maintain the status quo. The priority for Ann and Golding, was to create an illusion of equality with the Bicknells, who came from at least three generations of lawyers. The Bicknells were highly aspirational, and would expect to climb yet higher in the air pockets between the Church, the Admiralty and the royal family. The Constables, in the East Anglian corn and coal trade, were not in the same league, and with one epileptic son, another son who could not be fully trusted to say the right thing in company (John), one daughter married into the cheese trade, and two more unmarried and likely to remain so, the Constables could not be wholly expected to match up. Left alone they might have solved it together, but there was always the Rector, who thrived on insincerity. Ann Constable and Durand Rhudde were in a struggle for the acquiescence of Charles Bicknell in a proxy war in which John and Maria were caught in the crossfire.

John's sisters rallied round as they always would. The Whalleys of East Ham were close watchers of his career, and of the pattern of his health in general. Patty had particular concerns for John's chest, John's lungs, John's teeth, John's cold:

> I hope you did not take fresh cold the day we were together. I believe all the world have had a cold of some sort – but yours was of the worst sort, because the most painful.[1]

Their mother was characteristically direct:

> Sitting up late wastes the spirits, the circulation, the coals, the candles, & makes the morning languid – all apathy instead of being invigorated by one hour's sleep before twelve o'clock, which is allowed to be of more service than two afterwards

– but <u>this</u> you will I hope experience the benefit of, if you will but adhere to your present system of <u>early rising</u>.[2]

Historians have painted Dr Rhudde as the villain who kept the lovers apart for so long. As far as the first part of the courtship is concerned, this is an ungenerous reading. His courtesy, which is grating to a reader of Ann's letters, was probably genuine, and his way of keeping his parishioners' spirits up in the era of invasion threats, of Boney, and of the deep-rooted changes being processed in the Church of England against conflicting pressures from nonconformism and Rome. Rhudde's courtesy and pomposity went hand in hand. The benison of Rhudde's attention to the Constables, and his partial and decorative concern for John's career, threads through letters from Ann and Abram, to the extent that it seems that had Constable decided to become a portrait painter Rhudde's attitude might have been different. However, that is not how matters remained.

In 1810, Constable had found the courage to stand for election as an Associate of the Royal Academy, but that year he was one of thirty-one candidates and received no votes at all. He had had high hopes, and invested considerable emotion on winning against these very long odds. 'Were he to be elected,' Farington reported, 'it would have a great effect upon his father's mind by causing him to consider his situation more substantial: at present he thinks that what employment he has he owes to the kindness of friends.'[3] The following year he stood again, and, once again, nobody voted for him.[4] In 1812, the same – though he did get one vote.[5] Bruised, he did not stand in 1813. Nevertheless, John Constable was becoming noticed at the Royal Academy: he attended the annual dinners, and sat next to Turner at a dinner in 1813. They made an impression on each other: we do not know what Turner thought of Constable from this meeting, but they clearly had a pungent conversation. 'Turner is uncouth,' Constable told Maria, 'but he has a wonderful range of mind.'[6] In 1814, when Constable put himself through election again, there were thirty-five candidates, and, once again, nobody voted for him. To rub salt into this wound, Ramsay Reinagle, his early friend and flatmate, was elected that year.[7]

These were hard times, though there was a glimpse of pro-
gress. The cheerful Johnnie Dunthorne now worked for him
at Charlotte Street despite Ann's social misgivings: 'I intend
he should be usefull – he is not at all vulgar and naturally very
clever – but had he not these good qualities I should love him for
his father's sake.'[8] In East Bergholt the heart of Dr Rhudde to-
wards Constable was becoming icier, and the attitude of Charles
Bicknell in Spring Gardens Terrace was also hardening with
the growing threat to his wife's inheritance from Dr Rhudde.
Bicknell also thought (according to Maria) that John had cut him
dead when the three met at the Royal Academy exhibition of
1814, and had failed to acknowledge him appropriately with a
bow. The contortions of metropolitan etiquette may still have
perplexed John Constable the country boy: he must have called
at this time at Spring Gardens and been told to go away and not
come back. He pleaded with Maria 'to procure me an interview
with Mr Bicknell which you know I have always been most anx-
ious for from the moment that I was dismissed from his door.'[9]

In the meantime John spent some weeks in East Bergholt and
in Essex during a summer which became, for the nation, a summer
of celebration. He stayed with his old friend Walter Wren Drif-
field, by now vicar of Feering near Colchester, and while there
made drawings of Feering church and parsonage and the nearby
Layer Marney Tower. He travelled on to the Thames estuary
where he drew studies of Sheerness, Southend and the ruins
of Hadleigh Castle: 'I have filled as usual a little book of hasty
memorandums of the places which I saw which you will see.'[10]
He also painted a double portrait of his sisters Nancy and Mary,
a stylish pair of subjects, the culmination perhaps of studies in-
cluding the small oil sketch of Mary in her red cloak.[11] Nancy,
mannish in a glossy black riding hat, white stock and black coat,
has a strong, assertive face with high cheekbones and a glow of
warm pink on her cheeks, betokening her outdoor life. She wears
pale leather gloves and drop earrings. Mary, beside her, is dream-
ier, apart. Her rich red cloak with its detached collar covers her
high-waisted Empire-line white dress. Both look out directly to
the left, avoiding the beholder's contact. Ivy trails beside them,
representing the intertwined support of family and friendship,

a character trait that was engrained within the Constables of East Bergholt House. This could almost be a portrait of a more especially ruminative husband and wife, if we did not already know that the pair are sisters.

Peace at last – victory over Napoleon – caused the nation to celebrate when the Treaty of Paris was signed in May 1814 and Europe thought it was all over. Celebration parties broke out across the kingdom, none happier than in East Bergholt where eight hundred sat down on 9 July for a feast to celebrate 'the blessings of a general peace'. These eight hundred from the village and surroundings gathered together on the green and ate and drank through the generosity of landowners.[12] Between East Bergholt House and West Lodge, everybody packed in on benches and trestles under the awnings that Constable shows in his pencil drawing of the scene. In the shimmering little oil study painted from an upper window he omits the awnings which would have got in the way of the richly populated vista.[13] But in both we see the flags, the Royal Standard flying in victory above the black and white flag of Corsica, and in the painting the effigy of Napoleon in his tricorn hat dangles from a gibbet. The peace, like the feast, did not last long, and it took another year, and the Battle of Waterloo, before Napoleon was finally vanquished.

Though changed in their nature, Constable's anxieties re-mained for months, made worse by letters going astray: 'I have been really unhappy in not having heard of you so long . . . the same miserable anxiety about this.'[14] Charles Bicknell had his own dilemma: if Mrs Everard were to marry the Rector hopes of inheritance would be scattered to the winds. 'You must make every kind allowance for Mr B.,' Ann later exhorted after analys-ing the situation, '[he] is most assuredly not a free agent in this matter. He is under rigid restriction, from which, for the sake of his family, he must not appear to swerve.'[15] In the event, if it was ever Mrs Everard's intention to marry Rhudde, it failed. She moved into a house in the village, near East Bergholt House, where 'a great deal of visiting' soon went on, and where ani-mosity between her and the Constables calmed.[16] The Bicknells were resolute, however: unless John Constable began to find real financial success in his endeavours they would remain opposed

to the union, as they believed his incursion would deny them
Rhudde's inheritance and destroy their security as a family. John
had in February 1815 been given 'the sweet permission' of being
allowed to call on Maria 'as an occasional visitor',[17] but neverthe-
less Ann was outraged at the volatility of the man who had not
so long before welcomed John into his house in London, and even
paraded his daughter in front of him:

> The treatment you met, so derogatory to your respectability
> and honourable intentions – for indeed I never expected this
> turn in the tide of your affairs, "à l'amour." You have now
> only to wait for time and opportunity, to enable you to act in
> conformity and with propriety, to her deserts – which will ef-
> fectually prevent you from plunging her into difficulties totally
> uncongenial & inconsistent to her expectations.[18]

Ann was in her element now, firefighting, giving orders, pa-
trolling trouble-spots, calculating:

> Thursday next . . . is Dr Rhudde's birthday . . . If you think it
> will be taken in the right – it should be – perhaps you will call
> and pay all due respects, to your Grandfather in expectation;
> – do as seemeth best to your own feelings & ideas on this sub-
> ject – but kind words, we are told, please, are cheap and easily
> given, whereas grievous words, 'stir up strife'.

She redoubled her efforts to make the Constable family condu-
cive to the Bicknells, and to make Maria welcome and at home if
the wind would change. Dunthorne now became a subject of dis-
cussion; John had taken his part against Mrs Dunthorne's temper,
what he called 'old woman's conduct', while Ann took a counter
view of the imprudent ingrate next door: 'I assure myself Miss
B. would not countenance for a moment such a character.' This
important letter of 7 March 1815 was one of the last Ann wrote
to John; she had carefully and strategically prepared the ground
for Maria, but was not to live to see the outcome.

As Ann Constable busied herself here and there, tidied her
papers, tut-tutted over Dunthorne, and gave instruction to the
gardener, John looked over the paintings he would put into
the Academy exhibition of 1815. Central among them would be

the canvas he had been working on from drawings made at Flat-ford, and, during the heat of the previous summer, the picture he had actually taken down to the mill to paint in the sun. This was the work he listed in the catalogue as 'Boat-building', known to us now as *Boat-Building near Flatford Mill.*[19] Through the heat we can see a pause in the day's work, as if most of the men had gone off for their lunch, leaving their tools in the sun. The clinker-built hull of the barge, around forty feet long, is complete, its oak wall planed, rubbed and caulked with oakum, and in the prow is the framework for the barge-horse's platform. One man sits in the barge's shadow, doing something on his lap, perhaps rolling oakum from the pile beside him. Up five wooden steps laid into the bank another man is working on a curved plank above a sawpit; yet another is further off. On the river another barge waits – it is not moving because in has no motive power, no barge-horse is attached, and it is anchored to the bank. We can see the anchor. To the right-hand edge of the picture is a child, examining some little thing with the intensity that only a child can muster. Nearby, a dog lies in the shade, panting – dog and child must belong to the man by the barge in dry dock. And all around are the tools, Golding Constable's company's tools: a mechanical jack for keeping beams apart, an iron cauldron of pitch being kept at heat while the men are at their break, another cauldron with a broken lip, a ladle, a pitch-brush, a scoop. In the sun, to the right of the barge, are a mallet, two adzes and a trug for nails and so on; on the canal bank a grindstone and handle. All this is written out for us, clear as a bell, depicted with an ex-pertise gained from nearly forty years' intimate contact with the mill and barge business: barge-building was ordinary, everyday work for Constable & Co. The river sparkles, the sun is noon-high, the shadows are short, the ground very dry. But we can see that one or two expert bangs of a mallet will release the sluice in the dam, and let the river in to fill the dock to float the boat, another job well done. John Constable here has shown us exactly the birth of a modern barge, and celebrates the men who built it.

This was a season for deaths, a scattering of highly significant 'removals' within the Bicknell-Constable orbit. Maria's mother had been suffering at home in Spring Gardens and by the sea in

Brighton: 'Poor dear Mamma, how it grieves me to see her so poorly, she hardly likes me to leave her', Maria told John.[20] Of this sad internalised woman, ineffective, invalid and incapable, caught in the toils between her father's prejudice and her daughter's future, Ann said, 'poor Mrs B; in the midst of plenty no worldly enjoyment.'[21] She died on 12 May 1815. Ann Constable was by contrast everything that was selfless and empathetic. Her own death, drawn-out, but peaceful, had come a few weeks earlier, at the end of March 1815, following a stumble with what Constable described years later as a 'paralytic stroke' when she was pottering in the garden.[22] She would not see *Boat-Building* on show in Somerset House, but she will have seen it in progress, and would have recognised its unusual strength. Ann's legacy was her family of six beloved children, a mourning but proud husband, and a vapour-trail of many dozens of letters. Just over a year later, Golding, 'seiz'd with a chilly fit', died in his seventy-sixth year in his own bed 'without a struggle or a groan'.[23]

Between the deaths of wife and husband, Suffolk and Essex farmers enjoyed the most spectacular of summers. Constable took every opportunity to immerse himself in its fruitfulness: 'I live almost wholly in the fields,' he told Maria, 'and see nobody but the harvestmen.'[24] Eight weeks after Golding, on 29 July 1816, David Pike Watts died. 'My poor unhappy Uncle', is how Constable remembered him in 1824; on the other hand, the five-column obituary in the *Gentleman's Magazine* described Pike Watts as 'a man of retired disposition and inward piety . . . cool and dispassionate, he never boldly asserted'.[25] Constable might have taken issue with that. Pike Watts left his entire fortune to his one surviving child, his daughter Mary Watts Russell, of Ilam Hall, Ashbourne.

In the midst of these losses, Dr Rhudde, the 81-year-old widower, ploughed on, and still would not budge, despite being visited out of courtesy in his echoing Rectory by Constable, and out of duty by his son-in-law. He went so far as to give the impression that David Pike Watts should have left Constable a share of his enormous fortune. Maybe – that would indeed have eased matters for John and Maria – but this Constable family matter was none of Rhudde's business, and would not absolve

him of his moral responsibility towards Maria. 'The state of affairs seems as bad as ever', Maria told John. Dr Rhudde and his surviving daughter, the ungracious and scheming Harriet Farnham, were together 'entirely inveterate against me, but don't let this vex you'.[26] But then, of a sudden, as if hit by a punch on the nose, John had had enough. He released his lightning bolt:

> I wish you had married me before now, and depend upon it we shall act most unwisely in deferring it much longer – our enemies are busy and vigilant and unprincipled . . . We cannot be worse off . . . we may as well be unhappy in each other's arms as apart, and two they say can bear trouble better than one.[27]

Surprised perhaps at his own display of courage, Constable then said too much about Maria's younger sister, Elizabeth Catherine. He was confident now, impulsive. He rashly tried to advise on her education, and word came to the Rector's ear: this meant that the cocky young suitor had been visiting Spring Gardens Terrace against his express wishes. The fat hit the fire: as Constable put it to Maria:

> an ebullition of that same wretched spirit that has always pursued us, and . . . is as relentless as ever . . . this is a circumstance turned by all into a grand attempt to part us . . . we have been all along enjoying ourselves over a barrel of gunpowder.[28]

So together they turned to face the beast: 'the kind Doctor', Maria said of her grandfather, 'says he "considers me no longer to be his grand daughter", from the knowledge I have of his character, I suppose I may infer he means what he says.'[29] They now had nothing to lose. Constable considered his position, did his sums, and wrote to his love:

> Our business is now more than ever (if possible) with ourselves. I shall inherit a sixth part of my father's property, which we expect may be at least four thousand pounds apiece, and Mrs Smith of Nayland will leave about two thousand pounds more amongst us – and I am entirely free of debt . . . After this my dearest Maria I have nothing more to say – but that the sooner we are married the better.[30]

At last! After seven years of pussy-footing – 'seven years since I avowed my love for you!'[31] – they were on their way. Money, 'that necessary article Cash', remained a difficulty, but to hell with that. Over the years Constable had observed Maria's strength of character, while Dr Rhudde – well, 'as we both know the man, it will be but poor consolation for us to know that he is gone to the devil on our account ... [He] has begun his old story again about my being an infidel – poor man.'[32]

In the two months that remained before their marriage, Constable had a sudden in-rush of work: to paint General Rebow's house, Wivenhoe Park, Essex, to complete *Flatford Mill*, and to paint some unexpected portraits. John wanted to delay the wedding date to accommodate his work, to Maria's dismay, even fury. Her reply when John airily suggested they postpone until pressure of work lessened has unusually not survived.[33] Michael Rosenthal suggests that her response was 'blistering', and that John may have destroyed her letter in shame at his tactlessness.[34] John was plain to Maria that in their marriage his work would take priority, to generate 'that necessary article Cash', and he even began to suggest that Maria should not spend money on a wedding dress: 'I always wear black myself & think you look well in it ... I like black best – do as you like – but I think it advisable not to spend your money in clothes, for we have it not to waste in plumb cake.'[35] Maria was a match for any such behaviour, being expected to wear black on her wedding day: 'I am a strange creature as you will one day discover.'[36] He would also discover, and come up against, Maria's core of steel: her firm rectitude in domestic economy, her persistence in pursuing demands, an undercurrent of control, and her crisp retort and sharp temper when roused.

Before the wedding, John painted his 'strange creature' once again: strange she is not, however, but calm, content, with dark brown curly hair, a kiss-curl at her forehead, and well-marked eyebrows. Her eyes have a touch of grey-blue, her lips a subtle shine. She and John have guided each other to their happy out-come.[37] On the first of October, the day before John Constable and Maria Bicknell were married, Charles Bicknell was presented with a bill by Thresher & Miller, 'Hosiers & Flannell Drapers

to his Majesty, 152 Strand', just beside the Royal Academy in Somerset House: [38]

1 Y[ard] Ladies Superfine white Silk Rich Lace & Emb^d	15s
1 Y[ard] Extra Stout white Silk	13s
1 Y[ard] do. Superfine white Silk	12s
2 Y[ards] Superfine Gauze[?] white Cotton @ 2s6d	<u>5s</u>
	£2.5s.0d.

Charles must have heard about John's tight-fisted idea that the bride could wear black – from Maria no doubt; she and John were both 'strange creatures', well suited. So Charles took action to bedeck his beloved daughter in rich and wonderful white on her wedding day. There had been reluctance and equivocation from the Bicknells over the years, and Charles's generous act, now, speaks volumes.

John and Maria walked arm in arm through the west door of St Martin-in-the-Fields onto the steps and looked out across the Royal Mews. The bride was gorgeous in white silk and lace, her dark brown hair in its exuberant curls; the groom wore his black suit, and may have had paint under his fingernails. There were no bells, but above the rattle and shout of traffic, and across the Mews from the cramped zoo nearby at Exeter 'Change, came the uncivil growl of a bear. No guests had been present; just John's good friend the Rev. John Fisher to marry them, and, as witnesses, neighbours William Manning the Apothecary and his wife.[39] John, or perhaps his father-in-law, or even John Fisher himself, immediately put an announcement in the London papers so that small part of the world which cared would know. Rapidly the news went nationwide, and within days it was also news in Oxford, Norwich and Bury St Edmunds:

MARRIED: Yesterday, at St Martin's Church, by the Rev. John Fisher, Domestic Chaplain to the Lord Bishop of Salisbury, John Constable, Esq., of East Bergholt, Suffolk, to Miss Bicknell, of Spring-garden Terrace.[40]

III
Opera 1816–1828

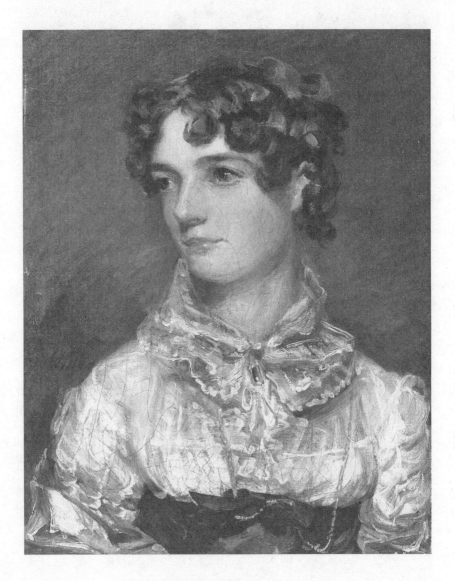

Maria Bicknell, Mrs John Constable
by John Constable, 1816
Tate Britain, London

21. The real cause of your want of popularity

John and Maria Constable spent their six-week honeymoon as guests of John and Mary Fisher in the cramped but cosy vicarage at Osmington, near Weymouth. The Fishers had married in July, so all were embarking on married life together. 'The country here is wonderfully wild & sublime', Fisher assured his friend when suggesting they share a honeymoon berth, '& well worth a painter's visit.'[1] An additional enticement was this:

> My house commands a singularly beautiful view: & you may study from my very windows. You shall [have] a plate of meat set by the side of your easel without your sitting down to dinner: we never see company: & I have brushes paints & canvas in abundance.

What could be better – Constable was being offered working conditions that would suit him perfectly, with the certain assurance from Fisher that the two women would behave themselves: 'My wife is quiet & silent & sits & reads without disturbing a soul & Mrs Constable may follow her example.' This was Helmingham Hall 1800 repeating itself sixteen years later. A result of these weeks, in which Constable also painted Mary Fisher's portrait to accompany his recent portrait of John, was his windswept paintings of Weymouth Bay, at least one of which was painted furiously outside on the beach as the wind whipped up the clouds and surf, and the sand sprayed like bullets around him.[2]

Marrying John and Maria at the end of their long and testing courtship, and inviting them to Osmington, was one among many acts of kindness and solidarity that John Fisher had performed for John Constable. Above all, he gave friendship at a time when Constable needed an intelligent, aware, sensitive and waggish man friend who was no kind of rival and not connected to the world of art. John Fisher the younger made Constable laugh, and took him out of himself. Friendship with the amusing nephew of

the Bishop of Salisbury was new, vital and sophisticated, and at an appropriate social level. John Fisher became the friend who offered more than Constable could ever expect, with opportunity and access discreetly in the background.

From the older generation, Beaumont and Farington offered Constable friendliness but not real friendship at a time when he most needed it, newly married as he was, with responsibilities and the confidences of others to be justified. While Beaumont and Fisher both had the social snobberies of their day bumping like thromboses through their veins, their prejudices differed. Beaumont's embraced, inter alia, the progress of 'the Art', the value of the work, and the relative place of particular artists up and down the busy barometer of fashion. Beaumont was a seasoned professional artist-watcher; his advice tended to warn of the dangers that accompanied new ideas, rather than encourage artists to take risks, and his own paintings were an expression of the principles of his taste. Both Fishers, on the other hand, while rooted in the orthodox practices of Anglican religion and English politics, found relaxation as enthusiastic admirers, envious and adoring of talent, and mischievous for its advancement. Their advice encouraged experiment, and Constable's experiment encouraged them. Fisher and Constable would paint side by side in the fields, just as Constable and Dunthorne had done, and Fisher persevered on his own from time to time. He told his friend,

> I am delighted with myself with reason ... But tho I am paying myself the compliment – I owe this pleasure to you – you fairly coached me & taught me to look at nature with clearer eyes than before I possessed.[3]

When he was approaching ordination in 1812, Fisher had urged Constable to be at the ceremony in London, and afterwards to join him in Salisbury. 'You know I take no refusals. All obstacles, be they of whatsoever nature they may, must be overcome by my impetuosity.'[4] John Fisher bounced through life: 'we will rise with the sun, breakfast, & then out for the rest of the day', Fisher wrote of the fun they'd have in the cathedral's shadow. He promised days of drawing, reading, bathing, or 'if the maggot so

bites' they would pore over Fisher's favourite classical authors, and 'puzzle out a passage or two in Horace together. I think this life of Arcadian or Utopian felicity will tempt you, so come and try it.' Fisher's energies were boundless; he darted about in his head and in his enthusiasms, never still, never without a new idea, never less than loving to his friend. Nevertheless, he seems to have felt that he had not gone far enough in describing the pleasures in store in Salisbury: 'I would have painted in more glowing colours, but I eat a great lump of cheese just now & it has got into my head and muddled it.'

There is something about the quiet and reflective John Constable, preternaturally uncertain of himself, that was attracted to the prolix and opinionated younger John Fisher, educated in the stylised Cambridge manner, and probably also over-fond of his own voice. Fisher's enthusiasms warmed Constable and gave him energy and sparkle to the extent that the Bishop described him to his nephew as 'your humming top friend'.[5] Fisher muses in a letter to this 'humming top friend' about Indolence – something Constable lacked – the 'Syren' [sic] who made him appear ungrateful for Constable's gift of a little picture:

> I was more gratified with the proof of your good will in recollecting my casual admiration of the painting than I was of being put in possession of the thing itself. The one was a proof of the painter's art the other of his esteem.[6]

He goes on to tell Constable how people look at his pictures, and that one elderly critic, the historian and churchman William Coxe, said that Constable's paintings 'put him in mind of the old Dutch forest painting school' – he means Jacob van Ruisdael and Jan Both. Of the small painting that Constable had just given to him, Fisher says: 'it is most pleasing. . . . But you must be taken to it. It does not solicit attention. And this I think is true of all your pictures'. Fisher concluded, to his own satisfaction, that this was 'the real cause of your want of popularity.' He then cites Rubens, an observation he has picked up, that 'one of his pictures illuminates a room. It gives a cheerfulness to everything about it. It pleases before you examine it or even know the subject.'

With his uncle's expressed assistance and influence, John

Fisher had already risen rapidly in the Church of England. He began to collect preferments and livings – by June 1812 he was attached to Salisbury Cathedral as Prebendary of Hurstbourne and Burbage (a stipend of £11. 2s. 6d. per year); shortly after that he became Rector of Idmiston with Porton, Wiltshire (c.£250 p.a.); and the following year he was vicar of Osmington with Ringstead in Dorset (£170 p.a.): these were all held concurrently. Within twelve months, aged only twenty-three, he was also appointed Archdeacon of Berkshire and became Rector of Winfrith Newburgh with West Lulworth in Dorset (£380 p.a.), in exchange for the lower-valued Idmiston with Porton. Across all these preferments, John Fisher was also Domestic Chaplain to the Lord Bishop of Salisbury, his uncle. The Berkshire appointment is the reason he is known as Archdeacon Fisher, while his uncle is the Bishop: they will be differentiated thus here. In 1819 young Fisher added to his portfolio Prebendary of Fordington with Writhlington, a cathedral seat three times the value of Hurstbourne and Burbage, which he let go. In due course he became vicar of Gillingham, Dorset, relinquishing Winfrith Newburgh. On account, it seems, of the Bishop's influence, easy and lucrative appointments came to this young priest. Influence was all. We may note that while Bishop of Exeter (1803–7), the elder Fisher also held three far-flung Rectories – in Suffolk, Hampshire and Devon.[7] That was how they did things then.

The Archdeacon's friendship with Constable was fond and frolicsome, despite the wide difference in their worldly earnings, and the security of their social and professional positions. The Fishers were, however, always kind and helpful to Constable, advising him on money, understanding his financial difficulties, and looking for ways to make things easier for him. Across the first few years of their friendship Constable surely earned this uninvited care by trying to satisfy the demands of both the Bishop and the Archdeacon in painting tuition, varnishing, framing, carriage of paintings, dealership and other professional tasks. 'I have been painting a little & will bring what I have done up to town for your inspection', the Archdeacon told Constable eagerly.[8] On another day Fisher casually asked his friend to send him 'a few skins of paint: flake white: blue: naples yellow: vandyke brown:

brown pink: brown oker: a phial of boiled oil & another of lin-
seed oil.'[9] This was not the easiest thing for a working painter
to do – these are the workman's tools – and Fisher should have
gone to a colourman himself. 'I will return them in a day or two',
he added, 'I have got your Osmington sketchbook & want to copy
one of your views': he had borrowed a sketchbook as well; he
was becoming rather demanding. Constable then became obliged
to give painting lessons to Dorothea Fisher, 'Dolly', one of the
Bishop's daughters: 'Papa desires me to send you one of my sea
pieces . . . & would be the better for varnishing. Papa begs you
would have the kindness to do it.' And more and more across the
family: 'I must trouble you again about my Daughter Dorothea's
Paintings. They are not arrived . . . Have the goodness to enquire
for them . . . We are all going out of town for a few days . . . I
must intreat you for your attention to my daughter for as few les-
sons.'[10] This bombardment became irksome: 'I hope I have quite
done with Miss F', John wrote later to Maria.[11]

Nevertheless the John Fishers, Bishop and Archdeacon, were
crucial to Constable's confidence and development as an artist
through their endless, generous and genuine encouragement. 'I
have just heard,' the Archdeacon wrote during the 1813 Acad-
emy exhibition,

> your great picture [*Landscape: Boys Fishing*] spoken of here
> by no inferior judge as one of the best in the exhibition. It
> is a great thing for one man to say this. It is by units that
> popularity is gained. I only like one better & that is a picture of
> pictures – the Frost of Turner. But then you need not repine
> at this decision of mine; you are a great man like Buonaparte
> & are only beaten by a frost.[12]

The 'frost' was Turner's *Frosty Morning*, a painting of quiet
grace and naturalism, woven through with tragedy and the slow
passage of time. It has complex undercurrents of emotion that
Constable had not yet experienced and could not yet express.[13]
He took heart in the Fishers' jollity and companionship, and was
happy to be chided by the Archdeacon:

> Pray as you regard your interest call on the Bishop & his Lady

as he attributes it to neglect & not to humility. Every body
does not know as well as myself that there is an Exhibitioner
& a Painter for fame, who is possessed of modesty & merit; &
is too honest & high minded to push himself by other means
than his pencil & his pallet.[14]

Following pressure from Maria, Constable had begun to dis-
tance himself from John Dunthorne. This ruminative, capable
friend, who had been such a thoughtful cushion to his growing
pains as an artist, was effectively dumped. Something had gone
on between them to cause Constable, in February 1816, to sever
their relationship. Dunthorne may have taken to drink, been
careless with his (and his wife's) money; he may have foresworn
his religious practices, whatever they were: something happened
to cause Constable to tell Maria 'I have given the best advice
[to Dunthorne] in my power for some time past – but as he
was determined to continue his perverse and evil ways, I was
determined not to countenance them by being seen with him.'[15]
This is priggish and ungrateful in the extreme; but Maria does
not come spotless out of the incident either. She had had it in for
Dunthorne for years, and evidently told tales to John:

> You have made me very happy by the conduct you have pur-
> sued in regard to Dunthorne, he never could be a fit compan-
> ion for you. I am delighted the acquaintance is broken off, I
> trust for ever, a man destitute of religious principle must be,
> if not a dangerous, at least a most melancholy associate. It has
> certainly been the astonishment of many that a man so every
> way your inferior, should be allowed and honored with your
> time and company, I assure you it has been a subject of wonder
> to me.[16]

Maria's latent controlling nature emerges in this directive, and
it feels as if John is having his arm twisted into giving up contact
with the friend who was so close to his feelings and his history
when growing up. Maria was charming and characterful, consist-
ent and loyal, and deeply in love with John, but her loyalty did not
reach as far as friends from his bachelor days. Dunthorne's rough
edge and direct way of speaking, his cottage-living and craft did

not sit well with Maria's metropolitan upbringing. Maria will not have been impressed by the way Dunthorne treated his wife either; nor indeed that John seemed to be taking Dunthorne's side in this. Despite the talents he set free in Constable, Dunthorne was too clever, accomplished and knowing for his own good, and, to Maria's anxiety, knew too much about John already.

22. Our little house in Keppel Street

John and Maria came home to the riot of colour in John's first-floor apartment in Charlotte Street, its salmon wallpaper and crimson upholstery. A letter was waiting for them. Maria's half-sister and ally Sarah Skey (by now Mrs Joseph Fletcher) had read the notice in the papers; indeed, that might have been her first knowledge that the wedding had taken place, 'that important and <u>interesting</u> ceremony at St Martin's, which was announced to me by the Morning Herald':

> I trust <u>the Dr:</u> will not remain incon[sol?]able but hasten his pardon and blessing before he is damned to his [illegible word] I felt my hopes on the subject revive from a paragraph in your letter. I shall rejoice to hear that he answered your Epistle <u>favourably</u> and that you may receive a <u>Substantial</u> proof of his forgiveness either now or hereafter, is my very sincere wish and desire. Have you had any congratulations from Farnham? I suspect the Revd. Dr will be influenced by the advice of his daughter, whatever that may be, whether a speedy or tardy reconciliation.[1]

Sarah's letter, written during the honeymoon, was timed to be awaiting the bride and groom when they returned home. Harriet Farnham would be crucial to the process of reconciliation, Sarah felt, but we already know that Mrs Farnham was jealous, duplicitous and difficult. Dr Rhudde would find or be shown the announcement in the *Bury and Norwich Post*, of that there can be no doubt – it may have been placed there especially for him: 'Yesterday se'ennight John Constable Esq., of East Bergholt, in this county, to Miss Bicknell, of Spring-garden Terrace.'[2] How would Rhudde respond? Not as hoped, it seems, as very soon the East Bergholt surgeon William Travis found the Rector to be 'rather violent' about the turn of events, and although he gradually calmed down, he nevertheless averred to Travis, 'I'll

not leave her a shilling.'[3] For her part, Maria had written to her grandfather before the ceremony, but that letter, remarked upon by Sarah, is lost, perhaps torn up by Dr Rhudde in a fury. It was a great mistake of Maria's that while she wrote to her grandfather to tell of the marriage, she failed to write to her Aunt Harriet. In a little over a year's time she would discover that this was a serious error.

The apartment was cramped, and certainly not suitable for bringing up the family which they expected would soon come along. The pair began to enter into the social swim. They dined with the Beaumonts and Farington, and the Ciprianis, Charles Bicknell's Treasury colleague and his wife, invited them to dinner on New Year's Day 1817 with 'no other company but a gentleman or two as we cannot see anyone in town as all our plate is at the bankers and there it will remain until we remove into our new house . . . in Harley Street.'[4] Maria was pregnant by now, but in February she miscarried, Nancy responding to the news in her affectionate but formal manner to John:

> sincerely do I partake of your every cause, of pleasure, or pain, but when the latter prevails the sympathy of a friend is doubly acceptable . . . I . . . trust that time may repair the loss, and that the time is not far distant when [Maria's] mind will be cheer'd with serenity.[5]

John's sister Patty was more direct: 'Next time I think she will succeed better.'[6]

Constable was now able to reflect on the state of his career. *Scene on a navigable river*, now known as *Flatford Mill*, with its exactitude, modulated light and empty middle, was on his easel in preparation for the 1817 exhibition.[7] Sales of his landscape paintings crawled miserably slowly, not enough to keep a bachelor going, let alone a family. Beyond the commissions in the 1800s from East Bergholt friends and family, and the special commission in 1814 for Thomas Fitzhugh, he sold exhibited landscapes across 1814 to 1818 to James Carpenter, a Bond Street bookseller, John Allnutt, a Clapham wine merchant, William Venables, a paper-maker, and the Rev. Frederick Barnwell, a parson and antiquary from Bury St Edmunds.[8] These were men with

modest wealth, most from businesses comparable to his father's, and not inheritors of the wealth of the landed and titled gentry. Constable's landscapes still lingered like the 'lumber' Golding had warned him about, despite their liberal exposure in exhibitions in Somerset House and at the British Institution.

After the disappointment of the 1810 Associate elections, and subsequent rejections, Constable gave up his quest for recognition for two years.[9] Then, in 1817, married, buoyant, renewed, and becoming part of London society, he put himself forward and did much better. For the two vacancies in 1817 he won five and then eight votes from the twenty-five Academician electors.[10] Even so, that was not enough, despite Constable exhibiting the paintings known now as *A Summerland* (1814), *Boat-Building at Flatford Mill* (1815), *The Wheatfield* (1816) and *Flatford Mill* (1817). The next year, 1818, was worse, back to the old grinding rejection: he got only one vote in the first round, and that was it. In the second ballot, nothing.[11]

A significant factor in Constable's failure to be elected was not only his character or attitude but the glacial pace of sales of his landscapes. Wilkie, Mulready, Callcott and Turner had their markets, and they got elected. Activity in the art market opens the eyes of others. Had Constable put himself forward as the accomplished portrait painter that he was, he would surely have been elected by now. Perhaps he eventually came to realise this, and so exhibited his portrait of Archdeacon Fisher in 1817, but it was too little, too late, and the portrait was ignored. He had no need to change his direction; he just needed to change his fellow artists' perception.

During the monotony of these rejections, Constable must have been contemplating the fact that larger landscape paintings got special notice, and, through the brushes of Turner and Callcott, found buyers at high prices: Turner's *Bridgewater Sea Piece* (250 guineas) had been hanging in the magnificence of Cleveland House, Pall Mall for more than fifteen years, and Callcott's *Market Day* was bought by Sir John Leicester in 1807 for 150 guineas. The larger landscapes of Gainsborough, by now dead more than thirty years, had been honoured by exhibition at the British Institution in 1814: one exhibit was *Cornard Wood*,

lent by David Pike Watts. The message, therefore, was to think bigger, stick with landscape, and fight disinterest with the fire of determination. Constable already understood all this, if slowly, as was his way: he painted a five-feet-long Lake District scene in 1809, six or more years after Turner's first large paintings had appeared at the Academy. He contemplated showing it, until Farington put him off the idea by suggesting that it was rather flat, 'wanting variety of colour & effect'.[12] Nevertheless, he was gradually expanding horizons, not only because he recognised a trend developing among younger artists, but also because bigger meant more likely to be noticed. Turner and Callcott had realised that years earlier.

However, canvas was expensive, as was paint, and to paint bigger pictures he would have to find a guinea or more for a five- or six-foot-long length of canvas, and perhaps three or four pounds or guineas for the paint, depending on how sparing he could be with it – and he was not sparing.[13] Short of money, and now with a wife to support, his perspectives had changed, though perhaps not his priorities. One change led to another, and in June 1817 he and Maria gave up the salmon-pink Charlotte Street apartment where it was impossible to paint large exhibition canvases, and moved the quarter mile east to 1 Keppel Street, where he was sure he could. Nearby was Montagu House, already the British Museum, with adjacent fields, gardens and grandeur. Confident in the future, Constable signed a seven-year lease on the property for £250 a year from midsummer.[14]

Maria's miscarriage might reflect an early instance of the fragility in her health. Nancy, expressing the family's concern, offered what she called a good 'family recipee [sic] ... Bergholt Air, which ... with our care cannot fail of being beneficial'.[15] Maria rapidly became pregnant again, and ten months after the miscarriage she gave premature birth on 4 December 1817 to John Charles, his names uniting at last the Constable and Bicknell families.[16] Patty had assured John that next time Maria would 'succeed better', and now perhaps she had; but Nancy responded with the true instinct of a practical woman. She got on her 'black poney' (this was in the depths of December) and rode across East Bergholt to Mrs Heebles, a mother of twelve. She was

making bread for her crowded offspring when Nancy arrived, and Mrs Heebles agreed to allow her eldest daughter Hannah to go to London to be the Constables' nursemaid. Nancy warned her brother that 'profess'd nurse maids in Town, are often apt, to ensure good nights to <u>themselves</u>, to give the children under their management, medicines of a narcotic quality.'[17] Thus, Hannah Heebles might be a better bet.

Across the latter part of her life, the intelligent, loving and thoughtful Maria became something of a baby-producing machine for her husband. He did not let up on his conjugal rights. Even after producing a son and heir, Maria remained out of favour with her grandfather. Dr Rhudde had told Travis, on hearing of the birth: 'You must now approach me with additional respect, as I am a Patriarch'.[18] Rhudde then went on to criticise his suffering and exhausted granddaughter for failing to write to her Aunt Harriet, to inform her of her marriage, 'perhaps the birth of a son may do as well.' Travis became an ally for John and Maria: he chided the Rector, being possibly the only person who could, given his status as a medical man: 'For God in 'aven's sake Doctor, think of what you are doing, persecuting her in your life & after your death too'. Rhudde softened mildly, but closed by saying he would leave Maria 'a child's part, but with some little difference for acting contrary to friends' wishes.' It may be that in due time, and with the beginning of a new generation, this making of a 'Patriarch' was the spark that prompted the smallest shift towards rapprochement between Rhudde and his granddaughter. A year later, when Maria was pregnant yet again, Rhudde signed his will in which Maria was, at last, included.[19]

Although it was 'so small a house in so genteel a place', they now had more room: 'I am quite in heart with our little house in Keppel Street'.[20] Constable busied himself with arranging decorators and bought furniture,[21] and also acquired a six-foot canvas length, pinning it to the wall of his painting room, most probably at the front of the house, facing north.[22] On it he sketched a view of Dedham Vale from Gun Hill looking east towards the sea, a favourite wide and familiar prospect for him that he had drawn and painted many times. With the breadth and distance there expressed, he must have had Rubens in mind, particularly

Beaumont's great *Château de Steen*. This experiment, on the larg-
est piece of canvas Constable had yet worked as landscape, cannot
have satisfied him, and he painted it out and started again.[23] He
now marked out on that canvas a lively wide landscape of the
Stour at Flatford from his mind's eye and from some of the tonal
pencil studies he had made on the spot. He was in new territory
again: a modest subject to be attempted on a very large scale.
This time he kept the subject close, avoiding the wide vista. He
caught the flat river, with its island – 'The Spong' – on the left,
and the roof of the house belonging to their neighbour Willy
Lott visible under a curving treetop in the background. The sky
is lively and lush with warm, rain-filled cloud, the trees are in
their July green, and cows dip into the water on the opposite
bank. At what stage he introduced the principle figure is unclear:
a white horse, with collar, blinkers, harness and reins is being
gently carried over the river by two men poling the barge.

In this full-size study the certainty of Constable's application
is palpable; in fact the whole thing – the sky, the water, the flank
of the horse – pulsates with life.[24] He is working with speed and
vivacity, inspired, sweeping through the colour registers. The
sky explodes like tinted steam – grey, white, pink; the calm water
is expressed in horizontal strokes of the dry brush, except left
of centre, where the millstream rushes out into the river. On
the barge the men push away from the bank with energy and
urgency. Only the horse, placid, blinkered, its form slapped with
pure white pigment, is unaware of the human, meteorological
and hydraulic activities that continue. This is painting as dance:
the spirit in the paintwork can only have been invoked by way of
physical movement, sway and rhythm. Here Constable must have
been trying to work as we know Gainsborough did in his larger
portraits – back and forward to the canvas, near and far, looking
and touching; but while he could get close up to the canvas, Con-
stable's longer view was hampered by the constrictions of the
room. What a change in attitude and application this is from the
precision of *Boat-Building* and *Flatford Mill*.

Constable was thinking deeply about East Bergholt at this
time, travelling there in his mind, corresponding with Nancy
and Abram, and feeling the tug of his 'careless boyhood'. East

Bergholt House was now empty of his parents: 'I never enter this dear village without many regrets', he told Maria on one of his decreasingly frequent visits,

> the affecting sentiment of this roof containing now no more those who nourished my childhood & indulged my early years in almost every way. The thoughts of these dear memories fill my eyes with tears while I am now writing.[25]

The current family issues he had to attend to were the final arrangements for their parents' gravestone, which Constable was designing, and the house itself, which 'must be sold', John told Maria, 'the sooner the better, as it is an expence & loss to keep it.'[26] Abram and their sister Mary would move into the mill house at Flatford, while Nancy would live with Golding in Wheeler's Cottage on the heath. John added to Maria with great glee, 'the wretched Doctor has got the gout . . . [he] and all his party were very very seriously attacked at Cromer with a bowel complaint including Aunt <u>Farnham herself</u> & both the young ladies.'

The subject of the white horse on the barge remained high in Constable's mind. We know the first canvas as a study, but there is nothing to suggest that when he began to paint it he expected to repeat the subject on a fresh length. He procured another six feet of canvas, had it mounted on a stretcher, and began a second version of his picture of the horse crossing the river. Now, Maria was pregnant again: Maria Louisa would be born in July 1819. 'Like bottled wasps' they were, as Constable would remark later, 'upon a southern wall'.[27]

23. The humming top friendship

By contrast with the six-feet-wide sketch, there is a particular reserve in the finished painting of the horse on the barge on the river.[1] The energy in application of paint is reduced, becoming more reflective, but the sparkle remains on water and willow, and the colour volume is increased. The lead bargee wears a red jerkin that sings out against the green; the horse's yoke is red, and there are now four men in the boat, three pushing with poles and one at the left-hand margin nonchalantly smoking his pipe as he guides progress at the rudder. It is a landscape of metaphor as much as it is a description of a crossing of the River Stour, as significant in its tiny local moment as the crossing of Styx, Rubicon or Rhine. The painting has three movements, left to right: wooded island, human habitation, open country. The horse, with its back to us, is the only participant who cannot see what's going on, and is at a moment of rest between the exertions of towing the barge. All are linked by the eternal river in the height of summer, a moment of impending change.

The painting, modestly and hermetically titled *A scene on the River Stour*, was sent for exhibition at the Academy only weeks after East Bergholt House had been sold, its contents cleared, its auctions held, and lock, stock and barrel distributed around the county to land who knows where. Everything went, even the toys they had played with as children: 'the doll's bed . . . sold for a guinea, the child's waggon and sundry other toys 17s[hillings]', Nancy reported.[2] 'We have had three days sale', Abram told John. 'Upon the whole the things generally sold well, so everybody says . . . such a bustle.'[3]

A scene on the River Stour was the first in what became a series of large paintings, the 'six-footers' in which Constable became increasingly enmeshed. This first subject was painted with more careful delineation, less loose-wristed passion than its study, and provided the impetus that Constable needed to break through

the incomprehension that surrounded his previously exhibited landscape work. While constantly fretting about the progress of his art, he never looked back. 'We will call it if you please <u>Life</u> and the pale Horse, in contradistinction to Mr West's painting', Fisher told Constable after the Academy exhibition had closed – Benjamin West's *Death on the Pale Horse* had been a star exhibit that year.[4] The Archdeacon retitled Constable's painting as *The White Horse* as soon as he saw it: this is the title by which it has since been known. Furthermore, Fisher linked patronage to true friendship, and bought *A scene on the River Stour* for 100 guineas, the asking price, 'exclusive of the frame'. This, in Constable's experience, was a staggering amount of money, drawing the artist to reflect that Fisher should buy it for less: 'Why am I to give you less for your pictures than its price', the Archdeacon retorted, 'it must not be'. He paid the 100 guineas by instalments.[5]

The Fisher–Constable association was a needle-fine balance between supply and demand, rare in nineteenth-century art, and comparable more to the passage of twentieth-century techno-industrial innovation, where a rich man funds the development of a racing car on the evidence of previous potential and hope of future winnings. In the Fisher–Constable world a modestly comfortable, well-connected and secure professional supports an artist of inscrutable talent, divining his character through friendship and correspondence, but, try as he might, never quite grasping the extent of the artist's achievements. It was an association of trust, neither party knowing their joint destination, but each expecting to learn profoundly from the other on the way. Their common medium was their unshakeable Christian belief and Tory principles. In buying at the asking price – metropolitan art rates – the Archdeacon put himself at the sharp end of art purchase, buying a work that no others would touch, investing in expression that few understood, and enjoying imagery that many mocked. Constable's style of painting demanded new ways of seeing by the eye and the mind.

Archdeacon Fisher was a modern man, who recommended that Constable read *The Natural History of Selborne* by the Rev. Gilbert White, another progressive, intellectual modern parson, one with the kind of clear perception and innocence of

eye that anticipated Constable's own qualities. 'I am reading for the third time White's history of Selbourne [*sic*]', he wrote to Constable:

It is a book that should delight you & be highly instructive to you in your art if you are not already acquainted with it . . . I am quite earnest & anxious for you to get it, because it is in your own way of close natural observations: & has in it that quality that to me constitutes the great pleasure of your society.[6]

Constable's rapid response reflects immediately on their congruity of thought, as it directly follows his thoughts about another book recommended by Fisher, which he wanted to throw out of the window:

The mind & feeling that produced the 'Selborne' is such an one as I have always envied . . . it only shows what a real love of nature will do – surely the serene & blameless life of Mr White, so different from the folly & quackery of the world, must have fitted him for such a clear & intimate view of nature.[7]

The White Horse settled well in the Archdeacon's drawing room in the Close, Salisbury. Fisher hung it low, 'on a level with the eye, the lower frame resting on the ogee'.[8] It was opposite the fireplace, with the room's west window to its right and the garden beyond. This was 'right for the light of the picture . . . It looks magnificently. My wife says she carries her eye from the picture to the garden & back & observes the same sort of look in both'. The Fishers were ideal purchasers, making sure that *The White Horse* hung in the best light, bringing the outside inside and carrying the inside out. Mary Fisher's use of the words 'eye', 'light', 'observes' and 'look' indicates that she and her husband understood a patron's responsibility. Thus it is as a knowing in-joke that the Archdeacon describes his uncle's reaction to the import of *The White Horse*, a remark we do not have to take too seriously: 'The Bishop likes your picture, "all but the clouds" he says. He likes "a clear blue sky"'.[9]

While the Archdeacon recognised Constable's revolutionary power, the Bishop was an inadequate critic: 'Dolly has finished her

Claude [copy]. The Bishop doesn't know it from yours.'[10] Bishop
Fisher was something of a pedant, and relentless. He had been
bugging Constable to give a valuation and opinion on pictures
owned by the former Bishop of Salisbury, which were to be sold.
These included George Morland's *Pigs* (this fetched 37 guineas),
a copy of Reynolds's *Ugolino* (6 guineas) and a watercolour by
J. R. Cozens that the Archdeacon coveted: 'Get me the Cousins
[*sic*]' the Archdeacon asked Constable, who did so, saying 'could
pictures choose their possessors you would have had many like
it long ago.'[11]

One might be led to the conclusion that when he saw *A scene on
the river Stour* on the walls of Somerset House, Fisher immedi-
ately thought its title inadequate. Constable's own title, however,
before Fisher gave it focus, was intentionally unspecific. This
was and continued to be the artist's practice: since 1802, and
until 1818, thirteen of Constable's exhibits at the Academy had
been titled '*Landscape*' or '*A Landscape*', a few later ones having
'*Boys fishing*', '*Morning*' or '*The ferry*' tacked on for their slight
additional information. These were invariably Suffolk/Essex
scenes; his Lake District exhibits were specified as *Borrowdale*,
Windermere and so on. In his large paintings of the Stour Valley,
Constable came to present a world view through the paradoxical
use of very localised subject matter. This was the heart of his
purpose. It was so different to the way Turner went about things:
his picture titles are long and serpentine, and pile on allusion and
explanation, even unto compass-bearings. When in 1819 Consta-
ble exhibited *Scene on the River Stour*, Turner showed *Entrance of
the Meuse: Orange-Merchant on the Bar, going to Pieces; Brill Church
bearing S.E. by S., Masensluys E. by S.* This reads as if it might be
three paintings at least. It is, of course, one.

There are many other examples of lengthy titles and lines of
verse inserted by artists to introduce, signal and enlarge cata-
logue space for their paintings. Constable went the other way, to-
wards clipped discretion and silence, a policy that his audiences,
beginning with the Fishers, endlessly frustrated. In 1817 he had
exhibited what he titled *Scene on a navigable river*, now known
universally as *Flatford Mill*. In 1820 he showed *Landscape*, which
we now know as *Stratford Mill*; in 1821 his exhibit was *Landscape:*

Noon, now known the world over as *The Hay Wain*; in 1824 *A boat passing a lock*, now known with its greater focus as *The Lock*; and, most pointedly, in 1825 *Landscape*, which is now known and forever shall be as *The Leaping Horse*. Even the 1822 exhibit, *View on the Stour near Dedham*, has its disjoint between subject and title, because it is not near Dedham (the church tower is prominent far in the background) but at Flatford Lock. How this disjoint in his expressed intentions affected him is unclear. The Archdeacon referred to *Landscape: Noon* as 'The Hay Wain' even while it was being painted, and Constable himself once called the painting 'Old Billy Lott's house'. However, to have his considered and published picture titles immediately done away with cannot have been wholly pleasing.[12]

Constable sent his pictures into the world effectively untitled: *'A Landscape'* is a generic title, akin to abstract paintings of the 1960s and 1970s being known as *Untitled*. In those days it gradually became clear that *Untitled* was actually a title, so curators had to use the notation '[no title]' when cataloguing such works. Constable was unintentionally zealous in this: when referring to individual paintings in correspondence he would say 'my large painting', so one has to work quite hard to determine which large picture he might mean. It was these large paintings that Constable discussed with the Archdeacon, trying to make it clear that they were a watershed: he was uncertain enough about their progress as it was. 'I should almost faint by the way when I am standing before my large canvases was I not cheered and encouraged by your friendship and approbation.'[13] Later that year (October 1821) he admitted to the Archdeacon, when *View on the Stour near Dedham* was in his mind, 'I do not consider myself at work without I am before a six foot canvas.'[14]

The rapport between Archdeacon Fisher and John Constable found its expression in the early 1820s, when their letters to each other catch fire. Fisher is clearly affected by their association, and begins to see the world through Constable's eyes:

> A large black misty cloud hung today over the sea & Portland. The Island could be but just discerned. The smoke of Weymouth was blown off towards Portland & was illuminated by

the Western sun & relieved by the dark cloud. As I rode home
a complete arch of a rainbow came down to my very feet: I saw
my dog running through it.[15]

Their correspondence – fifty-seven letters survive from Con-
stable; ninety-nine from Fisher – is seminal to an understanding
of both men and of their deep and occasionally quarrelsome
friendship. This was lifelong, and embraced older and younger
Fisher generations as their families grew.[16] John Fisher's aunt,
the Bishop's wife, loved Constable, and said that he had 'the ap-
pearance of one guileless.'[17] Both Bishop and Archdeacon sup-
ported him in buying pictures, commissioning him, and lending
him money when he was short. The Archdeacon settled a debt to
the Salisbury solicitor John Tinney by giving Tinney the 1820
six-footer *Stratford Mill*, bought for the purpose for 100 guineas
from Constable. Furthermore, the Archdeacon reminded him,
'my house is always open to you. I never want even notice to say
that you are coming.'[18] Their friendship brought out Constable's
unease about himself and his abilities, but gave him confidence
also: 'I now fear (for my family's sake) I shall never be a popular
artist', he wrote in 1821,

> a Gentleman and Ladies painter – but I am spared making a
> fool of myself – and your hand stretched forth teaches me to
> value my own natural dignity of mind . . . above all things.[19]

The friendship between Constable and this man of insight and
natural cultural understanding was as crucial to Constable's
confidence and sense of direction as was, for example, Gains-
borough's friendship with the actor David Garrick, and Turner's
with the Yorkshireman Walter Fawkes. With John Fisher to talk
to, Constable ceased caring what people said. London artists,
he confided, 'know nothing of the feeling of a country life (the
essence of Landscape) – any more than a hackney coach horse
knows of pasture.'[20] Like many good friends they could exasper-
ate one another. This exchange is typical: Constable has confessed
to losing his temper with the French dealer John Arrowsmith,
deeply involved in buying paintings from him, and John Tinney
is also wanting to buy a painting. Fisher spoke his mind, and in

return Constable articulated his priorities and sensibilities as an artist:

> *Fisher.* We are all given to torment ourselves with imaginary evils – but no man had ever this disease in such alarming paroxysms as yourself. You imagine difficulties where none exist, displeasure where none is felt, contempt where none is shown and neglect where none is meant. . . . [Tinney] says you are a devilish odd fellow. For you get your bread by painting. He orders two pictures, leaves the subjects to yourself; offers ready money & you declare off for no intelligible reason.[21]

> *Constable.* It is easy for a bye stander like you to watch me struggling in the water and then say your difficulties are only imaginary . . . You are removed from the ills of life . . . My master the public is hard, cruel & unrelenting, making no allowance for a backsliding . . . Your own profession closes in and protects you, mine rejoices in the opportunity of ridding itself of a member who is sure to be in somebody's way or other . . . I live by shadows, to me shadows are realities.[22]

While Constable's political views embraced anti-Reform Toryism, his humanity directed him to leaven his politics with a strong admixture of charity, patronage, unaffected sympathy and understanding of the plight of the rural and urban poor. From his high pulpit in the established Church of England, on the other hand, John Fisher had a different perspective, one in which he saw the Church being increasingly under threat:

> The vulture of reform is now turning its eyes on the Church & is preparing to fix his talons in her fat . . . There is a party who wish to reduce the clergy of this country to the level of the Scottish Kirk. No incomes larger than £180 per annum. The consequence of this will be that no gentleman or man of intellect will enter the profession.[23]

This was a tactless opinion to put to Constable, who was himself struggling on an uncertain income, while Fisher was drawing in excess of £450 p.a. He chided Fisher, telling him that his view 'does not speak [of] a just state of mind or thinking',

adding,

> the Nobility hate intellect – it is always in their way, and the
> only thing they are really afraid of ... consider the ages they
> have stood and the storms they have weathered. Let me hope
> your fears belong too much to yourself.[24]

The friendship of these two men, reasonably aligned in their
judgements and world view, was strong enough to admit their
differing shades of opinion. Bishop Fisher's description of
Constable as the Archdeacon's 'humming top friend' throws a
shaft of light on Constable's restlessness and his effect on the
ecclesiastical Fishers.[25] Through their elegant and informed
correspondence, their conversations are as vibrant today as they
were two hundred years ago: 'I like your conversation better
than any man's,' Fisher told him, 'and it is few people I love to
talk to.'[26]

With *The White Horse* now in their minds' eyes, Constable's
peers and elders considered his candidature for Associate of the
Royal Academy on his seventh attempt at election. He was inured
to failure, and told Farington on 1 November 1819 that 'he had
no expectation that Callcott would ever vote for him', and that
Thomas Phillips had advised, with an unpleasant condescension,
that he would do well to look carefully at Turner's 'Drawing
Book' to get some ideas, and 'learn how to make a whole.'[27]
With a heavy heart Constable awaited the result of the vote.
'Royal Academy General meeting I went to', Farington recorded.
'Members present: Fuseli in the Chair. Farington, Smirke, Sto-
thard, Shee, Soane, Rossi, Philips, Callcott, Westmacott, Bone,
Bigg, Mulready, Chalon, and the RA Secretary, Henry Howard
... There were 38 Candidates.' Among these were John Consta-
ble, Benjamin Robert Haydon and Charles Leslie. The voting
was scattered, but from the fourteen voting members Constable
received six votes in the first round, and eight in the second. He
was at last a winner. After years of trying, years that he could
measure by their dismal pulses of discord, disappointment,
sidelining and exclusion, Constable could add to the triumph he
attained when he vanquished Dr Rhudde and married his love,
with election as Associate of the Royal Academy. A runner-up

was his American friend Charles Leslie, while Haydon was elim-
inated. Farington told him the result, 'which he heard with great
satisfaction.'[28]

Turner had been an ARA since the age of twenty-four for
nearly twenty years already, Wilkie since 1809 (aged twenty-
four), Collins since 1814 (aged twenty-six), Mulready since 1815
(aged twenty-nine) – and the relatively youthful Mulready was
now among the electors. John Constable ARA was forty-three
years old, a married man and father of two. 'Let us now hope,'
the Archdeacon wrote with benign practicality, 'that ARA will
add a few guineas to the price of your pictures & enable you to
live as comfortably as you could desire.'[29] Associateship of the
Royal Academy was an accolade like none other, a sign of peer-
approval, but one demanding continued excellence in the art. It
was a signal to the uncertain Constable that he was indeed ap-
preciated and acknowledged, and while the prize had come late,
Fisher offered from the sidelines a proud assertion of its glory:

> Honourable it is: for the Royal Academy is in the first place an
> establishment of the great country . . . you owe your place in it
> to no favour but solely to your own unsupported unpatronised
> merits.[30]

Then, with much justification patting himself on the back,
Fisher added: 'I reckon it no small feather in my cap that I have
the sagacity to find them [your own unsupported unpatronised
merits] out.'

Constable himself seems to have kept quite tight publicly about
the accolade, though he did triumphantly confide to Abram:

> I was last night by a large majority elected an <u>Associate</u> of the
> <u>Royal Academy</u> – therefore I am now <u>J. Constable A.R.A.</u>
> for which I most humbly & sincerely thank them.[31]

24. On Hampstead Heath

Keppel Street induced mixed emotions in John and Maria. The little house gave John much joy: he had more room to paint, space to move and expand, even a yard at the back. It was close to the British Museum, where his friend J. T. Smith was now employed as a curator, five minutes from the Boar and Castle in Oxford Street where the coach picked up passengers to Ipswich, and ten minutes' walk to Somerset House and the Academy. Coach stops at Charing Cross and the Spread Eagle in Gracechurch Street for Suffolk and Essex were also within easy reach. That, however, was the problem: to Maria it was also deep in the heart of her 'hated London', a place of foul smells, filth and disease.[1] The London that this sophisticated young town-and-country woman knew best was marginally cleaner, further west in the generous houses of Pall Mall, Piccadilly, Whitehall, Spring Gardens, Stratton Street, the homes of aristocrats, government officials, politicians and her own family, not this poky little place down its narrow street with its coal merchant and at least five other trading businesses nearby.[2] Building sites were encroaching, and there was a noisy Anabaptist chapel in the street where adult dissenters were baptised to much urgent confession, crowds and wailing.

Constable was missing his son as he travelled back and forth to East Bergholt. The two-year-old John Charles and Maria, now six or seven months into her third pregnancy, had briefly escaped Keppel Street and were staying on Putney Heath in Bristol House, the Bicknell family house they called 'the Castle', on account of its many extensions. They also called it 'Louisa Cottage', because its most regular inhabitant was Maria's younger sister.[3] Despite its damp, Maria loved it, and loved the flowery gardens around. 'Kiss my darling a thousand times', John told Maria, 'call him my boy, my lovely boy, my darling Duck and tell him it is all from me – his father who is always talking about him . . . how I have been

tormented to see you.'[4] But he had work to do, and that was that: paintings were stacking up, and in East Bergholt he had to help his brothers and sisters deal with the aftermath of their parents' deaths. Life for the Constables of East Bergholt was busy with excitement and change, and John was necessarily swept up in it.

During March and April 1819, Dr Rhudde gradually lost his grip. He had been found one morning confused and forgetful when he was supposed to be travelling to London: 'the Doctor seems to be lost very much sometimes . . . cannot continue long, not many days, in all human probability.'[5] When Rhudde died on 6 May, Constable told Maria that her grandfather had been out of his mind, wandering from room to room looking for his dead wife.[6] The news of Rhudde's death seems to have brought relief to the village; his memory did not linger there: 'We never hear the Doctor's name mentioned in any way whatever', Abram told John the following month, 'clean gone.'[7] They buried him and forgot him. 'I will endeavour to forget those unhappy divisions & violent agitations', John told Maria.[8]

When the will was proved in July there may have been a rallying of residual affection: Rhudde bequeathed £50 to the poor of East Bergholt – those considered 'of the best character for honesty sobriety diligence and regular attendance at public worship' – and £50 for the 'poor children' of his other parishes, Brantham and Great Wenham, 'towards paying for instruction in reading'.[9] At the reading of the will they heard that Maria had at last been returned to her grandfather's legal embrace, if not his affection, and was left, under her married name, £4000 invested in 3 per cent Consols, which would produce an income of £120 a year. Her brother Samuel and their two sisters, Louisa and Elizabeth Catherine, would receive the same. These were, however, comparatively meagre crumbs which did not demonstrate equity between Rhudde's two daughters: Harriet Farnham inherited Rhudde's entire property in houses and land, including for her lifetime, the Bogdani Suffolk estates.

Across these months of change in East Bergholt John took himself off on his walks, sometimes alone, sometimes with Abram at his side. Some things changed, like the seasons, land ownership and crop rotation, but the shape of the landscape

remained. He went to Holton Hall, a mile and a half away, and at a high pitch of receptivity walked to Langham, high above the vale: 'in my life I never saw Nature more lovely ... Every tree seems full of blossom of some kind'.[10] John went here and there to the family's mills, made sketches, watched the barge traffic, the horses at work, the carts, the dogs, the builders repairing the mill house for Abram and Mary. With the influx of money from the sale of East Bergholt House, the new generation was replenishing its roots and getting ready for the future.

Constable knew his wife and son were safe and comfortable. Nonetheless, Maria responded crisply when it was time for them to come home; there was fever about in Putney, 'so I think on every account we may be glad we are coming, it must help to reconcile me to hated London. Let the sheets be well aired on the nursery bed, & a nice piece of roast beef for our dinner.'[11] John was all right; Maria less so. On 19 July, at a quarter before midnight, she gave birth to Maria Louisa (Minna), who was the image of her father.[12] Taking modern medicine seriously, they bravely engaged the still dangerous innovation of vaccination, already long practised on children in East Bergholt by Mr Spargin at 2/6d a shot.[13] John, in his element attending to detail, would later record in the family's Bible their children's births and birthplaces, god-parentage, vaccinations and infectious illnesses. John Charles was vaccinated against smallpox in February 1818, Minna in December 1819, and across their childhoods both survived whooping cough and measles.[14]

Sitting quietly by Minna's cot, Maria would listen to her baby breathing; lying together in bed, John and Maria would hear John Charles's agonising whoops and coughs through the night, and listen to the dull sounds of London in the small hours. A troublesome neighbour, Mrs Peartree, 'a bad woman', battened on to them in Keppel Street, paying, they felt, much too much attention to tiny Minna.[15] They became desperately anxious as Maria's health deteriorated and she gradually weakened. John also complained, year by year, of congested lungs, cold, infection, depression and his chronic toothache. This was emotionally and physically exhausting, as well as time-consuming and expensive in apothecary's bills, and they had to take action.

Soon, after Rhudde's death, Minna's birth, and the change in their circumstances following Maria's inheritance, Constable moved the family north of Keppel Street, up the long, slow Haverstock Hill to Hampstead. From George Fisher, a high-class poulterer in Duke Street, St James's, and no apparent relation of the Bishop and Archdeacon, they rented Albion Cottage (now disappeared) near Whitestone Pond in the fresh and open air at the top of Heath Street. This move, which was perhaps encouraged by Anthony Spedding, Charles Bicknell's partner who lived at Heath House, beside Jack Straw's Castle, took the family out of the smoke and filth, and also gave John the space to get on with his work in London.[16] Hampstead became a haven for rest and recuperation where Maria and the children would have good air, and John could easily commute to join them from Keppel Street, four miles away. Coach services were frequent: there were at least seventeen quick-paced return journeys daily from the city to Bird in Hand Yard behind Hampstead High Street, and forty or more services from the West End of London.[17]

What Hampstead shares with Constable's homeland is its domed height, its distant views, its sandy, spongy soil and heathy healthiness. There is a tiny morocco-bound sketchbook in the British Museum dated 'Hampstead – Sep 9th 1819' in which Constable made pencil notations of what must have been his first sight of the Heath and its activities – horses and carts, men digging, distant vistas with distant roofs, the parish church in its landscape.[18] Like Suffolk, Hampstead Heath had winding tracks, sudden ponds, lush bumpy grass and the sky-space for clear, unbroken weather fronts, wind-channels and cloud nurseries to develop. Where it differed was that there is no slow river running across Hampstead Heath, like the Stour in Dedham Vale, no sudden contrast in height between heath and vale, and no barges or heavy horses. There were, however, dells and copses, rough, unkempt hidden paths, all discreet places for ideas to hide. And more: it has distant views of London sparkling in the sun, a sight sometimes of a celestial quality which Suffolk could never match. Hampstead Heath was, for Constable, an escape from Suffolk, a place free from his old responsibilities: no ailing parents, no complicated siblings, and more to the point, no crucible of

memory of the odious rector, the constant heartache of love, and the burden of being an interesting boy in a remote village. Hampstead settled well in the family's bloodstream: on one of the pages of the sketchbook Constable has written: 'The pretty drawing on the next page was done from nature by Maria Elizabeth Constable', Minna.[19] For John and Maria's children focus switched 180 degrees: Constable wrote, when Minna was nine, that she 'thinks Suffolk very like Hampstead.'[20]

Constable's painting was immediately set alight by Hampstead: the sky is always present in earlier Suffolk and Essex subjects, but in paintings of the Heath it begins to dominate the canvas, now taking up more than half the area, and becoming the main actor on the stage. At home in East Bergholt Constable knew too much about his landscapes and what went on in them, the animals, the houses seen through trees, the watercourses, the activity of a milling life. Hampstead Heath, on the other hand, was new-found land for him. Stepping outside the front door of Albion Cottage he could sit and paint the view north-west towards Harrow, with Whitestone Pond – the highest point within London's modern boundaries – and, at a lower level down to the west, Branch Hill Pond, with a large house, The Salt Box, beyond.[21] Maria might sit beside him, enjoying the passing clouds, watch over John Charles taking his first steps on the sandy level, and bounce the baby on her knee. If Hannah Heebles had ever joined the family as John Charles's first nursemaid, she had gone home by now, to be replaced by Elizabeth Roberts.

In the first Hampstead paintings Constable let his brushes fly with the excitement he saw around him. In *Hampstead Heath with the Salt Box* a bushy tree breaks the horizon,[22] and in that detail, and only that, it is comparable to the painting of his home valley, *Dedham Vale: Morning* (1811). The distant hill at Harrow, however, is of a different scale to the Suffolk ridge: it is grand, imposing, moody, creating a huge perimeter to the extensive scene which makes Dedham Vale seem like a saucer in comparison. The sky is taking on a new life, too; again, he has let rip. In another version of the subject, *Branch Hill Pond, Hampstead*, he painted sensation in a stirring evocation of a passing storm. The turbulent sandy bank in the foreground, probably higher than in reality, serves as

a foil to a sky seething with present and incipient rain. A distant squall comes near, expressed by pulled grey paint, and flat, sharp light painted with a blade. The sun illuminates meadow, trees and pond with flash and sparkle, before the windswept clouds in the gathering storm.[23]

Constable took himself out in the weather, daring it, challenging it, getting wet and cold, while Maria, Mrs Roberts and the children had run inside to put a kettle on the fire. He was a man of action when he was in the field: Henry Trimmer reported how Constable put on his great coat 'and sallied forth in a snow-storm to Hampstead Heath to sketch an ash for some picture he was about.'[24] He took fieldwork seriously: Trimmer also remembered seeing him 'lying at the foot of a tree watching the motion of the leaves, and pointing out its beauty.' Looking down into a ditch he would say that he 'could see the finest subjects for painting.' With his discovery of Hampstead Heath, Constable put a marker down for his future. This was a place from which he could operate and venture forward; an alternative to the Stour Valley. In Hampstead he discovered a new focus, and from its heights he could see the Stour Valley in a new perspective.

It is no coincidence that it was on Hampstead Heath that he embarked on his series of independent cloud studies, many of them pure sky, nothing else – there are more than one hundred across 1821 and 1822, painted in oil on paper or card.[25] These were the skies that prompted Constable to urge Fisher to see that always the sky is 'the "key note", the standard of "Scale", and the chief "Organ of sentiment".'[26] When Constable says 'organ' he means the huge instrument at the back of a church that blasts out complex chords and startles the congregation. This is no abstract noun, but a clear musical descriptor, as the churchman Fisher, at whose call the organ would sound, will have appreciated immediately. Such musical analogies as this, and 'key note' and 'standard of "Scale"', pepper Constable's writing and enliven our understanding of his purpose.

Constable's understanding of the grandeur of the skies was sharpened by the work of two meteorologists: Luke Howard, who proposed names for cloud types in his *Essay on the Modification of Clouds* (1803), and Thomas Forster, whose *Researches*

about Atmospheric Phaenomena (1815) broadened understanding
of the science of the skies. The portmanteau words introduced
by Howard – cirrus, cumulus, stratus, cirrocumulus and others –
seem to appear only once in the inscriptions on Constable's stud-
ies,[27] but nevertheless clouds of all the types were in the air as
Constable looked upwards and began to articulate his thoughts.
He made a close reading of Forster's book, and annotated his
copy, sometimes taking issue: where Forster writes that stratus
'may properly be called the cloud of night', Constable interjects:
'but not in [?bad] wheather'; and to Forster's assertion that
cumulostratus sometimes 'overhangs a perpendicular stem, and
looks like a great mushroom', Constable confirms his experience
of wild weather by adding: 'it is only [. . .] a mushroom in thun-
der'.[28] These are Luke Howard's clear and determined words in
his lecture given in London in 1802–3:

> If Clouds were the mere result of the condensation of Vapour
> in the masses of atmosphere which they occupy, if their var-
> iations were produced by the atmosphere alone, then indeed
> might the study of them be deemed an useless pursuit of
> shadows . . . but . . . they are subject to certain distinct mod-
> ifications, produced by the general causes which effect all the
> variations of the Atmosphere: they are commonly as good
> visible indications of the operation of these causes as is the
> countenance of the state of a person's mind or body.[29]

Constable was constantly looking at the skies in Hampstead,
enjoying their variety of effect, studying them day after day as
he had in his youth at East Bergholt windmill. He observed them
now not as a young miller but as a natural philosopher observing
the elements and the forces of nature. At this exact same time,
practically to the hour, in the basement laboratory of the Royal
Institution down the hill in Albemarle Street, Michael Faraday
discovered how an electric current could make a wire move round
and round 'in a never ending circle . . . I have succeeded not only
in shewing the existence of this motion theoretically but exper-
imentally and have been able to make the wire revolve round a
magnetic pole.'[30] This was the discovery of electromagnetic ro-
tations, the principle on which the electric motor rests. Between

the third of September 1821, when Faraday's wire whizzed
around its central support, and the twelfth, when he described
this success to a French scientific colleague, Constable painted at
least four small oils on paper of the sky above Hampstead. Little
tufts of trees emerge at the bottom edge of the paintings to
ground them, and in each case the sky is alive with cloud – cumu-
lus, cirrus and cirrostratus. Hampstead, where all this happened,
was John Constable's laboratory, and he would come home from
this laboratory muddy, dishevelled and wet, but happy.

On the back of one of the sky studies he wrote:

September 3d. Noon, very sultry, with large drops of rain fall-
ing on my palate. Light air from SW.[31]

Constable's notes on his cloud studies are as clear and fresh as
Faraday's notes written that very same day:

September 3d. The effort of the wire is always to pass off at a
right angle from the pole, indeed to go in a circle around it . . .
Very satisfactory.[32]

Like Faraday, Constable was, now, uncovering secret laws. He
was fully aware of electricity, its presence in the air, as he noted
in a top margin of his copy of Forster: 'heat wind[?s] electricity
moisture'.[33] In Hampstead, Constable could experiment away
from the pressures of London and the highly competitive world
of art. As breezes ruffled his hair, as rain fell on his palette, he
would remember advice that Benjamin West had given him in his
student years: 'always remember, sir, that light and shade *never
stand still* . . . Continuity all is continuity.'[34] He was now acceler-
ating his practice, learnt in the Lake District fifteen years before,
of carefully dating his studies, and making a note of the location
and weather conditions.

They were content in Hampstead at first: Albion Cottage on
the Heath in 1819 and probably also 1820, then in 1821 and
1822 lower down the hill to the west, nearer to the Salt Box,
at 2 Lower Terrace. There he would lay his skyscapes out to
dry. One sprightly landscape view shows Anthony Spedding's
Heath House, where the families developed the friendship that
would continue into John's final years.[35] Constable told Fisher

in September 1821 of some studies of 'a natural (but highly elegant) group of trees, ashes, elms & oak &c' at Hampstead. Those trees particularly pleased him, and for a moment he could see that they might have a greater purpose, and one day fetch as much money as 'the field and hedgerow which contains them'.[36] They delighted one particular old man who had walked up to Hampstead from London. This was the artist and poet William Blake visiting his friend John Linnell, and evidently calling on the Constables also. 'Why, this is not drawing but *inspiration*', he said when looking through one of Constable's Hampstead sketch-books. Constable demurred: 'I never knew it before; I meant it for drawing.'[37] His confidence was rising; he was beginning to know his value. It had been a glorious autumn; Hampstead Heath was at its best, Constable was primed and pricking: 'The last day of Oct' was indeed lovely so much so that I could not paint for looking – my wife was walking with me all the middle of the day on the beautiful heath.'[38]

Constable's Hampstead was a relatively circumscribed area, each extremity – Lower Terrace to the west and the later addresses in Downshire Hill and Well Walk to the east – being within five minutes' walk of the village crossroads at Heath Street, Holly Hill and High Street. When at Stamford Lodge, their 1823 rented home, they were just beside the upper end of Heath Street, only a minute or two from Whitestone Pond.[39] The family lived in at least six addresses in Hampstead across the nine years between 1820 and 1828. This restlessness chimes poorly with their need to allay Maria's ill health, and while local landlord demands and leases must be taken into account, it does mirror the restlessness of Constable as a bachelor, when he moved between at least seven London addresses before he married.

As Constable's attachment to Hampstead grew fiercer, so he moved east, to 1 Langham Place, Downshire Hill (1826) and 6 Well Walk (1827 until 1834). They disliked Downshire Hill intensely: 'what a disagreeable place it is', Maria told her husband after reading of an opportunist theft of silver there.[40] 'I am glad we have left Downshire Hill', John replied, adding a couple of days later from Flatford Mill, 'our nice house in Well Walk far exceeds any of the houses inhabited by any of my family here

for comfort and convenience.'[41] Each move of the family brought them closer and closer to the one thing that might mitigate Maria's consumption, the waters of the chalybeate (iron-rich) well and spring – hence Well Walk – instigated as a public good in the seventeenth century by the Countess of Gainsborough. More of that later – but how extraordinary that beside the well to which the family gravitated, the source of Maria's chances of a healthy life, Constable should be reminded of the name of his hero, Thomas Gainsborough.

One afternoon, perhaps in Hampstead, or more likely at Keppel Street, Constable turned over a little wooden panel on which he had once made an indifferent copy of one of Beaumont's Dutch landscape paintings.[42] With John Charles and Minna wriggling on Maria's lap, he called for them to try to sit still. The back of the panel had already been covered in a dark primer, and with Maria holding the children as still as she could, John adjusted a curtain, and with flicks of his brushes, and some pink and orange tint, he evoked Maria's fragile features in a moment. A touch of red to her lips, blue to her eyes and some dark ochre for her exuberantly curly hair, and there she was, looking out at her husband. The children had been stilled by now, engaged with the book in front of them, and paler blues and greys, with touches of pink and light brown were quickly added before they were distracted from the book to see what was happening. Some white to Maria's collar, a flick of red at the window, and it was done. They shook themselves like puppy dogs, shimmered from their mother's lap, and ran round to see what their father had painted.

We are witnessing a moment towards the end of a day when Constable's brushes were still wet and paint-laden. He has had enough of the six-footer in front of him, and here real family life bursts in, thankfully distracting him. The mahogany desk, its edge a strong brown horizontal, is clearly sloped, and may be the artist's drawing table. We are with the family at the beating heart of Constable's practice as an artist, the paint he has just used up for his family being the final tails of the colours he has been working with all day.

Constable relaxing is as joyful as Constable at work, his hand

and arm now loose and supple after a day's employment. There are a good number of small works of this kind, where the children reach and wriggle, and Maria or Elizabeth Roberts keep them occupied. With his pencil or brushes, Constable opens the door of his heart in these little works, so rapidly achieved that they share the intimacy and immediacy of his correspondence.

25. I think it promises well

Beneath its filth and smoke, London was a dangerous place, politically unstable at a time when Queen Caroline had returned to England to claim her right to share the throne with her estranged husband, soon to be crowned King George IV. The streets were illuminated with flaming torches to deter troublemakers; windows were broken by the mob in support of the queen, or as an excuse for a smashing night out. The Constable family's move to Hampstead came much to their relief:

> I am glad to get them out of London for every reason – things do not look well though I fear nothing – but the Royal Strumpet has a large party – in short she is the rallying point . . . for all evil minded persons.[1]

Constable's unequivocally royalist political and social opinion expected a smooth transition from the reign of George III. His closest friend, the Archdeacon, shared these views, having formed his career, livelihood and sense of self on the principles and practices of the Church of England, and never deviated. He preached from the King James Bible, offered his prayers from the 1662 Book of Common Prayer, conscientiously tended his flocks on his archidiaconal circuit, and subscribed faithfully to the Church of England's Thirty-Nine Articles of Religion. It comes as something of a surprise, therefore, that John Constable and John Fisher, both conformist, devout and unswerving in their ways of life, could nevertheless harbour revolutionary vision. When the Archdeacon suggested they go together to Fonthill Abbey to view William Beckford's sale in September 1822, Constable waited until it was all over before putting his cards on the table:

> I do not regret not seeing Fonthill. I have never had a desire to see sights – and a gentleman's park – is my aversion. It is not beauty because it is not nature.[2]

There is his revolution. Constable describes a complex painterly idea to Fisher: 'Certainly if the Sky is <u>obtrusive</u> (as mine are) it is bad, but if they are <u>evaded</u> (as mine are not) it is worse . . . The sky is the "<u>source of light</u>" in nature – and governs every thing.'[3] He goes on to write with feeling of 'Mill dams . . . Willows, Old rotten Banks, slimy posts, & brickwork. I love such things . . . As long as I do paint I shall never cease to paint such Places. They have always been my delight.' From his direction, here is Fisher writing to Constable of the Dorset coast in colours he can only have extracted from his friend's paintings: 'To day is bright & delicious. The sea a deep blue. The shingle bank a bright gold, & the cliffs in brilliant patches of green owing to the constant rain.'[4] Their mutual respect and the high value they placed on their friendship was asserted by Constable when he wrote: 'that <u>love of patronage</u> which you mention, brought me known to you, and your excellent family, & which has brought with it most of the great blessings of my life.'[5]

As the years went on the friendship developed, and Fisher and Constable made themselves available to each other for prescient professional advice: 'Get rid of your <u>two</u> houses,' the priest urged the painter, 'as soon as ever the hot weather is over & paint some portraits. You will then keep yourself independent of the world & may consult your own taste only for Landscape.'[6] 'I will do all I can for you in this matter', the painter assured the priest when giving advice about the stained glass at Salisbury Cathedral, which was showing signs of corrosion.[7] He recommended a man from Birmingham, who 'often has large assortments of Antient Glass', adding trenchantly, 'all the modern glass which I have yet seen, makes me sick.' Fisher shared Constable's fascination for old master painting, and urged his friend to join him in touring to grand churches and, despite animadversions, rich men's houses to see what they could see. Together they visited, or planned to visit, Winchester Cathedral, where 'the roof has been nearly falling in: owing to the constant cutting the 4 great supporting pillars to let in monuments (of folly & bad taste)',[8] and Longford Castle to see Lord Radnor's old master collection. Generally when Constable went to grand houses it was to work: to Wivenhoe Park to paint the house and portraits; the weeks

with the Dysarts copying their portraits in London and Suffolk, and to Malvern Hall near Solihull for further commissions for Henry Greswold Lewis.[9]

Malvern Hall had been done over in the 1780s by John Soane, at Lewis's expense, but Lewis did not like what he saw and tore it all out again. Such fickleness and volatility might have served as a warning to Constable, but he ploughed on anyway and continued not only with the multiple Lewis portrait commissions but took on the complex exercise of the production of a historicising portrait of Lewis's ancestor Humphri de Grousewoulde 'who came over with William the Conqueror, & settled at Yardley within 5 miles of this place.'[10]

Lewis was a major landowner around Solihull and Leamington in the midlands of England, who wished to celebrate his family's history as far back as the Norman Conquest. His expansive and voluble letters to Constable are written in a scrappy hand, but bounce along with verve and vigour, filling the pages, squeezing every square centimetre out of the space available. He told Constable exactly where he could find source material for the painting of this 'Norman warrior in his Norman armour of coat armour for a panel in the stair case window, painted on Board, and an oak carved frame, after the old patterns'.[11] He recommended that Constable look at Montfaucon's engravings, at Froissart' *Chronicles*, at the Norman horseman in Bullock's Museum in Piccadilly, in the Dysart's library at Ham House, and at the British Museum 'close by you'. All this was a long way out of Constable's comfort zone, and it turned out to be one of the worst pictures Constable ever painted. Lewis would not be brooked: like Fisher, he had the ability to stop Constable taking himself too seriously.

Lewis, racked with gout for years, retained his sense of humour and his direct manner of criticism. He handed his Constable portraits out to friends and family, and of one version he said frankly: '[Mr Bruce] expressed a wish that his picture [of me] might be improved ... [I] think it not the best of your performances, & certainly might be much improved'.[12] This multiple commission was dragging on and on, but when the fourth version was delivered in 1813 after four years, Lewis was able to tell Constable that 'it is the best picture of Henry Greswold

Lewis now extant'.[13] Even so, this was not be the final one: that would be completed in 1827.[14]

Constable struggled with his Norman soldier, which was more Dunthorne country than a job for him. He endured Lewis's criticism for showing the wrong kind of lance or omitting a sword: 'I have had a hard battle [with my Norman warrior]', he told Fisher, 'his being in compleat armour made it almost too much for me.'[15] Fisher found an apposite remark when reading a text of Leonardo da Vinci that they enjoyed together, as Constable struggled with depicting lance and armour: '"One painter ought never to imitate the manner of another, because in that case he cannot be called the child of nature, but the grandchild."'[16] Here they were, Constable and Fisher, like two diligent students telling each other of their discoveries and enthusiasms.

Across this period of breath-taking experiment in Hampstead and pedantic historicising in Warwickshire, Constable began also to take his eye towards entirely new subject matter in comparison with the Stour Valley, the Lake District, Salisbury, Hampstead or Solihull. This was an idea for a painting of the heart of the metropolis, a celebration of modern life in the trading, political and social empire that was spreading across the globe from the centre of London. The Thames had been bridged since Roman times, and now London, Westminster and Blackfriars bridges were being joined by a fourth structure, to be called Strand Bridge. This had been under construction to designs by John Rennie since 1810. A recent battle, however, brought on a change of name, and on the second anniversary of the Battle of Waterloo, 18 June 1817, the nine-arched, granite bridge was opened by the Prince Regent, and named after that previously unknown village near Brussels: 'Waterloo Bridge'. It was one of the great engineering achievements of the decade, an audacious challenge to a boisterous and changeable waterway on which the wealth of the nation depended. Here was a subject that would raise Constable out of the rich but circumscribed melody of his Suffolk landscapes, and transform his work into new movements, new keys and new chords. 'I have made a sketch of my scene on the Thames – which is very promising'.[17]

Constable was on or near the river bank during the bridge

opening ceremony, and witnessed the razzamatazz surrounding it. He made a little oil sketch, one which he then mulled over in his mind and conversation for some months. We could almost be in Venice, so large, colourful and grand is the flotilla in the foreground, the crowds lining the bank on the left, and the distant bridge. Venice, yes, but the Thames is much wider here than the Grand Canal, and the bridge is neither the Rialto nor the Accademia. Then we see the shot tower at Lambeth on the right, and St Paul's Cathedral dome in the background. He clearly thought he was on to something as a subject, and showed the sketch to Farington:

> Constable called, and brought a painted sketch of his view of Waterloo bridge &c and the river as it appeared on the day of the opening the Bridge. I objected to his having made it so much a 'Bird's eye view' and thereby lessening [the] magnificence of the bridge & buildings.—He sd. he would reconsider his sketch.[18]

It is hardly a bird's eye view, though it is a high viewpoint from somewhere over the river, and the bridge is indeed a long way off. Constable took note of Farington's advice, but nevertheless did what he wanted, and, over the next thirteen years, maintained the composition in its entirety, while elongating the format. 'Go on with Waterloo bridge', Fisher urged, 'Macte virtute tua vir optime'.[19] Fisher gives no translation of this manly Roman compliment: he and Constable had shared much classical banter, so we can be sure that Constable understood the phrase immediately: 'a blessing on your strength, o best of men'.

Go on with the picture he did: 'I am putting my river Thames on a large canvas. I think it promises well.'[20] When a year later he asked Farington's opinion once more, he did not get the answer he was expecting or hoping for: stop! Farington said, advising him to 'proceed on & complete for the Exhibition a subject more corresponding with [your] successful picture [*Stratford Mill*] exhibited last May.'[21] To the consternation of some, including Bishop Fisher, he did so. What he produced he called *Landscape: Noon*, the painting now known as *The Hay Wain*. Nevertheless, a year later the Bishop saw *Waterloo Bridge* leaning against the wall

in Keppel Street and sat down in front of it: 'Equal to Cannelletti
[*sic*]' he said, begging Maria to tell John 'how much he admired
& wondered what you could have been about not to have gone on
with it.'[22]

26. Landscape: Noon

———◆———

Constable was an early reader of Maria Graham's pioneering life of Nicolas Poussin, published in 1820. The book moved and inspired him, as he told Fisher:

> I have lately read Miss Graham's life on N. Poussin – much more might be said on such a glorious subject, but still it amply proves how much dignity & elevation of character was the result of such patient, persevering and rational study.[1]

While Constable found both confirmation and justification in Graham's writing, he also found joy: here at last were words that he might himself have been groping for; he knew what he was about, what he was trying to say, but Maria Graham marked out the ground and revealed to him, with elegant and intelligent insight, the panorama of a great life whose tests and crises somehow echoed his own. Graham had spotted Poussin's weaknesses, and might also have been writing the preamble to the story of Constable's life when she says:

> the two or three pictures which he painted for altars in great churches, are not only below many other painters, but decidedly below himself.[2]

Maria Graham gave Constable the inspiration and encouragement he continuously required to concentrate, improve and go on.

Nicolas Poussin, Graham wrote, 'was really a Painter: cultivating philosophy and literature, because they were necessary for his improvement in art.' Constable also saw that as a central requirement, and had long been improving himself by reading and looking. She continued: '[Poussin's] industry was unremitting, and even his relaxations and pleasures were made conducive to the great end of his life – excellence as a painter': that was how Constable also disposed the pattern of his life. Then Maria Graham makes a key point:

It is much, but not enough, for a painter to know the various forms of nature, to understand the management of colours, and to handle the pencil with dexterity. *He must look into the minds of men* [my italics] that he may understand their feelings and passions.

This was a clarion call for Constable, one which he had heard many years before, from Cranch in particular, but now with added eloquence: to paint landscape that is not merely impression or experience, but metaphor also. Maria Graham continues:

[A painter] must be acquainted with history and poetry, that he may chose subjects worthy of his pencil; with the customs and manners of nations, ancient and modern, that he may give his figures the dress and action they require. The study of antiquity, anatomy, perspective with geometry, and architecture, are indispensable. And some knowledge of physical geography is necessary, that the vegetation and scenery may be true.

Constable's mission was also to depict what was true, to create a natural scene that would project its quotidian character. Further, it would offer one layer of meaning after another to challenge the eye to be a function of the mind, and the mind to be the driver of purpose. 'No circumstances,' Constable observed to Fisher, 'however impropitious could turn [Poussin] to the right or left – because he knew what he was about - & he felt himself above every scene in which he was placed.' In this context, 'above' carries the meaning 'in control of', and Constable had himself achieved the point of control. He had shown this to be so with *The White Horse*, where he was indeed in control of the scene: he had painted something, and what he painted means something more.

Constable read much; his library had grown apace since the 1790s, aided and abetted by his friends the booksellers James and William Carpenter of Bond Street.[3] Maria Graham's words and insights create a background narrative to the making of the full size study and the 'six footer' exhibition canvas that he would title *Landscape: Noon*.[4] The study has a pale grey-blue and brown cast beneath its effervescent paintwork: impasto dabs of white

dazzle on the bushes and water and distant meadow, applied with heavy-laden brushes and palette knife. Paint is almost smeared on in its urgency. The final structure is there already, high trees, massing clouds, the triangulated house, dog and rowing boat. The cart and horses are still indistinct in their form in the study, perhaps because Constable is working from memory – Johnnie Dunthorne would send him a drawing to remind him – and its root may be less Poussin than a variation on Rubens's *Château de Steen* composition of horse, cart and landscape.[5]

Such considered responses as Constable gave to Graham's biography of Poussin took time to formulate, and so we might reasonably see him thinking about Poussin while doing close work on his horses and cart, the distant haymakers, the pattern of light, and the problem of the foreground: the boy on the horse, beside the dog, was painted out in the final version. The plane of the mill stream echoes the elevated plane of the meadow; the stout structure of Willy Lott's house parallels the informal grandeur of the trees, with their dots of white sparkling in the sun. The high-piling noonday clouds carry a thousand times more water within them than the mill stream at Flatford ever could, though Constable may not have realised that. Nevertheless, the weight of the clouds is palpable. In the final version of the painting, the dog by the water, the woman at Willy Lott's landing and the man by the boat in the reeds, all hold the hay wain and its occupants in their gaze: their triangular structure bolts the composition as an engine is bolted to a chassis. Constable sent his canvas, as tightly constructed as any painting by Poussin, for exhibition in late April 1821.

Landscape: Noon: that is what he called it for the exhibition, and that is what it is. Noon. When Constable says noon he means noon, not lunchtime, not somewhere around midday. Noon. He is painting a stasis: the stationary wagon, the still horses, the silent angler, the quiet woman, the observing dog; stillness, and a moment held for ever on a canvas flooded with green. The cart in the water is not crossing the stream but is standing there, waiting. We can tell that because the driver and his mate are not at the reins, but chatting to each other. The gesture of one, the relaxed lean of the other, and their relative position at the front of the

cart clearly shows this. Really, they are the only sign of movement.
There are two reasons (at least) why the cart is stationary, and
these are in plain sight: the distant hay wain is fully loaded, even
overfull, and ready to depart. The path to the stream crossing (out
of sight, but implied) is narrow, so the two carts could not pass
each other without seriously churning up the field and damaging
crop. The foreground cart will therefore have to wait in the flat ford
– the only place where carts can cross – until the other one reaches
the river bank. And further, there is another reason why the cart
in the water waits. The day is hot and the water is cool. The heat
of the day and the morning's trundling has made the iron rims of
the cartwheels expand and loosen, and the wood of the wheels dry
out. The cart's pause in the water, therefore, both cools the iron
and makes it contract, and enables the wheels and spokes to swell
so that when the horses finally pull the cart out of the water its
wheels will be tight again and ready for another afternoon's work.
Constable has painted a moment: there is time before, and time to
come, but what we see here is now: noon. And it is about to pour
with rain.

Constable will have read these words of Joshua Reynolds
quoted by Maria Graham:

> No painter was ever better qualified [than Poussin] to paint
> such subjects, not only from his being eminently skilled in
> the knowledge of the ceremonies, customs, and habits of the
> ancients, but from his being so well acquainted with the differ-
> ent characters which those who invented them gave to their
> allegorical figures.[6]

Constable knew his subjects and their ceremonies, customs
and habits just as profoundly as Poussin knew his: he knew the
men in the cart, he knew the angler, he knew the woman kneel-
ing on the jetty, and of course he knew the name of the dog.
Graham writes of Poussin's 'resolve to begin anew his education
as a painter'; to 'enlarge the stock whence he was to compose his
pictures'; his 'diligent . . . study of architecture'; his enjoyment of
'the unrivalled landscape that surrounds [Rome], where every
hill is classical, where the very trees have a poetic air'. When
as an old man Poussin was asked how he had 'attained to such a

degree of perfection', he answered, 'I have neglected nothing'.[7] From Poussin, through Maria Graham's eyes and pen, Constable was reaffirmed in his constant intention to immerse himself in his subjects and his places, and to depict them from intimate and endowed personal knowledge. He too 'neglected nothing'. The publication of Maria Graham's life of Poussin is a hinge-point in Constable's art, and a clue to the foundation of what would soon become known as *The Hay Wain*. It must therefore come as no surprise that Constable rapidly discovered an extraordinary, vibrant interest in his painting from nobody so much as Poussin's own compatriots, the artists of France, and the Parisian art trade that surrounded them.

Maria Graham was a good friend of writers and painters – she was an artist herself, and would marry one, Augustus Wall Callcott, in 1827 – so the following reflection may have been prompted by conversations among her friends: 'modern artists are apt to complain of want of public patronage, and to lament that no fair occasion of distinguishing themselves can now occur.' Constable reflected for himself on patronage in the light of his reading of Graham's book, and remarked warmly to Fisher, who had *The White Horse* hanging on his Salisbury wall:

> [Poussin] had some <u>real patrons</u>, elegant & superior men who were his friends and who thought themselves the gainers when they allowed his judgement to exceed theirs in that study in which he had been all his life successfully engaged.

Constable was slowly developing his own portfolio of 'elegant & superior' men: John Allnutt, James Carpenter, John Fisher, Thomas Fitzhugh, Henry Greswold Lewis, General Rebow, John Tinney. These were men of substance and intellect who knew their own minds and knew also when to allow Constable's 'judgement to exceed theirs'. Only the Bishop was testy about the time Constable gave to *The Hay Wain*: 'Now your picture is gone to the Exhibition,' he wrote, 'perhaps you may be somewhat at leisure to give a little attention to your old friend and scholar Dorothea . . . Can you drop in upon us some morning?'[8] Dorothea – 'Dolly' – then sent him a long list of paint bladders she wanted him to get for her.[9]

Constable told Fisher of a Poussin that Beaumont owned, and
which he will have known from his many visits to Grosvenor
Square. This is the painting now titled *Landscape with a Man
washing his Feet at a Fountain*.[10] 'Noble', Constable called it, 'a
solemn, deep, still, summer's noon'.[11] Constable's words in due
course gave the National Gallery curators their cue for its title:
the painting, he said, shows 'large umbrageous trees, & a man
washing his feet at a fountain near them . . . It is the most affect-
ing picture I almost ever stood before.' He was looking at the
picture with eyes educated not just through his own experience,
but with the benefit of Maria Graham's sidelong analysis and
context. He added:

> It cannot surely be saying too much when I assert that [Pous-
> sin's] landscape is full of religious & moral feeling, & shows
> how much of his own nature God has implanted in the mind
> of man.

In this reflection Constable reveals what he considered to be
the highest purpose of the art to which he was himself strug-
gling, and which we can read as his intent, to merge the force of
art with the power of God and nature.

A man who was often in Constable's company was Joseph
Farington, *éminence grise* of the Academy and, quietly, one of
the finest and most informative diarists of the period. Constable
had continued to call on him across 1820 and 1821 when he was
serving the Academy as a responsible and valuable artist com-
mittee member. Farington remained an adviser, confidant, friend
and regular host to him and Maria, and in July 1821, when Maria
was in Hampstead with the children, Farington invited John to
dinner in Charlotte Street. Fellow guests that evening included
the President of the Royal Academy, Sir Thomas Lawrence, and
the artists Henry Howard and Samuel Lane. 'The ev[en]ing
went off pleasantly', Farington records, 'much conversation'.[12]
This is their last recorded meeting, for at the end of the year
Farington visited his brother Robert in Didsbury, to the south of
damp and rainy Manchester. The pair went to church together,
and sat in the Farington pew in the gallery at St James's. After

the evening service, encumbered with hat, umbrella, galoshes and prayer book, Joseph slipped on the wet stairs, bumped rapidly down, and landed heavily on the stone floor at the bottom. His neck was broken.[13]

27. A superior sort of work people

On the instant, this all-seeing eye on the world of art closed for ever. Joseph Farington's death brought to an end his fertile and peppery surveillance of the manners, mores, daily lives, relationships and ambitions of countless artists. Spendthrift patrons, scheming matrons, corrupt politicians, ruminative soldiers, men of business, invention and industry – all come under the gaze of this modest touchstone of the times. Few if any of his acquaintances realised that after they had exchanged a word or two with him, they would become meat for Farington's Diary, the subject of rapid and wry reflection as his candle burnt down at the end of the day, and his quill scratched across the paper.

'I could scarcely believe that I was not to meet the elegant and dignified figure of our departed friend,' Constable wrote to Samuel Lane, 'where I had been so long used to see him, or hear again the wisdom that always attended his advice, which I do indeed miss greatly.'[1] 'How he used to rule the Academy!' James Northcote said. 'He was a great man to look up to on all occasions; all applicants must gain their prize through him . . . he loved to rule.'[2] But very soon the waters closed over Farington and obscured whatever suspicions his contemporaries might have had about his activities as recorder and analyst. He had filled sixteen volumes in his clear, eloquent hand from 17 July 1793 until his last morning, 30 December 1820. For one hundred years, the volumes remained in his family, and moss grew over them until they were rediscovered, opened and published in the 1920s. Farington's encouraging presence had been crucial to Constable, who recalled to Fisher that Farington 'always said' he should be a success as an artist, 'I am certain my reputation rises as a landscape painter – and that I am . . . fast becoming a distinct feature in that way.'[3] Further, Farington had become Constable's adviser not only on the progress of his painting but on the management of his money and career strategies.

Keppel Street, where they lived in the winter and spring months, was becoming too small for the Constables, and as the family continued to grow they had to make changes. Constable told Fisher in August 1821 that he now used Keppel Street as a home and an informal showroom, 'hanging up only decent works' in his 'new drawing rooms': 'my large picture [probably *The Hay Wain*] looks well in them'.[4] He moved another 'large picture' [probably *View on the Stour near Dedham*, or its full-size study] down town to a room at a glazier's, which he took as a studio – by 'down town' he must mean west of Keppel Street, in the Oxford Street or Charing Cross area. At this year's rented Hampstead house, 2 Lower Terrace, he would paint smaller pictures, having cleared out a shed in the garden, removed sand, coal, mops and brooms, and turned it into a workshop, as well as 'a place of refuge'.

So, by August 1821 Constable was renting a good-sized workplace beside a glazier's shop where he could work on his next six-footer, *View on the Stour near Dedham*; a house and small garden studio in Hampstead, where he made easel paintings and experimented with sky studies; and a family house in Keppel Street, where he entertained friends and prospective clients. He displayed his work in Keppel Street, indicating a change of mind since 1813 when he had told Maria: 'I am indifferent about show – though all insist upon it.'[5] In addition, he had his tiny studio house in East Bergholt to retreat to if required, making plenty of places of refuge for him from the family. There were soon four children: after John Charles and Minna, Charles Golding was born at Keppel Street in March 1821, and then Isabel, in Hampstead in August 1822. Efforts to keep both Constable and Bicknell family names going was muscular: 'John' and 'Golding' are in there, as are 'Maria' and 'Louisa', and, emphatically acknowledging the Bicknell connection, there are two 'Charles'. To clarify this amalgam of names, John Charles will be referred to in this book as 'Johnny' and Charles Golding as 'Charley', more or less following their parents' usages. Young John Dunthorne will remain as 'Johnnie'.

At forty-five years old, and an ARA, John Constable had reached a level of recognition and status, which, though still

inadequate, was gently rising. 'You will be surprised,' he added
to Fisher,

> at the good looks of all my concerns, & still more when I tell
> you that I am going to pay my court to the world, if not for
> their sakes yet very much for my own. I have had experience
> enough to know that if a man descries himself he will find
> enough to take him at his word.

These were good days. Constable was back in the magic circle
of Sir George Beaumont's confidence, demonstrated on Beau-
mont's departure for Italy in 1821 by his gift to Constable of
his painting of Stratford Mill. It is difficult to divine motive
here: friendliness and admiration, certainly, but also a hint of
condescension and challenge – 'Sir G says he will not go out
of town without painting me a picture.'[6] Constable told Fisher
that Beaumont's 'beautiful little landscape' was of 'the same mill
as in Tinney's picture', but his response was generous: 'it is a
Rembrandt full of tone and chairo oschuro [*sic*]. He has given it
to me as a mark of his regard'.[7] Beaumont was more interested in
Constable acknowledging the qualities of his own paintings than
he himself was in acknowledging the paintings of Constable.

Constable's 1822 six-footer drew on new reserves of energy.
From two tiny pencil studies of 1814 he conjured *View on the
Stour near Dedham*, first as a full-size study, followed by an ex-
hibition version.[8] As with his six-footers from *The White Horse*
on, this study was painted at speed, as the energetic brushwork
amply demonstrates with its changes of detail on the go, and
the loose, even splashy paintwork and smearing with a palette
knife. The two pencil studies of eight years earlier were this sub-
ject's only link with home. Now, his Stour Valley scenes would be
composed and painted from his mind's eye, under London light,
their emotion recollected in the relative tranquillity of Charlotte
Street.

Farington gone, Constable was foremost among the parties
interested in moving into the dead man's house in Charlotte
Street, the warm domestic circumstance in which his career could
well be said to have begun. The house at 35 Charlotte Street
had deeper artistic connections: before Farington it had been

Richard Wilson's home. 'I am about Farrington's [*sic*] house', he told Fisher. However, he is seeing the opportunity solely from his own singularly self-centred perspective: 'I think this step is necessary. I shall get more by this movement than my family in conveniences ... occupation is my sheet anchor – my mind would soon devour me without it. I felt as if I had lost my arms after [*View on the Stour near Dedham*] was gone to the Exhibition.'[9] They had been happy in Keppel Street, he had painted, or at least begun, four six-footers in its rooms, and Maria had had four babies there, those 'bottled wasps upon a southern wall'. He added to Fisher 'the 5 happiest & most interesting years of my life were passed in Keppel St. I got my children and my fame in that house, neither of which I would exchange with any man.'[10]

In the autumn of 1822, the family, with servants and Elizabeth Roberts, moved into 35 Charlotte Street. It was perfect for him: an artist's house with a modest gallery linking to a wide, airy studio at the back. However, a disadvantage for Constable was that there was a brothel opposite. Fisher was blunt in his warnings: 'whoever is hardy enough to hire the house, will be subject to gentle midnight taps: and hackney coaches with elderly gentlemen drawing up about dusk: & roaring blades with a bottle of wine in their hands beating a sisserara [a torrent of language] about three in the morning.'[11] That was too much to contemplate: John Constable stood in front of the Middlesex justices at Clerkenwell and got the madam out:

[We] have agreed to pay all expense, about £30. The inmates have long since fled, some of whom were the old womans daughters – we hope the business is well done.[12]

In due course Constable continued his high-minded sense of civic responsibility by becoming a Commissioner for Paving and Lighting in the streets west of Tottenham Court Road, taking responsibility for 'preventing nuisances and obstruction'.[13]

Problems remained inside his new house. Farington had evidently neglected his property, letting it get grubby and smelly across his twenty-year widowerhood. Bricklayers and carpenters discovered a hollow wall communicating with 'the well of a privy' below the studio: 'That will have played the devil with the

oxygen of my colours.'[14] Very soon the builders got rid of the stink: 'I have got this room (the large painting room) into excellent order. It is light – airy – <u>sweet</u> & warm.' At just this same time, certainly at Constable's request, the young sculptor Joseph Bonomi sent drawings and plans of Claude's house in Rome to give him some guidance in the arrangement of his own.[15]

The insight which Claude and Poussin had given Constable induced a profound disquiet when he saw what he considered to be the parading of inadequacy at the Academy. These seventeenth-century artists together represented the height of moral courage and commitment to the power, purpose and principle of painting; the Academy, on the other hand, appeared to Constable to offer only pragmatic lack of principle. He was already disgruntled at the end of October 1822: the autumn vote for Associates was about to take place – three were to be chosen by the committee out of a field of forty candidates. 'They are at a loss entirely', he told Fisher, 'there is not an artist among them.'[16] What really put Constable's temperature up was what he saw as a corruption in the system, already endemic in the British Institution in Pall Mall, where he claimed the managers pressured artists to paint in the manner of old masters. Such attitudes were creeping into the Royal Academy, Constable averred with a passion that never burnt out.[17] 'It is a bad thing to refuse the "Great"', he would advise Charles Leslie in 1831, 'they are always angered – and their reasoning power being generally blinded by their rank, they have no other idea of a refusal than that is telling them to kiss your bottom.'[18]

In his criticism of the British Institution Constable is forgetting its rich pedagogical intent. The Institution provided opportunities for art students to study and to copy old masters on loan for the purpose, and while the exhibitions of works from private collections might have an element of vanity on the part of some lenders, the generosity was real, and the British Institution was one of the few places where anybody who wished to do so could look at great art. Constable steamed on about how its Governors were seducing younger artists into painting pictures that reflected what they themselves wanted to see, and which at best echoed or at worst aped the old masters hanging on their walls.

He saw the Governors as the 'owners' of gullible 'junior artists', and pined for the apparent golden age pre-Raphael when artists were 'without human exemplars', when they were 'forced to have recourse to nature.' The subsequent generation, he told Fisher, 'had the experience of those who went before – but did not take them at their word – that is, imitate them.'[19]

Not content with that, Constable rants on about the 'ruin and folly this day exhibited at the Gallery [i.e. the British Institution]'. It infuriated him: Van der Velde, Gaspard Poussin (Nicolas Poussin's brother-in-law, and a collectable painter in his own right), and Titian, he said, 'are made to spawn millions of abortions . . . to bring a penny into the empty hands of . . . frauds.' He singles out his contemporary Thomas Hofland for toadying at the British Institution, and selling for the large sum of 80 guineas a pastiche of Gaspar Poussin:

> it is nothing more like Gaspar than the shadow of the man like himself on a muddy road. It is a beastly [thing]. It is a shocking scene of folly & ruin – headed by Lords &c.

Constable allows – or rather fails to control – his spleen in explosive outbursts which reveal as much about him as they do about the world as he sees it. When John Constable explodes he scatters grapeshot. He needs his friends to understand the way he thinks, and Fisher fits that bill neatly: 'They talk of a pension to the senior Academicians – this would be no bad thing – were it granted only on condition of their relinquishing the easil [sic].'[20]

Fisher only made Constable steam yet more: 'You were sufficiently irritable . . . in consequence of the transactions at the gallery. I will increase your irritability.'[21] Fisher goes on to tell of a coming raffle at Wilton of a local artist's watercolour copy of a Rubens in the Earl of Pembroke's collection. This was expected to raise 100 guineas:

> You see wealthy people regard artists as only a superior sort of work people to be employed at their caprice: & have no notion of the mind & intellect & independent character of a man entering into his compositions. They regard the art as they do needlework & estimate it by its neatness.

Constable was up against all this. It is the flip side of the coin of patronage from which he was beginning to benefit, and he would rail against it impotently for the rest of his life. The titled collectors of British painting – the Marquess of Stafford, the Earl of Egremont, the Earl of Pembroke, Sir John Leicester, Bt., Sir George Beaumont, Bt. – bought nothing from him and never would. Constable's painting, with its revolutionary light and air, was the art of people who worked for their living, and so it would remain. And how Fisher loved Constable's letters of ire and insight:

> I generally leave you wiser than I came to you, and some of your pithy apothegms stick to my memory like a thorn, and give me a prick when I fall a-dozing. 'A man is always growing', you said 'either upwards or downwards'. I have been trying to grow upwards since we parted.[22]

28. I must go into Suffolk soon

Meanwhile, back in East Bergholt, Abram was in charge of the family business and facing very hard times in Suffolk: 'They are as bad as Ireland', he said. 'Never a night without seeing fires near or at a distance'. It could be terrifying: Abram told John of the agricultural unrest in England as it touched on his affairs and on the village. The new rector, the Hon. Rev. Joshua Rowley, such an important figure locally, had 'forsaken the village', as had Rowley's brother-in-law, the squire Peter Godfrey of Old Hall. There was 'no abatement of tithes or rents – four of Sir William Rush's tenants distrained next parish – these things are ill timed.'[1] It was the same all over the country. The Napoleonic Wars were won, but now they had to be paid for. Banks crashed, the price of grain soared, the price of grain fell, and as the reflective Essex doctor Jonas Asplin confided to his diary on three successive New Year's Days:

> The numerous failures of the London and Country Banks has caused severe private distress in every part of England (1826) . . . Farmers are not better off than they were last year. The ports are open to foreign grain, which has the effect of not merely lowering the price of corn . . . but of rendering that of our own growth unsaleable. Loads and loads of wheat have been sent from hence to the London market, not only without being sold, but have been absolutely brought back again in the barges to save expenses (1827) . . . The agricultural state of the country is as flat as possible (1828).[2]

A more tightly focussed view of the country's dire financial situation was drawn by Constable in a letter from Charlotte Street to his older brother, Golding. The execution of the banker Henry Fauntleroy, convicted of forgery in 1824, took him to the heights of expression:

The case of the wretched Fontleroy [*sic*] has occupied the minds of all ... he was certainly the greatest depredation in the greatest of all political crimes that ever was – and the distress and pain which that wicked bank has caused in this neighbourhood [Soho] is shocking. The cases of entire ruin are frequent.[3]

Despite all, Abram and the family at East Bergholt carried on: Golding, he reported, 'continues very well', which probably meant that his epilepsy was under control and he was usefully engaged as a gamekeeper.[4] Abram attended to running repairs on his vessel *Balloon*, which might be money down the drain, he thought, as 'she grows good for nothing'. The floodgates at Dedham and Flatford also needed repair: 'several millwrighting jobs coming in that I cannot keep my money in my pocket, but they must be done.'[5] There were also difficulties that reflect on the state of John's finances: he asked Abram for money from his share in the business, his inheritance from their father. Abram was able to make over £150 to him, 'which sums would be most agreeable to you – & certainly the bills you mention ought to be paid & it will be to your interest to pay them immediately.'[6] With the strain they all seem to be under, they noticed John becoming disagreeable. Abram went on to belabour his brother for his self-absorption: 'fame is desirable, & is what you aim at I know & admire, but your <u>claims</u> now increase upon you. They absorb your affection & kindness.'

He had become poor company, but Abram was wholly sympathetic to John's ambition and urged him to paint more portraits, 'made to gratify vanity & pride, in most instances, tho' not in all.' The siblings could not really understand why John did not spend more time painting portraits, but they failed to grasp the extent of the toll that refocussing from landscape would take. Abram mused on the certainty of John's future fame: 'I always think your [landscape] pictures will sell more, when there can be no more of them painted, a far distant day I trust.' Constable was in a particularly grumpy mood when he called on Nancy: 'The last evening you passed with me ... I must confess (for a time) left no favourable impression on my feelings', she told him frankly.[7]

Only his sister could be as blunt. He had promised to help the son of Gosling, an East Bergholt sawyer, to find work in London, but had let the young man down. Nancy ticked her brother off roundly:

> As a last resort he has at last urg'd his suit to me, and I have promised, and performed it, to write to you requesting your kind intervention on his behalf – if you cannot succeed . . . be so kind as to let me know.

Nancy was the fragile one. She was excessively formal in her manner, and now, living with her dogs and Golding in the cottage on the heath, was vulnerable in these difficult days. 'She does not find G.C. a pleasant companion', Abram reported, 'she could not expect it; they seem to struggle on'.[8] She had few visitors, and despite her practical nature and her concern for others, did not look after herself properly. Mary said that their eldest sister 'has numbness in her head & a deafness – owing no doubt to the wretched cold winds that she is always out in with her horses & carts.'[9] Mary, kind and loving, the homemaker who never married, suffered periods of anxiety.[10] Having looked after John in London when he was in agonies over Maria, she now lived with Abram and kept house for him. Golding, still subject to his fits, was 'far from right & totally unable to do anything . . . He seems to have lost all kindness for any body or any thing, but is entirely engross'd in himself, his mind more contracted than ever.'

A depressed and unemployed workforce led inevitably to petty crime, and Nancy and Golding were burgled when Nancy was at church, their father's watch stolen from her bedroom.[11] Patty reported this, but John and Abram took a bullish, uncharitable attitude towards Nancy, loving support being largely absent: 'I can't but smile,' Abram said to John, 'to read your remark of Jezebel & the dogs who ate her up' – comparing Nancy to Jezebel in the Old Testament who was eaten by her dogs – 'only she was dead before they began to knaw [sic] her bones. Ann is a living morsel.'[12] John wrote in his journal 'she will probably spend all her property if she lives long enough', adding, '"All passion, no reason" – true enough', a nod to Laurence Sterne's *Tristram Shandy*.[13]

Agricultural disturbance and depression notwithstanding, Abram remained more or less afloat in his business. He and Mary had improved and repaired the mill house at Flatford, which, being down a steep lane, was quiet and allowed Abram and his men to get on with their business:

> We live very retir'd round here, but we reap the advantages of it in many instances, one of which is the riddance of Beggars, very few finding their way down, not being a thorofare, and another, callers, or idlers, don't interrupt, & those who really wish to come or we wish to see, can always find their way.[14]

There were beggars and 'idlers' about because there was not enough work for agricultural families. Depression affected the state of repair and condition of land-workers' cottages, as the agricultural reformer Arthur Young pointed out:

> In Suffolk there are in general bad habitations; deficient in all contrivance for warmth, and for convenience; the door very generally opening immediately from the external air into the keeping-room and sometimes directly to the fireside; the state of reparation bad, and the deficiency of gardens too general.[15]

Turning a blind eye for a moment to the hardship in his industry, Abram – still, and for ever, a bachelor – considered himself:

> I may with truth say, the last year [1820] has been the happiest of my life, & should I be enabled, by the blessing of the Almighty, to go on, I shall be truly thankful If I can but make it answer & pay all the demands thrown upon me (which are heavy, & almost sink my spirits when I think of it), I shall be perfectly content.[16]

The milling trade was 'in a bad state just now', with minuscule profits. Abram made it clear that he would not be able to give John any more money 'until Michaelmas',

> but if I can keep on till times mend, I shall hope to get on when opportunity occurs . . . One thing is I don't live extravagantly.

There was a momentary whirlwind in the counting house when John became over-involved in a company management matter,

leading to a temporary fallout.[17] He had written a stiff letter to
his brother, which Abram burnt, so there is little chance of find-
ing what this was all about; but John had a share in the business,
and exercised his voice. Mary, who referred briefly to this 'war
with Brothers',[18] took their minds off it by inveigling John to
help her buy a carriage, and spend some of the money she had in-
herited. So John had to haul himself again and again around the
carriage works in Long Acre, sometimes with Mary and Abram
in tow, to look at carriage after carriage for her. Long Acre, off
St Martin's Lane, seethed with carriages: carriages skeletal, car-
riages crawled over by carpenters, carriages gleaming and pulled
up to the street edge for show. This was the world's centre for
transport manufacture and design: two-wheeled, four-wheeled
carriages, carriages plush, upholstered and fringed, carriages
decked with lace, leather and blinds, and always the constant
horse-clatter. The smell of paint and varnish lingered in the air
among the works of associated trades – trunk-makers, lacemen,
harness-makers and saddlers – and while Mary and Abram
stroked the panels and sniffed the leather, John might wander off
and discover the paintbrush-maker and artists' colourman in the
street.[19]

There was one carriage that caught his painter's eye; indeed, it
had Constable's palette – 'dark green & lined with dark blew',[20]
but the one that the choosy Mary settled on was a 'Landaulet . . .
a crimson . . . beauty . . . a very respectable looking thing without
being gaudy'. Mary had a sense of style, with ideas of gran-
deur, and employed a signwriter to paint the arms of the Burton
Constable family of Yorkshire onto the carriage doors. Whether
she had the right to those arms or not is unclear, but she did it
anyway, bringing exasperation and embarrassment to the proper
and frugal Abram: 'it will cause many remarks no doubt & much
spite will be spit but she asks no one to pay for it, & so she must
not mind the world & its tongue'.[21]

Busying about at Flatford for their younger brother, Mary
made the place shipshape with chintz and china.[22] 'Flatford Mill
looks beautifully', Constable told Maria on Easter Sunday 1821:
'Mary has done it up so well.'[23] Mary was the willing and able
sister, a blessing to Abram who gained hugely by her presence,

while being exasperated by her grand carriage now parked by his mill. She had a flair for calming her brothers, one that had bene-fitted John in 1816 when he moped for months about Maria and their marriage prospects. She was a sweet and gentle woman, and, while persistent and demanding in her wishes, it was she who seems to have been the main carer for their parents as they aged.[24] Mary gave abundantly to her importunate brothers, looked after Abram when he was ill, cared deeply for the difficult and isolated Nancy, and remembered birthdays.[25] Even the animals and birds around the mill seemed to respond to her, such as the pair of swans she named Gill and Jack, who 'sails round in regal state and frightens every coward like myself'.[26] For a man endowed with such rich humanity as John Constable, it comes as a disappointment to hear him say to Fisher, 'I have a sister who is rather cracked who doats on [old china].'[27]

With the births of Charley and Isabel, Maria had had at least five pregnancies in just over four years. Abram had made a jaunty masculine joke about the tight little house in Keppel Street when Maria was near term with Charley: 'I could almost wish your house was a little "swellded" as well as your good wife', he wrote.[28] A couple of days after Isabel's birth, Constable commented to Fisher about the size his wife had grown when great with child: there is a casualness about these attitudes which are probably standard male responses of the 1820s. Fisher was much the same: 'Mrs Fisher produced me another boy . . . & is now nearly recovered', he bragged.[29] It was Fisher who gave Constable what amounts to his definition of the ideal wife: 'My wife has the sense of a man to talk with, the mildness of a woman to live with & the beauty of an angel to look at': Constable had relayed that to Maria in advance of their marriage.[30] His egotism, of which he is openly aware, is remarkable – of the latest pregnancy he noted:

[Maria] was unusually large this time & our children have been ill, and many circumstances have happened to distress her – but God has helped me where I could not have helped myself – and all the rest of my (pictorial) anxieties are giving way to the length of the days and my own exertions.[31]

The sisters showed proper concern for Maria and her domestic

situation. Patty, who had moved from East Ham to Dedham with her family, sent a chicken to celebrate Charley's birth, and in due time Mary sent a chicken and a cake from Flatford to Hampstead for 'sweet Isabel' and 'her excellent Mother, and Nurse [Mrs Roberts].'[32] Of the 'many circumstances' that distressed Maria we can include her own delicate health, put at risk by multiple pregnancies. This led Constable to refer to 'a good deal of In-disposition in my family', and to Maria and their eldest child as 'great invalids'.[33]

Maria could benefit from the clear air and high ground of Hampstead, and at least she did not have to worry about what was going on in East Bergholt. There, ricks were set on fire; lonely houses were burgled; the churchwarden's wife, Mrs Woodgate, was 'nearly deranged'; Woodgate's sister-in-law 'lately hanged herself'; John's brother Golding 'entirely engross'd in himself'; and Dunthorne looking 'worse than ever'.[34] Thus village life in a period of acute local and national stress. Nevertheless, for Con-stable his home country continued to engage him in heart and head, but he remained blind to underlying social forces: 'How sweet and beautiful is every place', he wrote to Maria from East Bergholt,

> I visit my old haunts with renewed delight ... Nothing can exceed the beautiful green of the meadows, which are begin-ning to fill with buttercups, & various flowers − the birds are singing from morning till night but most of all the sky larks. How delightful is the country, but I long to get back to what is still more dear to me.[35]

He put the idea to Maria that he wished 'we had a small house' in Dedham, 'I think there may be one to be had', but Maria did not want to get drawn into all that, and was happier where she was, at arm's length from her in-laws.[36] John was away quite regularly, not only in East Bergholt and Dedham, but Salisbury, Wivenhoe, Manningtree, where he won a commission for a third altarpiece, and in June 1821 all over Berkshire, accompanying Fisher on an archidiaconal tour: 'pray do not expect me till I see you', he told Maria, 'as I still have something to do': he was forced still to take what painting jobs he could.[37] Despite the additions that

Maria's bequest of stocks could make to the family economy, he remained short of money, so commissions for portraits and the Manningtree altarpiece were essential, 'merely for something for my family to meet our additional expenses here [Hampstead], amounting to about £50 or 60.' He told Fisher: 'I hear something of a job of 3 portraits – I will do them if possible – for the children's sake.'[38] Some portrait sitters were slow to pay, leaving the family embarrassed: '[I] have not been able to get the money for any one of them . . . I must go into Suffolk soon on account of a job.'[39] In 1822 he told Fisher, the only man he could confide in thus: 'painting these large pictures has much impoverished me', and 'I must beg a great favour of you (indeed I can do it to no other person) the loan [of] 20 or 30 £ would be of the greatest use to me at this time.'[40] He remained uneasy and anxious about money: materials alone for his large paintings were expensive; paint and framing would remain a nagging debt if they were not paid for up front. It was not only the cost of materials, but the investment of his time in painting the full-size studies each year and then the final exhibitable work. Each year, his brain and body were bound up in these works from late summer to late spring, when the offering went to the Academy, and usually returned unsold. In the same letter to Fisher in which he asks for a loan he just drops in the news of what he describes as 'a professional offer' he had received of £70 for *The Hay Wain*, 'without the frame'.

Living now in London and Hampstead, with Salisbury and in due course Brighton and Arundel turning his head as subject matter, Constable has determinedly left home. Despite the sentiments he expressed towards his 'careless boyhood' in the Stour Valley, his 'six-footers' of river, canal, cows and carts, poignant though they are, would eventually run their course.

29. The French man

The 'professional' offer that Constable received for *The Hay Wain* was, however, derisory. His asking price for the paintings was £150, while the 'professional', the Paris art dealer John Arrowsmith − very French despite his English name − offered less than half that.[1] There had been some 'nibbles', as Constable called them, following its showing at the Royal Academy in the spring of 1821, but no serious interest until Arrowsmith came along. *The Hay Wain* had its second English showing in March and April 1822 at the British Institution, that exhibiting organisation that Constable would so happily rail against. The painting had been admired at the Academy: Robert Hunt in the *Examiner* said that it [as *Landscape: Noon*] approached 'nearer to the actual look of rural nature than any landscape whatever.'[2] Two significant French visitors had also seen the painting. One was the lonesome melancholic Théodore Géricault, who was in London in the aftermath of the exhibition in 1820 of his *Raft of the Medusa* at the Egyptian Hall in Piccadilly: he was 'quite stunned by it', he said.[3] The other was the writer Charles Nodier, who called *Landscape: Noon* 'the palm of the exhibition which ancient and modern masters have few masterpieces to oppose.' He added to his French readers, however, that 'no one should be discouraged, and the French are not easily discouraged.'[4]

The paintings Constable had shown in 1821, along with the all-dominating *Landscape: Noon,* included a *Hampstead Heath* and a weather effect which Constable titled *Shower.*[5] These were revolutionary in their damp and dapple: in his Journal, Eugène Delacroix wrote of 'an admirable and astonishing thing' [*'admirable chose et incroyable'*] when he first saw a Constable painting in France, an oil study owned by the French painter Jacques-Auguste Regnier.[6] *The Hay Wain* had even greater impact. Arrowsmith's offer was shrouded in conditions, of course: the painting would form part of an exhibition of English pictures in Paris, and it

would disappear out of Constable's control. 'I hardly know what to do', Constable agonised. 'It may promote my fame & procure commissions but it may not.' He was in a quandary, knowing the painting's importance and quality, but he was not certain he could trust the dealer. 'It [is] property to my family – though I want the money dreadfully.'[7] He thought about it for a few days, then wrote again to Fisher: 'It is too bad to allow myself to be knocked down by a French man . . . it [would be] disgracing my diploma [i.e. Associateship of the RA] to take so small a price & less by over one half than I asked.'[8]

From these hesitant beginnings Constable's reputation in France was to rise rapidly, and it was the artists, looking for new ways to go on, who had the eyes to spot him. Of fashionable collectors in England he complained to Fisher in 1824: 'None of them have any affection for new art'. He was referring here to the collector and aesthete Sir Richard Payne Knight, who told Constable, as he watched him at work in Charlotte Street: 'you are a most successful landscape painter'. He left without buying anything, and that same day, much to Constable's annoyance, Payne Knight paid £1600 for an album of drawings by Claude: 'I saw them', Constable said bitterly, 'they looked just like papers used and otherwise mauled, & purloined from a Water Closet.'[9]

Whether he knew it or not, Constable had hit a moment of crisis in French painting: the neo-classical Napoleonic bravado of Jacques-Louis David was dead or dying. He had experienced it at first hand when David's second version of his gargantuan *Coronation of Napoleon and Josephine* was shown in London in 1822: 'It does not possess any thing of the art much less the oratory of Rubens or Paul Veronese', he told Fisher.[10] Constable's attitude to the offer from the 'French man' worked in his favour in the long run. It was a signal that artists and collectors in France would relish the refreshment and release that they saw in 'the trees, water, and all the fleeting nuances of atmosphere', as Amédée Pichot put it, in the paintings of Constable and Call-cott.[11] By refusing Arrowsmith's first offer Constable was able to strengthen his own terms and assert his conviction of his value as an artist.

The tide was beginning to turn, and Constable knew it, and

certainly he could convince himself that change was on the way. John Tinney spoke of his hope that Constable might paint a companion six-footer for *Stratford Mill*,[12] but although that did not materialise it was another indicator, as was this in a letter to Fisher:

> I now have two six footers in hand, one of which I shall send to the gallery [British Institution] – at £200, or keep it. The time will come when they fetch some <u>dealer</u> £500.[13]

Hunger for Constable's large paintings continued, at least in Salisbury, where Fisher longed to hang *The Hay Wain*; but where would he put it, having already hung *The White Horse* in his drawing room:

> I have a great desire to possess your 'wain'. But I cannot now reach what it is worth & what you <u>must have</u>. But I have this favour to ask that you would never part with it without letting me know. It will be of most value to your children, by continuing to hang where it is, till you join the society of Ruysdael, Wilson & Claude. As praise & money will be of no value to you <u>then</u> personally, the world will liberally bestow both.[14]

Soon Arrowsmith was back, calling on Constable, urging him to sell not only the 'Vain', as he called it with his French accent, but also *View on the Stour near Dedham*, the 'six-footer' of 1822. Arrowsmith planned to show them both in Paris, and tempted Constable with the assurance that *The Hay Wain* would become the property of the French nation, and be shown in the Louvre.[15] This was a new peak in cross-Channel art-exchange: some British artists such as Richard Parkes Bonington, John Glover and David Wilkie were reaching a French market, but not even Turner had yet made so powerful an impact with a monumental work comparable to *The Hay Wain*. Turner had been painting French subjects for years, but it was not until after his death that a French collector would buy his work. Success of this kind would be transformative for Constable, but even so he prevaricated. 'Let your Hay Cart go to Paris by all means', Fisher urged; grab this opportunity in both hands – let it go for a lower price; think of the 'éclat it may give you': Fisher's use of the French

word here was no doubt deliberate. Then he gave his friend some home truths:

> The stupid English public, which has no judgement of its own, will begin to think there is something in you if the French make your works national property. You have long laid under a mistake. Men do not purchase pictures because they like them, but because others covet them. Hence they will only buy what they think no one else can possess: things scarce & unique.[16]

Constable took this backhanded advice, and when Arrowsmith came to see him this second time, the pair struck a deal: £250 for *The Hay Wain* and *View on the Stour near Dedham* together. This was reasonable; Constable was no push-over in negotiations, but he included additionally, perhaps as a deal-maker, one of his paintings of the sea at Yarmouth. Arrowsmith paid up as promised, and off the pictures went,

> destined for the <u>French</u> metropolis, thus again are honors thrust upon me ... I think they cannot fail of melting the stony hearts of the French painters. Think of the lovely valleys mid the peaceful farm houses of Suffolk, forming a scene of exhibition to amuse the gay & frivolous Parisians.'[17]

'The stony hearts of the French painters' were melting fast already. Delacroix wrote in his journal: 'Saw the Constables. That was quite enough for one day. This Constable does me good.'[18] The hearts of Fisher's 'stupid English public' were also beginning to melt. On the opening day of the 1824 Academy exhibition Constable sold *The Lock* to the newly rich draper James Morrison for 150 guineas.[19] In the same season, across the Channel, the painting which the French called *Une charrette à foin traversant un gué au pied d'une ferme; paysage* (*The Hay Wain*) and another, *Un canal en Angleterre; paysage* (*View on the Stour near Dedham*), were triumphantly displayed at the Salon de Paris in the Louvre. This was 'surely a stride up three or four steps of the ladder of popularity', Fisher proclaimed.[20] 'English boobies, who dare not trust their own eyes, will discover your merits when they find you admired at Paris. We now <u>must</u> go there for a week.'

John Constable now had London and Paris in the palm of his

hand, and suddenly found himself becoming a honeypot. He sold twelve smaller canvases to Arrowsmith and Claude Schroth, another French dealer, when they visited his studio, being told that the paintings were 'anxiously looked for in Paris' where they would be shown at the Luxembourg. The Director of the Antwerp Academy, Mattheus Ignatius van Bree, also called; Constable's pictures, van Bree said, 'will make an impression on the continent' – and so they did.[21] French dealers were followed to Constable's studio by French artists, one, carrying a letter from Schroth, was the 27-year-old Eugène Delacroix. He may have made it to Charlotte Street in late May 1825. This was *hommage* of the profoundest kind, one young energetic genius attending to the thoughts and works of another, now not quite so young. Delacroix will have paid the closest attention to the works in Constable's gallery and studio: some Hampstead Heaths will have been there, many cloud studies, studies of Flatford, Dedham Vale, and of course (if visible) the full-size sketches for *The White Horse*, *Stratford Mill* and *The Hay Wain*. These and other effervescent canvases were the seeds that years later drew the remark from Delacroix: 'Constable, admirable man, is one of the glories of England.' Constable and his work remained high in Delacroix's mind, for the younger artist to write in his journal in 1846:

> Constable says that the richness of the green in his meadows comes from his use of many different greens. The dullness in the green in the verdure painted by other landscape painters is that they tend to use a single tint. What he says about meadow green can be applied to all other tones.[22]

In due course, Maria translated Schroth's letter for her husband, who found that it included prescriptive instruction from the art dealer:

> I would only ask you to make your skies as calm as you can, your foreground fields as detailed as possible, for generally speaking the art lovers of Paris prefer things to be clearly expressed. Foregrounds which evoke a feeling of Wynants attract particular admiration.[23]

He took no notice: 'they want the objects more formed and de-
fined', he told Fisher, adding this extraordinary revelation about
his processes: 'They will soon go [to Paris] but I have copied
them, so it is immaterial which are sent away.'[24]

The turn of events were succinctly summed up by Fisher:

It makes me smile to myself when I think of plain English
John Constable who does not know a word of their language
being the talk & admiration of the French! That he should
own his popularity & his success to Paris![25]

But would Constable go to Paris himself? He did toy with the
idea, reminding Fisher that a steam boat goes from Brighton
to Dieppe,[26] but on receiving a letter from Arrowsmith he told
Maria: 'His letter is quite flattering, but I hope not to go to Paris
as long as I live. I do not see any end it is going to answer.'[27] Two
weeks later, having read criticism both hostile and encouraging,
he was even more determined in this view: 'They [French crit-
ics] can't get at me on this side of the water, and I will never
forsake old England, the land of my happiness'. He went on to
misquote a verse of Wordsworth's: 'O, England, if I forget thee
/ May I never more / Hear thy green leaves rustle / Or thy
torrents roar. – I can't remember particularly.'[28]

But then something contrary within him framed this reluc-
tance and exposed it to a sudden and remarkable degree. In what
became their final meeting in March 1825 Arrowsmith made a
remark that Constable thought was 'so excessively impertinent'
that the painter threw the dealer out of the house. That was
that: 'I sent him a letter withdrawing all my engagements with
him.'[29] Constable never did sail across the English Channel, but
memory of his painting did: 'He and Turner are true reformers',
Delacroix wrote in 1858. 'They came out of the rut of the old
landscape painters. Our school, which now abounds in talented
men of this kind, has profited greatly from their example.'[30]

However, did Constable and Delacroix actually meet in
London? It is possible, but not probable, because Constable
was also in Hampstead with his family across these weeks, and
Delacroix may have been received at Charlotte Street by Johnnie
Dunthorne.[31] Somehow, however, Delacroix came away from

London with an English sketchbook which may have been one of Constable's. He took it back to Paris and used its empty pages to draw on, and worked on some of the studies of Brighton within it.[32] The sketchbook is now in the Louvre. For his part, Constable does not seem ever to have referred to Delacroix in his surviving correspondence – not to Fisher, nor to Leslie, nor in his lectures. This suggests that they never, actually, met.[33]

30. I shall . . . throw them all out of the window

Behind this fragile success, Constable had gathering anxieties. He was wrestling with a totally unsuitable client, the former MP Albany Savile, son of the convicted fraudster Christopher Savile (formerly Atkinson), old Abram Constable's partner in the corn business seventy years before. The Savile family had come to stick to the fingers of the Constables. Christopher, he of the pillory outside the Corn Exchange, expulsion from Parliament and self-proclaimed rehabilitation, died aged eighty in 1819 full in years and full in pocket.[1] By then he had married a wealthy linen-draper's daughter, and in 1798 had changed his name to hers, Savile, by royal licence. Having had connection severed on the death of Elizabeth Atkinson (née Constable), the Saviles had no family ties with the Constables, who had no need to have anything more to do with them.[2] However, the Constables thought there might be money in it and continued the connection, and there remained some flutter in East Bergholt over the possibility of inheritance from Christopher. Ann Constable, in her warm-hearted way, became particularly fond of Harriet and Ann Savile, daughters by the second marriage, with a special concern for Harriet ('my dear Harry') when she became engaged to a Galway man who procrastinated for three years, jilted her, and married somebody else.[3] John thought Christopher was 'wicked', as indeed he was,[4] but nevertheless Abram seemed to be softening towards 'poor old Savile', pragmatically:

> It is a happy release for poor old Savile, I hope he has made a just will, – I suppose you attended today, I am fearful at your absence, it was nothing but a <u>compliment</u>, but we have really <u>a claim, to our own</u> . . . Pray what steps do you think we could take to obtain Mr Savile's legacy, the cash would come in most handily now indeed.[5]

Harriet remained close: on Ann Constable's death she wrote

'an affectionate tribute', and asked to be given a portrait of Ann and Golding. She became Charley's godmother in 1821, and three years later John gave her two landscapes to remind her of the Stour Valley, and made for her a copy of the double portrait of Nancy and Mary that he had painted in 1814.[6] Presents were exchanged between them: Harriet gave Nancy for her cottage window a blind with window panes painted on it.[7]

The contortions that Constable now found himself in concerned not Christopher Savile but Albany, who had himself had an inglorious parliamentary career, having been helped corruptly by his father into a seat in the rotten borough of Oakhampton.[8] Albany had married a baronet's daughter, and even after his parliamentary career had come to an ignominious end he persisted in trying to commission Constable to paint a substantial landscape for him. Albany Savile 'I believe is crazy', Constable told Fisher,

All that family are come to ruin – so awfully just is the scripture – for a bigger rogue than the father never came to or escaped the gallows . . . He is not only a fool, but he is as Crazy as a fool can be.[9]

He was undecided in what to do; painter and 'patron' were at odds:

I shall begin immediately on Savile's large picture. It will be a great bore but it may help to save me from ruin. I shall want at least 400£ at Xmas. He has mentioned the delay on my part about his picture. It was his own fault, he should have communicated with me. I wrote to him yesterday – he keeps the place open where it is to hang. A gentleman, who was with him the other day . . . told me . . . he was soon to take a penurious fit . . . Considering all the circumstances & how much I have done with the composition – would it be unreasonable in me to ask a 100£ in advance? But he is foolish & proud – and he might throw it up altogether – as he is so fragile & irritable.[10]

Then he added: 'I have got an excellent subject for a six foot canvas, which I should certainly paint for next year but for Savile: but I have neither time nor money to speculate with, & my children begin to swarm.' This 'excellent subject' was *The*

Lock. Fisher advised him to ask for 'earnest money' from Savile up front, now.[11]

While Constable was trying to make headway with this shifty client, his household in Charlotte Street was in an uproar of illness, with doctors coming and going – children ill, servants ill, John Constable himself ill, and Maria ill in her chronically weakened state.[12] He was 'with anxiety – watching – & nursing – & my own present indisposition I have not seen the face of my easil since X'mas.' With the added pressure of the Savile uncertainties, he was unable to finish a new painting for the 1823 Academy as a result of this turmoil, and so sent his *Salisbury Cathedral from the Bishop's Grounds,* just completed for the Bishop, to the Academy as a stop-gap.[13]

John Fisher the Archdeacon came to the rescue with an invitation to his friend to travel again to Salisbury to recuperate, 'and if you think it will do him good, & can get trusted with the care of him, we shall be glad to see little Johnny with you.'[14] So off he went in mid-August, but leaving Johnny with Maria and the other children in Hampstead, to experience once more the landscape that Fisher so seductively conjured for him: 'It is genuine home scenery. The greens are most vivid & the foliage in the greatest luxuriance. It has the true flat Claude horizon broken occasionally by a distant hill.'[15] Across the next three weeks he and Fisher travelled together around Wiltshire and Dorset, to Gillingham, Sherborne and Fonthill Abbey. Constable needed to consider and sketch new landscape forms and subjects to widen and diversify his vision, and enliven his repertoire for exhibition and sale. The pair arrived on a viewing day for another Fonthill auction, the remains of William Beckford's former collection, recently acquired, along with the 'Abbey', by the gunpowder millionaire John Farquhar. 'I counted more than 30 carriages,' he told Maria, 'and half the number of gigs, & 2 stage coaches ... so a great mixture of company – very few genteel people ... Mr Phillips's name (the Auctioneer) seemed here as great as Buonaparte's.'[16] Constable climbed up the 300 feet high [90 metres] tower of the Abbey: he could see Salisbury fifteen miles away to the west, its spire 'darted up into the sky like a needle'. Cranborne Chase and Salisbury Plain were laid out before him

to the north, and the Dorset hills to the south and east. The man who would call himself 'the man of clouds' was now, practically, among them, with a new world of subject matter below and beyond. He came down from the tower, and in his letter home took Maria on a grand tour – Fonthill Abbey was:

> magnificently fitted up with crimson & gold, antient pictures, in almost every nitch statues, large massive gold boxes for relicks &c., &c., beautiful & rich carpets, curtains, & glasses – some of which spoiled the effect – but all this makes it on the whole, a strange, ideal, romantic place – quite fairy land.

Mr Phillips would sell all this over the next few weeks, and then the pile itself was sold, wings and corridors, towers and spires and all. Two years later, the spire and tower fell down.

Constable came home to his family in Hampstead in mid-September 1823, but it was not long before he was off again. Sir George Beaumont had returned to his country house, Coleorton in Leicestershire, from two years in Italy, and lately from rambles in Devon. He wanted Constable's company, prompting his wife, Margaret, Lady Beaumont, to write: 'We should be glad to see you . . . before the trees are stript of their leaves . . . no time to lose . . . coach from Liverpool . . . Golden Cross Charing every morning . . .'[17] At this twitch upon the thread, Constable trotted off from home and family and went north, presumably by the coach service advised. Despite regular animadversions, he had a weakness for grandees, those whom he liked and who could see the point of him, such as Beaumont and Lady Dysart, and he would always go to them when they beckoned. Maria did not relish John's expedition to Coleorton so soon after his last to Wiltshire, nor was she lovingly content about it; but willy-nilly John would go, and she knew it.

He and Sir George Beaumont had never been easy friends in the same way he was with Fisher or Leslie; the social barriers were much too impervious to allow that. But for all his aloofness and casual benevolence, Beaumont's association with John Constable was stronger now than it had been twenty years earlier. Gone were the days in which Beaumont could grandly advise the younger John Constable on his painting technique, or offer

a palliative for tooth or heartache by gracious admission to his gallery. In London society they remained at arm's length; now, when they talked painting or worked on their canvases side by side, they were studio equals: 'Do you not find it very difficult to determine where to put your brown tree?' Beaumont would ask Constable, innocently. 'Not in the least,' the reply would come, 'for I never put such a thing into a picture.'[18]

Country terms applied at Coleorton: 'At the time you receive this letter,' Constable wrote to Fisher, 'I shall be at breakfast with Sir George Beaumont at Coleorton Hall, Leicestershire.'[19] He told Fisher that he 'looked to this visit with pleasure and improvement. All his beautiful pictures are there . . . Sir George so much desired to see me and it is such a fund of art, that I thought it a duty I owed myself to go . . . [I] shall leave my wife & children tonight.' Another imperative for Constable was that Beaumont's old master collection had been promised to the nation for a forthcoming 'National Gallery', and by his will he had left them to the British Museum, where a first-floor gallery was being prepared in a new wing under construction.[20] Constable's priority at Coleorton was to see Beaumont's pictures again, not the golden autumn trees that Lady Beaumont thought would be the main attraction. His true feelings about the autumn landscape emerged in his letter to Fisher: he preferred to be away from Hampstead where in late October he would witness the 'rotting melancholy dissolution of the trees &c – which two months ago [i.e. mid-August] were so beautiful & lovely.'[21]

At Coleorton Constable was boundlessly happy, as he told Fisher:

Nothing can be more kind and in every possible way more obliging than they are both to me – I am left entirely to do as I like with full range of the whole house – in which I may saturate myself with art, only on condition of letting them do as they like. I have copied one of the small Claudes [*Landscape with a Goatherd and Goats*][22] . . . Sir G. says it is a most beautiful copy . . . I draw in the evening and Lady B. or Sir G. read aloud. I wish you could see me painting at Sir George's side. I have free range & work in his painting room. It is delightful

to see him work so hard – painting, like religion, knows no difference of rank.[23]

Beaumont chattered on as they worked together: 'He has known intimately many persons of talent in the last half century,' Constable reported to Fisher, 'and is full of anecdote.' Constable was embarrassingly smitten by Sir George and his beautiful life. He had been attendant on him for years – cleaning his pictures (and painting out bad ones), tracing compositions, getting Johnnie Dunthorne to mount his drawings.[24] Even so, Beaumont's was a world that was not nor would ever be open to John Constable any wider than his role as a supplier of art would allow. Delighted though he may have been by Constable's company at Coleorton, Beaumont still did not go the extra mile and buy a painting from him. This attitude persisted: calling on Constable in London in 1825, when he would have seen studies made in Brighton and certainly *The Opening of Waterloo Bridge* in its early stages, Beaumont began again to give advice. As Constable put it to Maria, 'he liked what I was about, but wanted me to imitate pictures', that is, paint like seventeenth-century Dutch painters, or Rubens, or Claude.[25] It was the stony limitations of Beaumont's personal taste, not any limitation on his purse, which prevented him from buying Constable, or even really understanding what he was about.

With glee and certain tactlessness, Constable told Maria early one morning what fun he was having, and how well he was doing:

> I have worked so hard in the house that I never went out of the door last week, so that I am getting quite nervous – but I am sure my visit here will be ultimately of the greatest advantage to me and I could not be better employed to the advantage of all of us by its making me so much more of an artist. Indeed what I see and learn here is prodigious – and I can never expect such an opportunity again nor indeed shall I want it.[26]

Then the bell rang for breakfast and he put down his pen and scuttled off downstairs for egg and muffins. Constable's days passed as if he were on a retreat for tired creatives:

We do not leave the [breakfast] table immediately but chat a little about the pictures in the room, the breakfast room containing the Claudes. We then go to the painting room, and Sir George most manfully like a real artist sets to work on anything he may fix upon – and me by his side.[27]

In the evenings the party amused itself by listening to Beaumont reading from *As You Like it*, and Wordsworth's *Excursion*. Writing home to Maria, Constable does not let up in his annoying admiration for Beaumont: 'Sir George reads a play in a manner most delightful . . . the Seven Ages I never so heard before . . . Sir G. is so loathe to part with me that he would have me <u>pass the Christmas</u> with him.'[28]

News of income from Sir George might have placated Maria, 'my darling dear Fish', but none came from that purse until, as an afterthought and to encourage him to stay longer at Coleorton, Beaumont suddenly offered Constable 'a small commission which he wished me to execute here . . . this little job is to pay my expenses down here.'[29] What this might have been is unknown, unless it was preliminaries for *The Cenotaph*, but it never materialised. Maria became fractious, and we witness it: 'Had you not been so long at Mr Fisher's which was quite <u>unnecessary</u> I should have thought nothing of this visit . . . Pray finish your Claude or I think you will never be happy again.'[30] She told her husband that he has missed much enjoyment at home, and – with irony – told him that Johnny thinks 'he supposes you will return next summer.' Then a week later, this:

I begin to be heartily sick of your long absence. As to your Claude [copy] I would not advise you to show it to me for I shall . . . throw them all out of the window. Your friends begin to wonder what is become of you . . . How is it no letter today?[31]

Maria had been losing weight all year – 'everyone says how very thin I am grown', she told her husband.[32] She wanted him home. She had become thoroughly fed up with people turning up at the house looking for John and expecting to chat, as if Maria had nothing else to do than entertain them: 'that great bore

Peter Cox . . . nearly an hour . . . reading the paper and talking of himself . . . & Mr Judkin another of your loungers.'[33] When this letter was in the post, John wrote to Maria with some soft soap, in a tone he would have been advised to avoid had he read hers already. He says he has been missing her, using words which were firmly crossed out by a later (family) reader of the letters. However, the crossings out in loopy penwork are not as indecipherable as intended: '[blank blank] and my dear bedfellow [blank black] is a very [blank] and nobody but you can [blank blank].'

Constable became in thrall to Beaumont whom he saw as a paragon of virtue and taste:

> I really think that the [seemly] habits of this house will be of service to me as long as I live – everything so punctual – Sir G never omits Church, twice every Sunday – he never looks in his painting room, on a Sunday, or trusts himself with a portfolio – never puts himself into a pet, or is impatient – never uses an oath on any occasion, or takes God's name in vain – always walks or rides for an hour or two at two o'clock.[34]

Maria responded crisply: 'I shall expect you the <u>end of next week</u> certainly, it was complimentary in Sir George to ask you to remain the Xmas, but he forgot at the time that you had a wife.'[35] Charley, now two years old, was also missing his father. He had got it into his head that 'Papa will never come home.' John replied quickly and with mild contrition: 'I hope nothing will prevent me from leaving this place tomorrow afternoon, & that I shall have you in my arms of Thursday morning, and my babies.'[36] But then came this: 'Sir George is very anxious that I shall not leave him for another day or two that I shall stay 'till Friday . . . Nothing will detain me in this house after Friday.'[37] There is no reply from Maria.

When he returned he was struck down – 'quite disabled' – by his recurrent toothache, brought on also, perhaps, by *froideur* in his wife.[38] Coleorton had been a blessed respite, and now, back in the hurly-burly of domestic life and winter chill, the indulgent balm of the Beaumonts quickly evaporated. Running problems re-emerged: the problem of his *Waterloo Bridge*; the problem of

the irritating Saviles. This dragged on well into 1824 until, eventually, Constable faced the difficulty head on, as he had with Dr Rhudde in matters of love and marriage:

> I have seen Savile, and have shaken him off. In fact I have made a virtue of a necessity – and we are independent of him, and clear to finish the picture unshackled & unencumbered by an employer – such as he – at least ... Poor Savile is a wretched object, and his folly now stares him in the face, but he has a wife who married him for his riches and will not let him retreat while any is left. I am glad I have no hand in sending him to the Workhouse or something worse.[39]

As the summer of 1824 approached, temperatures in London rose, and in May Maria was suffering still more. 'This warm weather has hurt her a good deal', Constable told Fisher. 'We are told we must try the sea.'[40] There would be no Hampstead this year: 'on Thursday I shall send them to Brighton.'

So down to the sea they went, to a house Constable had found to rent – 9 Mrs. Sober's Gardens – close to the beach and within the sound of the breakers and the seagulls' interminable gossip.[41]

31. Brighton and home

They would be apart now until October, Maria and the family by the seaside, John working from Charlotte Street. To keep Maria amused and informed, Constable began a Journal in which he detailed his works and days, and from time to time he would send the latest pages down to the family on the coach. He visited them, but not as much as he might have done as 'really it is ruin to me to be out of town at this time of year – but I now want the sea air as much as you . . . I shall bring some little pictures down with me to keep going on with.'[1] He left London on his first visit to the family on the eighth or ninth of June for the week, then back to work in town. He loved his family, but he loved his work quite as much. For its brief duration, Constable's Journal shows flash, inconsequence and gossip comparable to Joseph Farington's diaries, but it had a further purpose and dimension: to give exercise to his pen, to release his thoughts, to express his feelings, to shape a picture of his life, and to make it clear to himself and his reader (only one reader was anticipated) the weight of effort that his days contained. 'I like your keeping a journal', Maria told him as she waited expectantly for the first instalment, 'I hope you will continue the plan.'[2]

Constable sent news that amused Maria and kept her informed, and very early on he sent her a large pat of butter: the news was welcome, the butter not. 'Do not be angry but I did not feel pleased at the sight of the butter. I am afraid it will not keep, & plenty you know sometimes makes waste . . . Indeed you study <u>all our little wants too much</u>.' The distance between them made him overcompensate. As Maria says in her occasional letters home, the children were 'all very, very noisy' in the house. Of course they were, so they went out for walks and rides together: they played on the beach, walked out to the chalybeate spring at Hove, and took rides to the Downs in a hired carriage. 'We can well afford it this season', John said proudly in one of his few expansive

remarks about the novelty of a healthy cash flow.[3] Opposite their house, in the present Sillwood Road, were the grounds of Western Lodge with its skylarks, and a gardener who said they could walk there so long as they bought his fruit and vegetables. Next door lived a pair of kindly but irritating neighbours, the painter Jean-Jacques Masquerier and his wife, Rachel. Masquerier infuriated Constable, though that was not so difficult: he had been a slick and successful portrait painter, retiring to Brighton on the fortune he had made. He and Constable had 'no one feeling in common on the Art', Constable confided to Fisher, adding, 'on the score of the Academy the grapes are sour, & although he has made a fortune in the Art, he enjoys it only as a thief enjoys the fruit of his robbery – while he is not found out.'[4]

This typically overheated and off-hand remark has to be set against both John and Maria's reliance on the Masqueriers as neighbours: Jean-Jacques recommended a tutor for seven-year-old Charley, while Rachel, who Constable referred to as 'vulgar – & clever – with the assurance of the devil', was generous enough with local help, and praised Constable's 'beautiful style of painting'; Maria told her husband 'you need not have a better trumpeter.'[5] It was at the Masqueriers' that the Constables met Henry Crabb Robinson, one of the few links that survived between Constable and Wordsworth. In conversation, Constable told Crabb Robinson of his acquaintance with the poet, and how he had learnt some of Wordsworth's poetry: 'preserved some memorials of his composition when they met [in 1807] at Sir George Beaumont's'.[6] While he was graceless with the Masqueriers, he did meet 'a most intelligent and elegant man . . . we are become intimate & he contributes much to our pleasure here.'[7] This was the botanist and schoolmaster Henry Phillips: 'all his works on natural history are instructive and entertaining – calculated for children of all ages – his history of trees is delightful – I shall buy them – & I think you would if you saw them.'[8] Phillips became a close and supporting friend, advising Constable on botanical detail, and in due course providing tuition in Brighton for Johnny.

The skies over Brighton were magnificent: Maria watched them out of the window: 'I do nothing but study skies all day',

she said, 'a fine situation for that': it was 'Hampstead with the addition of the sea', she thought.[9] She too loved sky-watching: 'I think there is nothing more interesting than the flying shadows on the downs'.[10] Maria was at one with her husband: 'I long to go with you to the [Devil's] Dyke', she told him. They had their share of rough weather, all that the Sussex coast could throw at them: 'what a day, wind & rain & smoke, the steam packet obliged to make for Newhaven'.

Something got into Maria across her early months in Brighton, concerning a white veil that she wanted. She knew it was somewhere in Charlotte Street, and asked John to tell the maid to find it. 'Sarah could not find the veil', John reported, but a fortnight later, after John had been down to Brighton and the subject was raised again, he 'had another hunt with Sarah for the white veil. Am almost certain it is not in the wardrobe – we turned out everything most carefully – and in all the little boxes in the right hand drawer.'[11] While John was happy and busy in London, Maria in Brighton was not, though she was not the complaining sort. Charley had not been well, and the doctor came and prescribed a powder for him, '& took his fee'.[12] She got wind of the notion that Lady Beaumont had summoned John to Coleorton again: 'I think it much better for you to resist Lady B, you have plenty to do at home.' The new housekeeper, Mrs Wood, was unsatisfactory: 'many have called & not got in, some I have heard of'. Things were getting on top of her: a towel has gone missing, it was too windy to go out, and little Johnny had woken up in the middle of the night screaming. And she wanted her white veil – this must surely have been the one she wore on her wedding day, and as it is not mentioned again John and Sarah must eventually have found it. This clue of Maria clinging tight to her home and her things is a sign of her craving for the love that she certainly had from John in abundance, but which she sometimes misconstrued in John's detached behaviour. Objects focus time and emotion; she wanted her white veil. Maria was in Brighton for her health, but with John absent, with housekeeping to manage, servants to handle and the children playing up around her, she was still carrying a burden of responsibility that she could do without, while John was swanning around in London enjoying freedom of

action and movement. This new arrangement in Brighton turns out to have been of greater benefit to John than to Maria.

Back in Charlotte Street, John got down to work. He made sure his signature was clear on the paintings that Arrowsmith had bought – on the bottom edge of *The Hay Wain* he wrote with his brush: 'John Constable pinxt.' and added 'London 1821' for good measure, so it would be perfectly clear, if it never returned from France, that this picture had been painted in *England*.[13] The days now were his own: he walked into town, went to the bank, and dropped into Paul Colnaghi's print shop and gallery in Cockspur Street for a chat. The Colnaghi family were in the middle of a business feud, the brothers Dominic and Martin sparring over the direction of the firm as their father approached retirement. Paul Colnaghi took solace in his little birds, all a-chatter in the shop: '[he] is so fond of [them] that he has nearly a dozen in the room.'[14] Walking down Spring Gardens, Constable called on Maria's father and on the by now 79-year-old Lady Dysart in Pall Mall. In Regent Street he bumped into a fellow artist, Henry Cipriani, a member of the family of Charles Bicknell's Treasury colleague, and they gossiped: life was pleasant with Maria away and the children not getting under his feet. Some visitors bothered him and wasted his time – 'Judkin . . . a great trouble to me. He brought me some of his pictures, very bad & cold. I should be glad if he never came again.'[15] A few weeks later he may have succeeded in banishing this nuisance by crisply speaking his mind about one of Judkin's pictures: 'He seemed quite hurt – & I do hope I have scared him away.'[16] Judkin was one of Constable's 'morning flies', as Fisher described them.[17]

Nevertheless, he had assistance – the efficient and capable Johnnie Dunthorne was with him every day, helping with finishing paintings, copying portraits and generally keeping things tidy and organised. 'Johnnie is getting on with Mr Lewis's portrait the copy,' he told Maria, '& so continually useful to me that he makes me keep at home to my work.'[18] To Fisher, Constable said of young Dunthorne 'he cheers & helps me so much that I could wish him to be always with me. He forwards me a great deal in subordinate parts such as tracing, squaring etc etc.'[19] Constable treated Dunthorne well, as he certainly should, having had

such strong, kind and generous friendship from the young man's ailing father, and despite Maria's dislike of that older man. He took Johnnie out with him on studio business, and to Somerset House where *The Lock* was on show, and where Constable would have been a perceptive if opinionated companion as they went from picture to picture. Johnnie was a remarkable young man, as accomplished in his own way as was his father. Already, in his mid-twenties, he was a passionate expert in telescopes: a visitor to the studio was impressed by him, as Constable told Fisher: 'a gentleman called on me who has "nine telescopes". You may judge how thick they soon got. It is John's forte. He is to see them tomorrow.'[20]

There were cats in the house, two or three at least: Billy, Johnnie Dunthorne's cat and kitten, and others passing through. Constable had his servants to look after him: 'Got home at 2 to a nice piece of roast lamb and a pudding – with an appetite – & today I am quite well again – or so much so that I cannot find out any where that I am ill.'[21] From time to time Kennedy the handyman came to do light building work and some brewing for the household. Constable helped him out: 'I have just tasted the wort', he told Maria.[22] Ambrose Wright, an upholsterer and furniture dealer living in Grafton Street, was another occasional handyman help, so the place was bustling.

The maid Sarah was not satisfactory, suspected of drinking, and always had a headache: 'she does not seem likely soon to be in a fit state for service', Maria thought, suggesting other good women who might be able to step in and do for John: Mrs Wood, Mrs Brown, Mrs Port or Mrs Jones. 'I am told 10 shillings a week is enough.'[23] Sarah seems to have been on the skids in those harsh times: she was nearly forty, had a bad knee, her arm may have had an infection because she could not do the washing, and to pile yet more misfortune on the poor woman, Fisher was unkind enough to say that he did not want her to cook for him because – he said – she was dirty.[24] A more companionable servant, Ellen, who had been with the family for at least five or six years, was in Brighton with Maria and the children, until Maria sent this 'very good & industrious' young woman back to London to look after John. She was gleeful and lively, one evening going out with

Johnnie Dunthorne to a performance of *As You Like It*, wearing
her hair 'thrown all on one side, & in white'. They came back late.
'I am now writing this while sitting up for them – quarter past
12 – not yet come home – a fine night & new moon', Constable
told Maria, adding at last: 'Quarter past one. They are just re-
turned.'[25] No chance of romance there, however: 'he is too good
for my maids'.[26] Elizabeth, who would make a beautiful apple
pie,[27] succeeded Sarah at Charlotte Street. Such an improvement
Elizabeth was: 'so careful and so very handy – and so clean.'[28] In
the kitchen was Mary, the chatterbox pantry girl and cook, who
was married to Ellen's cousin, a 'boot closer', that is, a stitcher-up
of uppers: 'he had better close her mouth to begin with', advises
Constable.[29]

When the bell rang or the door knocker went at 35 Charlotte
Street, Sarah, or Ellen, or Mary, or Elizabeth would show visi-
tors into the short hall. There was a parlour to the right where
they might wait, to be greeted perhaps by Johnnie Dunthorne or
by Constable himself. Beyond, in shadow, the hall led towards a
back parlour and stairs down to the basement kitchen, but ahead
were six or eight steps up to a half-landing. On a bright day light
fell here – 'very beautiful light to work by' recalled the painter
Claude Rogers in the 1970s – and there would be creaks as the
visitors opened a pair of double doors, because through these
doors was a short passage leading beyond the back of the house
to the studio.[30] But what a passage this was: barrel-vaulted, and
lit down its centre-line by skylights, this was where Constable's
visitors might pause to enjoy the current display of their host's
paintings, a gallery of greens and golds, subdued when the day
was over and candlelight flickered. Some pictures were framed,
some not, a few on the floor leaning against the wall, some
perhaps stacked when there had been no time to organise them
properly; this was Constable's shop window for the world, where
he could separate himself from his paintings and allow them to
try to stand alone.

Gainsborough had had such a 'shew-room' in Bath and Pall
Mall, as did Reynolds in Leicester Square and Benjamin West in
Newman Street. Turner had had one for twenty years already, first
in Harley Street and later Queen Anne Street. Artists' galleries

had cropped up all over London as the art market began to favour living artists: George Romney, Thomas Lawrence and Francis Chantrey all had galleries – but these were portrait artists, so the benefit of sitters seeing current work was obvious. The highly gregarious party-giver John Martin displayed his work within his house in Allsop Terrace, off Marylebone Road, as did Callcott and Wilkie, Flaxman and Ward in their homes.[31] There was new money around now, in addition to traditional aristocratic sources – money from commerce and manufacture, mining and materials, import and export, banking and the law – and in London the money pooled.[32] With a bookseller, a wine merchant, a draper, a paper-maker, a solicitor and a parson among his clientele, Constable was at the forefront of this developing trend. Like every clued-up professional artist, Constable knew that in order to sell into these markets he had also to display. As time went on he had cards of announcement printed.[33]

Beyond his gallery, through a second pair of double doors, was his engine-room, the studio, perhaps a cube painted in a 'sort of purple brown', the colour that Constable favoured for his painting room.[34] There he worked against an end wall lit from above by a long, north-facing line of windows. Onto his work in progress, and onto Johnnie Dunthorne working beside him, the light of London fell. This was a crowded, untidy place with stuff lying about, stacked canvases and frames, long canvas rolls, pieces of paper, drawings, prints in portfolios, cats wandering in and out, drawing desks, easels and chairs. The young painter William Powell Frith wrote an account of what he saw there in 1835 or soon after:

> There was a piece of a trunk of a tree in the room, some weeds and some dock leaves ... 'Never do anything without nature before you [Constable told him] if it be possible to have it. See those weeds and the dock leaves? They are to come into the foreground of this picture. I know dock leaves pretty well, but I should not attempt to introduce them into a picture without having them before me.'[35]

It was within such organised chaos that Constable sat down and painted his dock-leaf study and his fragile yet vivacious poppy

clump with its two blooms. These closely observed, common-or-garden subjects were to be among the source material for such paintings as *The Hay Wain* and *The Leaping Horse*.[36]

Helping Maria in Brighton when Ellen had gone back to London, was Mrs Inskip in the kitchen, 'always ready to do what she is asked', particularly making one of John's favourites, toad-in-the-hole: 'you have talked so much about a toad in the hole that I have had one today', Maria told him.[37] Elizabeth Roberts, who had been with the family since Charley was born, was always at hand and a treasure. She was reliable, good-humoured, and the entire family loved her. After Constable's death Abram described her as 'a valuable friend, and millions would not purchase such a one.'[38] The touching portrait of Mrs Roberts – 'Bob', as the children called her – with her wide eyes, her warm, loving expression and her high-tumbled curly dark hair, is a sweet response, replete with care and affection.[39] Back in London, Constable's final task for the day was to write his Journal: 'Had lettuce for supper. Tomorrow beans & bacon I hope, & now I have finished my journal. It is just gone twelve – & I am sleepy. Good night my darling Fish.'

Why Constable called Maria 'Fish' is a mystery, one of those private coinages that emerged unexpectedly and persisted inexplicably. A root might be found in the eighteenth-century usage 'an odd fish', meaning a strange, eccentric person. Maria referred to herself as 'a strange creature', and it may be a small step in private family expression from 'strange creature', to 'odd fish', to 'Fish'. We don't know; perhaps neither did their children.[40]

Nothing would get in the way of Constable's focus on his work, least of all the absence of wife and family. If the purpose of Brighton were not clearly for Maria's health, we might reflect that having the family by the sea allowed Constable to develop his main agenda: work. 'Set off for Piccadilly – got into a Richmond stage and was soon at Ham. Lady [Dysart] was alone & immediately wished to see me', so of course off he went.[41] He told Maria everything, every little detail and observation that John could squeeze in. This is his 30 May entry in 1824:

Had a long confab with her ladyship – went & had refreshment

– and saw her Ladyship again – and we walked arm in arm, into the gardens and fields. Met there by Mr Charles Tollmach [i.e. Tollemache, Lady Dysart's son] – saw her bulls which are great favorites & a huge black boar, who is likewise a great favorite.

And so on. He had pictures to complete for the Dysarts,[42] but one of his reasons for going to Ham was to discuss his brother Golding's employment as a gamekeeper in the Dysart's woods at Bentley, near East Bergholt. Golding replaced a corrupt land agent who had allowed his friends to hunt there, and probably took a kickback. The agent had set traps for dogs – 'dog spears' – and tried to draw Golding into friendship and persuade him to turn a blind eye on the poaching in these 'cruelly used' woods.[43] Both Abram and John supported Golding's part, and having read Golding's report on the matter, Lady Dysart, fully on the ball despite her age, took John on her arm to walk him round the garden for the 'confab'. Such East Bergholt family problems still pursued Constable and took his energies and attention, particularly when they crossed with his professional engagements with the Dysarts. However, it was this same Dysart connection that had enabled him to find employment for Golding in the first place.

When John travelled down to Brighton he brought his paints and boards and canvas, and found Maria and the family neat and tidy and thrilled to see him. Maria had spent hours wrestling with the domestic accounts, probably long after the children had gone to bed, when the light was failing and the candles lit. One evening she found herself two sovereigns short: 'I cannot make my accounts right', she said, telling him also that she would send this letter by post: '8 pence will be well disposed if it spares you an hour or two of inconvenience.'[44] Such an apologia may have been common coin between them, she so careful, he so tight. Later exchanges continue the theme: 'I had to pay half a crown [2s. 6d; 12.5p] for the birds, could that be right? ... Roberts says if I come [to London] on Saturday I shall save two guineas half a week.'[45] John and Maria must have had a very serious talk about the future during the 1824 summer in Brighton, because she makes a very serious point in a letter home: 'I am reading

a book on education for the advantage of my children, & I am
perfectly satisfied with my four without wishing for any more.'[46]
Nevertheless, she became pregnant once again.

So the Journal bounds along. John tells Maria – and the older
children – about the flight of the *Royal George*, the hydrogen gas
balloon that he watched being launched at Camden Town before
an audience of thousands. This had been long in the planning,
and as 1 July 1824 turned out to be windy, the balloon bumped
first into the ticket-paying stands, and after knocking up against
a cowshed, it blundered up into the air, just about cleared the
houses and, caught by the wind, shot off across Islington to-
wards Essex and Romford, where it landed about an hour after
take-off. Constable describes everything he saw: 'The men in it
waved the white flags, stood up, & bowed with their hats . . . It
went with enormous speed – owing to the high wind – and it was
lost in the dark heavy sky in less than ten minutes.'[47]

The Journal's rich and illuminating content ranges from re-
portage such as this, and also unexpected insights into the pattern
of his renewed bachelor life. Clutter is building up in Charlotte
Street in Maria's absence: 'Ellen has been on her feet all day
ironing, & has done a great deal. We had the rest of the mutton
hashed & a rice pudding . . . Kennedy was here and removed my
large frames out of the pantry room into Ellen's room, where
they stand quite out of the way.'[48] So when Ellen goes to bed she
has to squeeze in between a stack of empty picture frames. His
life was busy enough at home, what with one thing and another:

> Got up at 7 o'clock, and wrote a letter. I have had more writing
> than painting today . . . four letters . . . Mr Ottley the famous
> collector of prints . . . called this morning . . . Mrs Impey
> called and with her two young ladies, the Miss Bradstreets . . .
> nice genteel girls . . . Mr Bradstreet [came].[49]

Robert Bradstreet of Higham Hall, the published local poet –
author of *The Sabine Farm* so beloved of John and Maria during
their courtship – was 'humorous and always good natured'.
He wrote a piece of doggerel for John, 'On seeing some of
Mr Constable's landscapes'. John wrote it out for Maria:

These genuine scenes, in tints to nature true,
As plain to me as any pike-staff make it
That he who would do <u>justice</u> to his view
Should send and get this <u>Constable</u> to take it.

That same day was particularly full of distractions. Appleton, a tub-maker from Tottenham Court Road, wanted to know if Constable had a landscape '<u>damaged</u> that I could let him have cheap'. Constable went on to tea with William Young Ottley to look at his print collection, 'such a collection of Waterloo's etchings I never saw . . . & an abundance of his own drawings which gave me a great deal of pain – so laborious – so tasteless – & so useless – but very plausible . . . Got home half past 12.'

Eighteen-hour days were commonplace. There were scandals to relate – of Samuel Lane, whose housekeeper had a lover, the framemaker Tijou's apprentice: 'a blackguard . . . Lane found him in the cupboard, & pulled him out by the collar. She is to go.'[50] Lane was profoundly deaf so they must both have thought they could get away with it. How wrong they were. All these entries are in the tiny compass of the first five days of July 1824, and reflect on the variety, pace and detail of Constable's life, without all those other things like painting pictures, going to exhibitions, and attending dinners. And what close detail:

Jackson . . . said there had been a sad affair at Sir Thomas Lawrence's, something of a housekeeper destroying herself – but he gave but an imperfect account. Got home to a very large toad in the hole.

A man was making a strange noise in the street singing with a piece of toast in his hand at the end of a toasting fork, something about a mistress who beat her maid for having made half a toast too much . . . All heads were out of the windows & the street full.

Two ladies who live in this street . . . went to Margate for a little excursion – took lodgings in a house in which a family had been with the scarlet fever – & are both at home with it. One is nearly recovered – & the other, still bad. How shameful of the people not to tell at the lodgings.[51]

It is to be regretted that Constable's Journal only spreads across two years. He told Maria about a brawl in Charlotte Street, and how, as a newly-appointed Commissioner responsible for 'watching the streets' of the neighbourhood, he had to break up two boys fighting who had attracted a 'great mob ... of at least 100 people, butchers & all sorts of blackguards. The street was clear in a few minutes.'[52] He speaks without filter, and mocks himself as much as others. Spending a day and the night at Ham House, he makes it clear that while remaining very fond, Lady Dysart has spotted the prig in him: 'We shall shock Mr Constable', she said to a fellow guest, 'we are going to have a game of cards.' 'They played a four game, I know not what', Constable observed, adding: 'I walked out about the grounds and plucked as much fruit as I wanted – peaches & all sorts.'[53] While Constable was having a sybaritic time in the orchards at Ham, Maria was in Brighton coping with her health and her pregnancy, with no clue of complaint from this stoic woman who gave little of her inner emotions away. She was also suffering from a boil on her face, which must have been painful, and about which John – never wanting to be inconvenienced by bad news – told her that this was a sign that she was getting better, 'a certain proof of the air taking a good effect on your constitution.'[54]

At the end of October, Maria and the children had to vacate Western Place and come home. Maria was still fretting about money, and anxious about the missing towel when she checked the inventory.[55] John powered on in his particular way, as if the coming arrival of the family was a mere ruffle. His letter to Fisher written the day before their return harps on many subjects, including his own ill health and the implication that it is his moral duty to paint pictures. He becomes garbled, even incoherent:

> Tinney's pictures I see no prospect of my being able to afford the time from the publick to – and after a time they become a burthen – dead weight – and even a reproach to my own conscience, and lay me indeed open to the observation of my friends (& those the best) when no allowance is made for the real difficulties I have to encounter, because they cannot be made to understand them – I mean the world generally, <u>not</u>

you – but Tinney and such highly gifted common sense men.[56]

His extraordinary wife, chronically tubercular, three or four months pregnant and with a painful boil on her face, was trying, at that very moment, to pack up their holiday home by the sea, and get bag and baggage, four children, nurse and servants ready for the coach to London the next morning. Concurrently her husband was writing this to his friend:

All my indispositions have their source in my mind – it [is] when I am restless and unhappy that I become susceptible of cold – damp – heats – and such nonsense. I have not been well for many weeks – but I hope soon to rid myself of these things and get to work again. I expect my family home tomorrow from Brighton – my children will amuse me.[57]

32. My ambition is on fire

Brighton gave Maria the health-giving sea air she needed, and, when John joined the family there, it gave him the opportunity to relax, something he was particularly bad at. He did not let up. There might have been children running around, and Maria organising the house, but in Brighton when Constable was not painting he seems to have been taking pen to paper and talking to Fisher. 'In London I have so many occupations & interruptions, that I was glad to put [writing to you] off 'till arrived here – wither I am come to seek some quiet with my children.'[1] His relative success with Arrowsmith and the French, and the general uplift to his reputation in London, had prompted a sea-change in his popularity among buyers of art.

It was he, John Constable, who took English art to France on a monumental scale. While Géricault's huge *Raft of the Medusa* and David's even more huge *Coronation of Napoleon and Josephine* had travelled north in 1820 and 1822, *The Hay Wain* went the other way, and in 1822 must have been the largest modern painting by an English artist to have crossed the Channel – and that a horse and cart, not a death-raft nor an imperial coronation. In the wake of this, he was amused to receive a letter addressed to 'Monsieur John Constable, Peintre paysagiste 35 Charlotte Street Fitzroy Square à Londres'. He was writing his own rules, and in doing so found support in Laurence Sterne, whom he quoted: 'Never mind the dogmas and rules of the schools – but get at the heart as you can'.[2] At last the tangles of unrecognised and unrequited effort seemed to be over and he could say to Fisher: 'What a blessing it is thus to be able to carry my profession with me. A medical man cannot take his patients with him or you your flock.'[3] Not completely over, however: Lord Egremont of Petworth, Turner's patron, and the patron and laid-back cheerleader for so many artists, said, on being shown some of Constable's paintings, that 'he recollected all my pictures of any note, but he recollected

them only for their defects . . . The truth is that landscape affords him no interest whatever.'[4] That is, of course, quite wrong.

He blasted off his own wayward opinions to Fisher. Here is John Constable the sociologist (and prude) reporting on the state of the English seaside:

> I am living here but I dislike the place . . . Brighton is the receptacle of the fashion and offscouring of London. The magnificence of the sea, and its . . . everlasting voice, is drowned in the din & lost in the tumult of stage coaches – gigs – 'flys' &c – and the beach is only Piccadilly . . . by the sea-side. Ladies dressed and <u>undressed</u> – gentlemen in morning gowns and slippers on, or without them altogether about <u>knee deep</u> in the breakers – footmen – children – nursery maids, dogs, boys, fishermen – <u>preventive service men</u> (with hangers & pistols), rotten fish & those hideous amphibious animals the old bathing women, whose language both in oaths & voice resembles men – are all mixed up together in endless & indecent confusion.[5]

He goes on to talk about the 'genteeler part', Brighton's Marine Parade and its 'neat appearance & the dandy jetty, or chain pier, with its long & elegant strides into the sea a full ¼ of a mile.' He complains that there is nothing for the painter at Brighton except the breakers and the sky, 'which have been lovely indeed and always varying.'

One sudden rainstorm took him rapidly to work – a huge black cloud hung over the sea perhaps a mile away. A few hardy ships were out on the water, which was tossing surf in its motions as a shaft of sunlight shot out from behind the cloud. Then the rain fell, way out at sea, but in its long downward tresses of thick black paint pulled into whiskers by a dry brush and white, Constable makes it clear that the storm will come ashore very soon and soak him.[6] This is such a subtle and exciting painting, made perhaps in ten or fifteen minutes. The pinky-brown of the millboard or paper glows through, giving the whole thing a steady warmth and an unexpected optimism. It is packed with emotion, not only in the dramatic rainstorm, but in the two- or three-centimetre strip along the bottom edge of beach and sea and horizon, and four (or five?) sailing boats on both the far side

and the near side of the storm: some are through the storm, others have it to come.

Looking out to sea, or sitting on a barrel or a post, Constable found Brighton to be teeming with fresh imagery which exercised him in small drawings and oil studies: 'Nothing for the painter', he said? What rubbish! The sketchbook he appears to have given to Delacroix contains a number of little studies of people hanging around in the sun, of boats, the shore and so on.[7] When he came in from the beach he would work in Mrs Inskip's room: 'she can sit in the kitchen', he remarked.[8] One panoramic view, painted in July 1824 on a sheet of writing paper, shows the blue sea with a stiff breeze blowing, the scoured sandy beach, a damp tide line, ships bending to the chilly wind, and a line of colliers anchored in the shallow water. The Chain Pier, newly built to take steamers at any state of the tide, is just visible as a blob. The painting is immediately affecting in its tiny compass and enormous sense of scale, and is of the same proportions as Constable's exhibited six-footers.[9] The extent of the rapidly growing Brighton is marked by the end-of-terrace houses of Marine Parade in the middle ground and the distant chalk cliffs lit by the declining sun. The inscription on the back reveals that the painting was to be a present for Fisher, and indicates Constable's continuing practice of capturing fleeting information about the day: '3d tide receeding left the beach wet', he notes, 'Head of the Chain Pier Beach July 19 Evg., 1824. My dear Maria's Birthday Your Goddaughter. Very lovely evening – looking Eastward – cliffs & light off a dark [?grey] effect – background – very white and golden light.'

Perhaps without fully realising it, Constable was beginning to collect information in sketches in which he places a boat prominently on the left drawn ashore, and allows the beach and sea to stretch away into the distance, centre and right. The sea on the right-hand side shows that we are looking east from a point between the village of Hove and Brighton. Together, these studies begin to resolve into what became the grand six-footer *The Chain Pier, Brighton*.[10] With 'its long and elegant strides' a quarter of a mile into the sea, the Chain Pier was the most outrageously beautiful monument to the modern age, a delicate cobweb plainly

vulnerable to gathering storms: it weathered many until the one in December 1896 that finally blew it away. In *The Chain Pier, Brighton* a storm threatens. There is a magnificent sky on the edge of turbulence, sunlight just managing to shaft into the middle ground, boats running for home, and people taking not quite enough notice of the storm to come. The distant pier is the one still moment in the picture, a precise and pointed sewing-machine line of thread that pulls the whole thing together.

The painting is also a product of serious prevarication, the like of which we have come to expect of John Constable, but have not seen in such drawn-out circumstances. Waylaid by Brighton's Chain Pier, he was trying also to get on with his painting of London's Waterloo Bridge. He asked Fisher's advice, reminding him that 'it is a work that should not be hurried.'[11] Just so. Then in July 1824 all the air went out of his balloon, and he told his friend, 'I have no inclination to pursue my Waterloo. I am impressed with an idea that it will ruin me.'[12] He tinkered with it nevertheless, agonising a year or more later: 'My Waterloo like a blister begins to stick closer and closer – & to disturb my nights'.[13] In contradiction, he told Maria: 'Waterloo promises delightfully'.[14] Studio visitors told him what he wanted to hear: Robert Balmanno, Secretary of the Artists' General Benevolent Institution, Constable reported proudly, was so delighted with *Waterloo Bridge* in progress 'that he says it will be my triumph, and that I shall "certainly set the Thames on fire, if anybody can."'[15] Everybody had an opinion on *Waterloo Bridge*, and the more they went on about it the more Constable fretted.

He set its composition from the start: in his studies the bridge is always halfway into the distance, halfway to the right, and is comparable to the composition of *Chain Pier*. They are, or are becoming, echoes of one another – one urban, the other littoral, and one a bridge of stone with nine arches visible, the other of iron and four. Both bridges bound across their canvases, both equally divide water and sky, both are a confident foil to the turbulence of their skies, the uncertainties of their waters and their light's eternal caprice.

Within him now, if we can imagine it, were ideas for not two but three large paintings, each in embryo, each one already the

object of struggle, and each one getting into his brain: *Chain Pier, Brighton, The Opening of Waterloo Bridge*, and the painting that we call *The Leaping Horse*. In November 1824, when the family was settling in for the winter in Charlotte Street, Constable had sketched out on a six-foot canvas the figure of a horse jumping over a barrier on the canal bank at Flatford. That took enough intellectual and physical energy, but nevertheless Fisher, in his annoying way, thought Constable might have 'an idle minute' to make a sketch of a Gothic chair for him to use as the basis of a new look for the Salisbury Cathedral altar. Then further tactlessness from Archdeacon Fisher, advice to Constable to 'diversify your subject this year as to time of day.'[16] He reminded him that James Thomson wrote the Four Seasons, not 'four Summers . . . People are tired of mutton on top mutton at bottom mutton at the side dishes.' It is a measure of Constable's self-control that Fisher's advice did not cause explosion. His response included this:

> No man who can do any one thing well, will ever be able to do another different as well – I believe that from our physical construction no man can be born with more than one high & original feel – this in my opinion was the case with the greatest master of <u>variety</u>, Shakespeare.[17]

Maria, further on in her pregnancy towards the end of 1824, was 'quite well', John said, 'never saw her better and more active & cheerful – but she is rather stouter than I could have wished.' The children were growing up fast: 'John I am sorry to say is a genius – he is very clever – droll & acute – what he does & says is curious . . . Your goddaughter,' he tells Fisher, 'is so much the little lady that she delights every body.'[18] In January, Constable travelled to Woodmansterne near Reigate on a commission of a kind that harks back to his energetic pursuit of portrait work in the 1810s. The Lambert family were old friends of Maria's father, so he felt he had a duty to comply – Maria had stayed with the Lamberts when she was still Miss Bicknell.[19] The modest canvas, showing the three Lambert children and their donkey, effortlessly binds the figures together with a charm that, twenty years earlier, had eluded him in the Bridges family group portrait

and the giant painting of the Barker children.[20]

Maria was high in his mind as he sat in the evening at supper with the Lamberts: 'We talk much of you and there is disappointment that you are not with me.'[21] At Woodmansterne Constable was lionised; indeed, the flattery went to his head when he was embraced by the family and he fell momentarily in love with it. He talked about himself and Maria endlessly during this fleeting moment when everybody behaved beautifully, and the Lamberts congratulated themselves on their choice of artist:

Miss Lambert is my delight, so kind and sensible and amiable – and above all so fond of you & so well able to appreciate your character. She does not wonder now that we are intimate that you was so determined on not relinquishing me.

Self-regard was one of Constable's qualities, whereas self-awareness probably was not. As we remember, Maria had got very close to relinquishing John, but that is now history. 'Oh! What a work it was', the children's aunt wrote when the painting was finished:

He (Mr C.) has succeeded very happily, indeed he ought – such time and patience he bestowed upon it. He was extremely pleased with the darlings and has done them justice without flattery.[22]

Constable, writing to Maria from Woodmansterne during the process, said, 'My little group is much liked . . . all are delightfully kind to me here.'[23]

All was not well in Charlotte Street, however, despite John's earlier protestations. Maria was sick during the latter part of her pregnancy – 'for these two months she has been suffering under a diohrea [*sic*]' John told Fisher.[24] Emily was born on 29 March, premature, John suggested, on account of Maria's illness. 'It is a nice little girl – she is suckling her child but is in a sad weak condition – and we are obliged to watch her carefully – I hope all will go well.' The family went to Hampstead for the summer, and there in June and July Emily was vaccinated against smallpox and christened against sin.[25] Their house, near Fenton House above Holly Bush Hill, rented from a local shoemaker and his wife, was

not a success: 'the wretched Hooks. It was a sad place'.[26] They
realised they should have gone to Brighton after all, 'perhaps the
heat was not worse there – the sea cools it at night.'

After his recognition in France, Constable was being show-
ered with commissions, compliments and contact. The French
ambassador, Jules, Prince de Polignac, invited him to the French
embassy to present him with the gold medal awarded to him by
the King of France, Charles X.[27] 'My medal is handsome & was
given me in a handsome manner', Constable told Fisher, flattered
by the praise: 'When my name was announced to the whole body
of artists &c as a gold medal there was an universal applause'.[28]
The ambassador passed on the pleasure of the King, who 'was
fond of these things', and had been 'particularly struck' by *The
Hay Wain*. Constable passed these light compliments on to Fisher,
whose uncle, the Bishop, was now ailing. This courteous, urbane
man, always generous and thoughtful towards Constable and his
idiosyncrasies, died in May 1825. As Fisher put it to his wife, 'he
died at last of consumption. His meat & wine & cayenne pepper
had been poison all the time.'[29]

Even in these months of praise and acceptance, it was a rare
experience for Constable to have an enquiry from a complete
stranger. Francis Darby, the son of Abraham Darby the pioneer
ironfounder and bridge-builder of Coalbrookdale, wrote to him
to enquire of prices. *The Leaping Horse* Constable priced for
Darby at 230 guineas (including frame and packing), and the
smaller landscapes were 150 guineas for the pair.[30] These were
reasonable prices for Constable to ask, but even so Darby hag-
gled, and in the end got the pair of Hampstead subjects for 130
guineas in frames that had cost Constable £10 each.[31] The artist
put them on the waggon to Shifnal, packed together in one crate
as Darby would not pay for two. News of their arrival prompted
a letter to this man unknown to him that is as revealing as any
he might write to Fisher. Darby had rashly enquired after the
artist's health, a polite enough thing to do, but Constable replied
like a flash:

> I always find business a cure for all <u>my</u> ills ... your letter af-
> forded me the best excuse in the world for coming away from

the apothecary . . . the truth is, could I divest myself of anxiety
of mind I should never ail of any thing. My life is a struggle
between my 'social affections' and my 'love of art'. I daily feel
the remark of Lord Bacon's that 'single men are the best serv-
ants of the publick'. I have a wife . . . in delicate health, and five
infant children. I am not happy apart from them even for a few
days, or hours, and the summer months separate us too much,
and disturb my quiet habits at my easil.[32]

He went on to unload to Darby about his frustrations; how he
was being pressed to go to Paris, but really did not want to:

I cannot speak a word of the language, and above all I love
England & my own home. I would rather be a poor man here
than a rich man abroad. I am neither an ambitious man, nor
a man of the world, but am sincerely grateful to providence
and my own exertions for being enabled to do that for myself
which no human being could have done for me.

Why he thought Darby would be remotely interested in all
this outpouring is inconceivable, but it reads like an hour with a
counsellor to get frustrations off his chest. In fact, things were
going well for him now, better than ever:

I am now thank God quietly at my easel again . . . My income is
derived from it, and now that after 20 years hard uphill work –
now that I have disappointed the hopes of many – and realized
the hopes of a few (you best can apply this) – now that I have
got the public into my hands – and want not a patron – and
now that my ambition is on fire – to be kept from my easel is
death to me.[33]

Fisher was his better counsellor, as always:

Whatever you do, Constable, get thee rid of anxiety. It hurts
the stomach more than arsenic. It generates only fresh cause
for anxiety, by producing inaction and loss of time. I have
heard it said of Generals who have failed, that they would
have been good officers if they had not harassed themselves
by looking too narrowly into details. Does the cap fit? It does
me. Propitiate your wife.[34]

John and Maria were now preparing to return to Brighton. Johnny
had been seriously ill in Hampstead, so the family's second stay
at Brighton would be as much for young Johnny's health as it was
for Maria's. There had been reports of scarlet fever, smallpox
and measles in London, so Brighton was an essential escape plan.
Constable took 'my dear Fish, and all my Ducks to Brighton', to a
terraced house in the brand new development of Russell Square,
where a neat balcony runs from house to house across the first
floor. 'John[ny] is certainly better', Constable told Fisher after
a fortnight by the sea. They considered electric shock treatment
for him but thought better of it, taking him sea-bathing instead.
'He is now fond of bathing which we are told will help him.'[35]
When he was back in Charlotte Street, Constable took up his
Journal again: 'How is my pretty baby [Emily], my Isabel & my
Minna & my darling boy blew [Charley]?'[36]

He was now being bothered by small commissions, and decided
he would not do anything for anybody any more unless it was for
a proper price; that is, nothing under '20 or 25, or 30 guineas', so
no more low-cost portraits. He found it difficult to settle on his
minimum figure, but nevertheless he was brimming with confi-
dence. When asked to paint a portrait for 10 guineas, 'I declined
it ... I told them John [Dunthorne] could do it.'[37] Money was
still evaporating out of his hands, despite new successes: he was
in debt to Woodburn his framemaker and to Brown the colour-
man to the tune of about £400.[38] So when he told Darby that the
frames on the Hampstead pictures had cost him £20, he had not
in fact paid for them. 'I wish I was more for money', he moaned.
But reflecting later on his blessings, he thought about his home
in Charlotte Street, in paragraphs that he introduces as 'A Grand
Epoch':

> How much we have changed the circumstances of this house
> from what it was in Mr Farrington's [sic] time – his attics
> turned into nurseries – a beautiful baby born in his bedroom
> – his washhouse turned into a brew house – his back parlour
> which contained all his prints, turned into a bedroom – his
> painting room made habitable – besides which, best of all,
> made to produce better pictures than he could make – and

lastly the <u>French privy</u> turned into a <u>Coal hole</u> – Well done – What a catalogue.[39]

Then, two weeks later, he wrote more for Maria, and underlined the date eleven times: 'Sunday October 2nd our dear blessed wedding day, owing to which we have five babies.'[40]

33. The rubs and ragged edges of the world

John Constable had a talent to induce extreme animosity among fellow artists. While his friends of the older generation were largely insiders who would guide him – Joseph Farington, George Beaumont, James Northcote, Lady Dysart – friends of about his own age were mostly outsiders and thus unlikely to be rivals: the wayward genius John Dunthorne, the churchman John Fisher, the botanist Henry Phillips, the gentleman poet Robert Bradstreet, and, lately, Charles Leslie, a tall, slim, much-travelled American.

Leslie had been born in England in 1794, and was now settled in London, but he had crossed the Atlantic twice before he was seventeen years old. His father was a Scottish–American clockmaker, his mother Anglo-American. He was a cheerful, open, loyal soul, making friends with ease, able to cut through English class-bound reserve in the way only Americans can. He mixed as if on equal terms with such prominent figures as Samuel Taylor Coleridge, Sir Thomas Lawrence and Sir Walter Scott. As a fellow painter, Leslie could have been a rival, but he was charming, perceptive and kind, and when he and Constable came to stand against each other for election to Academician in 1826, Leslie handled his victory over his infinitely more talented friend with tact, accommodation and redoubled support. 'My acquaintance with him,' Leslie wrote of Constable, 'arose out of my admiration of his pictures. I cultivated his friendship because I liked his art.'[1]

Both of them also loved babies, and we first see Leslie with the Constables in Keppel Street in 1817, where John is dandling his first child on his knee, and no doubt proudly handing him round to mother, nurse and American friend: '[Constable's] fondness for children exceeded, indeed, that of any man I ever knew.'[2] Their surviving correspondence does not begin until nine years later, in 1826, but goes on to comprise more than 125 letters

from Constable.³ Comparatively few from Leslie have survived.⁴

Constable was as frank and personal with Leslie as he was with Fisher: 'My poor wife is very far from well', he wrote from their 1826 rented house on Downshire Hill, Hampstead. 'How much my wife would enjoy your new baby – her disposition is formed for the social affections – but ill health prevents the enjoyment of them.'⁵ Among the added reasons for the frail Maria's ill health was the physical pressures her uxorious husband would put on her, and a near-constant state of pregnancy. Alfred, baby number six, came in November 1826 – premature, as had been Johnny and Emily – so when John remarked to Leslie that Maria was 'very far from well', and unable to enjoy 'social affections', she was not only tubercular but also about six months pregnant. 'I am now satisfied and think my quiver full enough', he told Fisher, anticipating, on Alfred's birth, Trollope's Mrs Quiverfull, 'I have another boy, making my number six, being 3 of each': *my* quiver; *my* number six, note.⁶ Then, in the spring of 1827, Maria became pregnant yet again, giving birth to Lionel on 2 January 1828. 'I have not escaped,' Constable told Leslie, whose wife was also due to give birth, 'but my Wife (from fear or doubt) did not present me with my fourth son 'till the day after new year's day – we must now congratulate one another. I have now my <u>seven</u> children under this roof.'⁷ Three men – Constable, Fisher and Leslie – applauding each other for the babies their wives have been bearing for them was standard in the nineteenth century, and these three were probably typical.

A mild analysis of the pattern of Maria's births shows this: the average gap between live births is 19.5 months – the shortest is ten months, the longest thirty, so it is likely that Maria had unrecorded miscarriages and stillbirths. High among the reasons John Constable trotted from London to Hampstead and London to Brighton in the summer seasons was his unremarkable expectation of sex. His enjoyment of the erotic continued to the end of his life, into what turned out to be his last six weeks, when, engaged in a man-to-man exchange with Leslie, he transcribed a letter from William Etty concerning a life model: 'She is very much like the Amazon <u>and all in front remarkably fine</u>.'⁸

The thread that develops out of the correspondence with

Fisher is affectionate and often family-oriented: their conversations about each other's wives and children, for example. They exchange beefs with beefs – Constable about the Academy and his patrons, Fisher about the state of the Church of England and threats from Low Church dissenters and High Church Catholics. With Leslie, Constable becomes perhaps more personal, though there is no adequate balance available, given the disappearance of most of Leslie's side of the correspondence. We can trawl through Constable's letters to Leslie and find all sorts of character traits, and when these are laid out in a line they present a troubled individual, tormented, paranoid (sometimes), speaking his mind even to the extent of unkindness, a vehemently anti-Reform Tory, anti-clerical, chippy, touchy, hypochondriacal, sarcastic, gossipy, libidinous, tight with money, a bigot who disliked dissenter-artists (such as John Linnell, William Collins and John Varley), and a landscape painter who did not fail to show his dislike of other landscape painters' landscapes:

> What must I feel when I knock my head against the clouds and [waves] of poor Callcott – or breathe the stagnate sulphur of Turner – or smell the [blank] – of a public house skittle ground by Collins – or be smothered in a privy by Linnell or Mulready – but let them alone, is best of all.[9]

The artist and memorialist Richard Redgrave, writing in his diary, was more direct and pointed than Leslie's memoir had been: 'There he appears all amiability and goodness, and one cannot recognise the bland, yet intense, sarcasm of his nature; soft and amiable in speech, he yet uttered sarcasms which cut you to the bone.'[10]

Constable had been an Associate of the Royal Academy since 1819; so far so good. Associates were already distinguished artists, most of them, but nevertheless in Somerset House, a closed world that feigned openness, they were considered the lowest of the low by Academicians. They were treated like grown-up schoolboys in a world of entitled prefects:

> it is reckoned that every thing which an 'Associate' <u>can do</u> – <u>or think</u> – as well as what <u>he does not do</u> – <u>does not think</u> – <u>must</u>

be wrong, must be 'most ill advised' – must be 'most injudicious' and 'damn'd busy'.[11] ['Busy' here means, I think, 'nosey', certainly insolent.]

Constable put his name forward for the Academicians' election at the February 1822 ballot; he failed, of course, but did well enough to find that he had thirteen Academician supporters for the two vacancies. He cannot have been surprised at this 'failure', and Fisher cheered him up: 'The title of RA will never weigh a straw in that balance in which you are ambitious to be found heavy, namely the judgement of posterity.'[12] Fisher reminded him that he is painting for the future, a time when the names of Richard Wilson, Aert van der Neer, Jacob Ruisdael and John Constable will be spoken of in the same breath: 'Do not let your vision be diverted from this North star, by the rubs & ragged edges of the world which will hitch in every man's garment as he hustles through life.'

There was, however, one organisation within the orbit of London's art world that welcomed John Constable's presence and involvement, rather than dangling him on its thread. This was the Artists' General Benevolent Institution founded in 1814 to bring money and relief to those to whom its mission rapidly evolved to embrace 'decayed artists of the United Kingdom, whose works have been known and esteemed by the public; and for affording assistance to their widows and orphans. Supported by voluntary subscriptions.' The Royal Academy would occasionally dispense charity to its members and relicts, but it reached no further than its own. Money raised for the new Benevolent Institution was invested in stocks. Constable, with Turner, the architect John Soane, William Mulready, Cornelius Varley, James Ward, David Wilkie and other artists coming in over the years, joined collectors and politicians, including Sir John Leicester and Charles Long the Chancellor of the Exchequer, to organise funds and distribute money. For Constable, it was a life-long expression of commitment to those members of his profession who lacked his strength of body and will, and, caught on 'the rubs and ragged edges of the world', failed to achieve his relative fortune.[13]

During the next campaign that Constable waged to become elected Academician, in 1823, he was again hit by depressions, and had also to cope with his entire family and two of the servants being sick together. His cause this year was again hopeless, and it was not without some grim humour that he would write of the 1823 election that 'Daniell's party have got in Reinagle – the most weak & undesirable artist on the list as you said.'[14] Reinagle's triumph hurt. Across this time Constable was working on and exhibiting paintings that would together be transformative in art history: *The Hay Wain, View on the Stour near Dedham, The Lock* and *The Leaping Horse. The White Horse* and *Stratford Mill* had been exhibited and were sold – yet sold not to be visible in London collections, but hidden away in Salisbury. Other sold paintings could only be seen in such unsmart places as Epsom, Clapham, East Bergholt, Bury St Edmunds and Balham. Worse, *The Hay Wain* and *View on the Stour near Dedham* had gone off to Paris, where in 1824 they hung in the Louvre. It did Constable no good whatsoever in the Royal Academy to have his paintings admired in France.

And so it went on. The adamantine cruelty of the processes of the Royal Academy caught Constable on the quick: 'the field of Waterloo is a field of mercy [compared] to ours', he told Fisher.[15] Constable campaigned again in 1826, 1828 and 1829, sometimes with energy and a strategy, at others casually. He canvassed Turner in Queen Anne Street in 1828: 'My call on him was quite amusing. He held his hands down by his sides – looked at me full in the face (his head on one side) – smiled and shook his head.' Then Turner asked Constable what he wanted, as if he didn't know, and feigned anger that he had come on a Monday. Turner asked him if he had thought of approaching anybody else, a neighbour in Hampstead, for example. Clearly Turner knew Constable was renting in Hampstead, and must have been mocking: he knew perfectly well that the neighbour in Hampstead was William Collins, whom Constable had come to loathe. He, Turner, stood firmly like a turkey cock in his doorway and bombarded him with questions – what the questions were we do not know, but they will not have been entirely friendly or welcome, and there was

no chance of Constable being invited into the gloomy house.[16]

Friendship with Leslie, Northcote and Beechey illuminates the nature of Constable's shifting enmity with other artists such as Thomas Philips, William Collins, Martin Archer Shee, William Etty and Benjamin Robert Haydon (but Haydon hated everybody). His enmities did indeed shift: there was a time when he and Collins shared a companionable friendship: 'My compliments to Mr Collins who is a very sensible man', Fisher asserted.[17] The hearty portrait sculptor Francis Chantrey remained noncommittal about Constable's candidature, and tended go where the wind might blow. Chantrey was, after all, portrait sculptor to the aristocracy and to most of the politico-literary world, so he had the continuing security of his client-base to consider. Years later Leslie said: 'Constable could not conceal his opinions of himself and of others. What he said had too much point not to be repeated, and too much truth not to give offence.'[18] To one *obita dicta* Chantrey responded by a letter marked 'Private', underlined twice: 'I wish particularly to know by return of post if you entertain the opinion or if you ever said "Turner's pictures are only fit to be spit upon."'[19] John Constable did not dissemble; what he thought, he spoke. He may have been speaking his mind, but he was also uttering thoughts of the moment, and doing so must have made him feel better. In 1828 he attracted little support and much opprobrium, being set upon at the British Institution by Phillips and Shee, a future president of the Academy, and beaten up:

> Mr Phillips likewise caught me by the other ear – and kicked & cuffed me most severely – I have not yet recovered. I have heard so much of the higher walks of the art, that I am quite sick. I had my own opinions of that – but I was desired to hold my tongue and not 'argue the point'.[20]

These Academicians were unforgivably rowdy, but in Constable they found a persistent individual having the gall to question the centrality of history painting, to stand for election to Academician status, and to send for exhibition pure English landscapes with not a jot of history within them. Constable castigated the '"high-minded" members who strived for the "elevated & noble"

walks of art – i.e. preferring the <u>shaggy posteriors of a Satyr</u> to
<u>the moral feeling of landscape</u>.'[21]

Constable was a past master at annoying his Academy enemies
and he loved it; but he was also perfectly sweet to artists in dif-
ficulty, and would go out of his way to try to improve their lot
and lives. The architect and visionary draughtsman J. M. Gandy
could never get it right with the Academicians, trying again and
again to be raised from Associate to Academician status, but again
and again failing. 'I think he is a man that has been hunted down,'
Constable told Leslie, 'and that too, most cruelly and unfairly . . .
I however declared before the Council that I was shocked that
such a man should never have been elected an Academician.'[22]
The portrait painter Henry Pickersgill had been reasonably suc-
cessful despite his lack of the brio that Lawrence could generate.
In his Journal, Constable writes of calling on Pickersgill in Soho
Square and finding him 'almost dead with work & so nervous that
when a knock came to the door he danced like a top, & could not
hold a limb still.'[23] Pickersgill was one of Constable's supporters
in the interminable election process, and both shared a loathing
of William Collins, who made Pickersgill apoplectic with rage.[24]
'I despise no man,' Constable would write, 'but Collins the Royal
Academician.'[25]

Constable's empathy with the depressed and diminished
Academician Samuel Lane went to yet further depths than with
Pickersgill. Although he had an impressive list of portrait cli-
ents and exhibited annually at the Academy, Lane failed to make
money and succumbed to the safety net of being Sir Thomas
Lawrence's studio assistant. This was a menial and thankless
task, made worse by his having little or no hearing, and muffled
speech. Lane took to drink, and Constable was generous enough
to help his sad friend by learning a language of signs to com-
municate.[26] They had a heart-to-heart one evening in 1824 when
Constable called on him and found him fast asleep in a drunken
haze. Constable shook him by the shoulder, and 'we filled our
glasses – I drank 6 or 7 of port &c &c . . . Talked of his pictures
and heard all his grievances 'till I was half dead.'[27]

Academicians were suspicious of Constable because they saw
him as a stirrer, and resented the way he spoke his mind, although

he tried very hard to get things right and make his number with his colleagues. At times circumstances played against him, as Farington had reported, showing a sketch of the seating arrangement at the 1820 King's Birthday Dinner at the Academy. Constable was placed with Turner on one side and Samuel Lane on the other: between his monosyllabic and dangerous rival on his left, and his deaf-and-dumb friend on his right.[28] He told Fisher that a Collins landscape looked 'like a large cow-turd', and that 'Turner is stark mad . . . the picture seems painted with saffron and indigo'.[29] In another letter, Constable described serious internecine strife:

> The civil war is at its highest in the Academy . . . Collins, & the Sculpture & the portrait painters are for Turner . . . He is ruined in art – & he is watchful and savage. Lawrence is <u>deep</u> and sly and cold.[30]

John Martin also came in for a wigging from Constable, who told Fisher:

> I wish you could see Martin's 'Paradise' [*Adam and Eve entertaining the Angel Raphael*] now in the Gallery – all his admirers should have been in it, & it would then have been a paradise of fools – but it is always best to give a man the rope.[31]

Martin's characteristically red-hot palette, his fantasies and the absence from reality expressed through his paintings, was the polar opposite of Constable's drenched pastorals. By the mid-1820s John Martin, who like Constable came from provincial craft and mercantile roots, had risen from obscurity to fame and its associated riches of money and allure. He was thirteen years younger than Constable, and, like him, had arrived in London as a courageous and eager young man seeking training as a painter, recognition as an artist, and a living wage as a respectable and secure citizen.[32] He had much less financial support even than Constable on arrival from his home town, Newcastle-on-Tyne, and no infrastructure to speak of to hold him steady. Like other outsiders who had been determined to make their mark in the capital – Joshua Reynolds from Devon, Thomas Gainsborough from Suffolk, Francis Chantrey from Derbyshire – John Martin

had the edge of energy, grit and luck that made up for his lack of contacts. John Constable had arrived in London with a letter of introduction to Joseph Farington – none better. Martin had nothing like that, just the promise of an apprenticeship as a painter in a glass factory, and evidence of early talent. He and Constable were remarkably similar in their insecurities, but diverged fundamentally in their characters and their strategies for finding success.

Constable ran on orthodox lines, admiring, longing, and trying to find embrace in the Royal Academy, yet finding himself out in the cold. He was not clubbable: when approached in the first months of its existence to become a member of the Athenaeum, the new London club of artists, scientists and writers, he told Maria that he wanted to 'have nothing to do with it.'[33] John Martin was quite different. He fought his way into acceptance by hard work and by teaching himself perspective and architectural drawing, 'sitting up all night till two or three o'clock'.[34] When he exhibited his *Sadak in Search of the Waters of Oblivion* in 1812, its heated colour, desperate circumstances and over-powering and terrifying natural forces propelled him towards a club that he had become reluctant to join. 'I was ambitious,' he said in 1836, 'when I was a very young man, of becoming an Academician, but the desire ceased when I understood how the body was constituted.'[35]

Martin was nobody's creature, following no pictorial fashion, but one who had stumbled across a subject area that was waiting for the big-picture treatment: the Gothic novel and Old Testament stories. However, after an accident on Varnishing Day in 1814 he stormed out of the Royal Academy and refused to show his crowd-pulling pictures there again. Academicians did not miss him: when he was put up for Associate in 1820 he got no votes. John Constable, on the other hand, tried hard to please, remaining doggedly within the Academy, persevering for years until he found support and acceptance.

Comparison of Constable and Martin is illuminating because it draws out something of the tensions within the Royal Academy. Martin complained bitterly and often about his paintings being hung 'in very unfavourable positions indeed both as to light and position . . . My works . . . have always been hung high or in the

dark.'[36] Constable saw Martin as haughty, and observed that he 'looked at the Royal Academy from the Plains of Nineveh ... I am content to look at [it] from a gate, and the highest spot I ever aspired to was a windmill.'[37] These two contemporaries together illuminate the currents of personality and attitude in the Royal Academy. Constable could look a complete mess, as Martin's son Leopold recalled after they called on him in Hampstead. There they were received 'in his usual kind-hearted homely manner', but Leopold's frank and observant child's eye saw that he looked as if he had been dragged through a hedge backwards.[38] Martin, on the other hand, took immense pride in his appearance, and made sure he would shine at important gatherings. He saw the good sense of being hospitable, and of entertaining at a high social scale, of good deportment, of polishing his natural dandy-ish good looks – to W. P. Frith he was 'one of the most beautiful beings I ever beheld'.[39] Martin built up a wardrobe of glossy clothes, and might wear his primrose-yellow waistcoat inside out to reveal its silk lining. His blue tailcoat glittered with brassy buttons that shone in the gleam of gaslight. The best barber in London rubbed his curly hair with aromatics; he loved the success such oils reflected, and chuckled at the pleasure that sight of this walking fashion-plate gave to others. Constable, on the other hand, wore black.

Constable was highly critical of Martin for failing to comply with the rules of the Academy, and being so outspoken as to say that he had gone beyond the point at which the Academy could benefit him.[40] Artists, Constable among them, envied Martin's financial success. He not only sold his gaudy and populous paintings for high prices, but had the sense of self-worth and perspicacity to make engravings after most of his popular pictures, and produced many prints of biblical, classical and Miltonic subjects in his well-appointed and well-staffed workshop off Marylebone Road.

Constable was sharp to Fisher about Martin's *Belshazzar's Feast*: 'I spoke my mind – the shortest way', he said of a conversation about the picture with the Bishop and his wife.[41] *Belshazzar's Feast*, with its gaudy palette, terrifying perspective and the squealing emotion of the doomed, divided opinion when it

was shown at the British Institution in February 1821. Its over-
heated reds and oranges did for that colour range what Constable
was doing for greens in *The Hay Wain*, shown at Somerset House
a few weeks later. Martin upset audiences with his use of colour
as profoundly as Constable did with his. Beaumont's opinion was
that the only merit of *Belshazzar* was its composition, and sug-
gested – according to Constable's report to Fisher – that it was
as bad (and perhaps as pointless) as playing a work by Handel
out of tune.[42] Martin was in danger of becoming a figure of fun,
and soon went off the boil as an artist when, extraordinarily, he
invested his time and self-made fortune in a doomed venture to
transform London's water supply and sewage system.

At the 1823 Academy exhibition Constable was showing his
Salisbury Cathedral from the Bishop's Grounds, and walked round
the exhibition with an affectionate arm on old James Northcote.
He had long been fond of Northcote: having had a 'delightfull
conversation about painting and almost every thing else', he
told Maria that 'it is wonderfull to see him with all the energy
of youth, his eye sparkling & so bright & so sharp.'[43] Turner
came up to them and asked Northcote if he (Northcote) thought
that he (Turner) was mad. This was quite a leading question –
Turner's *Bay of Baiae, with Apollo and the Sybil* was on display,
and gradually attracting generous reviews. 'Gorgeous', the *Lit-
erary Gazette* had just written, 'like the vision of a poet'. That
review must have just appeared when this conversation took
place, cheering Turner up after years of being considered off his
head.[44] Northcote's response was typical of his conservatism: he
said that he did think Turner had taken leave of his senses, and
added, 'I can tell you over and over again, if you will persist in
imitating "<u>Martin</u>" . . . you must be ruined.' Turner thought this
was a good joke, but it had a ring of truth, 'too sure & pungent
to be laughed away'.[45]

Cross-currents of attitude and perception at the Academy
seem to meet in two central and resounding paintings at the
1823 exhibition: Constable's *Salisbury Cathedral from the Bishop's
Grounds*, painted for Bishop Fisher, and Turner's *Bay of Baiae*.
The four elements are shared between them: air and water in the
clouds, sky and fleeting light of *Salisbury*; earth and fire in the

dry, shimmering heat of *Bay of Baiae*. We see homely, tranquil, secure England in *Salisbury*, where the painting's principal figures (the Bishop and one of his daughters) are comfortably proprietorial. On the other hand, there is desiccation and threatening silence surrounding Apollo and the Sybil's ominous ceremony in the south Italian landscape of *The Bay of Baiae*. Coincidentally, the two compositions have parallels beyond their contrasts: two small-scale principal figures in each, towards the bottom left; one figure in each indicating rightwards into the painting's core; a left to right diagonal tendency in both; and the major vertical element of each being set to the right of centre. What this seems to suggest is nothing so much as the individual determinations of Constable and Turner to work to comfortable compositional rules, while flouting orthodoxies in the use of colour.

Benjamin Robert Haydon was another thorn in the flesh of the Academy, a cannonball-headed misanthrope whose prickliness and conceit Constable tended to exacerbate. He was a painter of indifferent but bombastic talent, convinced that he alone was capable of saving 'the Art', in particular history painting, which was his passion and purpose. He painted acres of canvas with classical and biblical subjects and wrote volumes of journals, diaries, autobiography and letters. He is in spleen what Farington is in quotidian reflection. Beaumont had strongly supported Haydon in early days, but dropped him when he became too overbearing and haughty even for Beaumont. He ended, having been bankrupt, imprisoned and scorned, a suicide: 'poor Haydon who nobody either pities or likes', Constable said to Fisher.[46] While Haydon suffered opprobrium, and meted it out in good measure to others, Constable's trials at the Academy were as nothing compared to those of Haydon, the contrarian's contrarian:

> I was opposed, calumniated and run down by the Academy for what they called my impertinence in thinking of such a picture [*The Judgement of Solomon*] without being commissioned . . . Yet what did this do for me? Nothing! Not a single commission, large or small, followed . . . No corporation, no public body, no church, no patron ever thought the picture worth enquiring after . . . And this is England, with its Royal Academy, its court

painters, its knighthoods and empty spaces! Shame on those who . . . let a work which was hailed as a national victory rot into decay and dirt and oblivion![47]

These words out-Constable Constable in their fury. Haydon, however, had one thing that Constable lacked, self-pity. Constable, indeed, had deep fellow-feeling with artists who were worse off than himself. He bought a watercolour by John Varley, the prolific and opinionated teacher, astrologer and painter on hard times. 'He told me how to do landscape,' Constable told Leslie, 'and was so kind as to point out all my defects. The price of the little drawing was a guinea & half — but a guinea only to an <u>artist</u>. However I insisted on his taking the larger sum — as he had clearly proved to me that I was no artist!!'[48]

Constable's *Salisbury Cathedral from the Bishop's Grounds* was, he said, 'the most difficult subject in landscape I had ever had' on the easel. This is unsurprising; it is not, exactly, a landscape. It is a topographical painting of a big church among some trees. If anything, it is an early Constable come late. There is no distance, no setting of the main subject in the wider context, unless you count the cows ambling down to the water. It is not, even, a very 'Constabley' painting, so no wonder he found it difficult to pull off with its extreme, even pedantic detail. It is more like early Turner, very close indeed to the large watercolour *General view of Salisbury Cathedral from the Bishop's Garden* that Turner delivered to Sir Richard Colt Hoare by 1805.[49] Constable will certainly have seen this and the other works in the 'Salisbury' set by Turner when he visited Stourhead with the Bishop in 1811. Apart from a slight change of angle — perhaps a mere five degrees to the west — Constable's version follows stone by stone, ogee and finial by ogee and finial, Turner's *General view*. Constable has the cathedral tower and spire slightly slimmer around its girth than Turner's, which also appears shorter. These may be tricks of the light, which in Constable's painting may be mid-morning, and Turner's a few hours later, past noon.

Further, Constable's *Salisbury* hankers after the Picturesque — the beckoning figure, the arch of trees, the foreground shadow, water, cows, and the middle ground splash of light. The one

thing that makes it Constable's own, just, is the 'dark cloud' that Constable insisted upon, and which the Bishop did not really like. As Constable said to Fisher, 'I have not flinched at the work, of the windows, buttresses &c &c, but I have as usual made my escape in the evanescence of the chiaro-oscuro.'[50] He loved the Fishers, and with this *Salisbury* he wanted to do everything he reasonably could to please them with this pleasing picture.

34. The life in common things

John Constable's writing is a treasure trove like none other. His letters were transcribed and edited in the 1960s by Ronald Beckett, a former judge on the Indian circuit who gave his retirement to their study.[1] The letters and Journal, published in eight splendid sap-green volumes by the Suffolk Records Society, comprise a lifeboat for European art history.[2] If all Constable's paintings and drawings somehow vanished, Ronald Beckett's insight into the correspondence, with his magisterial linking texts and incomparable indexes, would ensure Constable's centrality as a writer of stature.

In correspondence Constable is quicksilver: rumbustious to Fisher, brusque and brisk; analytical to Leslie, astute in art politics; revealing to his brother Abram, business-like and empathetic; to clients he can be sharp, precise and direct. Constable had a series of tones which he was able to slip into naturally, certainly without appearing to try. Letter-writing was for him a habit, quite as much as was the picking up of his brush or pencil and transplanting the catch in his eye and mind into a tone or colour on paper or canvas. He will have spent significant daytime and evening hours writing his letters and journals: more so in the evenings when it became too dark to paint, so we might suggest that the majority of his letters were written by candlelight. That may allow us to understand the blots and blemishes. He did not have to think much about what he was writing. That is obvious; his thoughts tumble like washing in a tub. What his writing also reveals is how natural letter writing was to him, a skill inherited from his mother, another master of colourful incidental detail.

The letters have had a dangerous passage between then and now. The collections gathered together by the Earl of Plymouth are on loan to the Archive at Tate Britain, as is the extensive Constable family collection deposited variously in the Tate and in the archive of Gainsborough's House in Sudbury. Other

important collections are in the V&A, the British Library, and in private hands. One particular collection, Constable's letters to John Dunthorne, had a particularly unfortunate passage. The late Ian Fleming-Williams recounted how some of these turned up in 1920 in a sale of the effects of an East Bergholt plumber and glazier whose business had inherited Dunthorne's effects. Lot 1 was a tea-chest of brass fittings, and other things including some 'packets of letters'. Enquiry after the sale as to whose letters these were brought the response: 'Dunthorne's and Constable's'. Asked what he did with them, the purchaser of the lot replied, 'Burnt 'em'.[3]

To his wife, Constable opens himself up and writes as we might guess he spoke when talking quietly to her at mealtimes or in pillowtalk. She calls him her 'Hub' or 'Huberdy'; he calls her 'Fish'. His letters to her are laced with fondness and affection, glimpses of passion, and silent understandings between them that neither of them needs to explain. The Journals, published by Beckett in the volume which also contains Constable's letters to Maria, are written neatly, closely and legibly on loose sheets that have been bound into two folders, one for each of the years 1824 and 1825. Page after page, usually with a wide left-hand margin for the date, they progress through Constable's day-to-day life, and are both an entertaining diary and a very long love letter. After Constable's death they were picked over closely by the couple's daughter Isabel, who made some curious, and sometimes furious, crossings out in ink. Where this censor has landed there is generally a curly line through Constable's words and phrases, and occasionally a hard straight line, the pen nib widening here and there through pressure and determination. Some of these deletions Beckett silently ignored, and recovered what was deleted, others he indicated with ellipses.

An example of the former is at 25 May 1824: 'Cold better as good a night as could be expected without my Fish.'[4] Beckett reinstated the deletion without comment, and we can only imagine what anxieties must have troubled Isabel to incline her to prevent the reading of those words. Other deletions ignored by Beckett concern Constable's health, for example: 30 May 1824: 'I was in some pain in my stomach owing no doubt to my eating

a large plate of ham'; and (15 June 1824): 'Set about what was
to be done, but I was ~~sadly bad in the~~ night – though the things
were taken off the bed by Ambrose.'[5] Another area of censor-
concern highlights Constable's plain report to his wife that he
has had a few drinks with his sad painter friend Samuel Lane: 31
May 1824: '. . . & we filled our glasses ~~– I drank 6 or 7 of port~~
~~&c &c, & I think it did me no harm~~. Talked of his pictures . . .'[6]
Perhaps the most curious group of deletions reveals the censor's
embarrassment (or disgust) at Constable's enjoyment of 'toad
in the hole', that traditional oven-baked dish not of sausages in
batter as today, but of beef or boned and stuffed chicken in a
batter shell. Each time 'toad in the hole' is mentioned it is de-
leted, and each time Beckett puts it back. This happens quite
a lot, as Constable enjoyed his toad in the hole and told Maria
so. A particular sausage that the censor objected to is 'poloney',
one of which Constable and Fisher enjoyed together on 16 June
1824: 'Fisher called on me & had some dinner, a ~~poloney~~ & bread
& Cheese & sherry.'[7] Nevertheless, there are contraflows in this
tide of embarrassment: Constable was just about to sit down one
evening to eat his ~~toad in the hole~~ when he was interrupted by
unexpected visitors. He closes by saying (4 June 1824): 'Sat down
& had them nicely done, quite in the humour for kissing my dear
Fish'.[8] The censor missed 'kissing', maybe because it was unex-
pected or misread, but Beckett clearly spotted it and, primly, set
it as '. . . ing'. Perhaps in the private areas of the Constable mar-
riage there were implicit connections between toad-in-the-hole
and sex which upset the censor and unusually confused Beckett.

In his letters to Maria we have a clear view of Constable's
thoughts on the dynamics of marriage and family as they im-
pinged on his life as an artist. A transparent remark of Fish-
er's, with which Constable undoubtedly concurred, is this: 'The
only grievance attending our marriages & families is that they
unavoidably keep us [i.e. John Fisher and John Constable] sep-
arate.'[9] The writing for Maria flickers with detail, stream-of-
consciousness *avant la lettre*, writing that is not so much unedited
as automatic:

Got up early and was soon busy in setting things to rights.

The post brought me a letter from Mr Darby with the draft [i.e. the cheque], expressing his pleasure that the pictures had arrived safe, and how much he was pleased ... Had a beef steak for dinner ... Digby Neave [Emily's godfather] called. He was just returned from the top of Snowdon – and was going another tour. He will send you some partridges ... Mr Fitzgerald sent me a cock and two hens. They came last night, and this morning – 3rd September, Saturday – we have commenced with such prodigious crowing, in answer to Mr Blatch's cock, that it is quite ridiculous – they seem quite at home already. I forgot to mention that the cats disagreed, as you know, so much that I did not know what to do with them. However as our old cat was so very savage and used John's cat so ill, I turned the tables upon her – by sending her and her kit off to St James's Street where Elizabeth lives yesterday in a basket – but with much trouble – she was so furious ... I am now going out on two or three errands and shall resume my Journal on my return.[10]

Constable's interest in the details of his daily life as expressed in his letters is of the same kind as the detail he puts into his paintings, imbuing them therein with deep consequence: the two adzes and the trug in *Boat-Building near Flatford Mill*, the broken line of haymakers and distant fully loaded cart in *The Hay Wain*, the terrified fleeing moorhen in *The Leaping Horse*, and the chickens in *Hampstead Heath*.[11] Detail, fully and tightly considered as key to a painting, is central in Constable, and is the product of an acute eye that, in essence, does not really care if it is the motor force for a painting or a journal entry. It is all the same to him: 'the life / In common things', as Wordsworth expressed it in the opening of *The Prelude*.[12] The detail in the paintings reveals how stuff works; the detail in the Journals reveals how he works.

Consider *The Leaping Horse*. We are at the Float Bridge on the River Stour about halfway between Dedham and Flatford, at the point where the river was diverted years before. The old course of the river takes the pressure off the navigable stretch, which has had its banks supported by timber posts and buttresses. The water is high, and the sluice is open, allowing the excess to run

off under Float Bridge, where there is a barrier or 'stop-gate' to prevent cattle from straying. Under the bridge, where the water falls a few inches, is a timber threshold set between the piers of the bridge as a strengthener – we cannot see it, but it is there under the water – and is a further prop to prevent any swaying. The bridge has to take heavy weights and sudden shocks, such as the leaping of the horse and the pressure of water. The low viewpoint, almost at river level, diminishes the visible extent of the distant meadow, but gives additional moment to the barge nosing out from the trees as its sail is being lowered or raised. A man in a red jerkin pulls the barge's leading rope, or 'painter', to attach it to the horse's harness after it has leapt. Ahead, the river curls upstream to Dedham – the church tower is there on the right – where the barge will collect another load to take to Mistley wharf and the sea beyond. This is active detail – nails in a timber post, steam from the barge's cauldron, the horse's shoe – all awaiting notice like forensic evidence.

Correspondingly, in Constable's writings we hear so much: in the Journal we meet the cocks and hens, the cats and a partridge; we hear what's for supper, where his friends go for their holiday, and so on and so on. The family's cats are referred to in twenty separate paragraphs of the Journals: accounts of their doings were clearly for the amusement of the children, and Constable goes into much detail: 'knocked down some flower pots . . . the kit opened its eyes this morning . . . John's cat dirties the house . . . is a most terrible thief'.[13] The eye that spots domestic detail and writes to Maria about it, is the eye that spots country detail and paints it for the world. He does not resist a husbandly boast to Maria, when his friend the actor Jack Bannister called: 'He is so fond of my landscapes', Constable told Maria, 'he says he must have one . . . he says he breathes my pictures, they are more than fresh, they are exhilarating.'[14]

Invited by Archdeacon Fisher's father, Philip Fisher, to dine at the Charterhouse, he gives Maria a blow-by-blow account of the evening. He was there from 4 o'clock until midnight: 'I slept pretty well for so good a dinner . . . Salmon – & a quarter of lamb, veal stewed – & some savoury side dishes, 2d course – large dish of green peas & 2 ducks – lovely puddings & tarts, beautiful

dessert & I drank only claret.'[15] He had a jolly good time and met Isabella Wolff, the beautiful estranged wife of the Danish consul: 'She is very pretty, & talks incessantly of the arts & sciences – & agriculture. She is quite an intimate of Sir Thomas Lawrence, who has often drawn her.'

The Journals are for Maria's eyes only, as of course are his letters to her; but journals have a different function to letters, they are running commentary with no end except paper supply and the will of the writer. Letters are limited to the size of the paper and the time of the next post. Letters have to end, journals do not. In projecting his Journal, Constable is behaving in a comparable way to the Rev. Gilbert White in his *Natural History of Selborne*, so it is not surprising that on being introduced to White's writing by Fisher he should respond: 'the mind & feeling which produced the "Selborne" is such an one I have always envied.'[16] Constable did indeed have White's sort of mind, and the detail with which White analyses the wildlife and the turning year in his garden and village is the detail which Constable employs when writing for Maria. This sometimes enters White's sphere: 'Looked into the coal cellar . . . Looked at John['s] Caterpullar [*sic*]. It had buried itself and formed quite a hollow cell like a small oven, in which it lay in a brown chrysalis – & closed it up again – and I want to know when they appear as moths?'[17] He is Whitean also about the pigeons and a robin he observes:

The pigeons make sad work & will not agree when there is an egg. They kicked a beautiful one out today – this makes four, & poor things they seem to know how unhappy they are by moping about & sitting with their feathers ruffled . . . When one egg is laid or[?] near it they scold each other about sadly. In their bustle the other day, they followed each other into the back drawing room where we found on going up hearing the noise, an egg broken & feathers &c . . . a dear little robin was at the window washing himself in the pigeon's dish – dipping himself all over & making such a dashing – & shaking – & bobling – & bustle – that it was quite ridiculous. His breast was quite red & beautiful.[18]

More characteristically, and revealing of his emotion, the journal

touches on Maria and their care for one another. He went to the jeweller Thomas Hamlet in Cranbourne Alley, behind Charing Cross Road, to collect 'his medal' – certainly the gold medal he had been given by the King of France. There he bumped into his cousin Richard Gubbins, the soldier whose portrait he had painted in 1804/05, and who fought the Emperor of France. The connection was lost on both of them. Gubbins was trying to choose a bracelet for his new wife, an act that prompted an affectionate musing from Constable: 'My poor Fish had none of these pretty things – though nobody deserved them more: but they go little way towards happiness or making a good husband.'[19] John Constable was a good husband, undoubtedly faithful; but Maria was an excellent wife, long suffering the stress of John's work and its obsessions and financial toll, suffering her chronic tuberculosis, her passing facial blemishes, her dutiful acquiescence to him and the subsequent pregnancies, and always being welcoming and courteous to her husband's manifold family members. She was an equable and calm woman, and we have identified only one (thrilling) reference to Maria losing her temper with John, when she threatened to throw his paintings out of the window. However, there are many references to her lying down to convalesce as a result of exhaustion brought on as much by husband and children, as from illness.

Constable's use of the time it took for him to write his letters and Journals was his own determined choice: he might otherwise have painted more, gone out more, or returned to playing his flute, which he came to admit that he had no time for. His choice was to write, from the intimate and personal Journal, to his letters to those friends who rose to the challenge of his exhausting ebullience and provocative impulsion. Constable is himself well aware of this: after one long 'ill written rigmarole letter' he feared he had annoyed Fisher, so in mitigation he wrote: 'but forgive it, as it has afforded much amusement to my mind to write it.'[20]

35. Gentlemen can never afford to buy pictures

Constable's staunch political rectitude went far back into his past, certainly beyond the days when he was surprised at the plethora of yellow ribbons tied around East Bergholt House during the 1812 election campaign. His Tory nerve-endings were massaged by his reading of the ultra-Tory journal *John Bull*; he and Fisher chuckled over it, and Fisher threatened (as a joke) to send Constable's splenetic opinion of Brighton to the paper for publication.[1] This profoundly traditional, establishment, anti-Reform stance tipped over into Constable's attitude to Church politics, which makes one reflect on the fact that he would surely have risen high in the Church of England, and been intimately involved in its politics, had his parents somehow smothered his artistic genius and persisted in their idea that they should send him into the Church. He would surely have become an extremely cantankerous old dean, or, with his eye for detail, decorum and good sense, he might even have been elevated to a bishopric: Bishop John Constable. He is rare among senior painters in keeping up so well with Church politics, but it is thanks to his friendship with Fisher that he managed it and it is on record. One of their many exchanges on the subject, about 'the vulture of reform . . . turning its eyes on the Church' has already been touched upon. To this Fisher added:

> The liberal, literary, & learned body [the Church of England]
> to which unworthily I belong, will disappear: the universities
> will be converted into charitable seminaries, & the illiterate
> offspring of grocers & tallow chandlers will fill the pulpits.
> This I am told the great Lords wish to be the case. We tread
> too close upon their kibes [very sore chilblains].[2]

Constable failed to reflect on the thought that it was wealthy tradesmen who might have included 'grocers and tallow chandlers' who bought his paintings. In responding to this jeremiad

he tried to rationalise Fisher's chaos-theory, and in doing so revealed prejudices of his own:

> I am sorry to see that you are again haunted by that Phantom
> – 'The Church in Danger' – it does not speak of a just state of
> mind or thinking. That the Vultures will attack it and every
> thing else, is likely enough – but you say they have failed on
> State – therefore it still stands between you and them & they
> can only fall together. The Nobility hate intellect – it is always
> in their way, and is the only thing they are really afraid of – but
> they know the value of it and endeavour to arm themselves
> from the same source as you – the Universities. And consider
> the ages they have stood, and the storms they have weathered.
> Let me hope your fears belong too much to yourself.[3]

The worldliness of some senior clerics amused them both, and led them to delightful gossip in which they could fearlessly parade all their distinguishing aversions: 'I dined the other day with our new puritanical Dean', Fisher wrote of the evangelist Dr Hugh Pearson:

> He gave me Champagne, Hock, Constantia & Claret: but would
> not suffer <u>cards</u>. Poor blind Coxe was obliged to forgo his game
> of cribbage tho his pricked pack of cards was in his pocket. I
> went afterwards to the Palace & found two Bishops & a Chan-
> cellor at whist.[4]

They are as hard on dissenting religious practices as they are on evangelists. The sect that had lately built a little meeting house at Burnt Oak near East Bergholt Common were 'half crazy idiots' in Abram's view: 'They are no acquisition to the parish whatever & whatever their religion it seems to banish every kind & amiable feeling from their hearts.'[5] Their mission to East Bergholt failed – certainly the Constables and other notables of the village were no help to them. The meeting house was sold, and the pulpit was taken away to be used as a dog kennel.[6]

Constable reveals his own political anxieties openly, and, to Maria, without restraint. He supposed that nobody else would ever read what he would write. He objected with petulance to embryonic trades unions, specifically 'the mechanicks at Brighton',

who had been organising themselves in support of striking wool combers and weavers in Bradford. The 'mechanicks' of Brighton were causing local uproar:

> There are sad doings – & almost every mechanic, whether master or man, is a rebel or a blackguard – dissatisfied, in proportion to his abilities . . . Remember that I know these people well – having seen so many of them at my father's. There are no such corrupt hordes, as any set of mechanicks who work in a shop together as a party – the taylors – the shoemakers – the millwrights - &c, &c, &c.[7]

Constable claimed the evangelist and anti-slavery reformer Hannah More to be in support of his argument, quoting without context her words 'hence man, though social, is not a gregarious animal'. He may have been reading More's *Strictures on the Modern System of Female Education* (1799) – quite likely given the fact that he had three daughters. When he casts back in his memory to his experience of his father's mills, we can read his feelings as a general fear of upset of the status quo, exacerbated in the 1820s by agitation for reform, and a naive expectation of the benevolence of individual employers. Undoubtedly Golding Constable had been a good employer, or had tried to be – the long service and testimonials of so many of his men attested to that – but he had had his share of labour troubles, as his wife related, and which John will have witnessed. John and Abram also discussed rick-burnings and other rural outrages, as did Fisher writing from Dorset:

> Nothing heard of here but Farmers breaking and sales of cattle. Wheat £10. 5s a load. Yet the greatest plenty of provision of all sorts . . . Ruin & prosperity walking hand in hand. Property will change hands . . . large farms will be broken down into small ones; the little yeomen will appear again & then things will go smooth once more.[8]

John Constable took a paternal attitude to rural and urban poverty, trying to alleviate hardship where he could, such as giving money to the Swiss organist Fontaine, who had lost his employment through xenophobic abuse, and faced destitution with his

wife and seven children.[9] Constable also made gifts of money to
sick and distressed villagers in East Bergholt; one we know of,
to Mrs Hart, the widow of one of Golding Constable's employ-
ees.[10] He expressed his humanity through personal charity and
heartfelt concern, and in his painting by other routes. He did not
go out into the fields and streets in search of the rural or urban
poor as narrative material, as did Hogarth in 1740s and 1750s
London, or Wilkie and Géricault in the 1820s, or, exceptionally,
the Bristol-based street artist John Dempsey in many places
around the country.[11] Constable's poor are without exception
working people at their work, earning their wage, carrying on
their trade usually in the middle-distance or background: hay-
makers, scythe-men, carters, barge-builders, ploughmen, sailors.
This trait he shares with Turner: we see few lords and ladies in
Turner, just some in the shadows in his Petworth studies, and the
odd backgrounded grandee in his *Picturesque Views* series. Apart
from a handful of travellers who may or may not be unemployed,
Constable's men and women are either working, resting or, on
Hampstead Heath, enjoying themselves strolling about or swim-
ming in the ponds. They are part of the living landscape, and to-
gether demonstrate how the landscape lives. Further, Constable's
landscape are cultivated, either well populated with housing vis-
ible, as in his Hampstead Heath subjects, or farmed, or the active
waterways of the Stour, Thames and the sea at Brighton with
bargees, fishermen and loungers. He railed against trades associ-
ations, and had he lived into the 1840s he might have objected to
the Chartists as much as he did to those working towards politi-
cal reform in the 1820s. 'The devil's viceregents on earth' is what
he called the political reformers Henry Brougham and Joseph
Hume, and he drew a long diatribe to Maria to an end by relating
how the gathered Brighton workmen displayed portraits at their
meeting: Nelson and Isaac Newton were greeted with cheers,
George III with laughter, and George IV with hisses, groans and
the Monty Pythonesque chorus 'What has he done for us?'[12]

Such bluster; but what was he currently doing in the painting
way? On the stocks in 1825 were the two long canvases, *Chain
Pier, Brighton* and the ever-languishing *Waterloo Bridge*. *The
Leaping Horse* had by now come back from exhibition at Somerset

House, where it had been shown under the title '*Landscape*', and was not leaping but sleeping in the painting room. Stacked up also – or rolled up – in Charlotte Street were the full-size studies for *The White Horse, Stratford Mill, The Hay Wain, View on the Stour near Dedham, The Lock* and *The Leaping Horse.* The smell of wet paint and turpentine, sharp and sweet, was everywhere and it crept out from the painting room through the double doors into Constable's modest picture gallery. Much as he wanted, and needed, to sell his exhibition pictures, the studies he determined to keep: the corn he sold, he would say elliptically, but not the field that grew it.[13] The exhibited version of *The Lock* had come back and was up and down on the easel before going on to the engraver Frederick Lewis, while *The Hay Wain* and Fisher's *White Horse*, lent to an exhibition in Lille, were away in France. Dotted about the house, and particularly in the gallery, were Hampstead Heaths and marine studies, with many smaller millboard oils of skies, of Brighton and its beach, of trees and fields and mills and Salisbury. Prints and drawings, sheets of paper, were everywhere on tables and chairs in this living, working, studio.

Writing his Journal kept Constable's spirits up for the extended periods that Maria was in Brighton. Looking around at what he had painted, and what he was working on, gave him pride in his achievement despite worries about his purse. 'I do hope that my exertions may at last turn towards popularity', he said plaintively to Fisher,

'tis you that have too long held my head above water. Although I have a good deal of the devil in me I think I should have been broken hearted before this time but for you. Indeed it is worth while to have gone through all I have, to have had the hours and thoughts which we have had together and in common.[14]

Fisher knew that his role was to keep his friend cheerful, and was confident that a backhander like this would do the trick: 'My father went to the Exhibition the other day,' Fisher told him, and 'on his return he said "The best picture [*The Lock*] is by John's friend – I forget his name." "Mr Constable, Papa". "Yes, Mr Constable". Always a little lemon with his sugar.'[15] Stop worrying so much, the Archdeacon might also have urged,

to how few is judgement confined & by how few is the taste of
the world guided! When Domenichino <u>lived</u>, nobody under-
stood him: the many, no doubt, abused him, as they do you: &
now his name will sell a canvass not fit for floor-cloth.[16]

Nevertheless, Constable could be his own worst enemy, and
such a misery:

All my indispositions have their source in my mind – it [is]
when I am restless and unhappy that I become susceptible of
cold – damp – heats – and such nonsense. I have not been well
for many weeks – but I hope soon to rid myself of these things
and get to work again.[17]

Fisher had now moved to Gillingham, near Salisbury, and he
reminded Constable that he would always be as welcome at his
new rectory as he had been at Salisbury: 'I am settled in Gil-
lingham, & have always a bed & a painting room for you there.'[18]
They now had something else in common – a chronic shortage
of cash. Fisher had been swindled, and was feeling fragile. 'In
what state are your finances?' he asked. 'I am woefully off. Owing
to defalcation of income I am £1200 in debt. It must tell with
your profession for gentlemen can never afford to buy pictures.
Certainly not at a remunerating price.'[19]

At Gillingham, Constable was particularly taken with a grand
line of elms, the kind of subject that he had been attracted to for
years, at least since his encounter with the oaks of Helmingham
in 1800. Late in 1823 the elms were almost all destroyed in a
storm, Constable's studies now being their only remaining trace:

The great storm played destruction at Gillingham. It blew
down two of my great elms, bent another to an angle of 45°
with the ground: stripped a third of all its branches; leaving
only one standing entire. This I have taken down; & your wood
exists only on your mill boards. The great elm in the middle
of the turf is spared. At Salisbury we had extensive floods; but
little wind.[20]

In due course, a Gillingham subject would emerge in oil on
canvas for exhibition. The first version of *Gillingham Mill* was

painted for Fisher in 1824, and a second, commissioned by a Mrs Hand, Constable exhibited at the 1826 Royal Academy exhibition along with his next 'six-footer', *The Cornfield*.[21] They make a strange pair, these two paintings, quite at odds with each other in manner, subject and ambition.

He had intended, or had hoped, to have finished his *Waterloo Bridge* for the 1826 exhibition, to be a strong and perhaps controversial successor to the previous year's '*Landscape*', or, *Leaping Horse*. He had become obsessed with *Waterloo Bridge*, and could not get it right, while at the same time he was struggling with its alter ego, *Chain Pier, Brighton*. Both were jockeying for position on the easel, both occupying his mind, both seeming to develop in the same way, both flicking their parallel compositions into his head, the one burning into the other's after-image. 'I am hard and fast on my "<u>Waterloo</u>",' he assured Fisher in November 1825, 'which <u>shall be done</u> for the next exhibition – saving only the fatalities of life.'[22] He had been encouraged again with *Waterloo Bridge* by Thomas Stothard, who suggested 'a very capital alteration – which I shall adopt',[23] and then by the Academy President, Thomas Lawrence, who called in his carriage at Charlotte Street. The day was dark – it was around 4 o'clock in January – and there was the painting, already part of Academy buzz, a monumental work-in-progress by the artist they could not quite make up their minds about. Lawrence had to squint at it by candlelight, and, as John told Maria, the President said it was 'admirable especially to the left not but the line of the bridge [on the right] was grand – &c &c – &c.'[24] The quizzy gentleman cast his lofty eye around the studio and the gallery as he passed through it to see what he could see, and spotted the portrait of Charles Bicknell above the fireplace. That was more his thing: 'how very like', he said, 'and how very well.' Constable had never seen Lawrence admire anything of his before, but even so at the Academician elections the following month Lawrence failed to vote for him, and the charming Leslie and the nervous Pickersgill, both portrait painters, were elected instead. With what may have been a scream of frustration after this election, Constable took *Waterloo Bridge* down yet again. Everybody had had an opinion on that painting, even Fisher who told him gracelessly

that 'The Waterloo depends entirely on the polish & finish given it. If I were the painter of it I would always have it on my easel, & work on it for five years a touch a day.'[25]

So he acquired another large stretched canvas, and, barely looking right or left, set off at speed on a new composition, deeply reflecting on his memories and recollections of East Bergholt. By the end of February, only a fortnight after the Academy election, he was well on with it. He discussed its detail with the botanist Henry Phillips, who was visiting London from Brighton, and came to have a close look. He wrote in due course with advice: 'I think it is July in your green lane', he told Constable, and added information that the artist probably knew already, but might have appreciated for confirmation:

At this season all the tall grasses are in flower, bogrush, bullrush, teasel. The white bindweed now hangs its flowers over the branches of the hedge; the wild carrot and hemlock flower in banks of hedges, cow parsley, water plantain &c; the heath hills are purple in this season; the rose-coloured persicaria in wet ditches is now very pretty; the catchfly graces the hedgerow, as also the ragged robin; bramble now in flower, poppy, mallow, thistle, hop &c.[26]

That seems to be too much information, but it is detail which, seen as words on a page, would thrill Constable, and take him straight back to his green lane in July. But Constable had his own agenda for the painting, which he did not see as a botanical treatise, or a kind of nineteenth-century reboot of an intense Flemish devotional painting. What he chose to include is cow parsley and ragged robin by the stream, flowering brambles which the donkey is nibbling, and white bindweed. The foreground staffage looks like dock. It was the trees rather than the flowers that exercised Constable. Five weeks after receiving Phillips's letter he had finished. He told Fisher:

I have despatched a large landscape to the Academy. Upright, the size of my Lock – but a subject of very different nature – inland – cornfields – a close lane, kind of thing ... The trees are more than usually studied and the extremities well defined

– as well as their species ... My picture occupied me wholly – I could think of and speak to no one. I was like a friend of mine in the battle of Waterloo – he said he dared not turn his head to the right or left – but always kept it straight forward – thinking of himself alone.[27]

This canvas became *The Cornfield*. However, with renewed reticence concerning its title, he exhibited it at the Royal Academy as, once again, '*Landscape*'. At the British Institution the following year it became '*Landscape: Noon*', the title he had already used for *The Hay Wain*. In *The Cornfield* we are at the bottom of the hill down Fen Lane, below East Bergholt, looking towards Dedham across the river. The corn is ready to be cut, a scytheman is waiting, and two more are in the field already getting on with the job. A plough has been left at the gate in readiness for use once the corn has been cut, and in the foreground a sheepdog waits with its flock as the shepherd lad takes a drink at the stream.[28] For all its size it is a deeply personal and intimate painting: this is the spot where, on his walk to school, Constable would have prepared himself for the final mile across the vale to Dedham; or on the way back where he might take a breather and a drink before the long climb up the hill and home.

The Cornfield captures Constable's heart and soul – the place, the narrative, the silence of high summer. By contrast, *Gillingham Mill* is dull and retrogressive, reflective not of youth or memory, but reminding us of the drawings of decaying rustic buildings that he had drawn in the 1790s for J. T. Smith. Only the dark cloud behind the mill carries the narrative juice of a kind that energises Constable's later exhibited paintings. This picture was a duty – Fisher had paid for a version of *Gillingham Mill*, but it was also now or never, because the mill had just burnt down, to be replaced with extraordinary speed by what Fisher described as 'a huge misshapen, new, bright, brick, modern, improved, patent monster'. Constable had to paint the old building from memory.[29] We might reasonably read the black cloud as smoke, and suspect an act of arson.

36. But still they tell me she does mend

Constable had long confided closely to Fisher about Maria's worsening medical condition: 'My wife is not well', he told him in 1823. 'Drew got her into a real illness by beginning with tonics. I told him the best medical opinion I know (yours) said they were worse than useless.'[1] During her confinements Maria was attended by the physician Richard Gooch, a trusted and competent friend of the family. The births brought anxieties along with their joys, and further, despite inoculations, the older children continued in their illnesses: Johnny and Isabel had sickened with whooping cough over the period of Emily's birth, and no physician had the slightest idea how to cure it.[2] The quack cure that Constable had heard, 'from an American' (probably Charles Leslie) was to 'hold the boy down the privy for a quarter of an hour every morning . . . Another certain cure was to put him 3 times over & 3 times under a donkey.'[3]

Brighton was simply too far away from London for Constable to work, exhibit, sell, and to attend to Maria, and so he needed somewhere more permanent on Hampstead's higher ground both to benefit Maria's health and 'to prevent if possible the sad rambling life which my married life has been, flying from London to seek health in the country.'[4] He sees things simply from his own point of view: 'It is an awful concern', he added to Fisher of his expanding family table when his invalid wife was in bed nursing tiny Alfred, 'the reflection of what may be the consequences both to them and myself makes no small inroad into that abstractedness, which has hitherto been devoted to painting only. But I am willing to consider them as blessings.'

A plague that Constable suffered was that of the Albany Saviles continuing. Savile and his wife would keep coming back and annoying him with friendliness. Failing him as a patron was bad enough, but in May 1826 the Saviles wanted Constable to go to tea with them: 'so I did', he admitted ruefully. 'They are as

disagreeable as ever – but rather worse as they grow older.'[5] He succumbed further by accompanying them to the Academy exhibition, where they would see *The Cornfield*, 'but they did enquire kindly after you, & the children . . . these unhappy beings.'

Chain Pier, Brighton was once again back on his easel. As a less complex and loaded subject than *Waterloo Bridge*, it had fewer tensions and vested interests, and fewer opportunities for people to tell him what he had got wrong. One of these might have been Sir George Beaumont, but he had died in February. At the Academy exhibition in April 1827 *Chain Pier, Brighton*, finished at last, was 'admired – "on the walls"', Constable told Fisher, 'I had a few nibbles out of doors. I had one letter (from a man of rank) inquiring what would be its "selling" price.'[6] 'One of his best works', said the critic Robert Hunt writing in *The Times*. 'He is unquestionably the first landscape painter of the day'.[7] *The Examiner*, six weeks later, wrote of Constable that he 'has, indeed, his manner, but he is less a mannerist than most others.'[8] Here were two distinct puffs for the accomplishments of Constable after so long and stumbling a career; the painting's reception pleased him, and he told Fisher so. *Chain Pier, Brighton* was one of the acknowledged highlights of the 1827 exhibition, the year Turner showed his idiosyncratically titled *'Now for the painter', (Rope.) Passengers going on board*: 'the painting of the sea has perhaps never been surpassed', Hunt wrote of Turner's exhibit. Here then, hanging perhaps within sight of each other, was the work of the twin titans of modern British art, both painting shipping and modern life, both painting the sea, both commended in the same column of *The Times*.

Before the decade was out Turner took on the Chain Pier as a subject himself. He painted it from its eastern side for Lord Egremont's dining room at Petworth, as one of a group of four canvases to be set beneath a line of grand portraits. The subject was perfectly relevant at Petworth: Egremont was one of the financiers of the Chain Pier, as he had been of the Chichester Canal, another subject in the quartet of the dining room pictures. Turner's long, narrow painting was not for exhibition, so public comparisons would never be made. Peer judgement would, however, be inevitable, for Petworth was a haven for

sophisticated artist-guests, many of them knowing and partisan assessors of the two giants: John Constable, 'unquestionably the first landscape painter of the day . . . less a mannerist than most others', and J. M. W. Turner, who was equally worthy of the 'first landscape painter' title, with his own distinctly controversial 'manner'. The Chain Pier brought out the best in both of them: Turner's refulgent yellow light, sunset and calm, compared to Constable's generous scale, sparkling sea, gusty wind, scudding cloud, imminent rain and lots going on.

While *Chain Pier, Brighton* was hanging at the Academy, Constable managed to find the 'comfortable little house' in Hampstead that he needed. This was number 6 Well Walk, at £77 a year. There the family moved, 'enjoying our own furniture and sleeping on our own beds'. It was (and remains) a neat yellow brick house, basement and three storeys with an attic, the last house (then) of a short terrace overlooking the spa attached to Gainsborough's Well – hence Well Walk – and on a gentle rise towards Hampstead Heath.[9] The basement kitchen leads straight out into a small garden through a low door, wide enough for generously hooped skirts to pass through without constriction. The particular delight of the ground-floor drawing room and first-floor bedroom is that they are at quite a height above the ground, which falls away at the back, and run the entire width of the house. Before trees grew up and late nineteenth-century buildings intervened, the drawing room and bedroom had expansive southerly views towards and over London, which only the delicately balanced guillotine shutters to the bedroom windows would obscure. 'My plans in the search of health for my family have been ruinous,' Constable wrote to Fisher:

> but I hope now my moveable camp no longer exists – and that I am settled for life. So hateful is moving about to me, that I could gladly exclaim – 'Here let me take my everlasting <u>Rest</u>' – no moss gathers 'on the rolling stone'.[10]

The upper rooms of 35 Charlotte Street he let to a dancing master for £82, potential income to help pay for the lease and repairs to Well Walk, making him just about in funds as long as his tenants paid up on time (they didn't).[11] He remained ambivalent:

to Fisher he wrote of his money difficulties, and his longing to settle out of London, while to Charles Leslie he took another line, that he missed his friends in London: 'I feel the absence of my friends most of all in this my pretty house, its distance from London – but the good overbalances – and I am not wholly out of hearing the "din of the Great Babel" – & can soon plunge into the midst of it.'[12]

Money continued to be a cause of anxiety. The investment cost of yards of canvas, paint and brushes could ruin him, he imagined. 'Ruin' was a fate that always hovered near, in his mind: the full-scale studies for his large exhibition pictures doubled, at least, the production costs of finished works. All this did not, of course, include rent, rates, coal and candles, food, clothes, servants, etc., etc., etc. There were no advance payments for Constables; the longer they took to complete, the further off was payday. Artists who had made it to the top of their profession joined one of the wealthiest sectors of society, among them, in Constable's generation, Turner, Martin, Lawrence and Chantrey. Money was the classic meritocratic way up in nineteenth-century society. For successful portrait painters and bust-sculptors, riches were axiomatic so long as the artist knew how to handle money, and was either an effective courtier or a clever businessman, able to exploit the market, or, like Chantrey, both.[13] Constable was such an exception to this: he had a thrilling talent as a portrait painter, but he suppressed it, and despite beckoning fashion he would follow his star and paint landscape his way. Those were among the reasons that, in the 1820s, and despite growing fame, he was always uneasy about money. His failed persuasion of Maria to eschew expensive white on their wedding day was a raw admission of his anxieties and his deep-rooted thrift.

Maria's illness carried on its relentless course, as did the parade of her pregnancies. Lionel Bicknell Constable was born at Well Walk on 2 January 1828, and according to moderately cheerful reports, Maria recovered well initially. '[My wife] goes on nursing famously', Constable told Leslie a few weeks later. 'My fourth boy is a great beauty – but "fair in the cradle, foul in the saddle." They seldom grow up fine looking.'[14] Constable had a rare ability to snatch misery from the jaws of joy.

Within weeks of seeing his new grandchild, Charles Bicknell died. He had been ailing for months, 'dead to the world a long time', as Abram put it.[15] The strain of Lionel's birth and of her father's death set Maria back once again. She went to Louisa Cottage in Putney to try to recover, and then, with the new baby, and Alfred only eighteen months old, travelled again to the sea: 'my dear dear Alfred sick with his mother in Brighton'.[16] Constable joined them, and friends and acquaintances in Brighton also rallied round: Henry Phillips sent arrowroot and a prescription in the hope that 'they may both contribute to the restoration of Mrs Constable's health. Fees are dispensed with, credit is all we wish to gain.'[17] Nevertheless, Constable could still wring his hands: 'Hampstead – sweet Hampstead that cost me so much is deserted'.[18]

On a journey to or from Brighton, Constable wandered for a while in the churchyard of St John the Baptist, Croydon, near the coach stop. He was looking for the grave of the young wife and two of the children of his good friend Robert Gooch. Perhaps Gooch had asked him to have a look at it, perhaps he wanted a drawing; in any event Constable made a sketch, and made too a note of the inscription on the slab.[19] Gooch's first wife, Emily, had died in 1811 aged twenty-five, after 'only the third [year] of her marriage'; their one-year-old daughter, also Emily, had died, as had Robert, aged five, the son of Gooch and his second wife, Sarah. This terrible line of bereavements was written out on the slab. Maria, in her fragile health still recovering from Lionel's birth, was on the brink and John knew it. He made a note of the lines in Latin that Gooch had had inscribed: *'Eheu! Quam tenui e filo pendet / Quidquid in vita maxime arridet.'* ['Alas! By how thin a thread hangs whoever smiles most in life.'] The source of this is unknown, and as it does not appear to be classical Latin it may have been composed by Gooch himself.[20] Constable knew these lines well: Gooch had quoted them to him from time to time, and they held deep meaning for him.[21]

Charles Bicknell left his son-in-law one hundred pounds, and, in trust to Maria and her sister Louisa, his stocks and 'effects', which, as Constable told Fisher, 'may be twenty thousand pounds'.[22] 'This I will settle on my wife and children that I may

do justice for his good opinion of me – it will make me happy – and I shall stand before a 6 foot canvas with a mind at ease (thank God).'[23] At last, some happiness, but of course it was not to last, despite cheers from Fisher and delight from East Bergholt. Fisher told him:

> Your legacy gave me as much pleasure as it could have done to myself. You will now be relieved from the carking fear of leaving a young family to privation & the world. You will feel that your fame and not your bread are dependent on your pencil. To work with success, we must work with ease.[24]

From East Bergholt, when word got out, good Abram responded: 'how delighted we all are . . . Mary is highly pleased & will tell Ann . . . dear Martha has my Mother's thirst to know how this affair turns out.' They must have known at East Bergholt that there would be little chance of Maria enjoying her father's bequest for long; and then Abram reveals a recent crass conversation he had had with Dunthorne: 'how happy I have made old Mr D[unthorne] by telling him of your good fortune.'[25] 'Old Mr Dunthorne' must have been rueful rather than happy, remembering how much Maria had disdained and rejected him.

Constable did not know where Maria should be for the best – with Louisa in Putney, at the sea in Brighton, or high above London in Well Walk with its chalybeate well behind the house. Anywhere but Charlotte Street; that remained Constable's working place, with its disobliging tenants upstairs: 'I retain my 2 parlors, large front attic – painting rooms, kitchen, &c.'[26] Brighton did not turn out as they had hoped: 'Brighton has done them a very little good, but we have had most untoward weather – & we must leave next week.'[27] Back in Hampstead, Maria rallied briefly, or at least Constable convinced himself that she had. He wrote to Johnnie Dunthorne, now in East Bergholt:

> I do believe Mrs Constable to be gaining ground. Her cough is pretty well gone and she has some appetite, and the nightly perspirations are, in great measure, ceased. All this must be good, and I am a great deal cheered. Still I am anxious, – she is so sadly thin and weak. I am determined to try and get her out.[28]

On top of all this, life went on: Constable's extended family extended its ability to irritate. His cousin Mary Watts Russell, the wife of Jesse Russell of Ilam Hall, Derbyshire, and sole inheritor of David Pike Watts's fortune, bothered him about the design of a Katharine of Aragon costume that she wanted to wear at a fancy dress ball.[29] Despite all, Constable responded helpfully, but that only encouraged Cousin Mary further:

> I fancy, a cap like <u>Queen</u> <u>Jane</u> <u>Seymour</u> (the new print from Holbein) but not the hood behind, but simply the white cap, made perhaps a little shorter at the ears for the sake of the Earrings.[30]

She advises John where he might find such a thing, at 'a shop leading somewhere between Covent Garden & the Strand'. This woman was relentless: 'PS Will you kindly get the old earrings mended & cleaned for me, & returned by the end of next week.'

From her high bedroom at the back of the house, Maria could see for miles over the Heath, due south across the Gainsborough Well. Looking further, she could see a view 'unsurpassed in Europe, from Westminster Abbey to Gravesend'.[31] The flasks of the spa's iron-rich waters did little or nothing to mitigate Maria's galloping consumption: 'Her progress towards amendment is sadly slow', Constable told Dominic Colnaghi in September. He was being fobbed off by the doctors: 'but still they tell me she does mend . . . I am much worn with anxiety.'[32] Mary Watts Russell wrote again, adding to the anxiety and Constable's sense of duty:

> Had I known how seriously ill Mrs Constable had been, I shd not have intruded my trifling affairs upon your graver thoughts, but as it turns out I hope they may have amused rather than bored you, & I will yet beg you to choose for me 7 yds of the handsomest Point Lace you can get at 10s a yard.[33]

By now the doctors were stringing Constable along. Charles Leslie called at Hampstead in mid-November to see his friends and try to bring comfort. Constable remained cheerful when he showed Leslie into the parlour to see Maria, but when he took Leslie aside he squeezed his hand and burst into tears.[34] On

23 November, in her husband's arms, Maria died.[35] John raised the shutters in their bedroom, obscured the vista, and with his children around him sat with the body of his wife. This mother of seven was forty-one years old. He loved her to death.

IV

Unfinished Symphony
1828–1837

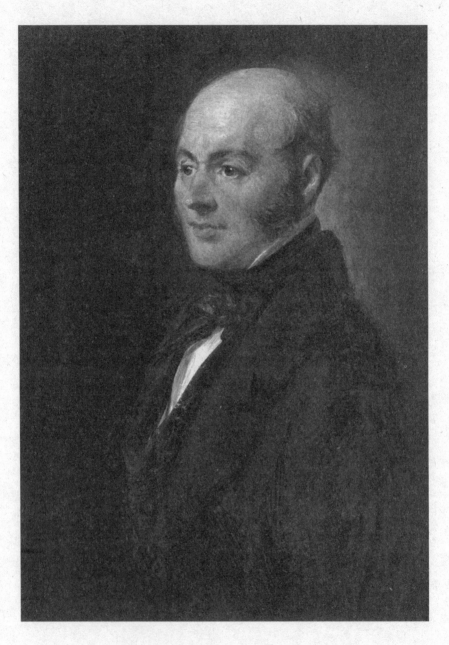

John Constable RA by C. R. Leslie RA, *c.*1830
Oil on canvas
Royal Academy of Arts, London

37. Rude ruins glitter

There had not been a year during which we could speak reliably of the comfortable Constables. They were happy, but they were all in ill health, John intermittently, the children from time to time, the servants now and again, and Maria suffering continuously from the sickness of chest and heart which would never go away. This sucked into the core of the family and into the very real *joie de vivre* with which Maria was naturally blessed. Her near-constant state of pregnancy was a further background ache, in concert with John's anxieties about his income, his need to invest time and money in each six-footer and its sketch, his meagre (as he saw it) professional recognition, and his constant fear of being overwhelmed by the rise in the cost of living presented by his ever-growing family and at least two homes at any one time. The price of John's sexual expectations, standard for his time and class, was increasing economic pressure from the growing family, and a slow drip-drip on Maria's health. The former they could have handled; the latter was beyond them.

Nancy was first to respond to the news, then came Patty, then Mary. Quick and fast, the sisters came to John with their love and support:

> offering my kindest Love, and Condolence . . . from the Bottom of my Heart . . . this most solemn, and awful crisis to you, and yours . . . look to the many virtues of her, whose removal is the subject of your Grief . . . 'Patience' & 'Meekness' were her prominent attributes, & they are ornaments of great price in the sight of God![1]

They touched John's hand, his sisters, across the counties, giving the bereaved family the comfort of their religion and the warmth of lifelong attachment. They urged him and the children to come to East Bergholt when they felt 'a little settled in [their] future arrangements'.[2] This notice appeared in the

Deaths column of the *Bury and Norwich Post*, the same paper
that had noted their marriage twelve years earlier:

> On Sunday se'nnight, at Hampstead, Maria Elizabeth, wife of
> John Constable, Esq. (the celebrated landscape painter, and
> son of the late Golding Constable, Esq. of East Bergholt, in
> this county) of Upper Charlotte Street, Fitzroy Square, and
> daughter of the late Charles Bicknell, Esq, of Spring Gardens
> Terrace.[3]

The form of words, perhaps the 'celebrated landscape painter's'
own formulation, places Maria's social position securely, but does
not acknowledge her relative youth nor the long line of children
she had borne. If her grave was marked by a stone, and it surely
was, the stone has gone, replaced probably in the early 1840s
by the family's tomb-chest. John chose the words so beloved of
Robert Gooch, repeated in Latin from St John, Croydon, to the
graveyard of St John, Hampstead: 'Alas! By how thin a thread
hangs whoever smiles most in life'.

The sisters embraced John and the children from afar, and
Golding might also have written a letter of condolence, though
this is unlikely, tied up as he was in his own affairs. It was to him
that John reached out after the funeral, to organise a cartload
of furniture for Golding and a local widow, Mary Abbott, with
whom his brother was co-habiting. Golding had at last moved
out of Wheeler's Cottage, where he had lived with Nancy, into
Pie's Nest, opposite the windmill, which he had bought in 1827,
and which he had spent the intervening months repairing.[4] He
and Mrs Abbott, 'a carefull respectable person',[5] needed furni-
ture, and John was able to oblige. He sent '20 parcels [i.e. items]
– cheap – sound – seasoned and good and free from the "bug-
gery" [triple underlining] – for what I know it is a noble bed.'[6]
There was also a nicely upholstered easy chair, a carpet to be
sent on to Patty in Dedham, and a 'shit pot': 'Abbott may want it
if you don't – but it is no bad thing for either in a cold showery
night on Bargell [sic; Bergholt] Heath when taken short.' Off
it all went as extra cargo on one of Abram's ships plying from
London to Mistley, with John wishing Golding 'health and many
many happy years in your new home'. The shipment occupied

John's thoughts in the letter to Golding for a while, but then he broke down:

> Hourly do I feel the loss of my departed Angel – God only knows how my children will be brought up – nothing can supply the loss of such a devoted – sensible – industrious – religious mother – who was all affection – but I cannot trust myself on the subject – I shall never feel again as I have felt – the face of the World is totally changed to me.

John mused to Golding how 'poor dear Bergholt will fill me full of sad – sad – associations – especially the sight of the Rectory - & its dark trees – but a few year[s] will set all these sorrows at rest – but I cannot recover my lost happiness – the loss grows upon me – but I must turn to my dear infants.'

Fisher took a different tack in response to Maria's death: 'For your comfort, during the trial upon you for the exercise of your patience, you should apply yourself rigidly to your profession'.[7] Constable hardly needed encouragement to work, but here was licence nevertheless. Fisher's challenge, and Constable's musing on 'dark trees', 'sad – sad – associations', and the changed 'face of the World', together prompted him to look back into his past, and to return to earlier sketchbooks. There, he lit upon the tiny study of Hadleigh Castle near Southend that he had drawn on his tour of the Essex coast in 1814, at a time when he and Maria were at one of the many low points in their courtship. We do not know if Constable had given any thought to Hadleigh Castle as a subject during the years of his marriage – probably not – but now with Maria gone, recall of the ruin's 'melancholy grandeur' came flooding back from one low moment to another.[8]

He made a modest pen and ink sketch, and in the quiet of his room painted a small panel in which a tortured sky is dominated by the two jagged structures of Hadleigh Castle, standing like broken teeth in their bleak and shattered landscape.[9] He unrolled a six-feet length of canvas, had it stretched for his easel by Johnnie Dunthorne, and on it he painted the most energetic, expressive, and, despite all, hope-filled sky he had yet created.[10] The horizon is pretty well on the centre line, dividing the clouds scudding in from the scintillating morning light on the damp

and drear saltmarsh. The castle's ruined keep and gatehouse are grim indeed, but while 'melancholy grandeur' surmounts the painting's left-hand side, to the right, the greater half, we see light overcoming darkness. We might reasonably guess that Constable initially chose the subject to stoke his melancholy, but as he worked on this large-scale study he must have begun to feel better, transforming the scene with wheeling gulls, some wandering cattle and a ruminative shepherd and his dog. There are touches of Rubens and Rembrandt in the vast expanse, and of homely Gainsborough in the figures to the left.

Fisher will have known nothing of Constable's Hadleigh Castle experiment, and a week after his first advice to 'shew the world what a man you are' he added a rider:

> I wish if 'Brighton' is not out of your possession that you would put it on an easil by your side, Claude fashion, & so mellow its ferocious beauties. Calm your own mind and your sea at the same time, & let in sunshine & serenity. It will be then the best sea-painting of the day.[11]

Fisher had always admired *Chain Pier, Brighton*; he had described it as 'a useful change of subject', and here it was, back again under discussion between them, even after having been exhibited twice in the preceding eighteen months.[12] It had not sold, so Constable was free to tinker with it as much as he wanted.[13] It is unlikely that he did any such thing – he had tinkered with it enough already – but turned instead to Hadleigh Castle because he now had plans. Time was short: the next Royal Academy exhibition would open at the end of April, and it was already New Year.

In the meantime there was other business, something that he may have forgotten about in his grief: he was to stand (again) for election to full Academician – and this time he got it, by the whisker of one vote: fourteen votes to Francis Danby's thirteen. This was much to the surprise of Sir Thomas Lawrence, presidentially favouring Danby, who felt he had been robbed. Danby accused Constable of 'intrigue which was beyond all meanness', adding harshly, 'For the Academy I have much cause to be ashamed as it lowers their value when it is so evident that they

have elected Constable for his money'.[14] This was unnecessary, untrue and unkind, particularly in the light of Constable's hospitality to Danby when he called 'to see my works' in 1824: 'he was delighted. I rather liked the young man.'[15] Unexpectedly, and in fond support of Constable, Turner and his tall, stately Academician friend George Jones came round to Charlotte Street after the vote, and stayed there talking with Constable until the small hours.[16]

Lawrence was less than generous on receiving Constable a few days later: he reflected on the new Academician's good fortune in the light of the strength of the other candidates, among them Eastlake and Landseer, as well as Danby.[17] Leslie wrote about the meeting, and carefully reminded his readers that Lawrence was a 'kind-hearted man' who had 'no intention to give pain'. Nevertheless something bugged the President about Constable's victory over the 'historical painters': the subject of a painting was all important, whether it be Hannibal crossing the Alps, a moment in Shakespeare, or a portrait of somebody. Lawrence's attitude, in Leslie's view, was that 'high art' meant history painting, no more, no less, and that Lawrence considered Constable's paintings to be landscape of 'the humblest class', with nothing 'historical' about them. He probably said so, not having paid enough attention to the paintings to consider their merit, and having only seen Constable's recent work by candlelight late on a January afternoon the year before. This was an embarrassing meeting for both of them, Lawrence on the back foot justifying his view, but he let Constable have the last word, to describe his election 'as an act of justice rather than favour'. What Constable did not say to Lawrence was the unvarnished truth, that the cruel timing of his election carried with it a backwash of pain. He could no longer share his triumph with Maria: 'It has been delayed until I am solitary, and cannot impart it,' he confided to Leslie.[18] However, he was thrilled to tell Abram, of course, and Abram – and Nancy, Patty and Mary – were overjoyed: 'but your Pictures will not need any other aid than their own genuine intrinsic genuineness & worth'.[19] This was a family triumph too.

Constable's struggles with the subject of Hadleigh Castle became common knowledge among his siblings. 'You will now

proceed with your Picture of the Nore [i.e. *Hadleigh Castle*] & I think it will be beautiful', Abram wrote.[20] What emerged in time for the Academy submission in late April 1829 was an ironed-down version of the turbulent study, in clearer, blander light. A week or more before he delivered it he admitted to Leslie that he was 'grievously nervous about it – as I am still smarting under my election . . . I am in the height of agony about my crazy old walls of the Castle.'[21] Nevertheless, he pressed on and made subtle but determined amendments to the mood he had evoked in the study. The sky in the exhibited painting is more dominant and energetic, the roiling cloud rising upwards, wide, dry brush-strokes curling anti-clockwise. The painting is brighter in tone with shafts of sunlight – *coups de soleil* – and movement. Seagulls wheel once again, the cows walk forward on their middle-ground slope, and the dog and the shepherd, now in a flash red jerkin, move into the picture. The vertical parts of the painting – castle gatehouse, sapling, keep, distant tower – march towards the water's edge, and the light dazzles on the water. The same pulled paint that we saw in *The White Horse* articulates the horizon, and we are perhaps a few hours later in the day compared to the study, as there are now at least sixteen sailing ships dotting the distance. They follow the route of Abram's ships, with their corn and coal, night soil, furniture and shit pot, demonstrating that ruin is left behind, as the eye is drawn to the light.

On sending the painting to the exhibition Constable acted uncharacteristically: he gave it a title which is Turnerian in its extent and its descriptive information: *Hadleigh Castle. The mouth of the Thames – morning, after a stormy night*. He also attached lines of verse, a practice first adopted by Academy exhibitors in 1798 nominally to underline the meaning of their paintings, but ac-tually also to give themselves greater prominence in the printed catalogue. In a further gesture to the previous generation, the poet whom Constable quoted was James Thomson, his *Seasons*, the popular and comfortable words celebrating Georgian bounty and the benison of nature. The lines Constable chose are from 'Summer', descriptive of sunrise, and follow Thomson's assertion that 'the doubtful empire of the night' is overcome, 'meek-ey'd morn appears . . . white break the clouds away . . . brown night

retires'. Hand in hand with Thomson, Constable is leading us if not into sunlit uplands, certainly into the joy-borne glimmers of the opening day:

> ... The desert joys
> Wildly through all his melancholy bounds.
> Rude ruins glitter; and the briny deep,
> Seen from some pointed promontory's top
> Far to the blue horizon's utmost verge,
> Restless, reflects a floating gleam.[22]

He could have chosen some of Thomson's jollier lines, but ruins glittering and a gleam afloat takes us far enough into the light to suggest that John Constable is already through the worst. As indeed he was, for soon it was party-time: having pondered on the tricky business of moving the large canvas from Well Walk to Somerset House, he was able to kick off his shoes at a double birthday party for eight-year-old Charley and seven-year-old Isabel: 'I sat down with "fourteen", the eldest of whom was only eleven.'[23] Such mood changes were endemic within him; the aspects he showed to the world were guided by the aspects the world showed to him. 'I have little enough of either self-knowledge or prudence (as you know),' he told Leslie, 'and I am pretty willing to submit to what you shall decide – with others whom I value.'[24] When *Hadleigh Castle* was on the Academy walls in the days before the exhibition opened to the public – the so-called 'Varnishing Days' – Francis Chantrey elbowed in and expected Constable to submit to his advice and solution: 'The foreground is too cold', the sculptor said, and, taking Constable's palette without a by-your-leave, spread on it a glaze of asphaltum, that is, a suspension of bitumen used by artists to darken bright surfaces. Even now they were patronising Constable, the at-long-last new Academician whose landscapes the President felt were of 'the humblest class', being blind to their naturalism, damps and heats. 'There goes all my dew!' Constable responded to Chantrey, and promptly dabbed the asphaltum off again.[25]

His spirits rising, Constable accepted invitations to dine with the widowed Lady Beaumont at Grosvenor Square and with

David Wilkie in Kensington, increasingly now a friend and col-
laborator. However, among fellow guests at Wilkie's were two
painters whom he could no longer abide, William Collins and
Ramsay Reinagle. Collins dominated the conversation: 'I wished
I had been at home', Constable confided to Leslie.[26] When he was
at home he made sure – or his children and Elizabeth Roberts
did – that he spent plenty of time keeping the children enter-
tained, with them keeping him amused and buoyant, and having
friends round. A party at Charlotte Street planned for the Leslies
generated bubbling energy and laughter:

> my little girls were all in 'apple pie' order to be seen – my dear
> Maria [i.e. Minna] had been practising her 'steps' & music all
> day that she might appear to every advantage – all my boys
> were in their best and had allowed a total clearance of the
> drawing room of all their numerous 'ships – & castles' – <u>books</u>
> – <u>bricks</u> – <u>drawings</u> - &c &c &c &c.[27]

Charlotte Street was now ordered chaos, and without John's
'dear Fish' in control standards of tidiness might have slipped
and room boundaries been renegotiated, though noise levels will
not have changed. With lodgers still on the middle floor, Con-
stable retreated at night to sleep in an attic bedroom which he
filled with his collection of drawings by Gainsborough and with
framed old master prints that consoled and enriched him.

Prominent downstairs in the Charlotte Street studio was a new
canvas larger by a few inches even than *The Hay Wain*. This was
Salisbury Cathedral in an epic composition, seen from across the
River Avon, in which the cathedral is elevated to symbolic status
piercing dangerous storm clouds, struck by lightning and en-
closed beneath a rainbow's arc. Constable and Fisher had spoken
together about 'the Church under a cloud', meaning the threat
to the status quo of Church and State by the forces of political
reform and social change. In *Salisbury Cathedral from the Meadows*
a cart drawn by horses crosses a river in what is a reprise of *The
Hay Wain*, while the cathedral looms up in the background like
artillery. The sky is alive with discordant weather – lightning, a
rainbow – paint spots scatter like grapeshot, and while the cart
moves from darkness into light, the future, it seems, is uncertain.

The evolution of society in England from a restricted aristo-
cratic system to one in which new money from industry, trade
and commerce flowed into the art and property market caused
an irreversible shift in taste and perception. One large painting,
The Lock, bought when still wet from the walls of the Royal
Academy in 1824 on the exhibition's opening day, was the first
purchase for his collection by James Morrison.[28] This Hampshire
inn-keeper's son had risen through intelligent and ruthless busi-
ness dealings from selling shirts as a young man in London to
building an empire of clothing shops and warehouses through
bulk purchase, outsourced manufacture, and quick profits. He
invested in engineering, notably railways in America, bought
grand houses and even a Scottish island (Islay), and collected
art. Spreading across the entire economy, the commercial trend
in which Morrison engaged supplied the bedrock of Constable's
livelihood from the mid-1820s into the 1830s.

Salisbury Cathedral from the Meadows, with its many working
studies, was Constable's growling expression of national foun-
dations under threat. He exhibited it in 1831 with further lines
from Thomson's *Seasons* appended:

> while as if in sign
> Of danger past, a glittering robe of joy,
> Set off abundant by the yellow ray,
> Invests the fields, and nature smiles reviv'd.

'Glitter' is the hope-filled verb that articulates both *Hadleigh
Castle* and *Salisbury Cathedral from the Meadows*. Beyond all his
anxieties, Constable must have recognised that he and his chil-
dren were beneficiaries of changing times.

38. Life slips

R oyal Academy exhibitions in Somerset House in the 1820s and 1830s might display between nine and twelve hundred works, oil paintings both huge and compact, watercolours florid and discreet, sculpture largely in plaster on plinths or extending out into space, architectural drawings and models.[1] Horizontally, eight feet from the floor, a wooden moulding ran around the exhibition rooms, creating a fixing for those paintings chosen to take prime position 'on the line' at the summer's exhibition. Being hung on the line was a guarantee of being noticed, or at least of being at the viewers' eye level, while hanging above the line was grand for grand portraits, history paintings or battle pieces lashed to a wooden support structure canted outwards for the purpose. Below the line, it was hide-and-seek for the paintings and hit-and-miss for smaller pictures as they jostled for space. At the very top it was practically hopeless. The line itself was the parting of the waters, which remained a determined horizontal rarely to be bridged.

Pictures were selected by the Committee of Arrangement, which included three or four Academicians chosen each year by their peers. In April 1830, the group comprised Constable along with James Ward, who later dropped out through ill health, Abraham Cooper and William Etty. The Academy Secretary, Henry Howard RA, was also a member, and all were under the chairmanship of the new President, Sir Martin Archer Shee, the successor to Sir Thomas Lawrence who had died in January. Pictures were paraded anonymously one by one before the committee. The selectors were a diverse group: Constable painted landscapes, Ward painted animals, Cooper painted battles, and Etty painted men and women naked. Collectively these men decided what was selected and, from those works, what was displayed. Not everything selected would necessarily be shown because space might simply run out, frustrating the committee's

choice. At the 1830 selection Constable's own landscapes came up for assessment. He had been uncertain about what to submit this year, having written to ask his bookseller friend James Carpenter to forgo a picture, still on the easel, that Carpenter had already paid 100 guineas for: 'I have no motive whatever in asking this favor of you than that the picture be my own property and that I do it and send it to the Academy independently of all other considerations.'[2]

It is not clear which painting this was, nor if Constable did indeed submit it, but one of his paintings that year did cause a fuss. 'That's a poor thing', said one of the selectors as the work was shown to them. 'It's very green', said another.[3] Too much green was still anathema, despite the evident fact that England was (is) a green country. Two of the committee members castigated the painting, while Constable looked on, saying nothing. Finally, somebody decided, 'It's devilish bad – cross it.' The green landscape was passed to an Academy servant to have an 'X' chalked on its back and be ejected. Constable then stood up, moved to the front, and said to the judges:

'That picture was painted by me. I had a notion that some of you didn't like my work, and this is pretty convincing proof. I am very much obliged to you.

Consternation; he had trapped the tormenting clique. 'Dear, dear', said the President, wringing his hands and casting about in embarrassment. 'Dear, dear,' he (Shee) said, 'how come that picture is amongst the outsiders? Bring it back; it must be admitted, of course.'

'No! It must not! Out it goes', Constable demanded, and walked out.

Water-meadows near Salisbury is a mild-mannered picture, one of modest size (18 inches [46 cm] high), simple construction and minimal incident: three horizontals, a breeze, the flowing river, one willow leaning slightly more to the right than the others, and a crow in the meadow beyond. We cannot rule out the thought that Constable submitted it for the exhibition precisely so that it would be called into question and rejected. After such a long, trying and debilitating wait to become an Academician, he

had successfully drawn his fellow artists' fire, spiked their guns and as far as possible opened their eyes.

Hanging the annual exhibition was a process in which chaos and order ran arm in arm. Carpenters, porters, upholsterers, scaffolders, men up ladders with ropes and pulleys, all under the committee's guidance, saying up a bit, down a bit, right or left a bit, and arguing about what goes next to which, as the jigsaw puzzle took shape. And the hubbub of lifting and calling and sawing and hammering, punctuated by crashes when something was dropped. 'It would amuse you much could you know how I am beset', Constable told Leslie during the course of hanging the 1830 show, with its 'mob of portraits'. To Carpenter he complained 'Everyone who can or cannot paint a head, thinks himself equal to fill the shoes of Lawrence.' To Leslie he added: 'I have earls, dukes, poets and even royalty at my [feet] (all painted on canvas of course).'[4] By his own account it seems that he was the only one usefully getting on with the job: 'on the whole I witness a melancholy display, of the selfishness of our profession. I only have Ward to help me "hang" – and he is half silly.' The display of his own paintings that survived the selection, a gloomy and introspective *Helmingham Dell,* and a more typical *Hampstead Heath,*[5] were 'plaguing me exceedingly', and on top of that he had to sort out an artist who complained that his painting was badly hung, and was making a fuss about it downstairs.[6]

Constable made a dismal sight around the Academy, dressed in black. His waistcoat was black, his gloves were black, even his silk handkerchief was black, but this was nothing new for him; his mourning for Maria was little different to his normal garb. The unremittingly miserable *Helmingham Dell,* a subject to which he had reverted time and again since 1800, may well have been the cause of his 'plaguing'. Indeed, it was picked on by the *Morning Chronicle* critic, who alluded to Constable's recent financial windfall of inheritance from Charles Bicknell (ignoring the loss of his wife). Echoing Danby's assertion that the Academy had elected him for his money, the critic described Constable as:

certainly not improved in art as he has in fortune, to which latter he entirely owes the obsequiousness of the Academy,

and the long struggled-for R.A. Though not without great merits, much impaired by silly affectation, and various clumsy attempts at singularity, he, as a painter, falls far short of CALCOTT and LEE in their respective excellencies – most of all in the charms of poetry and good taste.[7]

The following year Constable was on the Committee of Arrangement once more, now with Henry Bone and Charles Eastlake. There were the usual tense arguments during hanging, one of which overflowed into a bitter row between Turner and Constable.[8] Critics focussed their attention on two paintings in particular: Turner's *Caligula's Palace and Bridge* and Constable's *Salisbury Cathedral from the Meadows*. 'Fire and water' was the description from the *Literary Gazette*: 'If Mr Turner and Mr Constable were professors of geology, instead of painting, the first would certainly be a Plutonist, the second a Neptunist ... the one all heat, the other all humidity.'[9] Other critics wrote of Constable's 'coarse vulgar imitation' and Turner's 'freaks and follies'; and 'Turner's *fire* and Constable's *rain*'.[10] The pair were being harnessed together like a pair of mettlesome carriage-horses of opposed temperaments, perceived as equals and oppo-sites. 'Turner is admirable', wrote the *Athenaeum*, 'Constable is Constable'.[11]

As an acknowledgement of the slow march of time, and the relay of genius that is its heir, Constable paid 12 guineas at Christie's in June 1830 for the paint-smeared wooden palette used by Joshua Reynolds. This had been given by Reynolds to the young George Beaumont, then bequeathed by Beaumont to Sir Thomas Lawrence, and at Lawrence's sale bought by John Constable and presented by him to the Royal Academy. 'The President and Council received this liberal & interesting gift with great satisfaction', the Academy minutes recorded.[12] There is a sense that in 1830 and 1831 Constable was reassessing himself and considering the history of art and his place within it. Would he teach? Would he write? He was a fine writer, and he knew it; Fisher had known it also, and had encouraged his friend to write about art for publication:

You are in possession of some very valuable and original

matter on the subject of painting, particularly on the <u>Poetry</u> of the Art. I should be very sad to see this seed sown on some unvisited field where it would blossom in forgetfulness: while some thieving author, like a sparrow, would fly off with a sample & take the credit from you . . . Pray do not forget to put together the history of your life & opinions with as many of your remarks on men & manners as occur to you. Set about it <u>immediately</u>.[13]

Constable more or less declined this advice, though he did seriously consider writing a life of Sir George Beaumont: 'I must take care of being an author, it is quite enough to be a painter', he would say later.[14]

He did, however, write some paragraphs about Michelangelo's bas-relief *The Virgin and Child with the Infant St John* and submitted it to the *Athenaeum.* Beaumont had bought the marble in Rome in 1822 and installed it in his Grosvenor Square picture gallery. He bequeathed it to the Academy: 'One of the most beautiful works of art in existence', Constable wrote of it, 'a subject . . . which of all others awakens our sympathies and embraces the most lovely and amiable feelings.'[15] He will have noticed the sudden movement depicted in the marble, an event that he might see among his children every day at home: the child Jesus is alarmed at a gesture of offering (of a bird?) by his cousin John the Baptist. In wandering, fluid penwork, Constable made a small sketch of the marble, dated 1 July 1830, probably from memory, as he has not remembered the pose of Jesus correctly.[16] Saying little else about it as a work of art, he restricts himself to its discovery, price and provenance, and with a curatorial eye describes the way it was lit in the Academy's Council Room:

> In this favourable situation the light falls from the left, showing the more finished parts to advantage, and causing those less perfect to become masses of shadow, having at a distance all the effect of a rich picture in *chiaroscuro.*

The subject of 'chiaroscuro' had driven Constable for decades, certainly since he met John Cranch and began briefly to paint dark, soupy landscapes under his influence. One of the books

on Cranch's 'Painter's Reading' list, written out for Constable in 1796, was Count Algarotti's *Essay on Painting*, published in English in 1764. In his bachelor evenings alone in his rooms in London, Constable will have read this and thought about 'the rationale of light and shade', as Algarotti put it, 'and the nature of that *chiaroscuro*, by which . . . the various forms of things are distinguished.'[17] In Algarotti, Constable perhaps saw the word 'chiaroscuro' in print for the first time and was intrigued by it and its meaning, for the word and its purpose followed him thereafter. Michelangelo may also have been introduced to him at this time; Michelangelo who, as Algarotti expressed it, 'was a perfect stranger to all manner of gracefulness. But he was learned, profound, severe, bold in his postures, and the first that introduced the terrible into painting.'[18] For Constable, early seeds sprang up late, but not too late, for in the 1830s he was able to redirect the energy and emotion he had fed into loving and caring for Maria, into the widening of the boundaries of the expression of his art.

There is a sonnet by Constable, written in 1835, which may be a fragment of his consideration of new directions. The fourteen lines in praise of Wordsworth, 'Thou second Milton!', carry within them their own chiaroscuro, expressed through the gloom of Constable's present vision. The sonnet ends:

> Nor let us dread that this proud land is doomed
> To yield to violent men her Church or Laws,
> While lays like thine are framed to glad the strong
> And give the lowly surest hope from wrong.[19]

Constable had a high sense of justice, framed by his forlorn hope for the continuation of political *status quo*, which in the early 1830s was severely rocked by Catholic emancipation and the passing of the Reform Bill. His sense of justice and his search for the truth, however he saw them, manifested themselves in what he considered to be his duty to assert the beauty and form of the world around him, and to broadcast it through his work.

Constable's response to his own feared impending 'ruin' was to set in motion the creation and production of mezzotint engravings of his paintings in what he came to publish as his *English Landscape* series. 'Set about it <u>immediately</u>', Fisher had advised

his friend: 'life slips.'[20] During the year in which John Constable wrote his sonnet with its barely recognisable glimmer of hope, 'Nor let us dread this proud land is doomed', Charles Darwin arrived in the Galapagos Islands on board HMS *Beagle*, and Henry Fox Talbot created the first photographic negative. Of both of these and their consequences for the world, Constable would of course be ignorant.

Though little concerned with early ideas of evolution, and untouched by photography, Constable was, as we know, thoughtful and practical in building upon the foundations of experimental science as these impinged on his work as an experimental artist. Two pioneers of the interchange of science and art came into his circle in the 1820s and stayed with him into the following decade: George Field the colour chemist, and David Lucas the printmaker. Field had spotted an opportunity to develop his genius for chemistry with his talent for networking with art and artists.[21] By the 1820s, he had a flourishing colour-producing factory on Hounslow Heath, where he could synthesise the primary colours of red, yellow and blue, and all manner of other pigments. 'Mr Field called with some colours', Constable told Maria in his Journal in 1825, and a few days later: 'After dinner Mr Field called again – so I put off going to Hampstead & got to work - & Mr Field had tea with me. Mr Field brought me A Life of Wilson, which is an amusing book.'[22]

While they were affectionate professional colleagues, Constable and Field were also friends, Constable being an artist and customer whose opinion and support Field certainly required. He was one of many artist-subscribers to Field's pioneering book *Chromatography* (1835), along with Arnald, Beechey, Callcott, Etty, and artists all through the alphabet to Pickersgill, Reinagle, Shee, Turner, Varley and Ward. The subscribers' list is fat with Academicians and Associates: Field needed them on side and consuming his products. In his chapter 'On Green', Field writes that 'the general powers of green ... associate it with the ideas of vigour and freshness; and it is hence symbolical of youth.' He then quotes Constable, 'one of the most eminent of this distinguished class of British artists' from his 'Remarks on Landscape': 'the beautiful and tender hues of the young leaves

and buds . . . rendered more lovely by being contrasted with the
sober russet browns of the stems from which they shoot.'[23] Field
knew this from personal experience: Constable would take him
out, 'at all times of day, at night, and in all seasons of the year',
most probably in Hampstead: 'I have been out with him after all
colour of the landscape has disappeared, and objects were seen
only as skeletons and masses, yet his eye was still active for his art.
"These were the things", said he, "that Gainsborough studied."'[24]
In the 1896 'new revised' edition of Leslie's *Memoirs of Constable*,
the author's son Robert Leslie adds that later in life Constable
was 'constantly in communication' with Field, and always had a
'large store' of his powdered pigments, 'chiefly . . . ochres, mad-
ders, ultramarine, and the lovely greys known as ultramarine
ash.'[25] Field's business and his insight as a colour chemist gave
Constable, as so many artists, new horizons through the plentiful
supply and consistent colour-value of his materials.

39. David Lucas

'There is a look of nature about the picture', Frederick Lewis told Fisher of Constable's *Stratford Mill*. Its owner, John Tinney, had got wind of the fact that the artist wanted it to be engraved, and Tinney feared that when borrowing the painting back, Constable might find tinkering with it irresistible. 'He dreads your touching the picture. This of course is not his own thought,' Fisher added, 'for he would not discover any alteration you might make'. Lewis had warned: 'when Constable gets it on his easel, he may in an unlucky moment destroy [it]; and he will not paint another picture like it, for he has unfortunately taken to copy himself.'[1] That is a tough remark, and Fisher relayed this gossip with the warning that if it were true, Constable should be aware; if not, he should be on his guard.

The brief association with Lewis came to nothing: an engraving of *Stratford Mill* was not completed. Constable tried again by engaging Samuel William Reynolds to engrave *The Lock* soon after it was exhibited in 1824: Reynolds flattered him with the thought that Constable's 'freshness' exceeded any painter that ever lived; that to his colour he had 'added light'; and that his work was 'masterly without rudeness, and complete without littleness'.[2] Of course Constable acquiesced, but so delayed became the process, and so tense grew the relationship between the pair, that Reynolds's print never appeared, and all ended in acrimony.[3]

These hard experiences of the recent past made Constable wary of working with engravers, but having collected prints since his youth, the attraction remained and he still sought the opportunities to make the investment required to turn his paintings into the coin of engravings for circulation in the art market. He had himself learnt from engravings, and owned many hundreds of prints by now,[4] being fully aware also of the damage that could be done by an uninspired rule-driven engraver. In Reynolds's Bayswater workshop a young trainee caught Constable's

eye: David Lucas, who, like Constable, had a rural background – a Northamptonshire farm – a love of landscape, an understanding of country life and detail, and an instinctive ability to express atmospheric and weather effects through mezzotint.

Printmaking had been a lucrative profession up to the mid-1820s, when it was damaged by the financial crash that bankrupted engravers and broke banks. Constable was cautious. It had taken him years of watching how Turner went about it with his *Liber Studiorum*, the collection of engravings that that entrepreneurial artist had commissioned from 1806 as copyright protection.[5] He was aware of Turner's engagement with so many engravers – George and William Cooke, Charles Heath, Frederick Lewis, John Pye, J. T. Willmore and James Wyatt – to create a stream of prints for publication. These were major financial and artistic undertakings, and while Constable may not have been aware of how financially precarious Turner's engraving sequences were – he referred once to Turner's 'Liber Stupidorum' – or how tricky they were to project and market, he could certainly see that the engravings were of a pin-sharp quality, and that they put Turner's name around.[6]

In the extended process of selecting the paintings to be engraved, and nursing Lucas through production, Constable and he had a warm and mutually respectful relationship which was punctuated by volatility and verbal fireworks: 'I like your first plates,' he told Lucas of early stages of a plate of *Hadleigh Castle*, but he applied the pressure nevertheless:

> for they are by far (very far) the best, but I allow much for your distraction since, with these devils the printers . . . I want proofs of the water Mill printed . . . Do not neglect the Wood . . . Bring me another large Castle or two or three, for it is mighty fine – though it looks as if all the chimney sweepers in Christendom had been at work on it, & thrown their soot bags up in the air. Yet everybody likes it . . . Come early tomorrow evening.[7]

Constable kept Lucas jumping. Further fragments of advice, concern, criticism and praise came from Constable during engraving and printing: 'Take care to avoid rottenness'; 'I am

concerned at hearing nothing of you – and fear you are ill'; 'I should like the cloud darker about the house'; and 'the present state of the plate is <u>utterly</u>, <u>utterly</u> <u>hopeless</u>'.[8]

He is open and free with complaints about his health and the stress he is feeling over Academy matters, but throughout showed a palpable sympathy for the family and professional troubles that beset Lucas. Theirs became an interdependent and open creative partnership in which each was able to talk about his personal life and history, the older man describing at length his youth and upbringing. Constable thus revealed insights which later re-emerged in thoughtful and affectionate observations in Lucas's pencilled marginalia in his copy of Leslie's *Memoirs of the Life of John Constable* (1843).[9] It was, for example, to Lucas that he told the story of Benjamin West's advice – that 'light and shadow *never stand still*': this was a tip that Constable was determined to pass on to this other young, uncertain artist, who was also anxious about his future and income. In doing so, Constable was confident that Lucas would remember it, as indeed he did.

The first set of four of David Lucas's mezzotints appeared at the end of May 1830. 'Should it pay I shall continue it', Constable told Fisher with suppressed excitement for the success of *Various Subjects of Landscape, Characteristic of English Scenery from Pictures Painted by John Constable, R.A., Engraved by David Lucas*.[10] An anonymous *Athenaeum* critic, identified as the painter John Hamilton Reynolds, 'hit you off exactly', Fisher told Constable: 'the critique . . . was true, characteristic, and highly clever', and Fisher promised him he would have it reprinted in the *Salisbury Journal*.[11] In a lengthy article in which Constable was given the space and appreciation he deserved, we read the mildly patron-ising aside that Constable 'appears to have fed his genius, like a tethered horse, within a small circle of his homestead'. That was not entirely the case, as we know, though the remark was apt shorthand for an intensely focussed artist. The first four prints of the series were *A Mill* (i.e. Dedham Mill); *Spring*, (i.e. East Bergholt Windmill); *A Dell in Helmingham Park, Suffolk*; and *Weymouth Bay, Dorsetshire*. Production continued, and in De-cember 1830 Lucas's engravings of four more paintings were published: *Stoke by Neyland* (sic), *Suffolk*; *Noon*, (i.e. West End

Fields, Hampstead); *A Sea Beach* (i.e. Brighton); and *Old Sarum.*[12]
This is as broad a pattern of subjects as Constable was capable,
and demonstrated the range of his painting, its atmospheric var-
iances and its modest geographical spread. It had nothing like
the reach across the nation that Turner's engravings demon-
strated: nowhere in England and Wales lies more than about
forty miles from an engraved Turner landscape subject.[13] Never-
theless, for Constable it was a wide-cast net: Suffolk, Dorset,
Hampstead, Brighton, Salisbury and Weymouth, as far west as
Constable had himself travelled, and as far north (Hampstead)
as he was now interested. At the same time, the prints demon-
strated Lucas's mastery of atmospheric nuance as translated
into mezzotint.

The 1833 edition of *English Landscape*, subtitled 'The Phe-
nomena of the Chiar'Oscuro of Nature', collected all the twenty-
three prints together, and is rich in texts that express Constable's
vision and hopes. He is clear in his intentions at the outset, and
is honest that his focus had changed as the project developed:
'It originated . . . as a pleasing professional occupation, and was
continued with a hope of imparting pleasure and instruction to
others.'[14] Constable broadens the meaning of the 'chiar'oscuro'
that he wants to impart, because his is the chiaroscuro of nature,
not just of art. So it is not only Algarotti's 'rationale of light and
shade' that concerns him: he saw his task as:

> to mark the influence of light and shadow upon Landscape,
> not only in its general effect on the whole, and as a means of
> rendering a proper influence on the 'parts', in Painting, but
> also to show its use and power as a medium of expression, so
> as to note 'the day, the hour, the sunshine, and the shade'.[15]

Chiaroscuro enabled Constable to read and translate nature,
and it is significant that in his use of the word he wants other to
do so too. He sets it with an apostrophe to make it easier to read,
separating the Italian word for 'light' from its word for 'dark' –
and we should also note that in Italian 'oscuro' means 'dark', not
'shade' or 'shadow': that would be 'chiar'ombra'.

The mezzotints in the 1833 collection are almost all given a
place in their titles – from Yarmouth in the east, and west to

Weymouth Bay – but what is dominant in addition to these
locations is an indication of season, time of day and weather
conditions: Constable gives us 'Spring', 'Morning Breeze',
'Noon', 'Stormy Noon', 'Windy Noon', 'Tempestuous Evening'
and 'Morning, after a Stormy Night'. We are taken deep within
the moment, and might expect to find ourselves, as Constable
himself allegedly was, 'untidy ... plashy, wet, dripping ...
during storm, rain and wind.'[16] As he warms to his task of writ-
ing about the prints, Constable becomes more and more lucid,
revealing and interesting. His first gathering of mezzotints,
published in 1830, had no letterpress; three years later, seven of
the images are individually glossed and expanded, and enhanced
with verse.

The frontispiece, showing East Bergholt House, is a paradigm
which Constable chose specifically as his focus for the collection:
'This spot saw the day-spring of my life'.[17] Writing in the third
person, he says: 'with a view to his own feelings ... he may be
pardoned for introducing a spot to which he must naturally feel
so much attached ... to him it is fraught with every endearing
recollection.' As the prints flow by, they are, one by one, repre-
sentative of moments in Constable's own personal recall. The
texts articulate his feelings and present his commentaries on
the weather, variation in light, and the atmospheric effects to
be noted. They are intensely didactic, revealing Constable the
teacher, just as much as they demonstrate Constable the meteor-
ologist and weatherman, Constable the countryman, and Con-
stable the landscape historian. *Old Sarum*, 'wild, desolate, and
dreary', he writes, 'is grand in itself, and interesting in its associ-
ations, so that no kind of effect could be introduced too striking,
or too impressive to portray it ... This proud and "towered city"
... can now be traced but by vast embankments and ditches,
tracked only by sheepwalks.' As a gloss to *Spring*, Constable talks
of cloud types, though notably there are no references to Luke
Howard's Latinised cloud nomenclature: 'the clouds accumulate
in very large and dense masses, and from their loftiness seem to
move but slowly'. He continues by describing the smaller, lower,
faster-moving clouds, 'messengers' which foretell bad weather,
and float in the 'lanes' of the clouds: 'messengers' and 'lanes' are

old, country, descriptions. Above all, Constable offers his own added colour to the black-and-white scene:

> when at noon large garish clouds, surcharged with hail or sleet, sweep with their broad cool shadows the fields, woods, and hills; and by the contrast of their depths and bloom enhance the value of the vivid greens and yellows, so peculiar to this season; heightening also their brightness, and by their motion causing that playful change so much desired by the painter.[18]

Constable's *English Landscape* has an entirely different function to Turner's many collections of prints drawn from his travels. Those are overwhelmingly subjective and detached, with minimal or no letterpress; the artist quickly moves on, from place to place and from one engraver to another. In Constable, however, we have the artist with us all the way, hand in hand with David Lucas. Constable points out places and things of interest, telling stories from his life and the lives of others, and engages with his audiences' emotions through the eye. It was David Lucas, with his instinctive understanding of mezzotint, and ability to absorb Constable's volatile nature, who began the transformation of Constable from an artist serving discriminating private collectors, to an artist known and beloved by all.

Nevertheless, John Constable was a practiced pessimist: writing to David Lucas in June 1833, he moans: 'The whole work is a dismal blank to me – and a total failure & loss.'[19] He completed his requiem for printmaking with this gloom-soaked list of reasons why he will not have anything more to do with printmaking. He sent it to Lucas written out on the back of a prospectus for *English Landscape*:

1. Great interruption of my time – & peace of mind.
2. An anxiety that ought not to be with me.
3. Selling off the prints in lots or detail – a trouble.
4. Nobody will ever pay me what they owe me.
5. I never was able to get money of a printseller yet.
6. I must supply the trade with property.
7. I confer all the benefit – they not equally to me.
8. I commit myself with faithless and low people.

9. A disrepute in joining with them in trade.
10. Advertizing very disagreeable – & disreputable.
11. A great anxiety and disturbance of mind.
12. Better to pay money out than [be] in a bad job.
13. Consider the first loss as mostly the least.
14. Not to volunteer into all the above or
15. any of it – above all consider the weight on the mind.

J.C.[20]

Despite all this self-pity, Lucas prompted for Constable a pro-cess of transformation of his paintings unmatched by any other printmaker in the 1830s. His close attention to Constable's art and personality not only refashioned the potential availability of Constable's work, but it also guided the artist's perception of himself.

40. Brother labourer

An incident in 1831 drew a focus upon Constable's perceived attitude to others and to himself, and in doing so has long coloured perception of him. The young painter David Roberts described in his journal a quarrel between Turner and Constable which, he writes, took place in Mount Street, Mayfair, the home of the MP and collector, General the Hon. Edmund Phipps:

> a little cozey house, a bachelor's house, a Soldier's house. The Old General's little dinner parties were of the best always . . . A young man felt honoured and happy to be included . . . here I have dined with Wilkie, Chantrey, Landseer, The President of the Academy and last not least Seguier the Keeper director and instructor of all who loved or took an interest in art. The walls were covered with gems including all the best Modern painters and many of the ancient.[1]

Such was the setting of a dog fight that Roberts described as taking place after the 1831 hang at Somerset House had been completed, and presumably opened to the public. There had been the inevitable shifting around of pictures during the hang, with jockeying for position, and compromises. Turner had taken exception to the final decision on placing his *Caligula's Palace and Bridge* and Constable's *Salisbury Cathedral from the Meadows*:

> Most unfortunately for [Constable] a picture of Turner's had been displaced after the arrangement of the room in which it was placed . . . Turner opened on him like a ferret; it was evident to all present Turner detested him; all present were puzzled what to do or say to stop this. Constable wriggled, twisted, and made it appear, or wished to make it appear, that in his removal of [Turner's] picture he was only studying the best light or the best arrangement for Turner. The latter

coming back invariably to the charge, 'Yes, but why put your own there?' I must say that Constable looked to me and I believe to every one else like a detected criminal, and I must add Turner slew him without remorse. But as he had brought it upon himself few if any pitied him.[2]

David Roberts opened this account, written in the 1850s, twenty years or more after the events described, with the remark that Constable, 'a conceited egotistic person . . . was loud in describing to all the severe duties he had undergone in the hanging of the Exhibition', and that 'according to his own account nothing could exceed his disinterestedness or his anxiety to discharge that Sacred Duty.' Roberts closed by saying: 'My own opinion of Constable may be mistaken but he was not only an egotist in his own laudation, but what was far worse he was abusive & not sparing of any one else, a rare thing in a man of talent.'

That is a pretty remorseless, partisan attack, from an artist who, when he attended the dinner, was not yet an ARA, and who had an axe to grind. It led to further tittle-tattle, and cemented the posthumous, alternative view of Constable that Leslie had worked perhaps too hard to eradicate. When Walter Thornbury cast about for information for his *Life and Correspondence of J. M. W. Turner* (1862), David Roberts gave him this same scurrilous stuff, designed, it would seem, to contrast Constable's character with praise for Turner, who was 'ever modest in his own abilities, and I never remember him uttering a word of disparagement of others.'[3] That was Roberts writing to Thornbury, giving Turner a generous, elegant, but certainly uncritical testimonial, and setting up an attack on Constable, whom Roberts went on to describe as a man 'of a contrary disposition . . . ever talking of himself and his works, and unceasing in his abuse of others.' He goes on to describe the squabble at Phipps' house, amending his earlier account, by saying that Constable '*had* . . . replaced' a work of Turner's with his own, rather than that the Turner '*had been* displaced', as initially written, a more distanced and passive construction.

There had surely been some kind of contretemps between Turner and Constable, whatever spin Roberts later put on it, and

the following year the two rivals had another head-to-head. At the Academy exhibition of 1832, Constable and Turner came into a more direct contact with a larger crowd of witnesses. *Whitehall Stairs, June 18th 1817*, the initial given title for Constable's *Opening of Waterloo Bridge*, went on public display at the exhibition at last. Beside it was placed a historicising shipping-laden seascape by Turner, *Helvoetsluys – the City of Utrecht, 64 [guns] going to sea*. This was 'a grey picture, beautiful and true', one of six paintings Turner exhibited, including his hymn to the new age of steam-powered shipping, *Staffa, Fingal's Cave*, and the gilded beauties of *Childe Harold's Pilgrimage*. Constable, after having fretted and flailed for so long on *Waterloo Bridge*, now, at last, put it on show. Turner's *Helvoetsluys* is greeny-blue more than grey, while Constable's picture has all the riches of Venice within it, his crimson-bedecked Royal Barge there with its flotilla on the sparkling Thames. As Leslie put it, on Varnishing Day, with artists bustling here and there to 'varnish' their pictures, Turner blobbed a brush-load of red just off-centre of *Helvoetsluys*, on top of a foreground wave.[4] Constable was working on his canvas as Turner did so, and there they were, these two evident rivals, shoulder-to-shoulder for a few minutes at least. Recorded highlights of this moment – recorded by Leslie – tell us that the artists gathering around were agog. How would the volatile and anxious Constable respond? Would he walk off? Would he throw a punch? All he apparently said was: 'He has been here and fired a gun.' Turner left the room, and did not return for a day and a half, when he fashioned the blob into a buoy and applied his varnish.

This is one of the classic encounters of nineteenth-century painting, a High Noon of its era. The watching artists chattered, and one of them noticed George Jones's *Fiery Furnace* hanging opposite and joked that 'a coal has bounced across the room . . . and set fire to Turner's sea.' The key witness to this event who was not interviewed for a statement was Turner himself. So why had he done it? An alternative and kinder interpretation to the received view that this was some kind of cruel spoiler is that Turner, knowing, as he must have done, the years of agony that Constable had gone through in the genesis of his *Waterloo*

Bridge, wished to echo Constable's magnificent demonstration of the power of red against greeny-blue by making his own experiment, and standing together with Constable as a brother artist. Constable had for years been revealing in his work the power of complimentary colours, of the effect of a blob of red against green. Here was Turner doing what Constable might have taught him, a vivid demonstration of how together the reds became redder and the greens greener. This was not an unkind gesture; on the contrary, Turner's use of complementaries was complimentary.

Antagonisms between Constable and Turner have been much manufactured, and reported across the decades with various admixtures of glee or admonition. There are, however, some further fragments that suggest their attitudes to each other may have been equivocal, and that in these latter years their meetings were edged with mutual respect and admiration, rooted in their knowledge of each other's work. They watched each other. Constable visited Turner's gallery in 1813; not perhaps for the only time.[5] They dined together with George Jones more than once, and had these been social disasters Constable would certainly have said so: 'I dined with Jones & Turner, snugly – alone.'[6] In another instance of cooperation, Turner reportedly painted ripples into a foreground of a river or sea scene to help his brother artist, necessarily or not – 'the "something" just wanted to make the composition satisfactory' – and Constable does not appear to have objected to a request to paint a companion picture to a Turner.[7] More genuine admiration came from Constable in 1835: 'Turner's light, whether it emanates from the sun or the moon, is exquisite.'[8] In 1836, Turner exhibited his seminal painting *Juliet and her Nurse* at the Academy: the work was the seed for John Ruskin's opening volume of *Modern Painters* and all that followed, and it also sparked John Constable. He remarked that Turner 'has outdone himself – he seems to paint with tinted steam, so evanescent, and so airy. The publick thinks he is laughing at them, and so they laugh at him in return'.[9] There is no antagonism here whatsoever; it is brotherly support, underlined by a remark such as this on an early harbour subject by Turner: 'I think it was the most complete work of genius I ever saw.' Fisher

noticed this mutuality: 'Turner's presence [visiting Constable after his election as RA] was a high compliment. The great landscape painter by it claimed you as a brother labourer'.[10]

However disagreeable Turner and Constable may have been to each other in 1831, and however unkind that exchange, there is strong circumstantial evidence that the squabble at Phipps's was an isolated event, mischievously reported. In an aside in a letter of 29 December 1830, Constable thanked Leslie for the delightful day they had spent together in London: 'the relish of [our day] is yet lively on my mind. It was a continuous delight to me from the moment of knocking at your door to our parting at "Tyburn" turnpike, & to complete the day, I passed the evening with Turner at Mr Tomlinson's [sic]'.[11] 'Tomlinson' is a misreading for Thomas Tomkison of 55 Dean Street, Soho, just south of Charlotte Street, manufacturer of high-cost luxury pianos for the wealthy and titled, including George IV. Turner and Tomkison had known each other from boyhood, and the latter, by now eminent, sophisticated and with money to spend, was already an active collector of Turner's watercolours, and continued to have a lively interest in his work at least until the 1840s. Constable may have tried to entice Tomkison to buy his work, but it does not appear that he was successful. However, whatever it was that the three men discussed, the evening was highly convivial, and will have added considerably to the 'relish' of Constable's day off.[12]

Some of Constable's opinions, uttered on the spur of the moment, were just that, momentary. He would speak his mind, there and then, off the cuff. 'It is not, then, to be wondered at,' Leslie wrote in his *Autobiographical Recollections*,

> that some of his competitors hated him, and most were afraid of him ... He was opposed to all cant in art, to all that is merely specious and fashionable, and to all that is false in taste. He followed ... his own feelings in the choice of subject and the mode of treatment. With great appearance of docility, he was an uncontrollable man. He said of himself: 'If I were bound with chains I should break them, and with a single hair round me I should feel uncomfortable.'[13]

Leslie then focuses on Turner, in an analysis that is clear, modern, and empathetic to both:

Turner was a very different man from Constable, and yet quite like him in one respect, namely his entire reliance on a guide within himself ... But Constable could not help talking of his feelings, of his views of art &c. He talked well, and this made him extremely interesting to those who could feel with him, but either tiresome or repulsive to those who could not. Turner did not talk well, and never talked of his own art, or of the art of others. To me, therefore, he was far less interesting than his pictures, but, at the same time, his prudence prevented his giving offence. It was impossible, however, not to like Turner, there was something so social and cordial in his nature, I believe him to have had an excellent heart.

41. Yes Sir – this is Constable's country

Fisher's life, so cherished by Constable, was on the wane. The Archdeacon had been unwell across 1830, bringing anxiety, and causing Constable to dash to Windsor to see his friend: 'Prithee come – life is short – friendship sweet'.[1] Constable left a hurried note at home for Johnny and Elizabeth Roberts: '[Mr Fisher] has been so very ill ... I want to see [him] ... not to wait dinner or anything ... pray have what you like – and a little fruit if you please'.[2] Fisher rallied, became well enough again to preach in Salisbury; but in the autumn of 1832 he fell ill once more, and he and his wife sailed to Boulogne 'to try what change of climate would do for his health'. It was too late; he had contracted cholera.[3] Within a week the 'poor dear fellow ... was seized with violent spasms, which carried him off in a few hours.'[4]

This was a season of deaths: Johnnie Dunthorne, Constable's beloved studio assistant, died in 1832, and J. T. Smith, his old friend and mentor from Edmonton days, early in 1833: 'Poor Museum Smith died on Friday a miserable sufferer – & in great debt, and poverty.'[5] Smith had given his last years to the British Museum, where he had served as Keeper of Prints and Drawings since 1816. 'I knew him from 1796, a long time. His reputation will last at least as long as the fame of nobility ... I sent a present of 5 guineas to his poor excellent wife who is left without a shilling in the house – but this is between ourselves.' He also put his name to a public notice to raise money for Anne Smith, who had been so kind and hospitable to him in Edmonton.[6]

Across his own widowerhood, Constable felt a renewed attraction for East Bergholt, Dedham, Flatford and those other Stour Valley villages and settlements whose image it had been his life's work to create. His children knew little of the area, save from whatever their parents might have told them and through quizzing their father about his ever-expanding collection of

paintings. Brighton, for the four older children at least, was the place for sunlight and seaside and holiday fun, and Hampstead had become, increasingly, home. Minna was eight years old when she first saw Suffolk in 1827: 'Oh no, this is only fields', she said in dismay to her father when their coach had run down the shallow hill from Stratford St Mary, and she looked across the river valley from the bridge at Dedham. She added casually, with the assurance of a child, that Suffolk was very like Hampstead, 'only that the blackberries are so much finer'.[7]

Local gossip about Constable and his fame in the Stour Valley could lead to misunderstanding and ignorance of the value of his work in the small community. So it was that in May 1830, when the solicitor James Pulham died, Constable made a hurried journey to Woodbridge to buy back two of his landscape paintings lest they fall into the hands of local auctioneers and get knocked down for pennies. In his portrait-painting days Constable had painted a lustrous portrait of Frances, Mrs James Pulham, showing her as a highly prosperous, good-hearted, sharp-eyed, double-chinned, silk-begowned and fancy-ribboned woman of high local quality.[8] Frances's husband had acquired one of Constable's landscapes in a marginally underhand manner, offering just below the artist's modest price, and flattering him with 'so fond am I of your handy works ... you will not hurt a poor lawyer.'[9] Pulham continued to say very nice things about Constable, such as his response to news that *The Hay Wain* would be shown in the Louvre:

> It must be the forerunner of a Royal Academician ... I hope to see the day when the Suffolk Artist of Celebrity shall have arrived at the zenith of his ambition ... Would not even your poor father himself rejoice in the excellent perfections of his Son? and those perfections acknowledged too, by a foreign State, and placed in the first repository of fine Arts in the first City of their Capital?[10]

This was all very well meant, but even so the 'poor lawyer' managed to touch Constable for the gift of his *Harwich Lighthouse* and, at another special price, his *Helmingham Dell.*[11] So that is why, soon after Pulham went to the 'long home' he had foreseen, Constable travelled to Woodbridge, bought his landscapes

back from Widow Pulham, and came home with them strapped to the roof of the coach.

Family arrangements and support began to settle in the first years of the decade. The children went to stay with their Suffolk uncles and aunts in the summers, but Abram and Mary remained deeply anxious that when they did so they might fall into the mill-pond at Flatford and drown: 'a more dangerous place for children could not be found upon earth', Abram told his brother.[12] Once that worry had been overcome by reason and care, the children returned to their parents' former haunts: 'My children talk continually of their visit to Suffolk,' John told Abram, 'and of yours and Aunt Mary's kindness ... and perhaps they may see you in E.B. again.'[13] Their wonderful Aunt Patty – Martha Whalley – now living with her family in Dedham, took in the three girls – Minna, Isabel and Emily – across the summer of 1831. Patty had to work quite hard to convince her brother that this was a good idea. 'I hope you bear in mind your promise to bring Miny [sic] to Dedham during the approaching holidays', she wrote to John,

> then you can judge whether our cottage accommodation would be so satisfactory to you as to induce you to let her sisters follow? ... & you I trust would feel assur'd of my best care, & affectionate attention – in which Alicia [Patty's daughter] would join with much pleasure.[14]

Patty met her brother, the girls and their maid Betsy from the coach at the bridge, and she and Alicia rowed them along the short stretch of river to Dedham.[15] They spent a couple of days together, collecting bugs and bits and pieces for the boys' collections before John went back to London, but the boat ride gave Constable a fright. He was becoming over-anxious, and when he had returned to Charlotte Street wrote to Minna: 'John is much delighted with his specimens and so is Charles with his moth and stag beetle ... the microscope affords John much amusement', but ...

> I have great fear of the boat – and all of You being too much in this very hot Sun so pray dear children be carefull of both ... Pray – pray – take care of the boat – it is my only anxiety – or I may say my only alloy to being quite happy to have You with

dear Mrs Whalley.[16]

It looks as if Patty teased this worrier: 'We had another ride
in the Pony Van last Wednesday,' she told her brother, '& after-
wards took an evening drive to Mistley before 6 to tea. Next
Wednesday we are to swim to Flatford – and Betsy is invited
that her chickens may not be one moment unattended so near the
River.'[17]

This was the holiday that Constable described to Jane Sped-
ding when they all got home and told their stories: 'My dear
little Girls have had a happy-happy visit in Suffolk':

> they ran wild at large in a garden full of frogs – they lived with
> dogs – Catts – kittens – Horses – donkies – Cow Carts – Giggs
> – mules – & a boat ... Minna won all hearts by music and
> dancing – and above all by that sweet – unruffled – temper –
> and genteel demeanour ... My sister says she never saw three
> dear Children so orderly & well regulated.[18]

Although suffering from ringworm, the boys were in Hamp-
stead having 'a great to do with fishing', and from Charlotte
Street they enjoyed the sight of a pair of zebras pulling a cart
along Regent Street, carrying food for the animals in the zoo.[19]
We get a very clear picture of this holiday through the letters
that zipped between them all, enlarging on the fun they had, and
corroborating here and there. Young Johnny wrote to his sister
Minna about the fishing:

> I have been so busy lately. Fishing, unpacking the box of Mini-
> rals [sic], and placing them, and making a hot house, putting
> rings on my fishing rod ... Charles has got some insects, and
> has rearranged them. We are just returned from fishing, and
> have caught nine for our tea.[20]

Their father found it difficult to leave the girls alone, and
would pester them with news of Charlotte Street, Hampstead
and home life. To Minna: 'We have had two or three days of
such very hot sun that I was afraid you would take harm ... We
want to know if you would like to come home to see your Aunt
[Louisa, Maria's sister] Your dear birth day is on Tuesday the

19th. Should you like to come to us or pass it with dear Mrs Whalley ... Perhaps Roberts will come for you, but do write tomorrow.'[21]

When the girls were in Dedham, Constable had a VIP visitor in Charlotte Street, a 'guest of consequence' as he described it: the Duke of Bedford called. '[He] made me a long visit, & seemed pleased with what he saw [in my Gallery] – and I thought (what will not self love do for me) he seemed pleased with me – so much so that I can think of only one thing to make the visit abortive – it was on (a) "Friday".'[22] Constable might certainly have hoped for a purchase or a commission from the man who collected Canova and Landseer, but the 6th Duke appears to have declined to do more than look carefully and courteously and express his pleasure. Nothing more was heard; being on a Friday clearly dashed it.[23]

An additional reason that Constable had for travelling to East Bergholt with his daughters was to see the plaque to Maria and her father that he had commissioned for St Mary's Church. This had been cut in London by the letterer and medallist Alfred Stothard, son of Constable's Academician friend Thomas Stothard, and now installed on the north wall of the chancel of St Mary's.[24] The plaque commemorates not only Maria Constable and Charles Bicknell, but also Maria's grandfather, the Rev. Dr Durand Rhudde, DD, and his wife Mary. If the grandparents' inclusion was seen as an act of generosity, it was not. The Rhuddes are included because the new memorial displaced the pair of ovals installed to the Rhuddes a decade or more earlier by Harriet Farnham. These were resited opposite, on the south wall of the chancel, so the Rhuddes are thereby commemorated twice in this sacred space.[25] Stothard was well looked after during his days in East Bergholt; they were hospitable people, the Constables. 'Your family Branches are well,' Stothard told John, 'and only spoilt me by making too much of me. We drank tea this evening with your elder sister, and with Golding we did yesterday.'[26]

These were difficult days: Constable was mourning his best friend, John Fisher, mourning the best studio assistant he could ever have had, and mourning, still, his wife. 'His loss makes a gap

that cannot be filled up with me in this world', he wrote to Leslie of Johnnie Dunthorne. 'So with poor Fisher. I am unfortunate in my friendships', adding 'but yet thank God I have my children, and some valuable friendships, all of which I highly value.'[27] 'No one can supply his place', Constable said of Johnnie when he returned from young Dunthorne's funeral in East Bergholt. He was indeed a tragic loss, dying aged only thirty-four: painter, studio technician, picture restorer and astronomer; the telescopes that would be included in his father's posthumous sale may well have been, originally, Johnnie's. He would discuss astronomy with anybody whom he came across: 'Tell John Dunthorne with my regards,' Fisher wrote, 'that the great Herschel telescope . . . is a reflector of extraordinary power for examining extraordinary distances: & is not meant to be fit for general use.'[28] On the coach home from the funeral Constable looked out of the window as they crossed the river valley at Dedham, and the following exchange took place:

> *Constable*: 'Is this not beautiful?'
> *Fellow traveller*: 'Yes Sir – this is Constable's country.'
> *Constable*: 'I am John Constable.'[29]

Idyllic summer weeks in Dedham demonstrate the strength of the family as they pulled themselves together in the years following Maria's death. The wider family was always so proud of John, so pleased with his success and attainment, and always thrilled to see his name in the papers. 'Your fame at the Exhibition "puffs me up"', Mary told her brother. 'It delights me to know you stand so high . . . You will have all the chat of this neighbourhood.'[30] They chatted among themselves, with family news and shared anxieties. Golding's condition was giving them much concern: he was 'worse than when I left him last week', Abram told John, 'It is decidedly Jaundice, he is entirely yellow, & I am afraid it may terminate badly – I am told it kills most people of his age.'[31] They were worried about Golding in other directions also: Wenn, the Dysart's dastardly land agent at Bentley, had, with accomplices, been continuing to swindle his 89-year-old employer in 'their joint stewardship in iniquity', as Constable described it.[32] At Wenn's death in 1834 it became clear that he

had sold 'hundreds' of loads of Dysart timber from Bentley and kept the money, embezzling £5000, and even charging Lady Dysart with the cost of carting her timber as he did so.[33] John and Abram worked hard to ensure that Golding, 'a faithful and honest Steward', unworldly and innocent of collusion, was not implicated in Wenn's crime.[34]

Still unsettled after Maria's death, Constable suffered from his toothache again. Mary fussed over him at a distance:

> The attack on such a face as yours vexes me but I hope <u>cure</u> is at hand – do not '<u>Doctor</u>' any more – warm sea bathing I should prefer – Coffee too hot – Cheese not good – drink camomile tea – walk about when the sun shines – <u>fret for nothing</u>. So much for my advice.[35]

Constable was now contemplating a retreat from Hampstead. There was nothing to keep him there, except Maria's grave. In the group of letters written to and from Constable between 1834 and 1837, the latest that has Well Walk as its postal address is dated 15 May 1834.[36] This accords with the note in the July 1834 rate book for Hampstead, which lists 6 Well Walk as 'Empty, late Constable'.[37] Family talk was, now, beginning to contemplate even the possibility of John selling up completely in London and buying 'a house with a little land attach'd' in East Bergholt, 'to retreat into when you grow tired of the smoke & dirt of London'.[38] This whirlwind of an idea blossomed when Mary suggested: 'What should you say to "Fisher's" without buildings? If I could take "Old House Farm"? I think few better things to be had in <u>East Bergholt</u>, pray let us hear from you soon.'[39] These neighbouring properties on higher ground to the east, between Brantham and Bentley (Mary describes its position precisely), were on sale for 4000 guineas.[40]

John Constable, RA, widower and father of seven, was in the mid-1830s a legend in his own landscape. Memories of *The White Horse*, of *Stratford Mill* and *The Hay Wain* lingered still across those fields even as the paintings themselves languished far away in Salisbury and Paris. However, the majority of the paintings that Constable would exhibit at the Academy in the next few years would depict subjects not in Suffolk or Essex,

but in Leicestershire, Berkshire, Wiltshire, Middlesex, Buckinghamshire, Sussex and London. He also, in a break with his own tradition, exhibited watercolours illustrative of the gloomy Jaques from *As You Like It,* and morbid lines from Gray's *Elegy in a Country Churchyard.*[41] While he might still rhapsodise in words over his feelings for the Stour Valley, his exhibited paintings of those scenes of his 'careless boyhood' became fewer and darker.

42. Charles Boner

A new young man, Charles Boner, now came to Constable's notice as a prospective tutor to the older boys. The girls were more or less all right, but for the boys things were getting out of hand; Johnny was continuously sick and torpid:

> My darling boy John is in a sad state. My present fears lead me to think all is amiss . . . In this sweet youth I see all that gentleness – affection – fine intellect & indeed all those endearing qualities which rendered his departed mother so dear to me.[1]

Charley, hyperactive and passionate by nature, had also had spells of illness, and both boys had had interrupted schooling in Hampstead, Brighton and Folkestone. Their father was intensely prejudiced against schools, something that might explain this chopping and changing between establishments, and was bitterly opposed to corporal punishment. His boys would not suffer under the rod as he had in Lavenham.

For the girls, Minna (thirteen) was doing well at Elizabeth House, Sophia Noble's school in Hampstead, as were Isabel (ten) and Emily (seven). They were all developing good handwriting, they learnt to play the piano and to dance, and studied French and deportment. Minna, with the 'sweet unruffled temper and gentle demeanour' that surprised them all, was growing up fast, composing music as well as playing it. She wrote a piano rondo which she dedicated to her cousin Alicia.[2] Minna became her father's guardian angel, taking care of him like the sweet child she was. When she went off to Putney to stay with Aunt Louisa over Christmas 1831, Constable told Leslie:

> She is so orderly in her plans – & so full of method – so ladylike by nature – & so firm & yet so gentle, that you cannot believe the influence of this heavenly little monitor on this whole house – <u>but most of all on me</u> . . . [She] dressed up

my mantelpiece with X'mas [boughs] & likewise set out a little table that I might look pretty in the dining room in her absence.[3]

The following June, when Minna became desperately ill with scarlet fever, her father was beside himself.[4]

Charles Boner had been introduced as a prospective tutor by Jane South, the daughter of Constable's aunt, Mary Gubbins: 'He is very <u>gentle</u> & very <u>clever</u> – I am sure the dear children would like him.'[5] They certainly did like him, but there were problems that might have been foreseen. Boner, the son of a German émigré mathematician in Weston, near Bath, was less than two years older than Johnny, and, like both boys, had poor health. When he was five or six years old, Boner had a polio-like disease which confined him to a bed or sofa. He also suffered broken hands from violence done to him in childhood.[6] Despite this, Boner was diligent as a tutor, and indeed Constable soon gave him additional hours; but it clearly did not work as desired, in part because all concerned – employer, employee and pupils – suffered from one form of malady or another. When Constable was sick he fretted deeply about his finances, and without either Maria or Fisher to calm him he got into a lather about money and would make ill-thought-through decisions. The nub of the problem here, underlying his own sickness, was that he was already overstretched with his mezzotint commitments to David Lucas, and so Charles Boner's fee, quarter by quarter, would be one more burden that he just could not take. He might have thought of that earlier. Even before he started, Boner had Constable telling him of his prejudices about education:

> I am sadly troubled and always have been with the education of my boys – they are not fit for schools – nor could I endure at my last hour the thought of wilfully plunging their early minds into <u>accumulative evil</u>: the real word for schools ... They must do like their father as well as they can without [a school]'.[7]

This was particularly unfair to Boner, 'so severely ill'.[8] Constable gave him his quarterly fee of £20, with an additional five

pounds redundancy money, and let him go – or he thought he had.

There was, however, a silver lining, as Constable had already embraced this charming and highly intelligent seventeen-year-old as if he were his own son. It was not the tuition that was the difficulty, but its cost, and the weight of Constable's dislike of the education system. Getting rid of Boner was the wrong decision, and immediately Constable regretted it: '!! I now know not what to do !!' he said to Boner, with double-underlining and double exclamation marks, *after* giving him the sack! In the event, Boner did not go away, and through his own generosity and concern for the already shattered Constable family, he lingered and became invaluable by other means. Boner – loyal, consistent, helpful Boner – gradually changed his role from tutor to Johnny and Charley, to becoming Constable's secretary and studio assistant in place of Johnnie Dunthorne. This seems to have happened without anybody noticing; Boner simply stuck around, and retained an interest in and concern for the boys' education, and an enduring affection for them. The deciding factor for Boner was that he liked the Constable set-up, was intrigued by this curious family, and was himself 'exceedingly fond of pictures'.[9]

In the arrival of Boner, with his damaged hands and the after-effects of polio, we seem to be entering a Dickensian world distinct from the Jane Austenish village society that Ann Constable evoked in her letters. The young man became not only tutor and secretary, but he also organised Constable in managing David Lucas and the production and selling of the *English Landscape* prints, and aiding him with the management and the writing out of his lecture series to come. 'He is so useful', Constable told his eldest boy, while also engaging Boner as tutor to Alfred and Lionel.[10] When Charley started at his school in Folkestone it was Boner who accompanied him there. Charley had what his father saw as a severe handicap: Constable was convinced that his 'natural temperament partakes I fear that of genius . . . a natural ardour and activity of mind and habit, with no great power of volition, may perhaps cause his character not to be immediately understood'.[11] It was Boner's task to explain Charley to the

headmaster.

At the same time as he was being taken on by Constable, young Boner was writing about Seneca on the value of time: 'don't waste it', he sagely urged:

> I advise you, entreat you, not to waste that precious time, but to use it as a miser would employ gold, dividing it and portioning it out to the greatest advantage, never letting the smallest part lie idle ... As rust eats up hard iron, in like manner will your mind and its faculties become rusted ... remember [time] is never to be recalled.'[12]

This studious and thoughtful young man would grow up to be a powerful intellectual force in Germany through his writing and translations, including Hans Christian Andersen's stories, and through his travelogues and his tutoring of princely families. It was their mutual good fortune that he and Constable found themselves working together, two equally ruminative and introspective men from different generations. Boner was 'delighted beyond measure' with the thoughts expressed in Seneca's *Morals,* and thoroughly acquainted also with the more prosaic publication, Mason's *Self-Knowledge,* a book that 'arrested my attention very forcibly ... I read it with the greatest attention, and re-read many parts many times.'[13]

Boner's misfortune in his childhood illnesses brought for him, in its backwash, a unique opportunity: 'By thus staying at home I was thrown among grown-up people, heard their conversation, and asked the meaning of many things I did not understand ... I was obliged to think about what I had already heard, seen or read.'[14] This unintended consequence gave him time to read and reflect – he mentions Plutarch's *Lives, The Arabian Nights, Gulliver's Travels, Don Quixote, Bailey's Dictionary* and the Edinburgh and London encyclopaedias – essential preparation for a life of teaching, travel and writing. When in due course Leslie's *Memoirs of the Life of John Constable* was published, Boner said with emotion to Charley, '*I* ought to have done it. No one could write such a life of Constable as I might have done.'[15]

Boner's reflection on his own childhood suggests that his writing was influenced fundamentally by his conversations with

Constable. He describes the garden and landscape he knew as a child in detail that echoes the artist's own recollections: 'the sunny fragrant garden, the waving luxuriant laburnums, the strong, noisy, never-failing brook that tumbled along close by the house under the old willow, the gardener's cottage opposite, are all before me [Boner] now.'[16] In 1865, nearly thirty years after Constable's death, Boner and Charley, by now a naval captain, travelled to Suffolk together:

> [This] was a great delight to me. I never could have believed it possible that out of such material such grand works could be made . . . We saw the mill where [Constable's] name is carved on the beam, the house where his wife had lived, and the lanes through which he must often have passed – in short every tree and cottage reminded me of him.[17]

The service that Charles Boner performed for John Constable enabled the artist to manage the creative, financial, administrative and medical aspects of what turned out to be the last six years of his life. He almost persuaded this committed islander to 'tour to the Continent'.[18] What Boner performed for Charley Constable, however, was even more profound. He transformed this charming, hyperactive boy, with his bouts of laziness and inaction, into a young man courageous enough to go to sea aged fourteen as a midshipman with the East India Company, and to survive and rise to become a captain in the mercantile marine. Boner and Charley remained friends into Boner's last years: he was that rare stroke of luck – the right teacher appearing for the right child at the time of greatest need.[19]

43. Lecturer: novel, instructive and entertaining

Any number of good women looked out for Constable and sent him comfort and courage in his widowerhood. While Elizabeth Roberts was always on hand to manage the children and household, his sisters in distant Suffolk fussed about him constantly, and venison from the Dysarts' Suffolk estates gave him many an excuse for a party. Jack Bannister, retired comic actor, was invited more than once, and other guests during the 1830s included the Academy President Martin Archer Shee, the businessman collector Robert Vernon, the poet and banker Samuel Rogers, and Constable's friends the painters Eastlake, Howard, Jones, Leslie and Wilkie.[1] Constable was now giving back the kind of hospitality he had enjoyed as a younger man in the company of Beaumont and Farington, and there is a consideration also that by opening his house to his artist friends he was showing that this landscape painter was on the right side of art history, and that portrait and history painters might just take note.

Constable grew to like and be liked by neighbours: old Suffolk friends Jacob and Elizabeth Strutt were round the corner in Percy Street, and Henry Sass ran his private art school at 6 Charlotte Street. The Strutts were especially well rooted in Constable's life. Jacob Strutt, a portrait and landscape painter who exhibited at the Royal Academy, was the son of the Colchester antiquary and collector Ben Strutt. He had been a subscriber to J. T. Smith's *Remarks on Rural Scenery*, and was known to the Constable family since at least the 1780s; John and Jacob had known each other since boyhood.[2] Elizabeth Strutt was a linguist and traveller who wrote extensively about France, Italy and Switzerland, and, as 'Mrs Byron', three novels. Strutts and Constables slipped easily into each other's adult lives, and, forty years on, there were a number of cosy domestic instances between them: invitations to the theatre, family visits, fond talk of their children, as well

as a brief chill centred over the delayed repayment of a loan.[3]

Among the good friends remaining in Hampstead were two young medical men who attended to him and his family, Herbert Evans the surgeon and Haines the apothecary. Evans was an able and empathetic young physician, one whose sensitive features Constable had painted in 1829, across the months of Maria's medical crisis.[4] 'I retain the recollection of Evans in my mind with much vividity', Fisher recalled to Constable. 'I love that profession [surgeon], & he as a sample of it.'[5] Haines tended to Minna's scarlet fever – her pulse reached a hundred and fifty during the illness – and earned Constable's eternal gratitude.[6] Constable held both close to him: they were 'anxious about and attentive to me . . . acquainted with my constitution mentally and bodily', when he was 'scarcely . . . able to do any one thing' during a prolonged attack of rheumatic fever early in 1834.[7] He might have added that Boner, too, was an attentive and loving nurse at this time. Charley wrote later:

> I have never forgotten how Boner was up night after night attending to [my father]. I wondered how any man could be strong enough to do it. Charles Boner must have loved my father very much, but I think all did who knew him.'[8]

Jack Bannister, a regular at Constable's dinner parties in Charlotte Street and Hampstead, had been a promising art student at the Royal Academy Schools in the late 1770s, but went into acting instead. He had known Gainsborough, and through friendship also with Thomas Rowlandson and David Garrick he straddled the generations that linked the eighteenth and the nineteenth centuries. With his 'transcendent talents' he touched also the worlds of theatre and painting.[9] Invited to dine at Well Walk before Maria's death, Bannister responded: 'I accept your kind invitation with pleasure and am doubly bound to acknowledge it; – Your Painting and venison being perfectly to my taste.'[10]

Perhaps the most richly intelligent friend of Constable's was the classicist and translator William Purton of Squire's Mount, Hampstead – a young man with promise, only recently graduated from Trinity College, Oxford. He grasped the point of Constable straight away, and respected his 'pure apprehension

of natural effect'.[11] Constable trusted Purton's judgement suffi-
ciently to invite him to look again at *Salisbury Cathedral from the
Meadows* in the period after its first exhibition at the Royal Acad-
emy, and before it went to be shown in Birmingham in 1835. He
was tempted to continue working on it, perhaps risking going
too far: 'I am sure I have much increased its power and effect',
he told Purton briskly, 'I do hope you will say so. I should very
much like you to see it, because as you are so good as to look at
my things at all, I argue you see something to admire in them.'[12]

Purton, whose English verse translation of Homer's *Iliad*
would be published anonymously in 1862, came up with quo-
tations from English and Latin poets for Constable, supplying
some for the letterpress for *English Landscape*.[13] He was particu-
larly keen that his friend should use the right word, and would
consult Dr Johnson's dictionary for him.[14] Purton's knowledge
of Homer and of English poetry was immense; he seems to
have considered his assistance to Constable to be something of
a moral duty:

> I can only say that if I can be of the slightest use in digesting
> the matter of which you seem to have but too much into form
> it will be a very interesting occupation to me, & any thing you
> may send up to me I would return with such suggestions as
> may occur to me.[15]

Purton was modest in the extreme, introducing his Homer
thus: 'This translation was written many years ago, as a sort of
memoria technica of the original, on the principle that a coarsely-
drawn and even caricatured portrait makes a stronger impres-
sion, and more forcibly reminds one of an old friend, than a tame
and insipid one, however correct.'[16]

The artist's debt to Purton was deep and long: mutual trust
developed over the 1830s to the extent that Constable would
continue to run ideas past him after he had left Hampstead, pick-
ing up unspoken warnings. It was to Purton that Constable made
the admission that he 'must take care of being an author, it is
quite enough to be a painter.'[17] He had a developing thought in
the summer of 1835 for a new six-footer, a view of Stoke-by-
Nayland, and bounced ideas for it off Purton directly. In doing

so, he demonstrates how directly his paintings can be seen as ex-
periments: Constable is as precise in his measurement of the in-
gredients he might need in *Stoke-by-Nayland* as a chemist would
be in his measurement of chemicals: 'I am glad you encourage
me with "Stoke"', he told Purton,

> What say you to a summer morning? July or August, and
> eight or nine o'clock, after a slight shower during the night, to
> enhance the dews in the shadowed part of the picture, under
> 'Hedge row elms and hillocks green'. The plough, cart, horse,
> gate, cows, donkey &c are all good paintable material for the
> foreground, and the size of the canvas sufficient to try one's
> strength, and keep one at full collar.[18]

He went on to tell Purton that 'a large canvas will show you
what you cannot do, a small one will only show you what you
can.'

Friendship was a vital need for Constable, particularly after
Maria's death, and he sought people out as much as they sought
him as a public figure. Those who instinctively understood him,
like Field, Fisher, Leslie, Lucas, Purton and Trimmer, would
enter into conversation or correspondence with little preamble
or introduction. When he lost Fisher his distress was acute;
when he lost Leslie temporarily – to America for four months
in 1833 – he was almost as bereft, describing the departure as 'a
cloud casting its shade over my life, now in its autumn'.[19]

He visited Henry Trimmer in Heston, Middlesex, where
Henry's father, Turner's friend Rev. Henry Scott Trimmer, was
vicar. They climbed the church tower where Trimmer remem-
bers him scratching lines from Milton's *Lycidas* on the lead roof:
'Fame is the spur that the clear spirit doth raise / (That last infir-
mity of noble mind) / . . . comes the blind Fury with th'abhorred
shears, / And slits the thin-spun life.'[20] Such lines and such action
do not come from nowhere, and reflect on the nature of the con-
versation between two high minds in the breezy elevation of
a tower overlooking a graveyard. Trimmer's high mind would
not have known that this was a poem that Constable had shared
with Maria years before.[21] In his account of Constable, written
for Walter Thornbury in the 1850s, Trimmer touches also on

the advice Lairesse gave about painting nature, so we can be sure that during these years in which Constable was developing his landscape lecture series the subject of Constable's reading about art was part of their conversation. Whatever was high in Constable's mind would emerge in discussion with amenable friends.

Steaming with pent-up energy, burning with an indignation that his subject was ill-considered by his peers and misunder-stood by the mass, John Constable prepared to stand up in front of audiences to sound out his views on landscape painting. Despite misgivings, he became very good at lecturing, surprising even himself in the process. The newly founded Literary and Scientific Society in Hampstead, which invited him in 1833 to talk to them on the history and development of landscape painting, held its meetings in the Public Assembly Rooms in the house on Holly Bush Hill that George Romney had begun to enlarge during his brief and unsatisfactory residence there, 1796 to 1799. There was plenty of room in the building for the largest of meetings: Romney's ambitious plans for its enlargement had eventually been carried out to create a 45-feet-long ballroom, with a large card room beside it.[22] Many in Hampstead would have seen Constable out on the Heath, looking up at the clouds, sitting with his portable painting box and getting paint on his coat. He had been a well-known resident, one who attended lectures and added handsomely to the Society's programme of events.[23] These were not always of the highest intellectual tone: one November evening in 1833 he had fallen asleep at Well Walk in front of the fire and missed hearing 'a sort of Jack Pudding ... lecturing at the Holybush last Monday on Vocal music. He acted & grimaced and made himself vulgar and silly – as they told me.'[24]

When it came to his turn, Constable was nevertheless anxious in the days preceding his first lecture, and wrote to Leslie for moral support: 'Remember I play the part of Punch on Monday at eight, at the Assembly Room, Hampstead – to wit –!!!'[25] Charles Boner was also a crucial aide to Constable in the gathering of his thoughts: 'he is to stay a week to help me write & compose from a recollection of my lecture. He is so useful.'[26] Constable relished

the extension of the lectures when the time came: 'I must go [to Worcester]', he wrote two years later, 'they are fully expecting me with my sermons . . . Who would ever have thought my turning Methodist preacher – that is, a preacher on Method.'[27]

The history of art was for Constable a sacred flame, towards which he was drawn, by which he lit his way, and in whose light he knew he would be judged. His guiding principle, 'chiaroscuro', is a profound art-historical concept, the measure of the balance of light and dark that underpins every painting, and which every artist seeks to master: it is the means by which we distinguish the world. Naturally, when asked to speak about landscape painting, the lighting of landscape from the earliest ages became the underlying theme. He began deep in the past, with the writings of Pliny the Elder, who had named the earliest known artists in his *Natural History*. William Purton, surely present at the lecture, may have coached Constable in this, relishing the names of Aglaophon, Cephisodorus, Erillus, Evenor, Parrhasius and Apollodorus of Athens tripping by.[28] Fisher had guided Constable into the top-slicings of classical literature, but Purton took him into its depths. This was an extraordinarily early starting point, but out of near myth came dim light, and Constable moved on to the increasingly more secure ground of a papal missal in the Vatican, the Bayeux Tapestry, Giotto, Pisan frescoes and Titian.[29] By preparing to reach so deeply into art history, as far as the ancient Greeks for what he called his 'succinct and brief account of landscape', Constable demonstrated the endurance of his profession, and that he and his work was but one boat on the heavy swell of a mighty sea.

Constable illustrated his lectures with large-scale (*c.*100 x 140 cm) sepia and wash drawings pinned up on the wall, or held up by an assistant. Schematic copies after Giotto, Uccello and Titian have survived from later lectures in Worcester, London and Hampstead, and while these illustrations, and his charts and lists of artists' names, became more assured as time went on, their evolution will surely have begun in 1833.[30] He also displayed paintings of his own, some borrowed back from owners for the purpose.[31] Constable's surviving notes for the first Hampstead lecture are schematic – names, phrases to remember,

quotations from others including Opie, Algarotti and Fuseli, and his thoughts about the focus of the evening, Titian's *Death of St Peter Martyr*. Constable had every confidence in what he had to put across – the notes demonstrate this – and he found he was able to speak off the cuff, without looking down too much at his notes. Thus he was the ideal, engaging lecturer who would hold the audience in the palm of his hand. He took the opportunity to slip in a few political points: that it would be a 'National Disgrace' if Sir Thomas Lawrence's collection of drawings should not be acquired for the nation (they were not), and he takes a swipe at '[art] Dealers dark business'.

Lecturing became for Constable 'a <u>duty</u> – <u>on my part</u> – to <u>tell</u> the world that there is such a thing as Landscape existing with "Art" – as I have in great measure failed to "show" the world that it is possible to accomplish it': he wrote this 'mission statement' to Wilkie around 1834.[32] Thanks to the efforts of William Carpenter, Constable's library had kept on growing, and his reading over the past decades had helped him master his material.[33] He subscribed additionally to the new Stansfield House Library in Hampstead High Street from 1833.[34] He would argue with his authors: 'even Sir Joshua is not quite clear in this', he wrote of Reynolds's comments on the 'ideal' in landscape.[35] There were still details to be searched out, such as the birth date of J. R. Cozens which he particularly needed in his efforts to ensure accuracy.[36] He described his delivery technique: 'I have written little and I certainly shall rely on being conversational', he told Leslie, and 'I spoke what I had to say off hand', he reported to Boner.[37]

He was invited to exhibit at the new Athenaeum in Worcester in 1834, to which he sent *Salisbury Cathedral from the Bishop's Grounds*, and a version of *The Lock*, and the following year gave three lectures to the Worcestershire Institution for Promoting Literature, Science and the Fine Arts. By now he 'had the main thing – I could command my audience ... My lecture has given me great confidence – I shall now know what to do.'[38] He was lionised in Worcester, written about in the local paper, and drawn out to the extent that he touched on his youthful years working in his father's mills. His sister Mary urged him 'to take a view

of the beautiful China which is manufactured in the city.'[39] He was particularly complimentary about the town's societies – the Natural History Society and Athenaeum – 'but all these pretty things that would advance intellect are paralysed and chilled by the drones of the Cathedral. It is so in all cathedral towns.'[40] However, all this was taking him away from his easel: 'My rambles are my ruin – Worcester was a sad long distance.'

John Constable's lectures were revolutionary, and the revolutionary giving them was this medium-height fifty-something, with a quiet voice, a warm Suffolk brogue, perhaps some pauses for extra breath, probably going a little to fat, and certainly dressed in black. His sideburns were still luxurious, but what was left of his brown hair was edged with grey, and, as Leslie's portrait of him shows, could no longer cover his shiny cranium.[41] But he was on top of his form in Worcester, as he was in his final series of four lectures to the most sophisticated audience of all, at the Royal Institution, where he had invited himself to lecture.[42] There, Constable would talk of the essence of his life-long ruminations on the nature of landscape painting. He recounted its deep history, its friends, its enemies, and the pioneers who moved it along and onto exhibition walls, in spite of the scorn of those intent on populating every painted valley with ragged satyrs, drunken Bacchuses, and the sun-kissed cart of Apollo rushing out of the skies. He wrote this to Henry Pickersgill:

I am really tempted to make this exposure of myself – only in the belief that I may do the profession some good ... Landscape has never been treated single handed by any lecturer yet.[43]

Constable wanted to demonstrate that landscape painting was more than the glorification of self that kept portrait painters employed and rich; nor was it the property of classics and history; nor yet the special effects department of the state religion. Painting the landscape could show us how we lived and where; what it was that drove social economics; how geography and labour shaped the pattern of the fields and the balance of the market; and, above all, how it could provide a metaphor for the lights and darks of life. The balance of the content of the lectures

evolved as they went on, but an early note gives us a flavour of their tone and language. This is what he expected to say in his introductory remarks to his first lecture in Hampstead in 1833:

> The original and marked feature of this discourse is that it will be confined to the department of Landscape alone ... showing how by degrees it became a separate branch of Art, but to writers not professional the difficulty of doing this has been rendered greater owing to its origin being in Historical Painting.[44]

A second introductory note, written a year later, enlarges:

> ... its object being to afford a brief review of the rise and progress of this department of Painting to separate it from the Historical Art where it originated, and which by all writers has been the most zealously dwelt upon, so that this beautiful class of Art has not obtained a distinction to which it has been long entitled ... to see how by degrees it assumed a tangible form, and that from being the humble assistant it at length became the powerful aid of that Art to which it owed its origins ... The Painters of History were early made acquainted with the power and use of Landscape; it could describe a spot with all its localities, it marked the surrounding and so gained a dignity which has never forsaken it even when afterwards it stood alone and claimed distinction as a separate class of Art.[45]

These paragraphs show the sheer effort, passion and advocacy that Constable put into working out what he wanted to say, in marshalling his arguments, and in planning the trajectory of the lectures. His concise analysis of what landscape painting could be as it separated itself from history painting as a moon from a planet is terrific: it described a spot; it marked the surroundings; it stood alone; it became separate. Constable spent many hours working on the lecture, time which, had lecturing not interested him, he would surely have spent painting, and we would at the very least have the finished six-footer of *Stoke-by-Nayland*, to accompany the existing full-sized study. When the lectures evolved into what turned out to be their final shape, expanding

from the three in Worcester to the four in the 1836 Royal Insti-
tution series, they covered 'The Origins of Landscape', taking
the story from Antiquity to Titian and the High Renaissance
in Venice, then 'The Establishment of Landscape', in which the
Bolognese and Franco–Roman schools (Claude and Poussin) and
the Mannerists featured, then 'The Dutch and Flemish Schools'
and finally 'The Decline and Revival of Landscape'.[46]

To discuss Poussin, Constable relied on the translations of
the artist's letters that Elizabeth Strutt had made for him fol-
lowing their publication in French in 1824.[47] Since the early
1820s, his study of Poussin had been richly enhanced by Maria
Graham's biography, and Poussin's example had aided Constable
in his composition of *The Hay Wain*. Now, however, Poussin's
letters showed him how that artist had experienced the rough-
and-tumble of the art world of his day: 'I have not arms strong
enough to withstand the blows of the envious, and of the malice
and rage of our French', Poussin wrote to his patron Paul Fréart
de Chantelou, 'I must therefore be resigned, and suffer in pa-
tience.'[48] Constable himself could think on that and nod in sym-
pathy. In another passage, marked by pencil line in the margin, he
reads of Poussin complaining to Chantelou:

[Y]our picture of the Confirmation . . . contains twenty-four
figures so it cannot take less than five or six months to finish it.
Consider well, Sir, these are not things one can do in a moment,
like your Paris painters, who make pictures in twenty-four
hours. To me seems a great deal if I can do a head a day . . . I
beg you therefore to lay aside all French impatience.[49]

Very rapidly Constable attained the experience he needed to
teach at the heart of the lecturing establishment, and this began,
by degrees, to go hand in hand with interest in his painting
from outside London, being invited to exhibit in Birmingham
and Dublin, as well as Worcester. While the cause of the public
appreciation of landscape painting was central in his mind,
there was a further motive to his lectures: to raise sales for the
English Landscape mezzotints, and by public exposure to enliven
the market for his paintings. The lectures made him no money:
Michael Faraday, in his report to his management committee,

said quite clearly that no lecture fee would be due.[50] 'I am here on behalf of my own profession', Constable said in the presence of Faraday:

> I am anxious that the world should be inclined to look to paint-ers for information on painting. I hope to show that ours is a regularly taught profession; that it is *scientific* as well as *poetic*; that imagination never did, and never can, produce works that are to stand comparison with *realities*; and to show, by tracing the connecting links in the history of landscape painting, that no great painter was ever self taught.[51]

Scientific, poetic, dealing with realities, and *teachable*, he told his audience. After the second lecture at Hampstead, Constable wrote to Boner to say how 'immensely well' it went: 'I was never flurried – only occasionally referring to notes – spoke what I had to say off hand – was an hour and a half – and was "novel, instructive and entertaining", as the committee – Messrs . . . told me – so it pleased very much.'[52] The audiences went home happy and instructed: 'All say (& agree in this) "that it was impossible not to be amused and instructed by hearing me."'[53]

Such calm (and impervious self-regard) in front of an audience came to Constable naturally, but he will also have seen Faraday lec-turing when he had accompanied Johnny to the Royal Institution where the boy was studying chemistry, and taken note of Fara-day's professional style, his ease and clarity. That he went to Royal Institution lectures is suggested by his remark to Johnny that he would miss Dionysus Lardner's lecture on the steam engine in October 1833.[54] Of a lecturer's technique, Faraday had written: 'The most prominent requisite to a lecturer . . . is a good delivery':

> The utterance should not be rapid and hurried, and conse-quently unintelligible, but slow and deliberate, conveying ideas with ease from the lecturer and infusing them with clearness and readiness into the minds of the audience.[55]

If Constable had needed any encouragement as a lecturer, Faraday was near at hand, as was the support of the ancient Samuel Rogers, who had been active in the cultural world since the 1790s. He told Constable that he was 'on the right scent and

nobody can do it but myself.'[56] One of the most contented members of Constable's audiences, however, was Charles Leslie, who recalled how the rooms were:

> covered with pictures and prints to which he constantly referred. Many of his happiest turns of expressions . . . arose at the moment, and were not to be recalled by a reporter . . . neither can the charm of a most agreeable voice (though pitched somewhat too low), the beautiful manner in which he read the quotations . . . or the play of his very expressive countenance, be conveyed to the reader in words.[57]

When Constable stood up to speak at the Royal Institution, Michael Faraday, the natural philosopher who had discovered by experiment how electricity could be generated, controlled and used, was sitting at the feet of the artist who had painted *The Hay Wain*, and heard him say this:

> Painting is a science, and should be pursued as an inquiry into the laws of nature. Why, then, may not landscape be considered as a branch of natural philosophy, of which pictures are but the experiments?[58]

Nearly thirty years earlier Constable had listened to William Wordsworth on the subject of experiment; now the great experimenter Faraday was listening to Constable, and Wordsworth himself was also sitting nearby.[59] What a moment of cultural revolution: Michael Faraday who showed how natural forces might be harnessed and set to work for human benefit, and William Wordsworth who showed how words could be empowered to elevate the ordinary, together listening to John Constable who showed us how to see what lies around us all.

'How did I get on?' Constable wrote in response to Purton's enquiry: 'Faraday said it pleased him.'[60]

44. Papa, remember how happy you were

W hen one door closed another opened. After the deaths of Fisher and Dunthorne, Constable received a letter from a perfect stranger, George Constable, a brewer and maltster of Maltravers Street, Arundel. Despite their common surname the pair were not related. George Constable was up from Sussex, staying in Charlotte Street with friends who showed him some of the mezzotints from their neighbour's *English Landscape* series. George was immediately smitten:

> I am charmed with it! The perfectly natural yet masterly manner with which you have treated the light & shade is to me quite astonishing – I must say it is the most perfect and interesting work on landscape I have ever seen.[1]

John Constable took the prints round the next day, and George Constable bought a set; but even before the deal was done, the artist added a paragraph of high personal disclosure:

> I should feel happy in the belief that my book [*English Land-scape*] should ever remunerate itself, for I am gratifying my vanity at the expense of my children, and I could have wished that they might have lived on me, not the reverse. My only consolation is that my fortune has not sheltered me in idleness, as my large canvasses, the dreams of a happy but unpropitious life, will prove.[2]

Constable moved like quicksilver when his namesake showed interest in the prints because he had invested so much money and reputation in the success of the portfolio. Although he had unloaded some of his smaller unsold paintings, 'dead horses' or 'old men', as he called them, onto the Pall Mall art dealer David-son, his house was still 'too much encumbered with lumber, and this encumbers my mind.'[3] He had not sold a large painting from an exhibition since 1824, so the warm tone of George's approach

invited Constable to respond with his own natural openness. Whether further sales were his hope or not, the exchange was the beginning of an enriching friendship.

Without John Fisher, John Constable needed the companionship of a male friend, and he sensed that this might develop with George Constable. The key ingredient that the painter required to cause his affections and wry turn of phrase to flow was a man, like Fisher, who enjoyed talking about painting but was not in the art world; who had himself an interesting and engaging profession; was not needy; and was considerate, amusing, hospitable, literate and kind. George Constable gradually revealed all these qualities, and showed an additional intellectual bent that expressed itself in collecting. Furthermore, he lived in a place that attracted John Constable for its new pictorial possibilities. The tone of George Constable's letters echoes that of John Fisher, except that 'Salisbury' has been replaced by 'Arundel'. This letter could have been written by Fisher: one word only shows it was George Constable:

> I sincerely wish I could prevail on you to take a trip to Arundel. I am sure you would derive great benefit from it. I am from my own experience quite satisfied that the occasional removal from the monotony of domestic scenes and circumstances, is very beneficial both to mind and body.[4]

Early in their friendship George won John's trust by being generous and hospitable to young Johnny. The boy was mad about fossils, and George gave him some that had been found in the Arundel Gap: 'John[ny] is delighted with the collection you have sent him – he says they are very valuable indeed, and he highly prizes them. To me these pieces of "time mangled matter" are interesting for the tale they tell – but above all I esteem them as marks of regard to my darling boy, the darling too of his dear mother.'[5] Anyone who was good to his boys, and thereby blessing Maria's memory, had Constable's full attention. John helped George develop his picture collection, adding paintings by other artists as well as his own, though George's ambition to buy *Salisbury Cathedral from the Meadows* never took root. As the correspondence developed, John showed great sympathy when

George was thrown from a gig and broke his arm: 'Gigs are such bad things, one is so much at the mercy of the horse'.[6] He hoped George would mend soon, and that:

> the inflammation is gone, and the bone set. The former is much within the reach of the professors, our friends of the ditches, the leeches. These humble creatures have the power, and the will too, to render mankind essential benefits – and this grateful argument will hold good of everything in nature, more or less.

It is discursive thoughts of this kind that so enliven Constable's letters to Fisher and to George. Then, as to Fisher, he grumbles on about his lot:

> I have been sadly ill, and during the last week particularly so – still I have ventured to embark on a large canvas, and thus set forth on a sea of troubles, but it is a sea that generally becalms as I proceed – I have chosen a rich subject [*The Valley Farm*].

He grumbles further about the current student intake at the Academy, and how useless they are:

> I lament to say we must give away an abundance of our beautiful medals to little purpose – how are we to account for this? Perhaps, as Fuseli once told me, 'As the conveniences and instruments of study increase, so will always the exertions of the students decrease'.

As one close friend departs, and another slips silently into his place, Constable can rehearse his thoughts and nurse his bruises to keep them fresh. In an echo of his complaint to Fisher of 1821 that he would never be a 'Gentleman and Ladies painter', he mused to George Constable in a coat-trailing moment that "tis late in life for me to think of ever becoming a popular painter. Besides, a knowledge of the world, and I have little of it, goes further towards that than a knowledge of art.'[7] Directly after vacating Well Walk, Constable went to Sussex for a week or ten days with Johnny to stay with the Arundel Constables, a certain relief after the stress of moving house. The boy made friends with George's son George Sefton Constable, and, sketching in

the country around, John Constable and son went to Petworth for the day, where Lord Egremont generously urged them to stay, or come again and stay longer. Sussex was another new-found land for Constable, a bolt-hole away from London and the Stour Valley to replace Dorset, Hampstead and Salisbury, where there were no more Fishers.

He was uncertain about the propriety of inviting himself back to Petworth, and agonised to both Charles Leslie and Henry Phillips. But he wrote to Egremont nevertheless, and was invited, and within weeks of his first visit was again at Petworth, where Leslie was a fellow guest.[8] True to his word and reputation, Egremont gave Constable every facility – horse, carriage, local knowledge – to tour the county, and there Constable made drawings and watercolours of places including Petworth, Bignor, Cowdray, Chichester and Arundel.[9] A new pulse runs through these works, and through the further drawings and watercolours that Constable made when he returned to Sussex the following year. Dreaming of Arundel, he wrote to George:

> I long to be amongst your <u>willows</u> again, in your walks and hangers, among your books of antiquities &c, &c, and to enjoy your society – all as I did before without reserve, restraint, coldness & form, which belongs to 'no friendship', and 'great houses'.[10]

The Sussex drawings beat with energy in their thin, brushy watercolour and spirited pencil work. So distinct is Sussex in landform from the Stour Valley, as distinct indeed as the Lake District is from both, that we might reasonably compare the novelty of Sussex in 1834 and 1835, with its castles, downs and hangars, to the impact the Lake District had on Constable during his 1806 visit. He knew the downs already through crossing them on journeys to Brighton, but at Petworth and Arundel he was deeply immersed within them.

With George Constable's friendship and insight, John Constable found a soul-mate who had arrived out of the blue under their common surname: 'I live a life of more solitude than you or many would suspect, for the midst of London and in such a pursuit & wide field as the arts.'[11] He then talks to George as if the

Sussex brewer were interested in Academy machinations, which he probably was not. Fisher had enjoyed accounts of the cut and thrust, but we cannot be certain that George did. Nevertheless he got it on the chin:

> There is a committee of the House of Commons, sitting to enquire into the affairs of the Royal Academy ... They have mustered all the off scouring of our profession, all the black-guards – down to Haydon and Bob Stothard – & have collected volumes of falsehood, & slander, & ignorance ... The truth is [the committee] have had all of them such a horsewhipping from Sir Martin Shee, that they are sick of their job.

Then John slipped into a minor key, and was once again in a beloved landscape:

> I have never seen such scenery as your county affords. I prefer it to any other for my pictures – woods – lanes – single trees, rivers – cottages – barns – mills and above all such noble & beautiful heath scenery.

And back to the main theme:

> What for goodness sake will become of me and them [my children], the radicals will murder us all & eat us all. I hate the Whigs, but the Tories have done the greatest mischief, for it was they that passed the Catholic bill – but I hate politics & never see a newspaper, at all ... Almost all the world is igno-rant & vulgar.

With his talk and his correspondence Constable inspired friendship in those who enjoyed his idiosyncrasies and vibrant opinions freely given.

A valedictory quality begins to emerge across these years in Constable's painting, whether he noticed it or not – at any rate dampness and chill increase within his pictures, as does the windy movement of trees, autumnal shades and a palpable sense of profound weight and die-back. Constable referred to a change in his use of colour when he wrote to fellow artist John James Chalon about *The Valley Farm*: 'The "sleet" and "snow" have dis-appeared, leaving in their places, silver, ivory, and a little gold.'[12]

He was taken by surprise when *Valley Farm*, in which Willy Lott's cottage is seen from an unfamiliar down-river angle, was bought still wet and on the easel for £300 in an impulsive moment by the entrepreneurial horse-dealer of Pall Mall, Robert Vernon. However, despite the exceptional price he paid, Vernon would not have it to hang on his crowded walls until months after its exposure at the Royal Academy in 1835, and even then had to hand it back so the artist could show it at the British Institution the following year.

Constable opened up to George about his struggles with paint as he had with Fisher. They are now addressing each other in their letters as 'My dear friend':

> I have got my picture [*The Valley Farm*] into a very beautiful state, I have kept my brightness without my spottiness, and I have preserved God Almighty's daylight, which is enjoyed by all mankind, excepting only the lovers of old dirty canvas, perished pictures at a thousand guineas each, cart grease, tar and snuff of candles. Mr Wells, an admirer of common place, called to see my picture, and did not like it at all, so I am sure there is something good in it. Soon after, Mr Vernon called, and bought it, having never seen it before in any state.[13]

Hearing this news, Abram told his brother 'there are but few people can make a piece of canvas worth £300'.[14] Constable goes on to George about the stresses of his daily life, how he has been 'sadly vexed with myself for not writing to you long ago – but I am sorely perplexed with sundry matters that day after day eat up my time.'[15] The girls and Alfred and Lionel had gone back to school, so he was able to 'breathe, and recollect that I was a week or two ago at Arundel, passing a most delightful time with my dear friends – or was it a dream? For it seems like one. John[ny] was determined that this day should not pass without my writing to you – his words are, "Papa, remember how happy you were, and how kind Mr & Mrs Constable were."'[16]

There is a desperation for friendship in John Constable. With his aptitude for insults, for the harsh words he might release against fellow artists, rivals for public favour, or simple charlatans, he needed the assurance of recognition from solid and

reliable people who were outside his line of business, but who had the intelligence and experience to appreciate the strains of his creativity. Artists did not do this for him. This was entirely personal to Constable: he needed to be certain that he was both understood and admired; he needed a constant stream of approval. The best of these friends, such as Fisher, George Constable and, in Brighton, Henry Phillips, actually resisted all that, and considered Constable sceptically and with affectionate reserve. Another sensible outsider with attractive warmth was John Allnutt, the wine merchant, an early and very generous patron whose new house in Clapham had

> every luxury & comfort in the world . . . The house is full of pictures . . . the premises are full of livestock – rabbits so tame & pretty . . . he will give me a pair for the children . . . Hot house & grottoes – & almost every thing – & nothing could be more civil & polite – & kind.[17]

Other patrons, however, such as Richard Benyon De Beauvoir of Englefield, Berkshire, who commissioned a portrait of his house, and Francis Darby of Shropshire, failed to notice or had no interest in developing any relationship beyond the line of business. Constable had an insatiable desire to be loved: 'When you come,' he wrote to George, anticipating his friend coming to Charlotte Street, 'will you bring the little sketch of the Arundel Mill, as I should like to contemplate a picture of it, of a pretty good size.'[18] This study, showing Swanbourne Mill with the River Arun running by, had been painted by Constable for his friend. He worked the composition up to a larger scale, intending it for exhibition at the Academy. *Arundel Mill and Castle* shares its composition with *The Valley Farm*: a heavy middle-ground pile of a red brick building, a similarly complex multiplicity of roofs, both standing beside moving water among dark trees, with similarly severe right to left downward diagonals. 'For myself, I am at work on a beautiful subject, Arundel Mill, for which I am indebted to your friendship. It is, and shall be, my best picture.'[19]

During his process of developing the subject of Arundel Mill, Constable told George: 'I cannot plan a picture – and I lose time.' This was his default state, lack of time and the fret about it, but in this case, while it might have been momentarily so, he was also embarked on *The Cenotaph*, one of his most curious and atypical paintings.[20]

45. As regular as a clock

Constable's boys were his pride and joy, though he did make a passing remark to Leslie: 'I wish I could turn them into girls'.[1] The eldest, Johnny and Charley, had special characters which their father and Boner had to handle: Johnny had had a rheumatic ailment when he was eight, and 'could not stand on his legs or walk or hold a limb still . . . & now he is quite strong and able to walk any where.'[2] Despite their childhood illnesses of one kind or another, their individualities emerged as they grew up. Johnny – John Charles Constable – had become enthralled by natural sciences and collected shells, fossils and stone and rock samples, which he kept in the mahogany collector's cabinet he had been given.[3] When he went to school in Folkestone he was encouraged in these studies, and was given shell samples by a neighbour, Marianne Johnson, while George Field gave him 'a lovely bit of grey Lapis very beautifully spared[?] indeed.'[4] Their Hampstead neighbour, the geologist Robert Bakewell, also caught the boy's interest. He gave Johnny an inscribed copy of his *Introduction to Geology* (1829), and brought home some exotic fossils for him from Dorset, including a 'pineapple . . . as large as Alfred's head'.[5] Johnny was ingenious and inventive, and keen enough to have a 'horrid laboratory' with its associated smells in his room in Charlotte Street.[6] Boner witnessed this vivid curiosity when he watched the boy work at a press 'of his own making', printing a woodcut he had made of Saturn and its rings.[7] The letters Constable wrote to Johnny at school touch regularly on the boy's interests. He gave him news of well-sinking on Hampstead Heath where

> they dig up shell . . . a Nautilus has been found tolerable whole but they soon break – so have several . . . they have got down about 120 or 30 feet of the Well lower Heath – it is eight feet across. They make sure of Water. The book of Phillips

Mineralogy is so scarce that both copies You saw were gone –
and I was quite in a frown.[8]

Later, Constable told Johnny that the well was 250 feet deep –
then yet deeper, 260 or 270 feet, and that Boner would try to get
more shells for him from the workings.[9]

It was not all plain sailing, however. Constable had to rush
down to Folkestone to see Johnny who had begun to sleepwalk,
and in the process had injured himself. With the earlier problems
he had had with his legs, this alarmed them all:

> I do most truly wish I had never let you go from me – but what
> could I do – I was over persuaded and could not help myself.
> Poor Bob [Elizabeth Roberts] has fretted herself – quite ill
> about you – and not hearing from you to day she is crying
> about the house quite like a simpleton.[10]

On his journey home, Constable had to sit 'outside' and got
soaked, caught a chill and contracted erysipelas (aka St Antony's
Fire) in his right hand, which 'swelled up like a roll'. A benefit of
this journey high up in the air on top of the coach was that when
the rain stopped he saw 'wonderful fine effects' in the sky.[11]

At one unrepeatable moment, 16 October 1834, Constable
saw other 'wonderful fine effects' in the sky and, with Johnny
and Charley, jumped into a cab in Charlotte Street and rushed
to Westminster Bridge. There, along with thousands of others,
including Turner moving about somewhere in the crowds, they
saw the Houses of Parliament aflame, tongues shooting up into
the sky and backlighting its great gate. Always having the right
portable equipment with him, Constable must have made his
evocative little pen and ink study there and then, with its tiny
figures backing away from the heat at the edge of the drawing.
A second drawing, made after the fire had been put out, has also
descended in the family and been listed as Constable's own, but
it is stiff and incompetent, and much more likely to have been
drawn by one of the boys, probably Charley, venturing a day or
two later to the ruins.[12]

Constable was an inventive and interested parent, involving
himself wholly in his children's education. This was not least

because of his abhorrence of neglect and brutality among teach-
ers. Talking to Johnny about his work as an artist, he explained
perspective to the boy, telling him it was 'the whole grammar
of painting & drawing'.[13] Johnny, like his father, had a thirst for
knowledge and the drive to learn and understand the natural
world, while for his part Constable paid the fees; for example,
£199 for an apprenticeship to Walter Drew, the Gower Street
apothecary who, incidentally, mis-prescribed Maria in 1823.[14]
'My dear John is always in some study or other', Constable told
George Constable.[15] Johnny's interest in the sciences grew, and
he went on to London University to read surgery and physiol-
ogy. He also took anatomy at the King's College Medical School
in Great Windmill Street, and attended Latin and Greek classes.
Johnny did his best to make his younger brother Charley sick at
his tales from the Medical School:

> Now for the horribles. . . . As soon as I got used to the smell, I
> liked it very much, it was on the muscles of the Fore arm, the
> Demonstrator lectured on the real subject. I shall say no more,
> it would disgust you, prevent you from eating your dinner, but
> it did not me.[16]

At the Royal Institution, Johnny attended Faraday's chemis-
try lectures: 'To all these things he is as regular as a clock', his
father reported, 'all I pray for is that his health will continue
to bear it.'[17] In December 1836 he entered the rolls of Corpus
Christi College, Cambridge, to study chemistry and medicine,
with the eventual intention of becoming ordained in the Church
of England.[18]

Charley – Charles Golding Constable – gave his father other
anxieties: 'he has never been treated with severity.'[19] Constable
held the boy in a special regard: 'A more open and noble dispo-
sition there cannot be – or a more affectionate heart. I know of
no one thing amiss in him', he added, and went on to describe
Charley's lack of 'volition', otherwise his apparent indecision,
not uncommon in teenage boys. Constable need not have worried
about Charley: he shared Johnny's interest in the natural sciences,
but was developing his own interest in the sea. He helped his
brother collect the fossils from Hampstead Heath and analysed

the finds with him: 'it is formed of iron perites [*sic*] and chalk marl and cal[cite] this is the formation of the super stratum'.[20] Charley's aunt Mary found him to be 'a very interesting youth' when he stayed with her and Abram at Flatford: 'we all did all we could to make him, happy & his company was quite beyond his age', she said, as she put him on their cousin John Sidey's sailing ship at Mistley for the voyage to London.[21] 'The young water-man was in high spirits & he seemed without care or any earthly trouble.'

Charley's interest in the sea developed early: 'The sketch you sent is very pretty: the Indiaman scudding along is capital – I am very glad you have seen such fine large vessels', Boner told him; and to his brother Charley described the crowding of steamers at Gravesend: 'You can have no idea of the opposition of the Gravesend steamers on Gravesend Pier, such a pulling and fight-ing between the sailors, it was tremendous.'[22] There was nothing much wrong with either boy that time and application would not sort out, but nevertheless Charley's choice of career presented new anxieties. His fascination for the sea was of a different kind to his father's, who seems to have fostered a vain hope that Char-ley might have become a painter, 'who would have shone in my profession, and who is doomed to be driven about on the ruth-less sea. It is a sad and melancholy life, but he seems made for a sailor.'[23] Abram added his advice for what it was worth: 'I think the India service far preferable to the Navy at all times more especially now', he said, as Charley looked about himself for a ship, and signed up for the East India Company.[24] He became a midshipman; the scudding Indiaman that he had drawn for Boner, the sailors' brawl at Gravesend, and the voyages on HMS *Oakhampton* and other vessels together drew the boy towards the sea. Before Charley joined his first Indiaman, *Buckinghamshire*, his father painted a gentle, affectionate portrait of him, dressed in his midshipman's jacket, and with a background of vessels in a stiff wind: 'in the midst of my perplexities I have made a good portrait', he told George Constable, admitting at the same time that 'it has cost me two hundred pounds to get Charles afloat.'[25] 'Poor dear boy', Constable wrote to Leslie as departure drew near, 'I try to joke, but my heart is broken. He is mistaken by all,

but you & me – he is full of sentiment & poetry & determination
& integrity, & no vice that I know of.'[26]

At the dockside, John Constable walked slowly away from the
ship and from his son. 'My Charley boy is gone', he wrote to
Lucas, 'he is on the wide sea, with heaven to be his guide. God
Almighty bless and preserve him – he is full of genius!!!! But
perhaps it will be to his ultimate happiness that he should feel
the hand of controul.'[27] So, off Charley went, out into the blue.
He sent a sequence of vivid letters to his father across the first
few days of the voyage, when they were still in home waters,
uncertain whether their destination would be Bombay or China.
They lay in the Solent for a while, 'at a place called Sea View
in the Isle of Wight. It is a most beautiful fairy like Island.'[28]
Charley's 'sentiment & poetry' and his eye for telling detail was
with him on the voyage: he was up in the rigging when 'some of
the [gentlemen passengers] had a hearty laugh at seeing my cap
blow far away to leeward from the mizzen and just after went my
right shoe.'[29]

The two younger boys were alert and buoyant and at school.
Alfred remained sickly, having given John and Maria a fright
when he nearly died from whooping cough at six months, 're-
duced to the last state . . . given up altogether by our medical
men'.[30] He grew up with a charming sense of humour and was
a delight to his teachers, having 'mischievous propensities' like
many eight-year-olds, and requiring 'incessant watchfulness'.
Miss Noble reported 'an honourable & gentlemanly feeling' in
him, 'which scorns excuses or reservations.'[31]

The three girls came more or less in the middle, between the
groups of boys. 'All our little girls are well and happy', Constable
told Leslie. 'As for myself I really believe they cannot be in better
hands than that excellent woman's Miss Noble.'[32] Maria, 'Minna'
– another family nickname was Lady-bird – was musical, exu-
berant and doing well in French and dancing at Sophia Noble's
school. She was 'the nicest child in the house possible', Fisher
wrote of Minna to her proud father, when aged ten she stayed in
Salisbury in 1829. 'Nobody would know of her existence if she
were not seen . . . her ear is perfect; & she dances quadrilles with
the chairs like a parched pea on a drum head.'[33] As she grew older

and into her teenaged years, Maria seems to have become moody
– 'sadly inclined to stoop', Miss Noble reported.[34] Isabel, now
twelve years old, was charm itself: 'an affectionate, warm-hearted
child, whom it is impossible to know & not love; & though she is
not at present passionately fond of study, yet she takes far more
interest in her various employments than she used to do.'[35] There
is only passing mention of Emily (age nine) here, just a further
warning about Isabel who is also 'sadly inclined to stoop . . . we
do all we can to counteract the habit . . . her figure is so slight &
pretty that a pity that it should be spoiled.'[36]

46. Time

Constable was buoyed up after he had, for the time being, completed his lecture series, knowing perhaps that he had got one over his Academician fellows: 'Titian, Ruysdael & other worthies illuminated by the flashes of your genius', one Academician, Thomas Uwins, wrote.[1] Constable was on a mission, as he told another Academician, Henry Pickersgill:

> that I may rescue ourselves from the Obloquy of being in total Ignorance of the Principles & theory of that art we profess ... Landscape has never been treated single handed by any lecturer yet.[2]

A third Academician, Francis Chantrey, was furious he had not known about the Royal Institution lectures, and was for once wrong-footed. 'Why the devil did not you give me notice that you intended to <u>preach</u>. I could & would have attended your first <u>effort</u>. Your 2nd & 3rd <u>impossible</u> for I shall be fishing at Stockbridge.'[3] A fourth Academician, Constable's early friend Ramsay Reinagle, suffered confusion and obloquy of his own, being expelled from the Academy for displaying as his own the work of another artist. He became bankrupt.

Constable's life was no less complicated now that the children were away at school and he had got rid of the extra expense and responsibility of a Hampstead house. These were the same months – the first half of 1836 – in which he, Abram and Mary were together buying Old House Farm near Brantham. This was a passion of Mary's in which Constable acquiesced under the storm of her urgent and much underlined letters, but it is not really clear how keen he was, at bottom, with the idea. A decade earlier he had mused lightly to Maria about how nice it would be to move to Dedham one day, but these were words which he did not necessarily expect to be turned into action. Nonetheless, the three siblings did buy Old House Farm, and John paid his share.

In Leicestershire, in the grounds of Coleorton Hall, Sir George
Beaumont had put up a monument to Reynolds, and indeed had
also dedicated a large boulder nearby to Richard Wilson.[4] When
he stayed with the Beaumonts in 1823 Constable drew both me-
morials, and, from the Reynolds monument, he noted the lines
of Wordsworth's verse in honour of Reynolds that Beaumont
had engraved on the front slab. The cenotaph is raised on three
giant stone steps, and is flanked left and right by plinths carry-
ing busts of Michelangelo and Raphael. An avenue of lime trees
surrounds the whole, and progresses into distant darkness:
'Ye Lime-trees rang'd before this Hallowed Urn', Wordsworth
writes. In his painting, upright, and more or less the size of his
six-footers, Constable depicts a mature stag with splendid antlers
straying into the grove, emphasising the silence and grandeur
of the moment. This is a classical painting in homage to classi-
cal painting: it might be Giorgione's *Castelfranco Madonna* with
the figures having walked off at dusk. We can just make out the
name 'REYNOLDS' low down on the cenotaph flank, while on
the herms at either side the flat-nosed profile of Michelangelo
is unmistakeable, as is Raphael's luxuriant-haired gilded youth-
fulness. In its leeched-out colour, its browns, greys and wan
greens, *The Cenotaph* is a silent shudder of mourning, and an ac-
knowledgement that time passes. By exhibiting it as he did at the
Royal Academy in 1836, Constable is taking a leap beyond the
Academy's quotidian struggles and assuming the position of Re-
membrancer – the conscience of the Academy on what happened
to be the final exhibition before they all decamped from Somerset
House to their new premises in Trafalgar Square. This Constable
was still calling 'the square opposite St Martin's Church'.[5] Few at
the Academy would have known that this painting existed until
it had been delivered; indeed, Constable himself seems not to
have decided to send it until late in the day: he had planned to
show *Arundel Mill and Castle*, enlarged from the study he had
given to George Constable, but 'I found I could not do both – and
so I preferred to see Sir Joshua Reynolds's name and Sir George
Beaumont's once more in the catalogue, for the last time in the
old house.'[6]

The Cenotaph, a memorial for an artist, a philanthropist, a

friend, and a place, sits uneasily in Constable's oeuvre, and edges
into proto-Victorian graveyard painting with its grim allusion
to death. Had he lived longer than he did, Constable might have
created a context for this picture that would have absorbed its
stark sobriety, but, instead, absent is the joy in landscape and
open air and sky and cloud and the ever-present hint of people.
The Cenotaph muses on Reynolds's genius, but it reflects equally
on a man who could have helped Constable so much more, and
moved his career on faster, but never did. Beaumont was too
firmly stuck in his own social and cultural orbit, and blinded by
his taste; *au fond* he failed to make Constable out, and while he
may deserve such a tribute from the nation for his bequest, he
hardly deserves one from Constable. *The Cenotaph* is a memorial
for Maria as much as for Reynolds and Beaumont, but it steals
the mourning that Constable might have expressed in paint for
his wife. Even in death Sir George Beaumont took precedence
over her.

Constable was full of hope when he looked again at his *Cen-
otaph* on the walls of Somerset House. This was his farewell
not only to a person, but to a place. Having paid this homage,
he now had much to look forward to as the decade approached
its end. Here were opportunities to begin a fresh chapter after
long, painful years: Johnny would be reaching ordination once he
had completed his undergraduate years at Cambridge: 'he works
hard, as he wishes so much to get himself fit for Cambridge'.[7]
Charley would be home from China and would perhaps find ser-
vice closer to home in the Mediterranean: at the moment he was
having a very tough time, 'he has been sadly used in the ship –
but he is going out again with her, & to China'.[8] And surely the
girls would soon be married. The future seemed bright: he had
his share in Old House Farm; he would extend his experience as
a lecturer, and perhaps speak at the Royal Institution or Hamp-
stead again; he had been elected Vice President of the Artists'
General Benevolent Institution; and *Arundel Mill and Castle*,
still not quite finished, needed more thought and application. It
would, however, be a triumph, of that he was certain.[9] Yet fur-
ther, he had completed the full-size sketch for a large canvas of
Stoke-by-Nayland, and that was awaiting his attention.

At the Royal Academy, as a leading member of its teaching body – a Visitor to the Academy Schools – Constable was full of inventive ideas, and had become invaluable as a teacher. In the old rooms in Somerset House, still in use as the Life class, he set up a tableau vivant of the figures in Titian's *Death of St Peter Martyr*: 'I am engaged with the "Assassin" on Monday, and shall be em-ployed with him all week . . . Fitzgerald I shall set as the fallen saint . . . the running figure of the monk, Emmott . . . I am beset with "models" in spite of this cold weather.'[10] John Constable was now growing in excitement about his future at the Academy, and there was nothing that would stop him from helping to make the transition to the new premises a success. He might even become President one day; that would surprise them. Constable's 'public', that small part of the world who had relaxed conceptions of what painting could do, were warming to him. The response of the amateur artist and modest patron George Jennings, who had taken delivery of a special commission, must have been heart-ening: 'I am so delighted with [*Hampstead Heath with Rainbow*] that I do not know how fully to express my gratification, for it is most admirable. As for the sky & distance nothing finer was, or ever will be put upon canvas.'[11]

In the weeks of February and March 1837, Constable was busy at work, and in health he and the children were perfectly fine – Abram makes that clear in his reply to a lost letter: 'I am glad you are all well'.[12] To the print-dealer Francis Moon, Constable wrote asking for some proofs, perhaps of Lucas's mezzotints,[13] while to Abram he had written in such haste about a multitude of East Bergholt and Flatford matters that his brother found much of his letter illegible: 'I am sorry you had no more time to write your letter for I can hardly read what you have written, & you have written so very little.'[14] He was evi-dently anxious about Bergholt business, and about the solicitor Harcourt Firmin, Peter Firmin's son, whose business activities had become a thorn in the Constable family's side. There were delays over the completion of the purchase of Old House Farm with its financial transfers, and concern too over a transaction which appears to be about the money that Golding had collected as rents for Dysart properties. These were frustrations of a kind

that ruffled the surface of Constable's life but would not over-whelm it.

It was with joy and with some feeling of justification that Constable succeeded Turner as Visitor at the Academy. He was very happy working closely with students, and his assiduity and concern for them drew from them both attention and affection. 'I am out every evening from five to nine at the old Academy, visitor in the Life', he told Samuel Lane, preceding this news with particular advice to take care in the very cold weather: 'Pray keep your children within doors this grievous weather; I am told nothing breeds whooping cough so much as such bitter easterly winds as are now prevailing.'[15]

Saturday 25 March was a significant and poignant day for the Royal Academy, particularly so for its students. Somerset House was emptying – everything: easels, benches, chairs, tables, lamps, boxes of paintbrushes, charcoal and chalk down to the smallest pieces, and the Academy's entire collection of plaster casts – all carried load by load, by cart, by carriage, turning left into the traffic of the Strand, past Charing Cross and its conglomera-tion of coaches and horses, and turning right up the shallow hill towards St Martin-in-the-Fields and the brand new, gleaming, stone-columned and pedimented edifice built for the National Gallery and the Royal Academy. What grandeur. In the final days of March 1837 the Life Academy was lonely and echoing, cold too no doubt with the easterly winds blowing through every crack and everybody else having left. The students did their work, completed their drawings of Titian's *St Peter Martyr* poses, and then Constable gave them a final pep-talk as the shut-ters came down for the last time: be appreciative of the Royal Academy and what you can learn there, he urged them; do not be in too much of a hurry to study in France, Germany and Italy – the best teaching will be had where the best artists are, not where there are the best old masters. That was a controversial and challenging statement: the students were about to move into the same building as the National Gallery, where some of the finest old master paintings were already hanging. He went on: the French are not the best draughtsmen, even though they may think they are; and always look at Raphael's drawings, even his

slightest pen and ink sketches, he said, Raphael's figures 'live and move'.[16]

When he was preparing his *Memoirs of the Life of John Constable* Leslie spoke to Daniel Maclise, one of the students who had been there on that final day, and asked him what he remembered of the address.[17] Alas, Maclise could not recall that detail, or the substance of any particular address, but he did say this: Constable 'constantly addressed us collectively; or rather, whatever observation he had to make, he made aloud; and this was very frequent.' So his teaching method was to walk about, look hard at the work in progress, observe individual work, and announce to all. He would discuss the pose of the models with the students before they picked up their pencils, and always would draw their attention to the importance of background, to think hard about what objects or attributes might be relevant to the subject in hand. Maclise added that Constable was 'a most popular visitor' with the students. The students gave him a warm round of applause, thankful perhaps that they would no longer have to trudge up those dozens of steps to the top of Somerset House; the new ground-floor teaching rooms in Trafalgar Square would be much easier.

Constable's engagement with David Lucas continued to turn painted images into atmospheric and breath-taking mezzotints, and to generate lively correspondence between them: what was Lucas doing about the rainbow in the great *Salisbury* print, he demanded. 'I have put a pin in the centre of the rainbow', Constable told him on sending back a proof. 'It is in the elder bush.'[18] Lucas clearly did well, as a few days later Constable told him: 'The print is a noble and beautifull thing – entirely improved and entirely made perfect. The bow is noble . . . it is startling and unique.'[19] Content that at last this difficult print was nearing completion, Constable attended a meeting of the Artists' General Benevolent Institution, and on that same day – Thursday 30 March 1837 – he went to a General Assembly of the Royal Academy in the new rooms in Trafalgar Square. He and Leslie walked back together afterwards; it was getting dark as they went along Oxford Street. A child cried out from the other side of the street, and Constable crossed over and gave the girl a shilling. He told Leslie about

some bits of money he was owed, and became quite animated, but they parted in good humour.[20]

Johnny was at home that evening and the next day; so were the servants and Elizabeth Roberts. The house was ticking over well. *Arundel Mill and Castle* was on the easel, and Constable knew he only had a week at the most before he had to let it go to the exhibition in Trafalgar Square – the first Royal Academy show to be held there. His contribution had to be tip-top. He fiddled with the painting for most of the day, a touch here, some white there; and one or two people came to call. Among them was the miniaturist Alfred Tidey who remembered how Constable worked lightly with his palette knife, moving backwards and forwards 'to see the effect, It's neither too warm, nor too cold [he said,] too light nor too dark and this constitutes every thing in a picture.'[21] He was not feeling well, but in the early evening Constable went out to get some air and to take money round to a beneficiary of the Benevolent Institution's charity. He returned home around nine o'clock. Leslie tells us all this, adding that he ate 'a hearty supper', and, asking for his bed to be warmed, he went upstairs.

Leslie, however, was not actually present, and what he wrote about succeeding events would not be published for six years. Johnny, however, was there, and anxious about all sorts of things, principally his need to study hard to reach the standards that Cambridge required of him. He was worried too about his own health as well as his father's, and it is from Johnny, written down after less than a fortnight, that we learn that John Constable went to bed that night at about eleven, taking a book with him to read.[22] The so-called 'hearty supper' he had eaten was merely bread and cheese with cold water. After a little while he felt thirsty and called Roberts, who brought him some French plums – at that time of year these must have been last year's crop, so probably bottled plums, soft, liquid and digestible. He fell asleep, but quite soon woke up complaining of heartburn and called Johnny, who brought him 'magnesia and rhubarb'. The dose made him sick and unsteady.[23] Johnny was probably in bed by now, though Leslie said he had just got back from the theatre. For a while Constable felt better, but soon the heartburn came back and he took more magnesium and rhubarb. He asked for hot

water, which he drank in quantity. By midnight or soon after the house was in uproar. It looks, now, as if Constable was suffering a heart attack. Roberts was up and organising; somebody went to fetch the doctor; the servants were rushing up and down for more hot water; the cats had fled. Constable got up again and to relieve the pain sat on the side of the bed and bent over. Then he went to a chair and sat down; then he stood up again; then he raised his arms above his head. Nothing would relieve his pain. He tried to say something, but nobody quite knew what he wanted or how best to help him. The noise and turbulence in that small attic room was intense as he writhed and gasped and lay down again. At 2 o'clock in the morning, he died.[24]

Charles and Harriet Leslie came straight away. John Constable's body was lying as if he were peacefully asleep. At his feet was Bolswert's engraving of Rubens's *Landscape by Moonlight*. His Gainsborough drawings hung nearby. On the table by his pillow lay Southey's *Life of Cowper*, and just there, beside it, his watch ticked.[25] With Rubens, Gainsborough and Cowper as close as they could possibly be, time, of so much importance to him, had run out.

47. I knew Mr Constable

It was Johnny, as the oldest child, who took responsibility for the arrangements that had gradually to be made to clear the Charlotte Street house, and oversee the subsequent sales of pictures, furniture, books and everything else. It was he who wrote the note in the family's Bible recording the time and date of the death, initialling it 'JC': as the new head of the family he no longer needed to sign himself 'JCC'. Usually so punctilious, his father had not made a will: his death took him, as others, by surprise. This pressure of emotion and sudden responsibility came bearing down on top of Johnny's Cambridge studies, which would not let up, and all this together caused him exhaustion and pain. His anxieties were such that he did not attend his father's funeral.[1] Charley was at sea, Boner was in Germany, and the other siblings were at school, but Golding and Abram came up from Suffolk. They took the body to Hampstead, to lie beside Maria at St John's, and, as his coffin was carried through the graveyard, Hampstead friends appeared and stood together in silence. From the officiating parson, the Rev. Thomas Judkin, 'tears fell fast on the book as he stood by the tomb'. The quiet of mourning reached far beyond Constable's circle of family and friends. When told of the artist's death a local cabman responded:

> I knew Mr Constable; and, when I heard he was dead, I was as sorry as if he had been my own father – he was as nice a man as that, sir.[2]

The seven children were now, effectively, orphans, as Johnny, at nineteen, was still under age. William Purton kept his promise to keep an eye on Minna, Isabel and Emily for as long as they remained at Miss Noble's school, and Golding Constable and Lancelot Archer-Burton, Jane Gubbins' husband and Alfred's godfather, were appointed guardians.[3] The following year they moved with Elizabeth Roberts to 16 Cunningham Place, St

John's Wood, close to the Archer-Burtons in Grove End Road and Charles and Harriet Leslie in Pine Apple Place.[4] Minna carried a curl of her father's hair, cut off after his death, in a locket.[5]

Johnny Constable kept a diary across the last three years of the decade, and in it he clearly reveals his concern, inherited from his parents, for detail and precision, and his desire to maintain a sense of order even as it seemed constantly to be slipping from his hands.[6] People would turn up in Charlotte Street and expect to go away with a picture or two, and this began to upset and offend him. He tried to get some time away from London and Cambridge, and in July, four months after his father's death, he travelled to Suffolk to see his uncles and aunts and other local friends. The following year he went there again, having transferred in Cambridge from Corpus Christi to Jesus College, and began his medical studies in earnest, working on the wards of Cambridge hospitals. For a young man of fragile health he was training in an infectious environment, and this caused consternation on his 1838 visit to Flatford. There was a humdinger of a row with Aunt Mary and Uncle Abram, who got into 'a bit of a rage'. Aunt Mary, Johnny said, was 'out of her senses' when he came home late for dinner after a visit to Dedham.[7] They thought irrationally that he might have brought smallpox into the house and sent him back to Dedham to stay with Aunt Patty. 'I was a log of wood', Johnny wrote after this row. In church the following Sunday, Mary moved to another pew when she saw Johnny approach: 'she seemed afraid of me'. Aunt Ann, 'Nancy', was just as problematic. Johnny called on her in her cottage on East Bergholt heath: 'Had a row with Aunt [Ann] she said my father had spoken ill of them &c.' This was surely fantasy.

The lives of John and Maria's children were stalked by disappointment and tragedy. Emily died of scarlet fever in 1839, aged fourteen; and while continuing his medical studies on the hospital wards in Cambridge, Johnny also contracted scarlet fever and, in March 1841, died aged twenty-three.[8] Alfred developed a talent for painting, and studied at Henry Sass's school in Charlotte Street. This allowed him quite rapidly to reach a standard to exhibit landscape paintings at the Academy from 1847. 'Well I must say I am very glad to have a brother a painter,' Charley

wrote to him, 'for I have a great respect for that sort of thing. I feel somehow one of us ought to keep up the name at the Academy.'[9] Alfred, however, died by drowning in 1858 while swimming in the Thames at Goring with his younger brother. Lionel, still only nine years old when their father died, also studied at Sass's school and became a painter. He showed his work at the Academy from 1849 to 1855, when he ceased to paint and became a proficient photographer. He died aged fifty-nine in 1887. Neither Minna nor Isabel married; of the seven, only Charley married: his first wife, Caroline Helder, died in childbirth, as did their baby, but on marrying a second time Charley and his wife Anna Blundell had six children. In the year of the Great Exhibition, 1851, there was one painting by Alfred at the Academy, two by Lionel, and one, a flower piece, by Isabel Constable: together they were able briefly to 'keep up the name at the Academy'.[10]

Leslie, in his *Memoirs of John Constable*, writes that 'the vault which contained the remains of his wife' was opened for the burial of the artist. However, the size, form and the consistently engraved and weathered lettering on the family's chest tomb by the graveyard's southern wall suggests that this was built later, commissioned and installed after Constable's death, and also indeed after Johnny's. The left-hand section of the front panel carries Maria's inscription, and the right has John Constable's, spaced and abbreviated to accommodate a memorial for their eldest son. The names of their six other children are recorded on the two short ends.[11] Today, an oak tree grows beside the tomb, and drops its leaves on its table top in autumn.

Cast of Characters

Adams, John	Schoolmaster and mathematician	1757–1807
Allen, Mrs Jane, née Watts	JC's aunt	1757–after 1834
Allen, Thomas	Brewer and plantsman, JC's uncle	1739–1831
Alnutt, John	Wine merchant and collector	1774–1863
Arrowsmith, John	Art dealer, Paris	1790–1849
Atkinson, Christopher (later Savile)	Politician and fraud	1738–1819
Barry, James	Painter	1741–1806
Beaumont, Rachel, Lady	Mother of Sir George	d.1814
Beaumont, Sir George, Bart	Landowner and art patron	1753–1827
Bicknell, Charles Henry	Maria's half-brother	1776–1799
Bicknell, Charles	Solicitor, Maria's father	1751–1828
Bicknell, Durand	Maria's brother	1791–1811
Bicknell, Elizabeth Catherine	Maria's sister	1801–1825?
Bicknell, Louisa Bacon	Maria's sister	b.1789
Bicknell, Maria Elizabeth (née Rhudde)	Maria's mother	d.1815
Bicknell, Maria	JC's wife	1788–1828
Bicknell, Samuel George	Maria's brother	1797–1821
Bicknell, Sarah (later Mrs Samuel Skey, later Mrs Joseph Fletcher)	Maria's half-sister	b. 1775
Bogdani, William Maurice	Maria's great uncle	1735–1790
Boner, Charles	JC's assistant, writer and teacher	1815–1870
Boydell, John	Art dealer and entrepreneur	1720–1804
Bradstreet, Robert	Poet	1766–1836
Bryan, Michael	Art historian and dealer	1757–1821
Callcott, Augustus Wall, RA	Painter	1779–1844
Carpenter, James	Bookseller	1768–1852
Chantrey, Sir Francis, RA	Sculptor	1781–1841
Cobbold, Elizabeth	Poet, novelist and artist	1765–1824
Coleridge, Samuel Taylor	Poet critic and philosopher	1772–1834
Collins, William, RA	Painter	1788–1847

Colnaghi, Dominic	Art dealer	1790–1879
Colnaghi, Paul	Art dealer	1751–1833
Constable, Abram	JC's brother, merchant and farmer	1783–1862
Constable, Abram	JC's great uncle	1701–1764
Constable, Abram, 'of Wormingford'	JC's uncle	1742–1812
Constable, Alfred Abram	JC's son, artist	1826–1853
Constable, Ann ('Nancy')	JC's sister	1768–1854
Constable, Ann, née Watts	JC's mother	1748–1815
Constable, Charles Golding	JC's son, merchant seaman	1821–1879
Constable, Emily	JC's daughter	1825–1839
Constable, George	Brewer, of Arundel	1792–1878
Constable, Golding	JC's brother	1774–1838
Constable, Golding	Merchant and farmer, JC's father	1739–1816
Constable, Isabel	JC's daughter	1822–1888
Constable, John	JC grandfather	1704–1777
Constable, Judith (Mrs Thomas Parmenter)	JC's aunt	1731–1801
Constable, Lionel Bicknell	JC's son, painter and photographer	1828–1887
Constable, Maria Louisa ('Minna')	JC's daughter	1819–1885
Constable, Martha ('Pattie'), (Mrs Thomas Smith)	JC's aunt	1739–1820
Constable, Martha ('Patty') (Mrs Nathaniel Whalley)	JC's sister	1769–1845
Constable, Mary	JC's sister	1781–1865
Coxe, Rev. William	Historian and clergyman	1748–1828
Cranch, John	Painter	1751–1821
Danby, Francis, RA	Painter	1793–1861
Delacroix, Eugène	French painter	1798–1863
Dunthorne, John	Craftsman and artist	1770–1844
Dunthorne, Johnnie	Artist	1798–1832
Dysart, Louisa Manners, 7th Countess of	Landowner	1745–1840
Dysart, Wilbraham Tollemache, 6th Earl of	Landowner	1739–1821
Egremont, 3rd Earl of	Landowner and collector	1751–1837
Etty, William, RA	Painter	1787–1849
Faraday, Michael	Natural philosopher	1791–1867
Farington, Joseph, RA	Painter and diarist	1747–1821
Fisher, John, Archdeacon	Priest	1788–1832
Fisher, John, Rt Rev. Bishop	Priest	1748–1825

Frith, William Powell, RA	Painter	1819–1909
Fuseli, Henry, RA	Painter and teacher	1741–1825
Gandy, Joseph Michael, ARA	Architect and artist	1771–1843
Gardner, Daniel	Painter	1750–1805
Garrad, William	Farmer	1764–1816
Géricault, Théodore	French artist	1791–1824
Girtin, Thomas	Painter	1775–1802
Graham, Maria	Traveller and author	1785–1842
Grimwood, Dr. Thomas Letchmere	Schoolmaster	1740–1809
Gubbins, Captain Richard	Soldier, JC's cousin	1781–1836
Gubbins, James	Soldier, JC's cousin	1778–1815
Gubbins, James	Surveyor, JC's uncle	1745–1814
Gubbins, Jane Mrs Lancelot South, later Archer–Burton		d.1858
Gubbins, Mary nee Watts	JC's aunt	1751–1827
Harden, Jessy	Diarist	1776–1837
Harden, John	Artist and landowner	1772–1847
Haydon, Benjamin Robert	History painter and diarist	1786–1846
Hayley, William	Poet and biographer	1745–1820
Hoppner, John, RA	Portrait painter	1758–1810
Howard, Henry, RA	Painter	1769–1847
Hurlock, Rev. Brooke	Priest	d.1804
Lane, Samuel	Portrait painter	1780–1859
Lawrence, Sir Thomas, PRA	Portrait painter	1769–1830
Leicester, Sir John, Bt.	Landowner and collector	1762–1827
Leslie, Charles Robert, RA	Painter and author	1794–1859
Lewis, Henry Greswold	Landowner	1754–1829
Lucas, David	Mezzotint engraver	1802–1881
Martin, John	Artist and entrepreneur	1789–1854
Mason, Anne, née Parmenter	Constable's cousin	1770–1857
Masquerier, Jean-Jacques	Painter	1778–1855
Morrison, James	Merchant, politician and collector	1789–1857
Mulready, William, RA	Painter	1786–1863
Northcote, James, RA	Painter and author	1746–1831
Opie, Amelia	Novelist and poet	1769–1853
Opie, John, RA	Portrait painter	1761–1807
Ottley, William Young	Writer on art and collector	1771–1836

Parmenter, Anne (see Mason)

Payne Knight, Sir Richard, Bt.	Art collector and writer	1751–1824
Phillips, Henry	Horticulturalist	1779–1840
Phillips, Thomas, RA	Portrait painter	1770–1845
Pickersgill, Henry, RA	Portrait painter	1782–1875
Purton, William	Classicist	1803–1876
Ramsay, Allan	Portrait painter	1713–1784
Redgrave, Richard, RA	Painter and author	1804–1888
Reinagle, Philip, RA	Painter	1749–1833
Reinagle, Richard Ramsay	Painter	1775–1862
Rhudde, Mary (née Shergold)	Maria's grandmother	d.1811
Rhudde, Rev. Durand	Priest; Maria's grandfather	1734–1819
Robinson, Henry Crabb	Diarist and journalist	1775–1867
Romney, George	Portrait painter	1734–1802
Savile, Albany	Member of Parliament	?1783–1831
Shee, Sir Martin Archer, PRA	Portrait painter	1769–1850
Skey, Sarah (see Bicknell, Sarah)		
Smith, John Thomas	Draughtsman, engraver, author and curator	1766–1833
Southey, Robert	Poet	1774–1843
Spedding, Anthony	Solicitor	1776–1837
Stothard, Thomas, RA	Painter and book illustrator	1755–1834
Strowger, Samuel	Soldier and artists' model	d.1827
Taylor, Ann	Poet	1782–1866
Turner, J. M. W., RA	Painter	1775–1851
Wakefield, Priscilla	Author and philanthropist	1750–1832
Ward, James, RA	Painter	1769–1859
Watts, David Pike	Wine merchant, JC's uncle	1754–1816
Watts, John	Naval officer, JC's uncle	1755–1801
West, Sir Benjamin, PRA	Painter	1738–1820
Western, Rear Admiral Thomas, RN	Naval officer	1762–1814
Wilkie, Sir David, RA	Painter	1785–1841
Winter Lake, Sir James, Bt.	Entrepreneur	c.1745–1807
Wordsworth, William	Poet	1770–1850
Wyatt, Matthew Cotes	Painter and sculptor	1777–1862

Abbreviations to Notes

AbramC Abram Constable, JC's younger brother.

AC Ann Constable, JC's mother.

AnnC Ann Constable, JC's sister 'Nancy'.

Balston Thomas Balston, *John Martin 1789–1854: His Life and Works*, 1947.

BJ Martin Butlin and Evelyn Joll, *The Paintings of J. M. W. Turner*, 2 vols., 1984.

BM British Museum.

Burl. Mag. *Burlington Magazine*.

CB Charles Bicknell, JC's father-in-law.

CBS Centre for Buckinghamshire Studies, Aylesbury.

CFP Constable Family Papers.

CGC Charles Golding Constable, JC's son

CRL C. R. Leslie, *Memoirs of the Life of John Constable composed chiefly from his letters*, 1951 edn., edited by Jonathan Mayne, 1951.

CRL, Autobiog. Rec. Tom Taylor (ed.), *Autobiographical Recollections by the late Charles Robert Leslie*, 2 vols., 1860.

Discovery Ian Fleming-Williams and Leslie Parris, *The Discovery of Constable*, Hamish Hamilton, 1984.

DPW David Pike Watts, JC's uncle.

ERO Essex Record Office

FD *Farington's Diary*. Citations are abbreviated thus: volume, page no., date of entry.

FDC *John Constable: Further Documents and Correspondence*, 1975. Citations are abbreviated thus: book title, page no., followed where appropriate by initials of letter writer/recipient, date of letter.

GC Golding Constable, JC's father.

Gent's Mag. *The Gentleman's Magazine*.

GeorgeC George Constable of Arundel.

GH Gainsborough's House, Sudbury.

GoldingC Golding Constable, JC's older brother.

GR Graham Reynolds's catalogues of JC's paintings (see Select Bibliography) with catalogue number.

Hamilton, 1997 *Turner – A Life*, 1997.

Hamilton, 1998 *Turner and the Scientists*, 1998.

Hamilton, 2002 *Faraday – The Life*, 2002.

Hamilton, 2007 *London Lights – The Minds that Moved the City that Shook the World, 1805–51*, 2007.

Hamilton, 2014 *A Strange Business – Making Art and Money in Nineteenth-Century Britain*, 2014.

Hamilton, 2017 *Gainsborough – A Portrait*, 2017.

Hamilton, 2018 *The British Museum – Storehouse of Civilizations*, 2018.

HGL Henry Greswold Lewis.

IJ *Ipswich Journal.*

IRO Ipswich Record Office.

Ivy Judy Crosby Ivy, *Constable and the Critics, 1802–1837*, 1991.

JC John Constable.

JCC John Charles Constable, JC's son

JCC *John Constable's Correspondence*, 6 vols. edited by R. B. Beckett, published by the Suffolk Records Society (see Select Bibliography). Citations are abbreviated thus: volume, page no., initials of letter writer/recipient, date of letter.

JCD *John Constable's Discourses*, Suffolk Record Society series, 1970.

JD John Dunthorne, the elder.

JF Joseph Farington.

JFish Rev. Archdeacon John Fisher.

JTS John Thomas Smith.

LMA London Metropolitan Archives.

MarthaW Martha, Mrs Whalley, JC's eldest sister, 'Patty'.

MaryC Mary Constable, JC's younger sister.

MB Maria Bicknell (before marriage).

MC Maria, Mrs Constable (following marriage).

MWR Mary Watts Russell

NAL National Art Library

NG National Gallery, London.

NPG National Portrait Gallery, London.

ODNB *Oxford Dictionary of National Biography.*

RA Royal Academy of Arts, London.

RBB Roland B. Beckett.

RR Ramsay Reinagle

Shirley Andrew Shirley, *The Rainbow – A portrait of John Constable*, 1949.

Tate Tate Britain, London.

Tate, 1991 Leslie Parris and Ian Fleming-Williams, *Constable*, Tate Gallery, 1991.

Tate, 2006 Anne Lyles, Sarah Cove, John Gage and Charles Rhyne, *Constable: The Great Landscapes*, Tate Publishing, 2006.

Thornbury Walter Thornbury, *Life and Correspondence of J.M.W. Turner*, 1897 edn.

V&A Victoria & Albert Museum, London.

V&A, 2014 Mark Evans, *John Constable – The Making of a Master*, V&A, 2014.

VCH *Victoria County History.*

Yale, CBA Yale Center for British Art, New Haven, CT.

Notes

Introduction

1. *JCC*6, 65, JC/JFish, 1Apr1821.
2. Jonathan Mayne, in *CRL*, xi.
3. Frances Mary Redgrave, *Richard Redgrave, CB, RA, A Memoir compiled from his Diary*, 1891.
4. *JCC*6, 161, JC/JFish, lateMay1824.
5. *JCC*2, 336, MC/JC, 19June1824.
6. *JCC*2, 127, JC/MB, 3July1814.

1. Golden Constable

1. Judith (bapt. 1675): Cavendish Parish Registers, FL 546/4/1 (fiche 2), BRO; Judith (bapt. 1708): Bures St Mary Parish Registers, FL 540/4/5 (fiches 5 & 7), BRO. In fiche 7 John Constable and Judith Garrad are listed as 'both of this parish'. See: www.bures-online.co.uk /garrad. Twentieth-century Garrads are memorialised on the south wall of St Mary's Church.
2. Norfolk RO, Norwich Faculty Book, DN/FCB/4/1, 1786–1793. Cited, Tate, 1991, p. 86.
3. Baptised 20 Nov 1704, FL 540/4/5 (fiche 7), BRO.
4. IRO, HD 345/1. The farmhouse at the roadside exists today as 'Constable's Cottage'.
5. Family tree headed 'Constable of Everingham in Yorkshire and East Bergholt Suffolk', inscribed 'E.D. / June 1839'. The document 'Family of Constable' sets out family history up to the seventeenth century, CFP, GH. See also *JCC*1, 307–11.
6. Correspondence 1847–8 between Edward Dunthorne and Mary Constable is in the Dunthorne Papers, X1/4/41, files 1 and 8, IRO.
7. Will of Abram Constable, PROB/11/900/526.
8. *IJ*, 4, 21, 28July1792.
9. Shirley, p. 34.
10. Will of Abram Constable, PROB/11/900/526.
11. Judith Parmenter, Ann Garrad, Sarah Grimwood and Patty Smith.
12. Flatford Mill and appurtenances had been acquired by Abram in 1742. *JCC*1, 4–5. £1000 Consols at 3 per cent, £1000 Bank of England stock at 4 per cent.
13. *FD*11, 3900, 27Mar1811.
14. The family tree gives AC's birthday as 9 May 1748; but see *JCC*2, 66, JC/MB, 6May1812.

[15] *FD*11, 3900, 27Mar1811; *JCC*6, 267, JC/Mary Fisher, 15Oct1832.

[16] *JCC*6, 146, JC/JFish, 16Dec1823.

2. Family Album

[1] Whether he means in Golding's young life or his early career is unclear. *JCC*1, 191, AbramC/JC, 28Jan1821.

[2] *IJ*, 29July1769. The windmill had been built two years earlier. IRO, HD/11/475/1528. An undershot mill is one where the water power flows under the mill-wheel and turns it anticlockwise. In an overshot mill the water flows from above and turns the mill-wheel clockwise. See: www.bures. online.co.uk/garrad gives a comprehensive family tree of the Garrad family of Bures, showing connections between the Firmins and the Garrads.

[3] Fire insurance certificate, dated 14 Dec 1792, Sun Fire Office, LMA, MS/11936/390/608697.

[4] Settlement on the marriage of Peter Firmin Esq. with Miss Jane Masters, 10 May 1793, ERO, D/DB T 1063; Dedham Churchwardens' Accounts, 1797, ERO D/P 26/5/1. FDC, 114n. Cited Rosenthal, 1983, p. 239, n.13.

[5] *JCC*1, 149, AnnC/JC, 15Dec1816. RBB reads 'bottom' in the last line. However, it is clearly 'Balloon', one of the company's boats.

[6] *IJ*, 7June1788.

[7] Affidavits re floods caused by overflow at Nedging watermill, 1757. Acc.1878/3/1, BRO.

[8] Bowen map: HD 335/1; Bryant map: HD 345/1. IRO. The mill counts are my own.

[9] *JCC*1, 29, AC/JC, 4Mar1809. RBB gives '[Your Father]' as the first two words on this page. Patently, however, it does not read 'Your Father', and to my eye it is illegible. It may refer to a visit from Peter Firmin, whose money kept the Dedham mill running.

[10] Nathaniel Whalley, Cheesemonger, 15 Aldgate. *Johnstone's London Commercial Guide*, 1821, p. 11.

[11] *JCC*1, 16–17, AC/NancyC, 22Dec1789.

[12] *IJ*, 27Oct1792, Suffolk Game Duty, list of Gamekeepers.

[13] *JCC*1, 22, AC/ JC, 2Dec1807.

[14] *JCC*1, 192, AbramC/JC, 28Jan1821.

[15] For example, *JCC*1, 23, MaryC /JC, 9Dec1807.

[16] *JCC*2, 196, JC/MB, 16Aug1816.

[17] Grand Juror: *Bury and Norwich Post*, 1 Aug 1804, *IJ*, 16Aug1806. Guardian: Overseer's Account Book, IRO FB75/91/1; Sheila Hardy, *The House on the Hill: The Samford House of Industry, 1764–1930*, 2001, p. 38.

[18] Diary of John Crosier, Maldon Miller, May 1785, in A. F. J. Brown, *Essex People 1750–1900, from their diaries, memoirs and letters*, 1972, p. 32.

[19] RBB notes, *JCC*1, 6.

[20] *JCC*2, 114, JC/MB, 23Dec1813.

[21] *JCC*1, 279, MC/JC, 18Jan1834. The date is written in by another hand, perhaps taken from the postmark.

22 *JCC*1, 134, AnnC/JC, 17May1816.
23 *JCC*1, 208, AbramC /JC, 27Apr1824.
24 *JCC*1, 86, AC/JC, 22Nov1812.
25 *JCC*1, 62, GC/JC, 26Apr1811.
26 Prestney: *JCC*1, 83; Old Abrams's mother's portrait: 24, MaryC/JC,
 9Dec1807; Old Crosbie (1): 24, MaryC/JC, 9Dec1807; Old Crosbie (2): 301,
 AbramC/JC, 20May1836; Henry Crush: RBB note, p. 22; Gribling: 100,
 MarthaW/JC, 15Jan1814; Gosling: 202, AnnC/JC, 29Oct1821; Hart: 275,
 AbramC/JC, 30Apr1833.
27 *JCC*1, 87, AC/JC, 30Nov1812.
28 *JCC*1, 84, AC/JC, 12Nov1812.
29 *JCC*1, 26, AC/JC, 4July1808; 47, 26July1810.
30 *JCC*1, 34, AC/JC, 17July1809.
31 *JCC*1, 25, 19June1808, AbramC/JC. 'Darby and Joan': *JCC*1, 116, AC/JC,
 7Mar1815. 'Darby and Joan' seems to have first appeared in print in *Gent's
 Mag.* in 1753: Wikipedia.
32 *JCC*1, 25, AbramC/JC, 19June1808.
33 *JCC*2, 31, JD/JC, 21Mar1802.
34 *JCC*1, 95, AbramC/JC, 24May1813.
35 Bligh was later to be ejected from the Bounty by mutineers.
36 See: www.captaincooksociety.com/home/detail/peter-reynolds-1750-1836.
37 Arthur Phillip, *The Voyage of Governor Phillip to Botany Bay . . . compiled
 from authentic papers . . . [including] . . . the journals of Lieuts Shortland, Watts,
 Ball & Captain Marshall . . .* , 1789, ch. XXI, pp. 321ff and 331–58. Watts's
 portrait is facing p. 321. Golding Constable was one of the subscribers
 to the publication. See also: www.captaincooksociety.com/home/detail/
 john-watts-1755-1801.
38 Ibid., p. 347.
39 Obit, *Naval Chronicle*, vol. 5, Jan–July 1801, p. 544.
40 Arthur Phillip, op. cit., facing p. 321. Original miniature, CFP, GH.
41 Years later, in 1833, JC told the story of how Captain Cook promised to
 marry the baby girl to whom he stood a godfather. He kept his promise, and
 eventually married her. RBB suggests that JC may have heard this from his
 uncle John Watts. *JCC*3, 104.

3. East Bergholt

1 For an overview of the history of East Bergholt, see Anne Sanders, 'The
 Landscape of East Bergholt in the Eighteenth and early Nineteenth
 Centuries', parts 1 and 2, *Suffolk Review*, vol. 48 (Spring 2007), pp. 7–23, and
 vol. 49 (Autumn 2007), pp. 12–19. Award of the Commissioners of East
 Bergholt Inclosure, 1 May 1817, IRO, B150/1/4(2).
2 Anon, *Church of St Mary, Stoke-by-Nayland*, Friends of St Mary's, Stoke-by-
 Nayland, 2000.
3 J. F. Elam, *St Mary's Church, East Bergholt. A Building and its History*, East
 Bergholt PCC, 1968, pp. 8–9 and 14–20.

[4] John Kirby, *The Suffolk Traveller*, 1764, p. 63.

[5] A. F. J. Brown, loc. cit.

[6] Frederic Shoberl, *Suffolk, or, Original Delineations . . . of that County*, 1st ed.,
 1813, 1818 ed., p. 225.

[7] A. F. J. Brown, loc. cit.

[8] J. F. Elam, op. cit., p. 43.

[9] 1811 census, quoted Anne Sanders, op. cit., part 2, p. 15.

[10] IRO, X1/4/4.1/File 8, Collections of East Bergholt, Co. Suffolk by Edward
 Dunthorne. See also *IJ*, 11Jan1840.

[11] East Bergholt House burnt down in the 1840s. Only its stables remain. West
 Lodge is now known as Stour House.

[12] Brenda Gamlin, *Old Hall, East Bergholt: The Story of a Suffolk Manor*, East
 Bergholt Society, 1995, pp. 25–6. *ODNB*, Richard Rigby.

[13] Adam's church was demolished *c.*1870, but its twin towers remain.

[14] *IJ*, 31Aug1816. A 'geometrical staircase' turns around a central stairwell and
 has rounded corners.

[15] Shoberl, loc. cit.

[16] *JCC*1, 32–3, AC/JC, two letters, 18 & 26June1809.

[17] John Crosier's Diary, in A. F. J. Brown, op. cit, p. 13. *Swallow* is named as one
 of Golding's craft in his will, PROB 11/1538/476, 30 Aug 1816.

[18] Award of Commissioners of East Bergholt Inclosure, 1817, IRO,
 B.150/1/4/2a, and East Bergholt map 1816, IRO FB/191. Rosenthal,
 1983, suggests that Golding farmed 'no . . . more than ninety-three acres'.
 Although Golding rented further land, this inflated figure is incorrect and
 attributed by Rosenthal to faulty proof-reading. Emails between JH and MR,
 April 2021.

[19] There are many river Stours in England: 'stour' means 'strong'.

[20] B150/1/4(2) a&b, IRO. Typescript copy.

[21] *JCC*2, 167, JC/MB, 14Jan1816.

[22] The twenty-one copyhold acres (copyhold to the Manors of Illaries and Old
 Hall) are those fields furthest from East Bergholt House, north-east.

[23] In January and September 1809, the year of 'the great flood May 1st 1809',
 Golding bought 26½ bushels of wheat from John Gosnall, and from 1815
 or earlier he and Abram rented a nine-acre field listed as 'Cow Pasture' from
 East Bergholt's charities, £30pa in 1828. Farming account book, 1808–10,
 HB1/18a/1/26, IRO; East Bergholt Charities, 10 June 1815, 106/9/7,
 document signed by D. Rhudde, Rector, and Golding Constable as one of
 four feofees, 106/9/7, IRO; East Bergholt Charities, 1828, no. 4, payments to
 'Burnt Oak or Cloth Charity'. FB191/L1/1, IRO.

[24] David Lindley, 'The weather in East Anglia', The Foxearth and
 District Local History Society. Available at: https://foxearth.org.uk/
 EastAnglianWeather.html

[25] Ibid.

[26] *JCC*1, 66, AC/JC, 27Aug1811.

[27] Arthur Young, *The Farmer's Tour through the East of England*, 1771, vol. 2,
 Letter XVI, p. 219.

[28] Ibid., pp. 191 and 201.

[29] 'All her farming stock, implements of husbandry, dairy and brewing utensils, some household furniture, &c, comprising a capital bay mare, 5 years old, fit for the road or hunting, a chesnut [sic; traditional Suffolk spelling] cart stallion, 5 years old, 7 cart mares and geldings, 2 year-old cart colts, 2 suckrels, 2 fat heifers, 4 milch cows, 6 fallow ditto, in very forward condition; 2 road waggons, 2 tumbrels, a quarter cart, 2 gangs of harrows, 2 wheel ploughs, rolls, cart and plough trace, 3 barrel churns, 2 butter stands, and milk keepers, mash and guile tubs, and sundry other articles, which will appear in catalogues.' *IJ*, 6Oct1792, to be held at the White Hart, Wix. This may be Mary Constable (1741–1792), GC's sister, and thus a posthumous sale. There is a plaque to her high on the north wall of the chancel of St Mary's, Bures.

[30] Stour Navigation Act, 1705.

[31] Andrew Clarke, 'Navigation in the River Stour', The Foxearth and District Local History Society. Available at: https://foxearth.org.uk/TheStourNavigation.html

4. The Don and the Friday

[1] *JCC*2, 85, JC/MB; *JCC*1, 86n.

[2] *JCC*1, 135, Wren Driffield/JC, 22May1816.

[3] VCH, Essex; see: www.british-history.ac.uk/vch/essex/vol10/pp9-13#anchorn53. Anthony Bailey, *John Constable, A Kingdom of his Own*, 2006, pp. 3–4.

[4] https://theclergydatabase.org.uk/jsp/persons/index.jsp.

[5] *IJ*, 12 July 1788, and 14 July 1792.

[6] Linguard Rawson, *Lavenham, Suffolk*, 1958, p. 60. I am grateful to Fiona and Tom Carville who kindly showed me over their house.

[7] CRL, p. 4.

[8] JC's copy of *Juvenile Introduction to History*, is V&A, L.2677-1968. *FDC*, 41 & 48. Thomas Day, the author of *Sandford and Merton*, a friend of Charles Bicknell's brother John, had a curious history. See *ODNB*, and Gayford, pp. 39–43. Thirteen-year-old JC seems to have acquired this book long before he was seriously aware of the Bicknells.

[9] Tate 1991, p. 19.

[10] The timber fragment is coll. Victor Batte-Laye Trust, The Minories, Colchester.

[11] CRL, pp. 3–4; *JCC*2, 336, MC/JC, 19June1824.

[12] GR, 91.3; CFP, GH.

[13] *IJ*, 28July1792, and passim. The drawings are in CFP, GH.

[14] *JCC*2, 2.

[15] The scrapbook was sold by Sotheby's, Dec 2020, lot 208, bt.: Colchester and Ipswich Museums. The Masons are descendants of JC's aunt Judith Parmenter, Golding's eldest sister.

[16] GR, 94.1–3.

17 Victor Batte-Laye Trust, The Minories, Colchester; and Art Institute of Chicago; GR, 95.1,2,3.

18 Married 5 Sept 1793; reported *IJ*, 7Sept1793. East Bergholt Marriages 1754–1804 (Grooms), see: www.essexandsuffolksurnames.co.uk. The building survives; it is now (2019–20) a bakery and cake shop.

19 *JCC*1, 115, AC/JC, 7Mar1815.

20 A piece of lead, snipped from the roof in the 1970s, is signed and dated 'J. Dunthone/1796'. My thanks to the late Pansy Cooper for showing this to me in 2019.

21 *JCC*1, 72, AC/JC, 10 Dec 1811; AbramC/JC, 19Jan1812.

22 *JCC*2, 31, JD/JC, 21Mar1802; CRL, 3.

23 Label in the cello: 'JOHN DUNTHORNE, East Bergholt, Suffolk, March 11th 1803.' Christchurch Mansion, Ipswich, 1942-20A. See Brenda Neece, 'The Cello in Britain', *Galpin Society Journal*, vol. 56 (June 2003), pp. 199–214.

24 *FDC*, 54, Lucas annotations to CRL.

25 Ibid.

26 RBB suggests that this might be a later stage in their friendship, *JCC*2, 22. It is imaginative, and significant, that East Bergholt is today twinned with Barbizon in France.

27 *ODNB*, John Dunthorne.

28 *JCC*2, 21–36.

29 Will of John Dunthorne, PROB 11/2015/271, proved 15 April 1845.

30 *IJ*, 2Nov1844. *ODNB*, John Dunthorne. See also article by Michiel Plomp in *John Constable*, Teyler's Museum, Haarlem, Thoth Publishers, 2020, p. 201, n.2.

31 *JCC*6, 181, JC/JFish, 17Nov1824.

5. The Grand Caesar

1 Will of Brooke Hurlock, 1804, PROB/11/1406/320.

2 Will of James Hurlock, 1776, PROB 11/1026/42. Mortgage and other documents: HA 517/36, 37, 39, B45, 1794–1799, BRO. The properties were mortgaged to Hurlock at 5 per cent pa interest by John Timms Harvey Elwes.

3 HD 1382/2/11, 15, BRO. Agreements between Rev. Brooke Hurlock and Thomas Jackson.

4 John Rhudde, *A Letter to the Protestant Dissenting Congregation . . . in . . . Wapping . . . Occasioned by their Late Procedings against the Author, on his Profession of Unitarianism*, 1734.

5 My thanks to Sally Gilbert and Stephen Freeth, MT Archivists. E. P. Hart, *Merchant Taylors' School Register 1561–1934*, 1936, lists Rhudde's Cambridge college as Queens.

6 Mark of 'Edward Wakelin, London 1750'. Sold Christie's, 13 Dec 2019, lot 17.

7 CBS, D-W/34/13–14, 23 May 1776.

8 CBS, D14/8/6, 7, 18 May 1776.

9 See: www.theclergydatabase.org.uk/jsp/persons/CreatePersonFrames.jsp? PersonID=114795

10 *JCD*, 94.

11 Rev. Durand Rhudde, DD, *A sermon preached at the Anniversary Meeting of the Sons of the Clergy, in the Cathedral Church of St. Paul, on Thursday May 20, 1790*. Text: Epistle of St James, ch. 1, v. 27. Bodleian Library, G.Pamph.996 (1). 'Preaching for a bishopric': a remark of Mary Delany, in Augusta Hall, ed., *The Autobiography and Correspondence of Mary Delany, Mrs Granville*, vol. 2, p. 289. See also, Clarissa Campbell-Orr, *Mrs Delany: A Life*, 2019.

12 Will of William Bogdani, PROB 11/1191/186. See also Leslie Dow, 'The Rhudde family' Appendix D, *JCD*, pp. 93–6.

13 *IJ*, 19Jan1788, and *passim*.

14 PROB/11/1162/22, proved 1 Feb 1788. Note in margin re grant to Dr Rhudde 9 April 1811.

15 *JCC*1, 67, AC/JC, 26Oct1811.

16 *JCC*1, 160, AbramC/JC, 23Feb1817.

17 GR, 99.10. National Trust, Anglesey Abbey. See also: www.familysearch.org/ark:/61903/1:1:J7MR-V31

6. Young Baronet and Bishop-in-Waiting

1 Felicity Owen and David Blayney Brown, *Collector of Genius: A Life of Sir George Beaumont*, 1988, p. 8.

2 JC to William Wordsworth, 15 June 1836, Wordsworth Library, Grasmere, G/1/13/4.

3 *JCC*2, 1–2; FDC, 142; Letterpress to *English Landscape*, quoted *JCD*, p. 13n.

4 GR, 95.4.

5 Thomas Spring Rice, Lord Monteagle, in evidence for *Report of the Select Committee on the National Gallery*, 1853, para. 5080 cited Humphrey Wine, *The Seventeenth-Century French Paintings*, National Gallery, 2001, p. 114; CRL, p. 5.

6 George Jones, 'Recollections of J. M. W. Turner', in John Gage, *Collected Correspondence of J. M. W. Turner*, 1980, p. 4.

7 CRL, p. 5.

8 *FD*1, 233, 15Sept1794. A pen and wash study, *The River Stour at Dedham*, *c.*1790, by Beaumont is in Tate Britain, T01231.

9 See Horace Walpole, vol. 26, iii, 494, 1748: 'assembly at [Dedham] threatens Europe with a new war.' There is a pencil drawing by JC, *c.*1795, of Dedham High Street, sold in 1962 in aid of the Friends of Essex Churches. GR, 95.5.

10 *IJ*, 16Aug1788.

11 *ODNB*, John Fisher, 1748–1825.

12 He would become Queen Victoria's father.

13 Sarah C. Woolsey (ed.), *The Diary and Letters of Fanny Burney*, 1880, vol. 1, p. 419, 14 Jan 1788.

14 John Johnstone (ed.), *The Works of Samuel Parr, D.D.*, vol. 1, 1828, p. 749, 'Gallery of Dignitates' by 'Episcopus Episcoporum'.

[15] Cornelia Knight, *Autobiography*, 1861, vol. 1, p. 233.

[16] Woolsey, op. cit., 1 Jan 1788.

[17] A. Hayward (ed.), Hester Thrale (Mrs Piozzi), *Letters and Literary Remains*, 1861, vol. 2, p. 367.

[18] *JCC*6, 12, RBB notes.

[19] *JCC*2, 1.

[20] Examples of Fisher's work in the Royal Collection include www.rct.uk/ collection/917772/richmond

[21] *FD*9, 3204, 19Jan1808.

[22] Richard Cobbold, *The History of Margaret Catchpole, A Suffolk Girl*, 1846, p. 77. There are many other editions of this book.

[23] *JCC*1, 33, AC/ JC, 26June1809.

[24] *JCC*2, 90, JC/MB, 25Oct1812.

[25] My thanks to Alicia Herbert for this information.

[26] *JCC*1, 80, AC/JC, 12June1812.

7. This Cardinal Purpose

[1] *London Directory*, 1776.

[2] *JCC*1, 209, MC/JC, 8May1824.

[3] Linnean Society Fellows database. I am grateful to Luke Thorne for this reference.

[4] *Making History: Antiquaries in Britain, 1707–2007*, RA, 2007. Hamilton, 2007, ch. 2.

[5] He seems to have been in partnership with Robert Allen (a brother?) from 1792. *London Directories*, 1792, 1796 and 1798–1800. Farington describes him as 'a brewer' as late as 1813. *FD*12, 4298, 13Feb1813.

[6] *JCC*1, 267, and *FDC*, 196.

[7] *Trans. Baptist Hist. Soc.* iv. 58–63, quoted A. P. Baggs, Diane K. Bolton, Eileen P. Scarff and G. C. Tyack, 'Edmonton: Protestant nonconformity', in *A History of the County of Middlesex: Vol. 5*, ed. T. F. T. Baker and R. B. Pugh (London, 1976), pp. 188–196, available at: www.british-history.ac.uk/ vch/middx/vol5/pp188-196. See also William Robinson, *The History and Antiquities of the Parish of Edmonton*, 1819, pp. 184–6.

[8] J. T. Smith, *Remarks on Rural Scenery*, 1797, p. 22.

[9] There is a Blue Plaque on the side of 335 Firs Lane, Edmonton, marking the approximate site of Fir Hall. The Hudson's Bay Company trading post Fort Edmonton, named after Lake's home town, grew into the Canadian city of Edmonton, Alberta. D. M. Cruden, 'Sir James Lake Bart., The Firs, Edmonton', *History Society of Alberta*, 2004. William Robinson, op. cit., pp. 72–3, lists Winter Lake erroneously as FRS, rather than FSA. The heart of old Edmonton was destroyed in the 1960s and 1970s, and is buried under shopping centres, a bus station and roads.

[10] *JCC*2, 9, JC/JTS, 16Jan1797.

[11] Referred to in Smith, *Remarks on Rural Scenery*, p. 19. JC had a copy of the 1782 edition, *FDC*, 27.

[12] William Wadd, in *The Roll of the Royal College of Physicians*, 1878, quoted *FDC*, 198.

[13] *JCC2*, 5, JC/JTS, 27Oct1796; *FDC*, 195–9; J. T. Smith, *Nollekens and his Times*, 1828, vol. 1, p. 194. A proof of the portrait of Adams by Smith is in the Wellcome Collection, London.

[14] *JCC2*, 4–16.

[15] 'Painter's Reading', *FDC*, 199–201.

[16] C. R. Leslie and Tom Taylor, *Life and Times of Sir Joshua Reynolds*, 1865, vol. 1, pp. 15–16 and 23.

[17] I received similar advice in the 1980s from Dr David Brown (1925–2002), then Assistant Keeper at the Tate Gallery: 'You should always look at bad pictures,' he told me. 'They keep your eye in.'

[18] For a further clear overview of Cranch's advice, see V&A, 2014, pp. 16–20.

[19] *JCC2*, 5, JC/JTS, 27Oct1796.

[20] Not the copy he had as a young man, but one which had been owned by, successively, James Barry, Charles Fox and George Field. It is inscribed 'To John Constable Esqre RA. 1829', probably by Field.

[21] Constable's Library, *FDC*, 25–52.

[22] Smith, op. cit., p. 24.

[23] A remark within JC's second lecture on Landscape Painting, Royal Institution, *JCD*, p. 53.

[24] Samuel Redgrave, *Dictionary of Artists of the English School*, 1874, pp. 104–5.

[25] *JCC2*, 23, JC/JD, 4Feb1799.

[26] See *ODNB*, and Arnold Wilson, 'Eccentric Painter of the Rustic Genre: John Cranch, of Bath', *Country Life*, October, 1972, pp.906–8. A pamphlet *On the Economy of Testaments* (1794) was written by another John Cranch, possibly this one's father.

[27] *JCC2*, 23, JC/JD, 4Feb1799. John Cranch, *Narrative relating to the real embalmed head of Oliver Cromwell, now exhibiting in Mead-Court, in Old Bond-Street*, 1799.

8. Smith and Gainsborough

[1] *JCC2*, 5–6 & 9, JC/JTS, 27Oct&9Nov1796, & 16Jan1797. GR, 96.5–17. Another drawing for Smith was found in the Mason family scrapbook sold Sotheby's Dec 2020, lot 208, bt.: Colchester and Ipswich Museums.

[2] *JCC2*, 15, JC/JTS, 2Dec1798.

[3] *JCC2*, 8, JC/JTS, 2Dec1796.

[4] *JCC1*, 12, JC/GC, 11Aug1796.

[5] See: www.historyofparliamentonline.org/volume/1754-1790/member/atkinson-christopher-1738-1819]

[6] *JCC1*12, JC/GC, 11Aug1796.

[7] John Thomas Smith, *Remarks on Rural Scenery, with Twenty Etchings from Nature, and some observations and precepts relative to the picturesque*, 1797.

[8] *JCC2*, 10, JC/JTS, 23Mar1797.

9 *JCC*2, 11, JC/JTS, 7May1797.

10 *JCC*2, 14, AC/JTS, 2Oct1797.

11 *JCC*2, 15, JC /JTS, 2Dec1798.

12 Priscilla Wakefield's diary, 29 Jan 1799; *FDC*, 129.

13 *FDC*, 143; *JCC*2, 163; *FD4*, 1164, 25Feb1799.

9. A lusty young man

1 Henry Trimmer, in Thornbury, p. 264. JC uses 'Bargell' for 'Bergholt' in
 a letter to his brother Golding of 1828, *FDC*, 80. See also Edward Moor,
 Suffolk Words and Phrases, 1823, p. xvii, where 'Bergholt' is 'Barfel'.

2 V&A, 589-1888.

3 *JCC*2, 5, JC/JTS, 27Oct1796.

4 *JCC*2, 7, JC/JTS, 2Dec 1796.

5 *JCC*2, 9, JC/JTS, 16Jan1797.

6 CRL, p. 4.

7 *JCC*2, 10–11, JC/JTS, 23Mar1797.

8 They were married in December 1800. *Stamford Mercury*, 12 Dec 1800.

9 *JCC*2, 19–20, Lucy Hurlock/JC, 9Apr1800.

10 GR, 00.4-7, coll. V&A and the Whitworth Art Gallery, Manchester. A
 version of GR, 00.5 is coll. Ashmolean Museum, Oxford.

11 https://essexandsuffolksurnames.co.uk/wp-content/uploads/2018/12/
 dedham-baptisms-1774-1812.pdf

12 GR, 00.9. See C. Attfield Brooks, *The Dedham Lectureship*, 1983.

13 The Diary of Daniel Whalley, 25 July, 11, Sept, 7 & 23 Oct 1801, *FDC*,
 71–2.

14 Tate, 6130. GR, 04.1.

15 BM, 1971, 1030. 16. GR,07.6.

16 GR, 07.6 names Amy Whitmore erroneously as 'Ann'.

17 Cobbolds: GR 06.14-16. 06-14 inscr. 'Sophia / June 11 1806', Louvre.
 Hobsons, Emma, Susannah, Ann, Laura and Lydia: GR 06.28-77, and 80-84,
 Louvre, BM, Horne Foundation Florence, and Yale.

18 Joseph Gilbert (ed.), *Autobiography and other memorials of Mrs Gilbert*,
 (formerly Ann Taylor), 3rd edn, 1878, pp. 91–2.

19 *FD6*, 2060, 20June1803.

20 *FD6*, 2046, 4June1803.

21 *JCC*1, 25, AbramC/JC, 19June 1808.

22 Government Art Collection, acquired 1994, GR, 08.7. See: www.
 artcollection.culture.gov.uk/artwork/16867/

23 *JCC*1, 35, AC/JC, late July–August1809.

24 *JCC*6, 70, JFish/JC, 19July1821. 'Miss Webber' was Harriet Webber of
 Salisbury, later Mrs Heniage (*JCC*6, 56n.), and 'Miss Cookson' was Fisher's
 wife's sister (*JCC*6, 72, JC/JFish, 4Aug1821).

25 *JCC*2, 44, CB/MB, 10May1798.

10. Devoted to art

1 *FD4*, 1164, 25Feb1799.
2 *FD4*, 1167, 4Mar1799.
3 *FD4*, 1164, 26Feb1799.
4 *JCC2*, 22, JC/JD, 4Mar[Feb written]1799. A drawing of the head of the Apollo Belvedere is GR, 00.25.
5 *JCC2*, 23, JC/JD, 4Feb1799.
6 *JCC2*, 16–17, JC/JTS, 18Aug1799.
7 For lists of RA students see Sidney C. Hutchinson, 'The Royal Academy Schools, 1768–1830', *Walpole Society*, vol. 38 (1960–62), pp. 123–91.
8 *FD4*, 1316, 4Dec1799. *JCC2*, 23.
9 According to a later inscription on the back of the canvas Constable accepted the offer of the senior portrait painter, John Hoppner RA to improve the portrait, 'suggesting some alteration in my scheme of colouring ... much to his and my satisfaction.' Inscription in JC's hand, dated 1[?83]5. GR, 00.10.
10 See F. G. Notehelfer, 'The strange case of Ramsay Richard Reinagle (1775–1862), *BAJ*, vol. 21, no. 1 (Spring 2020), pp. 20–31.
11 Alistair Smart, *Allan Ramsay: Painter, Essayist and Man of the Enlightenment*, 1992, p. 217.
12 22 March 1847. RA Archive, CL/3/1/1
13 *FDC*, 268, R. Reinagle/anon female correspondent, 20June1848.
14 *FD8*, 3106, 15Aug1806.
15 *JCC2*, 16, JC/JTS, 18Aug1799.
16 Tate Britain and Colchester and Ipswich Museums, GR, 04.11, Tate 3902. The more accomplished version, in the Tate, has been catalogued as by Constable, but it is here given to Reinagle. See also F. G. Notehelfer, 'Constable and the "Woodbridge Wits"', *Burlington Magazine*, vol. 141 (Sept 1999), no. 1158, pp. 531–6.
17 *JCC2*, 16, JC/JTS, 18Aug1799.
18 *JCC2*, 24, JC/JD, Spring1800.
19 *FDC*, 115, Peter Firmin/JC, 30Aug1807. It is clear from this letter that by 1807 JC had already been to Helmingham to copy a picture: '[Dysart] asked if [it was] the Mr Constable who had Copied the Picture at Helmingham'.
20 GR, 00.1-3.
21 GR, 00.2, Leeds Art Galleries, 5/38
22 *JCC2*, 25, JC/JD, 25July1800.
23 *FD4*, 1516, 9Mar1801.
24 *JCC2*, 26, JC/Dunthorne, n.d. [early 1801].
25 Location unknown. The painting which Tate, 1991, published as Reinagle's *View of Dedham Vale during the Floods in 1799* (p. 100, fig. 32) has been identified as by Constable. Sotheby's, 6 Dec 2017, lot 40. See ch. 19.
26 Seven male nude studies have survived, GR, 00.18-24, V&A and Colchester and Ipswich Museums.
27 Reported CRL, p. 23 as 1811. See also *FDC*, 142ff.
28 *FD4*, 1397, 22May1800.
29 *FD4*, 1576, 13July1801. GR, 01.1.
30 *FD9*, 3431, 3Apr1809.

³¹ *FD*6, 2288, 1Apr1804 (Easter Sunday)

11. Boldness, care and patience

¹ John Davy (ed.), *The Collected Works of Sir Humphry Davy*, vol. 4, 'Elements of Chemical Philosophy', 1839, p. 43.
² See Hamilton, 2002, 2007 and 2014.
³ *JCC*2, 24, JC/JD, n.d. [spring 1800].
⁴ James Barry, Lecture 6, 'On Colouring', 1793; John Opie, Lecture 1, 'On Design', 1807; Henry Fuseli, Lecture 4, 'Invention (continued), 1801–2. Ralph N. Wornum, *Lectures on Painting by the Royal Academicians Barry, Opie and Fuseli*, 1848, pp. 216, 256, 435.
⁵ *FDC*, 200, 'Painter's Reading', notes written by John Cranch for JC, 1796. Gerhard van Lairesse, (trans. J. F. Fritsch), *The Art of Painting in all its Branches*, 1738.
⁶ *FDC*, 32, 'Constable's Library'.
⁷ Gerhard van Lairesse, op. cit., p. 3.
⁸ Fuseli, Lecture 6, 'Chiaroscuro', 1801–2, Wornum, op. cit., pp. 478–9.
⁹ *JCC*5, 14, JC/GC, 9Dec1833.
¹⁰ See Eric Shanes, 'Dissent in Somerset House: Opposition to the political *status-quo* within the Royal Academy around 1800', *Turner Studies*, vol. 10, no. 2 (Winter 1990), pp. 40–6.
¹¹ *FD*4, 1181, 22Mar1799.
¹² *FD*3, 947, 15Dec1797; *FD*7, 2525, 27Feb1805.
¹³ *FD*4, 1124, 1Jan1799.
¹⁴ *FD*3, 1078, 29Oct1798.
¹⁵ *FD*6, 2403–4, 4Sept1804.
¹⁶ Published 1798, inscribed 'John Constable Jan 7 1802'. CFP, GH; *FDC*, 45. CRL, p. 12n; *JCC*2, 27. The drawings themselves are untraced.
¹⁷ *JCC*2, 27–8, JC/JD, 8Jan1802.
¹⁸ CRL, p. 13; *JCC*2, 28; CRL Autobiog. Rec., p. 43.
¹⁹ *JCC*2, 118, JC/MB, 19Feb1814.

12. Constable's Seven Articles

¹ *JCC*2, 25, JC/JD, n.d. [early 1801].
² *JCC*2, 26, JC/JD, n.d. [early 1801].
³ *JCC*2, 24, JC/JD, n.d. [spring 1800]; *JCC*2, 26, JC/JD, n.d. [1801]; *JCC*2, 30, JC/JD, n.d. [?spring 1802].
⁴ *JCC*1, 72, AC/JC, 10Dec1811; AbramC/JC, 9Nov1812; JCC1, 33, AC/JC, 26June1809.
⁵ *JCC*2, 26, JC/JD, n.d. [early 1801].
⁶ Commissioned by the embroiderer Mary Linwood. *JCC*2, 28, JC/JD, 8Jan1802.
⁷ *JCC*2, 23–6, JC/JD, 4Feb1799 [?spring 1800–?late spring 1801].
⁸ *JCC*2, 32, JC/JD, 29May1802.

9 *JCC*2, 29, JC/JD, 29May1802.

10 The Bible and prayer book are CFP, GH. See also *FDC*, 38.

11 *JCC*2, 27–8, JC/JD, 8Jan1802.

12 *JCC*2, 30, JD/JC, 21Mar1802.

13 Colchester and Ipswich Museums, 1942.20A. The cello is labelled with the date 11 March 1803.

14 GR, 04.17; NPG, 901.

15 Balston, p. 184.

16 *JCC*2, 29, JC/JD, n.d. [spring 1802]. The identification of 'Edge of a Wood', GR, 02.1, Art Gallery of Ontario, Toronto, as JC's first exhibit has been discredited.

17 *FD*5, 1764, 6Apr1802.

18 *JCC*6, 158, JC/JFish, 8May1824.

19 *FD*6, 2031, 17May1803.

20 *FD*8, 2988, 13Mar1806.

21 Thornbury, p. 264.

22 *FD*6, 2034, 21May1803.

23 Colchester and Ipswich Museums; GR, 15.22,23. Stephen Daniels, 'Love and death across an English garden', *Huntington Library Quarterly*, vol. 55 (1992), no. 3, pp. 433–57.

24 *FD*4, 1515, 7Mar1801.

25 CRL, p. 14.

26 Four highly competent topographical ink and wash drawings of Windsor and Eton subjects are GR, 02.2-5.

27 *FD*5, 1779, 17May1802.

28 *JCC*2, 31, JC/JD, 29May1802.

29 *FD*6, 2238, 9Feb1804.

30 *JCC*2, 34, JC/JD, 23May1803.

31 *FDC*, 71, Daniel Whalley's diary, 28July1801.

32 *FD*5, 1591, 19Aug1801. JC drawings GR, 01.2-33.

33 *JCC*2, 33, JC/JD, 23May1803. JC drawings GR, 03.21-44.

34 *FD*4, 1568, 29June1801.

35 Court Baron, East Bergholt, 9 Sept 1802; *JCC*1, 14. *FD*6, 2340, 1June1804.

36 *FD*5, 1764, 6Apr1802.

13. Portraits prevail too much

1 *FD*5, 2031, 19Mar1803. For an overview of Constable's portrait painting, see Martin Gayford and Anne Lyles, *Constable Portraits: The Artist and his Circle*, NPG, 2009.

2 *JCC*2, 31, JD/JC, 21Mar1802.

3 Ibid.

4 *FD*6, 2340, 1June1804.

5 That Dunthorne had a significant production of local portraits is shown in the remark of one of his sons, who 'related in his old age in 1842 that "his father's local portraits were parted with some time since"'; 'Diary of William

Wire, Watchmaker and Postman of Colchester 1842–57', *Essex People 1750–1900*, 1972, p. 166.

[6] GR lists nine portraits painted across those five years; none seem to be of 'farmers . . . their children and relatives': GR, 01.36; 04.1, 4, 10-13; 05.57 & 58.

[7] *FD*4, 1576, 13July1801.

[8] *JCC*2, 108, JC/MB, 30June1813. A letter to JC from the East Bergholt curate Henry Kebbel (*JCC*1, 58, 12Mar1811) suggests that the going rate for an oil portrait in London was 50 to 100 guineas. JC would not expect to charge anywhere near that sum.

[9] Tate Britain, 6130; GR, 04.1.

[10] Now divided into apartments, its grounds a gated housing estate.

[11] Note written and signed, *c.*1910, by W. T. Bridges, George Bridges' great-grandson. CFP, GH. D.S. MacColl, 'Constable as a Portrait-Painter', *Burl. Mag.*, XX, 1912, pp.267–73; Anon, 'John Constable at Lawford Place', *Xylonite Magazine*, 106, Sept. 1953, p.9.

[12] GR, 04.4.

[13] *JCC*1, 60, AC/JC, 16Mar1811.

[14] Cobbold drawings: GR, 06.14-21; Hobson drawings: GR, 06.28-83.

[15] https://family-tree.cobboldfht.com/tree/view/person:56/marriage:147

[16] Sketchbook in Louvre, also BM, and Exeter, Royal Albert Memorial Museum. Gubbins drawings: GR, 06.86.

[17] BAC, Yale, B1976.2.5.

[18] *JCC*2, 133, JC/MB, 2Oct1814.

[19] *JCC*1, 91, AC/JC, 9Feb1813.

[20] *JCC*1, 120, AC/JC, 12Mar1815. See also: A. Liptrap to Mrs N. Whalley, 19 Aug 1819. CFP, Tate Archive.

[21] See *JCC*4, 48. Thanks to Victor Gray, Archivist of Helmingham Hall. GR, 08.5. St Mary's Helmingham, parish Register, ref 2119, marriage: 6 Sept 1805. See: www.fullerfamilyhistory.org.uk/Marriages/FFH_Mar_Data_00357.html The portrait remained in the Dysart family at Stobo Castle in Peeblesshire until it was sold in 1972. Sotheby's Stobo Castle sale, 10/11 April 1972. I am grateful to Michael Tollemache Fine Art, London, for supplying a photograph of this painting.

[22] Tate, T03901, GR, 15.9.

[23] *JCC*2, 87, JC/MB, 28Sept1812.

[24] LMA, MS 11936/389/607348, 28 Nov 1792. *JCC*4, 175–6, W. Thane/JC, 27Feb1836; *FDC*, 292–3.

[25] James Ward to J. G. Pratt, n.d., c.1805, Fitzwilliam Museum, Cambridge, quoted Hamilton, 2017, pp. 314–15.

[26] *FD*7, 2565, 1June1805. Graham Reynolds, 'Constable's Brantham Altar-Piece', *Emmanuel College Magazine*, Vol. 75 (1992–93), pp. 37–40. The painting now hangs outside the library of Emmanuel College, Cambridge. A full-size framed colour photograph hangs in the chancel of St Michael's, Brantham. GR, 05.2. According to a pencil study by JC the painting originally hung within a five-arch gothic structure behind the altar. GR, 05.5.

[27] *JCC*1, 74, GC/JC, 31Dec1811.

[28] Annuity: *JCC*1, 109, AC/JC, 6Dec1814: GC 'directed a certain sum – whether he said one or two thousand pounds I cannot say – to be laid out in an annuity that you might be at <u>certainty</u> not to <u>want</u> & this he said would make <u>his death bed easy</u>.' See also *loc. cit.*, 112, 29Jan1815.

[29] *JCC*1, 29, AC/JC, 12Jan1809.

[30] *JCC*4, 12–13, DPW/JC, n.d. [prob. 1805/06].

[31] *JCC*1, 63, AC/JC, 28Apr1811.

[32] *FD*7, 2712, 10Apr1806.

[33] *FD*8, 3153, 1Dec1807.

[34] *Gent's Mag.*, vol. 86, part 2, Aug 1816, pp. 182–4.

[35] *JCC*, 51, AC/JC, 29Nov1810.

[36] *FD*8, 3170, 15Dec1807.

[37] V&A, GR, 02.7.

[38] GR, 01.40; 02, 9; 02.13.

[39] Sotheby's, 4 Dec 2020, lot 208, bt.: Colchester and Ipswich Museums. *Portrait of Abram Constable*, Colchester and Ipswich Museum, GR, 06.295.

[40] *JCC*1, 25, AbramC/JC, 19June1808.

14. Through the walls we flew

[1] CRL, p. 18.

[2] Jessy Harden's Journal, 8 Sept 1806. Quoted Daphne Foskett, *John Harden of Brathay Hall 1772–1847*, 1974, p. 29.

[3] *FD*9, 3491, 19June1809.

[4] Quoted Juliet Barker, *Wordsworth – A Life*, 2000, p. 200.

[5] William Hazlitt, 'Mr Wordsworth', *Spirit of the Age: or, Contemporary Portraits*, 1825.

[6] *FD*8, 3162–5; see also *JCC*4, 241, and *JCC*5, 74, 12Dec1807.

[7] FDC, 78, W. Wordsworth/Minna and Isabel Constable, 6June1844. Burgess Collection, University of Oregon Library.

[8] *FD*, vol. 8, p. 3164, 12 Dec 1807.

[9] *JCC*, vol. 2, p. 32, JC to JD, 29 May 1802. There is an allusion to Coleridge here, suggesting that he too was present at Brathay, though it is not entirely clear that he was.

[10] William Wordsworth, *The Prelude*, Book II, ll. 131–6.

[11] Isabella Fenwick, note to 'Ode: Intimation of Immortality'. Grosart, *Prose Works of William Wordsworth*, 1873, vol. 3, p. 194. Quoted, Gill, op. cit., p. 33n.

[12] V&A, 794-1888, GR, 06.198; and 192-1888, GR, 06.204.

[13] *JCC*2, 25, JC/JD, 25July1800.

[14] *JCC*2, 29, JC JD, ?spring1802.

[15] See Jonathan Bate, *Radical Wordsworth*, 2020, Part One.

[16] GR, 06.186-286.

[17] Leeds City Art Galleries, 13.61/53. GR, 06.227. *JCC*5, 5 & 6, 25Sept1806; and *JCC*4, 12 & 62.

[18] Jessy Harden's Journal, 13 Sept 1806, quoted Foskett, *op. cit.*, p. 30. Portrait

of Jessy Harden, GR, 06.196.

[19] *JCC*5, 4 & 6, 15Sept & 17Oct1806; *FD*9, 3491, 19Sept1809. Portrait of
James Lloyd, GR, 06.290; other Lloyd portraits GR, 06.289, 291, 292.

[20] BM, 1896-8-21-18; GR, 06.194.

15. Industrious, temperate and plainly dressed

[1] *JCC*4, 16–18, DPW/JC, 8June1808, 29Jan1810, CFP, Tate Archive.

[2] *JCC*4, 13, DPW/JC, 3Oct1807. CFP, Tate Archive.

[3] GR, 07.1-5. *Keswick Lake* is coll. National Gallery of Victoria, Melbourne.

[4] *St James's Chronicle* reported briefly on JC's Lake District paintings: Ivy, 07.1.

[5] Crabb Robinson to Dorothy Wordsworth, 13 Dec 1824, E. J. Morley (ed.),
The Correspondence of Henry Crabb Robinson with the Wordsworth Circle, 1927,
vol. 1, p. 134. See also J. R. Watson, 'Wordsworth and Constable', *Review of
English Studies*, Nov 1962, vol. 13, no. 52, pp. 361–7.

[6] JC to W. Wordsworth, 15 June 1836, Wordsworth Grasmere Library
Archive, WLMS G/1/13/4. Mark L. Reed, 'Constable, Wordsworth and
Beaumont: A new Constable letter in evidence', *Art Bulletin*, no. 3 (Sept
1982), pp. 481–3.

[7] *JCC*4, 13, DPW/JC, 3Oct1807. CFP, Tate Archive.

[8] Ibid.

[9] *JCC*1, 42, AC/JC, 15Apr1810.

[10] *FDC*, 115, Peter Firmin/JC, 30Aug1807.

[11] *FD*8, 3142, 16Nov1806. The house in Pall Mall was demolished in 1836
to make way for the Reform Club. Among these portraits are GR, 07.8-10,
12.62-64 and 23.89.

[12] *FD*8, 3142, Mon16Nov1806.

[13] Which one is not known.

[14] These Dysart histories are told on the monuments in St Mary's Church,
Helmingham, and in Burke's *Peerage, Baronetage and Knightage*, 100th edn,
1953, p. 699.

[15] *JCC*1, 20, AC/JC, 23June1807.

[16] *JCC*1, 26, AC/JC, 4July1808.

[17] 'I do hereby certify that <u>Mr John Constable of</u> 13 Percy Street in the Parish
of Saint Pancras in the said County did on the <u>5th</u> day of February 180<u>8</u>
find and provide <u>Jas West</u> to serve for him as his Substitute in the said
Militia, and who was sworn in and enrolled accordingly, as appears by
the Roll of the Subdivision Meeting. As witness my hand, this <u>6th</u> day of
February 180<u>8</u>. <u>L. Hable,</u> Clerk of the Subdivision Meetings for <u>Holborn</u>
Division.' ⌈Sig. illeg.⌉ <u>Hanover Square</u>.' Release certificate, CFP, GH.

[18] DPW/JC, 8June1808. CFP, Tate Archive. Partial transcription at *JCC*4, 16.

[19] 'Progress of the Arts', in *The New Picture of Edinburgh*. The text is repeated
verbatim in the 1818 edition, p. 195ff.

[20] Government Art Collection; GR, 08.7.

[21] Yale, CBA; GR, 09.23.

[22] *JCC*2, 70, JC/MB, 27May1812. GR, 07.8 & 9, and 12.62-64.

[23] GR, 09.84. *JCC*1, 34, AC/JC, 17July1809.

[24] GR, 13.9.

[25] Sheila Hardy, op. cit., p. 38. See also, Overseers' Account Book, IRO, FB75/ G1/1.

[26] *JCC*1, 85, AC/JC, 22Nov1812.

[27] *JCC*2, 87, JC/MB, 28Sept1812 & 99, JC/MB, earlyDec1812.

[28] *London Gazette*, 27 Jan 1798, p. 88; 12 Oct 1799, p. 1053.

[29] *London Gazette*, 17 Sept 1814, p. 1827. Mrs Western's amethysts: private collection.

[30] *JCC*1, 85, AC/JC, 22Nov1812. See Paul Winby, 'Constable and Admiral Western, *British Art Journal*, vol. 5, no 1, (Spring/Summer 2004), pp. 77–9.

[31] *JCC*1, 86, AC/JC, 30Nov1812.

[32] DPW/JC, 18Aug1812, CFP, Tate Archive. Partial transcription at *JCC*4, 33–4.

[33] *JCC*1, 95, Abram/JC, 24May1813.

[34] *JCC*4, 34, DPW/JC, 1July[1813].

[35] *JCC*1, 55, AC/JC, 8Jan1811.

[36] *JCC*2, 80, JC/MB, 10July1812. JC substitutes 'Landscape' for 'Poetry' in Goldsmith's original. *FDC*, 41.

[37] Arnold Bennett, *Clayhanger*, ch. 14.

[38] *JCC*1, 45, AC/JC, 17July1810

[39] GR, 10.3/f.37.

[40] GR, 10.8.

[41] See Andora Carver, 'Bicentenary of the Installation of John Constable's Nayland Altarpiece, Sept 2010'; and Denis Halliday, *Notes on Constable's Aunts*, Nayland, 1994. See: www.naylandconservation.org.uk/archiveintro/ constableexhibition.pdf

[42] See: www.rct.uk/collection/search#/1/collection/11902/embroidery

[43] GR, 10.9.

[44] Coll: Nayland and Wissington Conservation Society, bt. Christies, July 2012.

[45] *JCC*1, 43, AC/JC, 8May1810.

[46] *JCC*1, 44, AC/JC, 2June1810.

[47] *JCC*1, 45, AC/JC, 17July1810.

[48] *JCC*1, 48, AC/JC, 7Aug1810.

[49] Removed in 1869, and replaced by a gothic stone reredos, the central painting being framed by carved vines and grapes, angels and panels lettered with the Lord's Prayer, the Ten Commandments and the Creed.

[50] *JCC*1, 51, AC/JC, 29Nov1810.

[51] *IJ*, 10Nov1810. The letter, from 'Clericus', is dated 30 Oct 1810.

[52] *JCC*1, 51, AC/JC, 29Nov1810.

[53] *JCC*4, 20, DPW/JC, 24Nov1810.

[54] *JCC*1, AC/JC, 72, 17Dec1811.

[55] Ivy, 10.1, 10.2: *Ackerman's Repository*, June 1810; *Examiner*, 17 June 1810. GR, 10.1.

[56] *JCC*1, 34 & 59, AC/JC, 17July1809 & 16Mar1811.

[57] GR, 09.24 & 25, 11.47. 13.28 and 27.46.

[58] *JCC*4, HGL/JC, 50, 19Nov1809.

[59] *JCC*2, 109, JC/MB, 30June1813.

[60] *JCC*1, 74, AbramC/JC, 19Jan1812.

[61] The majority are held in the Plymouth Papers, on loan to the Tate Archive.

[62] *JCC*1, 56, AC/JC, 18Jan1811.

[63] *JCC*1, 72, AC/JC, 17Dec1811.

[64] See: www.bures-online.co.uk/garrad/garrad.htm

[65] As used on the letter *JCC*1, 149–51, AC/JC, 25Dec1816. The original, seal 26 x 18mm, is in the Plymouth Papers, Tate Archive.

[66] *JCC*2, 130, JC/MB, 28Aug1814. The Author admits to being a descendant of the Admiral in the seventh generation.

16. Pray be careful of yourself

[1] GR, vol. 1, p. 177. *JCC*2, 80, JC/MB, 10July1812.

[2] *JCC*1, 90, AC/JC, 9Feb1813.

[3] George Bridgeman: GR, 13.11; Lady Heathcote: GR 12.64; Lady Louisa Manners, GR 09.85, 12.62, 63. *JCC*2, 108, JC/MB, 30June1813.

[4] *JCC*2, 74, JC/MB, 10June1812.

[5] *JCC*1, 70 & 77, AC/JC, 5Dec[?]1811 & 16Feb1812.

[6] *JCC*1, 71, AC/JC, 10Dec1811.

[7] *JCC*1, 69, AC/JC, 10Nov1811.

[8] *FD*11, 3900, 27Mar1811.

[9] Private collection, GR, 08.9; Fitzwilliam Museum, Cambridge, GR, 08.11.

[10] GR, 10.56; Tate, GR, 09.8.

[11] Paul Mellon Collection, GR, 10.37; V&A, GR, 10.28.

[12] V&A, 325-1888; GR, 11.32.

[13] Royal Academy, GR, 12.6.

[14] *JCC*6, 198, JC/JFish, Apr1825.

[15] V&A, GR, 08.57.

[16] *Examiner*, 26 June 1814, Ivy, 14.4.

[17] Private collection, GR, 11.2. Note by David Lucas, *FDC*, 55.

[18] GR, 10.59, 60; GR, 11.2-6.

17. Seven years since I avowed my love for you

[1] *Maria Bicknell*, oil, *c*.1810, private coll, GR, 10.13; *Maria Bicknell*, pencil, *c*.1809, Tate, GR, 09.82.

[2] Sun Fire Office record, 2 July 1812, LMA MS 11936/459/871478. The Admiralty pub is on the site of Spring Gardens Terrace, and the northern foot of Admiralty Arch springs from it.

[3] *Johnstone's London Commercial Guide*, 1817, p. 298; *Boyle's Court and Country Guide*, 1821, p. 168.

[4] Introduction to the first edition, 1798. The family's copy of this book is CFP, GH.

[5] Catherine Kelter, *Hayes Past*, 1996, p. 42. See also Elizabeth Hunt, *Hayes Past and Present*, 1861.

[6] Richard and Maria Edgeworth, *Practical Education*, 1798, ch. 7, 'On Obedience'.

[7] JCC2, 44, Charles H. Bicknell/MB, 10May1798. Addressed to Miss Maria Bicknell, Mrs Hinton's, Hayes, Middlesex.

[8] Will of Richard Firebrace, PROB 11/805/349.

[9] Buried St Dunstan-in-the-West, London, 27 April 1780.

[10] DR to CB, 21 Aug 1805, CFP, Tate Archive.

[11] Ibid.

[12] Prince Regent to CB, Royal Archives, n.d. RA GEO/ADD/3/38. Quoted by gracious permission of Her Majesty Queen Elizabeth II.

[13] 14 Feb 1801, National Archives, HO 47/28/10 ff.74–77.

[14] Gas bills: GEO/MAIN/25482-25483; sign-off: 18 Jan 1816, GEO/MAIN/25453. For further rich insights into Bicknell see Gayford, p. 28ff.

[15] JCC6, 97, JFish/JC, 6Oct1822 'Crinkum crankum scribbles': *FDC*, 273, RR/JC, 26 April [1833].

[16] JCC2, 118, JC/MB, 19Feb1814.

[17] JCC1, 22, AC/JC, 2Dec1807.

[18] JCC1, 31, AC/JC, 18June1809.

[19] JCC1, 35, AC/JC, late July/early Aug1809.

[20] JCC1, 38, AC/JC, 7Feb1810.

[21] Ibid.

[22] JCC1, 39, AC/JC, 20Feb1810; 53, AC/JC, 4Jan1811; 55, AC/JC, 8Jan1811. 'Brawn' is jellied calf's head.

[23] JCC1, 44, AC/JC, 8May1810.

[24] JCC1, 47, AC/JC, 26July1810.

[25] JCC1, 56, 18Jan1811. The watercolour is now coll. National Galleries on Merseyside, Lady Lever Art Gallery, Port Sunlight; GR, 11.7.

[26] JCC1, 57–8, AC/JC, 6Mar1811.

[27] The National Gallery and Trafalgar Square stand on the site of the King's Mews.

[28] JCC1, 40, AC/JC, 15Mar1810.

[29] JCC1, 53, 4Jan1811 (delivered).

[30] JCC1, 55, 8Jan1811.

[31] JCC1, 62, 15Apr1811.

[32] JCC1, 62, GC/JC, 26Apr1811.

[33] *London Gazette*, 2 Sept 1820, p. 1683; 8 Feb 1825, p. 226.

[34] JCC2, 179, JC/MB, 27Feb1816.

[35] JCC2, 50, JC/MB, 23Oct1811.

18. An artist unprovided for

[1] JCC2, 48, 16Mar1811. It is not known how much money Rhudde enclosed.

[2] Will of W.M. Bogdani, PROB/11/1191/186; *Notes & Queries*, series 11, vol. 5, issue 128 (8 June 1912), pp. 441–2.

[3] Will of the Rev. Dr Durand Rhudde, PROB 11/1618/345, proved 22 July 1819.

[4] Leicestershire and Rutland RO, DG9/1498, 27/28 May 1795.
[5] *ODNB*, Jacob Bogdani (1658–1724).
[6] *FD*11, 3916. 23Apr1811.
[7] *FD*11, 3944, June1811
[8] Now the West Midland Safari Park. The coincidence of place names is confusing, Spring Grove, Bewdley, and Spring Gardens, Westminster.
[9] *JCC*1, 76, AC/JC, 16Feb1812.
[10] *JCC*2, 50, JC/MB, 23Oct1811.
[11] *JCC*2, 50, MB/ JC, 26Oct1811.
[12] *JCC*2, 51, JC/MB, 29Oct1811.
[13] RBB's gives this as 'any prospects'. To my eye it is clearly 'our prospects'.
[14] *JCC*4, 31, DPW/JC, 1Nov1811; addressed to John Constable Esq, – Jackson's Esq, 7 Newman Street.
[15] Ibid.
[16] *JCC*2, 52, MB/JC, 2Nov1811.
[17] *JCC*2, 52, JC/MB, 4Nov1811.
[18] *JCC*2, 53, MB/JC, 4Nov1811; 103, MB/JC, 23Jan1813.
[19] *JCC*2, 55–6, MB /JC, 17Dec1811.
[20] *JCC*2, 57, JC/MB, 24Dec1811.
[21] *JCC*2, 54, JC/MB, 12Nov1811.
[22] *JCC*1, p. 70, AC/JC, 5Dec1811.
[23] *JCC*1, 73, GC/JC, 31Dec1811.
[24] *JCC*1, 76, GC/JC, 21Jan1812.
[25] *JCC*1, 74, AbramC/JC, 19Jan1812.
[26] *JCC*1, 78, AC/JC, 12Apr1812.
[27] *JCC*1, 76, AC/JC, 16Feb1812.
[28] *JCC*1, 78, AC/JC, 12Apr1812.
[29] *JCC*1, 82, AC/JC, 23Aug1812.
[30] *JCC*1, 84, AC/JC, 12Nov1812.
[31] Mrs Everard – Ever-hard – hence 'Durable'. *JCC*1, 91, MWhalley/JC, 17Feb1813, and *JCC*1, 88, AC/JC, 31Jan1813.
[32] *JCC*1, 88, AC/JC, 31Jan1813.
[33] *JCC*1, 90, AC/JC, 9Feb1813.
[34] *JCC*2, 86, JC/MB, 22Sept1812.
[35] M. E. Bicknell to MB, 19 May 1812 (1811 written in error). CFP, Tate Archive.
[36] Ibid.
[37] *JCC*2, 58, MB/JC, 8Jan1812.

19. Hearts so united

[1] *JCC*2, 78, JC/MB, 22June1812.
[2] *JCC*1, 93–4, AC/JC, 8Mar1813.
[3] *JCC*2, 78, JC/MB, 22June1812.
[4] GR, 11.12-25 and 12.4.
[5] *JCC*6, 14, Bishop Fisher/JC, 13–14Dec1811 and Jan1812; *JCC*6, 15, JFish/

JC, 8May1812.

[6] *JCC* 2, 74, JC/MB. 10June1812. GR, 12.22.

[7] *JCC*1, 80, AC/JC, 12June1812.

[8] *JCC*2, 127, JC/MB, 3July1814.

[9] *JCC*2, 90, JC/MB, 25Oct1812.

[10] Ibid.

[11] *JCC*2, 88, MB/JC, 18Oct1812.

[12] *JCC*2, 91, MB/JC, 28Oct1812.

[13] *JCC*2, 89, MB/JC, 18Oct1812.

[14] *JCC*287, JC/MB, 28Sept1812.

[15] *JCC*2, 89, MB/JC, 18Oct1812. There was another, lost, letter from JC between this and his of 28 Sept.

[16] *JCC*2, 92–3, JC/MB and MB/JC, 6Nov1812.

[17] *JCC*2, 95–7, JC/MB, 10&17Nov1812; FD12, 4252, 10Nov1812.

[18] *JCC*2, 95, MB/JC, 16Nov1812; *JCC*1, 84, AC/JC, 12Nov1812.

[19] *JCC*2, 109, JC/MB, 30June1813.

[20] William Cowper, *The Task*, Book 1, 'The Sofa', ll. 144–146. See *JCC*2, 64, JC/MB, 24Apr1812.

[21] *JCC*2, 78, JC/MB, 22June1812

[22] *JCC*2, 76, JC/MB, 15June1812.

[23] William Hayley, *The Life, and Posthumous Writings, of William Cowper Esqr with an Introductory Letter to the Right Honourable Earl Cowper*, 1803.

[24] *JCC*6, 78, JC/JFish, 23Oct1821.

[25] William Cowper, 'Tirocinium – A Review of Schools', lines at the end of this long poem. Cowper, not Elton or Gray, must be the source of Constable's usage, as it was Constable's response to Fisher's remark quoting Cowper (*JCC*6, 76, JFish/JC, 26Sept1821): '[I] was as happy as when I was a "careless boy"'. Gayford, p. 177, suggests that Constable took 'careless boyhood' from Charles Abraham Elton's poem 'Retrospection' (1810): 'Is there who, when long years have passed away, / Revisits in his manhood's prime, the spot / Where strayed his careless boyhood . . .'. Another suggestion [Parris, Fleming-Williams, Rosenthal et al.] is that it is from Thomas Gray's 'Ode on a Distant Prospect of Eton College' (1747): 'Ah, happy hills, ah, pleasing shade, / Ah, fields belov'd in vain, / Where once my careless childhood stray'd / A stranger yet to pain.' It is neither: Constable took it from Fisher who took it from Cowper.

[26] FD6, 2032, 18May1803.

[27] *JCC*2, 131, JC/MB, 28Aug1814.

[28] Archibald Alison, LL.B, *Essays on the Nature and Principles of Taste*, 1790, 5th Edn, 1817, Essay I, pp. 38–9.

[29] Ibid., Essay II, pp. 39–40.

[30] Ibid., Essay II, pp. 101–2.

[31] *JCC*2, 85, JC/MB, 22Sept1812.

[32] *JCC*2, 195, JC/MB, 16Aug1816.

[33] *JCC*2, 59, MB/JC, 20Feb1812 [postmarked].

[34] *JCC*2, 53, MB/JC, 4Nov1811.

[35] Ibid.

[36] *JCC2*, 103, MB/JC, 23Jan1813.

[37] *JCC2*, 136–7, MB/JC, 15Nov1814.

[38] *JCC2*, 59, MB/JC, 20Feb1812 [postmarked]. Both portraits descended to Isabel Constable: she gave the Gardner portrait to the South Kensington Museum [V&A] in 1888 [589-1888]. The self-portrait was sold in 1892, and is now NPG, 901.

[39] *JCC2*, 77, MB/JC, 19June1812.

[40] GR, 04.16, Louvre, RF6109. Inscr. Verso: 'Wm. Cowper died Friday 25 April at (noon) 1800. / Born 26 November 1731 / died 25 April 1800 / 1731 / 69.'

[41] *JCC2*, 70, JC/MB, 27May1812.

[42] *JCC2*, 67–8, MB/JC, 12May1812.

[43] *JCC1*, 145, AnnC/JC, 8Dec1816; *JCC2*, 353, Journal, 3July1824.

[44] Robert Bradstreet, *The Sabine Farm, a Poem*, 1810; *JCC2*, 100, MB/JC, 12Dec1812.

[45] *JCC2*, 182, MB/JC, 19Mar1816.

[46] *JCC2*, 69, MB/ JC, 26May1812. 'Robin Goodfellow' is Shakespeare's name for Puck 'that frights the maidens of the villagery' in *Midsummer Night's Dream*, Act 2, sc. 1.

[47] *JCC2*, 67–8, MB/JC, 12May1812.

[48] *JCC2*, 85, MB/JC, 10Sept1812.

[49] *JCC2*, 150, MB/JC, 29Aug1815.

[50] *JCC2*, 91 & 99, MB/JC, 18Oct & 12Dec1812.

[51] *JCC2*, 19, Lucy Hurlock/JC, 9Apr1800.

[52] *JCC2*, 134, JC/MB, 25Oct1814.

[53] Sotheby's, 6 Dec 2017, lot 40, *Dedham Vale with the River Stour in Flood, from the Grounds of Old Hall, East Bergholt.* www.sothebys.com/en/articles/important-constable-rediscovered-after-50-years, with essay by Anne Lyles.

[54] From 'On receipt of my mother's picture' by William Cowper. *JCC2*, 84, MB/JC, 6Sept1812.

20.Entirely and forever yours

[1] *JCC1*, 91, MW/JC, 17Feb1813.

[2] *JCC1*, 78, AC/JC, 12Apr1812.

[3] *FD10*, 3677, 28June1810; see also *JCC1*, 45, AC/JC, 17July1810.

[4] *FD11*, 4025–6, 4Nov1811.

[5] *JCC2*, 94, JC/MB, 6Nov1812.

[6] *JCC2*, 110, JC/MB, 30June1813.

[7] *FD13*, 4603–5, 7Nov1814.

[8] *JCC2*, 168, JC/MB, 19Feb1814; *JCC1*, 103, AC/JC, 24Feb1814.

[9] *JCC2*, 123, JC/MB, 11May1814.

[10] V&A, 1259-1888/1-86; GR, 14.11-15. *JCC2*, 127, JC/MB, 3July1814.

[11] *Portrait of Ann ['Nancy'] and Mary Constable*, Trustees of the Portsmouth Estates, GR, 14.52. *A girl in a red cloak (Mary Constable)*, private collection, GR, 09.41.

[12] T. F. Patterson, *East Bergholt in Suffolk*, 1923, p. 151.

[13] Drawing: V&A, 1259-1888/13, GR, 14.32/13; painting: Museum of Fine Arts, Budapest, inv. no. 4624, GR, 14–33.

[14] *JCC*2, 129, JC/MB, 15Aug1814.

[15] *JCC*1, 115, AC/JC, 7Mar1815.

[16] *JCC*2, 125, JC/MB, 5June1815

[17] *JCC*2, 138, MB/JC, 23Feb1815.

[18] *JCC*1, 115, AC/JC, 7Mar1815.

[19] V&A, F. A. 37; GR, 15.2.

[20] *JCC*2, 97, MB/JC, 2Dec1812.

[21] *JCC*1, 109, AC/JC, 6Dec1814.

[22] *JCC*1, 116–22, MWhalley & AbramC/ JC, 9Mar to 2 Apr1815. See also *JCC*2, 361, Journal, 13July1824.

[23] *JCC*1, 134, AnnC/JC, 17May1816. Golding's death was noticed in *Norwich Chronicle*, 25 May 1816 & *Jackson's Oxford Journal*, 1 July 1816.

[24] *JCC*2, 149, JC/MB, 27Aug1815.

[25] *JCC*2, 359, Journal, 10July1824; *Gentleman's Magazine*, Aug 1816, pp. 182–4.

[26] *JCC*2, 168, MB/JC, 18Jan1816

[27] *JCC*2, 170, JC/MB, 25Jan1816.

[28] *JCC*2, 173, MB/JC, 7Feb1816; 174, JC/MB, 8Feb1816, & 13Feb1816.

[29] *JCC*2, 176, MB/C, 13Feb1816.

[30] *JCC*2, 177, JC/MB, 18Feb1816

[31] *JCC*2, 179, JC/MB, 27Feb1816.

[32] *JCC*2, 195, JC/MB, 16Aug1816.

[33] *JCC*2, 203, JC/MB, 12Sept1816.

[34] Rosenthal, 1983, p. 104.

[35] *JCC*2, 205 & 207, JC/MB, 15 & 19Sept1816.

[36] *JCC*2, 206, MB/JC, 16Sept1816.

[37] Tate; GR, 16.13.

[38] Dated 1 Oct 1816, CFP, GH.

[39] *JCC*2, 211.

[40] *London Courier and Evening Gazette*, 3 Oct 1816, p4, col. 3; *Oxford University and City Herald*, 12 Oct 1816, p. 2, col. 5; *Bury and Norwich Post*, 9 Oct 1816, p. 2, col 1. My thanks to Karen Waddell of the BL News Reference Team for tracking these down.

21. The real cause of your want of popularity

[1] *JCC*6, 28, JFish/JC, 27Aug1816.

[2] *Weymouth Bay*, V&A, 330-1888. Fisher portraits: Fitzwilliam Museum, GR, 16.83 and 17.3.

[3] *JCC*6, 15, JFish/JC, 8May1812.

[4] Ibid.

[5] FDC, 117, JFish/JC, 1Oct1822.

[6] *JCC*6, 18, JFish/JC, 13Nov1812.

[7] Langham, Suffolk (1780–1807), Hartley Westpall, Hants (1796–1824)

and Shobrooke, Devon (1803–07). https://theclergydatabase.org.uk/jsp/persons/CreatePersonFrames.jsp?PersonID=40093

8 *JCC*6, 34, JFish/JC, 15Dec1817.

9 *JCC*6, 36, JFish/JC, June1818 [prob].

10 *JCC*6, 37–41, Dorothea Fisher/JC, 6[?]July1818, and Bishop Fisher/JC, 6Sept1818 & n.d. [1819].

11 *JCC*2, 248, JC/MC, 21May1819.

12 *JCC*6, 21, JFish/JC, n.d. [summer 1813].

13 See Hamilton, 1997, pp. 159–60.

14 *JCC*6, 21, JFish/JC, n.d. [summer 1813].

15 *JCC*4, 171, JC/MB, 2Feb1816.

16 *JCC*4, 172, MB/JC, 3Feb1816.

22. Our little house in Keppel Street

1 Sarah Skey had since re-married. 'SLF' [i.e. Sarah Fletcher, formerly Skey]/MB, n.d. [late Oct/early Nov 1816]. CFP, Tate Archive.

2 *Bury and Norwich Post*, 9 Oct 1816, p. 2, col 1.

3 *JCC*1, 141–2, AbramC/JC, 20Oct1816.

4 Maria Cipriani to MC, n.d., [late Dec 1816], CFP, Tate Archive.

5 *JCC*1, 158, NancyC/JC, 18Feb1817.

6 *JCC*1, 159, MW/JC, 22Feb1817.

7 Tate Britain; GR, 17.1.

8 1801: *Old Hall, East Bergholt*, comm. John Reade; 1804: *James Gubbins' House, Epsom*, comm. James Gubbins; 1814: *Willy Lott's House*, comm. [?] Perry Nursey [*JCC*1, 101, JC/JD, 22Feb1814]; 1814: *Boys Fishing*, bt BI James Carpenter; 1814: *Dedham Vale and the River Stour in Flood from Old Hall, East Bergholt*, comm. Thomas Fitzhugh; 1815: Ploughing Scene in Suffolk ('A Summerland'), bt BI by James Allnutt; 1815: *Brightwell Church and Village*, comm. Rev Frederick Henry Barnwell.

9 He did not stand in 1813.

10 *FD*14, 5095–6, 3Nov1817.

11 *FD*15, 5283–4, 11Nov1818.

12 *FD*9, 3432, 3Apr1809. See also John Gage, Tate 2006, p. 20.

13 Prices varied, but a guide might be the prices charged 1800s/1810s by the colourman J. Middleton, 81 St Martin's Lane. He supplied Constable and others including Lawrence, Northcote, Turner and West; see: www.npg.org.uk/research/programmes/directory-of-suppliers/m/#MI

14 *FD*, 12June1817. 'John Constable' is listed as resident at 1 Keppel Street in *Boyle's Court and Country Guide*, Jan 1821, p. 82.

15 *JCC*2, 221, AnnC/JC, 5May1817.

16 *FD*, 15Dec1817, do. *JCC*1, 164, MW/JC, 23Apr1817; and *JCC*1, 166, NC/JC, 9Dec1817.

17 *JCC*1, 167, NC/JC, 25Dec1817.

18 *JCC*1, 166, NC/JC, 9Dec1817.

19 PROB 11/1618/345.

[20] *JCC*2, 225, JC/MC, 5July1817.

[21] *JCC*2, 227, JC/MC, [early] July 1817.

[22] The painting room was upstairs: in 1821 Constable wrote 'the window on the stairs must be taken out' to remove the six-footers *Stratford Mill* and *The Hay Wain*. *JCC*6, 65, JC/JFish, 1Apr1821.

[23] X-rays have revealed this over-painted work. Sarah Cove and Charles Rhyne, essays in Tate, 2006. X-ray: p. 45.

[24] GR, 19.2, National Gallery of Art, Washington DC.

[25] *JCC*2, 238, JC/MC, 21Oct1818.

[26] *JCC*2, 239, JC/MC, 25Oct1818.

[27] *JCC*6, 99, JC/JFish, 7Oct1822. 'Bottled wasps' quoted from Cowper's poem 'Retirement', l.493: 'Prison'd in a parlour snug and small,/ Like bottled wasps upon a southern wall.'

23. The humming top friendship

[1] GR, 19.1, Frick Collection, New York.

[2] *JCC*1, 177, NC/JC, 21Mar1819.

[3] *JCC*1, 177, AbramC/JC, 19Mar1819.

[4] *JCC*6, 44, JFish/JC, 2July1819.

[5] *JCC*6, 45, JC/JFish, 17Jul1819; *JCC*6 46, JFish/JC, 19Jul1819, and *JCC*6 47, 11 Aug 1819.

[6] *JCC*6, 64, JFish/JC, 6Mar1821.

[7] *JCC*6, 66, JC/JFish, 1Apr1821. The book Constable trashed was *The Diary of an Invalid, The Journal of a Tour in Portugal, Italy, Switzerland and France* by Henry Matthews, 1820.

[8] *JCC*6, 53, JFish/JC, 27Apr1820. The 'ogee' was the moulding marking the dado line: this probably meant that the painting's lower edge was about three feet from the floor.

[9] *JCC*6, 60, JFish/JC, 3Jan1821.

[10] *JCC*6, 55, JFish/JC, 31Aug1820.

[11] *JCC*6, 44–5, JFish/JC, 2 & 17July1819.

[12] *JCC*6, 61, JFish/JC, 14Feb1821; *FDC*, 76, JC/GoldingC, 3Dec1824.

[13] *JCC*6, 63, JC/JFish, 1821 [nd, probably spring], speaking about *The Hay Wain*.

[14] GR, 22.1; sketch GR, 22.2. *JCC*6, 76, JC/JFish, 23Oct1821.

[15] *JCC*6, 58, JFish/JC, 28Sept1820.

[16] Published in *JCC* 6. Three further letters from Fisher are in *FDC*, 116–21. In addition there are forty-six letters from Bishop Fisher and eight from other Fishers, various. Those from Fisher are in the NAL, V&A.

[17] *FD*9, 3204, 19Jan1808.

[18] *JCC*6, 102–4, JFish/JC, 12Nov1822.

[19] *JCC*6, 62, JC/JFish, n.d. [Feb 1821].

[20] *JCC*6, 65, JC/ JFish, 1Apr1821.

[21] *JCC*6, 209, JFish/JC, 21Nov1825.

[22] *JCC*6, 210–11, JC/JFish, 26Nov1825. 'to watch me struggling' may be a

clearer reading for RBB's 'to watch one struggling'.

23 *JCC*6, 110, JFish/JC, 7Feb1823.

24 *JCC*6, 112, JC/JFish, 21Feb1823.

25 *FDC*, 117, JFish/JC, 1Oct1822.

26 *JCC*6, 47, JFish/JC, 11Aug1819.

27 That is, '*Liber Studiorum*', Turner's published collection of his engravings by which he asserted some copyright control. By 1819 it comprised over seventy mezzotints. *FD*15, 5422–3, 1Nov1819; and *JCC*2, 258, CB/JF, 6Nov1819, and JF/CB, 7Nov1819.

28 *FD*15, 5423, 2Nov1819.

29 *JCC*6, 49, JFish/JC, 4Nov1819.

30 *JCC*6, 49, JFish/JC, 4Nov1819.

31 *FDC*, 73, JC/AbramC, 2Nov1819.

24. On Hampstead Heath

1 *JCC*2, 250, MC/JC, 4June1819.

2 *Johnstone's Commercial Guide*, 1817, p. 275.

3 GR, 18.14–18. *JCC*2, 188, MC/JC, 20July1816.

4 *JCC*2, 247, JC/MC, 21May1819.

5 *JCC*2, 244–5, AbramC/JC, 5Mar & 3May1819.

6 *JCC*2, 245, JC/MC, 6May1819.

7 *JCC*1, 182, AbramC/JC, June1819 [probably].

8 *JCC*2, 246, JC/MC, 9 May 1819.

9 £30 to Brantham and £20 to Great Wenham.

10 *JCC*2, 245, JC/MC, 9May1819.

11 *JCC* 2, 250, MC/JC, 4June1819.

12 *JCC*2, 315, MC/JC, lateMay1824.

13 *JCC*1, 86, AC/JC, 22Nov1812.

14 CFP, GH.

15 *JCC*2, 340, Journal, 22June1824.

16 Tate, 1991, no. 117. Jack Straw's Castle was (and is) the inn near Whitestone Pond.

17 See: www.british-history.ac.uk/vch/middx/vol9/pp3-8#highlight-first

18 BM, 1972-6-17-15(1-25), GR, 19.28.

19 Ibid, p. 14. The page has been torn out.

20 *JCC*2, 441, JC/MC, 7Oct1827.

21 Mansion Gardens is built on the site of the Salt Box.

22 *Hampstead Heath, with the house called 'The Salt Box'*, 1819–20, Tate, N01236; GR, 21.7.

23 *Branch Hill Pond, Hampstead*, V&A, 122-1888; GR, 19.32.

24 Thornbury, p. 263.

25 John E. Thornes, *John Constable's Skies*, 1999, Appendix 1, pp. 202–74.

26 *JCC*6, 77, JC/JFish, 23Oct1821.

27 'Cirrus', written on the back of *Study of cirrus clouds*, V&A, 784-1888, GR, 22.59.

[28] *FDC*, 44–5.

[29] Luke Howard, 'On the modification of clouds', Askesian Society, 1803.

[30] Michael Faraday to Charles-Gaspard de la Rive, 12 Sept 1821. Frank A. J. L. James, *The Correspondence of Michael Faraday*, vol. 1, 1991, p. 222. See also Hamilton, 2002, ch. 11.

[31] V&A, 151-1888. Quoted Thornes, op. cit., p. 220.

[32] *Faraday's Diary*, vol. 1, pp. 49–50, 3 Sept 1821.

[33] *FDC*, loc. cit.

[34] Lucas annotations to CRL, *FDC*, 55.

[35] Tate, 1991, no. 117; GR, 22.48.

[36] *The Trees at Hampstead: The path to church*, V&A, 1630-1888; GR, 22.6. JCC4, 73, JC/JFish, 20Sept1821.

[37] CRL, p. 280.

[38] JCC4, 81, JC/JFish, 3Nov1821.

[39] Stamford Lodge has been demolished.

[40] JCC2, 441, MC/JC, 5&6Oct1827. 1 Langham Place is now renumbered 25 Downshire Hill.

[41] JCC2, 442, JC/MC, 7&10Oct1827.

[42] *Maria Constable with two of her children*, Tate, GR, 20.86.

25. I think it promises well

[1] JCC6, 56, JC/FC, 1Sept1820.

[2] JCC6, 98, JC/JFish, 7Oct1822.

[3] JCC6, 77, JC/JFish, 23Oct1821.

[4] JCC6, 83, JFish/JC, 16Feb1822.

[5] JCC6, 78, JC/JFish, 23Oct1821.

[6] JCC6, 57, JFish/JC, 11Sept1820.

[7] JCC6, 80, JC/JFish, 3Nov1821.

[8] JCC6, 79, JFish/JC, 24Oct1821.

[9] JCC2, 284, JC/MC, 29Aug1823; JCC6, 47, JC/JFish, 13Aug1819.

[10] JCC4, 57, HGL/JC, 19Feb1818.

[11] GR, 19.35, 36.

[12] JCC4, 55, HGL/JC, 30June1813.

[13] JCC4, 56, HGL/JC, 4Sept1816. GR, 09.24, 09.25, 11.47 & 13.28.

[14] This would be a copy painted by Johnnie Dunthorne. JCC2, 343, JC/MC, n.d. [24June1824]. GR, 27.46.

[15] JCC6, 45, JC/JFish, 17July1819.

[16] JCC6, 54, JFish/JC, [shortly after] 22June1820.

[17] JCC6, 45, JC/JFish, 17July1819. GR, 19.22-27, 37, 38.

[18] FD15, 5396, 11Aug1819; JCC6, 46, JC/JFish, 17July1819.

[19] JCC6, 55, JF/JC, 31Aug1820.

[20] JCC, 6, 65, JC/JFish, 1Sept1820.

[21] FD15, 5582–3, 21Nov1820.

[22] JCC2, 276, MC/JC, 11May1822.

26. Landscape: Noon

[1] *JCC*6, 80, JC/JFish, 3Nov1821.
[2] Maria Graham, *Memoirs of the Life of Nicolas Poussin*, 1820, p. vi.
[3] Constable's library is catalogued in *FDC*, 25–52.
[4] Study: V&A, Exhibition painting: National Gallery, London. GR, 21.1-3.
[5] Johnnie Dunthorne's drawing: *JCC*, 193, AbramC/JC, 25Feb1821.
[6] Graham, op. cit., pp. 129–30, from Reynolds's *Fifth Discourse*.
[7] Ibid., pp. 30–6.
[8] *JCC*6, 67, Bishop Fisher/JC, 12Apr1821.
[9] *JCC*6, 69, Dorothea Fisher/JC, 10July1821.
[10] National Gallery, London.
[11] *JCC*4, 74, JC/JFish, 20Sept1821.
[12] *FD*16, 5706–7, 26July1821.
[13] Note by Farington's niece, Marianne Farington, *FD*16, 5761.

27. A superior sort of work people

[1] *JCC*4, 247, JC/Samuel Lane, Feb1822.
[2] Ernest Fletcher (ed.), *Conversations of James Northcote with James Ward*, 1901, p. 165.
[3] *JCC*6, 91, JC/JFish, 17Apr1822.
[4] *JCC*6, 71, JC/JFish, 4Aug1821.
[5] *JCC*2, 109, JC/MB, 30June1813.
[6] *JCC*6, 66, JC/JFish, 1Apr1821.
[7] *JCC*6, 71, JC/JFish, 4Aug1821.
[8] 1814 sketchbook, V&A, 1259-1888; pencil studies c.8 x 10 cm; GR, 14.32/27 and 52. *View on the Stour near Dedham*, GR.22.1, 2.
[9] *JCC*6, 91, JC/JFish, 17Apr1822.
[10] *JCC*6, 99, JC/JFish, 7Oct1822. Isabel was born in Hampstead.
[11] *FDC*, 120, JFish/JC, 11Oct1822.
[12] *JCC*6, 105, JC/JFish, 6Dec1822.
[13] Certificate of Appointment as Commissioner of Paving, Lighting, Cleansing, Watering and Watching the Streets on the West Side of Tottenham Court Road in the Parish of St Pancras, 6 May 1824. CFP, GH.
[14] *JCC*6, 100, JC/JFish, 31Oct1822.
[15] *FDC*, 183–6, Joseph Bonomi/JC, 3Nov1822–July1823; note by Ian Fleming-Williams.
[16] *JCC*6, 100, JC/JFish, 31Oct1822. One of the artists standing was William Etty.
[17] See also Hamilton, 2014, p. 268.
[18] *JCC*3, 41, JC/CRL, [early] July 1831.
[19] *JCC*6, 101, JC/JFish, 31Oct1822.
[20] *JCC*6, 155, JC/JFish, 15Apr1824.
[21] *JCC*6, 103, JFish/JC, 12Nov1822.
[22] JCC6, 159, JFish/JC, 10May1824.

28. I must go into Suffolk soon

[1] *JCC*6, 88, JC/JFish, reported from a lost letter AbramC to JC, 13Apr1822.

[2] 'Diary of Jonas Asplin, Doctor of Prittlewell, 1826–28', in A. F. J. Brown, *Essex People 1750–1900*, from their diaries, memoirs and letters, 1972, pp. 134, 145–6 & 150.

[3] *FDC*, 75, JC/GoldingC, 3Dec1824.

[4] *JCC*1, 198, AbramC/JC, 17June1821.

[5] *JCC*1, 200, AbramC/JC, [very soon after] 17June1821. RBB's reading, 'the [gooses] good for nothing', is unsound. I read 'she grows good for nothing'.

[6] *JCC*1, 197, AbramC/JC, 17June1821.

[7] *JCC*1, 202, AnnC/JC, 29Oct1821.

[8] *JCC*1, 190, AbramC/JC, 28Jan1821.

[9] *JCC*2, 361, Journal, 13July1824.

[10] *JCC*1, 84, AC/JC, 12Nov1812.

[11] *JCC*1, 204, MarthaC/JC, [late] August1822.

[12] *JCC*1, 274, AbramC/JC, 15Feb1833. The story of Jezebel is in the Old Testament, 1 Kings.

[13] *JCC*, 2, Journal, 404, 23Oct1825. Four words have been irretrievably deleted here. The Sterne original reads: 'Whenever a man talks loudly against religion, always suspect that it is not his reason, but his passions, which have got the better of his creed.' *Tristram Shandy*, Book 2, ch. 17.

[14] *JCC*1, 190, AbramC/C, 2Jan1821.

[15] Arthur Young, *General View of the Agriculture of the County of Suffolk*, 1813, p. 11.

[16] *JCC*1, 190, AbramC/JC, 28Jan1821.

[17] *JCC*2, 345, Journal, 27June1824.

[18] *JCC*1, 213, MaryC/JC, 5June1824.

[19] *Johnstone's London and Commercial Guide*, 1817, pp. 311–12.

[20] *JCC*2, 341, Journal, 23June1824.

[21] *JCC*1, 216, AbramC/JC, 2Aug1824.

[22] *JCC*6, 140n.

[23] *JCC*2, 268, JC/MC, EasterSunday1821.

[24] *JCC*1, 121, MaryC/MWhalley, 24Mar1815.

[25] *JCC*1, 223 & 239, MaryC/JC, 11Apr1826, 24Jan1828.

[26] *JCC*1, 221, MaryC/JC, 2May1825.

[27] *JCC*6, 140, JC/JFish, 19Oct1823.

[28] *JCC*1, 190, AbramC/JC, 28Jan1821.

[29] *JCC*6, 89, JFish/JC, 16Apr1822.

[30] *JCC*2, 191, JC/MC, 1Aug1816.

[31] *JCC*6, 65, JC/JFish, 1Apr1821.

[32] *JCC*1, 194 & 204, MW/JC, 5Apr1821; MC/ JC, [late] Aug1822.

[33] *JCC*6, 76–8, JC/JFish, 23 Oct 1821.

[34] *JCC*1, 192 & 195, AbramC/JC, 28Jan1821.

[35] *JCC*2, 267, JC/MC, GoodFriday1821.

[36] *JCC*2268, JC/MC, EasterSunday1821.

[37] *JCC*2, 268, JC/MC, EasterSunday1821.

[38] *JCC6*, 57, JC/JFish, 1Sept1820.

[39] *JCC6*, 73, JC/JFish, 20Sept1821.

[40] *JCC6*, 88, JC/JFish, 13Apr1822.

29. The French man

[1] Linda Whiteley, 'John Arrowsmith', *Grove's Dictionary of Art.*

[2] *Examiner*, 27 May 1821, Ivy, 21.11.

[3] *Journal de Eugène Delacroix*, vol. 1, 1823–50, 1893, p. 39 n.3, 9 Nov 1823.

[4] Charles Nodier, *Promenade de Dieppe aux Montagnes d'Ecosse*, 1821, p. 85.

[5] GR, 21.4,5.

[6] *Journal de Eugène Delacroix*, loc. cit.

[7] *JCC6*, 87–8, JC/JFish, 13Apr1822.

[8] *JCC6*, 90, JC/JFish, 17Apr1822.

[9] *JCC6*, 149–150, JC/JFish, 17Jan1824.

[10] *JCC6*, 107, JC/JFish, 6Dec1822.

[11] Amédée Pichot, *Voyage historique et litteraire en Angleterre et en Ecosse*, 1826, vol. 1, p. 167.

[12] *JCC6*, 93, JC/JFish, Apr1822.

[13] *JCC6*, 100 JC/JFish, 31Oct1822.

[14] *JCC6*, 123, JFish/JC, 5July1823.

[15] *JCC6*, 149, JC/JFish, 17Jan1824.

[16] *JCC6*, 151, JFish/JC, 18Jan1824.

[17] *JCC6*, 157, JC/JFish, 8May1824.

[18] *Journal de Eugène Delacroix*, vol. 1, 1823–50, 1893, p. 133, 19 June 1824. *'Vu les Constable. C'était trop de choses dans un jour. Ce Constable me fait un grand bien.'*

[19] It was not actually quite six feet high. The price included the frame, which will have cost Constable at least £20.

[20] *JCC6*, 158, JFish/JC, 10May1824.

[21] *JCC6*, 160, JC/JFish, n.d. [mid-May 1824].

[22] *Journal de Eugène Delacroix*, vol. 1, 1823–50, 1893, p. 234, 23 Sept 1846. *'Constable dit que la supériorité du vert de ses prairies tient à ce qu'il est un composé d'une multitude de verts différents. Ce qui donne le défaut d'intensité et de vie à la verdure du commun des paysagistes, c'est qu'ils la font ordinairement d'une teinte uniforme. Ce qu'il dit ici du vert des prairies, peut s'appliquer a tous les autres tons.'* Trans JH.

[23] *JCC4*, 200, C. Schroth/JC, 17May1825, letter delivered by Eugène Delacroix: *'Seulement je vous prierai de rendre vos ceils aussi simples, vos terrains sur les premiers plans aussi faits que possible, en general les amateurs de Paris aiment que les choses qui sont sous les yeux soient tres rendues, aussi tous les premiers plans qui sont dans le sentiment de Winants attirent-ils leur admiration.'* Trans. JH.

[24] *JCC6*, 186–7, JC/JFish, 17Dec1824.

[25] *JCC6*, 162, JFish/JC, 31May1824.

[26] *JCC6*, 160, JC/JFish, [soon after] 23May1824.

[27] *JCC4*, 184, Journal, 22June1824.

[28] *JCC4*, 185, Journal, 7July1824.

[29] *JCC6*, 208, JC/JFish, 19Nov1825; JCC6, 211, 26Nov1825.

[30] *Journal de Eugène Delacroix*, vol. 1, 1823–50, 1893, p. 39, n3: '*Lui et Turner sont de véritables réformateurs. Ils sont sortis de l'ornière des paysagistes anciens. Notre école, qui abonde maintenant en hommes de talent dans ce genre, a grandement profité de leur exemple.*' See also John Gage, *Colour in Turner*, 1969, p. 268, n5.

[31] Letters written around the time of Delacroix's visit indicate that JC was in London on 14 and 31 May 1825. The letter from Schroth that Delacroix delivered is dated Paris, 17 May 1825. See *JCC6*, 201 & 202; *JCC4*, 199–200.

[32] GR, 24.80. Louvre, RF6234.

[33] Anne Lyles points out that 'the current art-historical consensus is that they probably did not [meet].' Anne Lyles, 'Later Brighton visits and posthumous acclaim in France', in Shân Lancaster (ed.), *Constable and Brighton*, ch. 5, p. 72.

30. I shall . . . throw them all out of the window

[1] In his brief will he leaves everything to Albany. PROB 11/1616/399.

[2] See: www.historyofparliamentonline.org/volume/1790-1820/member/atkinson-christopher-1739-1819#footnoteref3_xdqk1jk

[3] *JCC1*, 71, 73, 80, AC/JC, 10&17Dec1811, & 12June1812; *JCC2*, 97, JC/MB, 17Nov1812.

[4] *JCC2*, 64, JC/MB, 16Apr1812.

[5] *JCC1*, 179 & 193, AbramC/JC, 3May1819 & 28Jan1821.

[6] Huntington Gallery, San Marino, CA, GR, 18.37. Landscape gift: *JCC2*, 239, JC/MC, 25Oct1818.

[7] *JCC2*, 328 & 331, Journal, 14&16June1824.

[8] See: www.historyofparliamentonline.org/volume/1790-1820/member/savile-albany-1783-1831

[9] *JCC6*, 74 & 78, JC/JFish, 20Sept&23Oct1821. 'Crazy' in the 1820s meant broken-witted, weak and feeble' [Dr Johnson's Dictionary].

[10] *JCC6*, 100, JC/JFish, 31Oct1822.

[11] *JCC6*, 103, JFish/JC, 12Nov1822.

[12] *JCC6*, 108, JC/JFish, 1Feb1823.

[13] GR, 23.1; V&A, FA 33.

[14] *JCC6*, 118, JFish/JC, 9May1823.

[15] *JCC6*, 118, JFish/JC, 9May1823.

[16] *JCC2*, 284, JC/MC, 29Aug1823.

[17] *FDC*, 146, Margaret Beaumont/JC, 10Oct1823.

[18] CRL, 114.

[19] *JCC6*, 139, JC/JFish, 19Oct1823.

[20] Hamilton, 2018, p. 67.

[21] *JCC6*, 139, JC/JFish, 19Oct1823.

[22] National Gallery. Constable's copy is GR, 23.36.

[23] *JCC6*, 143, JC/JFish, 2Nov1823.

[24] *JCC2*, 353, Journal, 3July1824.

[25] *JCC2*, 395, Journal, 16Sept1825.

[26] *JCC2*, 301, JC/MC, 18Nov1823.

[27] *JCC2*, 292, JC/MC, 27Oct1823.

[28] *JCC2*, 292 & 301, JC/MC, 27Oct&18 Nov1823.

[29] *JCC2*, 301, JC/MC, 18Nov1823. For thoughts on the meaning of 'Fish', JC's nickname for Maria, see ch. 31.

[30] *JCC2*, 298, MC/JC, 10Nov1823.

[31] *JCC2*, 299, MC/JC, 17Nov1823.

[32] *JCC2*, 298, MC/JC, 10Nov1823.

[33] *JCC2*, 299, MC/JC, 17Nov1823. Peter Coxe was an auctioneer and poet; Rev. Thomas Judkins an amateur artist.

[34] Ibid.

[35] *JCC2*, 302, MC/JC, 21Nov1823.

[36] *JCC2*, 304, JC/MC, 25Nov1823.

[37] *JCC2*, 305–6, JC/MC, 26Nov1823.

[38] *JCC6*, 146, JC/JFish, 16Dec1823.

[39] *JCC6*, 161, JC JFish, mid-May1824.

[40] *JCC6*, 157, JC/JFish, 8May1824.

[41] The address is now 11 Sillwood Road, where there is a plaque on the house.

31. Brighton and home

[1] *JCC2*, 319, JC/MC, 28May1824.

[2] *JCC2*, 315, MC/JC, n.d. [late May 1824].

[3] *JCC2*, 319, JC/MC, 28May1824.

[4] *JCC6*, 172, JC/JFish, 29Aug1824.

[5] Ibid., and *JCC2*, 316, MC/ JC, late May 1824.

[6] E. J. Morley, (ed.), *Henry Crabb Robinson on Books and their Writers*, 1938, vol. 1, p. 312, quoted in J. R. Watson, 'Wordsworth and Constable', *Review of English Studies*, Nov 1962, vol. 13, no. 52, pp. 361–7.

[7] *JCC6*, 172, JC/JFish, 29Aug1824.

[8] *JCC5*, 79–82 has RBB's full account of Phillips. The *ODNB* has a shorter account.

[9] *JCC2*, 336, MC/JC, 19June1824.

[10] *JCC2*, 336, 19June1824.

[11] *JCC2*, 327 & 330, Journal, 7&16June1824.

[12] *JCC2*, 368, MC/JC, [late] Oct1824.

[13] *JCC2*, 316, Journal, 24May1824. He had also added 'London' to his signature on *The White Horse* (1819) and *Stratford Mill* (1820).

[14] *JCC2*, Journal, 347, 29June1824.

[15] *JCC2*, 318, Journal, 27May1824.

[16] *JCC2*, 341, Journal, 23June1824.

[17] *JCC6*, 233, JFish/JC, 3Sept1827.

[18] *JCC2*, 343, JC/MC, n.d., [24June1824].

[19] *JCC6*, 181, JC/JFish, 17Nov1824.

[20] *JCC6*, 181, JC/JFish, 17Nov1824. John Dunthorne is also listed as

a picture restorer; see: www.npg.org.uk/research/programmes/
directory-of-british-picture-restorers/british-picture-restorers-1600-1950-d

[21] *JCC2*, 322, Journal, 1June1824.

[22] *JCC2*, 340–1, Journal, 22–23June1824. 'The wort' is the mass of sugars produced during the mashing of the malt and liquor.

[23] *JCC2*, 337, MC/JC, 19June1824.

[24] *JCC2*, 342, JC/MC, n.d. [24June1824].

[25] *JCC2*, 348, Journal, 1July1824.

[26] *JCC6*, 204, JC/JFish, 10Sept1825.

[27] *JCC2*, 390, Journal, 11Sept1825.

[28] *JCC2*, 407, Journal, 31Oct1825.

[29] *JCC2*, 360, 12July1824.

[30] An annotated plan drawn from memory by the painter Claude Rogers (1907–1979), whose studio it was *c.*1939–40, supplies this information. The house was demolished after bomb damage. Rogers's original drawing is lost; photocopy in Tate, 1991, p. 43. See also J. R. Howard Roberts and Walter H. Godfrey (eds.), *The Parish of St Pancras, Part 3, Tottenham Court Road and Neighbourhood*, 1949, pp. 13–26; see: www.british-history.ac.uk/survey-london/vol21/pt3/pp13-26#h3-0010

[31] Admission cards to the home galleries of John Flaxman, James Ward and Benjamin West are in CFP, GH. For John Martin's parties, see Balston, ch. 18.

[32] Hamilton, 2014.

[33] Cards dated 1830 and 1831 survive in CFP, GH.

[34] *JCC2*, 110, JC/MB, 30June1813.

[35] W. P. Frith, *My Autobiography and Reminiscences*, 1887–8, vol. 3, pp. 318–19.

[36] GR, 28.24, 32.49; V&A, 338-1888, 329-1888.

[37] *JCC2*, 336, MC/JC, 19June1824. Toad-in-the-hole was not, then, sausages in batter as today, but beef or a boned and stuffed chicken in batter. India Mandelkern, http://homogastronomicus.blogspot.com/2012/10/toad-in-hole-revisited.html

[38] *JCC1*, 306, AbramC/John Charles, 1Feb1839.

[39] GR, 25.40. The portrait was accepted, and published, by RBB (*JCC2*, pl. 5, fp 267), but GR adds: 'I do not know on what evidence.'

[40] *JCC2*, 206, MB/JC, 16Sept1816.

[41] *JCC2*, 319–20, Journal, 30May1824.

[42] *JCC2*, 361, Journal, 13July1824.

[43] *JCC1*, 205–6, GC/JC, 6Feb1824; *JCC1*, 207–8, AbramC/JC, 27Apr1824.

[44] *JCC2*, 336, MC/JC, 19June1824.

[45] *JCC2*, 368, MC/JC, n.d. [late Oct 1824].

[46] *JCC2*, 337, MC/JC, 19June1824. The book will almost certainly have been Maria's mother's copy of Richard and Maria Edgeworth's two-volume *Practical Education*.

[47] *JCC2*, 350, Journal, 1July1824. See also Hamilton, 2007, ch. 11, and Richard Holmes, *The Age of Wonder*, 2008, ch. 3.

[48] *JCC2*, 351, Journal, 2July1824.

[49] *JCC*2, 352–4, Journal, 3July1824.

[50] *JCC*2, 355, Journal, 5July1824.

[51] *JCC*2, 330, 347 & 393, Journal, 16&29June1824, & 13Sept1825.

[52] *JCC*2, 358, Journal, 9July1824.

[53] *JCC*2, 383, Journal, 4Sept1825.

[54] *JCC*2, 346, Journal, 28June1824.

[55] *JCC*2, 369–70, MC/JC, 29Oct1824.

[56] *JCC*6, 175, JC/JFish, 22Nov1824.

[57] Ibid.

32. My ambition is on fire

[1] *JCC*6, 167. JC/JFish, 18July1824.

[2] *JCC*6, 157, JC/JFish, 8May1824, and *JCC*6. 168, JC/JFish, 18July1824.

[3] *JCC*6, 168, JC/JFish, 18July1824. 'to carry my profession' makes a clearer reading here than RBB's 'to carry one profession'.

[4] *JCC*6, 171, JC/JFish, [postmarked] 29August1824.

[5] Ibid.

[6] *Rainstorm over the Sea*, Royal Academy of Arts, 03/1390, GR, 24.67.

[7] GR, 24.80.

[8] *JCC*2, 336, Journal, 19June1824.

[9] *Brighton Beach with Colliers*, V&A, 591-1888; GR, 24.11.

[10] Tate Britain, GR, 27.1.

[11] *JCC*6, 150, JC/JFish, 17Jan1824.

[12] *JCC*6, 168, JC/JFish, 18July1824 [from Brighton]

[13] *JCC*6, 207, JC/ JFish, 19Nov1825.

[14] *JCC*2, 408, Journal, 2Nov1825.

[15] *JCC*2, 415, Journal, 28Nov1825.

[16] *JCC*6, 180, JFish/JC, 13Nov1824.

[17] *JCC*6, 181, JC/JFish, 17Nov1824.

[18] Ibid.

[19] *JCC*2, 372, RBB note.

[20] GR, 25.13 & 15.

[21] *JCC*2, 373, JC/MC, 21Jan1825.

[22] Jane Lambert to William Lambert, 21 Feb 1825, Derek Rogers, 'A John Constable Rediscovered', *Burlington Magazine*, vol. XCII, p. 228.

[23] *JCC*2, 373–4, JC/MC, 22Jan1825.

[24] *JCC*6, 197, JC/JFish, n.d. [early Apr 1825].

[25] Recorded by JC in the Family Bible, CFP, GH.

[26] *JCC*2, 387, Journal, 7Sept1825. Tate, 1991, p. 213.

[27] *JCC*4, 197, Le Comte de Forbin/JC, 4Mar1825. This was one of ninety-nine medals presented that year to artists by Charles X.

[28] *JCC*6, 198, JC/JFish, n.d. [early Apr 1825].

[29] *JCC*6, 201.

[30] *JCC*4, 97, JC/Francis Darby, 1Aug1825.

[31] *Branch Hill Pond, Hampstead*, coll. Virginia Museum of Fine Art, Richmond;

and *Child's Hill, Harrow in the Distance*, GR, 25.5,6.

[32] *JCC4*, 99, JC/Francis Darby, 24Aug1825.

[33] *JCC6*, 204, JC/JFish, 10Sept1825.

[34] *JCC6*, 203, JFish/JC, 24Aug1825.

[35] *JCC2*, 388, JC/MC, 9Sept1825; 6, 204, JC/JFish, 10Sept1825.

[36] *JCC 2*, 391, Journal, 13Sept1825.

[37] *JCC2*, 402, Journal, 21Oct1825.

[38] *JCC6*, 204, JC/JFish, 10Sept1825.

[39] *JCC2*, 394, Journal, 16Sept1825.

[40] *JCC2*, 398, Journal, 2Oct1825.

33. The rubs and ragged edges of the world

[1] CRL, *Autobiog. Rec.*, vol. 1, p. 114.

[2] CRL, p. 71.

[3] *JCC3*.

[4] One is at *JCC3*, 116. A further thirteen are published in *FDC*, 235ff.

[5] *JCC3*, 9, JC/CRL, 1Sept1826.

[6] *JCC6*, 228, JC/JFish, 28Nov1826.

[7] *JCC3*, 10, JC/CRL, 29Jan1828.

[8] *JCC3*, 147, JC/CRL, 25Feb1837.

[9] *JCC3*, 85, JC/CRL, n.d. [Dec 1832].

[10] Frances Mary Redgrave, *Richard Redgrave, CB, RA, A Memoir compiled from his Diary*, 1891, p. 65.

[11] *JCC3*, 13, JC/CRL, n.d. [8Feb1828].

[12] *JCC6*, 83, JFish/JC, 16Feb1822.

[13] For an overview of JC's involvement in the AGBI see *FDC*, 321–5. 'Rubs and ragged edges of the world': *JCC6*, 83, JFish/JC, 16Feb1822.

[14] *JCC6*, JC/Fish, 21Feb1823.

[15] *JCC6*, 108, JC/JFish, 1Feb1823.

[16] *JCC3*, 13, JC/CRL, 5Feb1828.

[17] *JCC6*, 49, JFish/JC, 4Nov1819.

[18] *CRL, Autobiog. Rec.*, p. 76.

[19] *FDC*, 193, Chantrey/JC, 8Feb1826.

[20] *JCC3*, 12, JC/CRL, 5Feb1828.

[21] *JCC3*, 19, JC/CRL, 21Jan1829.

[22] *JCC3*, 50–1, JC/ CRL, 4Nov1831 & n.d. [Nov 1831].

[23] *JCC2*, Journal, 320, 31May1824.

[24] *JCC6*, 232, JC/JFish, 26Aug1827.

[25] *JCC4*, 140, JC/William Carpenter, 15Feb1830.

[26] Lucas annotations to CRL, *FDC*, 57.

[27] *JCC2*, 321, Journal, 31May1824.

[28] *FD16*, 5533, 3July1820.

[29] *JCC6*, 198, JC/JFish, Apr1825; & *JCC6*, 116, 9May1823.

[30] *JCC6*, 125, JC/JFish, 10July1823.

[31] *JCC6*, 113, JC/JFish, 21Feb1823.

[32] This John Martin, who appears only briefly in *JCC*, is not to be confused with the bibliographer John Martin (1791–1855), a friend and collaborator of JC, who was instrumental in publishing engravings after his work. *JCC5*, 86–93.

[33] *JCC2*, 413, JC/MC, 26Nov1825.

[34] Balston, p. 27.

[35] Balston, p. 179.

[36] Balston, p. 178–9. Quoted from his evidence to the 1836 Select Committee of Arts.

[37] Balston, p. 181.

[38] Balston, p. 184.

[39] W. P. Frith, *My Autobiography*, 1887, vol. 1, p. 47.

[40] Balston, p. 182.

[41] *JCC6*, 63, JC/JFish, n.d. [Feb 1821].

[42] *JCC6*, 66, JC/JFish, 1Apr1821.

[43] *JCC2*, 392, Journal, 13Sept1825.

[44] *Literary Gazette*, 3 May 1823; Constable's letter dated 9 May 1823.

[45] *JCC6*, 116, JC/JFish, 9May1823.

[46] *JCC*, vol. 6, p. 77, JC/JFish, 23 Oct 1821. See Paul O'Keefe, *A Genius for Failure – The Life of Benjamin Robert Haydon*, 2009.

[47] Malcolm Elwyn (ed.), *The Autobiography and Journals of Benjamin Robert Haydon*, 1950, pp. 235–6.

[48] *JCC*, vol. 3, p. 43, JC/CRL, 22 Aug 1831.

[49] Birmingham Museum and Art Gallery. For a revised dating of the development of Bishop's grounds, see Ian Warrell, *Turner's Wessex – Architecture and Ambition*, 2015, p. 188.

[50] *JCC6*, 115, JC/JFish, 9May1823.

34. The life in common things

[1] See Norman Scarfe, 'John Constable's Biographer, R. B. Beckett: An editorial appreciation and personal tribute', *FDC*, xiii–xix.

[2] Volume 1, *John Constable's Correspondence: The family at East Bergholt 1807–1837* (ed. R. B. Beckett), published by the HMSO, is bound in red.

[3] *FDC*, 103.

[4] *JCC2*, 316.

[5] Ibid., 320 & 328.

[6] Ibid., 321.

[7] Ibid., 330.

[8] Ibid., 325.

[9] *JCC6*, 110, JFish/JC, 7Feb1823.

[10] *JCC2*, 380–81, Journal, 2&3Sept1825.

[11] Sheepshanks Gift, V&A, F.A. 36; GR, 21.10.

[12] Book 1, ll. 17–18.

[13] *JCC2*, 351, 384, 388, 407.

[14] *JCC2*, 411, Journal, 23Nov1825; *FDC*, 106, John Bannister/JC, 3Sept1827.

[15] *JCC*2, 339, Journal, 21June1824.

[16] *JCC*6, 66, JC/Fish, 1Apr1821. *A Natural History of Selborne* is comprised of a series of letters, rather than being a journal.

[17] *JCC*2, 382–3, Journal, 4Sept1825.

[18] *JCC*2, 338, 341 & 396, Journal, 20&23June1824 & 30Sept1825.

[19] *JCC*2, 387, Journal, 7Sept1825.

[20] *JCC*6, 183, JC/JFish, 17Nov1824.

35. Gentlemen can never afford to buy pictures

[1] *JCC*6, 174, JFish/JC, 8Sept1824.

[2] *JCC*6, 110, JFish/JC, 7Feb1823.

[3] *JCC*6, 112, JC/JFish, 21Feb1823.

[4] *JCC*6, 123, JFish/JC, 5July1823. Constantia, a South African wine, was a favourite of Napoleon in exile on St Helena. Wikipedia.

[5] *JCC*1, 217, AbramC/JC, 2Aug1824.

[6] *JCC*2, 443, JC/MC, 10Oct1827.

[7] *JCC*2, 403, Journal, 22Oct1825.

[8] *FDC*, 119, JFish/JC, 11Oct1822.

[9] *JCC*6, 57, JC/JFish, 1Sept1820.

[10] *JCC*2, 263, Robert Bicknell/JC, 3Sept1820, with RBB note; *JCC*1, 71, AC/JC, 10Dec1811; *JCC*2, 440, JC/MC, 4Oct1827.

[11] David Hansen, *Dempsey's People – A Folio of British Street Portraits, 1824–1844*, Australian National Portrait Gallery, 2017.

[12] *JCC*2, 403, Journal, 22Oct1825.

[13] Redgrave, 1866, Phaidon ed., 1947, p. 371.

[14] *JCC*6, 157, JC/JFish, 8May1824.

[15] *JCC*6, 162, JFish/JC, 31May1824.

[16] *JCC*6, 169, JFish/JC, 24July1824.

[17] *JCC*6, 175, JC/JFish, 2Nov1824.

[18] *JCC*6, 110, JFish/JC, 7Feb1823.

[19] Ibid.

[20] *JCC*6, 144, JFish/JC, 12Dec1823.

[21] Fitzwilliam Museum, GR, 24.4; GR, 26.1 and 4; *The Cornfield*, National Gallery, GR, 26.1.

[22] *JCC*6, 206, JC/JFish, 12Nov1825.

[23] *JCC*2, 398, Journal, 4Oct1825.

[24] *JCC*2, 424, JC/MC, 18Jan1826.

[25] *JCC*6, 144, JFish/JC, 12Dec1823.

[26] *JCC*5, 80, Henry Phillips/JC, 1Mar1826.

[27] *JCC*6, 216–17, JC/JFish, 8Apr1826.

[28] According to East Bergholt resident George Clark (eighty-one), interviewed by Brian Johnson on *Down Your Way* (BBC Radio 4, April 1976), the boy drinking at the stream is the grandfather of Ned Aldous of East Bergholt, who was aged ninety-three in 1976. I am indebted to Alicia Herbert and Jenny Chapman for this information.

[29] *JCC6*, 206, JFish/JC, September 1825.

36. But still they tell me she does mend

[1] *JCC6*, 147, JC/JFish, 16Dec1823.
[2] *JCC6*, 200, JC/JFish, 13Apr1825.
[3] *JCC6*, 232, JC/JFish, 26Aug1827.
[4] *JCC6*, 228, JC/JFish, 28Nov1826.
[5] *JCC2*, 430–31, Journal, 24May1826.
[6] *JCC6*, 231, JC/JFish, 26Aug1827.
[7] *The Times*, 11 May 1827; Ivy, 27.15.
[8] *The Examiner*, 1 July 1827; Ivy, 27.18.
[9] The stone porch was added after the Constables' occupancy. I am grateful to the owners for showing me its interior. The street has been renumbered; the Constables' house is no longer number 6.
[10] *JCC6*, 230, JC/JFish, 26Aug1827.
[11] *JCC1*, 243, AbramC/JC, 30Mar1828.
[12] *JCC4*, 11, JC/CRL, 29Jan1828.
[13] Hamilton, 2014.
[14] *JCC3*, 16, JC/CRL, Feb/Mar1828.
[15] *JCC1*, 241, AbramC/JC, 16Mar1828.
[16] *JCC4*, 249, JC/Samuel Lane, n.d. [May 1828]; *JCC6*, 237, JC/JFish, 11June1828.
[17] *FDC*, 123, Henry Phillips/JC, 22Aug1828.
[18] *JCC6*, 237, JC/JFish, 11June1828.
[19] Horne Foundation, Florence, GR, 28.21.
[20] I am grateful to Oswyn Murray for the translation and for this suggestion.
[21] *JCC5*, 90, JC/JM, n.d. [1833].
[22] Will of Charles Bicknell, PROB 11/1742/416. Bicknell's stocks in the Bank of England, South Sea House and India House were left in trust for Maria and Louisa to William Young Knight, Solicitor, of Great Marlborough Street and Charles Jones of Gower Street.
[23] *JCC6*, 236, JC/JFish, 11June1828.
[24] *JCC6*, 237, JFish/JC, 19June1828.
[25] *JCC1*, 241, AbramC/JC, 16Mar1828.
[26] *JCC6*, 231, JC/JFish, 26Aug1827.
[27] *JCC4*, 139, JC/James Carpenter, 23July1828.
[28] CRL, p. 167, JC to JDjr, 22 Aug 1828.
[29] MWR to JC, 20 Aug 1828, CFP, Tate Archive.
[30] MWR to JC, 26 Aug 1828, CFP, Tate Archive.
[31] *JCC6*, 231, JC/JFish, 26Aug1827. GR, 30.4 and 21.
[32] *JCC4*, 158, JC/Dominic Colnaghi, 15Sept1828.
[33] MWR to JC, 1 Sept 1828, CFP, Tate Archive.
[34] CRL, p. 168.
[35] *JCC4*, 282, JC/Henry Pickersgill, 27Nov1828.

37. Rude ruins glitter

[1] *JCC*1, 250–2, AnnC, MarthaW & MaryC (severally)/JC, 26Nov, n.d. [end Nov] & 12Dec1828.

[2] *JCC*1, 250, NC/JC, 26Nov1828.

[3] *Bury and Norwich Post*, 3 Dec 1828.

[4] *JCC*1, 236, AbramC/JC, 10Oct1827; *JCC*2, p.443, JC/MC, 10Oct1827.

[5] *FDC*, 76, JC/GoldingC, 3Dec1824.

[6] *FDC*, 80–1, JC/GoldingC, 19Dec1828.

[7] *JCC*6, 239, JFish/JC, 29Nov1828.

[8] *JCC*2, 127, JC/MB, 3July1814.

[9] Tate, see also Natasha Duff, 'Constable's *Sketch for Hadleigh Castle*, A Technical Examination', available at: www.tate.org.uk/research/ publications/tate-papers/05/constables-sketch-for-hadleigh-castle-technical-examination. Sketch: Tate Britain, GR,29.2; exhibition painting: BAC, Yale, GR, 29.1; studies, GR,29.3, 29.4, BAC, Yale and Priv. Coll.

[10] *JCC*3, 20, JC/CRL, 5Apr1829.

[11] *JCC*6, 2412, JFish/JC, 7Dec1828.

[12] *JCC*4, 155, JC/Dominic Colnaghi, quoting JFish, 6Apr1827.

[13] The painting was cut down on its left side in the later nineteenth century. See Tate, 1991, p. 279.

[14] Gibbons Papers, Bristol RO, 41197/1/49 & 53, Francis Danby to J. Gibbons, 24 Feb 1829, quoted Francis Greenacre, *Francis Danby 1793–1861*, 1988, p. 29.

[15] *JCC*2, 355, Journal, 5July1824.

[16] *JCC*4, 277, JC/John Chalon, 11Feb1829.

[17] CRL, p. 173.

[18] CRL, p. 171.

[19] *JCC*1, 254, AbramC/JC, 13Feb1829.

[20] Ibid.

[21] *JCC*3, 20, JC/CRL, 5Apr1829.

[22] James Thomson, 'Summer', from *The Seasons*, 1727, ll. 165–70.

[23] *JCC*3, 21, JC/CRL, 5Apr1829. Charles, b. 29 March 1821; Isabel, b. 23 Aug 1822. RBB identifies an illegible note on the letter which might have explained the inconsistencies in the date.

[24] Ibid.

[25] CRL, p. 177.

[26] *JCC*3, 22, JC/CRL, n.d. [early May 1829]

[27] *JCC*3, 24, JC/ CRL, 31Jan1830.

[28] *ODNB*, James Morrison.

38. Life slips

[1] John Sunderland and David H. Solkin, 'Staging the Spectacle', essay in David H. Solkin (ed.), *Art on the Line – The Royal Academy Exhibitions at Somerset House 1780–1836*, 2001, pp. 23–37.

[2] *JCC*4, 142, JC/James Carpenter, 2Apr1830. Artists were forbidden to submit

pre-sold paintings to the exhibition.

3 The rejected painting was *Water-meadows near Salisbury*, V&A, F.A. 38; GR, 29.41. The story is told in W. P. Frith, *My Autobiography and Reminiscences*, vol. 1, 1887, pp. 237–8. See also JC's note to Henry Howard listing the four paintings he sent to the RA in 1830, *FDC*, 220–1.

4 *JCC4*, 142, JC/James Carpenter, 2Apr1830; and *JCC3*, 28, JC/CRL, Apr1830.

5 *Helmingham Dell*, Nelson-Atkins Museum, Kansas, GR, 30.1; *Hampstead Heath*, Glasgow Museum and Art Gallery, GR, 30.4.

6 CRL, p. 185. Also RBB note, *JCC3*, 27.

7 *Morning Chronicle*, 3 May 1830, Ivy, p. 138.

8 See ch. 40.

9 *Literary Gazette*, 14 May 1831, Ivy, p. 150.

10 *Observer*, 29 May 1831; *Englishman's Magazine*, 1 June 1831, Ivy, pp. 152–3.

11 *Athenaeum*, 7 May 1831; Ivy, 31.13.

12 *FDC*, 285.

13 *JCC6*, 226, JFish/JC, 27Sept1826.

14 *JCC5*, 43, JC/WP, 17Dec1834.

15 *Athenaeum*, 3 July 1830, *JCD*, pp. 79–80.

16 GR, 30.9. Royal Academy, 04/205. The drawing was presented to the RA by Colnaghi's in 1966. Inaccuracies in the drawing – in the marble the child is practically horizontal; in the drawing nearly vertical – suggest it was made away from the subject, perhaps in conversation with Colnaghi, and left with him as a gift.

17 Francesco, Count Algarotti, *An Essay on Painting written in Italian*, 1764, p. 8.

18 Ibid., p. 162.

19 *JCC5*, 77.

20 *JCC6*, 226, JFish/JC, 27Sept1826.

21 John Gage, *George Field and his Circle: From Romanticism to the Pre-Raphaelite Brotherhood*, Fitzwilliam Museum, 1989; Hamilton, 2014, ch. 7.

22 *JCC2*, 386 & 394, Journal, 7&15Sept1825. The book was Thomas Wright, *Some Account of the Life of Richard Wilson, Esq, RA*, 1824.

23 George Field, *Chromatography; or, A Treatise on Colours and Pigments and of their Powers in Painting, &c.*, 1835, p. 123. Constables 'Remarks' are taken with minor variation from the letterpress to *Spring*, plate 4 in the 1833 edition of *English Landscape Scenery*.

24 CRL, p. 270.

25 C. R. Leslie, *Life and Letters of John Constable RA*, ed. Robert C. Leslie, 1896, p. 281n.

39. David Lucas

1 *JCC 6*, 134–5, JFish/JC, 2 Oct 1823.

2 *JCC6*, 181, JC/JFish, 17Nov1824; *JCC4*, 266, S. W. Reynolds/JC, n.d. [early Dec 1824].

3 *JCC4*, 267, S. W. Reynolds/JC, n.d. [early 1826].

4 V&A, 2014, pp. 81–105.

5 Gillian Forrester, *Turner's 'Drawing Book'* – *The Liber Studiorum*, 1996.

6 Luke Herrmann, *Turner Prints*, 1990; *JCC4*, 344, JC/DL, 12 March 1831.

7 *JCC4*, 325, JC/DL, 26Feb1830.

8 *JCC4*, 326, 330, 348 & 373, JC/DL, 2Mar & late July/Aug1830, 13Apr1831, & n.d. [?April 1832].

9 Huntington Library, San Marino, California. Annotations transcribed in *FDC*, 53–62.

10 *JCC6*, 258, JC/JFish, 24May1830. See Andrew Wilton, *Constable's 'English Landscape Scenery'*, 1979.

11 *JCC6*, 260, JFish/JC, 6July1830. J. H. Reynolds identified by Adele M. Holcomb, 'John Constable as a contributor to "The Athenaeum"', *Burl. Mag.*, Oct 1982, pp. 628–9. See also Ivy, pp. 142–4.

12 Publication advertised in the *Athenaeum*, 25 Dec 1830.

13 Hamilton, 2003, p. 126, map p. 127.

14 John Constable, Introduction to *Various Subjects of Landscape Characteristic of English Scenery*, 1833.

15 Ibid.

16 Balston, p. 184.

17 Latin quotation translated by Archdeacon Fisher, *JCD*, p. 14.

18 Letterpress to *Spring, EL*, 1833.

19 *JCC4*, 401, JC/DL, 27June1833.

20 *JCC4*, 406, JC/CRL, n.d. [after May 1832]. Lists and accounts for the *English Landscape* prints are published with notes by RBB in *JCC4*, Appendices A–D, 444–63.

40. Brother labourer

1 Quoted in Helen Guiterman, '"The Great Painter": Roberts on Turner', *Turner Studies*, vol. 9, no. 1 (Summer 1989), p. 4.

2 David Roberts' diary, quoted Guiterman, *loc. cit.*

3 Thornbury, 1897 edn, p. 228. This is Thornbury's own expression of intelligence sent to him by Roberts.

4 CRL, *Autobiog. Recol.*, p. 135. 'A grey picture, beautiful and true' is Leslie's description of Turner's *Helvoetsluys*.

5 *FD12*, 4355, 24May1814.

6 *JCC3*, 100, JC/CRL, n.d. [spring 1833]; *JCC4*, 366, JC/DL, n.d. [Spring 1832].

7 Cosmo Monkhouse, *Turner*, 1889, p. 101; *JCC4*, 153, MLColnaghi/JC, 17 July 1821.

8 *JCC5*, 22, JC/GC, 6June1835.

9 *JCC5*, 32, JC/GC, 12May1836.

10 *JCC6*, 243, JFish/JC, 11Feb1829 *JCC3*, 58, JC/CRL, 14Jan1832.

11 *JCC3*, 34, JC/CRL, 29Dec1830. RBB reads this as 'Tomlinson', and suggests (p. 34n) that he is William Tomlinson of 8 Charlotte Street. This may be an assumption inspired by street directories. However, it misses the importance

of Thomas Tomkison to both artists: CRL, p. 187, records the name as 'Tomkison'. See references to Thomas Tomkison in Hamilton, 1997, pp. 13–14 and 19–20.

[12] William Jerdan, *Autobiography*, 1852, vol. 3, p. 320. See also: www.lieveverbeeck.eu/Pianoforte-makers_England_t.htm I am most grateful to Norman Macsween for his help in identifying Tomkison.

[13] CRL, *Autobiog. Recol*, vol. 1, pp. 115–16.

41. Yes Sir – this is Constable's country

[1] As related by JC to CRL, *JCC3*, 145, 30Dec1836.

[2] *JCC6*, 262, JC/JCC, 10July1830.

[3] Preaching in Salisbury in 1831: *JCC3*, 40, JC/CRL, 2June1831; death from cholera, *JCC4*, 162, JC/D. Colnaghi, 23Mar1833.

[4] *JCC6*, 263, Mary Harley Fisher/JC, 3Sept1832.

[5] *JCC3*, 95, JC/CRL, 10Mar1833.

[6] Ivy, p. 177, 33.40.

[7] *JCC1*, 235, JC/MC, 4 and 7Oct1827; and *JCC2*, 441.

[8] GR, 18.8. Metropolitan Museum of Art, New York.

[9] *JCC4*, 89–90, James Pulham/JC, 11Sept1818.

[10] *JCC4*, 90, James Pulham/JC, 9July1824.

[11] *Harwich Lighthouse*: possibly GR, 20.6, *Helmingham Dell*: GR, 26.21, John G. Johnson Collection, Philadelphia.

[12] *JCC1*, 233, AbramC/JC, 30Sept1827.

[13] *JCC1*, 244, JC/AbramC, 25Apr1828.

[14] *JCC1*, 262, MWhalley/JC, 5June1831.

[15] *JCC1*, 263, MWhalley/JC, 22June1831.

[16] *FDC*, 82–3, JC/Minna, 5July1831.

[17] *JCC1*, 264, MWhalley/JC, 25July1831.

[18] Letter JC to Jane Spedding, 7 Aug [1831]. Wordsworth Library, Grasmere, WLMSS 2/2/24.

[19] *JCC1*, 265, JC/MWhalley, [late] July1831.

[20] *JCC5*, 133, JCC/MinnaC, [late] July1831.

[21] *JCC5*, 131, JC/MinnaC, 14July1831.

[22] Friday 5 Aug 1831. Letter JC to Jane Spedding, cit.

[23] There is no record in the Bedford archives at Woburn of the 6th Duke's visit to Constable's studio. I am grateful to Nicola Allen for confirming this.

[24] Installed 31 May 1831. *JCC1*, 262.

[25] *JCD*, p. 100, Alfred Stothard/JC, 3July1831. This declares, with some expressed anxiety, that the original plaque to Dr Rhudde – and, presumably, the plaque to Mary Rhudde also – has been removed from the north wall of the chancel, and asks if Mrs Farnham, the Rhudde's daughter, has been consulted. See also note at *JCD*, p. 100.

[26] Ibid.

[27] *JCC3*, 81, JC/CRL, n.d. [Nov 1832].

[28] *JCC6*, 169, JFish/JC, 24July1824.

29 *JCC*4, 387, JC/DL, 14Nov1832.

30 *JCC*1, 247, MaryC/JC, 12May1828.

31 *JCC*1, 273, AbramC/JC, 15Feb1833.

32 *FDC*, 78, JC/GoldingC, 23Dec1825; *JCC*1, 282, JC/Jane Inglis, 29Aug1834.

33 Ibid., & *JCC*1, 289, AbramC/JC, 23April1835.

34 *JCC*1, 279, AbramC/JC, 19Dec1833.

35 *JCC*1, 281, MaryC/JC, 8Jan1834.

36 *FDC*, 178, William Beechey/JC, 15May1834.

37 Hampstead Rate Books, 1834. Camden Local Studies and Archive Centre.

38 *JCC*1, 289, AbramC/JC, 23Apr1835.

39 *JCC*1, 296, MaryC/JC, 26Jan1836. 'Fisher's' here is the name of the farm, a coincidence of names, and nothing to do with John Fisher.

40 *JCC*1, 295–301, MaryC&AbramC/JC, 26Jan–20May1836.

41 Jaques: RA 1832, GR, 32.10; Gray's *Elegy*: RA 1834, GR, 34.4.

42. Charles Boner

1 *JCC*3, 18, JC/CRL, 21Jan1829.

2 *JCC*1, 260, MWhalley/JC, 15Feb1831.

3 *JCC*3, 54–5, JC/CRL, 28&29 Dec1831.

4 *JCC*3, 70–2, JC/CRL, 22,24&25June1832.

5 *JCC*5, 129, Jane South/JC, n.d. [Feb/Mar 1831]. See also, *ODNB*, Charles Boner (1815–1870).

6 R. M. Kettle, *Memoirs and Letters of Charles Boner*, vol. 1, 1871, pp. 6–8.

7 *JCC*5, 1345, JC/CB, 25Oct1831.

8 *JCC*5, 134, JC/CB, 25Oct1831.

9 *FDC*, 317, JC/David Wilkie, 18Dec1834.

10 *FDC*, 85–6, JC/JCC, 1&25Sept1833.

11 *JCC*5, 143, JC/Rev. Thomas Pearce, n.d. [Aug 1833].

12 R. M. Kettle, op. cit., pp. 17–18.

13 Ibid., p. 29.

14 Ibid., p. 6.

15 Ibid., p. 13.

16 Ibid., p. 4.

17 Ibid., pp. 14–15.

18 *JCC*5, 185, JC/JB, 26Jan1835.

19 They met in England, twice at least, in 1844 and 1865. Ibid., pp. 16ff & 68.

43. Lecturer: novel, instructive and entertaining

1 *FDC*, 138, 208 & 205; *JCC*3, 122–3, JC/CRL, 15Dec1834.

2 *JCC*2, 12 & 17.

3 For example, *JCC*2, 412, 420–1, Journal, November1825; *FCD*, 300–2, JGStrutt/JC, 25Jan1830.

4 GR, 29.53. Constable's unfinished portrait of Mrs Evans is GR, 29.52.

5 *JCC*6, JFish/C, 19June1828, 238.

6 *JCC3*, 70, JC/CRL, 22June1832.

7 *JCC3*, 107, JC/CRL, 20Jan1834; *JCC5*, 173, JC/Mary Allen, 20Feb1834.

8 Kettle, op. cit., pp. 14 & 15.

9 *FDC*, 318, David Wilkie/JC, 29Dec1834.

10 *FDC*, 106, John Bannister/JC, 3Sept1827.

11 RBB note, *JCC5*, 40.

12 *JCC5*, 42, JC/WP, 29July1834.

13 *JCD*, p. 4.

14 *JCC5*, 40, WP/JC, 8Jan1833.

15 *JCC5*, 42, WP/JC, 9Dec1834.

16 X. Y. Z. [William Purton], *Gradus ad Homerum; or, the A. B. C. D. of Homer: being a Heteroclite Translation of the First Four Books of the Iliad into English Heroics, with Notes*, 1862. Intro, p. iii.

17 *JCC5*, 43, JC/WP, 17Dec1834.

18 *JCC5*, 44, JC/WP, ?July1835.

19 *JCC3*, 103, JC/CRL, 11June1833.

20 John Milton, *Lycidas*, ll. 71–7.

21 *JCC2*, 70, JC/MB, 27May1812.

22 I am grateful to Karen Smith, and to Stephanie Macdonald of 6a Architects, for guidance and insight here.

23 *JCC3*, 78, JC/CRL, 17 July 1832. Thomas J. Barratt, *The Annals of Hampstead*, vol. 2, pp. 17 & 30–7.

24 *FDC*, 93, JC/JohnCC, [late] Nov1833.

25 *JCC3*, 104, JC/CRL, 11June1833.

26 *FDC*, 84–5, JC/JCC, 1Sept1833.

27 *JCC4*, 422, JC/DL, Sept1835.

28 Pliny the Elder, *Natural History*, 36, 'Artists who painted with the pencil'. See also *JCD*, p. 29, and *FDC*, 10–19.

29 Notes for the 1833 Hampstead lectures, *FDC*, 10–19.

30 GR, 36.12-16.

31 *JCC* 1, 282, JC/Jane Inglis, 29Aug1834.

32 *JCC4*, 229; FDC, 5.

33 *JCC4*, 149, JC/WCarpenter, n.d. [Dec 1835].

34 Hampstead Subscription Library minutes, 1833, Camden Local Studies and Archive Centre. I am grateful to Malcolm Holmes and Ingrid Smits for this information.

35 *JCC5*, 27, JC/GC, 12Sept1835.

36 *JCC4*, 147–8, JC/William Carpenter, June1835.

37 *JCC5*, 185–6, JC/CB, 26June1835.

38 Ibid.

39 *JCC1*, 291, MaryC/JC, [?] May1835.

40 *JCC4*, 30, JC/GC, 12Jan1836.

41 Coll: Royal Academy.

42 Michael Faraday to JC, 16 Feb 1836, Frank A. J. L. James (ed.), *The Correspondence of Michael Faraday*, vol. 2 (1832–1840), 1993, no. 897.

43 *FDC*, 265, JC/Henry Pickersgill, 23May1836. Letter coll. Philadelphia

Museum of Art.

44 *FDC,* 18. I have omitted the deletions noted in Parris and Shields's published transcription.

45 Ibid., p. 19.

46 *JCD,* pp. 38–69.

47 CFP, Tate Archive, paper watermarked 1831; *JCC2,* 421, Journal, 11Dec1825.

48 CFP, Tate Archive, Poussin letters, Letter lix, Folio 3/4. Paper watermarked 1831. Passage marked by pencil line, probably by JC.

49 Ibid., Letter lxiv, 20 Aug 1645. Folio 4/4. This folio is heavily pencil marked with lines in the margin.

50 Frank Greenaway, et al., *Archives of the Royal Institution, Minutes of the Managers' Meetings,* 15 Feb 1836, vol. 8, p. 401.

51 *JCD,* p. 39, Royal Institution Lecture I, 'The Origin of Landscape'.

52 *JCC5,* 185, JC/C Boner, 26June1835. JC writes abbreviated names here, thus: 'Messrs Ba _ Hol & [?]Larg...'

53 *JCC5,* 23–4, JC/GC, 2July1835.

54 *FDC,* 90, JC/JCC, 28Oct1833.

55 Peter Day (ed.), *The Philosopher's Tree, Michael Faraday's Life and Work in his own Words,* 1999, pp. 137–8. Hamilton, 2002, pp. 208–9.

56 *JCC5,* 197, JC/CB, 14Mar1836.

57 CRL, p. 331.

58 JC, Lecture IV, Royal Institution, 16 June 1836, 'The Decline and Revival of Landscape'. *JCD,* p. 69.

59 JC to WW, 15 June 1836, Wordsworth Library, Grasmere, G/1/13/4.

60 *JCC5,* 45, JC/WPurton, 28May1836.

44. Papa, remember how happy you were

1 *JCC5,* 10, GC/JC, 13Dec1832.

2 *JCC5,* 11, JC/GC, 14Dec1832.

3 *JCC2,* 379, Journal, 1 October 1825. *JCC5,* 15–16, JC/GC, 20Dec1833.

4 *JCC5,* 15, GC/JC, 18Dec1833.

5 *JCC5,* 16, JC/GC, 20Dec1833.

6 *JCC5,* 13, JC/GC, 9Dec1833.

7 *JCC6,* 62, JC/JFish, n.d. [Feb 1821]; *JCC5,* 27, JC/GC, 11Nov1835.

8 *JCC3,* 114–15, JC/CRL, 30Aug1834, & n.d. [early Sept 1834].

9 GR, 34.12-70.

10 *JCC5,* 23–4, JC/GC, 2July1835.

11 *JCC5,* 34, JC/GC, 16Sept1836.

12 *JCC4,* 278, JC/John Chalon, 29Oct1835. GR, 35.1, Tate Britain.

13 *JCC5,* 20, JC/GC, 8April1835.

14 *JCC1,* 289, AbramC/JC, 23April1835.

15 *JCC5,* 25, JC/GC, 3Aug1835.

16 Ibid.

17 *JCC2,* 398–9, Journal, 6Oct1825.

[18] *JCC5*, 30, JC/GC, 12Jan1836. *Arundel Mill and Castle, study*, GR, 37.2, Museum of Fine Arts, San Francisco.

[19] *JCC5*, 37, JC/GC, 17Feb1837. GR, 37.1, Toledo Museum of Art, Ohio. Swanbourne Mill belonged to the Duke of Norfolk. It was demolished in 1845.

[20] GR, 36.1, National Gallery, 1272.

45. As regular as a clock

[1] *JCC3*, 113, JC/CRL, 4Aug1834.

[2] *FDC*, 78, JC/GoldingC, 23Dec1825.

[3] *FDC*, 82, JC/MLC, 5July1831; CFP.

[4] *FDC*, 85, JC/JCC, 1Sept1833. Marianne Johnson: see *JCC5*, RBB note, p. 53.

[5] *FDC*, 90, JC/JCC, 28Oct1833.

[6] *JCC5*, 29, JC/GeorgeC, 16Dec1835.

[7] *JCC5*, 149, CB/CGC, 27Mar1833.

[8] *FDC*, 86–7, JC/JCC, 25Sept1833, & n.d. [soon after 25Sept1833]. The book JC is seeking for JCC is William Phillips, *Outlines of Mineralogy and Geology*, 1815, fourth edition 1826.

[9] *FDC*, 91, 92, JC/JCC, 28Oct1833, & n.d. [4Nov1833].

[10] *FDC*, 87–8, JC/JCC, 2Oct1833.

[11] *FDC*, 88, JC/JCC, 25Oct1833.

[12] GR, 34.71 & 72.

[13] *FDC*, 86, JC/JCC, 25Sept1833.

[14] CFP, Tate Archive. *JCC6*, 147, JC/JFish, 16Dec1823.

[15] *JCC5*, 34, JC/GeorgeC, 16Sept1836.

[16] *JCC5*, 144–5, JCC/CGC, 5Mar1833.

[17] *JCC*, 5, 20, JC/GeorgeC, 8April1835.

[18] *Alumni Cantabrigienses*, part 2, vol. 2, p. 112.

[19] *JCC5*, 143, JC/Thomas Pearce, n.d. [summer 1833].

[20] *JCC5*, 175–6, CGC/JCC, 10July1834.

[21] *JCC1*, 285, MaryC/JC, 19Nov1834.

[22] *JCC5*, 149, CB/CGC, 27Mar1833; *JCC5*, 176, CGC/JCC, 10July1834.

[23] *JCC5*, 27, JC/GeorgeC, 12Sept1835.

[24] *JCC1*, 294, AbramC/JC, 24May1835.

[25] *JCC5*, 27, JC/GeorgeC, 12Sept1835. The portrait of Charley is coll. Red House, Aldeburgh; GR, 35.40.

[26] *JCC3*, 129, JC/CRL, n.d. [Aug 1835].

[27] *JCC4*, 421, JC/DL, 6Sept1835.

[28] *JCC5*, 189, CGC/JC, n.d. [5/6 Sept 1835.]

[29] *JCC5*, 192, CGC/JC, 8Sept1835.

[30] *JCC4*, 154, JC/Dominic Colnaghi, 6April1827.

[31] *FDC*, 177, Sophia Noble/JC, 16Aug1834.

[32] *JCC3*, 147, JC/CRL, 25Feb1837.

[33] *JCC6*, 253, JFish/JC, 3Sept1829.

[34] *FDC*, 177, Sophia Noble/JC, 16Aug1834.

[35] Ibid.

[36] For fuller accounts of the children see *Discovery*, chs. 4 & 5, pp. 55–80, and Leslie Parris and Ian Fleming-Williams, Lionel *Constable*, Tate Gallery, 1982.

46. Time

[1] *FDC*, 303, Thomas Uwins/JC, 21[June]1835.

[2] *FDC*, 265, JC/Henry Pickersgill, 23May1836.

[3] *FDC*, 193, Francis Chantrey/JC, 29May1836.

[4] GR, 23.31 & 32, V&A, 835-1888 & 815-1888.

[5] *JCC5*, 34, JC/GeorgeC, 16Sept1836.

[6] *JCC5*, 32, JC/GC, 12May1836.

[7] *JCC5*, 37, JC/GC, 17Feb1837.

[8] *JCC3*, 142, JC/CRL, 29Oct1836.

[9] AGBI: *FDC*, 323; *JCC5*, 37, JC/GC, 17Feb1837.

[10] *JCC3*, 146–7, JC/CRL, 25Feb1837.

[11] *JCC5*, 52, W. George Jennings/JC, 13Sept1836. GR, 36.7, Tate Britain, 1275.

[12] *JCC1*, 304, AbramC/JC, 26Feb1837.

[13] *FDC*, 334, JC/Francis Moon, 28Feb1837.

[14] *JCC1*, 304, AbramC/JC, 26Feb1837.

[15] *JCC4*, 258, JC/Samuel Lane, Mar1837.

[16] Constable's address to the final life students to be taught in Somerset House, abstracted from CRL, pp. 261–2.

[17] CRL, pp. 262–3.

[18] *JCC4*, 437, JC/DL, 18Mar1837 [or a day or two later].

[19] *JCC4*, 437, JC/DL, [last week in] March1837.

[20] CRL, p. 265.

[21] Note by Alfred Tidey on the mount of a plan of the new RA, drawn by Constable for Tidey, 28 March 1837. CBA, Yale. See also *JCC4*, p. 303.

[22] Account of the death of John Constable, written out by Thomas Churchyard following a conversation with John Charles Constable and his uncle Golding Constable, 11 April 1837. V&A, NAL, MSL/1986/11. Published in Wallace Morfey, *Painting the Day, Thomas Churchyard of Woodbridge*, 1986, pp. 59–60.

[23] 'Magnesia and rhubarb' was an early nineteenth-century treatment for stomach conditions, marketed in the 1830s as 'Dr Gregory's Stomachic Powder'; see: www.rmg.co.uk/discover/behind-the-scenes/blog/medicine-chest-or-kitchen-cabinet

[24] A note on the opening pages of the family Bible initialled 'J.C.' records that John Constable died on 'April 1st at 2 o'clock in the morning 1837'. CFP, GH.

[25] CRL, *Autobiog. Recol.*, pp. 105–6.

47. I knew Mr Constable

[1] CRL, p. 266.

[2] CRL, *Autobiog. Recol.*, pp. 105–6.

3 Lancelot Archer-Burton was formerly Lancelot South; he changed his name by deed poll.
4 *Discovery*, p. 22.
5 Note in CFP, GH.
6 Extracts published as 'The Diary of John Charles Constable', *FDC*, 99–104.
7 *FDC*, 102.
8 Brief death notice: *Gent's Mag.*, vol. 1, p. 554, May 1841.
9 *JCC5*, 208, quoted by RBB.
10 Algernon Graves, *Royal Academy Exhibitors, 1769–1904*, 1904, vol. 2, pp. 123 & 125; Leslie Parris and Ian Fleming-Williams, *Lionel Constable*, Tate Gallery, 1982.
11 Emily (d.1839), John Charles (d. 1841), Alfred (d. 1853), Charles Golding (d. 1879), Maria Louisa (d. 1885), Lionel (d. 1887) and Isabel (d. 1888).

Select Bibliography

Biographies

Anthony Bailey, *John Constable – A Kingdom of his Own*, Chatto & Windus, 2006.

John Lloyd Fraser, *John Constable 1776–1837 – The Man and his Mistress*, Hutchinson, 1976.

Martin Gayford, *Constable in Love*, Fig Tree, 2009 (Penguin edn., 2010).

C. Lewis Hind, *Constable*, 1909.

Sydney J. Key, *Constable: His Life and Work*, 1948.

C. R. Leslie, *Memoirs of the Life of John Constable composed chiefly of his letters*, 1843, 2nd fuller edn. 1845. (The edition edited by Jonathan Mayne was published by Phaidon in 1951.)

Andrew Shirley, *The Rainbow – A Portrait of John Constable*, Michael Joseph, 1949.

Lord Windsor [Robert George Windsor-Clive, Earl of Plymouth], *John Constable RA*, The Makers of British Art series (ed., James Manson), 1903.

Documents

R. B. Beckett (ed.), *John Constable's Correspondence*, published by the Suffolk Records Society [SRS] and HMSO, 1962–1970:

1. *The Family at East Bergholt 1807–1837*, HMSO, 1962.
2. *Early Friends and Maria Bicknell (Mrs Constable)*, SRS, 1964.
3. *Correspondence with C. R. Leslie, R.A.*, SRS, 1965.
4. *Patrons, Dealers and Fellow Artists*, SRS, 1966.
5. *Various Friends, with Charles Boner and the Artist's Children*, SRS, 1967.
6. *The Fishers*, with a Preface by Geoffrey Grigson, SRS, 1968.
7. *John Constable's Discourses*, SRS, 1970.

W. P. Frith, *My Autobiography and Reminiscences*, 2 vols., 1887.

Kenneth Garlick, Angus Macintyre, Katherine Cave and Evelyn Newby (eds.), *The Diary of Joseph Farington, 1793–1821*, 17 vols., Yale, 1978–1998.

Leslie Parris, Conal Shields and Ian Fleming-Williams (eds.), *John Constable: Further Documents and Correspondence*, Tate Gallery and SRS, 1975. (With a tribute to R. B. Beckett by Norman Scarfe.)

Richard and Samuel Redgrave, *A Century of Painters of the English School*, 1866, new edn., Phaidon, 1947.

Tom Taylor (ed.), *Autobiographical Recollections by the late Charles Robert Leslie*, 2 vols., 1860.

Art historical studies

Kurt Badt, *John Constable's Clouds*, Routledge & Kegan Paul, 1950.

R. B. Beckett, *John Constable and the Fishers – The Record of a Friendship*, Routledge & Kegan Paul, 1952.

Mark Evans, *John Constable Oil Sketches*, V&A, 2011.

— *John Constable – The Making of a Master*, V&A, 2014.

— *Constable's Skies*, V&A, 2018.

Ian Fleming-Williams, Leslie Parris and Conal Shields, *Constable: Paintings, Watercolours and Drawings*, Tate Gallery, 1976.

Ian Fleming-Williams and Leslie Parris, *Lionel Constable*, Tate Gallery, 1982.

— *Constable*, Tate Gallery, 1991.

— *The Discovery of Constable*, Hamish Hamilton, 1984.

Martin Gayford and Anne Lyles, *Constable Portraits – The Painter and his Circle*, National Portrait Gallery, 2009.

Robert Hoozee, *L'opera completa di Constable*, Milan, 1979.

Richard Humphreys, *John Constable – The Leaping Horse*, Royal Academy of Arts, 2018.

Judy Crosby Ivy, *Constable and the Critics, 1802–1837*, Boydell Press, 1991.

Shân Lancaster (ed.), *Constable and Brighton – 'Something out of nothing'*, Scala Arts and Heritage, 2017.

Anne Lyles, Sarah Cove, John Gage and Charles Rhyne, *Constable: The Great Landscapes*, Tate Britain, 2006.

Anne Lyles and Matthew Hargreaves, essays in *Late Constable*, Royal Academy, 2021.

Wallace Morfey, *Painting the Day – Thomas Churchyard of Woodbridge*, Boydell Press, 1986.

Patrick Noon (ed.), *Constable to Delacroix – British Art and the French Romantics*, Tate, 2003.

Graham Reynolds, *Constable – The Natural Painter*, Cory, Adams & Mackay, 1965.

— *Catalogue of the Constable Collection*, V&A, 1960.

— *The Early Paintings and Drawings of John Constable*, Yale, 1996.

— *The Later Paintings and Drawings of John Constable*, Yale, 1984.

Michael Rosenthal, *Constable: The Painter and his Landscape*, Yale, 1983.

— *Constable*, Thames & Hudson World of Art series, 1987.

Conal Shields, Peter Bower, Michiel Plomp and Terry van Druten, *John Constable*, Teylers Museum, Haarlem, 2020.

David H. Solkin (ed.), *Art on the Line – The Royal Academy Exhibitions at Somerset House 1780–1836*, Yale University Press, 2001.

Basil Taylor, *Constable: Paintings, Drawings and Watercolours*, Phaidon, 1973.

John E. Thornes, *John Constable's Skies*, University of Birmingham Press, 1999.

William Vaughan, *Constable*, Tate, 2002.

Timothy Wilcox, *Constable and Salisbury – The Soul of Landscape*, Scala, 2011.

Andrew Wilton, *Constable's 'English Landscape Scenery'*, British Museum, 1979.

Local studies

Olive Cook, *Constable's Hampstead,* Camden History Society, 1976, new edn. revised and updated by Marilyn Green and Christopher Wade, 2003.

J. F. Elam, *St Mary's Church, East Bergholt – A Building and its History,* East Bergholt PCC, 1986.

Brenda Gamlin, *Old Hall, East Bergholt – The Story of a Suffolk Manor,* East Bergholt Society, 1995.

Heritage Collective Group UK, *Historic Landscape Study of East Bergholt and the Cultural Legacy of John Constable,* eds. Claire Browne and Anne Johnson, HCUK Group, on behalf of East Bergholt Parish Council, 2020.

Christopher Wade, *The Streets of Hampstead,* Camden History Society, 2000.

Film and websites

East Anglian Film Archive, *A Kingdom of My Own,* BBC film, 1962, 30 mins. Script by Norman Scarfe and Malcolm Freegard. Produced by Malcolm Freegard. Available at: www.eafa.org.uk/catalogue/223

The East Bergholt Society, see: www.ebsoc.co.uk

Charles Rhyne, *Constable – Towards a Complete Chronology,* 1990. Available at: www.reed.edu/art/rhyne/papers/jc_chronology.pdf

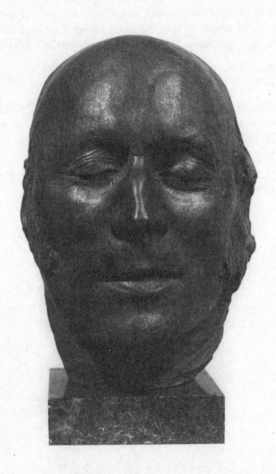

Death Mask of John Constable
by Samuel Joseph, 1837.
Royal Academy of Arts, London

Index

John Constable is referred to as JC throughout. Illustrations are denoted by an asterisk*.